POSTMODERNISM

STYLE AND SUBVERSION, 1970–1990

POSTMODERNISM

STYLE AND SUBVERSION, 1970–1990

Edited by Glenn Adamson and Jane Pavitt

V&A Publishing

Exhibition supporters

Founded in 1976, the Friends of the V&A encourage, foster, assist and promote the charitable work and activities of the Victoria and Albert Museum. Our constantly growing membership now numbers 27,000, and we are delighted that the success of the Friends has enabled us to support *Postmodernism: Style and Subversion, 1970–1990*.

Lady Vaizey of Greenwich CBE
Chairman of the Friends of the V&A

The exhibition is also supported by

Published to accompany the exhibition
Postmodernism: Style and Subversion, 1970–1990
at the Victoria and Albert Museum, London
24 September 2011 – 15 January 2012

First published by V&A Publishing, 2011
Victoria and Albert Museum
South Kensington
London SW7 2RL
www.vandabooks.com

Distributed in North America by Harry N. Abrams Inc., New York
© The Board of Trustees of the Victoria and Albert Museum, 2011

The moral right of the authors has been asserted.

Hardback edition
ISBN 978 1 85177 659 7

Paperback edition
ISBN 9781 85177 662 7

Library of Congress Control Number 2011923018

10 9 8 7 6 5 4 3 2 1
2015 2014 2013 2012 2011

Front jacket/cover illustration: Jean-Paul Goude and Antonio Lopez, Constructivist maternity dress, 1979. Worn by Grace Jones (detail of pl. 4)

Design
A Practice for Everyday Life

Copy-editor
Denny Hemming

Index
Hilary Bird

New photography by Richard Davis
and the V&A Photographic Studio

Printed in Singapore

V&A Publishing
Supporting the world's leading museum of art and design, the Victoria and Albert Museum, London

CONTENTS

Glenn Adamson and Jane Pavitt

CURATORS' FOREWORD

It may seem strange or even perverse for a large public institution like the V&A to tell the story of postmodernism. After all, this 'style' and the ideas that gave rise to it were explicitly antagonistic to authority. Postmodernism's territory was meant to be the periphery, not the centre. Its artefacts resist taxonomy, and its episodic cadence defies the orderly impulse of the historian. Yet exhibitionism was also a defining characteristic of postmodernism. Postmodern objects were often designed with their own mediation in mind, and circulated rapidly through magazine covers, music videos and mainstream feature film. Alessi's production of limited edition silver tableware in the 1980s, for example, was in part aimed at curators. The collection was sold directly to institutions eager to present the roll-call of postmodern architects through exhibition-friendly objects.[1] Postmodernism was often made with its own museumification in mind, and was supremely self-regarding in its methods, often circling back on its own tracks (pls 1 and 2). In reproducing postmodernist objects in this book, and placing them on exhibition plinths under hot lights for the viewing pleasure of thousands, we feel we are making them right at home.

Postmodernism: Style and Subversion, 1970–1990 follows several other major V&A exhibitions that have tackled the 'grand narratives' of twentieth-century style: Art Nouveau, Art Deco and Modernism amongst them.[2] Yet we consider our project to be unique within this series; given the slippery nature of postmodernism and the toxicity still associated with that word,

our venture might well be seen as a fool's errand. The assertive title we have chosen, with fixed and tidy dates appended to it, certainly does not seem to be getting into the spirit of the thing. Why begin in 1970 when many of our protagonists (Robert Venturi and Denise Scott Brown, Tadanori Yokoo, Ettore Sottsass) had made their key 'departure' works before that date (works that are found in the book and exhibition anyway)? Why close in 1990, years before the substantial impact of postmodernism had manifested itself upon vast swathes of China, India and the Gulf States? Singapore, Beijing and Dubai are arguably more postmodern now than Milan and London ever were.

So the choice of our 20-year span may be artificial. But it is also deliberate. By attending in detail to this fast-paced period of time, we can assess the phenomenal range and penetration of postmodern practice. Milan and London in the 1970s – not to mention New York, Tokyo, Los Angeles, Berlin and Sydney – would not have recognized their 1990s selves. The boom-bust turbulence of the postmodern moment left society, industry and even individuals' sense of selfhood fundamentally changed. From the 'years of lead' (as the 70s recession was known in Italy) to the 'designer decade' of the 80s, the economic policies and effects of late capitalism (to use a more specific nomenclature, Reaganomics and Thatcherism) were in a way the engines of postmodernism. But it was also powered by radicalism and resistance, which were established before inflationary culture took hold.

Right: 1
Tadanori Yokoo,
A la Maison de M. Civeçawa (To the Shibusawa House), poster for the Garumella Company, 1968. Silkscreen.
V&A: E.43–2011

Far right: 2
Tadanori Yokoo,
The Great Mirror of the Dance as an Immolative Sacrifice, poster for the Garumella Company, 1968. Silkscreen.
V&A: E.44–2011

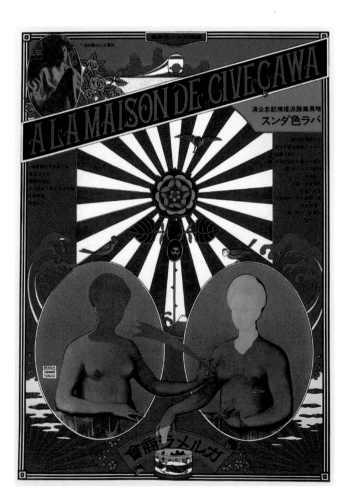

Our choice of dates is also meant to focus attention on the period immediately prior to the arrival of the World Wide Web (publicly available for the first time in 1991). Postmodernism was a pre-digital phenomenon. Yet one of its greatest distinctions was its anticipatory nature. Even though the arrival of the Apple Mac in 1984 started to transform graphic design, postmodernism was first achieved by conventional methods – paper, scissors and glue – and distributed by print, post and fax. The products and images of postmodernism, however, presaged the non-space of the screen and the clicking, hopping and surfing rhythms of hypertext. As Paul Greenhalgh says at the end of this book, postmodernism stands in relation to our own moment as the Steam Age did to its own oil-powered future.

Thirty years after the apex of the postmodern episode, it seems high time to sort out exactly what happened. Before plunging in though, it is worth mentioning three things this project has *not* tried to achieve. A first proviso: this is not a history of art or literature. As curators in a design museum, we have given ourselves permission to use paintings, sculpture and novels as an accompaniment or adjunct (much as our colleagues in other institutions tend to use chairs and teapots). Having said this, we have gladly exploited the fact that artists and writers in this period were very attentive to the language of design. Graphics in the work of Barbara Kruger and Jenny Holzer; commodities in the sculpture of Ai Weiwei, Ashley Bickerton and Haim Steinbach – these played a key role in eroding disciplinary lines between fine art and design, anticipating today's more fluid creative landscape (pl. 3). We include them here, partly as a way of indicating postmodernism's contribution to that relaxation of categories, and partly as a helpful commentary on the course of postmodern design. The latter motivation has also prompted us to engage in the quintessential postmodern tactic of the untethered quotation, pulling apt phrases from fiction, lyrics and theory.

Secondly, we have taken our subject to be postmodernism rather than postmodernity in general – that is, a set of intentional design strategies, not the overarching condition that made them possible.[3] We have not tried to write the history of Chicken McNuggets or nouvelle cuisine, for example, or shoulder pads or cocaine – though these examples of 1980s material culture could justifiably be described as postmodern. While we have tried to be acutely aware of shifts in attitude to history, identity and money over the course of these two decades (which social theorist David Harvey memorably summarized with the phrase 'time-space compression'), our emphasis throughout has been on design practice.[4]

A third, and final, note: the reader will not find anywhere in this book, or the exhibition it accompanies, a single handy definition of postmodernism. Recently, the critic Louis Menand noted that 'postmodernism is the Swiss Army Knife of critical concepts. It's definitionally overloaded, and it can do almost any job you need done.'[5] We recognize this flexibility as a strength, and do not believe that postmodern practice was ever carried out with precise parameters in mind. Our attempt has therefore been historical rather than definitional. We have tried to clearly set out, for the first time, the key practitioners, objects and techniques that make up this fascinating passage in design history. Doubtless any other curators would have picked a different path through the wreckage. But though we would make no claims about the definitiveness of this project, we would stand by its usefulness – the usefulness of assembling a postmodernism that is more than the sum of its many parts. Despite the seemingly vast literature on postmodernism produced in the 1980s and 90s, little that has been written on design extends beyond the standard survey text or hagiography. With a few exceptions in recent years, histories of postmodernism are surprisingly scarce. As curators, then, we started with objects, examining the whole circuit of design from production, through distribution and mediation, to consumption.

Like Robert Venturi and Denise Scott Brown, we have tried to uphold the values of both/and, not either/or. Postmodernism was both an extension and intensification of some aspects of Modernism, and a conscious departure from it. Moreover, its practitioners consciously played these two aspects against one another. They resisted classification, even running from the label 'postmodernism' itself as if it had turned back to bite them (which, indeed, it had a tendency to do). Amongst the many artists, designers, architects, performers and makers we have spoken to in the course of organizing this project, very few embraced the term with outright affection. The kaleidoscopic structure of this book – our own single narrative, accompanied by a 'heap of fragments', essays that are multi-vocal and wide-ranging, addressing the particular, episodic and personal – is the means by which we have sought to accommodate this complexity. This work has been informed by theory, but has not been in thrall to it. It has embraced the interdisciplinarity of postmodern practice whilst respecting the specificity of genre. Above all, it puts design at centre stage.

Opposite: 3
Haim Steinbach, *supremely black*, 1985. Plastic laminated wood shelf, ceramic pitchers, cardboard detergent boxes. Private collection

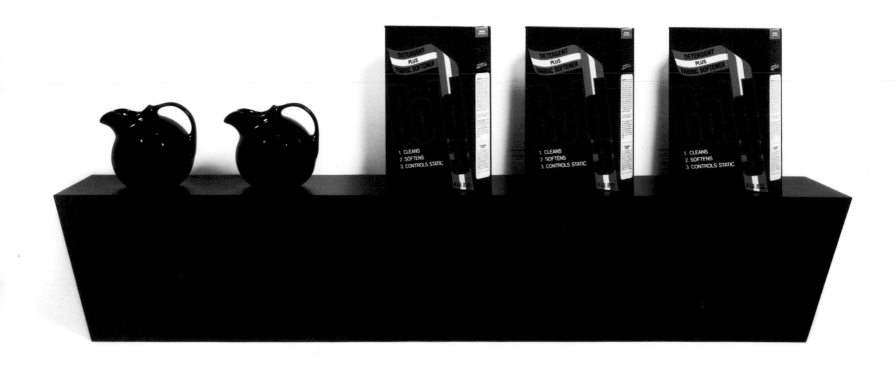

Glenn Adamson and Jane Pavitt

POSTMODERNISM: STYLE AND SUBVERSION

You may ask yourself, well, how did I get here?[1]
—*Talking Heads*

In 1985, art critic Hal Foster wrote: 'Postmodernism: does it exist at all, and if so, what does it mean? Is it a concept or a practice, a matter of local style or a whole new period or economic phase? What are its forms, effects, place?'[2]

By the time Foster posed these questions, there was no shortage of evidence of the forms, effects and place of postmodernism. Luxury tableware carried kitsch or historical motifs; TV advertisements were laden with ironic pastiche; public spaces bore the signs of 'Disneynification' or heritage styling; fashion had raided the dressing-up box to produce a mix of decadent looks. Nor was there a shortage of column inches devoted to postmodernism. Academics and journalists argued vociferously over its meaning. But what did this all add up to? If postmodernism was a territory, then it was contested. If it was a style, then that style was an agglomeration of all other styles. And by the time most people had heard of it, its demise had already been declared.

Foster might have added another item to his list of questions about postmodernism: 'And what is it called?' Postmodernism acquired an exhausting range of *noms de plume* and sub-genres: radical design, adhocism, counter-design, transavantgardism, neo-expressionism, radical eclecticism, critical regionalism. Similarly, the prefix 'post' was affixed to an assortment of social and theoretical constructs: one heard of post-industrialization, post-fordism, post-colonialism, post-disciplinarity, post-gender, even post-human.

The arrival of the 'post' signalled not only the end of grand narratives, but also the removal of certainty itself as a base of operations. Even at its peak in the mid-1980s postmodernism was hard to locate. Modernism had its manifestos and its schools, its camps and champions, and had been authoritatively claimed as a movement. Postmodernism, by contrast, was a collection of wry looks and ironic gestures. Modernists devised new windows on the world; postmodernists offered a shattered mirror. Modernism dreamt of utopian visions, which would transform society; postmodernism threw together a new look for a night on the town. Modernism declared itself to be beyond style (style was mutable, but Modernism was 'universal'). For postmodernism, style was everything. Instead of authenticity, postmodernism celebrated hybridity. In place of truth, postmodernism had attitude (pl. 4).

But if postmodernism was just a pose, it could nonetheless be found in almost every genre of creative and philosophical practice. During the 1970s, various fields claimed their own 'postmodern turn' – in film, dance and literature, for example – which marked either the crisis or the exhaustion of the avant-garde, as well as a renewed interest in sampling or quoting from the past. Nor did postmodernism occupy a series of niches. Its near-instantaneous spread meant that by the 1980s, postmodern style could be discerned not only in a building, a teapot or a poster, but also in a haircut, a poem, a music video or a dance step.

Despite its disciplinary diversity, postmodernism achieved its greatest visibility in architecture.[3] As Reinhold Martin has recently put it, architecture was postmodernism's 'avatar' – the form in which it was most frequently encountered.[4] As theory followed practice, early and influential formulations used architecture as a rubric to define postmodernism's terms of engagement.[5] Graphic design, the applied arts, fashion and styling, film: all were discussed in parallel to buildings as a way of understanding their own postmodern tropes. Architecture's 'postmodern turn' became the blueprint for other disciplinary histories: Rejection of high Modernism? Embrace of the popular, the 'low' and the kitsch? A prioritization of surface over depth, style over structure? Use of quotation, metaphor, plurality, parody? Check your work against Michael Graves' 1982 Portland Building and see (see pl. 208, p. 230).

Postmodernism also inhabited the peripheries of practice, often finding its most effective projections through the lenses of gender, race or identity politics. Perhaps unsurprisingly, this is one aspect of postmodern practice that did not take its lead from architecture. The postmodern reassertion of certain genres was a political act: the reclaiming of sewing and china-painting, for example, in the feminist artist Judy Chicago's landmark installation *The Dinner Party* of 1974–7; or quilt-making in David McDiarmid's *Disco Kwilts*, *c*.1980, ecstatic, sensual works celebrating the multi-ethnic club culture of 1970s Manhattan. Alongside such unique, one-off projects, postmodernism was favoured

4
Jean-Paul Goude and Antonio Lopez,
Constructivist maternity dress, 1979.
Worn by Grace Jones

by those involved in short-run, batch production, often with a high degree of artisanal involvement. Postmodernism came to the fore in genres such as furniture and interiors, glass, ceramics and metals in the late 1970s in Italy, and its influence spread across the world at an eye-watering pace. Late capitalist, post-fordist service culture could meet localized, specialist and traditional forms of production, shake hands, and do business. Postmodernism produced its own sort of subversive entrepreneur: post-punk British designer-makers fusing fashion, music and design; radical Italian and Spanish designers claiming the attention of family-run manufacturing firms; as well as more isolated figures like Pieter De Bruyne, single-handedly forging a pop historicist style in Belgium, or the Atika group in Prague, weaving together post-industrial aesthetics with Czech folk and surrealist traditions as a protest against a stultifying state-socialist culture (pls 5 and 6).

However, to understand postmodern design at its furthest extent we need to explore the more generic world of consumption – or over-consumption – that it engendered. For an image of this commodity-saturated world, it would be difficult to improve on the following passage from Bret Easton Ellis' *American Psycho* (1991), which describes the apartment of the novel's main character, the fashion- and technology-obsessed serial killer Patrick Bateman:

> Over the white marble and granite fireplace hangs an original David Onica. It's a 6×4 foot portrait of a naked woman, mostly done in muted grays and olives, sitting on a chaise longue watching MTV, the backdrop a Martian landscape, a gleaming mauve desert scattered with dead, gutted fish, smashed plates rising like a sunburst above the woman's yellow head, and the whole thing is framed in black aluminum steel. The painting overlooks a long white down-filled sofa and a thirty-inch digital TV set from Toshiba; it's a high contrast highly defined model plus it has a four-corner video stand with a high-tech tube combination from NEC with a picture-in-picture digital effects system (plus freeze-frame) ... A hurricane halogen lamp is placed in each corner of the living room. Thin white venetian blinds cover all eight floor-to-ceiling windows. A glass top coffee table with oak legs by Turchin sits in front of the sofa, with Steuben glass animals placed strategically around expensive crystal ashtrays from Fortunoff, though I don't smoke ... An Ettore Sottsass push-button phone [rests on a] steel and glass nightstand next to the bed.[6]

In this environment Bateman carries out the daily activities of a postmodern subject, reading his copy of *USA Today*, washing down his copious intake of pills with Evian, drinking grapefruit-lemon juice from a Baccarat St Remy wine glass, and listening to the new Talking Heads album. Easton Ellis' novel exemplifies the condition of postmodernity in its most terrifying form: consumed by self and status, and utterly lacking a moral compass. How *did* we get here? To answer that question, we need to return to an earlier imagining of death than the one presented in *American Psycho* – the death of Modernism itself.

Last Rites

> Let us then romp through the desolation of modern architecture, like some Martian tourist out on an earthbound excursion, visiting the archaeological sites with a superior disinterest, bemused by the sad but instructive mistakes of a former architectural civilisation. After all, since it is fairly dead, we might as well enjoy picking over the corpse.[7]
> —Charles Jencks

In 1978, the Chicago architect Stanley Tigerman produced a small photomontage entitled *The Titanic* in which Mies van der Rohe's 1956 Crown Hall at the Illinois Institute of Technology (Tigerman's alma mater) is shown capsizing in the smooth waters of Lake Michigan, frozen for a moment before its plunge to the depths (pl. 8). The death of Modernism had been proclaimed on countless previous occasions, most memorably by Charles Jencks, who located the moment to 3.32p.m. (or thereabouts) on 15 March 1972, when the notorious and crime-ridden Pruitt-Igoe modernist housing project in St Louis, Missouri, designed by Minoru Yamasaki in 1951, was dynamited (pl. 9).[8] Tigerman offered a more protracted farewell to the supposedly unsinkable certainties of the Modern Movement (see Emmanuel

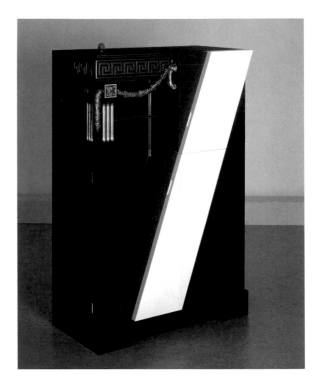

5
Pieter De Bruyne, *Chantilly* chest, 1975. Chipboard, lacquered in black, white and blue with section of historic furniture in ebony, partly gilded. Design Museum Gent (80/297 1/1)

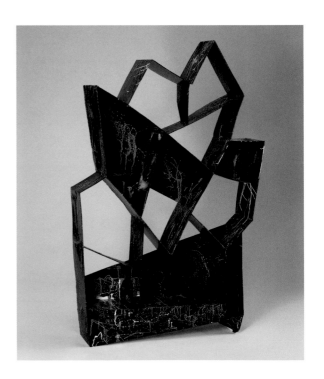

6
Bohuslav Horák (for Atika), *Labyrinth of Autumn* bookcase, 1987. Sheet steel and enamelling. Uměleckoprůmyslové Muzeum v Praze (Museum of Decorative Arts), Prague

7
Alessandro Mendini, *destruction of Lassù chair*, 1974

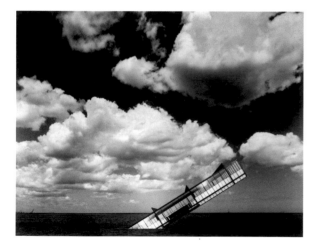

8
Stanley Tigerman, *The Titanic*, 1978.
Photomontage on paper. The Art
Institute of Chicago, Chicago, Illinois
(1984.802)

Overleaf: 9
Minoru Yamasaki, Pruitt-Igoe housing
project, 1954–5. St Louis, Missouri.
Demolition began at 3.32p.m., 15 March 1972

Petit's discussion of this on p. 124). Like a giant ocean liner set on its course, Modernism's turning circle had proven too wide to avoid impact with any obstacle fixed on its horizon.

Several years earlier, in 1974, in an empty industrial plot of land next to a furniture factory in Italy, the designer and impresario Alessandro Mendini poured gasoline over a chair of his own design, set it alight, and recorded the resulting funeral pyre for the cover of his radical architecture journal, *Casabella* (pl. 7). *Lassù* (meaning simply 'above the ground') was not so much a modernist chair as a platonic one – the kind a child might draw, of the most basic construction but mounted on steps like a throne. Its cremation underlined its ritual purpose: 'Its mass [was] reduced to ashes, and these were gathered; its life was closed with a rite: it passed from an object to a relic, from matter to memory.'[9] Mendini's projects at this time were Duchampian tributes to life's absurdities: a concrete suitcase for one's journey to the afterlife; a cast bronze desk lamp resembling a fossilized Bauhaus design; a transparent plastic chair full of soil, meant to invoke the basic human act of sitting on the ground – all graced the covers of *Casabella*.

Each of these gestures marked a moment in the long trajectory of dissatisfaction, beginning in the early 1960s, with the commercial and institutional mainstreaming of the Modern Movement. Tigerman's sinking of Mies was a 'killing of the father', as well as an attack on the academic hegemony of modernist architecture in America (enshrined in schools like IIT). Mendini's nihilism signalled an endgame, played out in Italian Radical Design in the late 1960s and early 70s. It staged the death of the 'beautiful objects' of Modernism, which had seamlessly and uncritically taken their place within the commercial nexus. Architectural Modernism in the post-war world, it seemed, had become detached from its early socio-political agendas and instead established itself as the style of choice for both corporations and the state. Reliant upon an exhausted faith in technology and a sterile vocabulary of industrial functionalism, Modernism could no longer claim legitimacy, relevance, or radicality. Nothing looks as dated as last season's future. Attempts in the 1960s to inflect the modernist utopian project with pop culture (by counter-cultural

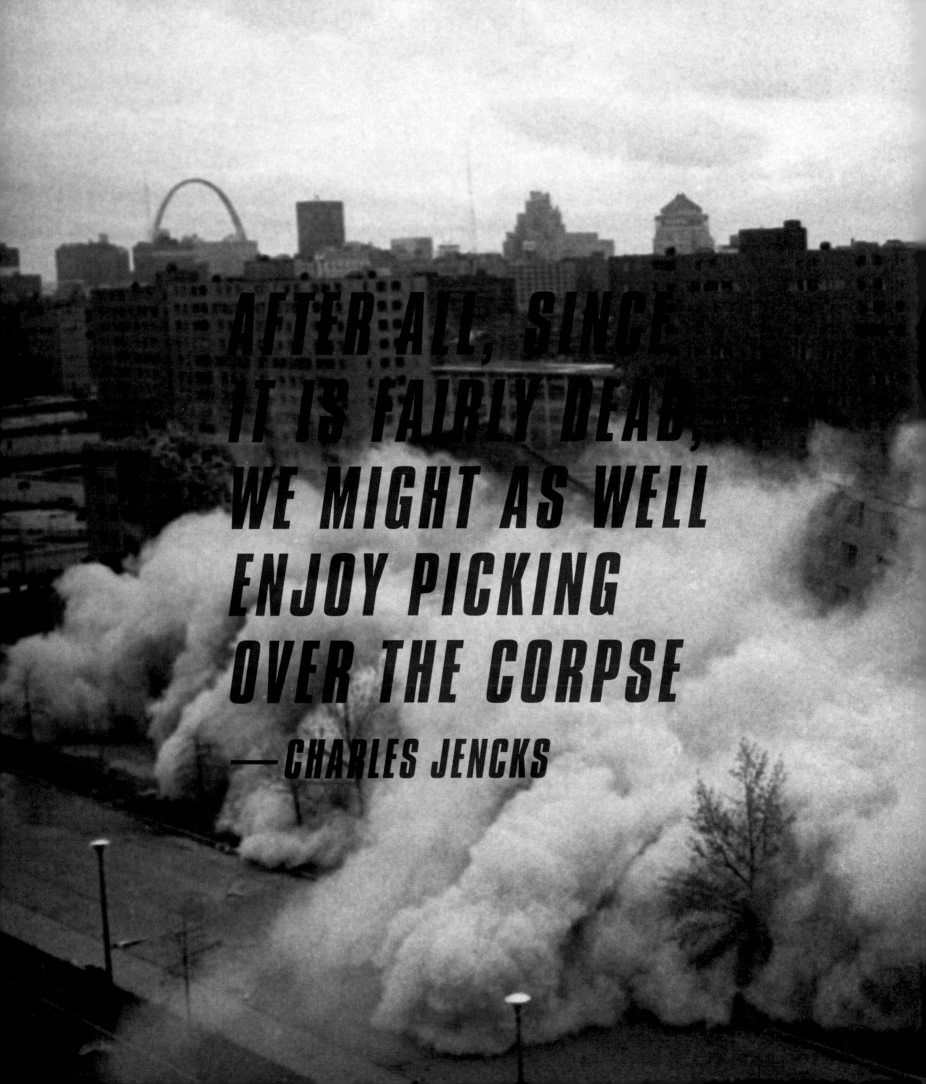

AFTER ALL, SINCE
IT IS FAIRLY DEAD,
WE MIGHT AS WELL
ENJOY PICKING
OVER THE CORPSE

— CHARLES JENCKS

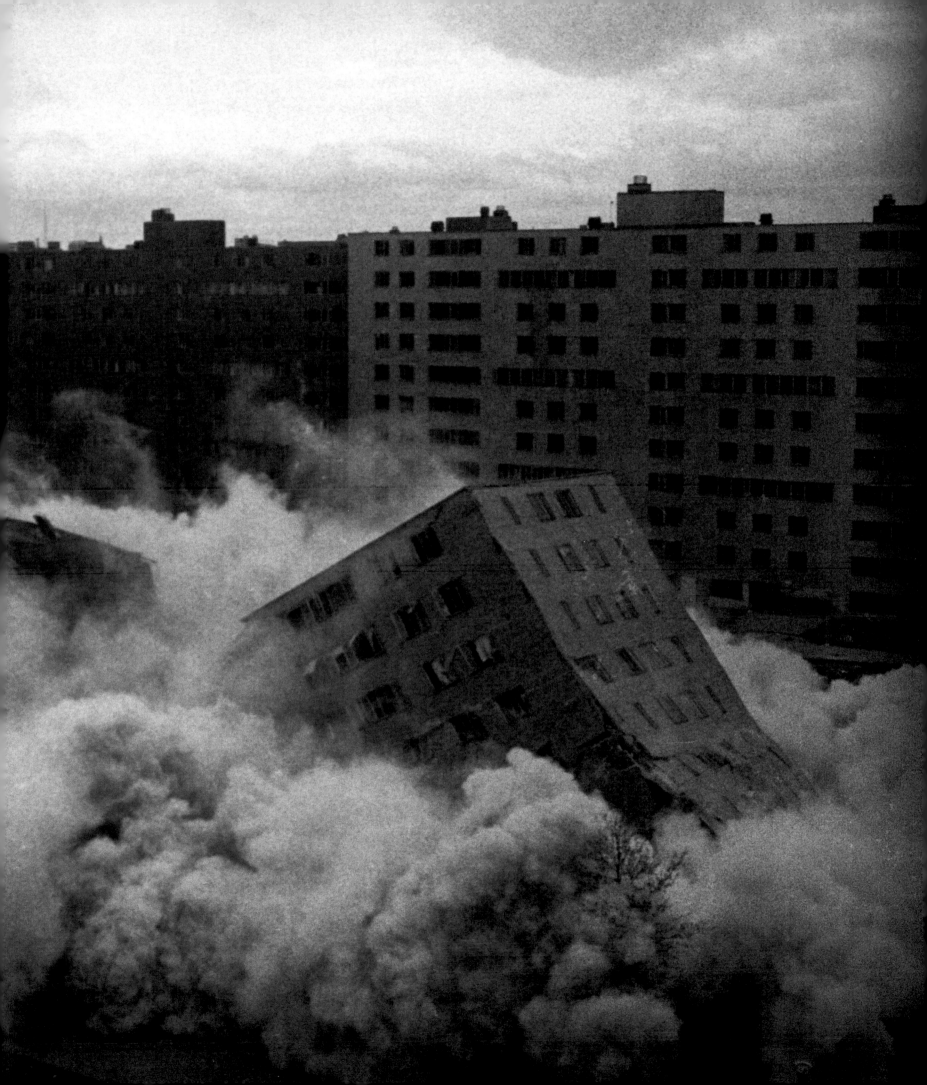

architectural groups such as Archigram, Archizoom and Superstudio) were derided as naive and anachronistic, a fetishization of technology.[10] Some of the most fervent attacks came from those who had themselves been participants. Jean Baudrillard, briefly a member of the French architectural/philosophical collective Utopie, turned his critical eye on the false consciousness of modernist architecture: 'Utopia is a luxury good, blinding us with its splendour.'[11]

Declarations of the many deaths of Modernism did not emanate from any fixed point, but rather from various quarters where architects and designers found themselves struggling to determine the relevancy of their practice both within, and in opposition to, the Modern Movement. But what were the alternatives? For some, the solution was to re-engage with the past, either through historicist architectural styles or by the exploration of the *experience* of architecture through ideas of place, memory and archetype. To elegiac effect, radical architects depicted modernity in ruins; Arata Isozaki's *Reruined Hiroshima* (1968) and Ettore Sottsass' *Planet as Festival* (1972), to name only two such imaginings, showed 1960s Space Age megastructures that had crash-landed onto a devastated or primordial earth.[12] For Isozaki, 1968, the pivotal year of political upheaval, brought Modernism to a dead-halt.[13] As Martin has put it, the 'unthinking of Utopia' became a central tenet of postmodernism.[14]

Road Trips and Gas Pumps

The alternative to the harsh responsibility of remaining faithful to the modern tradition lies not in pluralism, but in the open, courageous suicide proposed by Pop architecture, rejecting all cultural models, all open or closed orders, and returning to the primordial chaos, to triviality and artifice. Whoever decides to abandon the modern movement can choose between Versailles and Las Vegas, between sclerosis and drugs.[15]
—*Bruno Zevi*

For the Italian Marxist critic Bruno Zevi, abandoning Modernism could only result in a terrible choice between the binary poles of history and the vernacular, the highest art and the very lowest, grandeur and banality. In the eyes of architects like Charles Moore, Robert Venturi and Denise Scott Brown, however, that choice was a false and unnecessary one. All were in favour of 'both/and', rather than 'either/or,' in Venturi's famous formulation.[16] What was needed was a structure for the systematic analysis of both Versailles and Vegas (and, for that matter, the Campidoglio in Rome, A&P Parking Lots and the Miami Beach Modern Motel), which would allow them to be understood as phenomena of architectural communication.[17] Most American architects encountered the monuments of the past, in Rome, Athens and Venice, through the words of historians like Rudolf Wittkower, Colin Rowe and Vincent Scully.[18] Some got to Europe to see for themselves. (Long before his Damascene trip to Vegas, Venturi had spent two years in Italy as a recipient of the Rome Prize, awarded to architectural students by the American Academy in Rome.)

Moore found what he needed in his native California. His concern for a sense of place in architecture (as an embodiment of memory and history) took in Californian-Spanish, neo-colonial and Beaux-Arts architectural styles as well as local adobe architecture, suburban tract housing and the pseudo-public spaces of Disneyland. Moore advocated 'an architecture of inclusion', talking about the Piazza San Marco in Venice and the Madonna Inn, a tourist destination in San Luis Obispo, California, in (almost) the same breath (pl. 10).[19] The Inn, an exuberant pastiche of styles described by Umberto Eco as 'Archimboldi builds the Sagrada Familia for Dolly Parton',[20] was for Moore a moving and exhilarating 'architecture for the electric present' that gave its all and connected with the user in doing so.[21] The Madonna Inn exemplified the 'triviality and artifice' predicted by Zevi, and fulfilled the definition of kitsch as 'falsified nature' supplied by Gillo Dorfles in 1968.[22] It was both Vegas *and* Versailles. The same went for Disneyland, which Moore was prepared to settle for as a latter-day version of civic space, saying: 'Curiously, for a public place, Disneyland is not free. You buy tickets at the gate. But then, Versailles cost someone a great deal of money, too. Now, as then, you have to pay for the public life.'[23]

The mythic roots of early architectural postmodernism, it seemed, lay in such thrilling encounters with this world of popular 'low' taste, often experienced from behind a

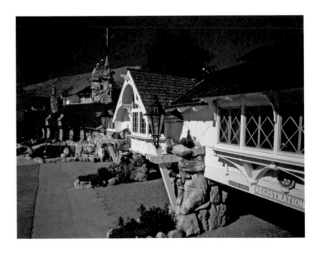

10
Alex and Phyllis Madonna, the Madonna Inn, San Luis Obispo, California. Opened December 1958
© Macduff Everton/CORBIS

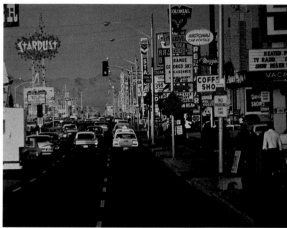

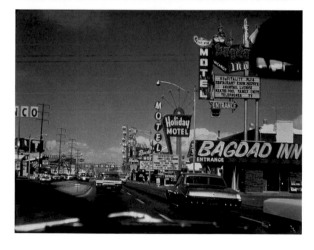

11
Las Vegas Strip, 1966. Photographs by
Robert Venturi and Denise Scott Brown

Overleaf: 12
Denise Scott Brown and Robert
Venturi in the Las Vegas desert, 1966

dashboard. The road trip had already been designated a modern rite of passage by writers like Jack Kerouac and Hunter S. Thompson. Route 66, Main Street and the Las Vegas Strip became familiar tropes in the literary accounts of the period, as did endless desert drives through California, across the Mojave Desert and down to Mexico, punctuated only by stops at service buildings along the route. From the Beat poets to Bob Dylan to Ken Kesey's Merry Pranksters (immortalized in Tom Wolfe's *The Electric Kool-Aid Acid Test* of 1968), the 1960s counter-culture took trips through a landscape of heightened contrasts – desert sun and neon light, hot rods and cacti, empty horizons and giant billboards – vistas often enhanced by psychotropic drugs. The architecture of signage, exemplified by the gas stations along Route 66, was immortalized in Dennis Hopper's 1969 film *Easy Rider* and inventoried by Ed Ruscha in his own road-movie-style artist's books, such as *Twentysix Gasoline Stations* (1962) and *Every Building on the Sunset Strip* (1966), a continuous folding strip of Los Angeles building façades photographed from the back of a pick-up truck. Ruscha's deadpan documentary method, with its lack of hierarchy and anthropological attitude to the urban landscape, had much in common with the image-making and research methods of Venturi and Scott Brown, working on their own inventory of the landscape of Las Vegas.

Vegas, with all its excess and pastiche, was the paradigm of rampant consumerism and celebrity.[24] Glimpsed from a heat-hazed highway, the billboards, gas stations and one-night-stop motels on the approach to the city seemed to announce a new kind of architectural order (pl. 11). The sensory overload experienced by the Vegas visitor was captured by Wolfe in his hilarious account for *Esquire* magazine in 1964: 'Las Vegas (What!) Las Vegas (Can't Hear You! Too Noisy) Las Vegas!!!', which evoked, above all, the competitive noisiness of the city's signage. Wolfe put it succinctly: 'Las Vegas is the only town in the world whose skyline is made up neither of buildings, like New York, nor of trees, like Wilbraham, Massachusetts, but signs.' Vegas fitted the hybridity and vitality that Venturi had called for in his so-called 'Gentle Manifesto' – *Complexity and Contradiction in Architecture*, written in 1962 and published in 1966. This levelling of cultural distinctions between high and low and his embrace of 'messy vitality over obvious unity' was borne out in Venturi and Scott Brown's socio-anthropological study of Vegas, carried out in the late 60s and published, with Steven Izenour, as *Learning from Las Vegas* in 1972. The book presented the Strip deadpan, in the manner of Ruscha, but also investigated its implications for urban planning in general.

Much of this was the contribution of Denise Scott Brown, who had taken a diversionary route on her way to Vegas. Born in South Africa and educated at the Architectural Association in London, she met Venturi at the University of Pennsylvania, where both were students of Louis Kahn. Whilst at Penn, she studied urban planning with social scientist Herbert Gans, best known for his case study of 1950s suburbia, Levittown.[25] When she went to teach at University of California, Los Angeles (UCLA) in 1965, she became interested in the way that West Coast cities 'seemed to hint at a new architecture for changed times'. She recalls the 'aesthetic shiver', composed of both 'love and hate', for an environment 'as beautiful as it was ugly'.[26] She invited Venturi to co-teach with her at UCLA, and then to join her on a road trip to Vegas (pl. 12). Arriving in a rental car along Route 91, the neon signs and blatant advertisements for the pleasures of the city shocked them into a new evaluation of the communicative power of the built landscape. She recalled, some years later: 'Dazed by the desert sun and dazzled by the signs, both loving and hating what we saw, we were both jolted clear out of our aesthetic skins.'[27]

Precisely because it was not overlaid on top of pre-existing urban patterns, the pop-up architecture of Las Vegas offered an unadulterated version of American vernacular: the effects of unregulated development in an automotive age. Just as the pioneers of modern architecture in the 1920s had found a new order in industrial forms (steam ships and aeroplanes), Las Vegas offered a recalibration of architecture. The city had evolved a new kind of symbolism, designed to be read while the body was travelling at 35 miles an hour, so that buildings acted as billboards, and parking lots as public piazzas. *Learning from Las Vegas* was an argument for the power of semiotics over space, assessing the visual architecture of the 'big sign and the little building'. But the book was neither a celebration nor an aestheticization. They were well aware that the Strip could be seen as sensorially deafening, as Wolfe had put it, and also aesthetically bankrupt, part of what critic Peter Blake acerbically referred to as 'God's own junkyard'.[28] Yet they asked the question: 'Is not

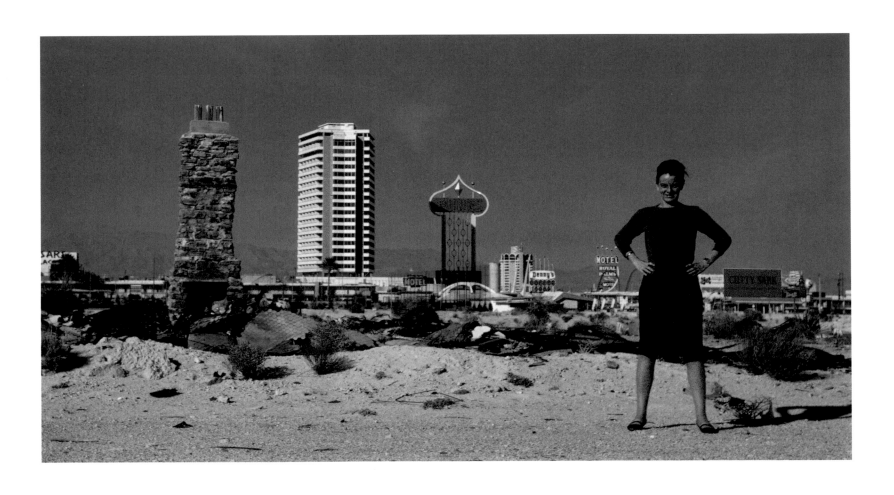

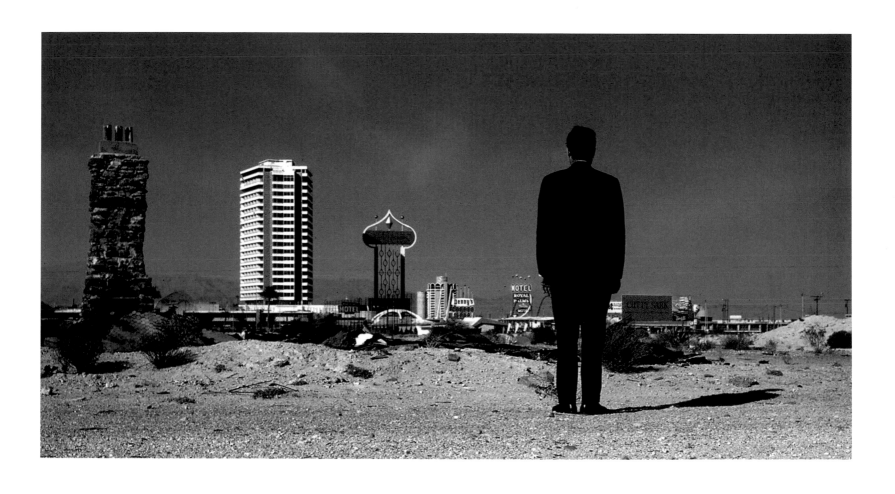

Main Street almost all right? Indeed, is the commercial strip of a Route 66 almost all right? What slight twist of context will make them all right?'[29]

Americans were not the only ones hitting the road in the 1960s. The Italian architect and designer Ettore Sottsass, Jr took an extended trip around India with his first wife, the literary translator and editor Fernanda Pivano, in 1961. He later described the journey as a search for origins and an exploration of the sensory (rather than the rational) terms of existence; India expanded his understanding of the connections between objects and the rituals of daily life. The colours, forms, language and mystical references of Indian culture reverberated in his work for decades to come. They were fused with a heady embrace of the pop and beatnik impulses of the 1960s, which he encountered on trips to the United States, crossing paths with the Beat poets Allen Ginsberg, Michael McClure, Neal Cassady and others (connections made through Pivano, translator and friend to the Beat generation).[30] These encounters came about after Sottsass was diagnosed with a life-threatening illness in 1962, on his return to Italy from India. The intervention of his friend and employer, Roberto Olivetti, arguably saved his life, as Olivetti paid for Sottsass to fly to Stanford University in California for specialist treatment. From his sickbed, Sottsass began a journal with Pivano, which they titled *Room East 128 Chronicle* (after his hospital room), largely as a means of keeping in touch with friends. The journal, hand-collaged and manually printed, offered updates on Sottsass' treatment and observations on American popular culture. Convalescing, Sottsass joined Pivano in San Francisco for a time, where she was working with Ginsberg.[31] The libertine tendencies of the Beat generation, their experimental lifestyles, fascination with Eastern mysticism and nomadic attitude to life, all influenced the course of his practice in subsequent years.[32]

On his return to Italy, Sottsass channelled his newfound interests into a series of ceramic works. The first, entitled *Ceramics of Darkness* (1963), and subsequent collections (*Offerings to Shiva*, 1964; *Tantric Ceramics*, 1968; and *Yantras of Terracotta*, 1969) employed a system of cosmological signs that allude to meditation, the relationship between the individual and the universal, and symbolic sexual union – all drawn from an amalgam of Hindu and Buddhist traditions. This fascination with non-Western culture offered a way out of the strictures of modernist practice which was rooted in the sensorial, and which he also equated with the easy pleasures of life encountered in America. These thoughts culminated in a collection of large-scale ceramic works shown first at the influential Sperone Gallery (known for exhibiting Pop Art and Arte Povera) in Turin and then Milan, and collectively titled *Menhir, Ziggurat, Stupas, Hydrants and Gas Pumps* (pls 13 and 14). In his series of lithographs *Planet as Festival* (1972–3), he imagined buildings which, like his ceramics, were containers for the pleasures of life: 'super-instruments' in which to take drugs, have sex, listen to music and watch the stars, in the form of Aztec temples, Indian shrines and giant teapots. In the series entitled *Indian Memories* of 1973, these temples shrink to actual teapots once more. Sottsass' objects are high-grade hits of signification, extracted from his imaginary planetary landscape and compressed to the scale of tableware (pl. 15).

Years later, Sottsass recalled his zest for life, rediscovered after his near-death experience, which had motivated the production of the works:

> I want to concentrate on life, I want to bring it into my mind, I want to make a bonfire, a signal, a pole, a pivot, a center, a mandala that will make me concentrate on life, I want to build myself a colossal phallus, dear Shiva, my friend, with an orange flower on its head, around which to stop or travel or sing songs like the saints of Nepal that fly over the valleys, or play gigantic trumpets, or cultivate gardens or scatter seeds, the seedman's and mine. I want to make myself a filling pump where I can fill up forever on 4-star fuel, fill up my veins and set them alight. I want to build myself a temple to deposit biscuits in, immense plates of meringues and cream for the gods of sleep.[33]

Sottsass' use of the symbolic languages of India did not mark a wholesale rejection of Western consumerism, but rather a re-calibration of his understanding of the relationship between people and things. He was struck particularly by the associative values of American goods, and how these were played out in Pop Art (Paolo Thea refers to Sottsass' idea of 'semantic charge' around certain objects).[34] His 'menhirs and gas pumps' were containers for the pleasures of the everyday, as well as monuments to life's absurdities; receptacles for

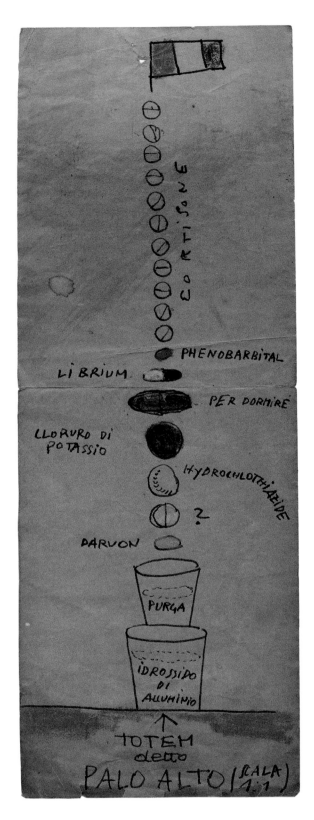

13
Ettore Sottsass, *Totem of Palo Alto*, 1962. Ink and pastel drawing on paper. Private collection

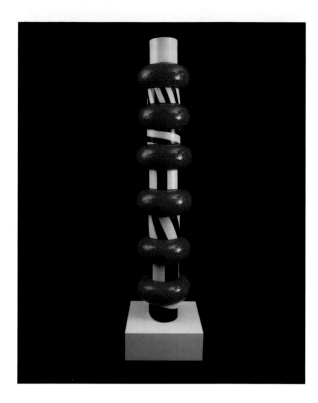

14
Ettore Sottsass, Totem, 1967. Ceramic
with pedestal and threaded attachment
rod. Private collection

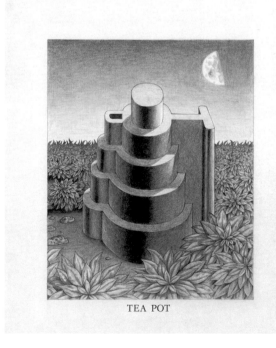

TEA POT

15
Ettore Sottsass, Study for Tea Pot
(rendered by Tiger Tateishi), 1973.
Graphite and self-adhesive letters
on paper. The Museum of Modern Art,
New York (1308.2000)

contraceptives, cigarettes, drugs, memories and ashes. Like his compatriot Mendini, Sottsass was beginning to redefine the terms under which design could be seen to operate. Back in Italy, he too found himself at the centre of a movement that came to be known as Radical Design (or Counter-Design). According to Sottsass, Mendini and others of their generation, design could be provocative and conceptually challenging; it could address social norms, market imperatives and assumptions of taste in critical ways. Radical Design had all the hallmarks of an avant-garde call to arms: 'We want to bring into the house everything that has been left out,' proclaimed the group Archizoom, 'contrived banality, intentional vulgarity, urban fittings, biting dogs.'[35]

Radical Design was a product of hard times. For Italy, the 1970s were the bleakest decade since the war: a time marked by intellectual crisis, a wave of domestic terrorism and severe economic recession. 'My personal view of the future is mainly pessimistic,' said Mendini in 1976. 'I belong to those groups of people who have not torches to throw their beams into the future.'[36] As industry suffered, both designers and manufacturers devised novel means to subsist. Radicalism appeared in the guise of the group Global Tools (active 1973–6), a collective that saw itself as a kind of incubator for design outside of commercial constraint. Almost everyone who was ever associated with Radical Design in Italy took part – Mendini, Sottsass, Gaetano Pesce, Ugo La Pietra, Riccardo Dalisi and Andrea Branzi, to name a few. Together they sought to reconnect design with essential themes such as the body, basic skills of making, communication and survival.[37]

Though Global Tools was partly motivated by frustration with the lack of commercial opportunity, it was also strongly anti-consumerist. Most of the figures associated with the group were politically on the left, and were profoundly suspicious of late capitalist society (despite designing products for its markets). Believing design to be an instrument by which social change could be achieved, they largely ignored the collusive nature of their profession. Some saw the contradiction. Italy's foremost Marxist critic, Manfredo Tafuri, argued in his 1973 essay 'Architecture and Utopia' that the inevitable fate of modern architecture and of the avant-garde was to collapse into the very system it professed to critique. Tafuri could see no way out of this crisis. The utopian project was unsustainable, and competing modes of practice, which had risen up to challenge the rationalist basis of Modernism, were merely cul-de-sacs in its ongoing development:

> The 'fall' of modern art is the final testimony of bourgeois ambiguity, torn between 'positive' objectives and the pitiless self-exploration of its own objective commercial-ization. No 'salvation' is any longer to be found within it: neither wandering restlessly in the labyrinths of images so multivalent they end in muteness, nor enclosed in the stubborn silence of geometry content with its own perfection.[38]

Tafuri's criticisms were aimed at bigger fish than the Italian design radicals, but he did single out Sottsass' work for its 'erotic exhibitionism'.[39] Here he put his finger on the designer's conflicted position, caught between his commissions for industrial firms and his role as *agent-provocateur* extraordinaire. Indeed, despite his close and symbiotic relationship with firms like Olivetti, Sottsass himself spoke in jaded terms about the state of professional design:

> Now that I am old, they let me design electronic machines and other machines of iron, with flashing phosphorescent lights and sounds which could be cynical or ironic. Now I am only allowed to design furniture which sells, furniture – they say – of some use, use to society – they say – so they sell more – for society – they say – and so I am now designing things of this kind. Now they pay me to design them. Not much, but they pay me.[40]

This tone of weary cynicism would not last, as we shall see. The harsh experiences of these years would eventually propel Sottsass towards Memphis, a design experiment in which the commercial and the conceptual merged. But in the 1970s, architecture was the main platform on which the discourse of postmodernism developed in critical and academic terms – not only in Italy, but in the United States, Britain, France and Germany as well.

The Presence of the Past

> I am very fond of ruins. [T]hey're what's left, all that is granted us by the unknown ...
> of thoughts, of plans, of hopes.[41]
> —*Ettore Sottsass*

From our twenty-first-century perspective, it is perhaps hard to imagine why the use of past styles in architecture would provoke such antipathy. Why would an exhibition of nineteenth-century architectural drawings in a modern museum be denounced as an act of sacrilege? Why might use of a seemingly innocuous stylistic idiom be taken as an act of daring provocation? Yet the architectural discourse of the 1970s was littered with such arguments and schisms. Whilst the revival and re-use of historical styles was a component of postmodern practice, it was generally distinct from historicism as such – the continued veneration of classical or Gothic architecture. The architects of the postmodern era employed history, but knew they could not ignore or unlearn the statutes of Modernism. They ran the gamut from academicism to parody, some applying complex coding to their evocation of past styles, others displaying a slap-happy delight in the plundering of a rich box of stylistic tricks.

Critics were divided. From the Marxist perspective of Tafuri, for example, postmodernism was less about the death of modern architecture (it had died already, he thought) and more about the impossibility of meaningfully replacing it, at least until society itself changed. '[N]othing remains,' said Tafuri, 'but to gather around the hearth to listen to the fables of the new grannies.'[42] The German philosopher Jürgen Habermas, speaking after the opening of the first architectural Biennale in Venice in 1980, denounced its international roll call of postmodernists as an 'an avant-garde of reversed fronts', who had 'sacrificed the tradition of modernity in order to make room for a new historicism'.[43] In Habermas' view, Modernism was not dead, only temporarily exhausted. Its progressive vision could be renewed only through constant critical appraisal, not evasion and retreat.

Other writers were intent on repositioning the relationship of Modernism to history, by establishing the presence of the past that existed within modern architecture itself. Historians like Colin Rowe and Vincent Scully both drew parallels between classical precedents and twentieth-century figures such as Le Corbusier and Mies van der Rohe.[44] Rowe's 1947 essay 'The Mathematics of the Ideal Villa' was a formalist analysis of the commonalities between the classical and the modern (specifically Palladio's Villa Malcontenta and Le Corbusier's Villa de Monzie), and was to have an abiding influence upon the revival of formalism in architecture in the 1970s. Scully's landmark study *The Shingle Style* (1955) analysed formal and spatial developments in nineteenth-century domestic buildings in a way that argued against the functionalist reading of architectural history. Scully, not surprisingly, became an early champion of Venturi and Scott Brown, in whose work he recognized the legacy of this American tradition. These ideas took root in academic institutions, first in the United States (Rowe at Cornell and Scully at Yale), and also in the pages of architectural journals, as historians were called upon to debate the future of modern architecture. Scully went head to head with the writer Norman Mailer in the pages of *Architectural Forum* in 1964, defending modern architecture against Mailer's charge that it was ruthlessly totalitarian and intent on destroying the past.[45] Whilst Scully argued for a more sympathetic view of Kahn, Frank Lloyd Wright and other leading American moderns, the basis of his position in the 1960s was to call for a more contextually aware modern architecture. As this new generation of architectural historians were well aware, context was everything.

Context was one reason for the stir created by an architectural exhibition at the Museum of Modern Art in New York in 1975. MoMA, a champion of avant-garde architecture since the 1920s and a bastion of modernist orthodoxy, took the unexpected step of staging *Architecture of the Ecole des beaux-arts*, a spectacular exhibition of drawings from the nineteenth-century tradition of neoclassical academicism. As historian Felicity Scott has written, 'The exhibition became a notorious landmark in architecture's turn toward postmodernism, a notoriety exacerbated by its presentation within an institution that had both codified modern architecture as the "International Style" [in] the 1930s and sponsored its ongoing legacy.'[46] Both the tradition of the beautiful architectural drawing (rather than

16
Aldo Rossi, *L'Architecture Assassiné
(Architecture Assassinated)*, 1975.
Etching. Deutsches Architekturmuseum,
Frankfurt-am-Main (216–014–011)
© Eredi Aldo Rossi. Courtesy
Fondazione Aldo Rossi

the axonometric plan) and the decorative embellishments of the nineteenth century were restored to value by the exhibition. As Robert A.M. Stern stated the following year, it made it possible for New York architects of differing persuasions to 'begin to reweave the fabric of the Modern period, which was so badly rent by the puritan revolution of the Modern Movement.'[47]

In the United States, this repurposing of architecture centred around two schools of thought. One group, identifiable as the 'New York Five', whose members had taken part in an exhibition of that name at MoMA in 1967, was comprised of Peter Eisenman, Michael Graves, Charles Gwathmey, John Hejduk and Richard Meier. Their work in the late 1960s shared a formalist commitment to the principles of interwar Modernism, and a belief in the artistic autonomy of architecture (a position later abandoned by Graves, but more or less maintained by the other four). Eisenman, the chief theorist of the group, argued for a 'post-functionalist' rather than postmodern turn, which would liberate modern architecture from orthodoxy and instead renew its avant-garde artistic principles. The group's adherence to Corbusian purity led inevitably to their being characterized as the 'Whites'. They were in sympathy with the view advocated by Rowe that Modernism shared with classicism some ideal principles of form and proportion. In the other corner of the ring were the 'Grays', a loose association of architects who favoured contextual and symbolic eclecticism: Robert A.M. Stern, Charles Moore, Alan Greenberg, Jaquelin Robertson and Romaldo Giurgola. They were supported by Scully, who had weighed in with his championship of Venturi and Scott Brown (honorary, if not actual 'Grays') and his revisiting in 1975 of his earlier 'Shingle Style' treatise — an essay on its contemporary relevance, cannily subtitled 'The Historian's Revenge'. The Grays eagerly laid claim to the Beaux-Arts show as evidence of the limitations of Modernism.

These intellectual battles over the legacy of Modernism and the future of architecture continued through the 1970s. There were as many commonalities between groups as there were oppositions: both Whites and Grays recognized the redundancy of late Modernism while acknowledging its early vigour. All parties recognized the inadequacies of a monolithic attitude to city planning, and the resulting denial of urban complexity and community. Modernism was now just one stylistic choice amongst many. And how many stylistic recoveries there were. The bouillabaisse of sources was cheerily described by Rowe, with only a soupçon of irony:

17
Aldo Rossi, Aerial perspective of cemetery in San Cataldo, Modena, Italy, 1971. Crayon and graphite on sepia diazotype. The Museum of Modern Art, New York (Jon Cross and Erica Staton, Digital Design Collection Project, Luna Imaging, 1287.2000. 2002) © Eredi Aldo Rossi. Courtesy Fondazione Aldo Rossi

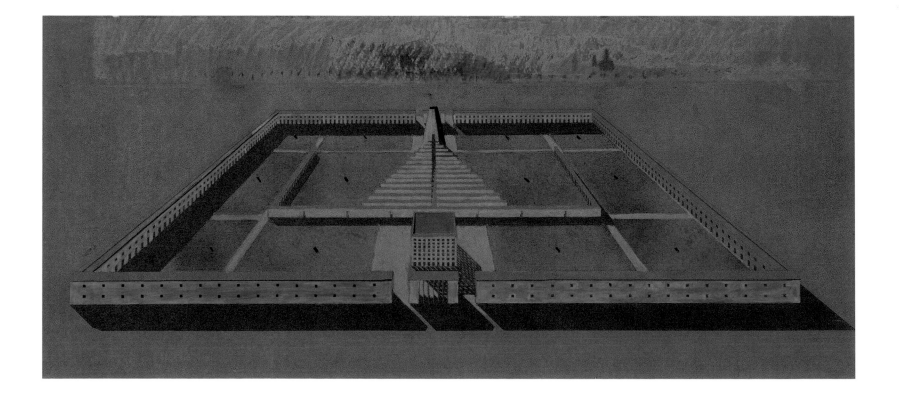

We will give a nod to Kaufman; we will give three muted cheers for the Stalinallee; we will adore the manifesto pieces of Boullée; we will (mostly) refuse to observe the built work of Soane; instead we will unroll a few hundred yards of neutral Adolf Loos façade, build a lot of little towers and stand around on top of them a quality of Ledoux villas, wave quietly but not too exuberantly to Louis Kahn …, insinuate a reference to the metaphysic of Giorgio de Chirico, display a conversance with Leonidov, become highly enthusiastic about the more evocative aspects of Art Deco, exhibit the intimidations of curtains waving in the wind, and, then, gently warm up the ensuing goulash in the pastoso of Morandi.[48]

The return to history that brought architectural historians into closer contact with practice also paved the way for architects to become historians and theoreticians. Italian architect Aldo Rossi, for example, published his influential study of urbanism and contextualism, *The Architecture of the City*, in 1966. Moore, influenced by phenomenology, published on the significance of place, experience and memory in architecture.[49] Venturi's visits to Rome provided the basis for his first published article, on the Campidoglio in 1953, and much of his observations in *Complexity and Contradiction in Architecture*. Rome was a parallel that Venturi continued to draw upon: 'Visiting Las Vegas in the mid-1960s,' he said, 'was like visiting Rome in the late 1940s. Las Vegas is to the Strip what Rome is to the Piazza.'[50]

Complexity was just one theme that united proto-postmodern discussions about the role of history in architecture. Another was memory and its proper symbolism. Rossi's approach to the city, for example, was elegiac: 'With time, the city grows upon itself; it acquires a consciousness and memory. In the course of its construction, its original themes persist, but at the same time it modifies and renders these themes of its own development more specific.'[51] He contrasted the effects of post-war destruction and subsequent redevelopment with the persistence of recognizable fragments, which for him stood as landmarks to the 'universal and permanent character' of urban experience.[52] He developed a language of archetypes and a typological system that reflected this theory, attempting to reinvest the city with meanings that had evolved over time. His iconic, primary forms – arcades, columns, cones and cubes – suggested an elemental language without recourse to explicit historicism (pls 16 and 17). Rossi extended this typology to include forms that suggest everyday objects like coffee pots, cups and bottles, forms that would reappear in his contributions to 1980s luxury micro-architecture.

A very different, but equally rich, symbolism was achieved in the building that many consider the finest of all postmodern architectural statements: James Stirling's Neue Staatsgalerie in Stuttgart (1970s) (pl. 18). Designed with his partner Michael Wilford, the project exemplified a postmodern attitude in its handling of public space, circulation, historical reference and wit. Stirling had been briefed to provide a series of new galleries for an existing museum (the Alte Staatsgalerie, built in 1843), coupled with a central courtyard and a public passageway through the site – an element recognized as a democratic gesture of openness on the part of the West German government regarding their public institutions. Stirling placed an open-air rotunda at the centre of his addition. A pathway meanders through the layers of the design, the exterior portion of which consists of a series of terraces dressed with elements that allude to archaeological fragments, including a tumble of loose stones that seem to have been dislodged from the façade. As Reinhold Martin has pointed out, the building 'stages a narrative of passage without an end' – its access route 'slides' across the forecourt, meeting several dead-ends, and is deliberately displaced from traversing the centre of the courtyard, whereupon it 'leaks' out across the back.[53]

The perceived authority of the public museum is countered by the indeterminacy of the visitors' experience. This ambiguity is heightened by the building's use of materials in combination – mostly pale sandstone and travertine marble, into which are sliced brightly coloured high tech elements – a snaking glass curtain wall with green steel mullions, blue and red steel handrails, doors and roof canopies. These overt references to high-tech Modernism (such as Richard Rogers and Renzo Piano's Centre Pompidou of 1972–6, or Stirling's own 1964 Engineering Faculty Building at the University of Leicester) were also inverted – the structural steel members serve a decorative function in their application over the stonework of the museum. With its many layered and fragmentary references,

18
James Stirling Michael Wilford and Associates, Neue Staatsgalerie, 1977–84. Stuttgart © Richard Bryant/ Arcaid/Corbis

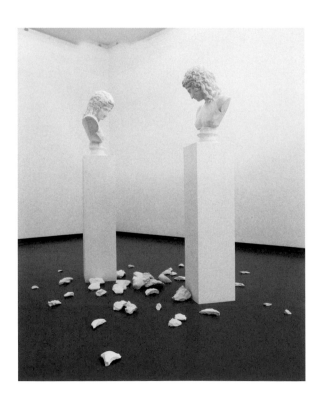

19
Giulio Paolini, *L' Altra Figura (The Other Figure)*, 1984. Plaster, plaster fragments, plinths. Courtesy of Studio La Città, Verona

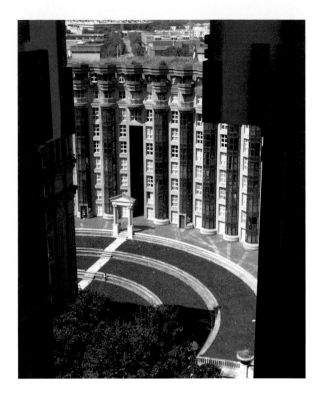

20
Ricardo Bofill, Les Espaces d'Abraxas, 1979. View of the Théâtre from the upper level of the Palacio. Marne-la-Vallée, near Paris. Photograph by Addison Godel

21
Ricardo Bofill, Architectural drawing of the Palacio at Les Espaces d'Abraxas, 1979. Collage, graphite, marker and ink on brown paper. Museum of Modern Art, New York (379.1985)

Overleaf: 22
Arata Isozaki, *Tsukuba Town Centre in Ruins*, 1979–83. Watercolour on paper. Deutsches Architekturmuseum, Frankfurt-am-Main

both general and specific, the building is collagist in nature: it incorporates Greek, Romanesque and Egyptian motifs, as well as quotations from Schinkel's Altes Museum in Berlin and Asplund's Stockholm Library (to name only two of the many sources). It was a perfect setting for artworks by the likes of Giulio Paolini, whose similarly theatrical essays in classical sculpture were shown at the Staatsgalerie soon after its opening (pl. 19).[54]

Another textbook example of postmodernist pluralism – not coincidentally, also centring on a public space – was Charles Moore's Piazza d'Italia in New Orleans (1976–9) (see pl. 127, p. 117). Like Venturi and Scott Brown's early collaboration on the planning of South Street in Philadelphia, which recognized the architectural eclecticism and social diversity of its downtown location, Moore's Piazza was designed to reinvest an anonymous urban area with a sense of community and inclusivity. Unlike Venturi and Scott Brown, Moore could not draw upon the locale for direct visual reference as the site was surrounded by bland and anonymous modern buildings, and no public space akin to a square existed. So instead he opted for an audacious fiction inspired by the neighbourhood's predominately Italian population. Moore sought to encapsulate the idea of Italy displaced: as the German curator Heinrich Klotz put it, 'The Piazza risks making the poetical statement "Here is Italy!" only to add immediately, with a sad smile "Italy is not here".'[55] As Patricia Morton explains elsewhere in this book (pp. 116–19), the circular site (achieved by claiming space from an adjacent development site) is the basis for a stage-set-like accumulation of fragments which form a map of Italy, with a fountain in the middle of the space. All the classical orders, including Doric, Ionic, Corinthian, and Moore's own specially created 'Deli' order, are there in the colonnades. The Piazza d'Italia mixes memory and fiction, humour and sentiment. Moore plays games with materials, using *trompe l'oeil* and other visual tricks (the stainless steel columns are smooth, for example, but an effect of fluted marble is achieved by courses of water running down them). Instead of the monumentality of a formal square, the Piazza declares its own cultural hybridity, with a neon-decorated arcade and casts of the architect's own face (spouting water) in place of classical deities or putti. This personal joke amongst the layers of more generally accessible visual puns and references exemplifies the postmodernist idea of double coding. Most users of the square could not be expected to recognize Moore, and even fewer would have known that his doctoral research had addressed the relationship between water and architecture, a subject on which he could conceivably have 'spouted' for some time.

Audaciously, Italy was also temporarily relocated to Japan by Arata Isozaki in his design for the centre of Tsukuba Science City, completed in 1983. Like the Neue Staatsgalerie, Tsukuba marked a prominent architect's decisive turn to postmodernism. It also reflected Isozaki's fascination with ruins – both the ruins of modernity (Hiroshima) and the more ancient ones of Rome – which he made explicit in a large-scale drawing showing the site as if it had already fallen into a state of decayed wreckage (pl. 22). Designed to take an overflow of population, and relocate in their entirety the universities and research facilities from nearby Tokyo, Tsukuba began life as a manufactured community.

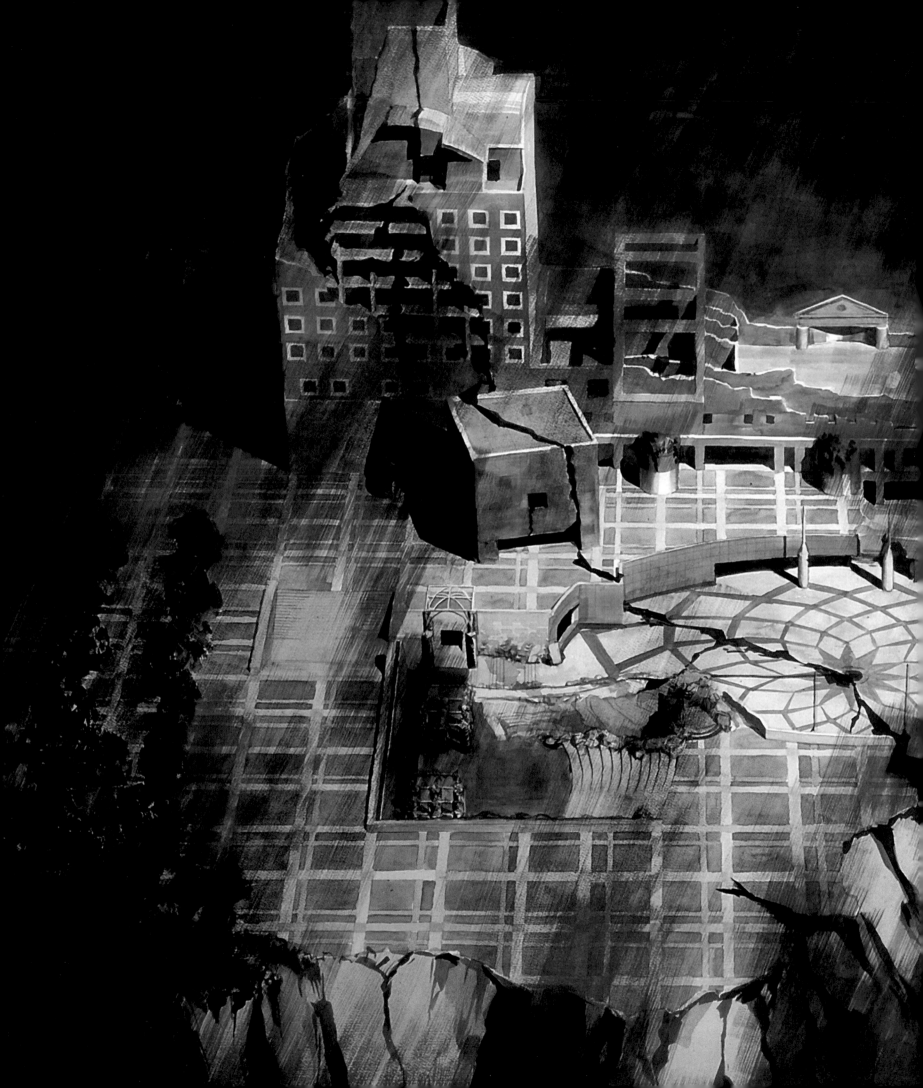

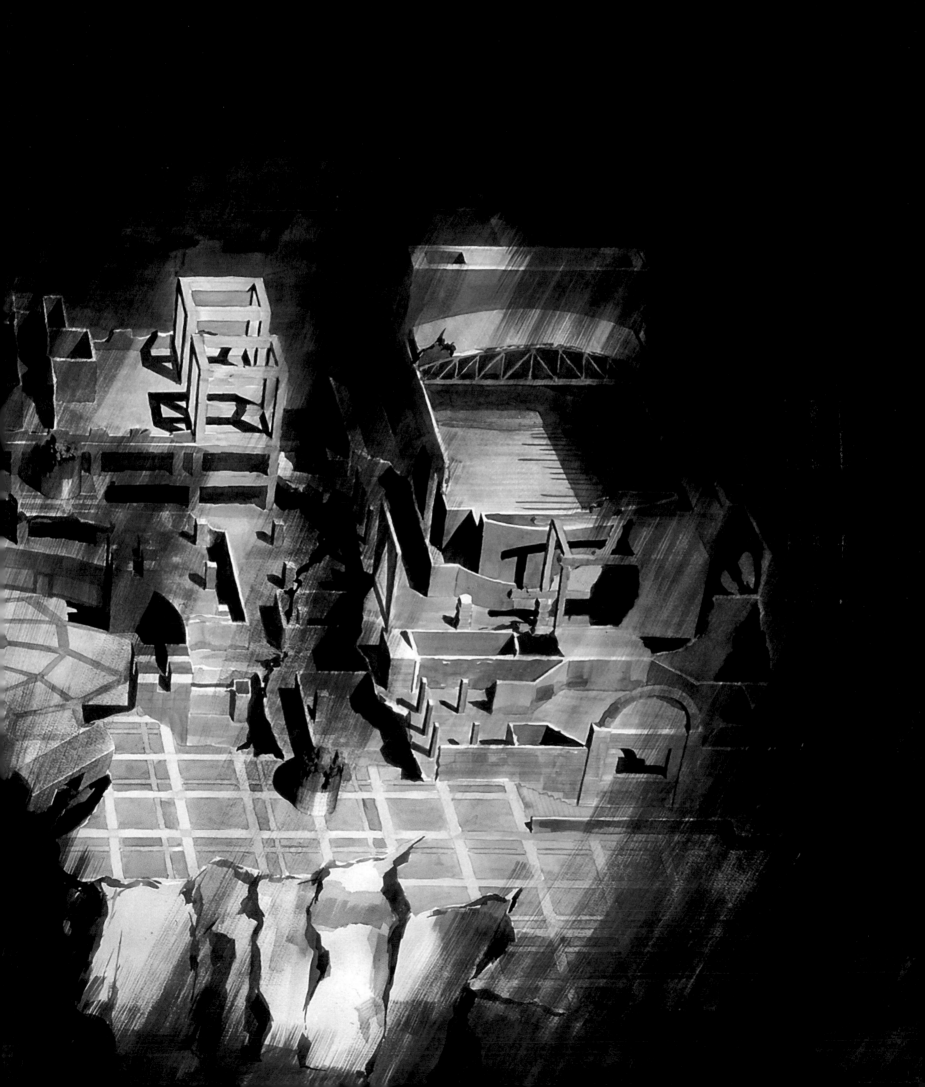

Isozaki himself found the commission to fill this 'vacant lot' to be oppressive: 'Upon first encountering this desolate textbook-designed modern city, I knew it was not the kind of place where I would want to live.'[56] His proposal was an elaborate piece of artifice, in which he superimposed Michelangelo's design for the Campidoglio in Rome in the central forum of the complex, but reversed its topography, so rather than being found at the high point of a hill (as in Rome) it is sunken into the well at the centre of the plaza. The building seemed to collapse upon itself: an unusual example of postmodern architecture as outright social protest.

A similar principle of reversal was employed to spectacular effect in the forbidding and enigmatically titled Les Espaces d'Abraxas, a public housing project by the Spanish architect Ricardo Bofill (1979) (pls 20 and 21). Bofill's office, the Taller de Arquitectura, found great favour with the French authorities in the 1970s, leading to a number of major commissions for public housing. Les Espaces d'Abraxas is in the dormitory new town of Marne-la-Vallée, on the suburban train line out of Paris (appropriately adjacent to the eventual site of Euro Disney). Bofill employed the language of the Baroque in a monumental composition, which is organized around a number of 'closed' theatrical spaces and forms: the Palacio (a housing block of 400 units), the Théâtre (another block of units, arranged around an amphitheatre) and the Arc (a triumphal arch of apartments, set at the centre of the amphitheatre). The complex is dressed throughout with monumental Baroque fragments: friezes, colonnades and columns modelled in the negative. Bofill claimed his use of a hierarchical, 'noble' architecture for public housing was a direct inversion of historical and social values.[57] The stage-set qualities of the site were highlighted when it was chosen as a location for Terry Gilliam's 1985 film Brazil, his postmodern take on George Orwell's 1984.

The cinematic possibilities of postmodernist symbolic architecture were also realized by Rem Koolhaas and his partner Madelon Vriesendorp. Koolhaas' 'retroactive manifesto', Delirious New York, was published in 1978, illustrated with Vriesendorp's anthropomorphic imaginings of skyscrapers cavorting in bed and the unlikely adventures of the Statue of Liberty (pl. 23). At the end of the book, Koolhaas offered a little tale entitled 'The Story of the Pool'. The setting is Moscow, 1923. A student, inspired by the visionary architecture of his day, designs and builds a floating swimming pool. Enthusiastic architects discover that by swimming in synchronized laps, the pool can actually be propelled backwards, enabling it to travel anywhere by water (pl. 24, see also pp. 136–9). The utopian thinking that inspired the pool, however, falls under suspicion as the political situation in the Soviet Union worsens in the 1930s. The architects decide to use the pool as a means of escape, by swimming in unison to America, dreaming of their vision of a futuristic society of skyscrapers and airships. But in order to do so, they must swim away from where they want to get to. They finally reach Manhattan in 1976. They see the skyscrapers, but are disappointed by the bland and uncouth populace they encounter. New York, in turn, does not favour the arrival of the Constructivists. Modernism is over, and the pool an outmoded symbol of utopian ambition. Instead, the postmodernist architects of New York reward their colleagues from Moscow with a medal commemorating the passing of the historical avant-garde. Disgusted, the Constructivists swim off again, only to collide with a giant plastic replica of Géricault's Raft of the Medusa, in use as a floating discotheque. 'The Story of the Pool' is a postmodern parable. Modernism swims backwards towards the future, where it collides with history. The tale is set against the backdrop of Manhattan, an urban testing ground for 'the splendours and miseries of the metropolitan condition': a place of congestion and delirium, which inspires 'ecstasy about architecture'; a vision without theoretical formulation, whose theory is simply that of Manhattanism. If Las Vegas is the city of depthless surface, Manhattan is the place of fragments, sediments and endless mutations, layer upon layer of which leave their trace upon the city.

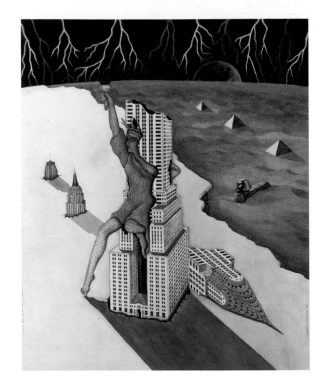

23
Madelon Vriesendorp, *Dream of Liberty*, 1974. Watercolour and gouache. Deutsches Architektur-museum, Frankfurt-am-Main (186-008-001)

Opposite: 24
Rem Koolhaas and Madelon Vriesendorp, cutaway axonometric drawing of the Welfare Palace Hotel Project, Roosevelt Island, New York, 1976. Gouache on paper. Museum of Modern Art, New York (1209.2000)

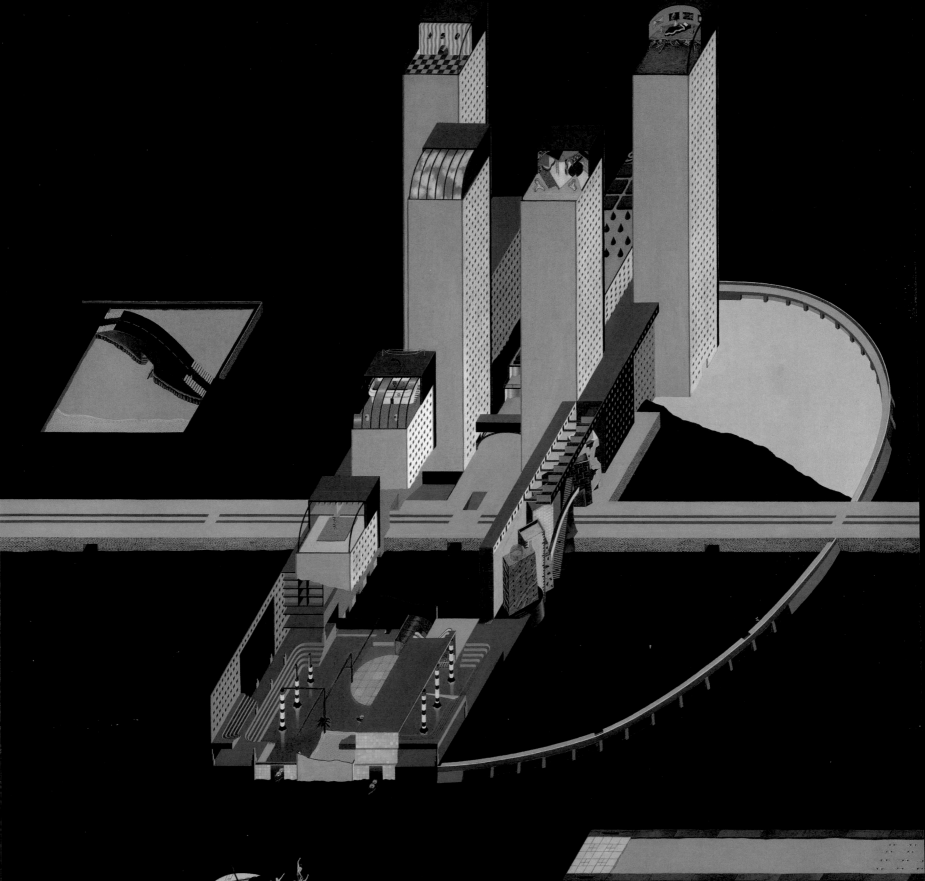

Cut and Paste

> Adhocism in its fullest sense is able to contain its opposites, since impurity is always a greater whole than purity.[58]
> —*Nathan Silver*

Despite the efforts of Charles Jencks and other supporters, who carefully parsed the variants of the new idiom, a wide range of architectural manners – Rossi's symbolic melancholy, Stirling's compositional sophistication, Moore's energetic post-Pop, Isozaki's informed criticism, Bofill's grandiose bombast, and sometimes even Venturi and Scott Brown's socially engaged contextualism – were often treated as indistinguishable. Often they were dismissed as 'pastiche', an imitative jumble of existing ideas. This accusation suggested that postmodern architecture was merely the spasm of a profession in its death throes. 'Irony', too – a word that is used more often, and more indiscriminately, than any other in relation to postmodernism – also underrates the achievement of the postmodernists, who were up to much more than a series of arch jokes at history's expense. The 1970s was not a period of defeat or cynicism among architects, but a radically expansive moment. In its years of emergence, postmodernism lived up to its ambition to replace a homogenous visual language with a plurality of competing ideas and styles.

There is, therefore, no single technique that binds together the architecture and design of 1970s postmodernism. Nonetheless, there is one method that the key players adopted to a greater or lesser extent: bricolage. This is a term that we might initially associate with fine art, particularly figures such as Robert Rauschenberg (pl. 28). Critic Leo Steinberg referred to the artist's assembled 'Combines' as being like the flatbed of a truck – as if the picture plane's job was just to carry whatever fell onto it.[59] Of course, Rauschenberg did arrange these elements according to a hermetic logic of his own devising. But this willingness to see his own expressive means as a constant compromise was in itself a postmodern, pluralist method. As American art historian Douglas Crimp wrote of Rauschenberg's work in 1980:

> Rauschenberg had moved definitively from techniques of production (combines, assemblages) to techniques of reproduction (silkscreens, transfer drawings). And it is that move that requires us to think of Rauschenberg's art as postmodernist. Through reproductive technology postmodernist art dispenses with the aura. The fantasy of a creating subject gives way to the frank confiscation, quotation, excerptation, accumulation, and repetition of already existing images. Notions of originality, authenticity, and presence, essential to the ordered discourse of the museum, are undermined.[60]

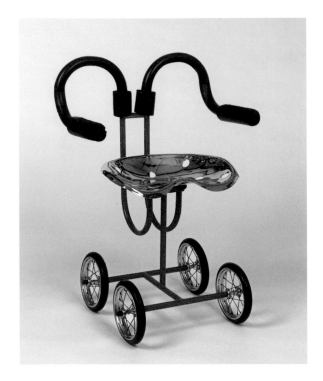

25
Nathan Silver, *Adhocist* chair, 1968. Steel gas pipe, plastic insulating foam material, wheelchair wheels, bicycle axles and bearings, auto bumper bolts, chromed tractor seat, paint.
V&A: W.37–2010

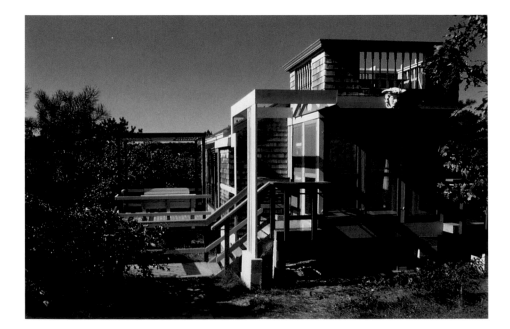

26
Charles Jencks, The Garagia Rotunda, 1976–7. Truro, Cape Cod, Massachusetts

Frank O. Gehry, The Gehry House,
1977–8. Santa Monica, California.
Photograph by Craig Scott

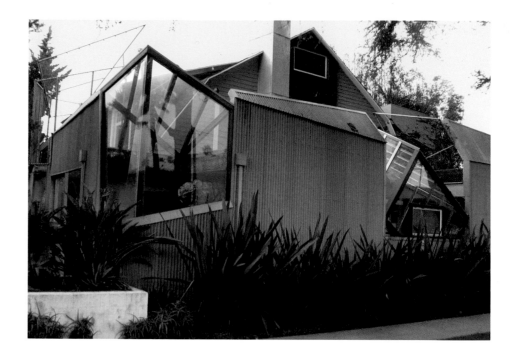

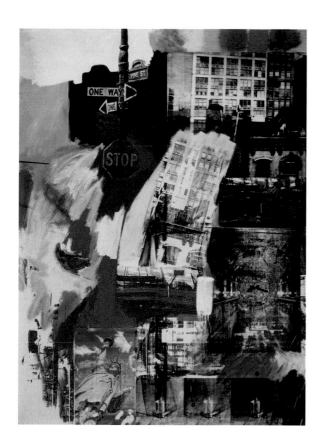

28
Robert Rauschenberg, *Estate*, 1963.
Oil and screenprinted inks on canvas.
Philadelphia Museum of Art,
Philadelphia, Pennsylvania (1967-88-1)

Crimp here suggests one way that we might distinguish between postmodern bricolage and earlier modernist collage (as in the Synthetic Cubism of Picasso, the ferocious Dada assemblages of Hannah Höch, or the films of Sergei Eisenstein), which it often resembles. Indeed, there are clear continuities between the two. For the modernists of the 1910s and 20s, 'cut-and-paste' technique was an expansion of formal and expressive means, and it might direct attention to the instability of language. The Marxist theorist Theodor Adorno suggested that modernist collage (or in film, montage) could be seen as a first step toward the death of the author: 'For the first time in the development of art, affixed debris cleaves visible scars in the work's meaning.'[61] Yet this did not entail a radical 'undermining' of artistic authorship, or any sense that the avant-garde might need to be replaced with a new set of artistic values. Postmodern bricolage was a way to do just that, through an acute self-awareness about medium and mediation, and a radical openness to the world beyond.

As Victor Buchli notes in his contribution to this volume (pp. 112–15), the concept of bricolage was drawn originally from the writings of anthropologist Claude Lévi-Strauss. In architectural discourse there was a clear lineage from his writings to a mature theory of postmodernism. The key figure here is Jencks, whose 1977 book *The Language of Post-Modern Architecture* did more than any other publication to popularize the term 'postmodernism', and fix it as a topic for debate. Five years before, he had adopted the figure of the bricoleur in *Adhocism: The Case for Improvisation*, written in partnership with the British architect Nathan Silver. The book bridged the counter-culture of the late 1960s and Jencks' later formulations. (It could even be argued that his writing style, which patched together a far-reaching argument through an assemblage of closely observed architectural criticism, was *ad hoc* in method.) Silver and Jencks highlighted multivalence, fragmentation, and Lévi-Strauss's idea of bricolage as a practice that defined contemporary experience. Gracing the cover of *Adhocism* was a chair designed by Silver, assembled from the seat of an agricultural tractor, wheels from a wheelchair, standard gas pipe, and insulating foam (pl. 25). Unlike much Italian Radical Design of the early 1970s, Silver's chair was made with a practical purpose in mind. Needing a form of seating that could cope with the rough brick floors of his own home, he devised a rolling chair made from at-hand materials, and employed a local engineering firm to manufacture it to the cost of £30 (half of which went on the purchase of its four wheels). Its cover-star status was an afterthought.

Jencks also put 'adhocism' to use in his own home, the so-called Garagia Rotunda, which he built in Cape Cod, Massachusetts, in 1976–7 (pl. 26).[62] The project was completed for a grand total of $5,500, yet it was an ambitious building: a hybrid of the vernacular shingle style, Queen Anne classicism, modernist gridwork and learned classical references.

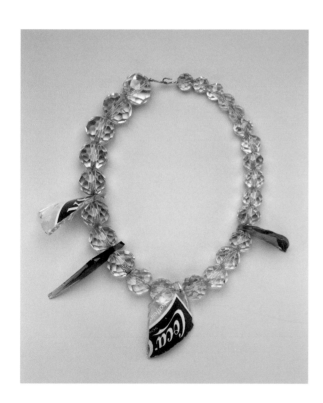

30
Bernhard Schobinger, *Scherben vom
Moritzplatz Berlin (Shards from
Moritzplatz, Berlin)*, 1983–4. Antique
crystal beads, television bulbs,
Coca-Cola bottle fragments, silver and
steel wire. Drutt Collection, Museum
of Fine Arts, Houston (2002.4062)

The plaster cast of a Medusa's head kept watch at one end of the building, the front door was marked with a twice-broken split pediment above the door, and of course the name was a nod to Palladio's domed Villa Rotunda. Jencks did all this on a shoestring budget, principally by using inexpensive stock millwork – doors, spindles, railings and finials, all bought off the rack – and a prefabricated garage, complete with a rolling door. The furniture, too, was built almost entirely from standard 4 × 4 studs. Jokes abound – apart from the 14 different hues of blue paint (homage to the skies and waters of the Cape), the only other use of colour is in the red-painted vertical elements used to carry the electrical wiring. Jencks' nod to De Stijl also serves as a handy health and safety warning. The Garagia Rotunda was knowing, and perhaps even academic, architecture, but it was also rough and ready. Jencks was not present during the construction, a fact he noted proudly in his writing about the project: his team of carpenters had been able to complete the house without supervision, or even detailed working drawings. This was a 'shed' aesthetic, created using cheap and easily obtainable parts. The house spoke the language of commercial building, not just symbolically but through its means of construction. It broke all the rules of modernist appropriateness, instead fulfilling all the principles of the *ad hoc*: speed, economy, improvisation, dissonance and multivalence.

On the West Coast, a related essay in adhocist improvisation was being explored in another architect's residence: Frank Gehry's house in Santa Monica (1977–8) (pl. 27). Gehry started with an existing house, a typical family property with a shingled roof and brick chimney on the corner plot of a residential street. Instead of demolishing the structure he extended it, wrapping it in an enclosure made from chain-link fencing, timber siding, glass and corrugated iron sheeting. The original house penetrates the new, a solid square which looks as if it is pushing through its temporary and unstable surrounds. The cheapness, banality and provisional nature of the materials (the most common materials, found on any building site) give the house an unfinished appearance of technical and constructional imperfection. It was aptly described by Heinrich Klotz as 'an expressive rendering of improvisation, and of the temporary, the unfinished and the jumbled together, through narrative illustration.'[63]

Adhocist strategies were also employed in diverse ways outside architecture. In graphic design, 'cut and paste' is given literal expression in the raw edges, glued overlaps and overlaid films assembled on the designer's light-box. In leaving these layers visible, the assemblagist aspect of the designer's work could be exposed. The approach was pioneered by the Swiss graphic designer Wolfgang Weingart, who is widely credited for blowing apart the rules of modern typography. Rather than abandon the modernist framework, Weingart retained the grid in order to subject it to assault: pushing jagged images across its surface, obscuring or curtailing words, sliding elements and images out of line, as in his *Kunstkredit* exhibition poster of 1977 (pl. 29). This shuffling of fragments succeeded in creating a new kind of graphic space, and influenced the work of American designers Dan Friedman and April Greiman, who both studied under Weingart.

By its nature, bricolage relies upon the hand assembly of elements, and tends to bypass technical drawing. This made it a suitable idiom for craft artists in the 1970s, many of whom were involved in a palace revolt within their respective mediums. Over the preceding decade the crafts had undergone a paroxysm of avant-garde activity. Makers were now more likely to be trained in art schools than traditional workshops. Many sought to cut ties with functionalist design and traditional crafts alike, and instead forged links with contemporary sculpture. In California, the Funk movement (named after a 1967 exhibition in Berkeley, California curated by Peter Selz), along with a healthy dose of bohemian lifestyle, fuelled the visions of ceramists such as Richard Shaw, Ken Price, Ron Nagle and Adrian Saxe, as well as the prodigious furniture maker Garry Knox Bennett (see pl. 126, p. 114).[64] Makers like these brought exemplary technique to *ad hoc* combinatory practices, infusing their decidedly odd objects with a single-minded sense of purpose. The Swiss jeweller Bernhard Schobinger attacked his medium with even greater fury. Fuelled by the energy of punk and industrial music, his bricolaged works were nonetheless assembled with a connoisseur's care. The prospect of lacerated skin was just one part of the extreme glamour he offered his clients (pl. 30). Though nobody described these craft artists as postmodern at the time, in retrospect they were ahead of the game, already infusing bricolage with a refinement and intensity that would not be seen in other design fields until the 1980s.

Apocalypse Then

> Struggle, fracture and fragmentation are counter-images to that of the smooth surface of post-Modernism ... cracks that become faultlines, creating gaps that may yet prove fruitful openings for the emergence of new patterns and forms.[65]
> —Robert Hewison

By the late 1970s, it was clear that the energy required to depart from Modernism would be found in the very force of Modernism's collapse. The 'death of the author' bred a proliferating range of authorial and interpretive strategies.[66] Antipathy to narrow functionalism led to an explosion of formal creativity. Distrust of progressive, teleological models of history – 'grand narratives', in Jean-François Lyotard's famous formulation – authorized a style of disordered temporal fragments, in which past, present and future were folded into one another.[67] The phoenix-like promise of Mendini's burning chair was now realized, as the apocalyptic became an explosively generative idiom across every area of design.

The maestro of this approach was the singular Italian designer Gaetano Pesce, whose apocalyptic leanings had already become clear in 1972. In that year he assumed the role of archaeologist in his contribution to the landmark MoMA exhibition, *Italy: The New Domestic Landscape*. Challenged to present a vision of future living, he circumvented the expected role of designer by imagining instead the discovery of an underground dwelling of the late twentieth century, excavated by archaeologists in the next millennium. Driven below the face of the planet by total cultural collapse (what Pesce termed a 'period of great contaminations'), the inhabitants of this subterranean plastic world had retreated to a life of isolation and self-destruction.[68] All that was left were the fragments of their last traumatic days, a fossilized modernity that rendered the material signs of progress (plastic, technology) as a language of decay.

Pesce's fascination with the lifecycle of objects was expressed the same year in the *Golgotha* chair, a project for BracciodiFerro (literally, 'arm wrestle'), which was an experimental offshoot of the Italian company Cassina (pl. 31).[69] The design was an enquiry into the nature of 'poor materials' – a padded cotton sheet was soaked in resin and then suspended across poles so it could be sat upon. As the resin hardened, the chair permanently assumed the imprint of its brief occupant. Rather than assert the value of newness in an object, Pesce created a shroud-like chair at the mid-point in its cycle of use, a process that will lead to its eventual discarding. In a later variation on this theme, Pesce experimented with fixing an object halfway through its own making. His *Pratt* chair design was produced as a limited series in plastic (1983–4), each successive version using the same process of production, but captured in a temporal moment of development (pl. 32). The first chair in the set is frozen in a state of soft collapse, the third is strong enough to support a child, while the ninth and final one is hardened to the point of uncomfortable resistance for the sitter. Pesce's fascination with death and decay echoes that of Jean Baudrillard in the early 1970s:

> From medium to medium, the real is volatilized, becoming an allegory of death. But it is also, in a sense, reinforced through its own destruction. It becomes *reality for its own sake*, the fetishism of the lost object: no longer the object of representation, but the ecstasy of denial and of its own ritual extermination: the hyperreal.[70]

Pesce's idea that an object might offer an elucidation of its own eventual obsolescence or decay was key to the postmodern strategies of the period. The tactic of designing objects that seemed hardwired to self-destruct was both an articulation of the problematics of Modernism, and a materialization of the punk slogan 'no future'. In Britain alone, the roster of designers working in the idiom was impressively diverse. In 1983 Ron Arad (with his business partner, Caroline Thorman) opened the shop One Off, in an old warehouse near London's Covent Garden, as an extension to their studio practice (pl. 33). Arad's business had initially been built on his ingenious use of scaffolding components to make furniture, using the Kee Klamp system (whose proprietary name aptly describes its function). The results included his 1981 *Rover* chair made from reclaimed car seats and tubular steel.[71] Arad's essays in industrial materials, including the iconic *Concrete Stereo* of 1983 (pl. 34), were paralleled by the experiments of other young designers such as Danny

31
Gaetano Pesce (for BracciodiFerro), *Golgotha* chair, 1972. Dacron-filled and resin-soaked fibreglass cloth. Private collection. Courtesy Gaetano Pesce Studio

32
Gaetano Pesce, *Pratt* chair (no. 3), 1984. Urethane resin. Courtesy Gaetano Pesce Studio

Ron Arad, *One Off Shop*, design and
production studio, 1984. London

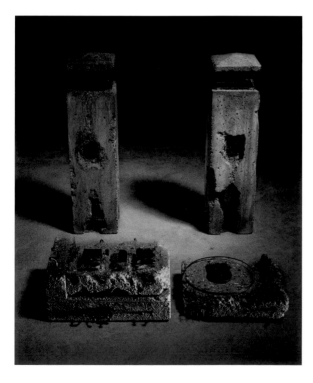

34
Ron Arad, *Concrete Stereo*, 1983.
Stereo system set in concrete. Museum
Boijmans Van Beuningen, Rotterdam
(V 1166 a–d, KN&V). Photograph
courtesy of The Gallery Mourmans
(V&A: W.7–2011 exhibited)

Lane (who specialized in stacked and smashed plate glass), as well as André Dubreuil, Mark Brazier-Jones, Tom Dixon, and Nick Jones whose works in found objects and bashed metal were created within a collective entitled Creative Salvage. All across London, artists and designers were pursuing similar effects. The artist Paul Astbury fired scraps of clay and bolted them to cardboard boxes and other objects, covering the resulting constructions with lashings of paint, while Bill Woodrow cut into the sheet metal of white goods in order to transform them into representational sculpture (pl. 35). Graphics and fashion literalized the slogan 'rip it up and start again',[72] with punk originators like Jamie Reid and Vivienne Westwood continuing to explore the possibilities of bricolage, and Malcolm Garrett and Zandra Rhodes following close behind.

Independent shops like Arad's One Off and Westwood's Nostalgia of Mud (see Claire Wilcox's essay in this volume, pp. 154–9) were essential to London's entrepreneurial, post-punk design culture. Not for the first time, of course; shops had been nodal connections between clubs, magazines and the music scene for at least two decades. Yet the proliferation of such establishments in the early 1980s was also a reflection of a new post-industrial economy. Former docks were being converted for new uses, whilst Covent Garden, finally vacated by its costermongers in the mid-1970s, was refashioned as a chic shopping district. Retail culture eddied out from there, claiming the warehouses and back alleys of the neighbouring area. Warehouses were repurposed as homes, offices and shops in ways that mirrored the reconfiguration of disused urban spaces in Manhattan, Paris and other cities. What had begun with ad hoc occupation by artists and designers continued with the rebranding of these districts as part of a luxury lifestyle. Inevitably, the aesthetic of these industrial spaces was the starting point for their reconditioning: there was a craze for ruined concrete, battered metal sheeting, scaffolding, exposed wiring and pipework. As well as scavenging the detritus of the industrial landscape, interior designers plundered multiple style cults: 1940s and 50s Americana, rock'n'roll, hip-hop and Japanese kitsch.

The dockland sites of London also attracted the attention of a young group of architecture students at the Architectural Association, led by their young tutor Nigel Coates.[73] The collective, which came together under the name NATØ (Narrative Architecture Today), combined the processes of architecture with those of film-making, photography, magazine editing and indiscriminate scavenging. Influenced by the French architect Bernard Tschumi, a more senior figure at the AA, they explored narrative strategies for understanding the multiplicity and layering of urban experience (pl. 36). Their starting points were clubbing, clothing and music cultures; they embraced the then novel term 'lifestyle' for its liberating potential:

> We look for the overlap between the nightclub and the computer graphics screen. We note clothing and music as the initial vehicles for this meshing, both of which have managed to put expression into life-style. Meanwhile, in Albion decay and disorder are heaped onto one another: invasion, reversal, perpetual upheaval, self-examination, reality-as-fiction, enclosure, mechanical overkill.[74]

NATØ manifested itself in a series of imaginative and speculative urban projects, brought together in their magazine of the same name, part fanzine, part manifesto, a bricolaged diary of visual and textual fragments. Through their projects, NATØ recast post-industrial Britain as Albion — a fusion in which the past and the present have hardened together like scar tissue. It was an aesthetic that closely matched the film-making techniques of another Docklands denizen, Derek Jarman. Coates and his NATØ colleagues envisioned a retreat for the film-maker, in the form of a sprawling archaeological site (pl. 37). The project was unrealized, but drawings showing Jarman as if he were a fragment of classical statuary remain.

The dystopian aesthetic of the times found its ultimate expression in Ridley Scott's 1982 film *Blade Runner*, set in an imagined Los Angeles of 2019: a teeming cityscape of dereliction and exhausted technology (pl. 61). The site was not a coincidental choice; LA was already associated with radical levelling, as Charles Moore put it, 'a model of the new unhierarchy' that had 'poured itself' across the landscape.[75] In the film it was presented as an amalgam of other cities, a stitch-up of Asian and Western urban fabrics evoking Shanghai in the 1930s, the street markets of Hong Kong, the neon scenography of Tokyo, and the Art Deco skyscrapers of Manhattan and Chicago. Garbage piles up and street gangs roam free. Darkness, rain and the electrical crackle of the lights are incessant. The city is cranked up to overload, crammed with detritus as if every future possibility has been grafted on to the remains of its previous iteration. There is an obsessive level of style-sampling in the film: Greek and Roman classical columns, Assyrian ziggurats and Egyptian pyramids; Soviet-style typography; 1950s automobiles, and *antebellum* interiors. The fashion styling is alternately 1940s and futuristic, and the narrative itself is an impure mix of genres: *film noir* meets sci-fi, a Chandleresque detective story with an electro soundtrack by Vangelis. Set designer Syd Mead summed it up: 'One of the principles behind designing this film is that it should be both forty years in the future and forty years in the past.'[76]

The compression of past and present, time and space, were all part of the *modus operandi* of postmodern design. As *Blade Runner* demonstrates, they could be employed in the stylistic rendering of an anterior future — the future as it will have been. The architectural subversions of the 1970s had been a clear articulation of this position. And as James Wines shows in his contribution to this book (pp. 98–105), architects played out a kind of 'nature's revenge' upon the effects of modernization, such as the purposeful shattering of functional structures (see Wines' own series of stores for BEST Products, in which façades collapse and nature intrudes). As with Gaetano Pesce, burial and excavation were a means by which the symbolic nature of inhabited structures could be reasserted. The pre-ruined artefact, building, landscape or garment was a conscious strategy for designers like Pesce and Wines, Arad and Westwood, and film-makers like Scott and Jarman to historicize the future. This was yet another means of articulating the crisis in Modernism, replacing a teleological version of history with its archaeological equivalent. As Jarman put it:

> My world is in fragments, smashed into pieces so fine I doubt I will ever re-assemble them ... So I scrabble in the rubbish, an archaeologist who stumbles across a buried film. An archaeologist who projects his private world along a beam of light into the arena, till all goes dark at the end of the performance, and then we all go home.[77]

35
Bill Woodrow, *Twin-Tub with Guitar*, 1981. Adapted washing machine. Tate. Purchased 1982 (T03354). Photograph by Edward Woodman

36
Narrative Architecture Today (NATØ), no. 1, 1983

37
Nigel Coates and the NATØ group,
Concept drawing for Derek Jarman's
ideal home from the exhibition
Starchoice at RIBA, 1984. Pastel
and acrylic on tracing paper.
V&A: E.1495–2010

The New Wave

> Memphis appeared to many, especially to the young, not only as the ghost of hope, the omen of a renewal and mutation, but as the answer that not only was it possible to change but the change had already occurred.[78]
> —*Barbara Radice*

Not all was doom and gloom at this key moment in the development of postmodern style. Quite the reverse was true in Italy, where Radical Design had abandoned its former austerity. Polka-dot chairs, teapots with wings, lamps that roll around on the floor: these objects could easily have leapt from the pages of a cartoonist's sketchbook. But behind this seeming absurdity lay a very serious intent: to completely transform the space of operations for design. As we have already seen, groups such as Archigram and Global Tools, as well as individual practitioners like Gaetano Pesce, rethought their activities from the ground up in the early 1970s, creating provisional, difficult objects. In the latter part of the decade, this radical project went still further, abandoning the sense of a 'ground' entirely. The covers of magazines like *Domus* and *Modo* depicted the designer floating in free space, with no clear orientation (pl. 38). Political conviction, commercial imperatives, principles of form and function: all had been jettisoned. Even radicalism itself, the critical posture of the avant-garde, came to seem a distant memory. What was left?

That was the question confronted by the two principal figures in Italian design in these years, Alessandro Mendini and Ettore Sottsass, Jr. It is almost too easy to juxtapose the pair as occupying oppositional roles: the intellectual pessimist and the sensual optimist. What's more, each stood at the head of a group that reflected his persona. For Mendini, this was Studio Alchymia (or Alchimia). In 1978 he joined forces with Sottsass, Andrea Branzi, and the architect and designer Alessandro Guerriero, who had founded a showroom of that name two years previously. The aim of Alchymia was, as Mendini later wrote, to act 'ambiguously outside the design itself, in a state of waste, of disciplinary, dimensional, and conceptual indifference.'[79] Sottsass founded Memphis in what his partner Barbara Radice described as 'an act of friendly secession' from this nihilistic worldview.[80] The collective comprised his senior colleagues at Sottsass Associati, as well as several young designers whose work had the breathless energy of a three-minute pop song. The formation of Memphis in 1981 announced a more positive, forward-looking, and perhaps commercial phase of Radical Design. As Sottsass put it, 'All that walking through realms of uncertainty … has given us a certain experience. Maybe we can navigate dangerous rivers, penetrate jungles where no-one has ever been. There's no reason for getting worked up. We can finally make our way with ease; the worst is over.'[81] It is also possible, however, to overplay the distinction between the two groups. Despite the differences in rhetoric, they drew from a common palette of materials, colours and compositional techniques. Though Alchymia was strongly identified with the concept of banality, Memphis also employed materials that could be seen as kitsch, notably plastic laminates. And there was considerable overlap in personnel: Sottsass contributed to Alchymia, and Mendini to Memphis, while Branzi and Michele De Lucchi were involved in both projects (pls 39 and 44). In certain respects, Memphis was an extension of strategies first explored under the Alchymia umbrella.

So what were these strategies, and in what sense were they postmodernist – a word that the Italians themselves preferred not to use? First and foremost, if earlier Radical Design had emphasized direct experience, then Alchymia was all about its own mediation. This should not be surprising, given that Mendini had been operating principally as a magazine editor since he took over the helm at *Casabella* in 1970. He would go on to function in the same capacity for *Domus*, *Modo* and *Abitare*, as well as writing a regular column for *Artforum*, moving back and forth fluidly between the roles of designer, editor and critic. This gave him a ready outlet for the promotion of his own work and that of his colleagues (much as Gio Ponti had done at *Domus* decades earlier), and also set the methodological tone for his design activities. Both the literal cut-and-paste work of assembling a magazine in the pre-digital era and the more figurative editorial work of arranging other people's ideas were central to Mendini's approach with Alchymia. As he puts it, 'My experience editing magazines gave me an interest in seeing design and architecture as a bit like conducting an orchestra … I don't always hold the last card; the cards are held by a lot of different people.'[82]

38
Domus, no. 643, October 1983.
Designed by Giancarlo Maiocchi
(Occhiomagico)

39
Ettore Sottsass, *Le Strutture tremano
(Trembling Structure)* table, 1979.
Enamelled tubular metal, glass, plastic
laminate-covered wood. V&A: W.8−2010

Though this position may remind one of the postmodern notion of the 'death of the author', in fact Mendini's editorial method was a clever way of extending his reach. At a point in his career when he lacked the patronage of large manufacturers, his neo-Duchampian strategy of 'redesign' – in which an existing thing was rearranged and/or decorated – was a clever and expedient way to make a charismatic, photo-ready object. By transforming an Art Deco chest of drawers into a jagged neo-Futurist collage, festooning a sofa with ornament derived from Kandinsky paintings, or simply adding little flags to a Gio Ponti chair, Mendini simultaneously mocked modernist art and design history, signalled his deep knowledge of that same history, and made obvious his desire to supersede it (pl. 40). His *Proust* chair of 1978 was the object that most successfully condensed these restless energies, at least to judge from its subsequent notoriety (pl. 41). It was another paste-up job: a title taken from literature, a form adapted from eighteenth-century Baroque furniture (albeit swollen to improbable proportions), and decoration swiped from a Pointillist painting by Paul Signac. This surface treatment was achieved through the ingenious means of projecting a slide of the painting onto the chair, and daubing paint onto its surface to match the dots.

The most explicit application of Mendini's strategy of design-as-editing was *Il Mobile Infinito* ('Infinite Furniture'), launched during the 1981 Furniture Fair in an exhibition space at the Architecture School of the Milan Polytechnic. Mendini's explanations of the project were grandiose, but also teasingly indeterminate:

Il Mobile Infinito is an attempt to obtain a non-mediocre result from a collection of mediocre conditions. Having said this, it is obvious that *Il Mobile Infinito* is not really furniture, but an allegory, an ex-voto, a metaphor of other problems, a pendulum

40
Alessandro Mendini with Prospero Rasulo and Pierantonio Volpini,
Redesign of a 1940s chest of drawers, 1978. Painted wood, mirror.
Private collection

41
Alessandro Mendini, *Proust* chair, 1978. Wood and painted textile.
Private collection

held over the history of objects, a kind of banality carried through to its classical state. More than furniture, then, *Il Mobile Infinito* resembles washing forever hung out to dry, a library that constantly renews itself, a collection of Pre-Raphaelite paintings, an arms store, a flower shop with a florist throwing away the faded flowers, a constellation cast adrift between heaven and earth ... *Il Mobile Infinito* is chatty, ill, mysterious, fleeting, uncertain, dreamy-eyed (and attracts and collects in the pores of its skin the maximum amount of mental dust around it). *Il Mobile Infinito* is 'philosophical' furniture, a desert where everything seems to happen but nothing ever does, that does not exist because if it existed it would no longer be infinite.[83]

In practical terms, however, the only thing 'infinite' about *Il Mobile Infinito* seemed to be the list of contributors to the project. Each part of each piece of furniture was designed by a different person: ornaments by Branzi, lampshades by Sottsass, handles by Ugo La Pietra, legs by Denis Santachiara, and so on. There was also an element of redesign. The interiors of the furniture were veneered with patterned laminates designed decades earlier by Italian modernists like Bruno Munari and Gio Ponti, and in one case Edvard Munch's iconic painting *The Scream* was appropriated as the face of a cabinet – an intensely expressive image of alienation rendered as harmless décor, like a museum-bought postcard tucked into a mirror at home (pl. 42). Though Mendini was the mastermind of this complicated scheme, he relied on his Alchymia colleague Paolo Navone to organize the manufacture of the furniture. The results shared not only the bricolaged quality of one of Mendini's magazine covers, but also the stylistic vocabulary that was already emerging as the postmodernist lingua franca: floating shapes in bright, solid colours; slick, obviously artificial surfaces; and intentionally awkward juxtapositions of linear and blocky elements.

Il Mobile Infinito was the most ambitious thing Studio Alchymia had ever done, and in many ways was the group's swansong. Though the group persisted for a few years, at least in name, another exhibition held at exactly the same time would definitively shoulder Alchymia from the spotlight. This was, of course, the inaugural presentation of Memphis, held at the gallery Arc '74 during the Milan Furniture Fair (the Salone del Mobile) in

42
Alessandro Mendini with Andrea Branzi, Ettore Sottsass, Mimmo Paladino and Francesco Clemente, Denis Santachiara and Ugo La Pietra, *Il Mobile Infinito* cabinet, 1981. Wood, paint and metal. Collection of Nick Wright and Swati Shah, London

43
Michele De Lucchi (for Girmi), Prototype toaster, hairdryer, iron and egg timer, 1979. Painted wood. Museum Boijmans Van Beuningen, Rotterdam (V 951 a–c,e, KN&V)

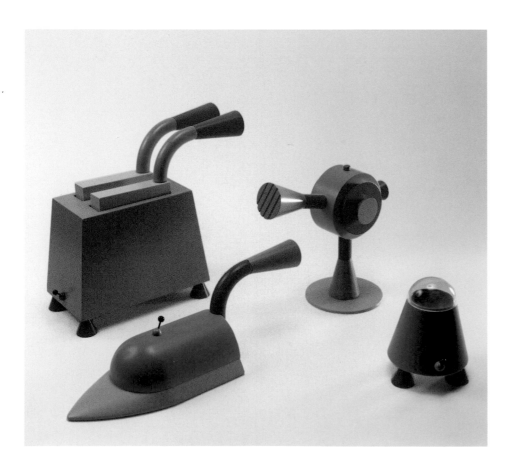

September 1981. There are many ways of approaching the tangled topic of Memphis, which was immediately recognized as a seismic disturbance in the design firmament. But perhaps the best route is through its individual contributors. Though they were understood as a band of like-minded *enfants terribles* – an impression that was fixed by the much-reproduced image of the Milanese-based members sitting in Masanori Umeda's tatami-mat boxing ring bed (pl. 45) – in fact the chemistry of the group was much more complex than that. Sottsass was obviously the leader. This was not only by virtue of his fame and charisma, which lent him by this time the air of a guru (he was 64 when Memphis was launched), but also because many of the other members worked as partners or staff designers in his firm.

Most influential among these, arguably, was the brilliant Michele De Lucchi, who had met Sottsass through the Radical Design group Cavart in 1973. He had already created convincing product designs in the postmodern style: a set of prototypes for the Italian manufacturer Girmi (pl. 43). These pastel-coloured, toy-like objects – stylistically related to the *Sinerpica* lamp he designed for Alchymia in 1978, and a coffee pot commissioned by Cleto Munari the following year – were intended to put a friendly face onto appliances that were normally functionalist and severe, like hairdryers and clothes-irons. Like the Memphis objects that followed, these were stage props for a hyper-real life. They anticipated the friendly, animated product designs of more recent years that have had such success on the market – even at the time, as De Lucchi said, 'everybody liked [them] but designers' – but they did not go into production.[84] They were, however, made famous through display at the 1979 Milan Triennale, and through photographic reproduction. De Lucchi would go on to be Memphis' most important furniture designer apart from Sottsass himself, creating (among many other designs) the group's biggest seller, the *First* chair (1983), which looked something like a diagram of an orbiting satellite.

Also drafted into Memphis from Sottsass Associati were four other members of the firm, each of whom had extensive practical experience of work with corporate clients like Olivetti. Matteo Thun was the scion of a well-to-do Austrian family, and had trained in Florence under the architect Adolfo Natalini (of Superstudio). He proved to be the most talented ceramic designer of the group, capable of satisfyingly resolving a complex semantic soup of zoomorphic, ornamental and architectural elements into a single animated form.[85] If there were any such thing as a 'typical' Memphis designer, Marco Zanini (not to be confused with the fashion designer of the same name) might fit the bill. He was the member of the group most engaged with glassware production, again apart from the prolific Sottsass, and also designed furniture and ceramics. Like De Lucchi, Thun and other members of the group, Zanini had come from the architectural scene in Florence, but was only in his mid-20s when Memphis was founded. For him the formation of the collective

44
Andrea Branzi, *Labrador* sauceboat, 1982. Electroplated nickel silver and glass. V&A: M.34–2010

45
Masanori Umeda, *Tawaraya* boxing ring bed, 1981. Memphis members from left: Aldo Cibic, Andrea Branzi, Michele De Lucchi, Marco Zanini, Nathalie du Pasquier, George J. Sowden, Martine Bedin, Matteo Thun and Ettore Sottsass

marked a passage from 'the utopias and illusions of the academies of architecture in the seventies, to the reality of the designer's profession'.[86] Aldo Cibic was another relatively junior partner, with minimal aesthetic leanings uncharacteristic of the group. His principal contribution was to function as a project manager, ferrying drawings and prototypes back and forth between the group and various fabrication firms.[87]

The fourth participating staff designer at Sottsass Associati, the British expatriate George Sowden, formed both a personal and professional relationship with one of Memphis' younger members, Nathalie du Pasquier. Only 24 when the group was founded, she nonetheless made a dramatic impact through her pattern designs for laminates and textiles, which bore the influence of her recent travels in Africa. Sowden, for his part, had been working on the Sottsass Associati account with Olivetti, specializing in electronics. He and Du Pasquier blended their expertise in an interesting Memphis spin-off project: *Objects for the Electronic Age* (pl. 46). This series of small domestic products – boxes, clocks, etc. – was meant to mark a theoretical transition between two phases in the history of design. As Sowden puts it, 'If mechanical design is about function, then electronic design will be about decoration' – because mechanical devices have substantive moving parts that must be housed in an exterior shell, but an electronic device can be any shape. This was the pair's key insight: 'Electronic age objects will be *anything*.' The two designers took up temporary residence at the Abet Laminati factory, quickly creating patterns and running them through the machines. This allowed them to produce very limited runs of a particular laminate for use on a particular design: 'one-off pieces made with an industrial process'.[88]

Martine Bedin, a childhood friend of Du Pasquier's from Bordeaux, was another of the Memphis 'young bloods'. Her *Super* lamp is an excellent example of how the group absorbed the ideas of its participants (pl. 47). Bedin had thought up the colourful lamp on wheels several years earlier. After she attracted notice for an ornament-rich installation entitled *La Casa Decorata* at the 1979 Milan Furniture Fair, she met Sottsass, leading to an invitation to join Memphis. When Sottsass saw her drawing for the *Super* lamp he asked her about it, and she explained that she had wanted something she could take with her anywhere – 'I can carry it behind me, like a dog.'[89] This was just the sort of insouciance that he was looking for, and the *Super* became one of the stars of the first Memphis collection. Bedin (whose father was an electrical engineer) was given responsibility for managing production of most of the rest of the Memphis lighting as well.

In addition to the close-knit family of Italians and expatriates gathered in Milan, Sottsass also drafted a handful of international designers into the group, among them Michael Graves, Kuramata Shiro, Masanori Umeda and Javier Mariscal. This had the double advantage of lending the project prestige and broadening Memphis' aesthetic palette. Graves' neo-Art Deco *Plaza* vanity (pl. 210, p. 233), Kuramata's confetti-coloured terrazzo tables, Umeda's action-figure-like *Robot* cabinet, and Mariscal's animated *Hilton* bar trolley, leaning back as if it were rolling downhill at top speed, were all typical expressions of their designers' personal styles (pl. 48). In the Memphis context, however, they contributed to an impression of a shared postmodern project, a 'new wave' of design that would sweep all before it.

Just how far one could ride that wave is clear from the career of Los Angeles-based ceramist, sculptor and furniture designer Peter Shire, who was the figure from abroad who participated most enthusiastically in Memphis (pl. 52). Prior to his alliance with the group he had been known mainly for his teapots, essays in postmodernist bricolage that he had been making since the early 1970s. These looked completely non-functional (though he always ensured they could in fact pour well) and incorporated influences from Pop Art, California 'Googie' architecture, and surf and hot rod culture. Sottsass became aware of Shire's work in the unlikely context of the West Coast lifestyle publication *Wet*, which had run a feature on Shire in which he commented, 'My work doesn't even relate to my own lifestyle. I'm not much of a tea-drinker … Actually my first impulse is to put Coke in teapots. I'm a big Coke drinker and I'd love to see Coke flowing out of the teapots and foaming on the ground.' (pl. 49)[90] Sottsass immediately recognized that Shire would bring to the group a welcome dose of humour and colour – what Barbara Radice later described as 'plastic color, hot dogs, sundaes, artificial raspberry colour'.[91]

After a get-acquainted trip to Milan, Shire set to work with his customary enthusiasm, not in his usual medium of ceramics but in metalwork and furniture. Among his first

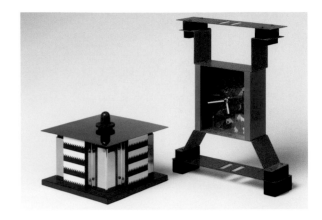

46
Nathalie du Pasquier, *Gracieux accueil (Gracious Reception)* box, 1983. Wood, metal and plastic laminates. V&A: W.32–2010

George Sowden, *Heisenberg* clock, 1983. Painted steel and clock parts. V&A: W.22–2010

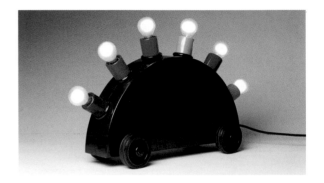

47
Martine Bedin (for Memphis), *Super* lamp prototype, 1981. Painted metal, lighting components. V&A: M.1–2011

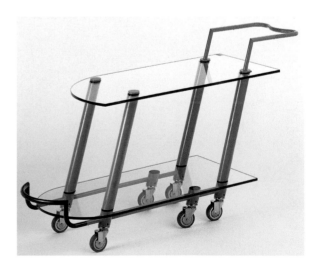

48
Javier Mariscal (for Memphis), *Hilton* bar trolley, 1981. Painted metal trolley with shaped crystal glass and industrial casters. V&A: W.15–2010

Opposite: 49
Peter Shire, *Bel Air* chair, 1982. Laminated wood and wool upholstery. V&A: W.19–2010

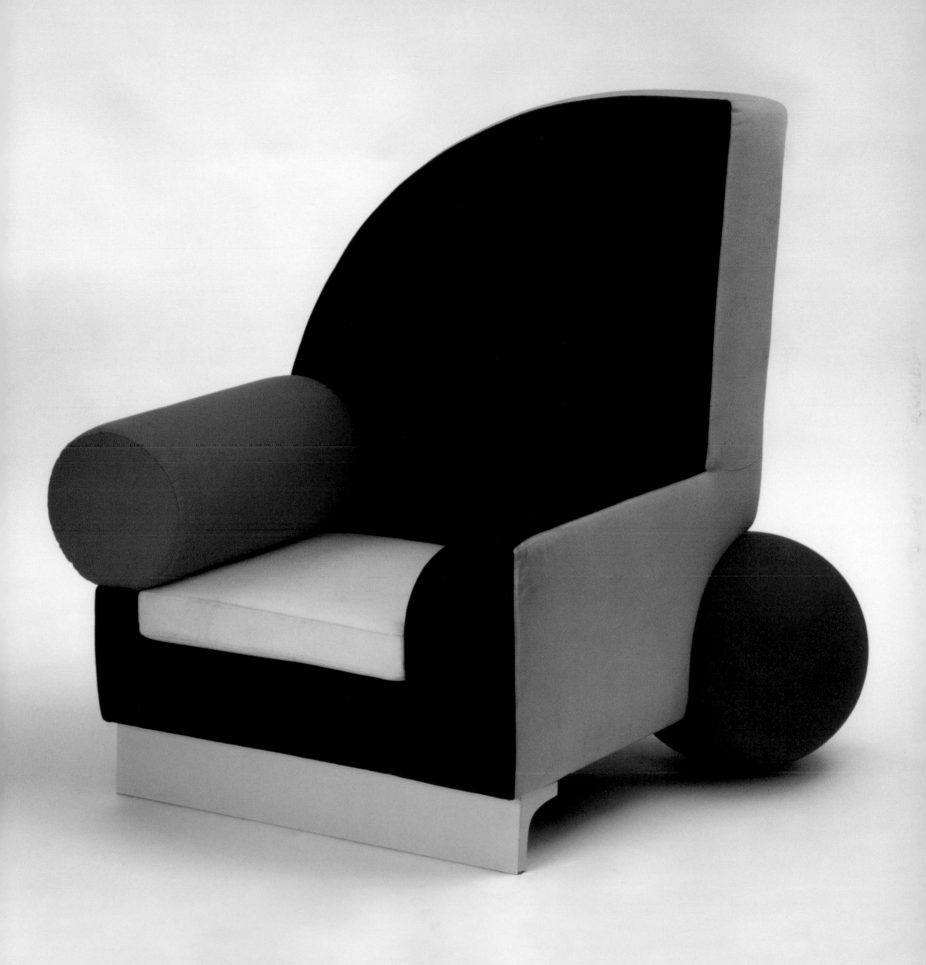

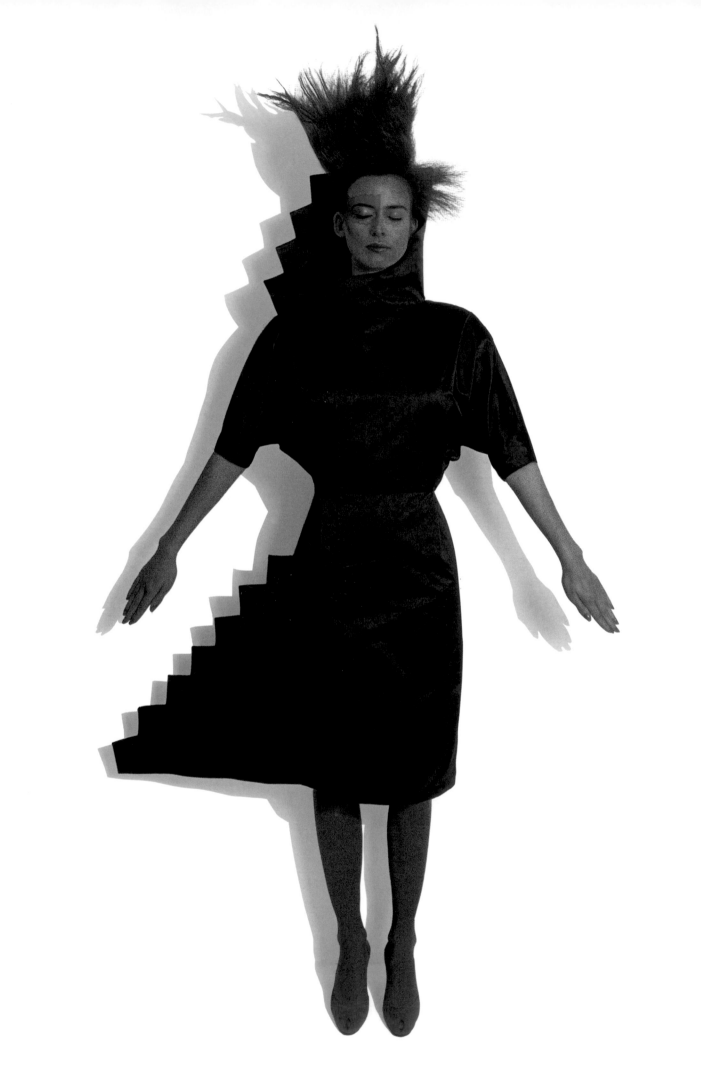

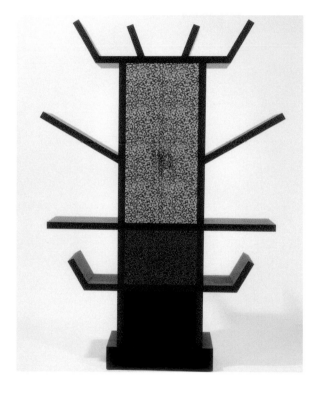

51
Ettore Sottsass (for Memphis), *Casablanca* sideboard, 1981. Plastic laminate over fibreboard.
V&A: W.14–1990

designs for Memphis was the iconic *Bel Air* chair, which featured a brightly coloured beach-ball of a rear foot and an asymmetrical shark-fin back (pl. 49). Shire was thinking partly of similar forms used by the American sculptor H.C. Westermann, but also of the Stevens House by architect John Lautner, located on the 'surfer beach' in Malibu. Like all the early Memphis furniture, the chair's title was taken from the name of a hotel – in this case, a five-star establishment in Beverly Hills. (Shire says he wanted to give it the more punning title *Bone Air*, as in 'debonair', but Sottsass preferred not to; he used it anyway a few years later, pl. 52.) This 'branding' strategy, originally Radice's idea, was perhaps intended as a subtle joke about the limited run and craft production of Memphis objects, which inevitably made them luxury goods. But according to Shire the main purpose of the titles was to lend a sense of coherence, much in the manner of a thematic couture collection.[92]

At the edges of Alchymia and Memphis, artists in other fields also flourished, such as the photographer Giancarlo Maiocchi, who designed a two-year series of covers for *Domus* magazine under the label Occhiomaggico; and the fashion designer Cinzia Ruggeri. If Memphis objects were like props for a stage performance, then Ruggeri provided the requisite costume. Her dress *Homage to Lévi-Strauss* (a reference to the French anthropologist) featured a bold ziggurat profile and a vivid green colour, making its wearer a match for any Sottsass sideboard (pl. 50). Ruggeri also undertook futurist experiments with clothing, inserting LED lighting into the fabric or installing micro-ventilators that inflated the garments when they were worn.

As is clear from this extensive roster of participants, Memphis was in every sense a group effort – an alignment of pre-existing tendencies that lent credence to the fact that there was a 'New International Style', as the collective's first promotional materials claimed. But, inevitably, Sottsass played the starring role. He was the group's *de facto* spokesman, issuing proclamations like, 'The only thing I know is that Memphis furniture is very intense and that it can only live with very intense people, very highly evolved and self-sufficient people'.[93] Sottsass' prominence was further enhanced by the fact that the other 'front person' for Memphis was Radice, who wrote fiercely intelligent manifestos on the group's behalf. It was Sottsass' work that spoke loudest, however. He seemed to have boundless energy, working across more media than any other Memphis designer – furniture, metal, ceramic, glass, even a television – and producing the group's most iconic objects. And like other members in the group, he seamlessly integrated his previous design approach into the new brand; as Radice put it, 'almost all the Memphis ideas, in a less virulent, clear, and emblematic form, had already been in his work for twenty years'.[94]

Yet it was precisely the emblematic quality of Sottsass' Memphis designs that made them so devastatingly effective. His furniture, in particular, has assumed symbolic status as the *sine qua non* of 1980s design (pl. 51). The principal material used to make it was plastic laminate: cheap, artificial and dimensionless, a surface seemingly without inherent properties apart from its role of being a surface, a role which it performs without inflection. Memphis was funded, in large part, by Abet Laminati (it is only a slight exaggeration to say that Memphis served as a publicity stunt for the company) and Sottsass was not shy in putting their products front and centre. Away with your Modernism, Sottsass seems to say. This too is a possible truth about materials: sheer theatrical effect, only skin deep. Like other Memphis objects, his *Casablanca* and *Carlton* sideboards could be used in a domestic interior despite their oddly canted shelves (as Sottsass was fond of saying, books always fall over anyway), but they were made principally for the purpose of taking a photo. As Peter Shire has observed, 'Memphis was *of* the media. There was never any problem with colour separations, it always reproduced true, because we were using synthetic colours in the first place. The priority was to go for the image. The difference was between its existing and not existing.'[95]

So where did Memphis objects go, once they had been produced and reproduced? As so often in the 1980s, it is helpful to follow the money. Dealers played a key role in making the 'new international style' a reality; even projects as well capitalized as Memphis could not have succeeded without the support of a new retail environment, in which design galleries were styling themselves after their fine art counterparts. The New York gallery Art et Industrie was a pioneer in this regard. Its proprietor Rick Kaufmann leveraged early shows of Alchymia and Memphis to support the careers of several home-grown American furniture designers, all of whom approached their work as a form of sculpture.[96] The stable

52
Peter Shire seated in *Bone Air* chair,
c.1985. Photograph by Kevin LaTona

Opposite: 53
Howard Meister, *Nothing Continues
to Happen* chair, 1980. Painted birch
plywood. V&A: W.6–2010

included neo-modernists such as Forrest Myers, 'fantasy furniture' makers like Terence
Main, and Howard Meister, whose *Nothing Continues to Happen* chair (inspired by images
Meister had seen of the latest Italian provocations) became one of the widely circulated
postmodern designs (pl. 53). The chair was hand-carved from MDF and then painted a flat
grey to mimic ruined concrete: an emblem of disintegration reminiscent of Mendini's ritual
torching of a similarly Platonic chair form several years earlier. This was a chair for looking
at, rather than sitting in, and though it was published extensively in magazines and design
books, only three were ever made. Art et Industrie's strategy was not necessarily very
profitable – as Kaufmann puts it, 'Sales were a struggle all the way through … that usually
shows that you're doing something right' – but designs like Meister's achieved a level of
exposure at odds with their availability.[97]

Keith Johnson's firm Urban Architecture, based in Detroit until 1998, was another key
conduit between Italian design and American buyers. Johnson got his start while working
as an inner city loft developer in 'Motown' in the 1970s. This work brought him into contact
with stylish lighting and furniture firms such as Artemide and Driade, and he soon shifted
from importing products for his own buildings to acting as a dealer and distributor for the
Italians. Johnson remembers cold-calling executives featured in *Fortune* magazine as a way
of drumming up clientele (among the buyers he secured in this fashion was Asher Edelman,
the noted corporate raider and arts patron who inspired the character Gordon Gecko in the
1987 film *Wall Street*, which also featured some of Meister's furniture). This bold approach
to salesmanship led to his becoming one of the first to handle Memphis design in the United
States, eventually becoming their sole American distributor in 1985.[98]

Despite the efforts of middlemen like Kaufmann and Johnson, Sottsass never had any
real intention of making money out of Memphis — he considered it a sideline and an
antidote to his lucrative corporate work. Even the group's most famous pieces, like Graves'
Plaza, Shire's *Bel Air* and Sottsass' *Carlton*, sold fewer than 50 copies over the course of the
1980s. Memphis, then, was never built to last. In its second year, 1982, Sottsass was already
saying, 'I would be terrified to think that Memphis may carry on as it is for 10 years, or even
only five.'[99] That proved to be about right. The collective did undergo several dramatic
changes in tactics over its short lifespan, turning to a more luxurious set of materials for
its second collection and then experimenting with mass production in its third (which
included De Lucchi's *First* chair), all the while undergoing internal paroxysms at the
implications of any form of commercial success. Perhaps it was inevitable that an attempt
would be made to make Memphis profitable, given the enormous influence of the group
in the marketplace of style. (As one design buyer reportedly said, when some of the young
Memphis designers first paid a visit to London, 'My immediate reaction is that all this is

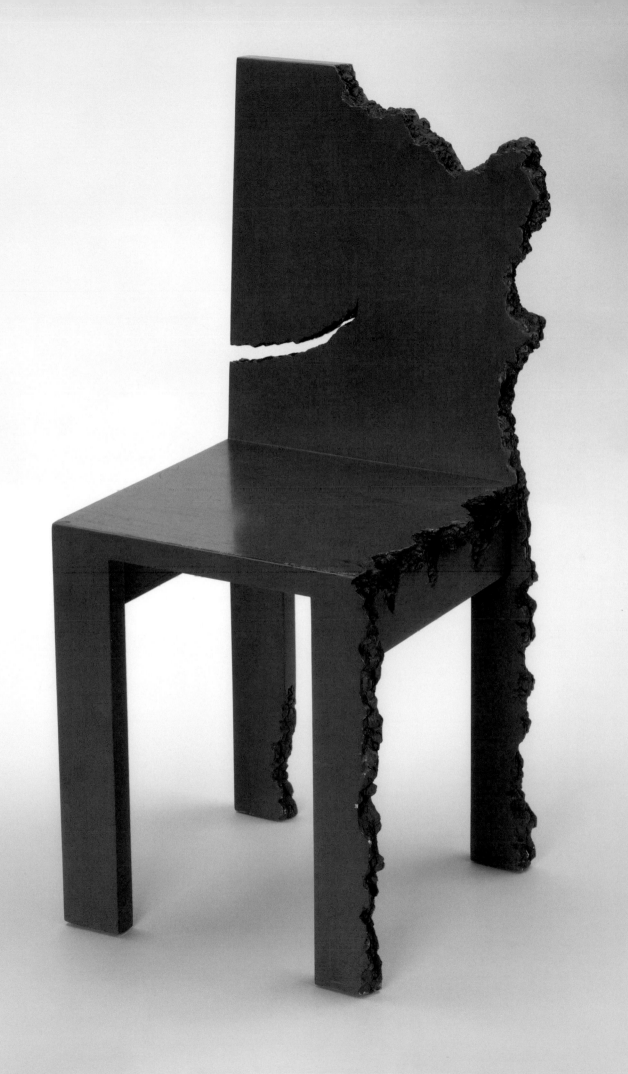

irrelevant to serious design. But, God help me, this lot is our next generation of customers.')[100] In practice, this took the form of a transfer of ownership. While other possibilities were debated, including ownership by the designers themselves, the original partnership structure (see Catharine Rossi's essay in this volume, pp. 160–5) was dissolved. In 1987 the Memphis name and the right to reproduce the designs were sold to the entrepreneur Alberto Albricci.

At around the same time, Sottsass announced that as far as he was concerned, it was over. Bedin recalls the scene: 'That created an incredible reaction – very Commedia dell'Arte, very Italian, though we weren't all Italian. De Lucchi, who has a very low voice, was screaming at him: "Ettore, you can't leave us!" But Ettore said, "It's like a love story. When you get used to it, you have to quit"'.[101] That was one way of understanding the unravelling of Memphis; the other was that the commercial sphere had bested this attempt to ridicule its own imperatives. You can almost hear Mendini's taunting words on the subject hovering in the background: 'What pleasure we get, what intellectual exercise, from this egotistic exploring of markets, catalogues, seductive shop-windows, advertisements, other people's houses ... the more you repudiate this immoral demon of temptation, the more it bobs up and wins again.'[102] Yet even if its residual radicalism was drowned out by the ringing of cash registers, Memphis had a huge impact on design. It inspired many outright imitations and, more generally, a looser, more art-oriented, and above all more permissive visual language. Memphis showed that innocuous, domestic things – sideboards and teapots – could play a part in the hyper-real life of the postmodern subject: a life lived as if always on stage.

Synthetic Identities

Fame, gonna drive me insane,
like it drove you away from me.
Fame, all alone with my name,
even that don't belong to me.[103]
—*Grace Jones*

Are you for real?[104]
—*Zhora from* Blade Runner

Before theorists started to talk the talk – before Judith Butler anatomized gender identity as a performative act, and before Donna Haraway delivered her cryptic pronouncement that 'we are all chimeras, theorised and fabricated hybrids of machine and organism' – performers of all kinds were already walking the postmodern walk.[105] Dancers and choreographers; art directors for sci-fi films, pop promo videos and style magazines; performance artists; drag queens; pop stars; disc jockeys; cabaret singers, partygoers, poseurs and nightclubbers: these were the unlikely authors of the first visualizations of postmodern identity.

In the 1970s diversity was a rhetoric within professional design practice, but not a reality. Even in the most radical architectural enclaves, where postmodern pluralism was embraced as a guiding principle, straight white men dominated the profession. Women such as Gae Aulenti and Denise Scott Brown faced routine discrimination.[106] Underground performance culture, however, was an entirely different matter. The roots of this 'scene' can be found in jazz clubs, illicit gay bars, and bohemian art culture, and most of its key innovators were female, gay, black, or otherwise 'other'. In this context alterity could itself be the basis of professional identity. The names said it all: Steve Strange; Klaus Nomi ('no-me'); Public Enemy. And yet, paradoxically, it was these apparently marginal figures who brought postmodern ideas their greatest fame. Performers in various disciplines brought techniques like quotation and self-referentiality to a much wider audience than even the most commercially successful designers of chairs, teakettles and buildings. Over the course of a few short years, they managed to rewrite the rules of pop culture.

In many respects, postmodern performance strategies resembled those being explored elsewhere in design. Performers deconstructed and re-assembled. They worked in a language of pastiche. But to this basic toolkit they added further layers of complexity, combining visual style (dress, graphics and stage sets) with music, movement and words, fully realizing postmodernism's potential for interdisciplinary crossover. Most importantly, they drew explicit attention to the *mediation* of their own work, creating (in Kate Linker's words) 'shimmering synthetic appearances that flaunt their artificial origins'.[107] As we have

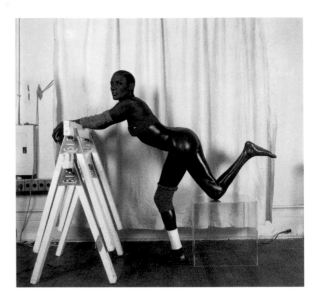

54
Jean-Paul Goude, Preliminary photograph for *Grace Jones Revised and Updated*, 1978. Photographic print

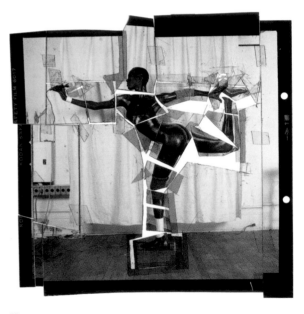

55
Jean-Paul Goude, Preliminary collage for *Grace Jones Revised and Updated*, 1978. Cut-up Ektachrome

Opposite: 56
Jean-Paul Goude, *Grace Jones Revised and Updated*, 1978. Photographic print

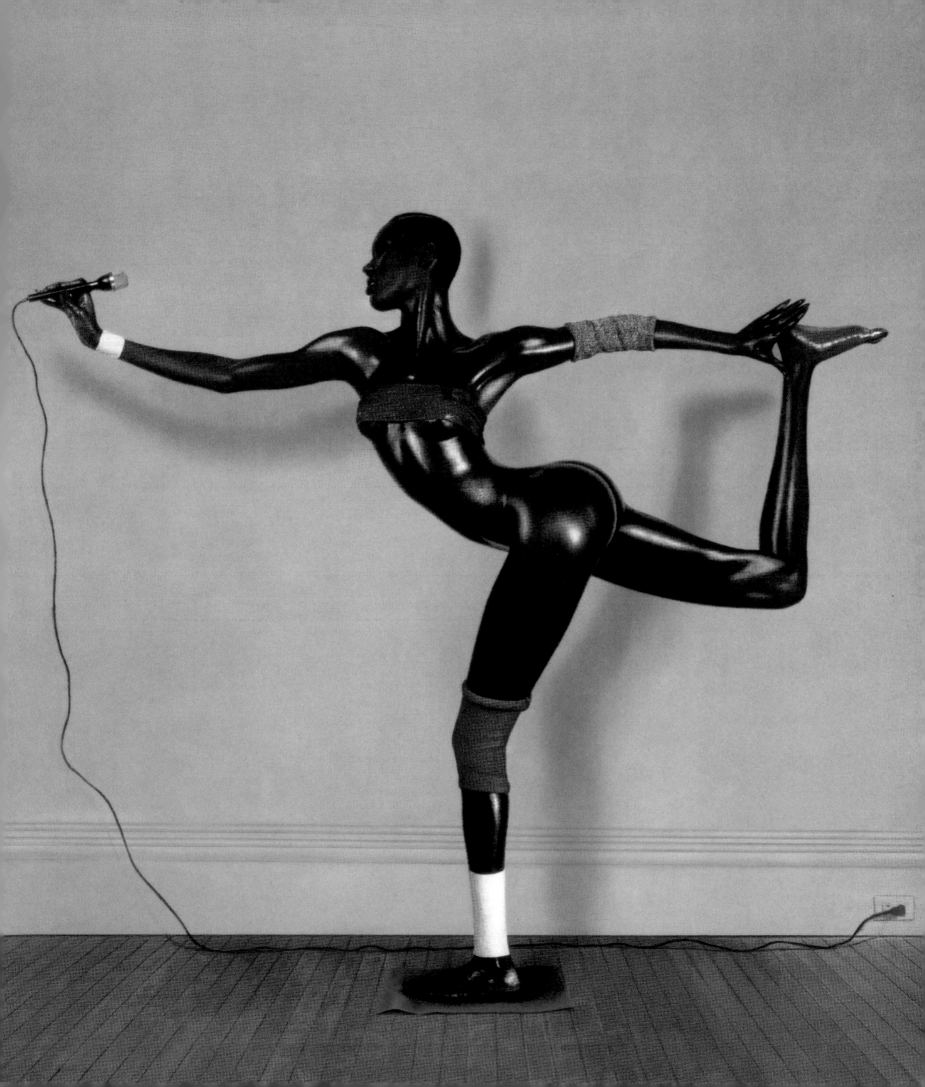

seen, being media-friendly was an important aspect of Memphis and other New Wave design, but that fact was left largely tacit. For performers, by contrast, the operations of stage and screen were a topic of obsessive interest. The means of reproduction, like TV and magazines, were taken up as primary content. As the literary critic Larry McCaffery noted at the time, this was a natural response to the postmodern condition:

> This is a milieu of near-infinite reproducibility and disposability, a literal and psychological space that has been radically expanded by recent video, computer, digital, Xerox, and audio developments, by technology's growing efficiency in transforming space and time into consumable sounds and images, and by the population's exponentially increased access to cultural artifacts which can be played, re-played, cut-up, and otherwise manipulated by a casual flick of a switch or joystick.[108]

For the most part, theorists of postmodernity were inclined to see this expanding empire as terrifyingly anti-human. (As Lyotard memorably put it, 'We are like Gullivers in the world of technoscience: sometimes too big, sometimes too small, but never the right size.')[109] They portrayed the mass media as manipulative, its simulations tending to erode authentic experience and put in its place an all-conquering 'society of the spectacle'.[110]

But what if being spectacular is your primary objective? For some postmodern performers, acting out the part of a celebrity was an expressive act in its own right. As Rosetta Brooks, the editor of avant-garde style magazine *ZG*, put it, 'The poser is his/her own ready-made art object ... whose circulation is not the microcosm of the art world but the self-consciously constituted clique.'[111] While it might be possible to see such figures as tools of the 'culture industry', it is hard not to feel that when they hit the stage or screen, they were very much in charge. This is certainly true of Grace Jones, for example. After emerging in the late 1970s as the doyenne of New York's underground club and disco scene, Jones worked with her lover, the stylist Jean-Paul Goude, to fashion herself into an iconic, even superhuman character. Photographed in a maternity dress that looked like a Memphis sideboard, perched atop a Mendini-esque ziggurat, or appearing on stage alongside a phalanx of masked Jones clones, she exploited the vocabulary of postmodern style to devastating effect. The truest portrait made of her during these years was probably the cover of the album *Island Life*, fabricated by Goude out of many separate photographic fragments (pls 54–6). The resulting image showed her in a seamless arabesque – a potent, hyper-real action figure. (Will the real Grace Jones please stand up? Why would she want to?)

Jones might be taken as emblematic of postmodern performance, too, in the way her career progressed. She got started by playing in the New York disco scene, frequently to gay audiences. By the 1980s, she was at the top of the charts and starring in Hollywood action films. To some extent, this passage from the underground to the mainstream was the shape of postmodern performance in general. It first blossomed underground, a hybrid of glam, punk, funk and drag. Then, it moved through a great churning mill of clubs and fringe venues, breaking out into popular culture via large-scale engines of style like MTV (Music Television, launched in 1981) with unprecedented speed. To this day, the postmodern techniques of self-regard, irony and exaggeration form the bedrock of the commercial pop repertoire (witness Lady Gaga). This arc conforms to the customary course of stylistic diffusion, already explicated in 1970 by Alvin Toffler in his book *Future Shock*:

> While charismatic figures may become style-setters, styles are fleshed out and marketed to the public by the sub-societies or tribe-lets we have termed subcults. Taking in raw symbolic matter from the mass media, they somehow piece together odd bits of dress, opinion, and expression and form them into a coherent package: a life style model. Once they have assembled a model, they proceed, like any good corporation, to merchandise it. They find customers for it.[112]

By the time of Dick Hebdige's 1979 book *Subculture*, Toffler's skeletal account of mainstream absorption had become the basis for a satisfyingly thorough analysis of the operations of style. The thinking went like this: as new ideas migrate from their niche or avant-garde position and then proliferate, at first through an 'in-crowd' and eventually via appropriation

and exploitation to a broader public, the potentially disruptive energies of the subculture are controlled, and the hegemony of mass culture is continually re-asserted.[113] Whether this just-so story is ever valid is hotly debated by theorists.[114] In the case of postmodernism, however, it is clear that it does not apply in at least one key respect: the processes of mediation and commoditization were factored in all along, so how could there be a moment of 'selling out'? Tricia Rose has made this point about the supposed commoditization of hip-hop music:

> Hip hop's explicit focus on consumption has frequently been mischaracterized as a movement into the commodity market (i.e., hip hop is no longer 'authentically' black, if it is for sale). [But] hip hop's moment(s) of incorporation are a shift in the already existing relationship hip hop has always had to the commodity system.[115]

From this perspective, the disruptive potential of postmodern genres such as hip-hop were actually implemented rather than de-fanged when they were taken up by the culture industry.

Take another example: Leigh Bowery. An Australian-born club denizen, resident in London, Bowery fashioned himself into a 'living artwork' through extraordinary, body-distorting costumes of his own design and make. Alterity was at the heart of his activities. He was a front-man for the nightclub Taboo, contributed outfits to Michael Clark's radical dance company, and started a band called Minty which was notorious for, among other things, its graphic on-stage depiction of a birthing process (with Bowery in labour). In 1988

57
Leigh Bowery posing during a performance at the Anthony d'Offay Gallery, London, 1988. Photograph by Nils Jorgensen/Rex Features

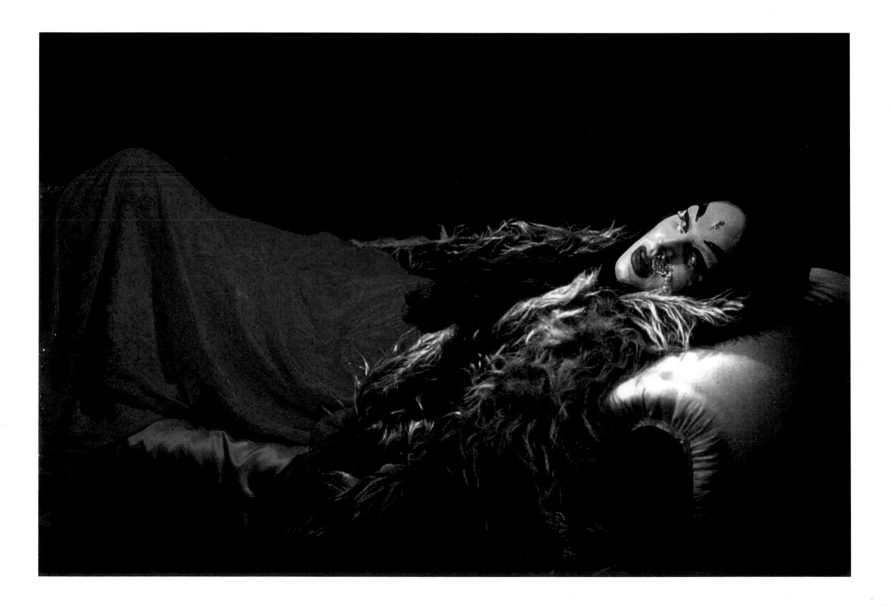

he staged a week-long performance at London's Anthony d'Offay Gallery in which he displayed himself in a variety of costumes behind a one-way mirror (pl. 57). An object in a vitrine, he nonetheless looked at himself posing and therefore shared in the voyeuristic gaze of the visitor.

Clearly Bowery was not bidding for mainstream acceptance. Yet gradually his ideas permeated the worlds of cutting-edge fashion and art. Even before his death of AIDS in 1994 he was one of the most name-checked figures in London's art and fashion worlds, and he is regarded today as something like a national treasure. At first this looks, again, like the defusing of an avant-garde gesture – initially shocking, eventually mainstreamed. But it should be remembered that, for all Bowery's outrageousness, he was camera-ready from the beginning, and highly conscious that 'image' was his principal medium. Already in 1983 he was modelling his clothing at London's Institute of Contemporary Arts and in fashion shows, and he appeared on catwalks and on television throughout the decade. The same year that he appeared at the Anthony d'Offay Gallery he staged a similar performance in the window of a Japanese department store, demonstrating his indifference to the distance between art and commercial venues. Even for this most seemingly indigestible of radical performance artists, finding an audience and holding its attention was a constant preoccupation – in some ways, the point of the whole exercise. Bowery's intelligence as a designer and performer was premised on the infrastructure of fame.

Another fascinating instance is the case of 'voguing'. This concept was made famous by Madonna, the queen of pop, in 1990:

> Ladies with an attitude
> Fellas that were in the mood
> Don't just stand there, let's get to it
> Strike a pose, there's nothing to it
> Vogue[116]

The term had perhaps been drawn to Madonna's attention two years earlier, when it was adopted by the omnipresent subcultural gadfly of postmodernism, Malcolm McLaren, for his single 'Deep in Vogue'. The song was a tribute to the drag queens of New York City, such as Paris DuPree (a kindred spirit of sorts to Grace Jones), who had invented voguing a decade earlier. According to disco historian Tim Lawrence, African-American transvestites would flip open a fashion magazine – not necessarily *Vogue*, but it was a popular choice – to a random page, and adopt whatever pose they found there.[117] It was one way of 'throwing shade' (displaying attitude) on the dance floor. So when Madonna hit No.1 in the pop charts and got herself into fashion magazines yet again, she was returning the practice to its origins. Voguing was always already mediated.

Postmodern performances are almost always built around these recursive effects. The music video for the 1980 song 'Fade to Grey', by the pop group Visage, is typical in its attitude, though superlative in its realization (pl. 58). The band's singer, Steve Strange, is first shown plunging from a town car into a scrum of fashionistas (a nod to his real-life activity as impresario of London's Blitz Club). Photographers gather around him and his beautiful young male companion: he is the centre of media attention. Then we ourselves are looking at him, in close-up. He stares back, eyes wide in deadened astonishment, pseudo-Cubist make-up dividing his face. Moments later he is broken into fragments through montage: an eye and a pair of rouged lips, patches in the darkness slowly coalescing into a face. Then, true to the song's title, he fades away into nothing. Meanwhile, Strange sings of alienation:

> One man on a lonely platform
> One case sitting by his side
> Two eyes staring cold and silent
> Show fear as he turns to hide [118]

He presents himself as a postmodern subject: an object of constant fascination who is only a cosmetic shell, an identity formulated through a process of disintegration. Strange's impassive voice and mask-like face recall, too, the 'deadpan' methodology that Denise Scott

Opposite:
58
Visage, *Fade to Grey* album (UK release), 1980. Make-up by Richard Sharah, hair by Keith of Smile, clothes by Judith Frankland, photograph by Robyn Beeche. V&A: E.231–2011

59
Devo, *Freedom of Choice* album (USA release), 1980. Photograph by Joep Bruijnje. V&A: E.230–2011

60
Kraftwerk, *The Man-Machine* album (German release), 1977. Artwork by Karl Klefisch, photograph by Günther Fröhling. V&A: E.48–2011

Overleaf: 61
Blade Runner, 1982.
Directed by Ridley Scott

Brown and Robert Venturi brought to Las Vegas. This studied neutrality of style – detached, a little artificial – was common in 1980s pop. Bands like Talking Heads and Eurythmics delivered vocals, conventionally the most expressive aspect of rock music, in a flat monotone. Musical inflection was now located not in the singer's voice and lyrics – what the song meant – but rather in the song's mediation, how it worked: its technical fabrication through samples and synthesizers, and its subsequent distribution through recordings, videos and live performance.[119]

The American band Devo was exemplary in this regard. Their name was derived from an apocalyptic theory of 'Devolution' developed by founders Gerald Casale, Bob Lewis and Mark Mothersbaugh while they were students at Kent State University in the early 1970s. Casale writes:

> There's no question that we exhibited post-modern trends before we knew of the label. Our Dadaist send-up of the modernist idea of progress and technological utopia was at the core of the Devolutionary aesthetic that we so stridently advanced. We attacked the thin veneer of certainty posited by what we saw as a gang of illegitimate authority (cops, preachers, TV hucksters, psychologists, etc). We asked the seminal question 'Are We Not Men?' and gleefully proclaimed the answer.[120]

By the time they hit the mainstream in 1980 with their album *Freedom of Choice*, Casale and Mothersbaugh had designed a sophisticated 'fashion/anti-fashion' look composed of silvery Naugahyde suits and vacuum-formed headgear (the iconic 'Energy Domes') (pl. 59). Whether they were on stage, in magazines, or starring in videos broadcast during the first years of MTV, Devo projected an unnervingly 'post-human' quality.[121]

In Germany, a similar approach was being pursued by Kraftwerk, who emerged from the experimental electronic music scene in Düsseldorf in 1970. Appropriately for a band whose name translates as 'power plant', they fully embraced the idea of technological determinism. (Asked about their instrumentation, Kraftwerk's Ralf Hütter and Florian Schneider would reply, 'We play the studio', rather than guitars and keyboards.)[122] For their 1978 album *The Man-Machine*, they re-fashioned themselves in the image of their own 'robot pop' music, having themselves depicted as androids on the neo-Constructivist record sleeve and in music videos (pl. 60). On one track, the group intoned:

> We're functioning automatik
> And we are dancing mechanik
> We are the robots [123]

At the press launch for the album, they appeared in person for only five minutes, allowing most of the event to be handled by four inert showroom dummies. Kraftwerk was an early and unusually extreme example of the performer as completely synthetic creation. They were early adopters of an important postmodernist motif, which might be termed the 'authentically inauthentic' subject.[124] The idea is perhaps best known from *Blade Runner* (pl. 61) which features characters called 'replicants' who are physically and mentally superior to humans but are in fact commodities, fabricated by a corporation to provide free labour. Poignantly, one of the replicants, Rachel, is unaware of her own status as an artificial life form. Her tragic, amnesiac, and completely constructed identity is a template for the postmodern condition.[125]

In New York City, the performance artist Laurie Anderson was engaging with a similar range of ideas. But if groups like Visage and Kraftwerk were radically reductive in their approach, she used 'deadpan' as a springboard, creating a dazzling repertoire of synthetic effects. Anderson's work resists both disciplinary categorization and easy understanding. It is wilfully scrambled and indeterminate, but also politically committed and poetically evocative. (As the Marxist scholar Marshall Berman once put it, she is 'ironic, maybe quixotic, but the more determined for all that'.)[126] Anderson is above all a storyteller, but her tales are invariably non-linear. She has noted that 'language can be very fragile – it can be used in so many different ways', and she fashions her persona out of fragments, as if her words and music had fallen to the floor and she were picking up the pieces.[127] Stray bits of media broadcast, political speeches and the sweet nothings of lovers are all set to a

dizzying soundtrack of jazz, classical orchestration, Steve Reich-style minimalism, and transcendent chorale. Her lyrics, too, occupy a tonal never-never land, caught somewhere between a public address announcement, deconstructivist theory and modernist poetry. In the song 'From the Air,' for example, Anderson imagines her anonymous addressee as a postmodern subject in freefall, and in need of consolation. Whether she provides it or not is not obvious.

> Put your hands over your eyes.
> Jump out of the plane.
> There is no pilot.
> You are not alone.
> Standby.
> This is the time;
> And this is the record of the time.[128]

The identity that Anderson projects is at once multiple and, as is suggested by the cover of her album *Big Science*, a completely blank screen, ready for projection (pl. 62). She processes her weirdly persuasive speaking voice through a vocoder (or voice encoder, a device invented in the 1930s to transmit encrypted messages over the radio). This artificial means

62
Laurie Anderson, *Big Science* album (USA release), 1982. Art direction by Perry Hoberman, design by Cindy Brown, photograph by Greg Shifri. V&A: E.229–2011

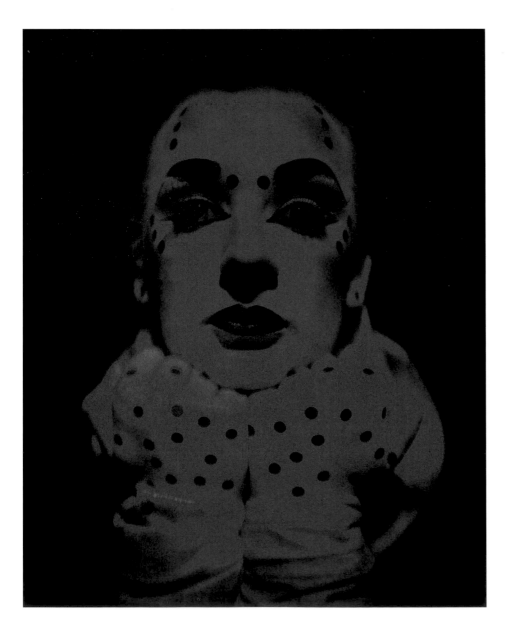

63
Richmond Holographic Studios (Edwina Orr and David Trayner), *Boy George* reflection hologram, 1987. Silver halide on glass © Richmond Holographic Studios (Edwina Orr and David Trayner). Courtesy Jonathan Ross Hologram Collection, London

allows Anderson to shift fluidly among various 'modes of address', each of which seems to signify a different stereotype, a different perspective on the world.[129] Out of all this, though, arises a powerfully unified artistic vision — an act of synthesis encapsulated in the punning title of Anderson's sprawling 1983 masterpiece *United States*.

Anderson's work, with its eclectic bricolage of performance disciplines, is all about assuming different guises — a fragmentary persona built around a teasingly unknowable core. Her work might be considered a polymorphous, staged equivalent to Cindy Sherman's rather more focused photographic project *Untitled Film Stills* (1977–80). With their combination of specific narrative and absent identity, these images are an inevitable reference point for postmodernism in art history (pl. 65). If Grace Jones and Jean-Paul Goude used a single image to assemble an identity from parts, Sherman achieved the same end through an open, fragmentary series. Nor is there a huge gap between the work of Pictures Generation artists — that is, Sherman and her conceptualist colleagues such as Richard Prince and appropriationist Sherrie Levine, so-named for a group exhibition of 1977 — and the popular image-making that they mined so effectively (pl. 64). Fashion photography in this period often employed the same combination of quotation and impending violence that one finds in Sherman's work.

And how different, really, are a Sherman film still and the portrait of Boy George, Steve Strange's friend and fellow Blitz Club habitué, taken at the Richmond Holographic Studios in 1985 (pl. 63)? This may seem a strange comparison, juxtaposing as it does a benchmark of post-conceptual art with an apparently frivolous image destined for the gift shop market.[130] Yet David Harvey's concise description of Sherman's work could apply equally to both images: 'They focus on masks without commenting directly on social meanings other than on the activity of masking itself.'[131] In each case, identity is shown in the process of its own construction from raw material. It consists entirely of pre-existing codes. If anything, the hologram of Boy George is the more eerily synthetic of the two portraits. It shows the pop star posing coquettishly in the garb of a clown, decorated all over with polka dots. Even in reproduction the photo has an unearthly quality, but in person, the hologram projects a powerful sense of non-space. Boy George floats in an undefined 3D void, and no matter where we stand in front of the glowing green image he stares right through us. His look recalls Jean-Claude Lebensztejn's memorable description of the postmodern gaze as 'calm and blank', seeing everything in its field of vision but withholding all judgment.[132] In an image like this, disillusionment creates its own kind of magic.

64
Richard Prince, *Untitled*, 1983.
C-type colour print. V&A: E.334–1994
© Richard Prince, courtesy Gagosian
Gallery

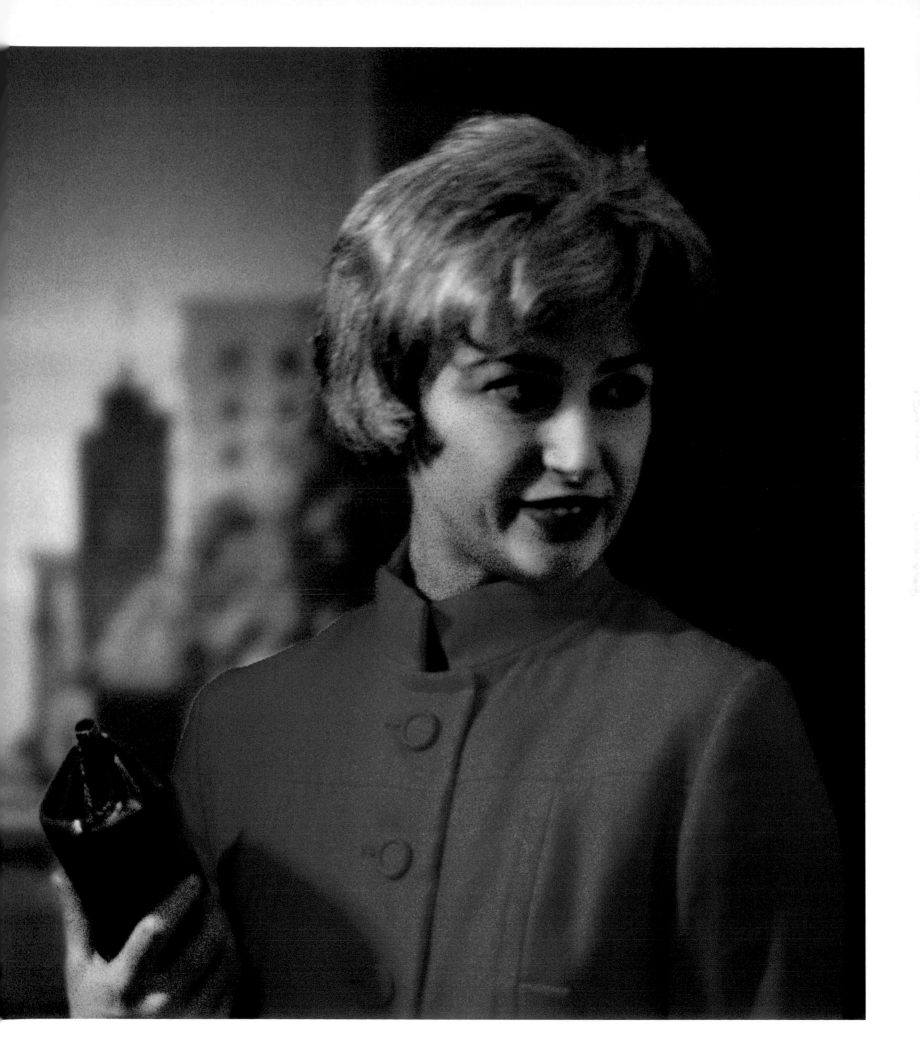

Style Wars

Unlike all the other genres of music, there are no boundaries to hip-hop. We can lyrically describe and talk about anything we want to. Musically, we could use almost anything. We don't have to sing in key. We don't have to have a bridge or a chorus. It doesn't matter. This particular style of music ... is it.[133]
—*Grandmaster Flash*

If one were seeking a single metaphor to bind together postmodern performance culture, a good choice might be 'sampling'. The sample resembles the historical quotations that are used widely in postmodern practice. Just as in architecture, reproducing a pre-existing fragment of a sound, image, or text creates a layer of temporal complexity. Past and present sit side by side in unresolved juxtaposition. But as Ulrich Lehmann argues in his contribution to this volume (pp. 178–81), sampling is also distinct within postmodern technique, in that it 'is a means by which technology enters into the very core of the artwork'. This observation has particular force within reproductive media like recorded music, video or film, where the replication of a copy is essentially indistinguishable from the original. This implies that the technique is anti-material, but actually sampling was still achieved through strictly manual means in the 1970s and 80s. The electronica artists (Brion Gysin, John Cage, Karlheinz Stockhausen, Brian Eno) and reggae and hip-hop innovators (Lee 'Scratch' Perry, Kool Herc, Grandmaster Flash and Afrika Bambaataa) who pioneered the techniques of sampling and mixing were all working with their hands. They painstakingly assembled loops and entire compositions from bits of tape, or mastered the difficult art of turntablism, by which a DJ mixed two (or more) records on the fly to create a unified composition. Like breakdancing and graffiti, turntablism lent itself to head-to-head competition, or 'battling' – it was part of the hip-hop repertoire of stylistic warfare. A benchmark recording was 'The Adventures of Grandmaster Flash on the Wheels of Steel' (1981), which ran for an astonishing seven minutes, and consisted of nothing but manipulations of vinyl (including recognizable snatches of mainstream hits by the likes of Queen and Blondie) on a trio of turntables. It announced the possibility of a completely unprecedented musical form – new because every bit of it was recycled.[134]

For graphic designers, this 'cut-and-paste' method was not a metaphor but a literal description of practice – and it was equally craftsy. April Greiman's collaborative work with Jayme Odgers may look as though it was done using Photoshop, but it predates that software by more than a decade (pl. 68). It was actually laboriously clipped out and pasted down in the manner of a collage, and then photographed to create a unified image, which could then be reproduced through offset printing. It is not surprising that Greiman was among the first graphic designers to turn to Macintosh computers when they were introduced in 1984 (a moment marked by a celebrated advertisement created by *Blade Runner* director Ridley Scott, inspired by George Orwell's dystopian predictions for that year). As Umberto Eco once put it, 'lying about the future produces history',[135] and like many postmodernists, Greiman was ahead of the curve – anticipating the possible aesthetic impact of technologies that did not yet exist.

Sampling was primarily a formal concern for Greiman and Odgers, not a way of indicating common cause with other practices. But many other graphic designers of the New Wave generation had a much more intimate relationship with performance genres. This is especially true in the music industry. Before the advent of the CD and the Internet, graphic pieces such as record sleeves, posters, magazines and flyers were important promotional mechanisms. It is useful to think of these designs as applying, in two-dimensional form, the aesthetics of sampling and active contradiction that one finds everywhere in postmodern performance. Peter Saville's groundbreaking record sleeves for New Order, for example, took advantage of an anarchic working environment at Factory Records (founded but not exactly led by Tony Wilson, and connected to the iconic postmodernist Hacienda nightclub, designed by Ben Kelly) to transform a youth commodity into a 'radical object'. Partly because Factory was so unprofessional, and partly because New Order had lost their charismatic leader, the troubled singer Ian Curtis (frontman for the band's previous incarnation Joy Division), Saville had a completely free hand. No one objected to his designs, even when they included no title, no image of the band members, no clear

66
New Order, *Power, Corruption & Lies*
album (UK release), 1983.
Design by Peter Saville (FACT 75)

67
New Order, *Movement* album
(UK release), 1981.
Design by Peter Saville (FACT 50)

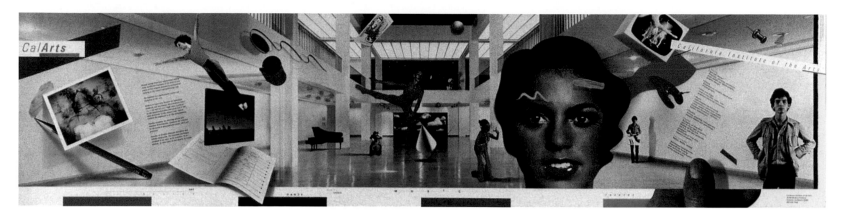

68
April Greiman and Jayme Odgers,
Cal Arts (California Institute of the
Arts) poster, 1978. Four-colour offset
lithograph. V&A: E.1498–2010

relationship to the music within. In place of these standard elements, there were only quotations and cryptic codes. Saville was a voracious consumer himself, who surrounded himself with used books and other source material, and the imagery he swiped was rather esoteric. One New Order sleeve was based on a still life by Henri Fantin-Latour; another on the graphic work of Futurist designer Fortunato Depero (pls 66 and 67). Neither was an obvious point of reference, but both resonated with the times nonetheless. Fantin-Latour's flowers found a fashion-world parallel in Scott Crolla and Georgina Godley's ironic use of chintz, while quoting Futurism allowed Saville to simultaneously evoke and undermine the avant-garde's breathless pursuit of the new.[136] Alongside these sampled images were bars of colour, which simultaneously referenced the graphic's nature as a reproduction (they looked like proofing strips) and functioned as an intentionally illegible language. Each square of colour corresponded to a letter of the alphabet in a system of Saville's own devising. It was an example of postmodern play, as well as a gift to New Order's cultish audience, who thrived on the sense of being insiders.

The graphic designer Vaughan Oliver enjoyed a similarly attentive audience in his work for the label 4AD, which produced post-punk bands like the Cocteau Twins, Modern English, and the Pixies. Founder Ivo Watts-Russell gave Oliver free rein in developing the graphic identity of the label. He responded with a body of work that is remarkable for its visual density and consistency, featuring quintessentially postmodern tactics like erratic typography, cut-and-paste visuals, and appropriated imagery. Though they used more or less the same techniques, Oliver and Saville make an instructive contrast, suggesting the aesthetic range of postmodern graphics: the sensual, Dionysian expressionist and the cerebral, Apollonian conceptualist. Even when using found images, Oliver sought to achieve an air of mystery and ambiguity – as in his 1985 sleeve for the band Colourbox (pl. 69). While it seems to be a piece of custom-made bricolage, the image is actually a Japanese printer's 'make-ready' sheet – that is, a piece run through the press to absorb excess ink in advance of the production run. In this case, there is a collision between two banal pop images: a fashion shoot and an advertisement for peaches. It was unusual for Oliver to leave his material completely untransformed in this way. Typically, he cut apart and layered his appropriated images into a suggestive palimpsest. But in this case the work seemed to have been done for him by happenstance. It was also appropriate to the band, which was one of the first in Britain to use sampling. Unlike Saville, whose practice was premised on self-aware gamesmanship, Oliver always tried to form an explicit and embodied tie to the music he was representing, in this case 'the manipulation of something already existing, something ephemeral and throwaway'.[137]

The use of appropriation by designers like Saville and Oliver marked an important moment in the proliferation of postmodern technique because it was distributed to a massive audience via the echo chamber of the post-punk music scene. New Wave and hip-hop, with their limited recording equipment, DIY musicianship and street-style clothing, were documented by a proliferation of handmade fanzines and flyers. As these musical genres came of age, intermingled and reached a wider listenership, the graphics that supported them did too. They became glossy, both literally and figuratively. The 'zine gave way to large-format, post-punk style bibles like New York City's *Bomb* (edited by

69
Colourbox, *Colourbox* album
(UK release), 1985. Design by
Vaughan Oliver (CAD 508)

Far left: 70
i-D, no. 28, The Art Issue, August 1985.
Styled by William Faulkner, design by
Terry Jones, photograph by Nick
Knight, featuring Lizzy Tear

Left: 71
Ryūkō Tsūshin (Fashion News),
no. 196, May 1980. Styled by Hideharu
Kanno, photograph by Shingpei Asai,
art direction by Tadanori Yokoo

Betty Sussler), *New York Rocker* (edited by Andy Schwartz and designed by Elizabeth van Itallie) and *Fetish* (designed by Doublespace Studios); London's *i-D* (edited and designed by Terry Jones, with the declared purpose of 'finding fashion at its source, and [giving] credit to the new ideas born on the streets'),[138] *Arena, Blitz* and *City Limits*; Tokyo's *Ryūkō Tsūshin* (*Fashion News*), designed for a short time by Tadanori Yokoo; and the unforgettable *Wet: The Magazine of Gourmet Bathing* (a California publication, needless to say, edited by Leonard Koren and designed by a rotating cast including Greiman and Odgers) (pls 70, 71 and 72). These magazines unleashed the complete battery of postmodern graphic techniques on their eager young audiences: cut-and-paste graphics; the use of registration marks and colour bars as found ornaments; hand-drawn, quasi-legible type; a New Wave palette of colours, often in vivid juxtaposition with stark (and cheaper) black and white; and above all, a free-for-all of sampled content. Often it was impossible to tell whether a given bit of graphic information, text or image, was appropriated or not.

The Face, founded by former *New Musical Express* editor Nick Logan, was the quintessential example of these postmodern style guides (pl. 74). As its name suggests, the magazine was completely in tune with the postmodern fascination with the façade. But this is not to say it was superficial, especially once Neville Brody was brought on to give the magazine a spiky, intricate design identity. He brought his punk-era affinity for 'cut ups' to *The Face*, creating typography from manipulated, mixed and matched bits of Letraset. He violently cropped both text and images, sometimes near the point of illegibility, and certain motifs were repeated and abstracted over several issues so that attentive readers could follow the gradual transformation – an ingenious exploitation of the magazine's serial character. Yet even as Brody's graphics took on autonomous life, and the slogan 'the world's best dressed magazine' appeared on the contents page, *The Face* remained receptive to the contributions of other photographers and stylists. The result was a cocktail of visual stimulants that readers could navigate as they wished. As Brody put it, '*The Face* had two narratives, the writing and the design. We wanted people to be their own editors.'[139]

Thematically speaking, the constant collision of forms could not have been more appropriate. Though *The Face* was all about personal style – subject matter that would have seemed frivolous in other places and times – that topic had become deeply politicized in 1980s London. Not for nothing did Brody emblazon the *New Socialist* with the title 'Style Wars' when he was asked to redesign the magazine (pl. 73). In the wake of the subculture-strewn 1970s and at the heart of Thatcher's 80s, style was a key cultural battleground. One index of this fact is the vituperative criticism that was launched at *The Face* not from the right, but the left. Dick Hebdige took aim at the magazine in his 1988 follow-up to *Subculture*,

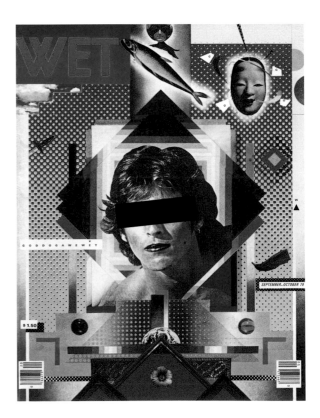

72
WET, no. 20, September/November
1979. Design by April Greiman with
Jayme Odgers

73
New Socialist, no. 38, May 1986. Design by Neville Brody

74
The Face, no. 69, January 1986. Design by Neville Brody, photograph by Jean-Paul Goude, featuring Grace Jones

a book entitled *Hiding in the Light*. Though he conceded that the editors at *The Face* were impressive innovators, he was deeply alarmed by the slippage between editorial, advertising and art direction that made the publication distinctive:

> *The Face* is a magazine which goes out of its way every month to blur the line between politics and parody and pastiche; the street, the stage, the screen; between purity and danger; the mainstream and the 'margins': to flatten the world. For flatness is corrosive and infectious ... To stare into the flat, blank *Face* is to look into a world where your actual presence is unnecessary, where nothing adds up to much anything anymore, where you live to be alive. Because flatness is the friend of death and death is the great leveller ... Advertising takes over where the avant garde left off and the picture of the Post is complete.[140]

A similarly damning conclusion was reached by another partisan of the 1970s punk scene, Jon Savage, in his 1983 article 'The Age of Plunder'. It was an early statement of an argument that would become more and more commonplace over the course of the decade: that postmodern quotation was an admission of creative paralysis, a form of surrender.[141] Savage placed an even more political spin on this issue than Hebdige had: 'This nostalgia

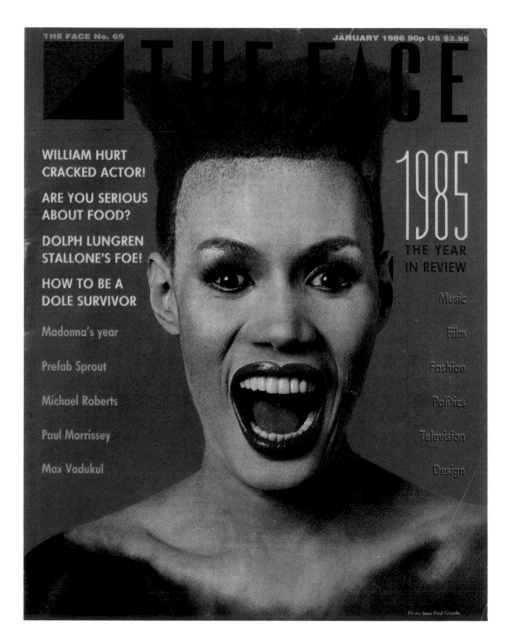

Overleaf: 75
The Face, no. 33, January 1983. Design by Neville Brody

Image-conscious pop has taken its pillaging of history to new extremes, plundering postwar culture, its own rich past and the whole of twentieth century art in a manic effort to fill sleeves, posters, videos and adverts, to elevate packaging over content. This is just part of a rampant nostalgia that acts as a major piece of weaponery for the militant New Right, argues Jon Savage, who provides the visual evidence, tracking an array of "new" images back to their original, often uncredited, sources

THE AGE OF PLUNDR

NEW ORDER
FACT. 50 1981
MOVEMENT

FUTURISMO
1932 ANNO X°
S. E. MARINETTI
NEL TRENTINO

● Peter Saville sleeve for New Order's "Movement" LP, 1981

● Fortunato Depero's original Futurist poster, 1932

44

- EMI's 1982 reissue of The Beatles "Love Me Do"
- Fifties curtain pattern: inner sleeve of Tot Taylor's "Playtime", 1982
- Mari Wilson & Beehive from the "Beware Boyfriend" single, 1982

Beatles 12 inch flops onto my desk, sporting a rather fetching colour pic of those well-known faces in their velvet collar Burtons and their famous pink tab collars. The record contains their first – not very good – single "Love Me Do" with an *alternative take*. Train-spotting sleeve notes and a facsimile of the original label add up to a product that is perfectly anachronistic (they didn't have Beatles' collectors *or* 12 inchers in 1962, but that's another story). It's perfectly aimed: backed up by a clever campaign on the London buses – youthful pics of the Four with the captions "It Was 20 Years Ago" and "Did You Know That John Lennon Was In The Beatles?" – the record charted and peaked at number 5. I thought it was shit in 1964, but now?!

This alerts me, and I start noticing things. A few days later, I'm on a quick shoot: Manchester's Christmas lights are being switched on in the City Centre. There's a bit of razzamatazz: a brass band, an electric organ, appearances by the stars of *Coronation Street*. What gets me is the large crowd, and how it's behaving: this is, after all, only a low key event but there are thousands more out than have been expected and they're ravening.

The crowd is pinched, cold and in sections obviously very poor. As they surge and yell, I catch a note of real desperation and chilling frenzy beneath the surface jollity that could turn any which way. Things are nearly out of control. And, supreme irony, this crowd, which has been ground down by Tory policies reinforcing the divide between the two Nations, starts singing and bawling between the carols; *Beatles songs*, those songs of hope from another age. "She Loves You" and "A Hard Day's Night". "Help" might have more appropriate.

You wouldn't catch them singing ABC songs. Back to the wonderful world of pop, I turn to the *Daily Mail* of November 16. A full page feature trumpets Mari Wilson as "The Girl Behind The Return Of The Beehive". The piece adds, revealingly, that "Mari, 25 . . . is dogged by the fact that her hairstyle has always been bigger than her recording success". *Quite*. A few days before, she has appeared on *The Old Grey Whistle Test*: a quick interview reveals that she's done all the homework necessary on the beehive and the late Fifties early Sixties, that she rilly wants to emulate Peggy and Judy and that she is going to perform one of her fave songs, "Cry Me A River".

She perches on a stool, surrounded by her violinists, the "Prawn Cocktails" – so *Ealing* – who actually look like punks. It's not bad, but nothing like Julie London. But then Mari is one camp joke that has transcended as things tend to at present: she records for a very studied little label called Compact which has also done all the necessary homework: silly cod sleeve notes by "Rex Luxore", silly inner sleeves with Fifties curtain patterns and a name taken from a cruddy early Sixties television serial that is hip enough to drop.

The thing that really floors me is that in the same *Daily Mail* of November 16 there is a tiny news item on Page 5: "Compact", the twice weekly TV serial set in a women's magazine office, is to be brought back by the BBC in the spring of 1984. The original series was killed off 17 years ago". Clearly, we are dealing with something quite complex, that is beyond the bounds of parody.

We are inundated by images from the past, swamped by the nostalgia that is splattered all over Thatcherite Britain. Everywhere you turn, you trip over it: films, television series of varying quality, clothes, wars, ideologies, design, desires, pop records. A few more examples, to make your hair really curl: the Falklands War – *so* Empire, *so* Forties war movie; *Brideshead Revisited* and *A Kind Of Loving*, two Granada serials that looked at the Twenties and the Fifties respectively through rose-coloured glasses with the design departments having a field day with all this "period" nonsense. *The* British film of 1982 that has the Yanks drooling is *Chariots Of Fire*, a 1920's morality play. There's a rush of public-school and working class boys into the army, an event unthinkable ten years ago and a new respectability and confidence in the middle classes, just like the Fifties, with the rise of formerly moribund magazines like *The Tatler*, and the runaway success of *The Sloane Ranger Handbook*. It's all underpinned by a reinforcement of the old class and geographical divisions by the most right-wing government since the war. And I haven't even *mentioned* the Sixties.

Craving for novelty may well end in barbarism but this nostalgia transcends any healthy respect for the past: it is a disease all the more sinister because unrecognised and, finally, an explicit device for the reinforcement and success of the New Right.

Part of this is a response to increased leisure. Because we don't produce solid stuff any more – with the decline of the engineering industries – we are now all enrolled in the Culture Club. In the gap left by the failure of the old industries comes Culture as a Commodity, the biggest growth business of the lot: the proliferation of television, video (especially in the lower income groups), computers and information. But this flow of information is not unrestricted: it is characteristic of our time that much essential information is not getting out, but is instead glossed by a national obsession with the past that has reached epidemic proportions.

Pop music, of course, reflects power politics, and it is fascinating to see how it has toed the line. As elsewhere, 1982 has been the year of the unbridled nostalgia fetish: consumers are now trained – by endless interviews, fashion spreads, "taste" guides like the *NME's* "Artist As Consumer" or our own arch "Disinformation" – to spot the references and make this spotting *part of their enjoyment*. It is not enough to flop around to "Just What I've Always Wanted", no, you have to know that Mari has done her homework and you should be able to put a date to the beehive. Thus pop's increasing self-consciousness becomes part of the product and fills out nicely all the space made available by sleeves, magazines and videos.

These days, it is also not enough to sling out a record; it has to be part of a discrete world, the noise backed up by an infrastructure of promotion, videos, and record sleeves that has become all-important and now is in danger of making the product top-heavy with reference. Basically, it's mutton dressed as lamb: do ABC *really* have to dress up (badly) as country squires to promote "All Of My Heart"? Of

transcends any healthy respect for the past: it is a disease all the more sinister because unrecognized and, finally, an explicit device for the reinforcement and success of the New Right'.[142] This was another case of postmodernism eating itself; for the article was published in — where else? — *The Face*. Brody, in laying out the spreads for the essay, was not shy about including his own peers as targets for Savage's ire — including his former colleagues at Stiff Records, the graphic designers Barney Bubbles, Malcolm Garrett and Peter Saville. The act of 'plunder' that anchored the opening spread was Saville's straight lift from Futurist design discussed earlier, directly juxtaposed with the original (pl. 75). Brody thus entered into the fray, supplementing Savage's commentary with one of his own. It was a curious form of brinkmanship; while his own work rarely included that kind of direct appropriation, he certainly participated in the general postmodern practice of fragmenting and deploying pre-existing styles. Savage's critique could easily have been read as a condemnation of the very magazine that published it. In his heartbroken concluding lines, it seemed clear that he was speaking to *The Face*'s editors and readers alike: 'The Past is then turned into the most disposable of consumer commodities, and is thus dismissable: the lessons which it can teach us are thought trivial, are ignored amongst a pile of garbage ... What pop does, or doesn't do, ceases to be important'.[143]

Whether that was true probably depended on who you were. For Savage, who had experienced the glory days of punk firsthand, the New Wave years seemed a rapid slide into vacant consumerism. But for those a little younger, or working at a different end of the industry, the early 1980s were the glory days. Every kid making a mix tape, decorating it and passing it on to a friend was articulating the postmodern shift in music culture.[144]

76
Big Money Is Moving In, from the Changing Picture of Docklands, series 1, 1981–4. Original photomontage and digital remastering by Peter Dunn © Peter Dunn and Loraine Leeson, Docklands Community Poster Project

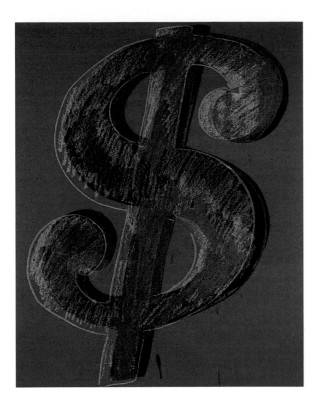

77
Andy Warhol, *Dollar Sign*, 1981.
Synthetic polymer paints and
silk-screen inks on canvas. Private
collection. Photograph Christie's
Images 2011 © DACS London

The righteous purity of punk's nihilism had given way to a situation of general pastiche and commercial experimentation. At the professional level, new careers emerged: pop stylists, video makers, independent producers, and art directors. Styles were created from whole cloth, with (of course) a winking acknowledgement of the artificiality of that process.

One example was Buffalo (see pp. 182–5), a true style without substance, which was promoted heavily through *The Face*. It centred on the pastiche stylings of Ray Petri, who found inspiration in everything from reggae (Bob Marley's song 'Buffalo Soldier' inspired the name of the look) and mod styles of the 1960s to *noir* films and Scottish kilts. Vivienne Westwood fashioned a couture collection in tribute to Buffalo in 1982, the same year that Malcolm McLaren got in early on the commercial exploitation of hip-hop with his song and video 'Buffalo Gals'. A group of models and musicians gathered around Petri, including fellow stylist Judy Blame, producer Cameron McVey and singer Neneh Cherry, who would hit it big with the hip-hop dance track 'Buffalo Stance'. In the accompanying video (1989), Cherry appears within a sliding bricolage of turntablists, computer-generated images, floating texts (including the question 'Know what I mean?' translated into four languages) and Buffalo-styled dancers, all against a constantly shifting backdrop of lurid neo-psychedelic patterns. Despite Cherry's reiterated claim in the chorus that 'No moneyman can win my love/It's sweetness that I'm thinking of', her primary ornaments are a massive pair of gold earrings and a single matching '$' hanging from her throat. Call it a dollar sign of the times.

Big Money Is Moving In (pl. 76)

Money doesn't mind if we say it's evil, it goes from strength to strength. It's a fiction, an addiction, and a tacit conspiracy.[145]
—*Martin Amis*

Do you really think this is *your* city any longer? Open your eyes! The greatest city of the twentieth century! Do you think *money* will keep it yours? ... Come down from your swell co-ops, you general partners and merger lawyers! It's the Third World down there! Puerto Ricans, West Indians, Haitians, Dominicans, Cubans, Colombians, Hondurans, Koreans, Chinese, Thais, Vietnamese, Ecuadorians, Panamanians, Filipinos, Albanians, Senegalese, and Afro-Americans! Go visit the frontiers, you gutless wonders![146]
—*Tom Wolfe*

In 1981, as if to greet the new decade, Andy Warhol created one of his signature silkscreen paintings. It featured a big, beautiful dollar sign (pl. 77). Ever since the heady days when his studio, the Factory, had been the epicentre of New York chic, Warhol had been a poster boy for postmodernism. He was obsessed with surface, and his paintings seemed to be unmatched as depictions of the pervasive, affectless flatness of the commodity sphere. As he put it in his memorably titled book *The Philosophy of Andy Warhol (From A to B and Back Again)*, 'all the Cokes are the same and all the Cokes are good. Liz Taylor knows it, the President knows it, the bum knows it, and you know it.'[147] He might just as easily have been talking about money.

For many in the art world, Warhol had been a big disappointment. His early Pop works had been those of a gimlet-eyed observer, a new type of realist who held up a mirror to American mass culture. But in 1969, he had founded the magazine *Interview*, which gave him a chance to indulge his chatty, cliquish side, and in the late 1970s he became one of Studio 54's most prominent habitués. By the 80s, he seemed to be little more than a society portraitist, churning out identikit images for anyone who would pay for the privilege. In a transparent bid to regain art world attention, he initiated a collaboration with the hot young graffiti artist Jean-Michel Basquiat. The art press immediately saw that this alliance was more like a corporate merger than a meeting of the minds. A *New York Times Magazine* article about the rise of marketing in the art world used Basquiat as a case study, and opened with a vignette of him chatting amiably with Warhol, Keith Haring and Nick Rhodes (of Duran Duran) at the restaurant Mr Chow's over 'plates of steaming black mushrooms and abalone', drinking kir royale (pl. 78).[148] This was Warhol's milieu now: not the Factory, with its inspired freaks, but the nightspots of the glitterati. Instead of deepening his artistic vision, he was cashing in.

But then, Warhol had never been about depth in the first place, and for those who thought that 'face value' was not necessarily to be despised, he was still very much in the frame.[149] Among those who still took him seriously was Fredric Jameson, one of the few major theorists of the 1980s who analysed specific works of art and design. For a generation of critics, artists, academics and students, Jameson's article 'Postmodernism, or, The Cultural Logic of Late Capitalism' (1984; expanded to book length in 1991) seemed to capture the condition of postmodernity better than any other text. And Warhol was central to this account. Jameson was fascinated by the artist's billboard-like images: they 'ought to be powerful and critical political statements. If they are not that, one would certainly want to know why.'[150] He found Warhol's glittering series *Diamond Dust Shoes* (1980–1) to be particularly unnerving. He saw in them an art that was not only completely in thrall to commodity, but also thrilled about that fact. The paintings, he wrote, have 'a strange, compensatory, decorative exhilaration, explicitly designated by the title itself, which is, of course, the glitter of gold dust, the spangling of gilt sand that seals the surface of the painting and yet continues to glint at us.'[151]

Exhilarated, or critical? Commodity, or commodity critique? Both/and. This was the dichotomy that ran right through postmodernism in the 1980s. As we shall see, Jameson identified a similarly vertiginous experience in architecture, but had he written a few years later he could scarcely have avoided mention of another artist: Jeff Koons. While Jameson found in Warhol a 'waning of affect', Koons was too full of love for comfort. His iconic sculpture *Michael Jackson and Bubbles* (1988) put the changeling pop star on a pedestal – literally – and rendered him in the gilt-edged white porcelain of a Meissen figurine (pl. 81). The contradictory energies of postmodern celebrity were certainly there: a black man turned white; the human face (already surgically altered) turned into a hard, smiling mask; and even, in a detail that might have been drawn from the pages of Haraway's 'Manifesto for Cyborgs', a weirdly familial relationship between human and animal. Yet all these conflicts were resolved into an object of supreme, hermetic perfection. In a self-portrait of the same year, published as an insert in *Artforum*, Koons gave himself his own makeover (pl. 80). Presiding over a gaggle of school children, he was flanked by sinister slogans – 'exploit the masses' and 'banality as saviour'. But with his teen idol looks and beguiling smile, and the word 'mentality' tilting upwards encouragingly behind his head, he came across as a bearer of the true word. Squeaky-clean, benevolent, powerful and disturbing, Koons seemed to have stepped out of the back room of the art world, where all the secrets were kept. A new religion of commodity art had arrived, and he had appointed himself its redeemer.

Of all the anxieties that attended this blithe celebration of banality, the one that cut most deeply was the same prospect Hebdige had glimpsed in the pages of *The Face* – the possibility that they marked the end of the avant-garde. Koons himself was unusually explicit on this point; as he put it, 'I was telling the bourgeois [sic] to embrace the thing that it likes, the things it responds to.'[152] That was in direct contradiction to the modernist tactic of shocking the bourgeoisie, of course; but if the avant-garde was a thing of the past, what would the future hold? One possibility was that art would now operate according to the dictates of fashion, which would mean relinquishing art's critical autonomy. It is striking how many artists of the 1980s adopted not just the appearance but also the context of advertising, placing their works on commercial billboards or poster displays (see pl. 249, p. 285), as Keith Haring did with his subway drawings – an honest attempt to reach an audience that lacked any prior involvement in contemporary art.[153] But such an entry into the commodity sphere had an unsettling corollary: it might mean that art would henceforth be propelled not by ideas, but by money. Koons' provocations aside, the booming art market of the 80s seemed to be settling this question of its own accord.[154]

Equally telling was the fact that the world of fashion responded in kind, claiming the status of an avant-garde, but without the dimension of radical social critique usually implied by that phrase. As discussed in Claire Wilcox's essay in this volume (pp. 154–9), the Japanese fashion designer Rei Kawakubo, and to a lesser extent her peers Issey Miyake and Yohji Yamamoto, were received as prophets of postmodernism on their arrival in Europe.[155] But Paris fashion also had its own postmodern figurehead, as outré and glamorous as Kawakubo was monkish and austere. This was Karl Lagerfeld. With his dramatic black cape, aviator sunglasses and fluttering Japanese fan, he was a high camp German in the heart of France. He had been an early adopter of New Wave design, filling his flats in Monte Carlo

78
Jean-Michel Basquiat in his SoHo studio, illustrated in 'New Art, New Money', *The New York Times*, February 1985. Photograph by Lizzie Himmel

79
Karl Lagerfeld in his Monte Carlo
Memphis-furnished apartment, 1981.
Photograph by Jacques Schumacher

80
Jeff Koons, from *Art Magazine Ads*,
originally published in *Artforum*,
1988–9. Photograph by Matt Chedgey
© Jeff Koons

81
Jeff Koons, *Michael Jackson and
Bubbles*, 1988. Ceramic, glaze, paint.
San Francisco Museum of Modern Art,
San Francisco, California (91.1) © Jeff
Koons. Purchased through the Marian
and Bernard Messenger Fund and
restricted funds

and Paris with Memphis furniture and photo blow-ups by Helmut Newton (pl. 79).[156] A
German magazine described the scene: 'He sits at ease at his little building-block table –
in a khaki green cotton suit, handmade glasses and hand-sewn shoes, his grey-flecked hair
drawn into a tight ponytail, coated in his own sharp "Lagerfeld" scent – and gazes round
his new surroundings with amusement. The only thing missing is a robot to clatter along
the marbled rubber floor and serve its master a Coca-Cola in a plastic cup.'[157] Lagerfeld had
been a freelance designer for over two decades, noted particularly for his work for the
brand Chloe, when he took on the job of chief designer at Chanel, the most hallowed brand
in Parisian fashion, in 1982. Coco Chanel had died in 1971, and the label had slipped into the
doldrums since. It was badly in need of a revamp, and this is exactly what Lagerfeld
provided. Out went the sober restraint and elegantly unified ensembles associated with
Chanel. In came tight miniskirts, swags of gold jewellery, and above all the interlinked
double-C logo, which Lagerfeld plastered over everything: handbags, shoes, belts, fabrics.
The ultimate modern brand in fashion had been postmodernized (pl. 82).

The volte-face that Lagerfeld performed at Chanel found its architectural equivalent
in the unlikely form of Philip Johnson, who had for decades been America's most tireless
promoter of high Modernism. All the way back in 1932, he had co-curated the Museum of
Modern Art's landmark exhibition *The International Style*, and his best-known building was
his own residence, the Glass House (1949), a highbrow exercise in modernist clarity. Those
who had paid close attention to Johnson over the previous decades might have detected a
gradual turning in his thinking. In 1961, he commented: 'How long ago it was that Goethe
said the pilaster is a lie! One would answer him today – yes, but what a delightfully useful
one.'[158] His interiors for the Four Seasons Restaurant (1959) in New York and for the New
York State Theatre at Lincoln Center (designed 1964) had been glitzy, almost kitsch. They
looked like, and were perhaps inspired by, Hollywood film sets.[159] And as recently as 1975,
Johnson had confessed to postmodernist relativism in a lecture at Columbia University:
'It takes moral and emotional blinders to make a style. One must be convinced one is right.
Who today can stand up and say: "I am right!" Who, indeed, would want to?'[160]

But none of this prepared the architectural community for the AT&T Building (designed
1978, completed 1984). With its Chippendale top, arched entryway and pink granite
detailing, the skyscraper was a return to the ornamental historicism that Johnson himself

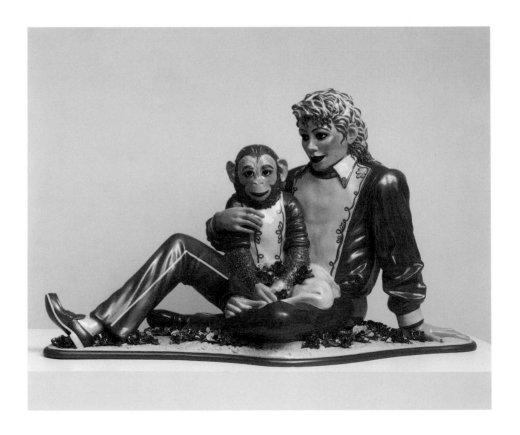

83
**Judith Grinberg (for the studio of
Johnson and Burgee Associates)**,
Presentation drawing of the AT&T
Building, 1978. Ink, graphite and ink
wash on tracing paper.
V&A: E.522–2010

had helped to banish, seemingly forever (pl. 83). There was no denying that it was the work of an informed architect, with quotations from Palladio, Brunelleschi and New York Art Deco. But the building hardly seemed scholarly, or even gentlemanly. It was a provocation and sure enough, many people hated it, none more than the spirited critic for the *Village Voice*, Michael Sorkin, who fumed, 'the so-called "post-modern" styling in which AT&T has been tarted up is simply a graceless attempt to disguise what is really just the same old building by cloaking it in this week's drag and by trying to hide behind the reputations of the blameless dead.'[161] From this perspective, Johnson's Chippendale ornament, high above the city streets, seemed an emblem of lofty detachment from the real job of architecture. Posed on the cover of *Time* magazine with the model for the building cradled in his arms – as if he had just given himself an award for Best Architect – he seemed a capricious giant, gleefully visiting incoherence on America's cities (pl. 84). (Johnson's other projects of the time, designed with his partner John Burgee, included Houston's step-gabled Pennzoil Place and Pittsburgh's neo-Gothic PPG Place.) The magazine *Progressive Architecture* argued that Johnson's defection to postmodernism lent 'a kind of dignity and stature to the movement which, in large part, it heretofore lacked', and Mendini was quick to welcome him as an ally, describing him as 'at once the last architect of the epoch of the Masters, and the first of an epoch without Masters'.[162] But many others hated the AT&T Building, not only on stylistic grounds but also because it so effectively put architecture in the service of corporate identity. As Jencks noted, it was at once the first major postmodern monument and 'the grave of the movement to detractors.'[163] At the age of 78, Johnson had demonstrated that it was never too late to sell out.

As shocking as it seemed at the time, Johnson's embrace of corporate postmodernism was a bellwether for the architectural profession. In 1980, Leo Castelli held an exhibition in New York frankly entitled *Houses for Sale*, in which the designs of eight architects were offered directly to any client who would have them.[164] Another of Manhattan's gallerists, Max Protetch, had success selling renderings by architects like Aldo Rossi and Michael Graves, who produced skilfully finished presentation drawings, often for projects that remained unbuilt. Such schemes were originally motivated by a lack of building opportunities in a down market. But as the 1980s arrived, their meaning shifted. The circulation of renderings as art commodities now signalled the transformation of architecture into a name-brand enterprise. As Robert A.M. Stern observed at the time, the popularity of drawings represented a departure from modernist architects' preference for scale models rather than renderings, which were often seen as 'tarted-up drawings expediently conceived for presentation (that is, selling) purposes'.[165] For the postmodernist architect, however, the persuasive quality of a beautifully made presentation drawing was completely desirable. A flat rendering was a perfect medium to capture not only the ornamental surface of the postmodern building, but also its iconic qualities.

Over the ensuing decade, buoyed by this rhetoric of the architectural image, the 'starchitect' became a fixture on the urban scene. Newly moneyed patrons, both corporations and private individuals (such as the famously tasteless but vastly rich Donald Trump), offered architects a chance to realize their ideas, and also to become famous – all the while placing new constraints on their work. You would never know it from the key journals of postmodern architectural theory at the time, such as *AD* or *Perspecta*, but architecture in the 1980s was above all a service industry. Buildings cost money, and lots of it. From a corporate client's perspective, the architect's most important job is not to incite debate, but to create value: to provide return on investment. Postmodern technique proved to be a perfect means to that end. As Magali Larson noted in 1993 in an important early analysis of 80s corporate architecture, 'If what is desired is a new image, minimizing risk compels the client to "style" the building superficially – the massing, the façade, the lobbies, the skin – while keeping the routine invisible and the costs down.'[166]

As for John Portman's Bonaventure Hotel in Los Angeles, which Fredric Jameson famously analysed in *Postmodernism, or, The Cultural Logic of Late Capitalism* as a spatial manifestation of postmodernity – well, you really have to see it in person. Even Jameson admitted, 'I am [at] a loss when it comes to conveying the thing itself.' The hotel ought to be easily navigated: it is structured around four evenly spaced elevator towers, and the plans helpfully posted around the building seem relatively straightforward. But then you look up – and down (pl. 86). Crisscrossed by escalators, lined by ramps and shops and cocktail bars,

JANUARY 8, 1979

$1.25

TIME

IRAN
Violence and Chaos

U.S.
Architects

Doing
Their Own
Thing

Philip Johnson

0 02

724404

and furnished with an indoor lake, the atrium of the Bonaventure is indeed astounding in its scale and complexity. Jameson saw this Piranesian space as a sealed environment, a world unto itself, filled with pure movement. As proof he pointed to the exterior of the building, with its 'curiously unmarked entrances' and its sheath of mirrored glass that reflects the surrounding city, dematerializing the mass of the hotel behind a play of reflection (pl. 85). If Johnson's AT&T Building was an arch joke writ large on the skyline, Portman's Bonaventure was something much more total. This architecture 'does not wish to be a part of the city,' Jameson argued, 'but rather its equivalent and replacement or substitute'.[167]

With three decades of hindsight, however, this claim can be called into question. Despite Jameson's characterization of the Bonaventure as hermetic, the hotel is today one of the most photographed places in Los Angeles, appearing in movies, television shows, commercials, and even hip-hop and rap videos. Far from being invisible within the urban fabric, the refractive structure has proved remarkably durable as a media icon. And though Portman would probably agree with Jameson that kinetics were in some sense the subject of his architecture, he would certainly reject the accusation that this makes him a postmodernist. The material vocabulary of the Bonaventure – glass curtain walls and formed concrete – is in fact quintessentially modernist, and the building lacks any of the applied décor that an architect like Michael Graves might have employed at the time. Thus, the intentions that lay behind the hotel (and its subsequent reception) would at least complicate and perhaps contradict Jameson's interpretation. This suggests something of the complexity that surrounds corporate architecture of the 1980s, which was only rarely a manifestation of postmodernist style, even if it did inhabit the broader 'condition' of postmodernity.

Jameson's discussion of the Bonaventure is now remembered as the paradigmatic text on postmodern corporate architecture, but the powerful critic for *The New York Times*, Ada Louise Huxtable, was equally influential at the time. Faced with the historicism of Philip Johnson's various projects, she made no attempt to hide her revulsion:

If the sources are diverse, the results suffer from a certain sameness; rarely do these eclectic exercises coalesce into an architectural statement with the authority of the examples so blithely exploited. Their so-called playful use of history is heavy-handed, their paper-thin pretensions misfire, no matter how solidly enclosed or dazzlingly surfaced … these buildings are simply not clever enough. The problem is not that they fail to say the same thing as the buildings they crib from – that is neither possible in today's world nor their avowed intention – it is that they say nothing at all.[168]

Right: 85
John Portman, Westin Bonaventure Hotel, 1976. Los Angeles, California. Photograph by Dennis O'Kane © John Portman & Associates Archive

Far right: 86
John Portman, Westin Bonaventure Hotel (atrium), 1976. Los Angeles, California. Photograph by Alexandre Georges © John Portman & Associates Archive

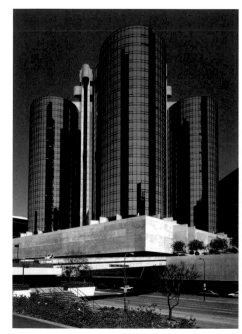

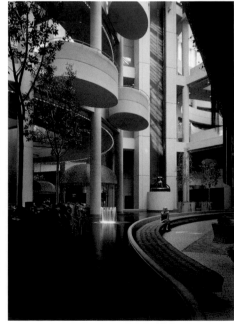

Among the points made by Huxtable, perhaps the most incisive was that postmodernism's embrace of difference, once it was processed according to the exigencies of profit margin, was actually producing an urbanism of soul-crushing homogeneity. The style became merely routine over the course of the decade, as one city after another sprouted a crop of skyscrapers festooned with second-hand, flattened ornament and sheathed in dematerializing reflective glass. When it opened in 1982 – just before the AT&T Building – one could make a case for Michael Graves' Portland Building as a provocative intervention into a modest north-western city (see pl. 208, p. 230). But it was not long before its stage-set quality – like four billboards clapped together at the corners – quite literally wore thin. The building was built on a shoestring budget for a civic client, and it is in shockingly poor condition today. It would be unfair to blame Graves for the inadequate execution of his design, but the paint peeling from every surface of the Portland Building nonetheless lends credence to Charles Jencks' perceptive observation that Art Deco-style postmodern ornament often did serve a sort of functionalist purpose: 'to hide faults in construction'.[169] In his widely read condemnation of superficial postmodern architecture, 'Towards a Critical Regionalism', Kenneth Frampton enlarged on this point. Buildings had become so 'universally conditioned by optimized technology' that architecture was now limited to either a pure high-tech system, speaking of its own functions, or the use of a 'compensatory façade' to cover up system building. The Portland Building, he wrote, was both.[170]

As postmodernism proliferated, it seemed to prove that historicism – while it could be a vivid interruption into modernist urban fabric – was merely insipid when applied in broad strokes, as at Ed Jones' massive complex at Mississauga near Toronto, Quinlan Terry's Richmond Riverside development in Surrey, or the toy town community of Celebration, built by Disney in the 1990s.[171] Not that the problem was limited to questions of style. Denise Scott Brown directs our attention away from that plane of architectural thought, and toward the question of social responsibility (see pp. 106–11). She charges that 'PoMo' architects abandoned 1960s ideals of social responsibility and instead decided to 'license indulgence' (echoing David Harvey's concise statement that 'postmodernists design rather than plan').[172] Her position finds common cause with Reinhold Martin's ambitious revisionist history of postmodern architecture, *Utopia's Ghost* (2010). Martin argues that the reflective and ornamental character of buildings themselves, and the endless debates about those stylistic choices, all served to disguise an underlying truth about corporate architecture in general – its literal extension of power in space:

The tricks with mirrors and other real materials performed by corporate globalization produce the illusion that there is an illusion: the illusion that their materiality is illusory, unreal, dematerialized ... [This] describes what a new stage in commodity fetishism might actually look like: the inability simply to look at something directly, rather than attempt to see through it. This mode of distraction draws us in even as it keeps us out.[173]

Fredric Jameson, who serves as Martin's jumping-off point throughout much of *Utopia's Ghost*, went so far as to argue that the transition away from classical city layouts and toward *Blade Runner*-like sprawl spelled an inevitable end for style as a relevant concern for architecture (see pl. 61). In a discussion of bubble-economy Tokyo, he noted that it was hard to see 'how any specific building would ever stand out in this kind of fabric, since it is a bewildering, infinite, endless series of built things, each of which is different from the next'.[174] The inside of the Bonaventure thus becomes a template for the built environment at large; it is movement that now has meaning, not static form. This idea of the postmodern city was also captured in popular culture, as in Godfrey Reggio's 1982 film *Koyaanisqatsi* (pl. 87). With its obscure, portentous title (Hopi for 'world out of joint'), *Koyaanisqatsi* was yet another 'postmodern denunciation of the culture of postmodernism'.[175] Its stop-motion footage of faceless office workers coursing like water through the streets and train stations, down escalators and into mirrored office buildings, and its hectoring musical score by Philip Glass, presented the postmodern city as completely dehumanized and alienating – but captivating all the same.

88
Mario Bellini, tea and coffee service (or piazza), 1980. Silver, rose quartz, lapis lazuli. The Metropolitan Museum of Art, New York (1988.191.1–6)

Living in a Material World

> The acquisition of an image (by the purchase of a sign system such as designer clothes and the right car) becomes a singularly important element in the presentation of self in individual identity, self-realization, and meaning. Amusing yet sad signals of this quest abound.[176]
> —*David Harvey*

However one settles the accounts of 1980s postmodern architecture, it is undeniable that the decade witnessed the rise of a new 'trophy building' mentality. Richard Bolton, taking note of the sudden appearance of architects in advertisements for such products as Hennessy cognac, argued that 'the architect is a plausible spokesperson for luxury products because the architect is a member of the corporate class. He already speaks for the system through his own work – the building is just one more luxury commodity.'[177] This made for a natural alliance between architect-designers and the manufacturers of high-end domestic wares, and also opened up opportunities for a new form of middleman, the 'design editor', who had no production capacity but rather brokered relations between architect-designers, craft workshops, interior designers, and retail outlets or galleries.[178] These entrepreneurs functioned rather like producers in the film or music industries, investing in projects and then trying to maximize profit.

The practice of design-editing emerged first in Italy, where a strong craft base and a well-established design press made the prospect feasible even before the economic boom. The first company to work in this way was arguably Danese, founded in the 1950s, which produced tablewares and domestic furnishings by a range of designers such as Bruno Munari and Enzo Mari.[179] But the strategy was expanded and perfected by Cleto Munari, an aesthete and collector from Vicenza, who founded his eponymous luxury goods company in 1972. Though Munari, like Danese, worked mainly with modernist designers such as Carlo Scarpa and Gae Aulenti, he occasionally produced objects reflecting the new stylistic ideas coming out of Milan. A coffee pot designed for the firm by Michele De Lucchi in 1980 shared the palette and cartoonish, Art Deco styling of the designer's Girmi prototypes; and in the same year, the otherwise unimpeachably modernist architect Mario Bellini designed a tea and coffee 'piazza' for Munari in the historicist style then being explored by Paolo Portoghesi at the Venice Biennale (pl. 88).

A few years later, Munari launched his most ambitious project. He worked with an international all-star list of designers, including De Lucchi, Peter Eisenman, Isozaki, Shire, Sottsass, Stern and Zanini to produce a collection of postmodernist jewellery (pl. 89). The project strategy resembled that of Memphis, and included many of the same players (including Barbara Radice, who wrote a promotional book about the collection). But if Memphis had held luxury at arm's length, only teasingly acknowledging it through such devices as titling, the Munari jewellery was an emphatic entry into the production of aristocratic *objets d'art*. In a sense the project was customized to an Italian design scene where 'the shock of Memphis had worn off', as critic Deyan Sudjic wrote in the inaugural edition of *Blueprint*, leaving as a main attraction fashionable parties with 'relays of white-gloved waiters, decked with chains of office, dispensing champagne, mountains of *langoustines*, baby octopuses, risotto and blueberries to brawling crowds of elegantly tanned ladies wearing great chunks of brass around their necks and wrists'.[180]

By the mid-1980s, seemingly every country boasted at least one design-editing firm chasing this upscale market: Swid Powell and Sunar in America, Néotu and XO in France, Anthologie Quartett in Germany, Sawaya & Moroni in Italy, Akaba in Spain. In Japan, the designer Kuramata Shiro depended on his colleague Takao Ishimaru to subcontract work in acrylic, metal and other materials. In all of these cases, entrepreneurs with expertise in sourcing and marketing helped architects and designers to realize their ideas. This distribution of design agency was another means by which postmodern style proliferated into the marketplace. The commoditization was even more explicit in the case of large-scale manufacturers, who began in the mid-1980s to commission architects to design postmodernist products, very much in the manner of the smaller 'editing' firms. These alliances might seem improbable, given the way in which they brought together purposefully indigestible design ideas with mass distribution. But even if the objects failed to sell, they

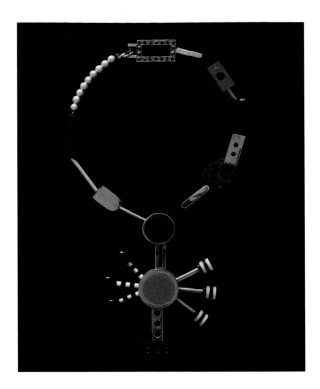

89
Michele De Lucchi (for Cleto Munari), necklace, *c.*1987. Yellow and white gold, black and white onyx, green agate, turquoise, emeralds, sapphires, pearls. Private collection

90
Robert Venturi and Denise Scott Brown (for Knoll), *Chippendale* chair with *Grandmother* pattern, 1984. Laminated plywood. V&A: W.21–1990

91
Formica Corporation ColorCore exhibition,
retitled *Post Modern Colour*, a Boilerhouse project
at the V&A, London, 1984. View from left to right
includes Stanley Tigerman's *Tête-à-tête* chaise
longue, Lee Payne's *Neapolitan* and SITE's *Door*.
Photograph by Mark Fiennes

92
Aldo Rossi (for Alessi), tea and coffee
service (or piazza), 1983. Electroplated
silver, enamel and glass.
V&A: M.57–1988

Overleaf: 93
Oliviero Toscani, United Colors of
Benetton poster, 1992 (detail).
Colour offset lithograph on paper.
V&A: E.2170–1997

might attract attention to the company and establish its design credentials. They were loss leaders at worst, and might just bring unexpected success.

It was on this basis that the storied American furniture company Knoll (which, not unlike Chanel after the death of Coco, had been flailing about, unsure of their direction following the retirement of the visionary modernist Florence Knoll) invited Robert Venturi and Denise Scott Brown to create a new line for them. Today the pair look back on this episode somewhat ruefully. As Scott Brown puts it:

> We were overjoyed that Knoll wanted and paid for the project, but we had thought we were helping to produce, in early Modern terms, cheap but good objects lovable for the 'masses'. [But] they were using us to rub off on their trade objects, to brand and rebrand themselves ... as if we were a *recherché* book of poems published by a large press to polish its image rather than to sell.[181]

Even so, the chairs are quintessential postmodernist objects, extensively reproduced then and since, perhaps because they speak so directly of the architects' eye for form and pattern (pl. 90).[182] The cut-out plywood chairs, partly inspired by the example of Alvar Aalto's furniture, were ingenious adaptations of their interest in façades and historical ornament, processed through a mix-and-match system of cheerful cartoon profiles based on historic styles (Chippendale, Sheraton, Art Deco, etc.). With their wide, flat fronts and completely linear side view, they are like design drawings unfurled into space. They are adorned with patterns drawn from vernacular and high style sources – most famously, *Grandmother*, a floral print borrowed from 'Fred's grandmother's table cloth' and overlaid with ungrandmotherly black hash marks. ('Fred', the New York architect Frederic Schwartz, was a young employee of Venturi and Scott Brown at the time.)[183] The backs, however, were left plain – as Scott Brown puts it, they were 'decorated in front and shed behind'.[184]

At the same moment that Knoll was working with Venturi and Scott Brown, the manufacturer Formica decided to follow in the footsteps of their Italian competitors Abet Laminati, who had been intimately involved in the production of Memphis. Formica had a new product to sell, called ColorCore, and it is telling that they first chose to promote it through architect-designed furniture. Traditional laminates had an unsightly black line around the edge of each sheet, a ticky-tacky, obviously fake quality that Sottsass and the other Memphis designers had enjoyed. As the name implies, however, ColorCore was patterned or coloured all the way through its depth. This meant it could be used rather like a hardwood veneer – either applied to a surface directly, or stacked, glued, and then sawn, carved, finished or even inlaid. This was a clear instance of the original orientation of postmodern design, toward kitsch and surface effects, giving way to the values of quality workmanship.[185] Formica launched the new product at the NeoCon Furniture Fair in Chicago in June 1983 with an exhibition entitled *Surface and Ornament*, curated by the company's creative director Susan Grant Lewin (pl. 91). The selection of architect-designed furniture, including contributions from Gehry, Moore, SITE and Tigerman, was shown again in New York, then alongside Memphis in Milan that autumn, and in London the following year.[186] Gehry's contribution was particularly ingenious. Snapping a piece of ColorCore between his hands, he exposed a jagged edge that appealed to him. He undertook a series of lamps that exploited this literally deconstructive technique, as well as the translucency of the plastic.

For its next act, Formica engaged the New York gallery Workbench, operated by Bernice Wollman and Judy Coady, to organize several independent furniture makers to experiment with the material. The result was *Material Evidence: New Color Techniques in Handmade Furniture* (1985). This was arguably the most successful privately sponsored craft project of the decade, despite the fact that the makers found ColorCore difficult to work – hard, but also brittle and easily chipped.[187] Whereas the architects had left the fabrication of their designs to Formica, skilled craftsmen like Garry Knox Bennett, John Cederquist and Judy McKie explored the technical qualities of ColorCore in a way that architects never could, exploiting its potential as a carving medium, sandblasting or polishing it to produce a varied surface, and stack-laminating it into complex constructed forms.[188]

Knoll and Formica achieved a certain degree of prominence with their editing projects, and in both cases successfully breathed new life into their long-established brands. There were plenty of other companies who tried the same trick: postmodernists were hired to

94
**Michael Graves (for Moller
International)**, Mickey Mouse
Gourmet Collection, 1991. Stainless
steel. V&A: M.29 to 32–2010

Opposite: 95
Swatch watch USA poster, 1984.
Offset lithograph. Design by Paula
Scher. Paula Scher/Pentagram

make handbags (Martell), wristwatches (Swatch), crystal decanters (Swarovski), shopping bags (Bloomingdale's) and wall clocks (Lorenz). But by far the most famous of the postmodern editing jobs was the Alessi Tea and Coffee Piazza collection, launched in 1983 simultaneously at the Brera Gallery in Milan and the Protetch Gallery in New York. This 'micro-architecture' project was instigated by Alessandro Mendini, and ultimately involved 11 international architects including Graves, Hollein, Jencks, Meier, Portoghesi and Venturi. Aldo Rossi's contribution became the most iconic: a flag-topped tabernacle that bespoke hermetic preciousness (pl. 92). The influential German curator Volker Fischer, based in Frankfurt, was among the few who took this manoeuvre seriously. He argued that the 'iconophilia' of the tea and coffee piazzas represented a welcome incursion of 'a more consciously cultural attitude to the design of everyday products'. In a memorable formulation, Fischer predicted that form would now follow fiction, not function.[189]

If buildings were already like trophies, operating according to the dictates of a corporate symbolic order, then the scaling-down of an architect's ideas did not necessarily represent an act of trivialization. Yet the Alessi services undeniably marked the culmination of a shift away from radical prototypes and toward luxury objects. Indeed, it could be said that these tabletop trophies were more a sign of things to come than the buildings made by the same architects. As often when confronted with postmodern excess, Sudjic was moved to satire, noting that Graves' silver tea and coffee set 'will cost you rather more than getting a house built to his plans'. But he also added, presciently, 'Can Michael Graves designer bed linen, sun-glasses and jeans be far behind?'[190] In fact it was only a few years before Graves became a kind of franchise in his own right, applying his postmodern idiom not only to Disney's buildings but also to a tea kettle and accoutrements crowned with the ubiquitous mouse ears (pl. 94). His later work for Target, though produced long after the heyday of postmodern design, continued the process, bringing pastel colours and cartoon shapes to middle-class homes across America.

Graves was unusually prolific as a muse to the corporate class, but he was hardly alone. Now under the direction of Aldo Cibic, designers at Sottsass Associati were kept busy designing stores for Esprit, founded by self-styled 'image director' Doug Tompkins, who had emerged from the counter-cultural scene in California that also produced Peter Shire, April Greiman and *Wet* magazine. *Blueprint* aptly described the company's approach as 'fashion retailing that has passed the age of innocence. Every aspect of the chain is handled with as much care as if it were being watched over by corporate identity consultants with a battery of identity manuals.'[191] Swatch developed their brand in close consultation with Mendini, and commissioned one of the most recognizable of all postmodernist graphic designs – Paula Scher's wholesale quotation of a 1934 Constructivist poster by Herbert Matter (pl. 95).[192] MTV was often identified as a mainstream delivery system for postmodernism; its

96
Arata Isozaki, Team Disney Building,
1989–90. Orlando, Florida. Photograph
by Victoria Slater-Madert

rapid-fire superficial barrage of style statements quoted the counter-cultural tropes of the 1960s even while 'divesting them, for commercial reasons, of their originally revolutionary implications'.[193] Even its logo featured applied paste-on ornament, much like Venturi and Scott Brown's chairs for Knoll. Benetton pursued a more provocative tactic, hiring the photographer Oliviero Toscani to create print advertising with highly charged documentary-style and still life images (pl. 93). This was an unusually bold use of the postmodern technique of quotation, in which profoundly divisive issues such as AIDS deaths, race relations, refugees and Third-World conflict were appropriated as the raw materials for brand formation. Was this a progressive use of media power to engage in mass activism? Or was it rather a case of unprecedented cynicism, in which any content, no matter how upsetting, could be made to serve the interests of a middle-market clothing company? Nothing could show more clearly how a corporation can absorb adjacent critique, and render it instead into technique. Benetton shows how subversion – even when self-inflicted – can serve as an ideal corporate strategy.

A similar quandary arises concerning Disney, at once the most reviled and beloved of entertainment companies, not to mention the most active corporate patron of postmodern architecture. Back in 1972, Venturi had offered the then-unthinkable opinion that 'Disney World is closer to what most people want than what architects have ever given them.'[194] By the mid-80s, not only his and Graves' firms but also those of Isozaki, Gehry, Rossi and Stern were working for the company.[195] And they were taking the jobs seriously. Some of the buildings that resulted, like Graves' spectacular double hotel the Swan and Dolphin, or Isozaki's masterfully collaged Team Disney Building (complete with mouse-ear gateway), rank among their designers' best work (pl. 96).[196] This meant, in turn, that the architects were open to criticism. Books like Dorfman and Mattelart's *How to Read Donald Duck: Imperialist Ideology in the Disney Comic* (1975), Louis Marin's *Utopiques* (1984), Richard Schickel's *The Disney Version* (1985), Michael Sorkin's *Variations on a Theme Park* (1992) and George Ritzer's *The McDonaldization of Society* (1993) all used Walt and his company as both symbol and instance of everything that was manipulative in late capitalism. For these critics, Disney was a 'degenerate utopia', whose offer of an apparently harmless escape into Fantasyland was actually 'a sort of amnesic intoxication, born of the triumph of forgetting over memory and of effect over cause'.[197]

But to some other observers, particularly those who sympathized with postmodern practice, this hard-line opposition rang false. The music critic Greil Marcus portrayed academic attacks on Disney as a sort of hysterical blindness: 'What they mostly produce [is] polemical, ideological, or merely self-congratulatory ... they can hardly be bothered to investigate which rides are fun and which aren't, let alone why.'[198] Steven Fjellman, in his subtle book *Vinyl Leaves* (1992) – the title evoking the Swiss Family Robinson Treehouse, a monumental simulacrum – also tried to distance himself from the chorus of alarm around Disney. Fjellman was quite happy to confess his attraction to the Magic Kingdom: 'I love it! I could live there. I love its infinitude, its theatre, its dadaisms. I love its food, its craft, its simulations.'[199] In the book, he attempted the difficult balancing act of acknow-ledging both the awe-inspiring power of Disney World and the genuine pleasure it brings to consumers. And in this respect, he probably approximated the ambivalence with which many people, including designers, regard the company (pl. 97). On the one hand, it is easy to see Disney as an epicenter of corporate power and control. On the other hand, it is a space apart, a heterotopia, premised on the temporary realization of total happiness, as in the (borderline racist) 1946 Disney film *Song of the South*:

It's the truth,
It's actual
Everything is satisfactual[200]

How exactly should one feel about that as a general condition of life?

That's yet another question with no easy answer, of course, and perhaps the best way to grasp the postmodern consumer experience of the 1980s is as an amusement park thrill ride: a disorienting, high-speed passage through places formed by and through the workings of capital. Like Disney World, this experience of dynamic identity formation projected a powerful, but illusory, impression of totality.[201] In hindsight, it is clear that the postmodern

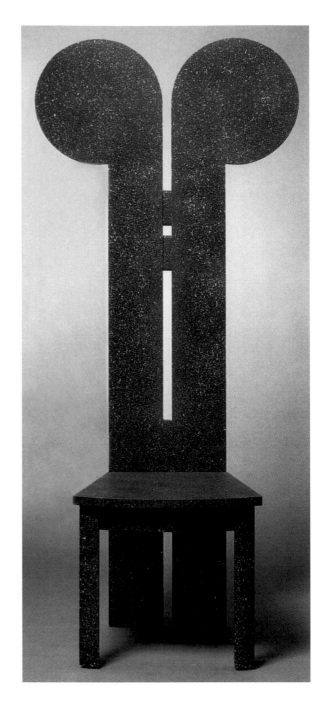

97
Wendy Maruyama, *Mickey Mackintosh* chair, 1988. Painted maple wood. V&A: W.10–2011. Photograph courtesy of Pritam & Eames

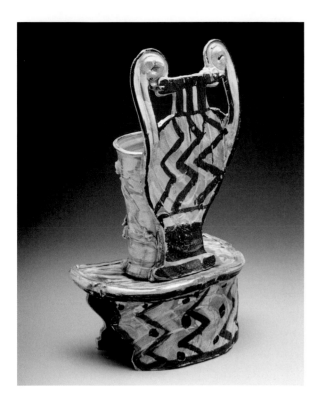

98
Betty Woodman, *Arezzo*, 1984. Glazed
earthenware. Courtesy of the artist and
Meulensteen Gallery, New York

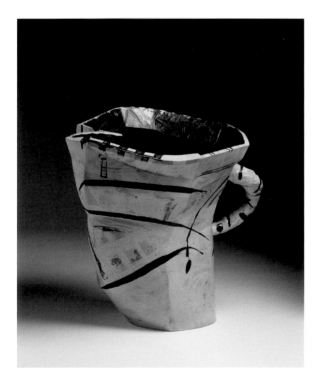

99.
Alison Britton, *Big White Jug*, 1987.
Hand-built and painted earthenware.
V&A: C.233–1987

world of commodities was only in its nascence in the 1980s; we have witnessed a dramatic global expansion of its techniques in the two decades since. But for many, the brandscape already felt all-encompassing. This was, after all, the designer decade, a time when seemingly anything could profit from the magic of a brand name: designer jeans (Jordache), designer water (Perrier), designer drugs (Ecstasy).

Surface Effects

> The simple attachment of the right name to a product or an interior has a measurable economic value. It's not simply a matter of kettles or pasta, there now seems to be no aspect of life which is free of the designer phenomenon.[202]
> —*Maurice Cooper*

So one read in *Blueprint* (founded 1983), one of a host of new lifestyle magazines promoting the flow of new designer goods. Like the Italian magazines that Alessandro Mendini was busily editing (by the 1980s, he was working on *Modo* and *Domus*), or the publications of the Condé Nast empire, or the metastasizing colour supplements of Sunday newspapers, the whole world seemed to be turning inescapably glossy. Even Neville Brody, the *enfant terrible* of British graphic design, had an abortive turn as a design consultant for the bubble-gum teenage magazine *Mademoiselle*. It was, as he observed, 'the sort of thing that American magazines love to do, the big splash, the smell of money burning'.[203] It is hard, indeed, to find a single area of the creative arts that was not obsessed with the prospects and problems of commoditization.

The pervasiveness of money culture is attested by the degree to which even the least capitalized areas of cultural production became dominated by talk about money. Take, for example, the crafts. One might expect that potters, furniture makers and metalsmiths would have taken one look at postmodernism and run the other way. The traditional associations that craft has with authenticity, depth and tacit knowledge are all directly counter to the period fascination with superficiality. But in fact, craftspeople were among the earliest and most enthusiastic adopters of postmodern technique because it allowed them to express longstanding discomfort with the substance of their own work. Craftspeople had been treated as second-class citizens within the arts throughout the post-1945 period, and already in the 1960s many makers were embracing exaggerated decoration, anti-functionality and absurdity as a way to address their own status.[204] Of particular note as precedents for postmodern craft are West Coast Funk ceramics, led by satirists such as Robert Arneson and Howard Kottler; and the Pattern and Decoration movement, which was partly fuelled by feminist artists' interest in historical women's work. P&D (as it was known) found expression across many media, particularly ceramics (Betty Woodman, Joyce Kozloff), textiles (Miriam Schapiro) and furniture (Kim MacConnell) (pl. 98).[205] Like the radical Italian design of the same period, these objects drew from a language of decorative art but were intended as provocations in the manner of an avant-garde.

In the 1980s, this ongoing inquiry into the politics of craft intersected with the growth of new, dynamic markets. The result was an expansion that was both commercial and discursive. As prices rose, craftspeople engaged in lively, self-critical debates whose terms were often drawn from the art and design school cultures in which most of them had been trained. The pages of *Crafts* magazine in Britain amply catalogue the way that the postmodern culture wars could turn local. On one side were the artists: ceramists like Alison Britton, Carol McNicoll, Jacqueline Poncelet and Richard Slee; metalsmiths like Michael Rowe; furniture makers like Fred Baier; and jewellers like Caroline Broadhead, Susanna Heron and Pierre Degen (pls 99 and 100). Every one of the traditional craft media was turned inside out in the process. As the critic Martina Margetts, who edited *Crafts* from 1978 to 1987, puts it: 'It was an assault on convention on every front.'[206] This generation of troublemakers and experimentalists was embraced by adventurous souls such as the Crafts Council's founding director Victor Margrie and its curator Ralph Turner. Controversially and rather bravely, given that it depended on government funding, the Crafts Council enthusiastically supported the most avant-garde activity and distanced itself from tradition.[207] Some observers were delighted. Rose Slivka, formerly editor of the American magazine *Craft Horizons*, professed herself bowled over by the new jewellery coming out of Britain:

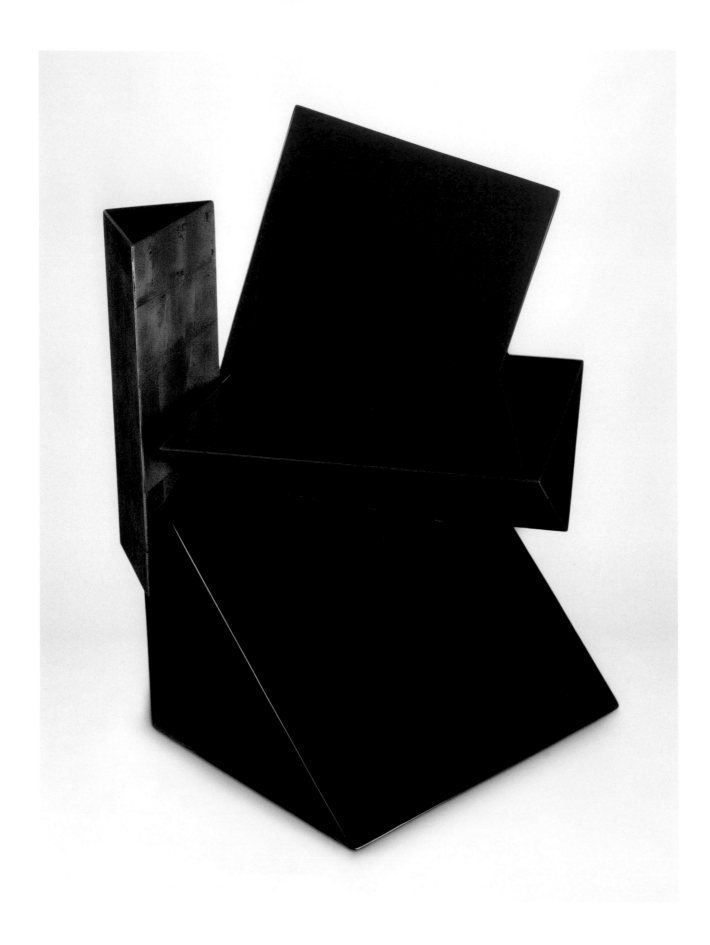

100
Fred Baier, *Prism* chair,
designed with technical
assistance by Paul McManus,
1982 (made 1993). Lacquered
MDF in four finishes,
including gold leaf
(re-lacquered 2009).
V&A: W.13–2010

Postmodernism: Style and Subversion, 1970–1990

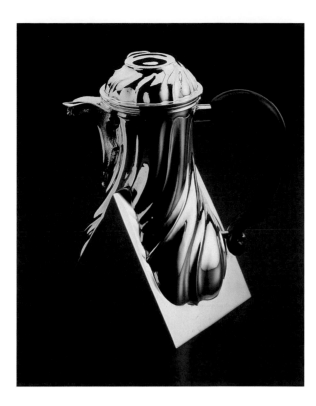

101
Gabriele Devecchi, *Equilpiemonte*
coffee pot, 1983 (made 2009). Silver
with wooden handle. V&A: M.15–2010

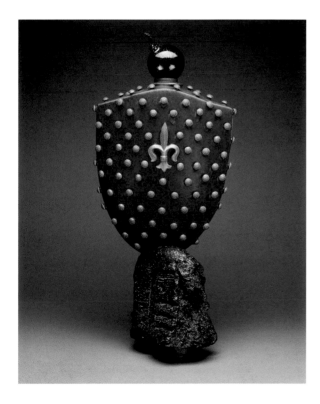

102
Adrian Saxe, covered jar, 1985.
Porcelain, raku, stoneware, lustres.
V&A: LOAN:AMERICAN FRIENDS.581–2011

It is in orbit around the body, a galaxy of planets whirling on their dervishes. Jewellery is now a body cage and a mind expander. Not only are the materials no longer precious, they are anti-precious. They are the modern synthetic materials – neoprene, fibreglass, plastic tubing – of post-industrial life and extraordinary consciousness.[208]

But not everyone was so impressed. Conservative voices (given ample space in *Crafts* magazine by Margetts, who was a progressive but also an ecumenical editor) attacked the newfound pretensions of the artisan. As in architecture, postmodernist ceramics and jewellery attracted unusually vituperative critique. Theo Crosby, one of the principals at the leading design firm Archigram, came to the conclusion that the new tendencies were so much sound and fury, signifying nothing: 'When I look at the Crafts Council shows I am filled with despair at the smartness, the uselessness of the products.'[209] Critic Peter Fuller was equally incensed by the 'sterile pretension' being promoted by the Council, which he saw as motivated by the sinister belief 'that a better world can only be established by the eradication of every manifestation of aesthetic life, and of all the preconditions necessary to nurture it'.[210] Even Peter Dormer, a key critical supporter of the new direction, thought it important that craft hold on to its roots: 'It would be as well if those who promote or attend to the welfare of the crafts understood its conservative heart; I believe it is this which accounts for the potency of the crafts now, a potency which can be summarised in one word: consolation.'[211]

But fewer and fewer craftspeople were interested in staging such a holding action. They were rushing headlong into the postmodern condition, and for them the prevailing concern with commodity status was particularly acute. Just as the modernist avant-garde had tried to retain a distance from the market, so studio craftspeople had sought to remain unsullied by the brute forces of supply and demand. This ended in the 1980s. In England, craft was reframed by the Thatcher government as a type of 'small business', with all the attendant political implications of that phrase. For a field often caricatured as a hippie counter-culture, the sudden infusion of money made a huge impact. In the United States, first studio glass and then other media were swept up into the luxury trade, driven by galleries, large-scale selling fairs, private collectors, ambitious museum exhibitions, and glossy magazines such as *World of Interiors*.[212] Some craftspeople, like Wendell Castle, Dale Chihuly, John Makepeace and Albert Paley, thrilled to the possibilities of individual entrepreneurship. They forged links with dealers and private collectors that were (of course) not only lucrative, but also enabled them to drastically expand the scale and vision of their careers. Others worked behind the scenes, collaborating with interior decorators to execute private commissions for wealthy clients.

The luxury turn in the crafts played out very differently according to geography. In Japan, craft already enjoyed an unusually high status thanks to its historical connections to tea ceremony and associated collecting practices; the government actively recognizes and funds artisanal work through its 'living national treasure' programme.[213] Postmodern style and quotations were integrated into this milieu with seeming ease. In Italy, similarly, historicism and refinement came easily to makers. The Italian silversmith Gabriele Devecchi, for example, created postmodern versions of an eighteenth-century coffee pot form common to the Turin area. Though everything about these objects was a pastiche, from the collided shapes to the punning titles, the execution was immaculate (pl. 101). Devecchi's son Matteo, who helps to run the firm today, suggests that 'silversmithing was already postmodern. Every day, you make the same coffee pot you have been making for 200 years. There is no evolution.'[214] In America, which lacks such a deeply embedded artisanal culture, historicism was inevitably a more assumed pose, and it came with a more cutting edge. Craftspeople in the United States made exquisite objects, but many seemed to writhe in discomfort at the idea of luxury. Richard Mawdsley fashioned extraordinary neo-Baroque presentation cups, which look richly ornamental from a distance but prove to represent desolate American Midwestern water towers at close range. In ceramics, Adrian Saxe appropriated the materials and motifs of French Sèvres porcelain to make biting comments on contemporary culture (pl. 102). In the Netherlands and Germany, meanwhile, a strong academic base helped conceptualism to flourish, particularly in the field of jewellery – an ideal medium to explore questions of value. Some, like Dutch jeweller Robert Smit, outlined a defence of traditional materials like gold, while others

parodied the instinct for display – as in Gijs Bakker's rendering of a court necklace in cheap, flat PVC plastic (pl. 104).[215] The German jeweller Otto Künzli asked his clients to sport gold frames from their necks, a chain of threaded Deutschmark coins, or a lapel pin in the form of a single, huge gold ingot marked '300g, 10.5 oz'. It was fake, of course (pl. 103).

Wonders Taken for Signs

> Superficiality has depth if understood and accepted as the profound difficulty of human life.[216]
> —*Alessandro Mendini*

In all areas of creative practice, then, there was an inversion of polarity as the 1980s wore on. The postmodernist's position was no longer that of a critical outsider who lacked a ready public. Distribution was now beginning to drive production, not only in economic terms, but also in determining the preoccupations of designers and makers. Fine artists felt this too, and the most lastingly relevant works from the 80s and early 90s are those that draw on design as the most appropriate language to confront postmodernity. This is why rather than the neo-Expressionist paintings by Julian Schnabel and Anselm Kiefer, it is the Commodity Art works of Koons, Sherman and Warhol, as well as Ai Weiwei, Peter Halley, Jenny Holzer, Barbara Kruger, Louise Lawler, Sherrie Levine, Allan McCollum, Haim Steinbach, Ashley Bickerton and Yasumasa Morimura that speak to us most strongly from this era (pls 106 and 107). All of these artists directly faced the nature of their own works as goods to be bought and sold. But they did more than that; they also saw commodity status as a raw material, like paint or clay: a medium in which they could operate.

This was the highest, but also the most tragic state of postmodernism. The dramatic collision between art, design and money had many negative consequences, not least of which is the skewed understanding it imparted to the present. The late 1980s saw a consensus form around postmodernism, still shared by many, which ignored its expansive and liberating qualities, and instead saw it as a shell game – at best derivative and caustic, at worst the new clothes for an empire of corporate greed. In fact, though you are reading about postmodernism right now, there's still a good chance you hate it – if not the ideas, then the look of it. And if you don't, your parents almost certainly do. (All that plastic laminate, those clashing colours and disjunctive forms – who could live with it?) Postmodernism never asked to be loved, to be sure, but whatever aggression it put out into the world has been repaid in full. Jürgen Habermas was among the first to voice opposition, finding in postmodernism a dangerous turning away from the Enlightenment project of creating and extending a liberal, consensus-seeking public sphere.[217] Feminists were early in launching a critique too, rightly pointing out that postmodernism's vertiginous doubt of any stable truth had conveniently arrived just when women were starting to lay claim to equal discursive status. As Rita Felski asked, 'How can feminism justify its own critique of patriarchy, once it faces up to a pervasive legitimation crisis that corrodes the authority of all forms of knowledge and reveals truth as nothing more than the reuse of power?'[218] From a post-colonial perspective, too, postmodernism's emphasis on play and doubt has sometimes been seen as a callow abdication of responsibility. 'Postmodernism preserves – indeed enhances – all the classical and modern structures of oppression and domination,' wrote Ziauddin Sardar. 'Those enslaved by poverty and those trapped in an oppressive modernity do not have the luxury of postmodern freedom of choice.'[219] For many living outside the Euro-American enclaves of postmodernism, as Nigerian author Dennis Ekpo put it, postmodernism looks like 'nothing but the hypocritical self-flattery of the bored and spoilt children of hyper-capitalism'.[220]

Even the practitioners documented in this book, the very people who formulated the style and the subversive strategies of postmodernism, tend to dislike being called postmodernists. Those who have at some time or other renounced the title, either in published statements or in conversation with us as curators include Ron Arad, Mario Bellini, Denise Scott Brown, Frank Gehry, Hans Hollein, Barbara Radice, and even Ettore Sottsass and Robert Venturi, whose comments on the matter could hardly have been more definitive: 'I don't consider our group Memphis to have anything to do with Postmodern at all'; and 'I am not now and never have been a postmodernist and I unequivocally disavow fatherhood

103
Otto Künzli, *300g, 10.5 oz* ingot pendant, illustrated in *Crafts* magazine, no. 71, November/December 1984

Opposite: 104
Gijs Bakker, *Pforzheim 1780* necklace, 1985. PVC-laminated photographs, gold leaf, precious stones. Drutt Collection, Museum of Fine Arts Houston (2002.3593)

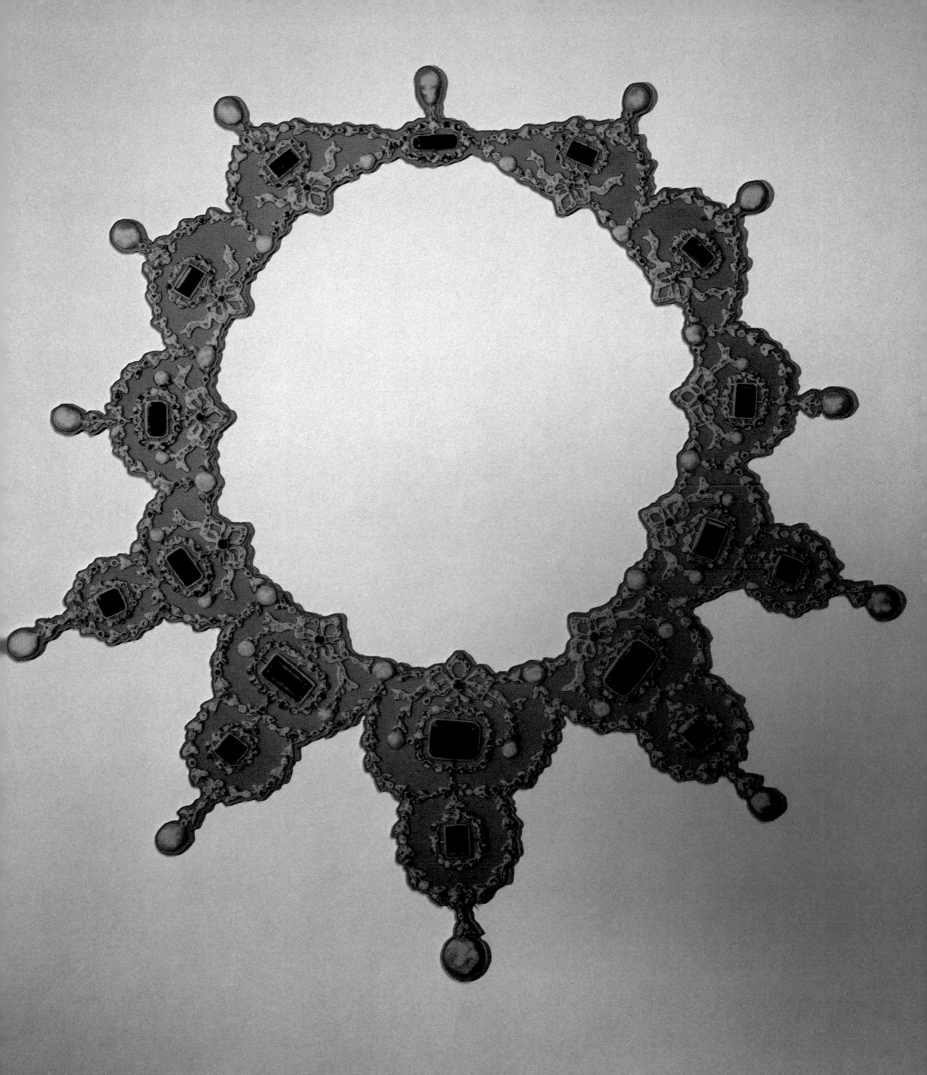

of this architectural movement.'[221] Many other designers and architects, if the question is put to them, just smile warily, and perhaps invoke Groucho Marx (who famously refused to be a member of any club that would have him). The same holds for whole geographies of design culture. In Europe, especially Italy, postmodernism is often defined in narrow terms as a principally American architectural style employing a historicist classical vocabulary. According to this version, Portoghesi's 1980 Biennale was a one-off event, Michael Graves is the kingpin of PoMo, and Radical Design is a continuation of the modernist project. In America, conversely, postmodern design is often spoken of as a largely European phenomenon, emblematized by the work of Sottsass and his fellow Italian radicals. And everywhere, there are doubters who consider the whole thing a charade, which has no reality outside the books of theorists such as Jean-François Lyotard and Charles Jencks.

Alessandro Mendini is one exception. When we put the question of postmodernism's legacy to him – is it still with us today? – his reply was simple: '*Claro. Sono ancora qui, non?*' ('Sure. I'm still here, aren't I?')[222] What does it mean to stand up for postmodernism now? As a master of indirection, Mendini would seem unlikely to provide the answer to this question. But a self-portrait of sorts that he contrived may be as good as we can hope for. It is not a painting, or even a chair, but rather a three-piece suit, printed with the logos of all the companies that Mendini worked for – Abet Laminati, Alessi, Artemide, Driade, Domus, Interni, Memphis, Vitra, and the rest – alongside those of multinational corporations such as Ford and McDonald's (pl. 105). Mendini thereby styled himself a true company man – like a Formula One car, plastered with its sponsors' brands, or perhaps an animated version of Ashley Bickerton's sculptures, which included the logos of various art world power brokers (pl. 106). By the late 1980s, corporations were in the driver's seat, treating prominent architects and designers as the engine of their own project of self-fashioning. But as marketing directors were already learning in the 1980s, the most powerful effect of any commodity is often outside its creator's control. Mendini's self-branding gesture is his way of acknowledging the true conditions of professional design, in the pocket of his patrons, but is also a suggestion that brands too can be the material for bricolage. They are, to invert a phrase of post-colonial theorist Homi Bhabha's, 'wonders taken as signs' – entities of superhuman economic and cultural force, reduced to the level of communicative ornament. In the process they become manageable, even as they retain their power. When we claim a brand as our own, we give ourselves permission to articulate our own complicit position in mass culture.[223] If practitioners – and indeed, the rest of us – do not want to admit to being postmodernists, that may
be because it is uncomfortable to do so. But maybe a little discomfort is what we need.

What has struck us most as curators is the range of ways in which the questions posed by postmodernism remain open to this day. This has to do not only with the relation between commodities and systems of power, but also the other themes charted in this book: the proper use of history, the interactions of identity and mediation, the use of found objects of all kinds within creative work, and lateral movement across disciplines. The postmodern surface afforded the exploration of all of these issues in depth, and they remain central to design discourse. Since 1990 we have seen huge changes in design, the rise of digital technology above all. Unsurprisingly, many new ways have been found to describe design and its social role – network theory, mass customization, risk society, liquid modernity, viral advertising, 'Design Art,' etc. But in many ways these catchphrases are refinements or recapitulations of postmodernist discourse, not departures from it. The term itself may have gone out of fashion, partly no doubt because of sheer exhaustion brought about by overuse. Equally, the rhetorical points to be scored by declaring an end to postmodernism must be considered. Donald Barthelme wrote an imaginary letter to a literary critic that began 'Yes, you are absolutely right – Post-Modernism is dead' all the way back in 1975, and French curator Nicolas Bourriaud has proposed the end of postmodernism and the inauguration of a new dispensation, which he calls Altermodernism, as recently as 2008.[224] Evidently postmodernism's death is its most lasting feature. But once postmodern fragmentation is introduced as technique, it can never be got rid of. As Zygmunt Bauman memorably put it, 'The modern crusade against ambivalence and the "messiness" of human reality only multiplies the targets it aims to destroy.'[225] Thus postmodernism always has been, and is still, an endgame, an ongoing gambit in which the apocalyptic impulse serves as an entry into the new.[226]

105
Alessandro Mendini with Kean Etro,
Logo suit, 2004. Photograph by
Carlo Lavatori

106
Ashley Bickerton, *Commercial Piece
#1*, 1989. Anodized aluminium, wood,
leather, acrylic paint, rubber. Courtesy
of the Artist and Lehmann Maupin
Gallery, New York

107
Ai Weiwei, *Han Dynasty Urn with Coca-Cola Logo*, 1994. Painted Han Dynasty urn. Private collection, USA

If postmodernism never goes away, despite the repeated claims of its foreclosure, what does its future (which is of course our present) look like? The most obvious way to approach this question is to think about 'globalization', another term that has achieved currency since 1990, and which perhaps more than any other idea conveys a sense that we have entered something discrete, something post-postmodern.[227] It will not have escaped the reader's notice that the geography of this project is essentially Euro-American, with Japan as an exception that proves the rule, and the majority of the objects it documents are the work of white men. Furthermore, as mentioned above (and in Arindam Dutta's essay for this volume, pp. 270–3), the presumption of a 'universal' postmodern condition is astonishingly Eurocentric. All the same, postmodernism has itself demonstrably 'globalized' since 1990. In the past two decades, major postmodernist art and architecture appeared in Cairo, Singapore, Shanghai, and almost every where else where capital accumulates (pls 107 and 108).[228]

More important than this matter of stylistic diffusion, though, is the fact that contemporary globalization itself is best understood as a postmodern phenomenon. As Mike Featherstone has written, 'On the global level, postmodernism not only signifies a revival of the interest in the exotic other, but the fact that the other now speaks back.'[229] This suggests that today's asymmetries of power can still best be viewed in terms of postmodernism, in both a positive and an oppositional (that is, anti-postmodern) sense. We want to pursue this claim, in a rather limited way, by focusing on one exhibition: *Magiciens de la Terre*, which was staged in 1989 at the Centre Pompidou and the Parc de la Villette in Paris. This situated the project within two buildings whose relations to postmodernism were complex, the former being a late modern structure by Richard Rogers and Renzo Piano, whose overstatement of functionalism tipped into colourful expressionism, and the latter a deconstructivist complex by Bernard Tschumi. What made the event controversial, however, was not the architectural setting, but rather the curatorial premise. Curator Jean-Hubert Martin and his colleagues set out to present a universal picture of contemporary art, which included blue-chip conceptual artists from Europe and America alongside wood carvers, metalworkers and painters from Africa, India, the Australian outback and other 'marginal' spaces.[230] The project has recently, and aptly, been described as the moment when 'the international art market was awakened to the potential riches of another period of global colonisation, of what then would have been referred to as "the other"'.[231] Though the divide between occidental artists and '*les autres*' was in some ways clear and absolute, Martin argued that they all drew from a common wellspring of human creativity:

> All of these objects, from here or elsewhere, have one aura in common. They are not simple objects or functional tools. They are meant to act upon the same mentality and the ideas from which they are born. They are receptacles of metaphysical values.[232]

A perhaps surprising aspect of *Magiciens de la Terre*, given this emphasis on spiritual authenticity, was its emphasis on 'salvage culture' – just the sort of bricolage that Jencks and Silver had celebrated all the way back in 1972 in their book *Adhocism*, but now more explicitly in the context of the global movement of commodities and images.[233] Many of the Euro-American artists included operated in this way – whether it was British sculptor Tony Cragg's assemblages of plastic junk, German painter Sigmar Polke's pastiches of pop and historical motifs, or French conceptualist Daniel Spoerri's neo-primitivist masks made from disparate found objects.

Two of the most resonant figures in the show were African artists whose objects also seemed the products of globally-inflected bricolage; in fact, their work looked uncannily like postmodernist design. These were Samuel Kane Kwei, a cabinet-maker from Ghana, who had been making sculptural coffins since 1951 in the shape of automobiles (pl. 109), fish, houses and cameras; and Bodys Isek Kingelez, from Zaire (Congo), who in 1977 had begun fashioning imaginary visions of Kinshasa. Kingelez's models, made of painted cardboard, looked for all the world like the creations of a New York architect (pl. 110). After Kane Kwei and Kingelez were showcased at the Pompidou, other institutions lined up to celebrate them: the Museum for African Art in New York, the British Museum, MoMA, and the definitive postmodern museum in Groningen (designed by Mendini) all exhibited one or both artists. Jean Pigozzi, a Geneva-based venture capitalist, worked with the assistant

curator from *Magiciens*, André Magnin, to form a groundbreaking collection of contemporary African art that included both Kwei and Kingelez.

It was not only the style of these objects that made them register; they also spoke to the status-obsessed art and design world of the 1980s. Kane Kwei drew on longstanding pageant customs but also marked the passage of new foreign goods into his community (Teshie, a suburb of Accra), and his work spoke directly to the ambition of his clients. It was an echo of that key postmodern preoccupation, the construction of the self through commodities, even though the motivations and symbolism of the objects were local in character: 'These extravagant coffins are chosen by the deceased's family, most often according to their social background or their profession. A lion for a traditional chieftain, a Mercedes for the boss of a fleet of taxis, a chicken for a mother with a large family.'[234]

Kingelez's architectural models were also a hit with the postmodern set. A few years after *Magiciens de la Terre*, his work propelled Ettore Sottsass into a paroxysm of rhetorical flight that echoed the exhibition's transcultural vision:

> The memories of Bodys Isek Kingelez are those that are possible, maybe even those that are foreseeable, to a traveller who leaves an ancient, dark, tiring, fierce world of African nature and finds he's being aroused by, that he's falling in love with, and understandably so, that part of the Western modern landscape, in fact that part of the American landscape that is most brightly lit, most colourful, noisiest, most artificial, most 'anti-nature,' the very part that is precisely 'history-less', the part that is projected to reassure everyone, to transport everyone, if possible, toward happiness, toward a total Existential blessing. Aren't Las Vegas, Miami, Atlantic City, divine places, blessed by good fortune, placed where time doesn't exist, places without history, places to dream, rainbow places, places with tall plastic palm trees and celestial breezes?[235]

Sottsass gives himself permission to forget the real context of these objects' production – which he caricatures in terms drawn from Joseph Conrad's *Heart of Darkness* (1902) – and instead see them as monuments of a transcultural postmodernism, devoid of history but filled with happiness. One can detect this strain of multivalent idealism throughout the reception of Kane Kwei and Kingelez, and indeed all the 'other' work in *Magiciens*: a range of conflicting and conflicted responses that combined old-fashioned exoticism, well-intentioned universalism, and a shock of recognition, all fuelled by self-projection.

108
Ahmed Mito, Supreme Constitutional Court of Egypt, 2000. Cairo

109
Samuel Kane Kwei, *Mercedes-Benz Shaped Coffin*, 1993. Enamel paint and wood. Contemporary African Art Collection, Geneva. Courtesy CAAC – The Pigozzi Collection, Geneva © Samuel Kane Kwei

The exhibition was, in other words, postmodern not only in its content but also its attitude. Martin and his colleagues staged a globalist gesture that was nonetheless exquisitely self-regarding.

For many observers this was the worst kind of false hybridity. In her scathing critique of *Magiciens*, the art historian Annie Coombes wrote a passage that is worth quoting at length:

> In the same way that bricolage superficially reproduces the qualities of [modernist] collage but smoothes over the fracture that collage retains, 'difference' as an analytical tool can simply revert to the pitfalls of the older cultural relativist model, concealing the distances between cultures while affirming that all are equal. The chasm is too great between the actual experience of economic, social, and political disempowerment, and the philosophical relativism of postmodernism's celebration of flux and indeterminacy as the product of the mobility of global capital. We need an account of difference which acknowledges the inequality of access to economic and political power, a recognition which would carry with it an analysis of class and gender relations within subaltern and dominant groups, and would articulate the ways in which such differences are constituted, not only in relation to the western metropolitan centres.[236]

Coombes issues a tall order here, probably one that no exhibition (not *Magiciens*, and not the present exhibition either) can fulfil, at least on its own. What is most striking about her criticism, however, is the fact that it is itself framed in terms of postmodernism – by being against it. Like its intermittent demises, postmodernism's inadequate claims of universality are a gift that keeps on giving. Or to put it more seriously: attending to difference still requires the flux and relativism of the postmodern position. It is only as a rift in an otherwise undifferentiated, connective field that the particular becomes political, rather than simply descriptive or constraining. Here it may be worth remembering the words of one last theorist, Trinh T. Minh-ha, who wrote in 1987: 'Difference is an ongoing process; like authenticity [it] is produced, not salvaged.'[237] From this perspective, postmodernism's engagement with the global, as embodied in such events as *Magiciens de la Terre*, is worth holding on to precisely because it is so objectionable. Postmodernism's self-presentation as a difference machine may be fraudulent, but at least the apparatus is there for all to see.

110
Bodys Isek Kingelez, *Zaire*, 1989. Paper, coloured and decorated cardboard, polystyrene, plastic. Contemporary African Art Collection, Geneva. Courtesy CAAC – The Pigozzi Collection, Geneva © Bodys Isek Kingelez

Conclusion

Whenever I get this way
I just don't know what to say
Why can't we be ourselves like we were yesterday?[238]
—*New Order*

When choosing a director for their video *Bizarre Love Triangle* (1986), the pop band New Order turned to Robert Longo. At the time, Longo was just on the cusp of a brief stint as a video-maker, but he was also one of the hottest contemporary artists in New York.[239] Another member of the so-called Pictures Generation, he was probably best known for his *Men in the City* series. These life-sized, full-length figure studies were based on photographs in which men wearing suits were captured in the throes of a mysterious convulsion (pl. 111).[240] Were they dancing? Had they been shot at close range (by a gun, as well as a camera)? It was impossible to tell, and of course that was the point. Like so many other postmodern poseurs, his figures were at once ambiguous and ecstatic.

In the video that Longo made for New Order, this indeterminate motif is adapted into the key image accompanying the chorus. As we hear Bernard Sumner singing the lines 'Every time I see you falling/ I get down on my knees and pray', we see well-dressed bodies floating in an endless freefall against the backdrop of a blue sky (pl. 112). The sequence emblematizes the condition of the postmodern subject, adrift in frictionless space (and it is even more haunting now than it was when conceived, given our memories of corporate employees plunging from windows on 11 September 2001).[241] Wrapped around the tumbling figures, during the verses, is a world of quickly changing imagery, which seems to have been assembled from found footage but was actually shot on location in New York. The subject matter sometimes recalls the urban flux of *Koyaanisqatsi* – escalators, industrial architecture and crowds on the move. At other times Longo surveys the technological infrastructure of the song itself, in shots of reel-to-reel tape, scrambled footage of the band in performance, and black and white televisual 'noise'. Occasionally, as in Laurie Anderson's performances, the video becomes suddenly and unexpectedly poetic. Fireworks light up the night sky, and a child runs through the city, scared, clutching a doll to her chest. And then, toward the end, there is an inexplicable rupture, unlike anything you expect to find on MTV. A (very) short film-within-the-film, shot in black and white:

Woman: I don't believe in reincarnation, because I refuse
to come back as a bug or as a rabbit.
Man: You know, you're a real 'up' person.

This brief exchange could be taken as a joke about the idea of the 'post-human', then gaining ground in academic and subcultural circles. Plastic surgery, breast implants, steroids, crash diets, mood drugs, genetic engineering: all these developments had given rise to the idea that identity was now something manufactured, and hence as much a question of control and manipulation as any other form of consumption.[242] The man's rejoinder both satires this world of self-creation, and refers obliquely to the pervading idea of postmodern identity (those floating figures might be seen as permanently 'up'). But even this interpretation is probably too literal. As the video's rapid-fire images flash back across the screen, it's clear that the sheer experience of media fragmentation constitutes the real message.

In the spirit of Longo's flickering yet revealing video, we now turn to a kaleidoscope of views on postmodernism. The territory we have laid out here, in this long introduction, will now be remapped from the beginning. We have invited 39 authors to deliver short essays on a subject of their choice. The resulting multivalent perspectives capture not only the complexity of postmodernism, but also its incommensurability. We hope each of these essays will take you closer to a particular moment, practitioner or idea; and also that, taken together, they will constitute a compelling story (but definitely not a grand narrative). A few of the authors are leading figures from the period: architects James Wines and Denise Scott Brown, graphic designer April Greiman, dancer and choreographer Matthew Hawkins, curator Wolfgang Schepers. Among the contributing historians are some who lived through the period and helped to shape it, like Charles Jencks and Rick Poynor. But for most of our

essayists, looking back at postmodernism means looking back at their own youths. Some were children in the 1970s and 80s; others were in university or graduate school, having these ideas laid out before them when they were hot off the press. It is the same for us as curators. One of us was born in 1967, the other in 1972, and our first encounters with design history were conditioned by the insights of postmodernist theory.

It would be naive to suggest that such generational affinities play no role in the history of ideas, and this is one explanation why, after a period in which postmodernism seemed to have been exhausted as a topic of discussion, it is now back in vogue. But there are many other reasons why this project seems to have come along at the right time. We have curated this exhibition during a period of sudden economic distress, which makes the recessionary decade of the 1970s, the 'bubble' of the 80s, and the crash years that followed, all feel uncannily familiar. We have also conducted our research at a time when many postmodern practitioners are seeking to consolidate their own legacies – a good time to gather collections and recollections alike. And, of course, there are all the arguments to be made about the ongoing importance of postmodernism, both as a historical subject and a set of unresolved intellectual provocations. The history we have set out here should help us to understand the permissive, fluid and hyper-commodified situation of design today. Even so, these issues are subsumed under our own personal relation to the period: the sense that when we look back at the years from 1970 to 1990 we are looking at the moment of our own formation. And this will be true of many, if not most, people who read this book. Why can't we be ourselves like we were yesterday? Because like it or not, we are all postmodern now.

111
Robert Longo, *Untitled (Joe)* from the *Men in the City* series, 1981. Charcoal and pencil on paper. Tate: Presented by Janet Wolfson de Botton 1996, London (T07177)

Overleaf: 112
Robert Longo, stills from *Bizarre Love Triangle* video for New Order, 1986

James Wines

ARCH-ART: ARCHITECTURE AS SUBJECT MATTER

It is no secret that postmodernism has acquired a (mostly undeserved) bad name in certain architectural circles. So the timing is right for an alternative assessment of the movement's inclusive legacy – especially when the design world's bombastic excesses of the past two decades are being threatened by a global economic crisis, and at a point when architects are scrambling to embrace the new frugality and green demands of an age of information and ecology.

A good deal of the critically disdained architecture of the 1970s and early 80s was targeted mainly as a consequence of its decorative excess, pop culture parody and the tendency to favour anachronistic quotation from history as a source of imagery for a post-industrial habitat. This narrowly framed view of postmodernism is a casualty of early over-exposure in the mainstream press, which latched on to some of its more superficial and hyperbolic manifestations – notably, Disney World caricature, New Urbanist populism, Vegas casino hybridism and the Florida pastiche of Seaside, and Disney's planned community, Celebration.

In fact, postmodernism in art and design was inspired by a multi-faceted rebellion against the authoritarian conventions of Modernism, in favour of less dogmatic sources of content such as flux, indeterminacy, entropy, inversion and the convolutions of social change. While it is most often associated with architecture in the general media, postmodernism's most innovative and influential impact has resided in the areas of literary criticism, environmental art, filmmaking and performance – emblematically in the work of such luminaries as Michel Foucault, Jean Baudrillard, Jacques Derrida, Robert Smithson, Joseph Beuys, Gordon Matta-Clark, Vito Acconci, Alice Aycock, David Lynch, Richard Foreman and Laurie Anderson. Unfortunately, in the building arts, the postmodern imagery of choice seemed to quickly congeal into a litany of predictable stylistic devices and, in some cases, a cloyingly decorous form of mannerism. But, as in the other arts, the more conceptually significant aspects of design remained concerned with social meaning, narrative content and a response to context.

While rarely associating themselves with the term postmodernism, a number of the most influential artists in the early 1970s were motivated by an interest in architecture and the possibility of communicating in the public domain. Some of the key precedents leading to 'Arch-Art' developments in the United States and Europe were associated with the Fluxus group – particularly its key innovator, Joseph Beuys – as well as the materiality-based aesthetic of Process Art and Arte Povera. For example, when the large retrospective of Beuys' work arrived at New York's Solomon R. Guggenheim Museum in 1979, it revealed his extraordinary two-decade-long checklist of conceptual ideas related to social action, public performance, engagement with humble materials and a concern with the natural environment. By the mid-1970s some of these tendencies had surfaced in New York's SoHo galleries – significantly in the work of Acconci, Robert Morris, Eva Hesse, George Brecht and Bruce Nauman – yet their origins in Beuys' work were downplayed by a chauvinistic Manhattan art world (perhaps to protect an increasing number of American artists who had cribbed from Beuys and wanted to avoid a tag

of plagiarism). Subsequently, the Italian critic and curator Germano Celant became a leading voice on behalf of Fluxus and Arte Povera, serving as curator for setting the record straight. He properly credited Beuys, as well as a number of other influential European artists, who favoured a more sociological orientation and the use of discarded materials in the art-making process. Within Fluxus, these voices of change included Beuys, George Maciunas, Yoko Ono and Nam June Paik; while in Arte Povera, the main contributors were Mario Merz, Jannis Kounellis, Alighiero Boetti and Giulio Paolini.

The goals of both Arte Povera and Fluxus were generally focused on dismantling the conventions of gallery display – that is, paintings on walls and sculptures on pedestals – and challenging the art market, with its qualifications of permanence and re-sale value as measures of excellence. They also questioned the notion of 'acceptable versus unacceptable' media choices in the creative process. Although aligned with certain aspects of Dadaist anarchy and Duchampian irony, a number of the most significant artists in these two movements abandoned those influences in favour of art dedicated to greater humanitarian responsibility. Beuys spoke of his work as 'social sculpture', a mission he described as 'a new kind of art, able to show the problems of the whole society, of every living being'.[1] While this confidence in the supremacy of aesthetic forces tends to sound naively optimistic in the face of today's economic and environmental crises, his proclamations did set the 1970s' stage for a much wider interpretation of the goals of art. His appeal for social change helped stimulate a rebellious climate and new forms of artistic hybridism, which included opposition to the conventional parameters of architecture. For example, during the early 1970s watered-down Modernism was seen as inextricably linked to business-driven design agendas, as a reinforcement of corporate identity and a symbol of the liberal wing's favourite institutional adversary, the 'industrial/military establishment'. This meant that progressive opponents viewed commercial buildings as the embodiment of social, political and environmental exploitation. Within this rebellious climate, architecture became a logical target for critical insurgency and the ideal foil for avant-garde artists' public interventions involving buildings and public spaces.

In addition to his curatorial role in defining Arte Povera, Celant is also credited with titling the 1970s Radical Architecture movement, which included Alessandro Mendini, Ettore Sottsass, Michele De Lucchi, the writer Barbara Radice and groups like Superstudio, UFO, Archizoom, Coop Himmelb(l)au, Ant Farm, Missing Link, Haus Rucker and Archigram. While marginally connected to postmodernism because of their interest in communicative content, a number of the radical designers' mission statements resembled the 'architecture or revolution' pronouncements of Le Corbusier in the 1930s and the later 'salvation through art' theories of Joseph Beuys. In terms of late twentieth-century positioning, radicals saw their work as responses to the failure of modernist autocracy, as solutions to the social inequities of urban planning and as politically charged pleas for new, more ecumenical, paradigms for human habitat. To demonstrate their combative politics and disdain for corporate design, the more restless architects' built works often took the form of what were then

called 'event structures'. These were mostly temporary installations – sometimes motivated by political agendas – and frequently used to take advantage of the inherent symbolic value of public spaces, civic buildings and environmentally threatened terrains. By the late 1960s and early 70s some of the interventionist methodology were converted into actual habitats for organized groups of dissidents. Among the memorable examples were the Drop City communes of the American Southwest, with their nomadic lifestyles, geodesic domes and experimental collage architecture constructed out of consumer culture detritus and other forms of industrial waste.

Architectural discourse of the early 1970s was also heavily influenced by Robert Venturi's seminal book of 1966, *Complexity and Contradiction in Architecture*. His thesis challenged what he saw as the oppression of modernist orthodoxy by proposing a preferred source of design vitality, based on the communicative iconography of American vernacular dwellings, Main Street storefronts and the signification of highway billboards – summarized in what he viewed as 'the everyday landscape, vulgar and disdained'. While Venturi's re-evaluation of commonplace structures generated a good deal of interest among the advocates of Arch-Art and

Radical Architecture, his focus on buildings as 'decorated sheds' became too readily appropriated by the fashionable design scene and his most relevant social/aesthetic messages were subsequently buried under a ubiquity of 'if-you-please' stylistic misinterpretations by others.

The diversity of these art and design ideas set the stage for Arch-Art and what, in retrospect, many critics and theorists have come to regard as among the more substantive contributions of postmodernism. The key difference from mainstream postmodernism was the Arch-Artists' use of architecture as a 'subject matter for art and social commentary', as a way of opposing formalist/functionalist building design and, from the perspective of radical critique, as an alternative to the compromise of art in deference to the expedient. During the period when postmodernism was mining historical references, popular culture and vernacular precedents as its origins of ideas, Arch-Art drew upon psychological, environmental and phenomenological sources within a more broad-based social situation. If the dominant characteristics of postmodern architecture could be seen as adaptive, referential and objectified, Arch-Art tended to be subversive, absorptive and contextual.

113
Gordon Matta-Clark, *Splitting*, 1974. Deconstructed house. Englewood, New Jersey

The SoHo environmental and performance art community of the 1970s was a miraculous fusion of large loft spaces for cheap rents, an assembly of remarkable talent in a compressed community and the financially suicidal compulsion by many artists to resist the standard rewards of a gallery-dominated marketplace. The key players in this vigorous scenario included Matta-Clark, Smithson, Aycock, Acconci, Nancy Holt, Dennis Oppenheim, Alan Saret, Mary Miss, Alan Sonfist and the Diaghilev-like entrepreneur of Process/Conceptual/Environmental Art (plus publisher of art magazine *Avalanche*), Willoughby Sharp. Collectively gravitating around a troglodyte basement space at 112 Greene Street and a restaurant called FOOD at the corner of Greene and Spring Streets, Matta-Clark's group was comprised of a number of artists who worked with the existing components of interior and exterior architecture. For his own interventions with buildings – an activity he called 'anarchitecture' – Matta-Clark's approach paralleled the more orthodox 1990s design world's interest in 'deconstruction'. By using conventional buildings as receptacles for dissection and penetration, he engaged the actual surface structure of architecture to expose 'deep structure' thresholds of significance. For example, what Jacques Derrida identified as 'archetexts' in writing constitute an observable arrangement of words and meanings, parallel to 'archetypes' in architecture. In dealing with buildings, this immediately legible language is embodied in the familiar elements of construction and conventional design choices – or, what can be seen as an archetypal set of building profiles, methods and materials that trigger reflex associations in the mind of the viewer. Given these objectives, the similarities between Matta-Clark's process of cutting away to reveal hidden meanings and Derrida's excavation of language were more conceptually substantive than establishment architecture's decon-redux of some years later (especially as manifested in the kind of stylishly fragmented formalism that attracted a lot of critical endorsement in the late 1980s).

One of Matta-Clark's most significant works – *Splitting* of 1974, Englewood, New Jersey – was also a persuasive example of dissection as revelation (pl. 113). The site was an archetypal rural dwelling in a depressed neighbourhood, which had already been destined for demolition. Rejecting what he saw as 'the functionalist aspect of past-due Machine Age moralists',[2] Matta-Clark used this abandoned structure as a vehicle for dematerialization. He imposed his incisions as a commentary on American consumer culture's warped notion of built-in obsolescence as evidence of progress. He also saw surgical operations on discarded buildings as a form of preservation by demolition – since these structures were converted from obsolescence to art by his actions – and as a questioning of the American middle-class view of architecture as a means of perpetuating isolationist standards of privacy and segregation.

For his famous *Conical Intersect* at the Paris Biennale of 1975, Matta-Clark cut a series of giant holes in the walls of a seventeenth-century apartment building. Consistent with his usual choice of derelict structures for intervention, this dwelling had been chosen to be demolished in the wake of President Mitterrand's then burgeoning *grands projets* in France. Matta-Clark's guerrilla operation was conveniently

situated directly across from the Beaubourg area and the on-going construction of the Centre Pompidou. As a critique of the museum's over-zealous glorification of Machine Age values, he confronted the emerging institution with what he called a celebration of the 'non-umental ... an expression of the commonplace that might encounter the grandeur and pomp of architectural structures and their self-glorifying clients'.[3]

During the early 1970s Gianni Pettena, a professor at the University of Florence, created several inversions of architecture for critical effect in the United States. Whereas Matta-Clark favoured operating in the gaps between construction and demolition, Pettena's work engaged buildings as an extension of 'nature's revenge'. Although loosely associated with Radical Architecture in Europe, he was more appropriately identified with Arch-Art through his preference for subversive intervention as opposed to the design of functional habitat. Also, as a consummate architectural historian, he felt at ease with the past and uncomfortable with postmodernist architects' penchant for mannerist quotations from Italy's Greco/Roman heritage.

Pettena's most significant architectural works involved three buildings in the United States during 1971 and 1972 – a suburban dwelling in Salt Lake City, Utah and a house and college administration building in Minnesota, Minneapolis. To achieve the Salt Lake City project, he and a coterie of students

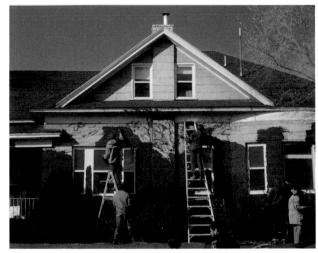

114
Gianni Pettena, *Clay House*, 1972. Inhabited house covered in hand-spread clay. Salt Lake City, Utah

covered the exterior of a private residence with a layer of wet clay, which quickly hardened into an epidermis of dry adobe under the summer sun (pl. 114). For the Minnesota interventions, entitled *Ice One* and *Ice Two*, Pettena again marshalled students to help him hose down two buildings from access positions at roof level in the middle of winter. The resulting deluge enveloped both structures under ominous skins of frozen water. While not exactly ecological in substance, Pettena's clay and ice projects offered a sardonic view of the Industrial Age's naive conceits related to the conquest of nature and environmental destruction as qualifications for progress.

Robert Smithson's *Partially Buried Wood Shed* at Kent State University, Ohio, a seminal interventionist project of 1970, attained subsequent social significance as a trenchant memorial to the four students killed on campus by National Guard soldiers during the anti-Vietnam War protests in spring of that same year. Starting with an existing wooden structure on campus, Smithson used bulldozers to dump several tons of earth on the roof, crushing the building's internal support and partially enveloping it in a mound of mud. These collapsed sections, plus the burial ceremony itself, offered a dual metaphor for the mounting political strains within American society and the majority of citizens' growing despair over the obscenities of a preemptive, costly war in Asia.

Burial and excavation became increasingly explored themes in Arch-Art for the remainder of the decade. Alice Aycock – an artist associated with Matta-Clark's 112 Greene Street enclave – created her 1973 troglodyte project entitled *Low Building With Dirt Roof* near New Kingston, Pennsylvania as an exploration of 'psycho-physical space, housing people and events that didn't exist'. From Aycock's perspective, this underground experience offered a hypothetical shelter where inhabitants could search for their own identities – in some ways reflecting Carl Jung's references to architectural space as a premise for analyzing people's psychic state. Her choice of imagery was a low, shed-like building that could have qualified as the archaeological remains of some Iron Age agrarian society. In theory, she proposed that if architecture doesn't encourage people to act out personal and subliminal scripts, it fails to provide one of its most important levels of function.

Vito Acconci's *SUB-URB* in Lewiston Artpark, New York of 1983 was another subterranean project – a 27m × 2m (90ft × 7ft) wide linear corridor, with a pitched roof at the bottom level and an interior painted to resemble two American flags (pl. 115). This complex was sheltered by sliding panels of Astroturf and engraved with letters spelling out words like 'bum', 'slut', 'scum' and 'mud'. When aligned in a closed position, these roof sections repeatedly formed the title of 'Sub-urb'. Visitors were required to sit in modular rooms decorated with silhouettes of rats, squirrels, rabbits, deer and other wild animals, as well as graphic commentary on American suburban lifestyle choices. Whereas postmodern architects like Robert A.M. Stern, Charles Moore, Michael Graves and others tended to endorse the iconic and lifestyle elements of the American home, Acconci used his interior spaces to question issues of patriotism, regionalism, consumerism, family values and alienation from nature.

Among the various innovators in Arch-Art of the 1970s, a nascent architectural group in New York called SITE (Sculpture

in the Environment) was among the few firms to engage actual functioning buildings as sources of environmental critique. SITE's work became the focus of considerable controversy in the art and design worlds with the construction of a series of nine showrooms for the BEST Products Company of Richmond, Virginia, a retail merchandiser of hard goods in the United States. From 1972 to 1984, these architectural concepts treated the standard 'big box' prototype – situated in suburban shopping centres surrounded by extensive parking lots – as the subject matter for an art statement. These structures were based on the observation that public art at that time was usually separated from architecture and most commonly installed as a self-contained entity in a plaza, or applied to a building as an after-thought decoration. SITE developed a more 'situational' approach, interpreting public art *as* the environment, rather than an object sitting *in* the environment. Described another way, SITE's view proposed that wall surfaces, interiors and the spaces surrounding buildings reflected certain ambient information, drawn from outside the familiar design world lexicon. This led to the treatment of architecture as 'idea, attitude and context', as differentiated from a composition of 'form, space and structure'. In the case of the BEST showroom series, each edifice was based on the assumption that people have a subliminal acceptance of certain archetypal buildings in their daily lives – suburban homes, office towers, civic centres and, especially, big box stores – so this reflex identification could be used to challenge routine expectations. One of the key motivations behind the BEST stores was the placement of art in situations where people

would least expect to find it. Consistent with certain aspects of conceptual art, SITE's work of this period became less of an exercise in sculptural shape-making and much more of a dialogue in the mind. For example, the *Indeterminate Façade Building* in Houston, Texas of 1974 and the *Tilt Building* in Towson, Maryland of 1976–8 were conceived with the idea of transforming the most familiar design/function/material/construction elements of architecture into an ambiguous commentary on the proper roles of these rhetorically accepted ingredients (pl. 116).

SITE's inversions of architecture – starting with the *Peeling Building* in Richmond, Virginia and ending with the *Inside/Outside Building* in Milwaukee, Wisconsin – provoked an unusually vociferous volume of indignation in the American design world, while simultaneously meriting applause in Europe and Asia (pls 117 and 118). A 1975 feature in *Architectural Record* and a 1979 exhibition at New York's Museum of Modern Art provoked floods of outraged letters to the press, condemning the BEST buildings as 'atrocities and abominations, affronts to human dignity, insults to architectural innovation, evidence of sheer lunacy and tailor made to incite the anarchistic tendencies in our society'.[4] Fortunately, this negative press didn't seem to curtail SITE's progress and, in fact, the rabid negativity expressed by some mainstream camps only seemed to stimulate more vociferous enthusiasm from supporters.

Looking back on the contributions of the postmodern era in architecture, it is understandable why the marginal (and now mostly extinct) legacy of Arch-Art has never received sufficient

116
James Wines (for SITE),
Indeterminate Façade Building,
showroom for BEST products,
1975. Houston, Texas

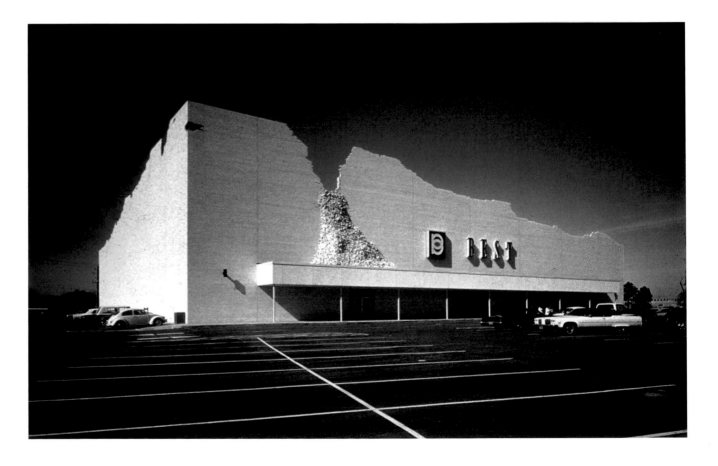

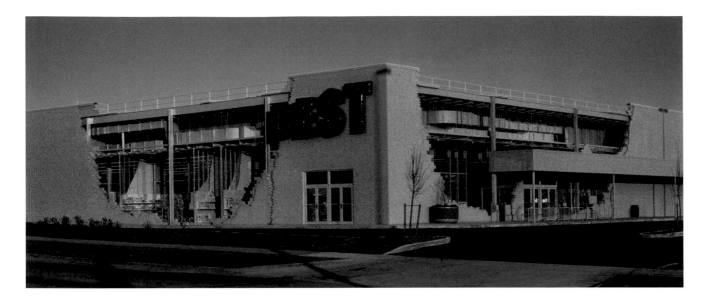

117
James Wines (for SITE), *Inside/ Outside Building*, showroom for BEST products, 1984. Milwaukee, Wisconsin

scholarly and curatorial credit. Mainstream postmodernism's celebration of surface values was more adaptable to strip mall kitsch, corporate tower branding and chain restaurant faux-regionalism. Recently, however, the sociological and environmental messages of the Arch-Art movement have been enjoying a widespread re-evaluation in the light of twenty-first-century political upheavals and the global attention being focused on urban planning and ecological responsibility. In terms of timing and relevance, the Victoria and Albert Museum exhibition has provided a unique window of opportunity to assess the positive and negative influences of postmodernism and credit fully the collective arts' contributions to current post-industrial thinking. The most affirmative aspects of this inheritance have been architecture's acknowledgement of its role in absorbing and communicating contextual values in the public domain and the profession's (belated) realization that designers have a crucial role in green and sustainability initiatives. On the down side, a good deal of the quest for iconic significance has been squandered on ornamental surfaces and various choices of imagery that failed to tap into people's 'collective unconscious' or resonate with a broader society. Also, on the deficit side, Arch-Art and Radical Architecture proponents have spent too much energy churning out idealistic manifestos, visionary drawings and temporary interventions, where the key messages have been lost to audience apathy and physical eradication.

In today's global economic crisis – including the inevitable end of several decades of architecture's profligate consumption of resources for the sake of visual pyrotechnics – the most enduring legacy of Arch-Art will be its message of resourcefulness and economy of means. Now that building design is increasingly forced to accept environmental accountability in the new millennium, this notion of a

reductive aesthetic sensibility has acquired greater relevance. It calls for a special quality of innovation where the condition of frugality itself becomes the basic inspirational source for art. The works of Matta-Clark, Smithson, Aycock, Acconci, Pettena and SITE – formerly treated as marginal in the postmodernist architecture movement – have provided some valuable guidelines for revised priorities. While many Arch-Artists' projects have met the fate of elimination by enforced removal, acts of nature, or subsequent development, their interventionist sensibility is ideally applicable to the adaptive re-use of existing buildings and preservation initiatives in general. Both objectives are of paramount importance in architecture's mandatory quest for energy conservation and sustainability.

Philosopher Fredric Jameson viewed postmodernism as the 'dominant cultural logic of late capitalism', citing the supremacy of consumerism and globalization as prime motivations of post-Second World War international commerce. As manifested in the proliferation of costly, wasteful and visually flamboyant postmodernist and neo-Constructivist architecture over the last three decades (which, ironically, became the most critically acclaimed examples), Jameson's observation has been borne out in fact. Voicing a contrary position in the face of these omnivorous tendencies during the early 1970s, French art critic Pierre Restany proposed that 'Art will no longer aspire to account for everything. It will have left forever the ambiguous sphere of transcendency for the scattered, humble, everyday universe of the relative.'[5] Prophetically, in the earliest days of postmodernism, Arch-Art explored this poverty of means and methods, plus the importance of psychology of situation as a source of communication for the public domain. Belatedly, these ideas have become leading forces of change for the future.

Opposite: 118
James Wines (for SITE), *Peeling Building*, showroom for BEST products, 1971. Richmond, Virginia

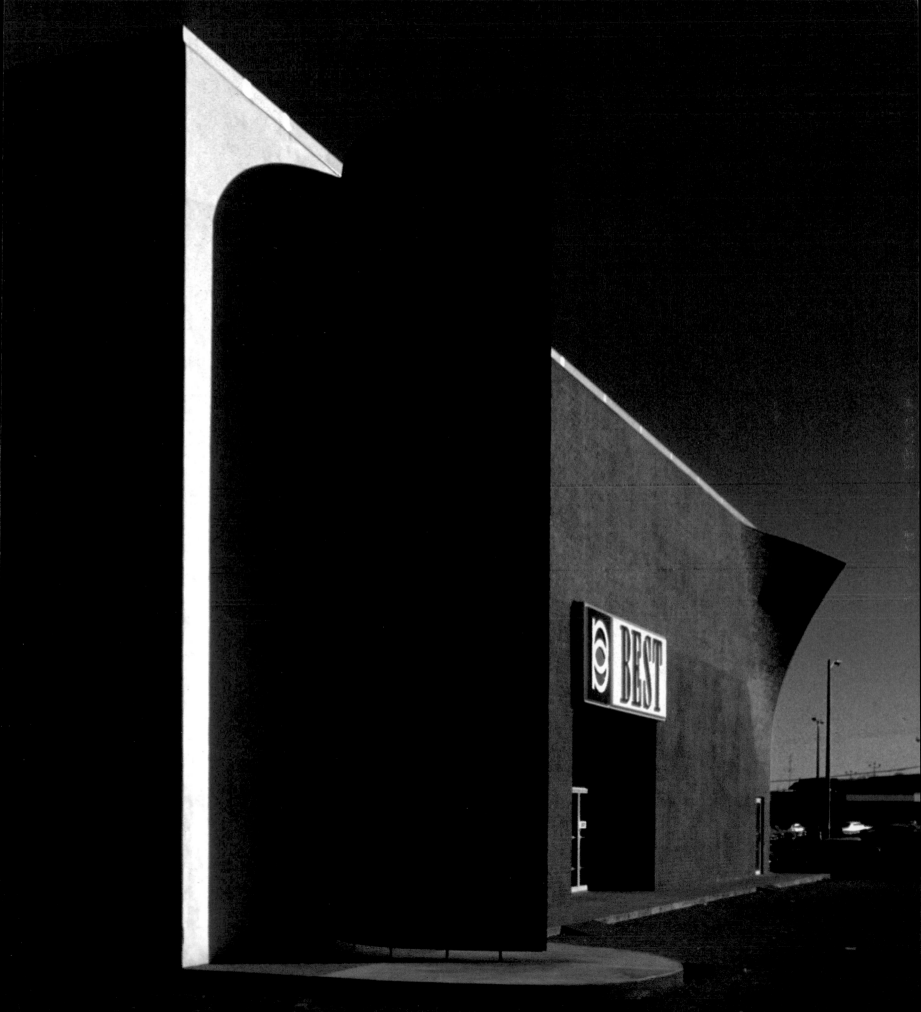

Denise Scott Brown

OUR POSTMODERNISM

When was postmodern architecture born? The exhibition *Architecture after Las Vegas* (Yale, 2010) flagged the day in 1968 when Steve Izenour and I flew west with 13 Yale students to research our Learning from Las Vegas studio project (pl. 12, pp. 20–1).[1] But Robert Venturi and I set the origins of our postmodernist thinking in the 1940s. For us it evolved via study, travel and work on three continents in the 1950s and began to coalesce at the University of Pennsylvania in 1958.

Some ideas lay outside architecture. Our interest in Pop Art and popular culture derived from experiences in Africa and England and was furthered by studies of the everyday landscape in America. Pop was exhilarating. It took us to automobile cities of the American Southwest and led, via their iconography, to what could be considered our major contribution – not a plastering of neon everywhere but a reappraisal of the role of communication and symbolism in an architecture of community, and a joyful understanding of the 'messy vitality' of cities.[2]

My studies at Penn's planning school led to the same fun destination, and I did indeed find in its many disciplines 'a liberating, creative and subversive force'.[3] But urban planning, like our Postmodernism (PM), was also deeply serious. Its social concepts originated with philosophers and thinkers during the Depression and the Second World War, and developed in response to the Civil Rights struggles of the late 1950s and 60s. Further ideas came from theologians who believed there could be no innocence after the Holocaust and challenged us to consider whether visions for a new world

could be propounded in good faith in our time. Loss of innocence was a PM theme that led artists to irony and self-deprecation and architects to test their romance with industrial technology against Second World War death factories and Vietnam napalm.

Primary concerns of the 1960s were social problems, civil rights and Vietnam. As riots erupted on city streets, visions of protest flourished, and the emerging discipline of social planning took up slogans such as 'I have a dream' and the maligned 'political correctness'. But activist planners rejected architects' visions of social change via building as naive and coercive. They stressed instead ideals of equality and wealth distribution, and issues of diversity, values, tastes and popular culture. These became important dimensions of our Postmodernism. So did the destruction of European and American cities, whether by bombs or 'urban renewal'. This damage, and the complicity of the profession in socially inappropriate rebuilding projects, caused a younger generation of architects to turn to theories of evolution rather than revolution and a reconsideration of history.

We drew as well on the English architectural rebels Alison and Peter Smithson, who rejected the post-war new towns and studied street life in London's East End. And on the sociologist Herbert Gans, who moved to Levittown in 1958 to watch its development as a participant observer. Their shifts to the inner city and lower-middle-class suburbia had in common a desire, which we shared, to understand life as led by members of various social groups, to be open to the values of people

119
Venturi, Scott Brown and Associates, Inc., Guild House, 1964. Philadelphia, Pennsylvania

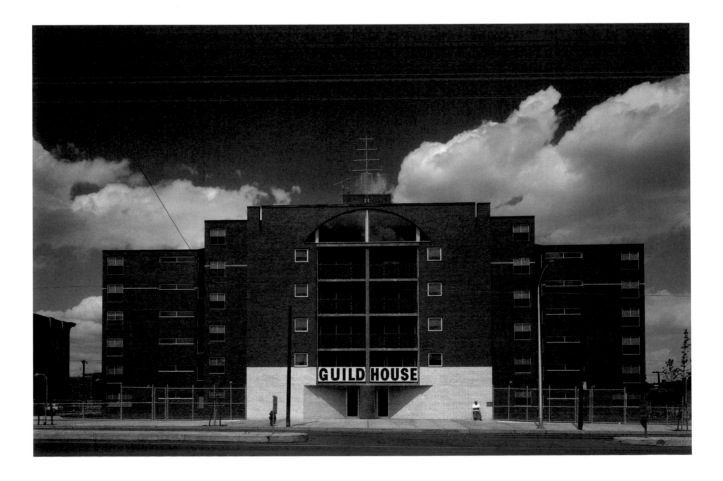

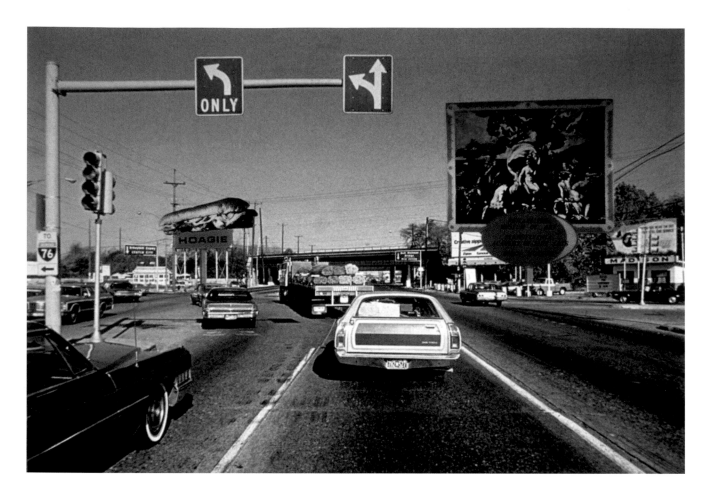

**Venturi, Scott Brown and
Associates, Inc**, Franklin
Court, 1972–6. Philadelphia.
Photograph by Mark Cohn

123
**Venturi, Scott Brown and
Associates, Inc**, The Sainsbury
Wing, 1985–91. National
Gallery, London. Photograph
by Timothy Soar

different from themselves, and to investigate popular culture, everyday architecture and emerging types of urbanism.

In 1968, while working as architects on quite small buildings, we were also advocate planners for Philadelphia's South Street and researchers on the Las Vegas Strip. These projects were subtended by an intellectual terrain that stretched from theology to comic strips, and encompassed the social sciences, history, art, ecology – even architecture. Traversing these thought ways was deadly serious and grand fun, and – helped by regional science, an economics discipline, and mannerism, a philosophy of breaking rules – we endeavoured to translate such ideas onto the ground.

The Qualities of PM

In the late 1960s Bob and I played a game: 'I can like something worse than you can like'. My friends at the Architectural Association had called their hate-love objects 'gothic', meaning 'they're bad, or good, or so bad they're good'. We said ours had *terribilità*, or were impure, or mannerist, or transitional. Glenn Adamson describes PM design wares as 'undecidable things', difficult to assess because they are 'at once avant-garde and kitsch, handmade and artificial, funny and hostile, completely embedded in the manipulative sphere of consumption, but also alien and disruptive'.[4] These pronouncements describe a stance of the 1960s: suspend judgement to make subsequent judgement more sensitive. We applied it to an archetype of roadside commerce, the Las Vegas Strip. This became our best worst thing, our supreme 'found object' through which, says Adamson, we 'brought new depths to the question of flatness'. And he adds that the paradox applies as well to the 'cartoon cut-outs and cheap pattern' of our furniture. But none of this is just for fun. Although we feel flat is good, that Ugly and Ordinary is usually the way to go, and that the Decorated Shed is a paradigm for much (but not all) building in our time – yet high aims must go with the high jinx. We use our 'worst things' not only to open our eyes and refine our judgement, but also to keep our purposes honest, control costs, maintain protective scepticism, avoid the dangers of false innocence and deflate hubris (our own).

In the end, we are functionalists in the Neue Sachlichkeit tradition. For aesthetic as well as moral reasons, we follow Peter Smithson's 'new objectivity', believing with the early Moderns that a hard-minded search for form in function can hold the key to a new sensibility for new times – even if it leads, for our unaccustomed eyes, to seemingly ugly architecture (pl. 119). Le Corbusier found industrial buildings beautiful and berated 'eyes which do not see'. Louis Kahn said of an ugly but functional solution, 'you hate it and you hate it and you hate it until you love it, because it's the way it's got to be'. But although we consider functionalism a glory of Modern architecture, we criticize architects' naivety in handling it. Today we must extend our functionalism to include the pulsating contexts of our projects, and the forces of nature and society within which we design (pl. 123). Our processes of conception must go beyond those of architecture and design, into the city, where the objects we may swipe are Rome, Las Vegas, Lagos, Tokyo and Shanghai; David Crane's 'City of a

Thousand Designers', where the producers, mass and artisanal, whom we work alongside may be found. We must consider these potential mashers of our vision intently and objectively, and learn, like action painters, to roll with their punches and draw beauty from their tough mandates – because, most of the time, we can't tell them to go away. But of course, it's not that simple.[5]

That was our take on PM. Then along came PoMo.

From PM to PoMo

Our 1976 exhibition *Signs of Life* (Smithsonian Institute, Washington D.C.) was a diatribe on the place of symbolism in cities and suburbs (pl. 124). It was designed to allow viewers to scan headlines and pause at details of interest, yet according to rumour Philip Johnson read it all, especially the City Room. From this, it seems, his PM arose, but his was so different from ours that I called it PoMo.

PoMo was practice-oriented and commercial. A similar focus had produced great architecture in Chicago 75 years earlier; so what made PoMo so specious? For me, one factor was disregard for social concern, which by the 1970s had become branded in some circles as 'an old hang-up of the 1960s'. To my cry 'There must be a way to be socially concerned in the 1970s', PoMo architects replied, 'Your own social planning friends say there's little we architects can do to help social problems, so why try?' Did PoMo architects wilfully misread the planners' critique of their favourite remedy for political and social problems, summed up by the nostrum 'build a building'? I don't know, but the effect of the PoMo response was to license indulgence.

Yet indulgence, though it may outrage our sense of the appropriate, has produced aesthetically good architecture in the past, so why not here? In my opinion, PoMo's aesthetic faults lie in the realms of cultural preparation, architectural knowledge and design ability. For example, while we were studying varieties and juxtapositions of scales in cities, Johnson, a modern recidivist, continued to handle the scale of his history-draped buildings according to modernist precepts of 'human scale'. Bland sameness of scale resulted and, in situations of mass use, too 'human' a scale brought inhuman conditions.

PoMo architects handled history self-indulgently, often humourlessly, and by imitation rather than allusion (for us, PoMo decoration wasn't flat *enough*). Their borrowings paid insufficient attention to cultural relevance, their philosophies took too narrow a view of context, and their architecture, even when mannerist in style, showed little feeling for mannerist adjustment to impinging and/or conflicting realities.

'I am not a postmodernist and have never been a postmodernist'

PoMo caused Bob to deny he was a postmodernist. And if this was what PM had become, he was right. However, many architects tarred us with PoMo's brush, declaring we lacked social conscience and were involved in only the superficial. Galled by PoMo excesses and confused, perhaps, by a fashion shift to NeoMo (that's PoMo using modern not renaissance

referents), these architects saw us as both neon-obsessed and old fogeys. Some faults in their reasoning ('Who could be non-judgmental if Alabama decided to go for desegregation?') brought into question the basic education of architects.[6]

By describing here the origins of our thought, I am attempting to set the record straight. We are postmodernists, but in a sense derived from the arts, humanities and social sciences of the 1960s and before. The conditions we responded to – called 'postmodern' in many fields – continue to influence us today. We are also modernists, engaged in the traditional modern project of updating modern tenets to allow for change – a task undertaken in the 1930s, 1950s, 1960s and today.

The ideas set out here contradict statements we have made since the 1970s, disassociating ourselves from PM. And they diverge from Bob's outcry (this was Bob crying as he laughed), which paralleled the tragic HUAC-enforced denials of Cold War America.[7] We changed because, in contemplating our experience, we realised that the critical and substantive PM that formed us need not be conflated with PoMo.

Earlier generations who confused the two had us so wrong that we gave up trying to explain. When I told them that *Learning from Las Vegas* was in part a social tract, they said 'You've got to be kidding!' But students and young architects today reply 'What else is new?' We hope they will carry the (neon?) torch of serious high jinx into social and technical situations that we are too old to grasp, and in so doing serve need and achieve (a possibly agonized) beauty.

124
Robert Venturi and Denise Scott Brown, *Signs of Life* exhibition, held at the Renwick Gallery (Smithsonian American Art Gallery), Washington, DC, 1974–6

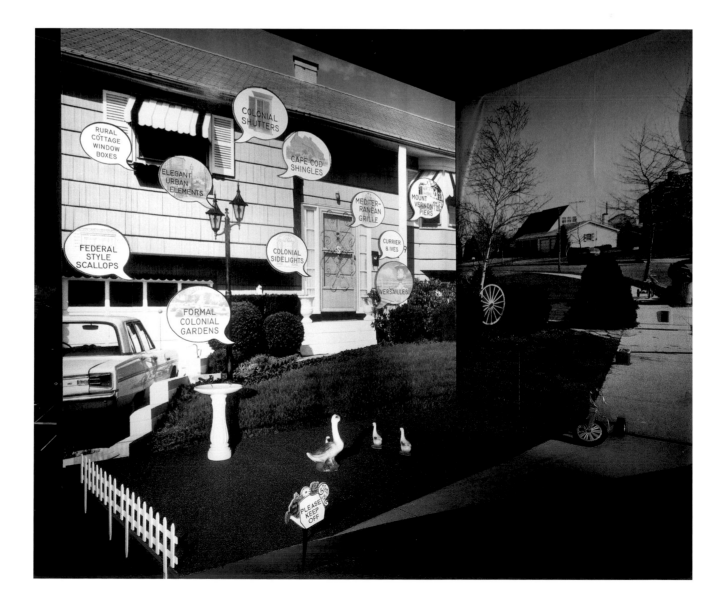

Victor Buchli

ON BRICOLAGE

Anthropology as a discipline probably has much to answer for in the development of postmodern thought. This is particularly true in relation to the practice known as bricolage, and the qualities of fragmentation, quotation, parody and pastiche associated with it. The postmodern use of citation, the amalgamation of different references in the creation of a postmodern ethic and aesthetic, owes a significant intellectual debt to the anthropologist Claude Lévi-Strauss, whose concept of bricolage he developed most fully in his work *The Savage Mind* (*Pensée Sauvage*), first published in French in 1962 at the height of what we would call Modernism. While Lévi-Strauss could never have anticipated the wider significance his concept would assume, it represents, in his writing, a certain timeless universality. It occurs at various times and in various places but attained a particular significance for postmodernism.

The bricoleur is a 'jack of all trades' who, with cunning and resource, ransacks the 'ready-at-hand' to create something new. Inherently anti-modern, the bricoleur accepts the world as it is and reconfigures it, rather than anticipating a new world and inventing it. In this respect the bricoleur has a different concept of time compared to the modernist: one that is retrospective, based on the continuous reworking of the received elements of the world, as opposed to prospective and filled with imagined new conditions and possibilities. Lévi-Strauss's notion of bricolage as the manipulation of the at-hand derives from his theories regarding mythic thought, the characteristic feature of which is that 'it expresses itself by means of a heterogeneous repertoire ... whatever the task in hand because [it] has nothing else at its disposal.'[1] Lévi-Strauss's definition of the bricoleur distinctly emphasizes the maker, and particularly the impoverished one. Bricolage is

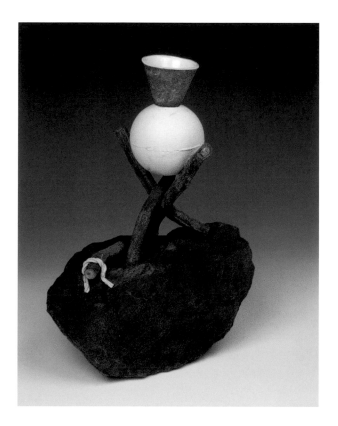

125
Richard Shaw, *Cup on a Rock*, 1972. Glazed porcelain. V&A: C.41–2011. Photograph courtesy of Braunstein/Quay Gallery, San Francisco, California

about manipulating the world as it is received in its finitude to create infinitely diverse configurations (pl. 125). The bricoleur is thus primarily concerned with some sort of inventive displacement, rather than inventive novelty. This is why Lévi-Strauss emphasizes the distinction between the bricoleur and the engineer: 'It might be said that the engineer questions the universe, while the "bricoleur" addresses himself to collection of oddments left over from human ndeavours ... The engineer is always trying to make his way out and go beyond constraints imposed by a particular state of civilization while the "bricoleur" by inclination or necessity always remains within them.'[2]

This concern with the at-handedness of the world led Lévi-Strauss to pay particular attention to the world's empirical qualities, particularly its materiality:

> A particular cube of oak could be a wedge to make up for the inadequate length of a plank of pine or it could be a pedestal – which would allow the grain and polish of the old wood to show to advantage. In one case it will serve as extension, in the other as material. But the possibilities always remain limited by the particular history of each piece and by those of its features which are already determined by the use for which it was originally intended or the modifications it has undergone for other purposes.[3]

The materials at-hand in the world thus may be deployed in all manner of guises not true to any a priori function or materiality. They are used in relation to certain pre-existing things and their 'secondary qualities', which are separated out and then joined together in ways that might seem contradictory, particularly from the perspective of modernist rationality.[4] Such displacements also address the detritus of the given world which, contrary to rationalities that would insist on such matter as waste, is treated as a 'resource' to be reworked through cunning juxtaposition. This is the 'composting' action described by another anthropologist, Mary Douglas.[5]

Of particular importance is the question of scale within the practice of bricolage, which similarly exploits secondary qualities. Miniaturization, for example, can be used to 'compensate for the renunciation of sensible dimensions by the acquisition of intelligible dimension'.[6] Lévi-Strauss discusses two 'miniatures': Michelangelo's Sistine Chapel and the lacework in Clouet's *Portrait of Ann of Austria*. Both use scale in various ways to produce intelligibility – the unrepresentable grandeur of 'creation' is reworked into a decorative ceiling scheme, and the materiality of lace finely rendered in minute detail on a panel painting. We can see postmodernism as using scale in the opposite direction to these historical precedents. Kitsch is often understood as the domestication of the grandiose: indexing something incommensurable through miniaturization. However, the bombast of postmodern output, such as Michael Graves' Portland Building (Oregon) (see pl. 208, p. 230), Claes Oldenburg's sculptures and the Chippendale roof line of Philip Johnson's AT&T Building (New York City) (see pl. 83, p. 73) works with scale in the

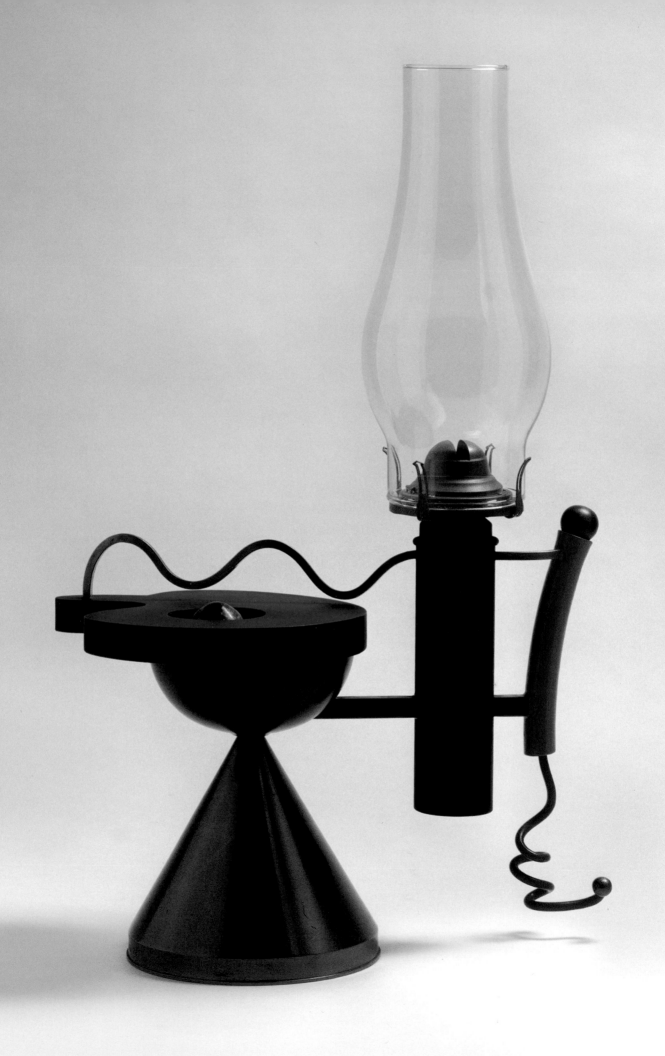

Opposite: 126
Garry Knox Bennett,
Unbelievably Modern Lamp (oil),
1978. Brass funnel, paint,
glass eye, copper and gold plate.
V&A: M.214–2011.
Photograph courtesy of the artist

opposite direction, facilitating intelligibility from the mundane upwards to create a distinctly radical set of relations.

The productive capacity of scale is further attested in Lévi-Strauss's discussion of a Tlingit club, which sits in front of him on his bookshelf as he writes about bricolage. This he deploys literally as an element at-hand – as any good bricoleur would – with which to address the task before him as he writes. To be at-hand literally requires that things are available to manipulate, and thereby enable a transformation. We know nothing about the circumstances of the history of this particular Tlingit club. But the political, economic and infrastructural pathways that would have enabled it to arrive on Lévi-Strauss's shelves, rendering it at-hand for the bricoleur-anthropologist's manipulation, are deeply implicated in the casual at-handedness of the elements of the bricoleur's work. Yet these unacknowledged circumstances are by no means casual. A specific technology, or a set of technologies (portable artefacts transported by ship or land), and a specific political economy (colonial and post-colonial global capitalism) are directly implicated in the object's presence in front of Lévi-Strauss. New forms of knowledge are made possible through the secondary qualities and effects (such as portability) of this encounter. Bricolage not only represents these processes; it also reproduces them.

But as Lévi-Strauss points out, the bricoleur assembles bits of an existing world into another imaginable one. One world must be disabled so that another can be configured. The result is radically dissimilar, even if the constituent elements of the effect remain largely undisturbed. Lévi-Strauss is keenly aware of the role of technique: the way a given technology employed by the bricoleur creates meaning, and by extension the political and economic circumstances that enable a given technology. Bricoleurs are avowedly non-utopian in the sense that they do not imagine a new language or set of material circumstances that would remake the world.

It is no accident that postmodernism should have emerged in the wake of the collective disillusionment with progressive movements such as communism, following the Prague Spring of 1968. Any hopes still held by the European left for the project of Soviet socialism were brutally dashed. What some might call a nihilistic impulse, which postmodern design groups such as Studio Alchymia embodied, can be understood more as an acknowledgement that the utopian promise of Western rationality was doomed. All that could be done was to work with the ready-at-hand, the structures of capitalist industry and consumerism within which postmodern output emerged. But this was not progressive in the modernist sense; bricolage merely rearranged what was already there, suggesting an alternative imaginary world, at once out of history and archaic, a world that does not exist and could never exist (pl. 126).

Fredric Jameson, in his famous discussion of the Bonaventure Hotel in Los Angeles, railed against the incapacity of the human senses to come to terms with the disorienting effects of postmodernism's affront to rationalism. Yet even within the idiom of late capitalism, postmodernism insists on a critical distance, an awkward dis-ease, which the AT&T Building's profile on the Manhattan skyline still inspires today. It is neither utopian nor dystopian (since it was never intended to trump progress). It was precisely because postmodernism was instantly atavistic, inauthentic and out of time that it continues to be a resource, something easily displaced, and hence readily available amongst the bricoleur's 'treasury' of 'heterogeneous objects'.[7] Postmodern objects are still there to be reworked, and used again to reconfigure the world as it is.

Patricia A. Morton

KITSCH AND POSTMODERN ARCHITECTURE: CHARLES MOORE'S PIAZZA D'ITALIA

Charles Moore's Piazza d'Italia in New Orleans, Louisiana has become an unlikely monument (pl. 127). An object of bitter controversy from its inception in 1976, neglected for decades to the point that it fell into a state of ruin, it was restored in 2004, spared by Hurricane Katrina, and persists today as an icon of postmodern kitsch. The Piazza generated a torrent of criticism when it opened, making it a litmus test for the reception of postmodern architecture.[1] Its defenders, notably Charles Jencks, championed its architectural whimsy and visual puns, its plurality of meaning and use of architectural languages legible to diverse audiences. The architecture critic Martin Filler called the Piazza a 'masterpiece' and lauded it for evoking the pleasure and delight of the Italian *gioia de vita*.[2] Other critics dismissed it as a calculated stage set or a capricious architectural joke. Modernists reviled the Piazza d'Italia for its revival of classical language, while neo-traditionalists loathed its vulgarization of classicism with honky-tonk neon and flamboyant materials. In a retrospective essay, Moore professed himself surprised at the vehemence of the initial reaction, but pleased that the Piazza had proved to be a flexible enough public space to accommodate a cohort of homeless inhabitants, a 'welcome confirmation that this public space is not just flexible, but special'.[3]

The original site plan by Moore's Urban Innovations Group and New Orleans-based partner firm Perez Associates encompassed St Joseph's Fountain, a monument to the local Italian community, and a set of surrounding buildings that occupied a redevelopment block in New Orleans' Central Business District (pl. 127). Sited beneath a generic 1960s tower block, the former Lykes Building (1968), the Piazza was planned as a hidden courtyard glimpsed through a neon-trimmed campanile and classical temple pergola on Poydras Street, the Lafayette Archway, and narrow openings between commercial buildings that were never developed. Of the original scheme, only St Joseph's Fountain was constructed. Today the Piazza sits forlornly amid parking lots, lacking the adjacent buildings that would have made it a figural space and ameliorated its stage-set quality. Themed on Italian geography and culture in honour of its clients, the space consists of concentric rings of pale granite and dark slate paving, partial colonnades in six classical orders (Doric, Ionic, Corinthian, Tuscan, Composite and Moore's own Deli Order), a 24m (80ft) map of Italy with Sicily at its centre, and three rivers (the Arno, Po and Tiber) flowing into pools representing the Tyrrhenian and Adriatic Seas. Water, one of Moore's obsessions, features throughout the Fountain and forms the columns and the 'wetopes' on the Tuscan order, the acanthus leaves of the Corinthian capitals, and the egg-and-dart moulding of the Ionic order. Double cartouches of Moore's smiling face spout water from the Tuscan colonnade, a reference to Lorenzo Ghiberti's self-portrait on the Baptistery doors in Florence. Constructed of slate, marble, cobblestones, mirrored tiles, brightly coloured stucco, stainless steel and neon, the Piazza contravenes standards of architectural decorum and taste, and flaunts its glib silliness, tawdry materials and excessive, whimsical connotations.

Moore and his collaborators parodied the classical vocabulary rather than reviving historical forms literally, in keeping with Linda Hutcheon's notion of postmodern parody as 'repetition with critical distance that allows ironic signaling of

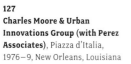

127
Charles Moore & Urban Innovations Group (with Perez Associates), Piazza d'Italia, 1976–9, New Orleans, Louisiana

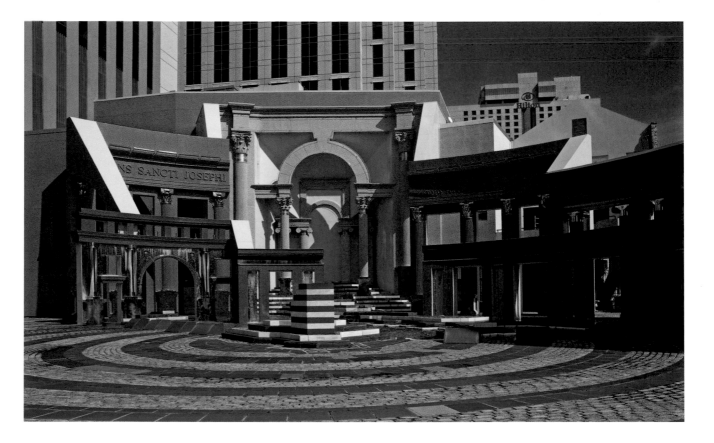

difference at the very heart of similarity'.[4] For the tall columns flanking the central arch, meant to lead to a restaurant, he invented the Deli Order with 'neon necklaces … [which] further indicate that this is the twentieth century and that commercial bad taste is part of it', as Jencks quipped.[5] The Piazza d'Italia deliberately integrated kitsch with esoteric architectural allusion, in what Moore called a 'loose fit' of familiar and surprising images (pls 128 and 129). In a 1974 interview, Moore summed up his method as a putting together of the cheap and familiar, 'in ways that have never been before, so as to get something that's strange and revolutionary and mind-boggling and often uncomfortable, but only using the ordinary pieces'.[6] He compared his work to the 'semipop' music of Dave Brubeck, who took familiar themes, altered them, but ensured that they were still recognizable: 'You notice them for the first time, because something, maybe something awful, is happening to them, they're being kicked around in a way you didn't expect.'[7] This strategy, derived from the avant-garde practice of defamiliarization, resulted in an oscillation between an accessible, inclusive architecture and simple bad taste, between the banal and the extraordinary. Moore embraced the ephemerality and superficiality of pop, espousing ornament that was cosmetic, cheap and easily changed.[8] Not everyone valued these qualities. Filler reported that New Orleans residents felt the neon at the Piazza d'Italia 'speaks of sleazy barrooms and cheap hotels', thereby highlighting the difficulty of using pop images outside an authentically vernacular context.[9]

The polarized reception of the Piazza d'Italia echoed postwar controversies over popular taste, typified by Gillo Dorfles' 1969 anthology, *Kitsch: The World of Bad Taste*. Dorfles republished canonical interwar texts on kitsch – including an excerpt from Clement Greenberg's 'Avant-Garde and Kitsch' (1939) – and a set of new essays giving a panoramic view of kitsch in relation to religion, architecture, film, tourism, advertising and other topics. Greenberg's concept of kitsch

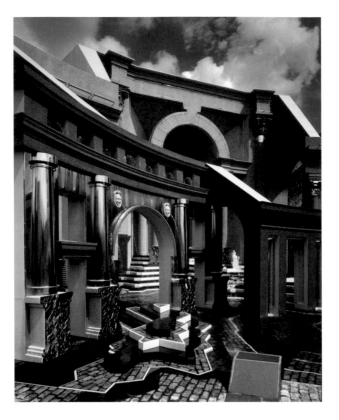

128
Charles Moore & Urban Innovations Group (with Perez Associates), Piazza d'Italia, 1976–9, New Orleans, Louisiana

as a debased product of industrialization antithetical to avant-garde art established the volume's discursive terms. In his schema, kitsch is inauthentic popular culture that repeats both ordinary and high-art elements. It merely imitates the effects of art, evoking artificial sentimentality and vicarious experience by employing 'the debased and academicized simulacra of genuine culture'. Mechanical, formulaic and superficial, kitsch provokes no criticism of society – a fatal flaw that makes it susceptible to manipulation as propaganda.

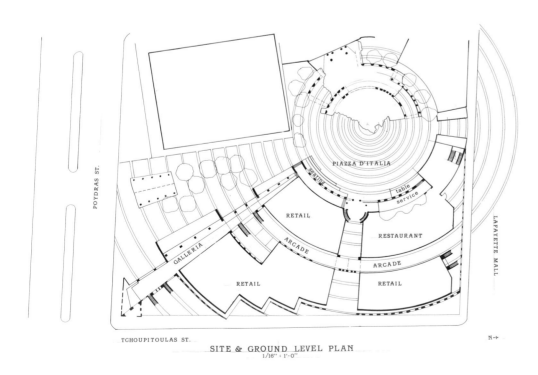

129
Charles Moore, Piazza d'Italia site plan. Artwork by Bari Hahn

SITE & GROUND LEVEL PLAN
1/16" : 1'-0"

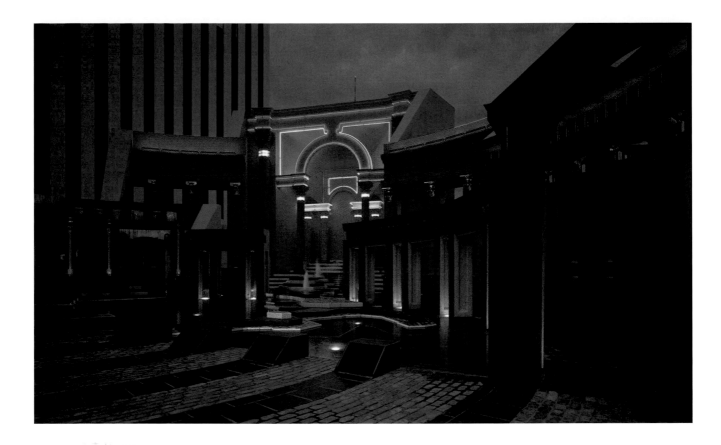

Greenberg asserted that kitsch is popular due to its genuine appeal to rootless urban masses who have lost their taste for folk culture, but demand the diversion that only culture provides. The new ersatz culture is 'destined for those who [are] insensible to the values of genuine culture' and lack the cultural discernment to distinguish kitsch from real art. Kitsch, 'the epitome of all that is spurious in the life of our times', appeals to the snobbery of the masses that consume imitation high culture in imitation of the upper classes.[10]

Following Greenberg, Dorfles located mass reproduction at the centre of the problem of kitsch. For Dorfles, the loss of aura in the replica, famously identified by the cultural theorist Walter Benjamin as a consequence of mechanical reproduction, signals a degeneration into kitsch to the degree that any reproduction of unique artworks is equivalent to forgery. Kitsch art reproduces images or motifs, detached from their original context, to evoke a ready sentimental response. Even the conscious use of kitsch by certain artists (Duchamp, Picasso, De Chirico), in which it is recontextualized as art, can turn into what Dorfles calls 'cultural élite kitsch'. The work reiterates the same superficial emotions and artistic falseness as its referents.[11] At the Piazza d'Italia, Moore endeavoured to execute a similar redemptive operation. In its laissez-faire eclecticism, the Piazza d'Italia simultaneously evokes the Trevi Fountain, Michelangelo's Piazza del Campidoglio, roadside neon signs, the Canopus at Hadrian's Villa, Bernard Maybeck's Palace of Fine Arts, and the Roman Forum (pl. 130). Yet all these ironic allusions could be read as literal quotations, rather than Situationist-style *détourned* fragments: in other words, as elite kitsch.

According to Greenberg, the pre-condition for kitsch is 'the availability close at hand of a fully formed cultural tradition, whose discoveries, acquisitions and perfected self-consciousness kitsch can take advantage of for its own ends'.[12] In his assault on modernist taste, Moore had recourse to just such a repository. In a series of essays published in the architectural journal *Perspecta*, he valorized such kitsch environments as the Madonna Inn (pl. 10, p. 18), whose dining rooms are encrusted with neo-Baroque ornamentation, and Disneyland.[13] In *The Place of Houses* (1974), Moore and his co-authors condemned the tyranny of good taste as a means for enforcing cultural distinction and selling design 'expertise' to those lacking confidence in their own taste. Appealing to popular and elite audiences simultaneously, Moore's Piazza d'Italia embodies the Radical Eclecticism that Jencks identified as necessary for postmodern architecture in a consumer society. This eclecticism, borrowing from the established tradition, made it kitsch, but that in turn was integral to its postmodernism. The Piazza was a self-conscious gambit that parodied architecture, an unembarrassed mix of high and low. Its double-coded borrowings gathered motifs eclectically, fragmenting the cohesion and continuity of high architecture, and re-presented them in a loose fit of witty and parodic allusions that demonstrate the close relation of postmodernism and kitsch.

Emmanuel Petit

IRONY AND POSTMODERN ARCHITECTURE

For his section of the *Strada Novissima* at one of the showpiece exhibitions of postmodern architecture, the Venice Biennale in 1980 (see Léa-Catherine Szacka's essay in this volume, pp. 132–5), Oswald Mathias Ungers put up a large, opaque façade panel with a cut-out silhouette of a column (pl. 131). While this 'negative' image was a sign of, and reference to, the tectonic supports of the exhibition hall of the Arsenale and one of the central elements of classical architecture, it also quite literally reversed the figural relationship between solid and void. With some backing from René Magritte, Ungers suspended the divide between physical and conceptual reality; the semantic space of the column itself could now (literally and metaphorically) be 'inhabited'. The installation was entitled *Ceci n'est pas une colonne*.

Ungers' project echoes the spatial description of irony, which Søren Kierkegaard – the father of philosophical existentialism – had put forward in his Ph.D. dissertation *Concept of Irony, With Continual Reference to Socrates* in 1841. In it, Kierkegaard described an engraving of Napoleon's tomb as an illustration of the workings of irony:

> Two tall trees shade [Napoleon's] grave. There is nothing else to see in the work, and the unsophisticated observer sees nothing else. Between the two trees there is an empty space; as the eye follows the outline, suddenly Napoleon himself emerges from this nothing, and now it is impossible to have him disappear again.[1]

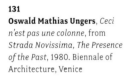

131
Oswald Mathias Ungers, *Ceci n'est pas une colonne*, from *Strada Novissima, The Presence of the Past*, 1980. Biennale of Architecture, Venice

Overleaf: detail of pl. 8, p. 13
Stanley Tigerman, *The Titanic*, 1978. Photomontage on paper. The Art Institute of Chicago, Chicago, Illinois (1984.402)

Together, Napoleon's corpse (this mysterious 'presence of an absence', hidden under the tombstone), and the place where the commander's figure appears as this empty shape, generate a special category of spatiality, which hovers between 'form' and 'meaning' – between the ontologies of 'thingness' and 'textuality'.

The structural analogies between Ungers' and Kierkegaard's spaces point towards a shared interest in a spatial epistemology, which hinges on notions of undecidability and paradox. For Kierkegaard, this space epitomized nothing less than the Socratic foundation of Western thinking, which he cast against the abstract *Systemdenken* of German idealism. Both Ungers' and Kierkegaard's spatial tropes played with the ambiguous state of meaning between presence and absence. Death is this moment of hovering par excellence, where the finitude of form and the infinity of meaning intersect. Maurice Blanchot argued in his *Space of Literature* (1982) that the imaginary image 'is not the same thing at a distance but the thing *as* distance, present in its absence, graspable because ungraspable, appearing as disappeared', and further added that 'the cadaverous presence [of the image] establishes a relation between here and nowhere'.[2]

Attention to this type of epistemology of paradox, or irony, is the most constructive way to theorize postmodernism in architecture. It is not useful to rehearse what has now turned into an historiographic cliché, according to which postmodern architecture is seen as synonymous with a certain type of parochial aesthetics assembled from an uncritical pillage of history – which is, in turn, effortlessly and uncritically assimilated by the market. What might be the case with the more stylistically defined PoMo (largely attributable to the influence of Philip Johnson, on the one hand, and to Charles Jencks' prolific campaigning for postmodernism, on the other) is not simply transferable to all postmodern architecture.

The 1970s and 80s heard the critical voices, which formulated (mainly Marxist) protests against postmodern architects' alleged easy acceptance of consumerism. Hal Foster, Kenneth Frampton, Andreas Huyssen, Fredric Jameson and Manfredo Tafuri are just some of the theorists who identified complacency at the core of architecture during these years. Jameson saw 'pastiche' as one of the key modes of the cultural and artistic production of postmodernism, and defined it as 'the wearing of a linguistic mask, speech in dead language … amputated of the satiric impulse, devoid … of any conviction'.[3] While Jameson's critique stands, his notion of pastiche is mainly preoccupied with the question of cultural superficiality and disillusionment (the 'weightlessness' of cultural signifiers). It ignores the reflective space of irony which, on the contrary, suggests the vitality and depth of endless dialectics. Did not Kierkegaard adopt from G.W.F. Hegel the definition of irony as 'infinite absolute negativity'?[4] The existentialism of architecture was a blind spot in the historiography of postmodernism.

How can one describe the spirited vertigo of meaning so central to architectural postmodernism? Unquestionably, irony has many different faces, and its 'essence' can only be revealed by looking at its radically plural phenomenology. In this short text, I will discuss just one of the self-declared, postmodern ironists – Chicago-based architect Stanley Tigerman. Tigerman was drawn magnetically to the intellectual tradition of

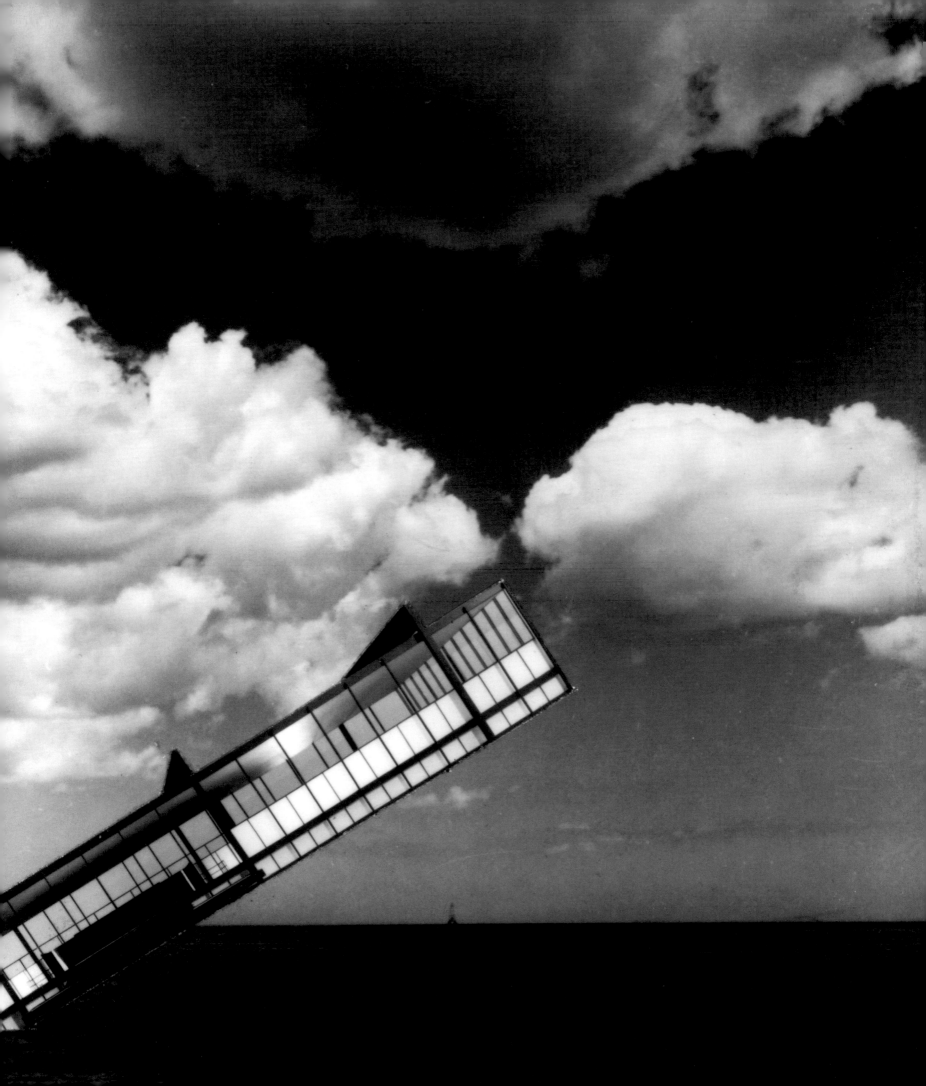

existentialism: from Socrates to Kierkegaard and Nietzsche, from Dostoevsky to Kafka and, finally, Mark C. Taylor's (a-) theological speculations, themselves based on Kierkegaard.[5] Tigerman liked to think of his own position in architecture as analogous to the place Kierkegaard occupied in philosophy. What Kierkegaard was to Hegel, Tigerman thought he could represent in relation to Mies van der Rohe. (Mies had come to Chicago following the close of the Bauhaus, as part of what Tigerman called the 'German invasion'[6] of Chicago Modernism.) Hegel and Mies both attempted to 'systematize' existence through sterile metaphysics, in the service of a universal *welt-* or *zeitgeist*. Kierkegaard and Tigerman, by contrast, insisted on the importance of subjective freedom. They maintained that singular, contingent acts and reflections were not dictated by any universal will, but instead belonged to the free initiative of every discrete human being – the sphere of 'That Individual'.[7]

Tigerman could not simply reject the modernist architecture of his hometown (though he thought it had become stale), seeing that it had been instrumental in forming his own character and career. He was well aware of this conundrum and illustrated it in a 1978 photomontage called *The Titanic*, in which Mies' Crown Hall at the Illinois Institute of Technology campus, Chicago, was shown to sink into the ocean under a cloudy sky (see pl. 8, p. 15; detail previous pages). Tigerman insisted, however, that this psychoanalytically-charged collage lent itself equally well to an opposite reading, in which this icon of Modernism was rising upwards. This simultaneous sinking and ascending was, effectively, a suspension of modernist doctrine, which Tigerman found petrified in its timeless aesthetic. In many of his cartoon drawings on architecture – his 'architoons' – Tigerman illustrated the existential double bind of the architect. On the one hand, he stands atop an architectural column (the past), which breaks underneath his feet; at the same time, he stretches to grasp the umbilical cord of his creative offspring, which takes flight on a cloud (pl. 132). This predicament is encapsulated in his Hermaphrodite Daisy House (1975–8), built in Chicago for an owner of burlesque show venues.

Without a doubt, Tigerman's struggle with Mies' legacy had all the Oedipal dimensions characterized by Harold Bloom as the 'anxiety of influence'.[8] Yet Tigerman found in Mies much more than a modernist precedent from which to swerve. For him, Mies epitomized the 'Hellenic' impulse of all Western architecture – based on the ideology of ideality, perpetuity and, ultimately, 'presence'. Not least because of his Jewish background, Tigerman felt distanced from this Hellenic paradigm: 'It is my contention that ideality and perpetuity – the bookends of architectural aspiration – have no place in the temporal thought contained within the tradition of Judaism.'[9] In his book *Architecture of Exile* (1988, pl. 133), Tigerman located the conceptual origins of the Jewish interpretation of architecture in the negative event of the destruction of Solomon's Temple.[10] The fundamental absence of the Jewish temple lay in stark contrast with the extant presence of the Greek sanctuary, the Parthenon in Athens, so influential for Mies. Unlike the haven of Hellenic culture, the architecture of Solomon's Temple had to be remembered through narration

132
Stanley Tigerman, excerpt from *Stanley Tigerman Architoons*, 1980

133
Stanley Tigerman, *Architecture of Exile* (above) and *Sign, Challenge, Displacement and Exile* (below), from *Architecture of Exile*, 1988

134
Stanley Tigerman, *Double Cube*,
from *Architecture of Exile*, 1988

and interpretation. It was also important that during the temple's destruction the Scripture was removed from its sanctuary. As Tigerman argued, the building and its locus of meaning were irrevocably disconnected from one another. This distance between the thing and the word of architecture was an 'irreparable wound'.[11]

Tigerman visualized a simple but evocative axonometric diagram to depict the space of irony in architecture. The drawing was composed of two disassociated cubes connected by dotted lines (pl. 134). One of the cubes had a continuous (solid and 'present') outline, while the other was represented with dotted lines, denoting a fleeting apparition. This diagram was not supposed to easily revert to, or be 'applied' to, a building (unlike, for example, Robert Venturi's 'decorated shed'). On the contrary, the drawing's double structure suggested the cleft between allegedly original meaning and transformational interpretation. Tigerman was pointing to an other way of conceiving architecture, at a distance from any unified architectural metaphysics. This thematic of distancing and suspension came to constitute the connective motif throughout Tigerman's work – from his writing, to his architectural sketches and cartoons, to his furniture, jewellery and tableware designs, to his projects on an architectural and urban scale.

135
Oswald Mathias Ungers,
*Self Portrait with Magritte
Shadow*, 1988

Tigerman's ideas are paradigmatic of postmodern architecture in the sense that they cast existential ideas of finitude and individuality against abstract and universalizing claims. His projects contain markers of an epistemological self-division. (This was also the reason Ungers 'inscribed' his self-portrait within the empty figure of Magritte, pl. 135.) Often the aesthetic of postmodern architecture appeared so 'artificial' precisely because its architects felt the need to denote the impossible leap between architecture's double ontologies of 'thingness' and 'textuality'. Architecture hovers between those two conditions. The naive utopian belief in an infinitely progressive future, which had driven much in modernist architecture, was replaced with the restrained optimism of Sisyphus. Despite its essential emptiness, architectural form will survive as a framework to receive individual deeds and thoughts. Irony will see to it.

Thomas Weaver

CIVITAS INTERRUPTUS

The architectural academic and historian Robert Maxwell once took a photograph of his wife, the sculptor Celia Scott, as she completed the final stages of a bust of the architect Léon Krier (pl. 136). Despite the fact that in the resulting picture there are two Léon Kriers, one real, the other ideal (a duality that Krier has played out ever since), the true subject of the photograph appears to be the figure in the doorway: the critic Kenneth Frampton, watchfully overseeing proceedings and seemingly ever so slightly suspicious of the whole endeavour. If, as Robert A.M. Stern has suggested, 'postmodern architecture is characterised by contextualism, allusionism and ornamentalism', then this scene and its elision of history and practice, the decorativeness of celebrity and self-anointed 'critical' criticism, could well stake certain claims to the movement, regardless of the fact that all the participants have subsequently vigorously denied their own postmodernity (Krier: 'I never considered myself a postmodernist but Charles [Jencks] keeps telling me that I am whether I like it or not'). Such disavowals seem prompted less by the need for the participants to distance themselves from Jencks and more by an empathy for Marx (Groucho, that is), not wanting to belong to any club that would have them as a member.

However, if one examines the photograph again in detail while combining two methodological tropes of postmodernism – looking to the edge of any given subject rather than to its centre, and following the maxim that real architectural comprehension is framed always by the strands of Krier's famously bouffant hair – then one can see a drawing in the corner of the room that in many ways holds greater claims to postmodernity than any of the figures in the foreground. This is the Nolli map of Rome, a reproduction of an original engraving from 1748 that in the late 1970s and 80s found itself on the walls of architectural offices and studios all over the world, emblem of a professional affinity as if it were an architectural barbershop pole (see pl. 137).

The map's later symbolic association with a movement more conventionally characterized by the silhouettes of buildings shaped like ducks or Chippendale furniture is something that its author would never have been able to predict. Giambattista Nolli (1701–1756) was an Italian architect and surveyor whose *La Pianta Grande di Roma* (*Great Plan of Rome*) was the result of a papal commission to survey the city in order to help create demarcations for the 14 traditional *rioni*, or districts. In architectural terms, what is interesting about the map is less the circumstances of its commission and more the way that Nolli actually went about drawing it. Before Nolli, Renaissance art and architecture defined itself through the representation of three-dimensional space in perspective, but this system, despite its radicalism, was only suited to scenes that could be viewed by a single observer situated at a single point. In order to represent something as complex as a city, which could never be seen in its totality from just one location, a new method had to be developed. Nolli's map is the result of this rethinking. Indebted to other 'ichnographic' (or ground plan) maps produced by Leonardo da Vinci for Imola, in 1502, and more obviously to a figure-ground map of Rome by

136
Celia Scott, Kenneth Frampton and Léon Krier, 1981. Belsize Park, London. Photograph by Robert Maxwell

137
Giambattista Nolli, map of
Rome, 1748. Engraved from
twelve copper plates. Courtesy
of the University of Oregon,
Nolli Map Project

138
Plates from the *Roma Interrotta*
competition, 1978. Rows top
to bottom, from left to right:
Piero Sartogo, Constantino Dardi,
Antoine Grumbach; James Stirling,
Paolo Portoghesi, Romaldo
Giurgola; Robert Venturi, Colin
Rowe, Michael Graves; Robert Krier,
Aldo Rossi, Léon Krier. Various
media. Courtesy of Piero Sartogo

Leonardo Bufalini in 1551, Nolli's own meticulousness (the map took 12 years to complete) and use of surveying tools enabled him to produce a two-dimensional map of unparalleled detail. Delivered to Pope Benedict XIV in 1748 in the form of 12 copperplate engravings, and accompanied by a scaled-down version with illustrations by Piranesi, Nolli's simple graphic reduction of the city to white for streets and public spaces, black for monuments and a hatched grey for the anonymous urban fabric lent it a clarity that, allied to its astonishing accuracy, meant that the map was used as the basis for all government planning in Rome right up until the 1970s.

Despite the fact that Nolli's map proved to be a useful resource, it has ultimately become more enduring for what it symbolizes than for what it actually shows. This symbolism has less to do with the streets of a particular city than it does with the way architecture presented itself from around 1972 onwards. This was the year that Robert Venturi, Steven Izenour and Denise Scott Brown used a Nolli map as a vehicle to conceptually navigate the Strip in *Learning from Las Vegas*, and it was also the period when historians Colin Rowe, Manfredo Tafuri and Christian Norberg-Schulz reaffirmed the value of architecture's classical and fragmentary past, and when architects like Peter Eisenman, Léon Krier and Michael Graves responded to this historicism. What drew all of them to Nolli was the way the map presented space – demarcating as white, and therefore as publicly accessible, not only the open piazzas of the city but also the colonnades and interiors of the churches, presenting Rome as a sequence of civic, yet almost domestic, spaces. Nolli, in this way, was used as a legitimizing force, offering proof to an anxious profession that real, tangible qualities did exist in the thing that modern architects had consistently sought to dismantle – the city. Within the Italianate turn of postmodernism, Nolli also provided a long-delayed riposte to Le Corbusier's provocation, in *Vers une architecture* (1923; translated as *Towards a New Architecture* in 1929), that 'To send architectural students to Rome is to cripple them for life'. Instead, borrowing Bernard Rudofsky's line that 'Italy represents the rear-view mirror of western civilisation', the architects with the Nolli map on their walls saw Rome's charms not as fleeting but as eternal.

Five years after the publication of *Learning from Las Vegas*, and following a series of illuminating encounters with Rowe, the Italian architect Piero Sartogo used an opportunity presented to him by the Incontri Internazionali d'Arte institute in Rome to invite 12 architects to revisit the Nolli map and propose their own urban vision of the city (pl. 138). The resulting show, *Roma Interrotta* (*Rome Interrupted*), opened at the Mercato di Traiano in May 1978 and involved contributions from Sartogo, Rowe, Venturi (pl. 139), Graves, Constantino Dardi, Antoine Grumbach, James Stirling, Paolo Portoghesi, Romaldo Giurgola, Léon and Robert Krier, and Aldo Rossi. Each of the participants was assigned one of Nolli's 12 plates which, taken together, would form the complete map and city. The contention behind the exhibition (and particularly its title) was

that after Nolli something integral to the urban fabric of Rome had been lost. As Rowe pointed out, since very few architectural and planning proposals had been carried out in the city between 1748 and 1870, the show was by definition a critique of the 'urbanistic goings-on' that did manifest themselves in the following century, for which the exhibition offered the chance to correct this 'interruption'.

By requiring each of the architects to develop proposals that considered their allocated area as much as their interconnection to the segments (and architects) that bordered them, *Roma Interrotta* transformed Nolli's plan from a map of Rome to a map of adjacency – of architecture's relationship to itself. What is interesting about the 12 responses, however, counter to the new spirit of pluralism and tolerance that postmodernity was supposed to herald, was just how monumental and myopically insistent the majority of proposals were. Even the critic commissioned by *Architectural Design* to review the show (in a special celebratory issue of the magazine that exists today as the best physical documentation of the exhibition) slammed the whole thing as a 'lavish indulgence devoid of meaning or value'. It was really only Rowe (whose own map combined a historical zeal with footnotes that were entirely fabricated) and Stirling who treated the commission with the requisite combination of seriousness and mischief. Stirling subtitled his proposal 'The MFA (Megalomaniac Frustrated Architect) Solution', and presented himself as inheritor of a tradition established by Boullée, Vanbrugh, Soane, Sant'Elia and Le Corbusier (in other words, the whole of architecture) – that of the architect constantly frustrated by projects designed but not built. His solution was to revise Nolli by incorporating all his unbuilt works, immediately recasting Rome from a city of the sacrosanct to one of the absurd.

Stirling's irreverence and self-deprecation is revealing because ultimately the interruption that *Roma Interotta* really sought to correct concerned not history but the architect, or rather the missing ideal of the architect. Interestingly, it was Nolli himself who established this precedent. Before he completed his map he was known only as a surveyor; afterwards, though, having rendered the city intelligible, he merited a kind of professional benediction that enabled him to be called 'architect'. Almost 250 years later, elevating this model of architectural ascendancy even further, an allegiance to Nolli's map and to *Roma Interrotta* appeared to usher in a kind of successionism that placed a cartel of late-twentieth-century architectural heroes in the font of architecture's greatest triumph. Graves, Rossi, Krier, Venturi et al could now be read alongside Bramante, Raphael, Bernini and Borromini. The legacy of the Nolli map, then, is not about the small scale, or the localized or residual, or architectural form emerging out of the consequences of space rather than the self-standing edifice. It is about the cult of celebrity. As pervasive today as it was in 1978, what the postmodernism of *Roma Interrotta* tells us about Nolli is that only through the genius can you learn to appreciate the loci.

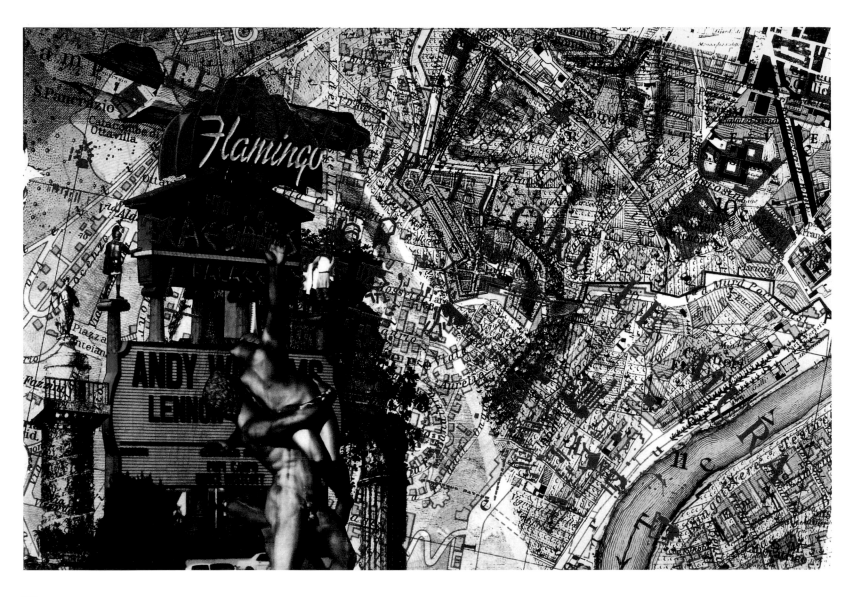

139
Robert Venturi, plate from
the *Roma Interrotta*
Competition, 1978.

Léa-Catherine Szacka

THE PRESENCE OF THE PAST: POSTMODERNISM MEETS IN VENICE

Hans Hollein, façade from
*Strada Novissima, The Presence
of the Past*, 1980. Biennale of
Architecture, Venice

On 27 July 1980, the first International Architecture Exhibition of the Venice Biennale opened to the public. This event marked the launch of a new architecture component of the famous art event, and presented, both to a local and an international audience gathered for the occasion, the hitherto closed Arsenale. The multi-stranded exhibition, entitled *The Presence of the Past*, controversially inaugurated the idea of postmodernism as a supermarket of styles. This essay examines the circumstances behind the show's curation, putting special emphasis on the large-scale *Strada Novissima* – a street of façades, which subsequently toured to Paris and San Francisco, and became the subject of divided architectural opinions (pl. 131, p. 121).

Preparation began in 1979 when the Roman architect Paolo Portoghesi was chosen to be director of the new architecture section. He was a political choice, but also an unexpected one. His selection caused an uproar: despite his extensive experience as a teacher and editor, and his undoubted charisma, Portoghesi was an outsider to the Venetian architectural scene, then dominated by the Istituto Universitario di Architettura di Venezia (IUAV) and its most important figure, Manfredo Tafuri. Portoghesi, inspired by architects such as Philip Johnson, had denounced the academism of the Modern Movement, and imagined a landmark exhibition that would have, as its main focus, the idea of 'the presence of the past'.

To assist Portoghesi, the Biennale steering committee nominated an advisory commission composed of the architects Constantino Dardi, Rosario Giuffrè, Udo Kultermann, Giuseppe Mazzariol and Robert A.M. Stern. This commission then chose a group of critics to lead the exhibition: Charles Jencks, famous for *The Language of Post-Modern Architecture* (1977); Christian Norberg-Schulz, known for his writings on Baroque architecture and his phenomenological critique of modern

architecture; the American historian Vincent Scully, for his interest in ancient architecture; and Kenneth Frampton (who resigned in May 1980) for his defence of regionalism. In September and November 1979, as well as in February 1980,[1] the advisory commission, together with the critics, convened in Venice to discuss the exhibition's form and content.

The exhibition was divided into eight sections. The most important part of the exhibition was the *Strada Novissima*, an artificial street showcasing the work of 20 architects[2] from nine different countries. This ground floor display was continued on the mezzanine with drawings and models by 55 younger architects. The result of this collage was a 70m (230ft) long simulacrum of a street, built by unemployed technicians of the Roman cinema studio *Cinecittà*. At one end of the street were presented three homage exhibitions to Philip Johnson (including a model of the AT&T building, New York City), Mario Ridolfi and Ignazio Gardella (pl. 141).[3] At the other end of the street was the critics' exhibition: a room in which Scully, Norberg-Schulz and Jencks presented their vision of 'the presence of the past'. In the centre of the room an enormous leaning pencil, the creation of Charles Jencks, was inscribed with words reflecting the many facets of postmodernism (historicism, straight revivalism, neo-vernacular, ad hoc, etc.), while recalling the leaning towers of Venice: 'a representational comment on the existing language,' as Jencks himself put it (pl. 142). Next to it was an 'hour long illustrated lecture on architectural trends prepared by Scully'[4] and along the walls some photographs, put together by Norberg-Schulz to 'illustrate the continuity of architectural language across time and national cultures'.[5] At the end of the street was a small exhibition called *The Reopened Den*, presenting a short history of the Arsenale. Finally, there were two displays entitled *Nature-History* and the *Banal Object*, the latter curated by Alessandro Mendini. The entrance portal and the *Theatre of the World*, both temporary constructions by Aldo Rossi, were also part of the exhibition.

Strangely, the idea behind the *Strada Novissima* came from German Christmas markets. Portoghesi had visited Berlin with Aldo Rossi and Carlo Aymonino in 1979, and it was the sight of the stalls in the Alexander Platz that gave him the idea of creating a street of papier mâché, in which each architect would build his own house. The idea was to show actual buildings rather than images, thereby 'offering the public the chance for a direct tactile and spatial contact with architecture,'[6] a 'gallery of architectural self-portraits made for play, for rediscovering the very serious game of architecture'.[7] Portoghesi wanted to draw upon the then-current interest in the urban street, while bringing back colour and imagination, as well as an element of competition.[8] Each architect was asked to design a façade of 7m × 9.5m (23ft × 31ft). Neither abstract interdisciplinary installation, nor mere didactic presentation of plans and models, each façade was meant to express the architect's 'own particular sense of form, with special reference to the theme of the "Presence of the Past" ',[9] that is, the return of history as a concrete basis for design.[10] Yet, when the projects started to arrive in Venice, the organizers were slightly disappointed. As Portoghesi and others recalled, some of the participants turned out to have been more attached to the idea

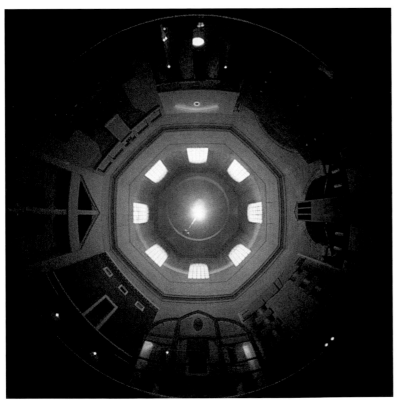

Postmodernism: Style and Subversion, 1970–1990

of ephemerality than that of the street, and made their façades look like carnival masks.

Behind each façade, participants had a small kiosk in which to present their work. While not explicitly mentioned in the official documents for the exhibition, this 'commercial' aspect of the display was acknowledged by the organizers. Notes from a preparatory meeting read: 'It is possible to imagine the facades alternately as that of a museum for the work of the individual architect or as a shop front to sell that architect's ideas, or both.'[11] One of the innovative aspects of this exhibition was its ambivalent position between the thematic and the informational. (As Vittorio Gregotti, former director of the Art and Architecture sector of the Biennale, recollects, at the end of the 1970s there was a debate as to whether the Biennale should have an overall critical point of view, or whether it was better for it to be purely descriptive.) Despite the strong thesis on postmodernism, each architect presented his own work on its own terms.

When the exhibition closed on 19 October 1980, 36,325 paying visitors had seen it,[12] an extraordinarily high number for an architecture exhibition at the time. But popularity did not come without controversy. In Venice, the polemic was particularly intense: according to the journalist Nantas Salvalaggio, it provoked a sudden wind of change in a city that had seemed dead.[13] The first public criticism came from Vittorio Gregotti, who, in the pages of *La Repubblica*,[14] denounced the *Strada Novissima*'s emphasis on façades in isolation from real buildings. Tafuri, if acknowledging the spectacular effect of the street built inside the Arsenale, deplored its fictional aspect and its reliance on 'more modern circuits of information and consumption'.[15] Other attacks, unsurprisingly, came from those who believed in the continuity of the Modern Movement. The historian Bruno Zevi, in a public debate with Portoghesi, claimed that the Modern Movement was perhaps in crisis, but certainly not finished.[16] Zevi accused Portoghesi of an evasive and anarchic neo-academism.[17] Similarly, the philosopher Jürgen Habermas condemned the exhibition in 'Modernity: An Unfinished Project', his famous lecture delivered in 1981 upon his acceptance of the Adorno Prize. Referring to the

Strada Novissima's exhibitors, he wrote: 'They scarified the tradition of modernity to a new historicism'.[18]

Despite all the polemic, two visitors to the Venice exhibition were particularly impressed by what they saw and decided to prolong its life: Michel Guy, then director of the Paris Festival d'Automne; and Virginia Westover, a PR agent for various arts groups in the San Francisco Bay area. Thanks to Guy, an adapted version of the *Strada Novissima* was shipped to Paris and rearranged in the form of a piazza inside the Chapelle Saint-Louis de la Salpêtrière (pl. 143). Renamed *The Presence of History: After Modernity*, the Paris version sent a slightly different message, leaning even more towards historicism. In France, the polemic was even stronger than in Italy, giving rise to public debates on architecture broadcast on national television. After Paris, the façades travelled to the other side of the Atlantic, to San Francisco, where in mid-1982 they were presented in the Fort Mason Center, a Mission-style industrial building (pl. 144). Here, the exhibition took a more commercial direction due to the agenda of its organizers and sponsors, including Westover and her husband, the real estate developer Joe Weiner.

In addition to external criticism, internal discord came from within the exhibition's initial organizing group. Kenneth Frampton found the exhibition to be more anti-modern than postmodern, and he disliked the 'star status' accorded to Johnson and Gardella, and the transatlantic exclusivity of the enterprise.[19] According to Charles Jencks, Portoghesi and Stern shifted the exhibition towards the past and historicism, rather than towards his own view of postmodernism as a multicoloured mosaic. On the other hand, Portoghesi now claims that time has proved the fallacy of Jencks' thesis: 'For me, this total liberty from any rules has been a calamity for architecture.'[20] The four essays in the catalogue, written by Portoghesi, Jencks, Scully and Norberg-Schulz, each proposed an alternative vision of postmodernism. If the exhibition *The Presence of the Past* appeared as a supermarket of styles, it was due not only to the differing agendas of the organizers, but also to the then-uncertain direction of postmodernism itself. In short, it was not clear exactly what was to come after 'the end of prohibitionism'.[21]

Martino Stierli

THE ARCHITECT AS GHOST-WRITER: REM KOOLHAAS AND IMAGE-BASED URBANISM

If postmodernism can be characterized by one single criterion, it may be the concept of the image. Images are treated with the certainty that everything is, and appears to have always been, present visually. A return to the original is no longer feasible nor desirable because it never existed in the first place. According to this conception, the production of knowledge lies in the logic of reproduction. 'Iterability', wrote Jacques Derrida, 'is a structural characteristic of every mark.'[1] The inevitability of 'repetition' has been a topic of much concern for cultural theorists such as Jean Baudrillard, who sees reality itself as seriously threatened by a secondary level of signs and signification, constituting a so-called hyperreality with the (alleged) consequence that 'reality' and representation can no longer be told apart.[2] Critics like Gérard Genette have countered this argument by indicating that the palimpsest-like 'second degree' texts (or images) resulting from postmodern strategies of production are not merely debased copies, but rather original works of art with both critical and creative potential.[3] Accordingly, rather than merely re-presenting a pre-existing reality, these artefacts present and indeed produce their own distinct form of reality. What is essential for this postmodern aesthetics of production is montage, i.e. the particular way that fragments are arranged and re-composed into a new visual (or textual) entity. Meaning is derived not so much from the individual parts and their original contexts, but from their combination and/or juxtaposition within a new framework. What deserves attention in the postmodern object is not its allegedly secondary nature, but its inherent constructedness.

Delirious New York, an architectural treatise published in 1978 by Dutch architect Rem Koolhaas, is generally considered one of the theoretical foundations of postmodern architectural discourse (pl. 145). Its author proposes to understand Manhattan as the '20th century's Rosetta Stone' and as the

epitome of the modern metropolis. The book initially appears to be a history of New York's built fabric, but it is in fact a highly subjective account of the theoretical potential of the modern metropolis. To make its case, *Delirious New York* draws heavily from popular sources and in particular picture postcards: reproduced images of an actual or imagined state of Manhattan at a certain point in its history. Koolhaas' method epitomizes postmodern strategies of dealing with images. It draws from an archive of pre-existing reproductions and combines them into a new (visual) narrative; one that is both internally consistent, and highly subjective and selective at the same time. *Delirious New York* does tell the city's 'prehistory' including the myth of its founding, but the four subsequent chapters cover those episodes most relevant for Koolhaas' narrative of urban history: Coney Island as a repository for technological fantasies; the evolution of the skyscraper; the construction of Rockefeller Center as apex of New York's superurbanism; and the European avant-garde's intellectual appropriation of the city, exemplified by the figures of Salvador Dalí and Le Corbusier.

While earlier attempts at writing an urban history – John Summerson's study of Georgian London comes to mind as an example[4] – strove for a detached and objective account of the facts, *Delirious New York* contents itself with fragments. While this strategy could be interpreted as an example of so-called 'operative criticism' – a representation of history that is instrumentalized in order to prescribe, and not just describe, the history of architecture with regard to contemporary and future developments – it is at the same time symptomatic of a postmodern sensibility. Here, the all-encompassing master narratives (or *grands récits*, in Jean-François Lyotard's terminology), seem no longer adequate. History is replaced by a multitude of (hi)stories.[5]

Koolhaas' introduction of popular picture postcards into architectural discourse calls for a closer inspection. The invention of the postcard is closely linked to the advent of tourism in nineteenth-century modernity. It can be seen as a visual cliché of a personal experience, much as modern tourism is a clichéd appropriation of the aristocratic Grand Tour for a broader (eventually, a mass) audience. As Mike Crang has pointed out, the medium of the picture postcard is characterized by an intrinsic dialectic of 'sites' and 'sights'.[6] Actual topographical locales become invested with symbolic meaning, a process of transformation directly dependent on mass consumption and technical reproducibility. The cultural value of a sight is amplified through popular imagery; its power lies in the supersession of the object represented by the pictorial representation (in the postcard) itself. The postcard, then, stands for a cultural condition in which images and their circulation are more important than their referents. For Koolhaas, it may well serve as an allegory of the image in the age of its technical reproducibility.

Even though Koolhaas used other types of illustrations such as drawings, regular photographs, and paintings to build his argument visually, it is primarily reproductions of picture postcards on which both the aesthetic and the argument of *Delirious New York* are predicated (pl. 146). Evidence from which his theses are deduced is not so much the real New York,

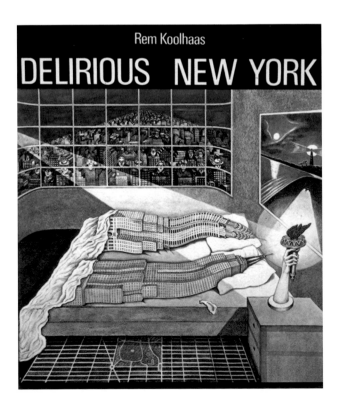

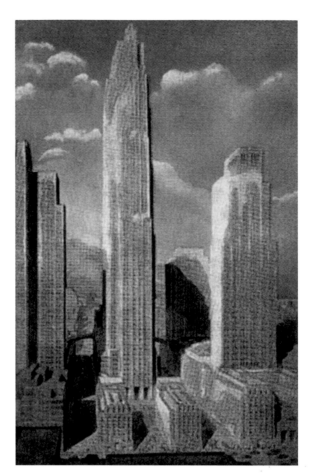

146
**Walter Kilham Jr, postcards
from *Delirious New York*,**
1930s, showing each step in
Radio City's development

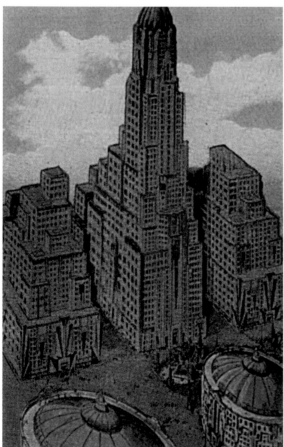

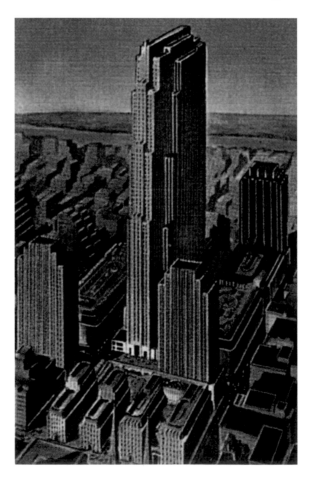

but the images and imaginations circulating about it. These postcards are taken as the repository of 'Manhattanism', the principle of superurban density in its purest form, the realm of ideas about the city uncompromised by reality. The basis for this historiographical (re)construction is a large collection of postcards that Koolhaas began putting together in the 1970s with his partner, the artist Madelon Vriesendorp, when they were living in upstate New York. While Vriesendorp's interest extended to any kind of 'Americana' and in particular to its strange, almost surreal occurrences, the architect's focus was primarily the visualization of a real or imagined Manhattan.[7] Their joint efforts led to a collection of several thousand postcards, meticulously filed under a number of typological categories. Both the Americana and the Manhattan postcard collections were stored in suitcases – one metallic, the other tan leather – reflecting the intrinsic relationship of the postcard to tourism (pl. 146). These suitcases are reminiscent of those owned by the main character in Peter Greenaway's epic web-based project *The Tulse Luper Suitcases* (2003–4), in which the missing protagonist's life is reconstructed from the contents of the 92 suitcases he has left behind.[8] Luper's suitcases constitute a sort of encyclopaedia of the twentieth century, and those belonging to Koolhaas amount to the same for the built fabric of Manhattan. The obsession with an encyclopaedic world order has been constitutive for modernity ever since the Enlightenment, but the certainty that this totality can only be displayed in a fragmentary way is the hallmark of postmodernity.

The impressive image archive permitted a second step for subjective reconstructions and narrations of history through choice and re-arrangement – a process based on the montage principle that is characteristic of Koolhaas' buildings as well. Thus he commented on *Delirious New York*: 'The structure of the text is very architectural … It is a book without a single "however", and that to me is very architectural. It has the same logic as a city. Anyway, a crucial element of the work – whether writing or architecture – is *montage*.'[9] Coherence is founded on the unmediated juxtaposition of individual autonomous elements/images in dialectic pairings or groupings. By being collected, the postcards are attributed a new meaning: they acquire a mnemonic function. Often, they represent anonymous and unrecognized histories. Sigfried Giedion and the Architectural Association chairman Alvin Boyarsky took a keen interest in such vernacular histories, and a similar preoccupation is evident in Koolhaas' collection.[10]

Nevertheless, it is notable how much the pictorial discourse of *Delirious New York* dwells on those elements of the city that have been the subject of mass reproduction and circulation.[11] The history of the city, one could argue, can only be told insofar as it is reproduced in popular imagery. Koolhaas' book is an allegorical account in retrospect: 'The fatal weakness of manifestos is their inherent lack of evidence. Manhattan's problem is the opposite: it is a mountain range of evidence without manifesto.'[12] *Delirious New York* was therefore a 'retroactive manifesto'. Rather than prospectively formulating a programme according to which architecture and the city should develop (the modernist stance), Koolhaas inverted the methodology, supplying a *post facto* programme to decipher and interpret the already existing city: '[T]his book describes a theoretical Manhattan, a Manhattan as conjecture, of which the present city is the compromised and imperfect realization.'[13]

The role Koolhaas proposes for the architect *vis-à-vis* the modern city is that of the ghost-writer. The collection of postcards and other instances of popular imagery form the starting point for an image-based urbanism. They are the evidence of the city's unconsciousness, waiting to be uncovered by means of historiographic narration. The architect is a storyteller who revives forgotten representations of the city that haunt the modern consciousness, and invests them with meaning. If the French theorist Michel Foucault saw the architect as a psychiatric warden charged with disciplining society, *Delirious New York* suggests that the architect can act as a therapist: one who renders visible the dreams of modern society about its spatial equivalent, the metropolis. The architect is thus the liberator of collective images and imaginations, and his working instrument is the archive of popular imagery.

David Crowley

PAPER ARCHITECTURE: THE COLUMBARIA OF BRODSKY AND UTKIN

Architects in the Soviet Union experienced a strange premonition of postmodernism 50 years before its domination of the architectural scene in the West. The monumental classical style known as Socialist Realism, which was required of almost all buildings during the Stalin years (1928–53), not only laid a claim to being sensitive to the regional and national character of architecture; it was also promoted by its champions as a sublation of Modernism. In ways that anticipated arguments in the West about the 'end of history', Socialist Realism presented itself as the culmination of all that had gone before it, including Modernism.[1] 'According to Stalinist aesthetics,' writes Boris Groys, 'everything is new in the new posthistorical reality … There is no reason to strive for formal innovation, since novelty is automatically guaranteed by the total novelty of superhistorical content and significance. Nor does this aesthetic fear charges of eclecticism, for it does not regard the right to borrow from all ages as eclectic; after all, it selects only progressive art, which possesses inherent unity'.[2] In other words, Socialist Realism – like postmodernism – had the potential to synthesize all that was best about the past, or so its champions claimed.

Postmodernism 'reappeared' in the last decade of the Soviet Union, a particularly feeble period of architectural production when the central economy was grinding into bankruptcy even as intellectual life was energized by President Mikhail Gorbachev's programmes of *perestroika* ('restructuring') and *glasnost* ('openness'). Critique was at that time more stirring than the conventional Soviet rallying cry of 'construction'. Postmodernism in the Soviet context has been closely associated with the phenomenon of 'paper architecture', visionary or impossible schemes designed by architects for entry into competitions and exhibitions.[3] These fantastic cities and buildings often functioned as forms of architectural and social critique rather than as propositions for actual structures. As Svetlana Boym puts it, 'Immateriality was almost a sign of integrity.'[4] Paper architecture also became an important site for the exploration of utopia, a forlorn concept in the years that preceded the demise of the Soviet Union. Enlightenment temples of reason and science conceived by Étienne-Louis Boullée in France on the eve of the French Revolution and the floating cities of the Suprematists from the Leninist years were revisited with the hindsight that came from living in a failed social experiment. Foremost amongst the paper architects were Alexander Brodsky and Ilya Utkin, who had studied at the prestigious Moscow Institute of Architecture (MArkhI) in the 1970s. They drew early international acclaim in 1982 when their design for a fantastic Crystal Palace, formed from a series of massive glass wall 'sections', won a competition organized by *The Japan Architect* magazine.

Brodsky and Utkin's *Columbarium Architecturae* of 1984 (pl. 147) and its sister work *Columbarium Habitabile* of 1989 (see pl. 148) share the same concept. Both etchings depict a memorial structure in which old buildings threatened with destruction are preserved like the ashes of the dead. Yet these buildings have not quite expired. They demand the careful attention of the viewer, whether the occupant of the building or the passer-by. If a building is forgotten or overlooked, the massive ball in the centre of the structure swings into action to destroy it. The *Columbarium Habitabile* places the highest pressure on the occupant. According to Brodsky and Utkin, each building has its place on the concrete shelf, 'only if the owner and his family continue living in the house … if they cannot live in these conditions any more and refuse, their house is destroyed.' On reading these words engraved in English *bas-de-page*, and figuring out that the dark frame is a niche in the Columbarium, it becomes clear that you too are one of these terrorized occupants.

Brodsky and Utkin's schemes were explicitly critical of the processes of modernization that had swept old buildings from Soviet streets. Moscow, their home town, has periodically been the site of acts of domicide, with historic districts destroyed to make way for new monuments to progress. The paper architects' fascination with antique structures like Columbaria, as well as the use of the traditional medium of engraving, emphasize the melancholic character of their interests. Other works by the duo from this period ripple with nostalgia for epochs marked by architecture of excess. Lois Nesbit points out that 'they prefer the overripe classicism of the Stalinist period to what came afterward.'[5] From the late 1950s, Soviet architects were asked to master the techniques of industrialized architecture. Curiously, the grid-like concrete structure of Brodsky and Utkin's two Columbaria invokes the high-rise blocks of the 1960s and 70s known as *Novostroiki*. Prefabricated panel construction and standard parts turned architectural construction into an exercise in slotting square boxes into square holes. 'Everything about the *Novostroiki* – their location on the city's edge, their sameness, the sameness of their tawdry furnishings – proclaims that the private life of Moscovites is marginal, an afterthought, a coda to their "real" lives as Soviet citizens and workers,' wrote one commentator in 1989. 'Privacy and individuality must be created and celebrated despite this spacelessness, in defiance of It.'[6]

Both schemes by Brodsky and Utkin seem to address the human need for privacy and individuality, albeit in different ways. The *Columbarium Architecturae* presents itself to the street as a section of a three-storey house with a smoking chimney, a visual cliché symbolizing the happy life. A private world is projected onto the public face of the building. By contrast, many structures – distinguished by their exterior forms – are stacked in the interior of the *Columbarium Habitabile*. Public and private conditions are blurred. This had, in fact, long been the Soviet experience.[7] One of the most common types of Soviet home was the communal apartment. Large pre-revolutionary flats, once occupied by the wealthy and their servants, were sub-divided after the Bolshevik Revolution to provide homes for a number of working-class and peasant families. In his Moscow diaries of 1926–7 Walter Benjamin, employing a characteristically surreal metaphor, described how these private homes had become common property and were now over-populated by numerous families and their meagre possessions: 'Through the hall door one steps into a little town'.[8] He could have been describing Brodsky and Utkin's collections of houses.

Once imagined as a temporary stage on the path to full communism, where mankind would abandon selfish desires, the communal apartment became a standard feature of Soviet life. In 1989, for instance, one-quarter of the population of St

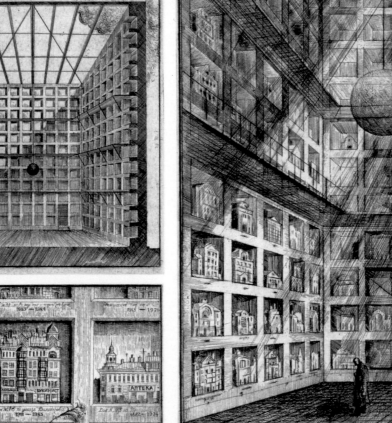

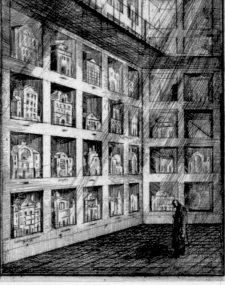

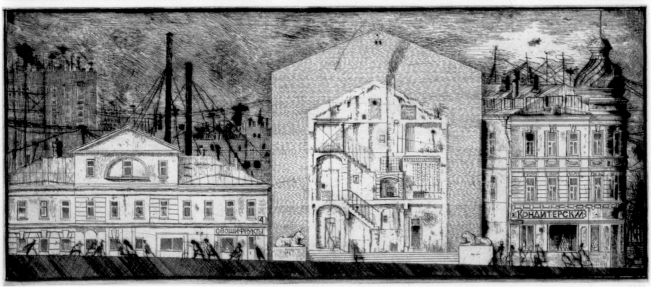

147
**Alexander Brodsky and
Ilya Utkin**, *Columbarium
Architecturae (Museum of
Disappearing Buildings)*, 1984.
Etching (impression 1990).
V&A: E.1494–2010. Photograph
by Hermann Feldhaus, courtesy
Ronald Feldman Fine Arts,
New York

Petersburg lived in communal apartments, sharing a common kitchen, a common toilet and a common telephone in a space subdivided by flimsy partitions, sometimes little more than curtains.[9] Life in shared quarters often became an unpleasant theatre, filled with strangers, arguments, intrusive noises and unpleasant smells.[10] Famously, the communal apartment was adopted by the Russian nonconformist artist Ilya Kabakov as the setting for his domestic dramas. *Ten Characters*, an installation shown in New York in 1988 which takes the form of a series of cell-like rooms off a dark, shabby corridor lit with exposed electric light bulbs, presents the possessions and living spaces of ten absent Soviet citizens.[11] Their lives are described in a series of vivid extended texts (often in the heterogeneous voices of official reports, newspaper articles, diaries and *ad hominem* reflections) and, of course, their possessions. The viewer is invited to be a psychologist, archaeologist or perhaps a secret policeman, extracting meaning from the debris of life and fragmentary reports. Conventionally critics and art historians have turned to Kabakov's *Ten Characters* as a comment on the forms of horizontal surveillance that operated not in only in the communal apartment but also throughout Soviet society.[12] Constantly aware of one's movements and opinions being detected by others, the individual modifies his or her behaviour. Life is reduced to an interplay of vigilance and performance; as Boris Groys elegantly puts it, 'the communal turns everyone into an artist'.[13]

Although related to Kabakov's explorations of anomie (and sharing his non-conformist sensibility), Brodsky and Utkin's schemes emphasize different values. Their collections of dream-homes are full of memories and desires. Each functions nostalgically as what art historian Andrzej Turowski has called a 'utopie rétrospective'.[14] Such places idealize settings and times – like the homes of childhood – which can no longer be accessed. They become all the more perfect by acts of recall. Yet memory-work in Brodsky and Utkin's projects was not just a subjective matter. The threat of destruction – issued by the wrecking ball – and the duty to watch over the homes of the past make the occupant something like a conservator or even a curator. In a society where the terror of Stalinism had penetrated so deeply into the home that the mere possession of a photograph of a 'purged' relative was viewed as an act of sedition, remembering could be understood as an act of resistance. Milan Kundera, the Czech writer, described this in rather lofty terms when he wrote, 'the struggle of man against power is the struggle of memory against forgetting'.[15] Viewed in this way, the *Columbarium Architecturae* and the *Columbarium Habitabile* represent not just the preservation of all buildings (whether 'progressive' or not) but also of all memories.

148
Alexander Brodsky and Ilya Utkin, *Columbarium Habitabile*, 1989. Etching (impression 1990). V&A: E.1495–2010. Photograph by Hermann Feldhaus, courtesy Ronald Feldman Fine Arts, New York

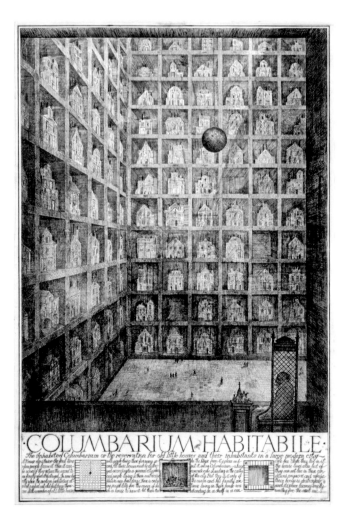

Claire Zimmerman

PHOTOGRAPHY INTO BUILDING: THE SMITHSONS AND JAMES STIRLING

Because production serves human development, we must try to expand *applications* used up to now solely for the purposes of reproduction, to productive uses.[1]
—*László Moholy-Nagy*

Despite evident and important continuities between Modernism and postmodernism, the two are separated by differing attitudes to media and commerce. In architecture, this separation can be seen through photography. Just as some things are easier to see obliquely, through parallax or anamorphosis, so architectural photographs reveal how architects adapted to ever-changing commercial markets and advertising. Further scrutiny shows how photography entered into building itself.

Differences between the work of James Stirling and that of the architectural couple Alison and Peter Smithson illustrate the gap between late Modernism and postmodernism in useful ways.[2] The Smithsons and Stirling were not friends, but they worked in the same context, within an architectural culture connected to that of patronage, commerce and advertising in post-war Britain.[3] All three were members of a young group interested in relations between architecture and society, connected by London's Institute of Contemporary Arts and the intense personality of the critic and historian Reyner Banham.

Banham shared with the Smithsons and Stirling a penchant for photography. The archives of both architectural practices are full of photographic images, and not solely images for publication. The Stirling Archive at the Canadian Centre for Architecture, for example, contains not only commercial photographs of Stirling's buildings but also photographs of the architect ensconced in his own work – in one case inside the belly of his History Faculty Library for Cambridge University (pl. 149). It contains photographs by Stirling himself, of a variety of different subjects, including his own buildings. In addition, it houses copious images that Stirling collected, snapshots of his buildings taken by others, and, finally, a large body of on-site photographs taken of selected projects during the course of construction. The quantity and range of these pictures illustrates a new historical phase that began after the war, one characterized by intensive photographic documentation of buildings. The same holds true of the Smithsons: they owned numerous images documenting the many facets of an architectural project as well as their dual career as architects.

These two cases show how many architectural practices approached photography after the war. The evolution of other reprographic processes, from early Prussian Blue printing to diazo to Xerox, suggests how architecture in the twentieth century was produced by and based on the imaged facsimile. It was surely late Modernism that made us aware of this fact, but postmodernism gave architects the tools to take advantage of it. There are unfathomably more published images of the Smithsons' Hunstanton School in Norfolk, for example, than of Mies van der Rohe's building at the Illinois Institute of Technology in Chicago on which it is partially based. This sort of call and response between buildings and photographs was accepted by and familiar to most young architects in the postwar years.

The importance of architectural photography to history, or to the continuing survival of an architectural office, is clear. Historians generally depend on paper evidence – photographs,

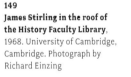

149
James Stirling in the roof of the History Faculty Library, 1968. University of Cambridge, Cambridge. Photograph by Richard Einzing

2 Looking toward gymnasium from the north-west.

150
Peter and Alison Smithson, Smithdon High School (formerly Hunstanton Secondary Modern School), 1949–54. Norfolk (shown in *The Architectural Review*, September 1954)

Opposite: 151
Stirling and Gowan, Leicester University Engineering Building, 1963. Leicester. Photograph by Richard Einzig

SCHOOL AT HUNSTANTON

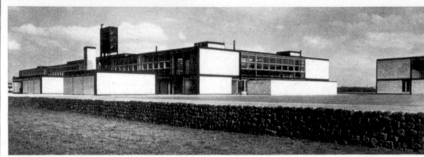

3 The western end of the main block.

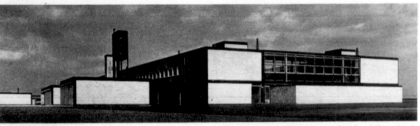

4 Eastward view along the north side of the school.

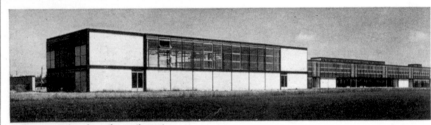

5 The gymnasium from the south-west.

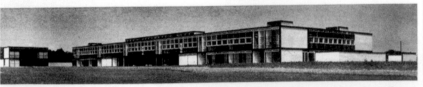

6 The entire complex of buildings seen from the south-east.

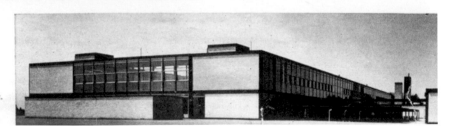

7 The eastern end of the main block.

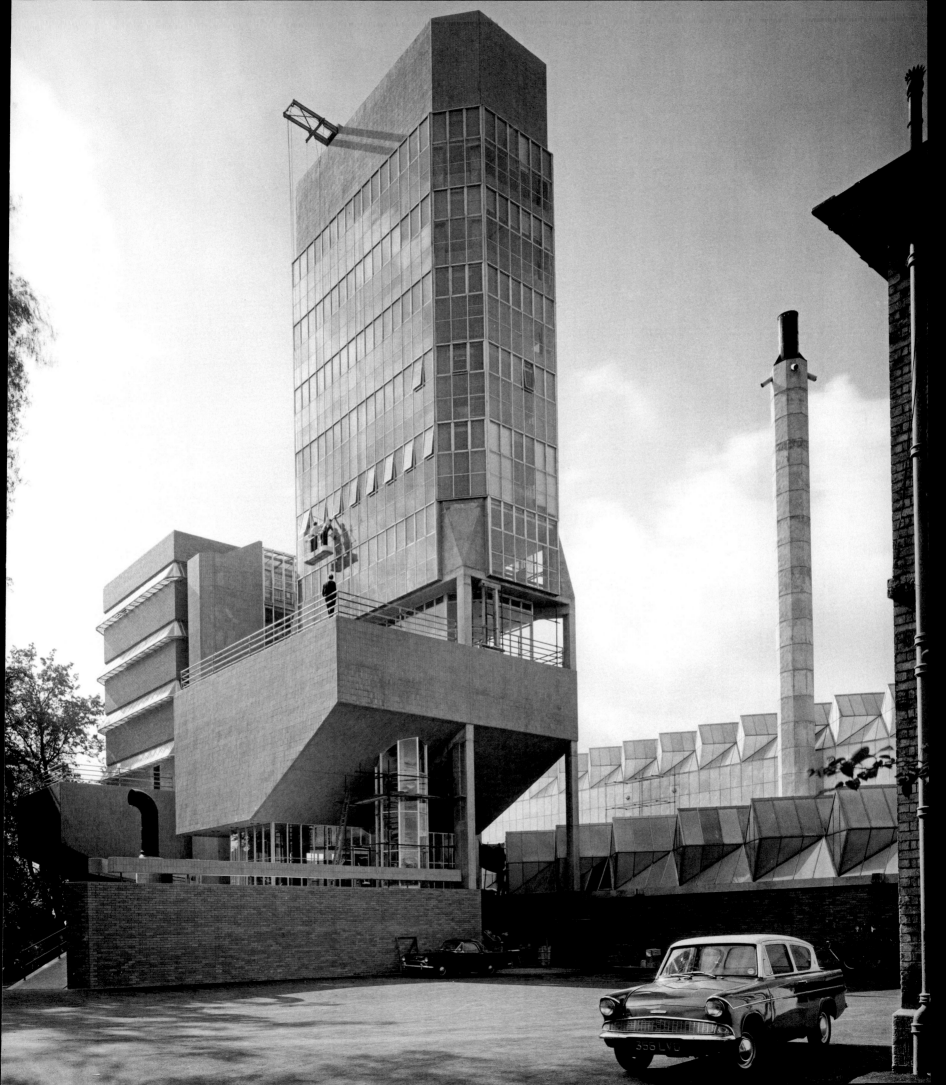

drawings and a host of other administrative documents – for primary research into buildings. This information may be complemented by on-site archaeology – but twentieth-century architectural history is often written without recourse to physical excavation. Instead, it includes a great deal of historical analysis, some of it conducted by looking at photographic images. Practising architects, similarly, depend on documents like photographs to disseminate their work and capture new commissions. The effectiveness of this marketing tool is attested by the increasing internationalization of architectural practices after the war (following earlier precedents such as Albert Kahn or Edwin Lutyens).

Less well examined is the status of the image in architectural pedagogy. As the twentieth century wore on, architects increasingly learned from images in books, journals, exhibitions and slide lectures. As images of important buildings appeared with greater frequency, so ideas gradually came to be associated with particular photographs. The Smithsons' famous line, 'But today we collect ads', subsumes the tacit idea 'But today we collect pictures (of buildings)'. Pilgrimages to important buildings remained crucial experiences for architects; but after the war photography played an increasingly important role in setting the stage for those pilgrimages, and carrying the burden of memory, communication and elaboration. This was not a matter of sudden pedagogical innovation, but rather of acceleration and accumulation. Gradually, it became easier and more commonplace to see things in images than it had ever been to see them *in situ*. Architects responded by making fuller photographic records of their own projects.

How were the effects of photography and its practices be reflected in buildings that were designed and constructed after the war? In considering this question, it is important to note the difference between photographs and other kinds of images, particularly architectural drawings. The evidentiary character of photography rests on its indexical status as a direct trace – a 'truth function' of photographic procedure frequently noted since 1839. From the architect's standpoint, the physical indexicality of a photograph – the inscription of light into a surface – is analogous to architectural processes like casting, in which one surface imprints and forms another. The materiality of photography resembles the materiality of certain construction processes, and thus has recognizable authority within the field. Furthermore, this similarity of facture elides the difference between two and three dimensions by locating the same process in both – the flat auto-facture of the photographic image and the rounded manufacture of the architectural cast. This similarity may relate to the way in which postmodern architects absorbed photographic procedure into building.

The Smithsons and Stirling provide answers to the question of photography's relationship to architecture, as a comparison of the first major breakthrough commissions for each suggests. The Smithsons' Hunstanton Secondary Modern School (1949–54) in Norfolk, and Stirling and James Gowan's Engineering Building at the University of Leicester (1959–63) are separated by a decade – although the architects were close in age. A tiny fissure between the late Modern and incipient postmodernism appeared in the years between Hunstanton's genesis in 1949, and the completed Leicester building in 1963.

The buildings do not have much in common. The Smithsons' school is rigorously ordered: two rectangular steel-framed boxes in-filled, and clad in brick and glass. Processes of fabrication (the manufacturer's name, Dorman Long, is embossed on every steel beam) and modularity of construction were left deliberately evident. The plan might suggest infinite extension or reproduction. The clarity of the architecture is evident in images precisely because of its emphatic character on the ground (pl. 150). Anything less rigorous would look unremarkable when photographed, as the concurrent Hertfordshire Schools buildings often demonstrated. The building asserts itself, through photography, as a building in which appearance and reality coincide.

Stirling's Leicester building reflects a different approach. Composed of numerous volumes designed according to different formal orders, the building is episodic (pl. 151). Each part has its own set of formal referents, some of which can be traced with precision. Discrete formal objects that resemble Russian Constructivist theatres, and a spiral stair from nineteenth-century architect Peter Ellis' small office building in Liverpool, give the building the quality of photomontage, where individual pictorial entities stand juxtaposed in simple contradistinction with little mediation (pl. 152). The shiny surface of glass, glazed brick and tile that sheathes the building unifies it like the glossy surface of a photographic image. In subsequent projects, Stirling deepened this method to collapse images onto and into one another, so that the image of heroic modern architecture was overlaid with the requirements of British national traditions, or German neoclassical idealism.[4] In Stirling's Neue Staatsgalerie in Stuttgart, for example,

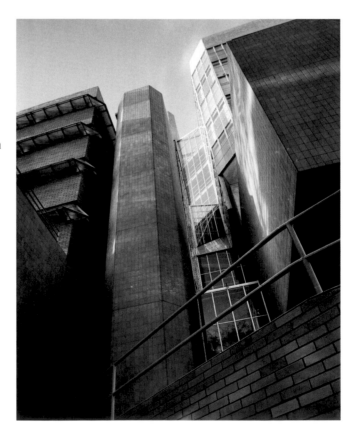

152
Stirling and Gowan, Leicester University Engineering Building, 1963. Leicester. Photograph by Richard Einzig

the architect muses on the legacy of Karl Friedrich Schinkel in modern Germany in fragmentary tableaux set up in an eviscerated shell (pl. 153).

At Hunstanton, the importance of photography for architecture resulted in a building made to be explicit in its pictures – the logic of the photograph appears to inform architectural structure and infill. In fact, the rigorous correspondence between structure and appearance is common to both media. It is as if both practices could close the gap between appearance and reality; photography through its evidentiary character, architecture through structural and functional transparency. First in structural rationalism of the nineteenth century, and then through functionalist doctrine in the twentieth, architects sought the 'truth value' of a building. Yet the photographs of Hunstanton School reflect two forms of truth – photographic and architectural – which are not, of course, the same. The Smithsons dubbed the latter 'an architecture without rhetoric', but they displayed that architecture through the rhetorical mode of the photographic image.

Stirling's postmodernism rested in part on his awareness of the contradiction inherent in this idea. Photographs do not necessarily communicate the 'essence' of architectural experience: the body in space, surrounded by material. Yet photography had become the currency of architecture, the means through which business was conducted. Stirling, like other postmodernists, took on the contradiction by returning the image to the body of the building. He too drew from the history of architecture, including the history of functionalism, but his buildings are also something like photocollages. The varied logics of the individual parts are explained in texts. Banham's article 'The Style for the Job' reflects insight into this episodic architecture, while Stirling's own essay, 'Anti-structure', describes an ad hoc approach to form.[5] Other texts by Stirling also express a rejection of existing methodologies of building. This refusal of received method privileges a method of its own: a pictorial method of building. Where the Smithsons embraced photography as a parallel endeavour, allowing it to infiltrate the very skeletons of their glass architecture, Stirling took photography into his capacious embrace. This was not photography as parallel practice, but photographic procedures viewed as architectural in their own right, with only slight modifications necessary to transform reproductions, illustrations and photomontages back into buildings. Thus the Neue Staatsgalerie, blown up from plan into building, lost the domed roof of its model – Schinkel's Altes Museum – and became an open court.

Herein lies an essential difference – one that we might understand as the very constitution of the postmodern. An episodic, ad hoc method took pictorial concerns in the age of photographic reproduction, right into the heart of building itself.

153
James Stirling Michael Wilford and Associates, Neue Staatsgalerie, 1977–83. Stuttgart. Photograph by Sven Prinzler

Paola Antonelli

POSTMODERN ANGEL: SHIRO KURAMATA

Generations of curators at the Museum of Modern Art in New York have tried their hand at writing an epic history of modern architecture and design, at defining its canon, sometimes by exclusion. Among the voluntary omissions – glaring to some, obvious to others – are a number of the most famous icons of postmodernism. One will not find at MoMA important pieces such as the 1978 *Proust* armchair by Alessandro Mendini for Studio Alchymia, or the 1981 *Carlton* bookshelves by Ettore Sottsass which launched Memphis. Though these are historical milestones, they go against some of the tenets of the modern dogma, from the desire to be true to the materials employed and the need to be always projected towards the future rather than looking into the rearview mirror, to the dream of timelessness, which warned against anything ephemeral and stylistic, and therefore quickly dated.

Please note, however, the capital 'P' in Postmodernism. The heavily made-up buildings and objects that celebrated 'the presence of the past' so dear to one of the fathers of the retro-revolution, Paolo Portoghesi,[1] went on to become an easy formalist style that was mimicked all over the world and was even labelled PM, or worse still, PoMo. In truth, postmodernism is like cholesterol: there is the bad one, and there is the good one. This latter, a critique of Modernism that was and is essential to its evolution and survival, is what MoMA is devoted to. Shiro Kuramata is one of its champions and his work is one of the pillars of MoMA's design collection (pl. 154).

As clear-cut as it might seem, MoMA's history is fraught with ambivalence, *faux pas*, and constructive self-doubt, as often happens in institutions and always will, at least as long as they are run by human beings. When it comes to postmodernism, many agree that MoMA's 1975 'enormous

Beaux Arts show provided an intellectual underpinning for what was becoming postmodernism, however undone the movement was to end up in its execution'.[2] In truth, the re-examination of Modernism had begun long before, ever since Modernism, too, had earned a capital 'M' and had become a suffocating and anachronistic formalism. Looking to keep the modern flame alive, several thinkers, architects and designers had been looking for new avenues, including an attention to local material cultures, as safe and convincing ways to move beyond Modernism without giving up the great qualities of modern design.

In 1964, Bernard Rudofsky organized at MoMA the epochal show *Architecture Without Architects*. In the exhibition and in the catalogue, Rudofsky celebrated 'vernacular, anonymous, spontaneous, indigenous, rural' architecture from all over the world.[3] His declaration brought dramatic expression to an already existing, quite sensible trend. Architects and designers in many parts of the world were moving beyond the modernist rulebook by interpreting it not with local stylistic accents, but rather through a local mindset. They were celebrating a modern attitude with non-modern forms. In the 1970s, both architecture and design became heavily politicized and some of the most violent, rebellious and interesting postmodern works – Mendini's burning *Lassù* chair (see pl. 7, p. 15), for instance – represented the *zeitgeist*.

Most of the attention, and the work, was focused on the Western world and yet even in Japan, the future was beyond the modern. After the Metabolist architects' contribution to the Osaka Expo of 1970, politics seemed to be taking a back seat to technology, materials and form. Before innovation had become the cliché rallying cry it is today, Japan had set out to rule the world with it. That is when Kuramata came of age and that is when he gave the world many examples of exquisite modern design beyond Modernism.

Having established his Tokyo office in 1965, Kuramata took part in an exceptional moment of creative and industrial growth in the late 1970s and 80s, raising the Japanese flag high while also bringing in Western influence through his close ties with some of the most interesting designers abroad, Sottsass first among them. He designed many memorable objects and interiors, some of them for another titan of Japanese design, Issey Miyake. He took the most established rules of modernist design and tilted them, gently deforming a classic black-and-white rectilinear dresser and making it wave on its vertical axis. He took white bookshelves formed in a rigid grid, and varied the rhythm of the grid within the piece. By attacking only one of the variables in the modernist equation at a time, instead of many, he created surprise and enlightenment.

MoMA has been engaged in an exceptionally long and solid love affair with Japanese design, whose most celebrated and public act (besides the new MoMA building by Yoshio Taniguchi, which opened in 2004) was the Japanese House and Garden built by Junzo Yoshimura in the Sculpture Garden in 1954. This real-estate feat was recalled by Shigeru Ban in 2000, when he covered half the garden with a beautiful cardboard-tube trellis. MoMA keeps alive the rigour and discipline of modern design, according to its own sensibilities, by taking liberties that can turn an object into pure poetry, high technology into music, and the simple into the baroque. A gushing sensuality and a taste

154
Shiro Kuramata, *Cabinet de Curiosité (Cabinet of Curiosity)*, 1989. Acrylic resin.
V&A: W.25–2010

for paradox pervade MoMA's collection as a design form of surrealism, a well-established vein of the modern experiment.

Marcel Duchamp was one of Kuramata's great inspirations, together with Dan Flavin and Donald Judd. A celebrated Kuramata piece is *Miss Blanche* (pl. 155), a 1988 armchair officially inspired by the corsage worn by Blanche Dubois (played by Vivien Leigh) in the 1951 film adaptation of Tennessee Williams' *A Street Car Named Desire*. A chair only in name, it is in fact a lyrical exercise in beauty. Its goal is sheer emotion. Red paper roses float in clear acrylic, their shadows cast onto the floor, while four tubular legs made of purple anodized aluminium unceremoniously pierce the seat in their supporting roles. It is at the same time sublime and vulgar, all Japanese drama yet reminiscent of a Fiorucci disco leotard. Kuramata admitted that the roses embedded within the clear acrylic are an homage to Duchamp's female alter ego, Rrose Sélavy, and her/his ready-mades.[4]

Captivated by Sottsass' irresistible charisma and affected by the camaraderie that came from the abundance of commissions and opportunities which followed the tough 1970s, Kuramata became part of the Memphis launch in 1981 – which this writer attended by pure chance, a teenager strolling around Milan and finding herself in the right place at the right time. But while his Memphis companions were drowning their objects under layers and layers of decorative laminates, appendices and historicist make-up, Kuramata was pursuing nothingness: how to stand a dresser on two feet in the lightest, most transparent way; how to seat people on feathers and rose petals; how to stand flowers prettily in a pink aura. In order to accomplish these feats, he studied materials and technology with the seriousness of an engineer and the abandon of a poet – or vice versa?

Kuramata's dedication to lightness and surprise has been formative for a whole generation of Japanese designers, from Tokujin Yoshioka – who worked with him – to Kazuhiro Yamanaka and Nendo. To the wider world, he indicated many new directions for design, employing the most up-to-date technologies to show how materials and objects can consciously and deliberately carry meaning, feeling and memory. He departed this life early, leaving behind an aching feeling of unfulfilled potential and scores of admirers touched by his personality.

Is design relevant, now that we have so many bigger thoughts to think? Can a beautiful chair reach beyond its immediacy and be something more than just beautiful – and comfortable? Can a handsome space teach us something about life, and possibly inform our future actions in a positive way? The answer is yes, sometimes. When design is really sublime. Any designer who is able to present us with a deep, transformative experience is adding something special to the world. And is therefore modern.

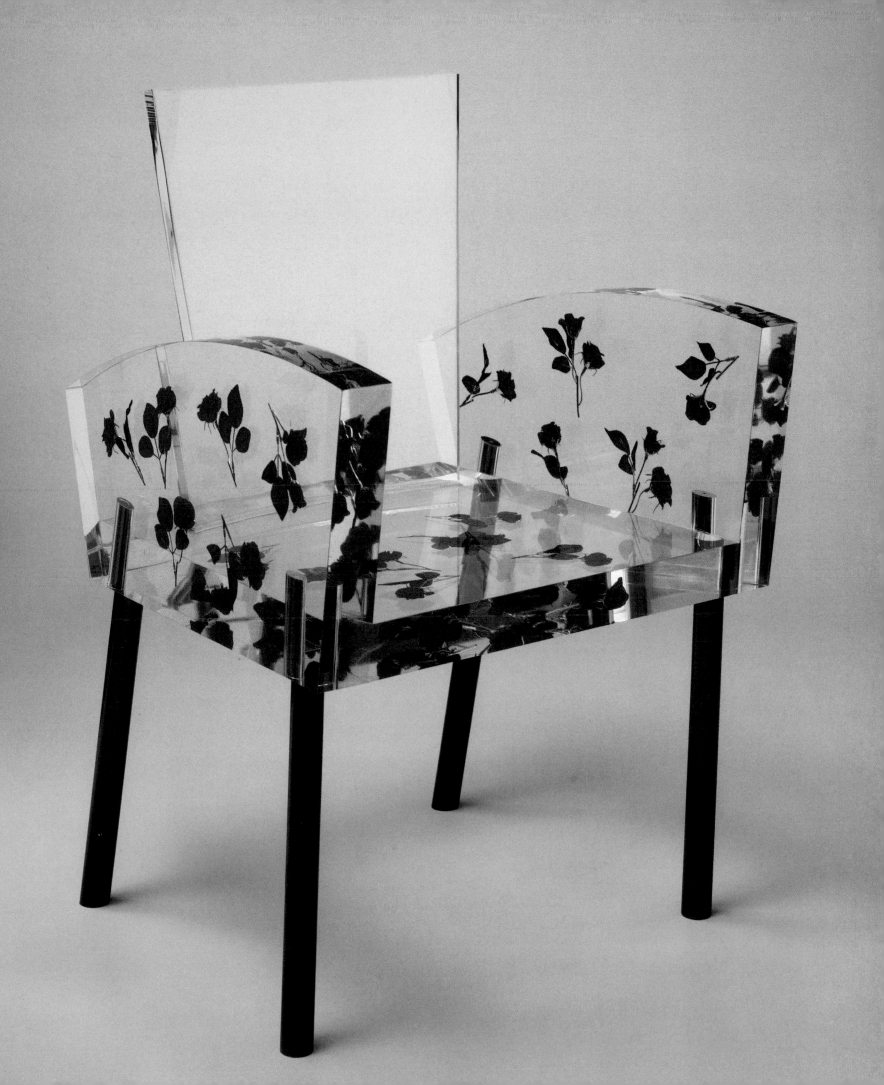

Claire Wilcox

WE ARE ALL IN THE GUTTER: RETAILING POSTMODERN FASHION

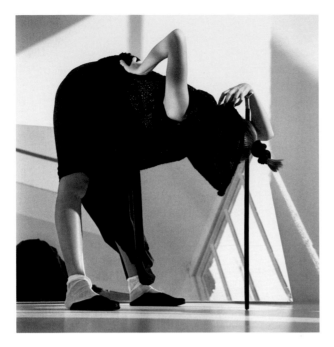

In early 1981, radical Japanese design arrived in Paris. Though she shared the spotlight with her peers Issey Miyake and Yohji Yamamoto, it was Rei Kawakubo, designing under the company name Comme des Garçons, whose work most aggressively challenged existing conceptions of the fashionable body. Press coverage relentlessly linked Kawakubo's monochrome parades of asymmetrical, oversized clothes, and the bruised face make-up of the models, to Japan's post-atomic trauma. In reality, Kawakubo's stance was primarily aesthetic, a sombre riposte to the bright sexuality and 'fit' of 1980s fashion. 'I find beauty in the unfinished and the random,' she said (pl. 156). 'I want to see things differently, to search for beauty. I want to find something nobody has ever found ... It is meaningless to create something predictable.'[1]

Working with designer Takao Kawasaki, Kawakubo opened her first shop in 1976 in Tokyo. Its lack of mirrors denied the first principle of fashion, self-imaging, suggesting self-reflection as an alternative state of mind. The minimal interior of the store situated the act of shopping within a wider conceptual context that drew on concurrent movements in art, graphics and architecture. A Paris shop opened in 1982, followed a year later by her first American outlet at Wooster Street in New York, amidst the artist hang-outs and galleries of up and coming SoHo. Deyan Sudjic wrote: 'No merchandise was visible in the window, and little was on show within the store itself. Instead of broadcasting its wares to passers-by, the store acted as a filter. Its character demanded a certain confidence from the customer – those who would not feel comfortable with the clothes would be unlikely to brave the shop.'[2] Kawakubo was unapologetic about her approach: 'Opening the shop doors wide for all sorts of people to buy the clothes is one way of doing business, but I want the shops to be comfortable for those who like Comme des Garçons.'[3]

The Japanese designers of the 1980s presented an alternative to the Western preoccupation with symmetry and body form achieved by cutting and tailoring, with exacting

darts, fastenings and fabric piecings. Saying 'Perfect symmetry is ugly ... I always want to destroy symmetry', Kawakubo offered a radical concept of mutable form that layered the body with minimally scissored textile, so creating an idiosyncratic and ever-changing relationship between body and garment.[4] Yuniya Kawamura, of the Fashion Institute of Technology, New York, views Kawakubo's statement as 'a perfect summing-up of post-modernism applied to fashion' (pl. 157). Although operating within the fashion system by showing their collections in Paris, Japanese designers offered some release from the fashionable state of anxiety about transgressing, or falling behind a 'now' that is forever just out of reach, for these clothes had longevity. In Kawakubo's case, this was partly because her garments were deemed to have intellectual weight; they were invested with seriousness, perpetuated by the gravity of her avant-garde magazine *Six* (first published in 1988), and highly controlled advertising campaigns. In Japan, aficionados were known as the *karasu zoku* or 'crow tribe'.

However, dressing in this new Japanese style demanded commitment top to toe, for such garments were incompatible with flashy high street accessories, or high heels. Nor was the experience of the consumer comparable with conventional shopping. At Comme des Garçons shops the clothes were often secreted behind screens, neatly folded like textiles or *kimono* rather than splayed on hangers (a relatively recent arrival in Japan), and were only reluctantly divulged by grave shop assistants. The rite of acquisition was played out in an environment of total aesthetic control and a baffling new kind

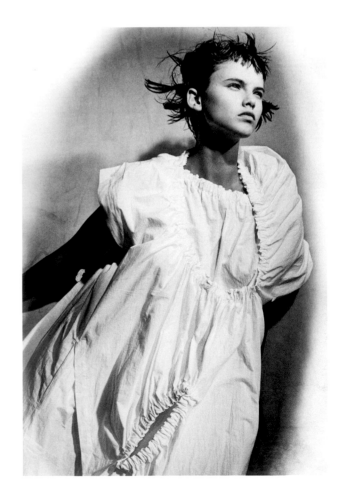

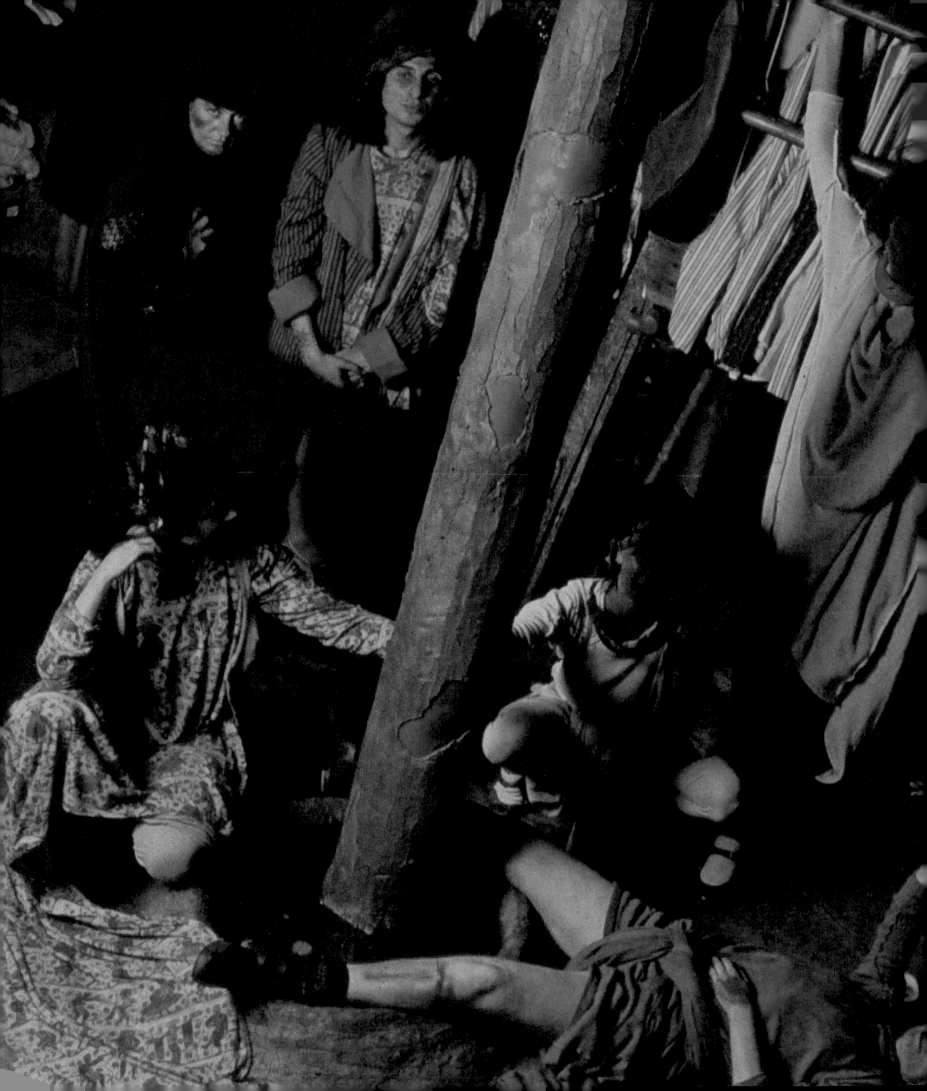

of luxury; the carpeted interiors and lush settings of couture were exchanged for a reductive environment that was closer to an art gallery than a clothes shop. In Wooster Street, the concrete floor was cracked, the walls distressed and unpainted, a stage set for 'a band of survivors from some catastrophe [who] gather in the ruins to barter over the last remains of a more technologically advanced society'.[5] Kawakubo said, 'I don't really want to be called a designer. Design should be understood in a broader sense from now on. Managing a company is also design. I believe that clothes and shops are just different forms of our same expression.'[6]

Kawakubo's retail futurism briefly found a corollary in post-punk London. During the 1970s, Vivienne Westwood and Malcolm McLaren's shop at 430 Kings Road had been a rapidly evolving stage for their political and sartorial preoccupations, and a meeting point for McLaren's 'dispossessed'. After 1980, the shop settled into its final, Dickensian manifestation as World's End. In March 1982, a second, short-lived shop called Nostalgia of Mud was opened in St Christopher's Place, W1 (pl. 158). According to McLaren, the space 'looked like an archeological dig; I purposely made it look as if it was permanently closed or under construction'.[7] The shop had no ground floor; scaffolding steps descended into the basement where an iron pillar caked in verdigris rose up from a bubbling pit of oily liquid, while the clothes were hung from rusting poles. A meld of African mud hut and Regency detailing, it also owed a debt to the filmic visions of Stanley Kubrick's *2001: A Space Odyssey* (1968) and Ridley Scott's *Blade Runner* (1982). Outside, a muddy relief map of the world obscured the front, while the door was draped with ex-army tarpaulins which customers had to pull back in order to go inside. 'This imposing act alone made entry quite intimidating, as they couldn't see into the shop any other way,' wrote Roger Burton, who designed both World's End and Nostalgia of Mud. 'I felt that this was in the tradition of Malcolm and Vivienne's previous shops, which were certainly not for the faint hearted.'[8] Impatient with the demands of trade, McLaren declaimed, 'These shops were beautiful stage sets and never designed to sell anything.'[9]

In their subversion of glossy power dressing and manipulation of scale, the McLaren/Westwood collections of 1982–3 momentarily inhabited the same landscape as Kawakubo and her compatriots, a fact that Westwood acknowledges, saying, 'The Japanese designers were all the rage ... they were very clever, they looked at my silhouettes and then enlarged them, and so I enlarged mine too.'[10] *Savage* (Spring/Summer 1982), *Nostalgia of Mud* (Autumn/Winter 1982) and *Punkature* (Spring/Summer 1983) retained the tribalism of punk but introduced a global beat, even if this was only plundered from the pages of *National Geographic* magazine (as McLaren put it: 'Wear an African dress, and put it with a Dominican hat, throw in some Peruvian beads, and wear make-up like one of the tribes in New Guinea').[11] The hobo inhabitants of Nostalgia of Mud, with their smudged faces and baggy layers, shared a sense of time and placelessness with

Kawakubo's waifs, with their voluminous, archaic wrappings, seemingly patched from fragments. The footwear (flat shoes cut from a single piece of leather and heavy walking boots in the case of Kawakubo, fabric-wrapped shoes and fall-down boots in the case of Westwood) suggested the trudging journeys of exiles and refugees, while Kawakubo's cut and reformed jumpers with their giant moth-eaten holes found a next of kin in Westwood's patched, faded dishcloth fabric cardigans buttoned with rusted Vim lids (pl. 159).

However, Westwood's literalness ('my stimulus is always intellectual')[12] and kaleidoscopic collaging could not have been further from Kawakubo's instinctive, reductive approach, 'from nothing, from zero'. 'I start every collection with one word,' Kawakubo stated. 'I can never remember where this one word came from. I never start a collection with some historical, social, cultural or any other concrete reference or memory. After I find the word, I then do not develop it in any logical way. I deliberately avoid any order to the thought process after finding the word and instead think about the opposite of the word, or something different to it, or behind it.'[13] Certainly McLaren agreed, writing of Westwood's increasingly historicist work, 'I never understood her deep interest in form; I was always wanting to *destroy* form. Concept, on the other hand – in fashion, making clothes out of nothing, destroying form, constructing form, which Rei Kawakubo has spent a lifetime doing – is a very different, very new way of thinking, a new way of writing the story. It's a matter of synthesis, of combining elements from radically different sources, rather than telling a traditional narrative.'[14]

Kawakubo's success in the West allowed her to achieve *gyaku yunyu* ('reverse importation'), reintroducing to the Japanese consumer an authorized, distinctive, postmodern vision of Japan's own sartorial codes. Westwood arguably achieved a similar coup in bottling up English eccentricity and her ironic critiques of femininity are still an important influence on Japanese street fashion. While the two designers' deconstructivist approaches eventually took different trajectories, it would appear that punk and the forces that shattered music, design and fashion liberated both of them. In turn they triggered an alternative series of fashion and retail landscapes. Richard Martin commented in 1995 that 'It took Kawakubo to open the West's eyes to punk as more than a musical aberration or a costumed theatrical.'[15] However, both designers showed that in the wake of punk, and by the abandonment of Western 'fit', in both its literal and conceptual sense, fashion could slide forwards and backwards in time, in what Westwood described as a 'nostalgia for the future'.[16] Despite the fact that they were drawing on entirely different sartorial traditions of East and West, as entrepreneurs in the postmodern landscape both Kawakubo and Westwood were able to deconstruct and reconstruct fashion to their own agenda and offer revolutionary retail models based on more than a hint of peril. As Kawakubo said, 'Playing it safe is the risky business.'[17]

159
Vivienne Westwood and Malcolm McLaren, Ensemble from *Punkature* collection, Spring/Summer, 1983. Photograph by Michel Momy

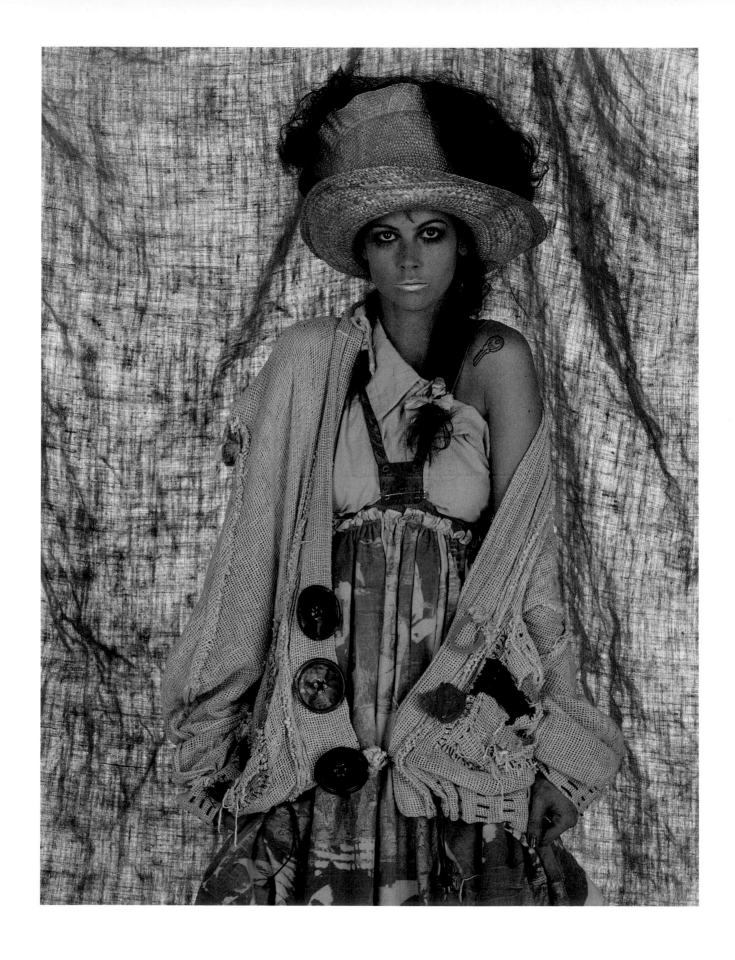

Catharine Rossi

MAKING MEMPHIS: 'GLUE CULTURE' AND POSTMODERN PRODUCTION STRATEGIES

Ettore Sottsass nearly didn't make it to the launch of the first Memphis collection, unveiled in September 1981 during the annual Milan Furniture Fair, the Salone del Mobile. Instead, he and several other members of his design group were stuck in traffic, blocked by the crowd of 2,500 who turned up to get a glimpse of the 55 pieces of furniture, clocks, lamps and ceramics on show at the Arc' 74 gallery.[1]

This was just the start of the media frenzy that erupted over Memphis. Over the course of several years, more than 100 articles, several exhibitions and much debate were devoted to what the catalogue declared to be the 'New International Style' or 'New Design'.[2] Neo-modern, neo-primitive, neon-coloured plastic laminates and new formal possibilities: novelty was inscribed into the Memphis rhetoric. Yet the reality that lay behind this façade was not what we might expect.

Memphis hadn't come out of the blue. Sottsass traced its origins back to 1965, and the 'very strange' laminate-covered *Superboxes* he designed for Poltronova. The Pop-inspired totemic wardrobes bear similarities to the Memphis aesthetic, yet it would take '10 years of anti-design', as Sottsass put it, for Memphis to be realized.[3] Sottsass' leading role in Radical Design saw his involvement in both the Global Tools collective and Studio Alchymia, and in 1976 led to his inclusion in the Cooper-Hewitt Museum's 1976 exhibition *MANtransFORMS*, curated by Hans Hollein.[4] This in turn became the subject of the first article that Barbara Radice, future Memphis art director

and Sottsass' partner, would write about the architect. The article was titled 'Sottsass e il Memphis Blues 76' and it was this article, as much as Bob Dylan's record stuck on loop one fateful night in December 1980, which lay behind the group's name.[5]

Early documents declared a guerrilla approach to the collective: 'Memphis is not a company, a factory, an artisanal workshop or a retail shop, but a point of reference'.[6] In fact, Memphis actually was a registered company, with Sottsass Associati, Mario and Brunella Godani (the owners of Arc '74) and local furniture-maker Renzo Brugola as partners. Brugola provided some financial backing, as did the lighting manufacturers Fausto Celati and Ernesto Gismondi, whose firms were responsible for producing lamps such as Martine Bedin's *Super* (pl. 47, p. 44). Gismondi, head of Artemide, would become Memphis' president.

Abet Laminati produced the plastic laminates (layers of Kraft paper set in plastic using heat and pressure) for the furniture, and also sponsored the first Memphis publications. Italy's largest laminates manufacturer, Abet had been both benefactor and beneficiary of Radical Design; in 1972 it had provided sponsorship for the Museum of Modern Art's *Italy: The New Domestic Landscape: Achievements and Problems of Italian Design* (New York, 1972) and had realized experimental designs by Alchymia, Sottsass and Superstudio. Sheathed almost entirely in Abet laminates, Memphis furnishings only provided more publicity for the firm.

160
Marco Zanini (for Memphis),
Colorado tea pot, 1983.
Earthenware. V&A: C.207–1985

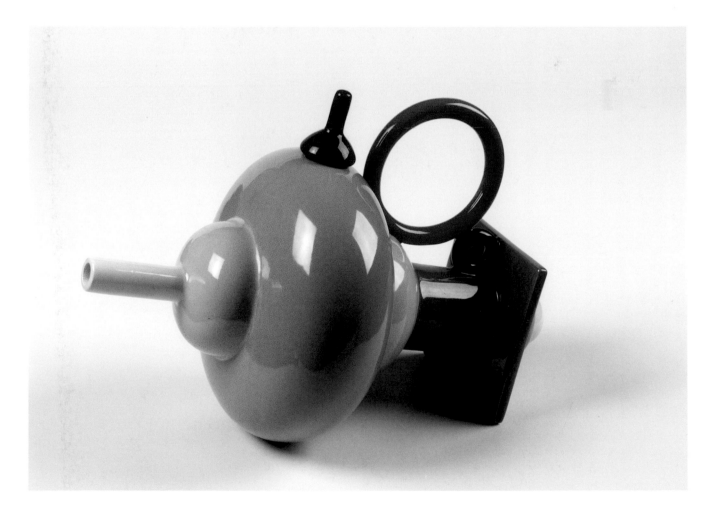

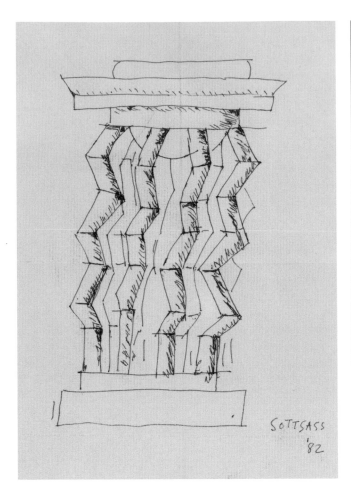

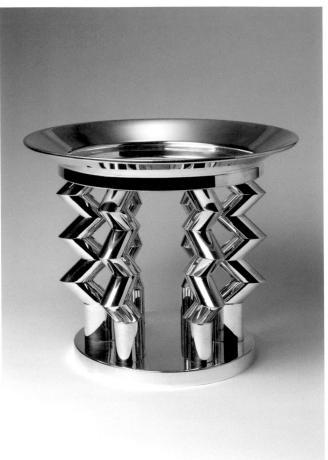

Other manufacturers also lent support to the Memphis project – Lorenz and Brionvega provided clock mechanisms and televisions respectively. Despite the support of large-scale industry, however, small-scale craftsmanship was at the heart of Memphis. The objects displayed at Arc '74 were all prototypes, handmade within the network of artisanal workshops that had long played a key role in Italy's design success. *Design* magazine's 1983 special issue on Italy confirmed the artisan's importance in the post-industrial landscape: with industry stagnant, it was the flexible, family-run craft workshop – though an 'anachronistic industrial structure' – that was recognized as Italy's productive strength.[7]

Memphis conformed to this picture. Brugola, at one time the owner of a jazz shop but also the third in a generation of carpenters, oversaw production of the Memphis furniture from his Lissone workshop, while the nearby firm of Nino Ornaghi upholstered the furniture in fabrics designed by Nathalie du Pasquier and printed by Rainbow in Como.[8] Matteo Thun's ceramics were made by Ceramiche Flavia in Montelupo Fiorentino.

The more Memphis progressed, the more it engaged with the strongholds of Italy's craft traditions: for the second and subsequent collections Ceramiche Flavia and Alessi Sarri in the Florentine hinterland and Porcellane San Marco in Nove produced ceramics designed by Sottsass, Thun, Masanori Umeda and Marco Zanini (pl. 160). To the north of Milan, Elio Palmisano oversaw the weaving of Du Pasquier's rug designs.

The 1982 output also marked a turn toward more luxurious materials, with objects made by marble producer UP&UP in Carrara, glassmaker Toso Vetri d'Arte in Murano (pl. 163) and the silversmiths Rossi & Arcandi in Vicenza, this last overseen by design impresario Cleto Munari (pls 161 and 162).

Long-standing relationships between architects and artisans bred mutual understanding, vital for the realization of Memphis objects. Brugola had been executing Sottsass' designs since the late 1950s; together they had created his installation for the 1960 Milan Triennale, interiors for Olivetti and numerous international clients. Brugola's knowledge of Sottsass' approach, from the thickness of materials preferred to the finishes used, negated the need for formal design drawings, allowing the designer to work through informal sketches and workshop-based verbal discussion.

Although situated in Italy's historic centres of craft production, the majority of the firms involved had only been set up from the mid-1960s onwards.[9] This arguably made them not only more receptive to Memphis' provocative designs, but also more amenable to the new relationship its designers were trying to forge with craft and industry. This was what Andrea Branzi described as the 'New Handicrafts' of the post-industrial society, first seen in Alchymia's 1979 *Bauhaus* collection:

The craftsmanship employed, given that production is made up of small runs or unique pieces, does not depend on the use of particular techniques, but rather on the speed

with which the models whose design makes no concessions to the possibility of future mass production are constructed by craftsmen using the most advanced techniques of modern joinery.[10]

According to Branzi it was expediency, not ideology, which accounted for the handmade status of Alchymia and Memphis, something Sottsass confirmed. Memphis, he said, had 'nothing to do with the craft revival'.[11] As proof, he claimed that the furniture and materials 'can all be produced by machines'.[12] This, however, proved untrue. As Gismondi later conceded, Sottsass' *Carlton* sideboard cum room divider 'is built up of numerous pieces of plastic laminate glued onto wood, each piece being different from all the others. On no account can this be produced in series. There is no option other than doing it by hand.'[13]

Sottsass did acknowledge one area of Memphis' production as reliant on 'manual skill': the glassware he designed alongside Michele De Lucchi and Zanini from 1982 onwards.[14] The pieces were made by Toso Vetri d'Arte, set up in 1980 by Luigi Toso and three glass-blowing *maestri*: Luigi Visentini, Dino Toso and Carlo 'Caramea' Tosi. Tosi had worked for over 30 years on Murano, and was renowned for his particular skill in goblets.[15]

The 1982 *Sirio* goblet exemplifies Sottsass' first Memphis glassware. The bright colours and skill necessary to hot-join the stacked and encased glass elements situate it in the long and prestigious tradition of Venetian glassmaking. But its totemic assembly, toy-like appearance and asymmetric handles signalled Sottsass' irreverence towards Murano's fabled production. For the 1986 collection Sottsass went further. Fruit bowls and vases such as *Attide* were adorned with glass earrings, dangled off handles that were glued, not hot-welded, onto the glass surface. As he explained: 'Don't be surprised … if some of the glass is glued together to allow a little more speed rather than melted together according to custom. And what difference does it make? Isn't glue-culture an invention like the culture of glass?'[16] Adhesive permitted Sottsass to import into a luxury craft context a DIY collage aesthetic explored in transgressive punk graphics, such as the fanzine *Sniffin' Glue*; but through this contamination of the island's

canon of glass techniques, it also offered the opportunity to depart from what he saw as a 'hermetic' milieu of specialized skill.[17]

Sottsass was not the first Italian designer to experiment with glue. New possibilities had arisen from post-war technological developments in the adhesives industry. Gaetano Pesce's *Golgotha* fibreglass and polyester resin chair and table for BracciodiFerro, the experimental workshop set up by Cassina in 1972, had explored the formal and productive potential of this new material.

Sottsass himself had used glue to join glass before, in a series of geometric plate glass vases and desk objects for Fontana Arte from 1979. But really it was the Californian ceramist Peter Shire's experiments that should be credited as providing the inspiration. Sottsass spoke admiringly of Shire's approach to clay: 'He was producing ceramic planes and gluing them together like you would build a house of cards. And then he was gluing together other elements like strings or cylinders or cubes or handles – spouts, cups, and everything.' The result was that you could 'produce figures that nobody could produce, ever'.[18]

As a material, method of assembly and idea, glue binds Memphis together. It liberated glass from its cultural and material constraints. Laminates could be glued to fibreboard, fake marble juxtaposed to the real thing. Memphis designers even made adhesive a visual trope in its own right: the colourless glass globules in *Sirio* that join the handles to the vessel, and the exposed black lines of the laminate edges on *Carlton* that signal the technical means of the furniture's fragmentation (pl. 164).

Though 'glue culture' may have been iconoclastic, the production strategies involved point to an underlying conventionality in Memphis. Just like Italian designers of the 1950s and 60s, Sottsass and his colleagues relied on progressive manufacturers, open to aesthetic and technical innovation, and the ability of artisans to turn their skills to materials and processes, both new and old. Post-war Italian design is in part a story of the negation of craft. The degree to which the artisan was complicit in making Memphis suggests that its story, too, was not just one of revolt and rupture, but also of continuity and consensus.

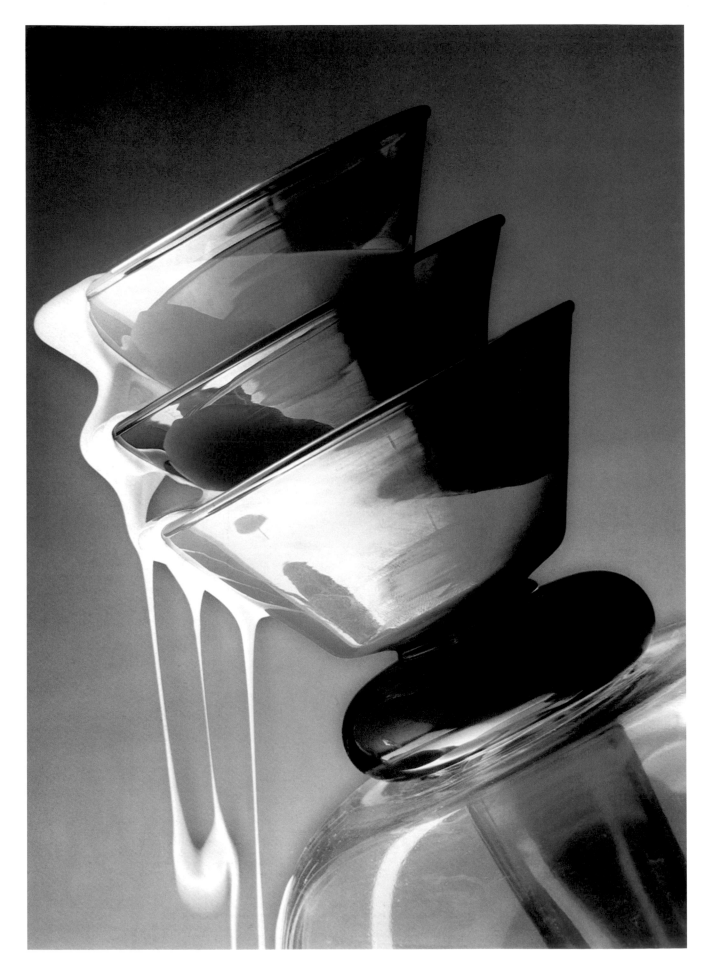

Marco Zanini (for Memphis),
Alpha Centauri overflowing
with Dior face cream for *Donna*
magazine, no. 29, 1982–3.
Blown glass. Photograph
by Robert Carra

Opposite: 164
Ettore Sottsass (for Memphis),
Carlton bookcase, 1981.
Multicoloured and patterned
laminate over chipboard.
Photograph courtesy of
Christie's Images 2011

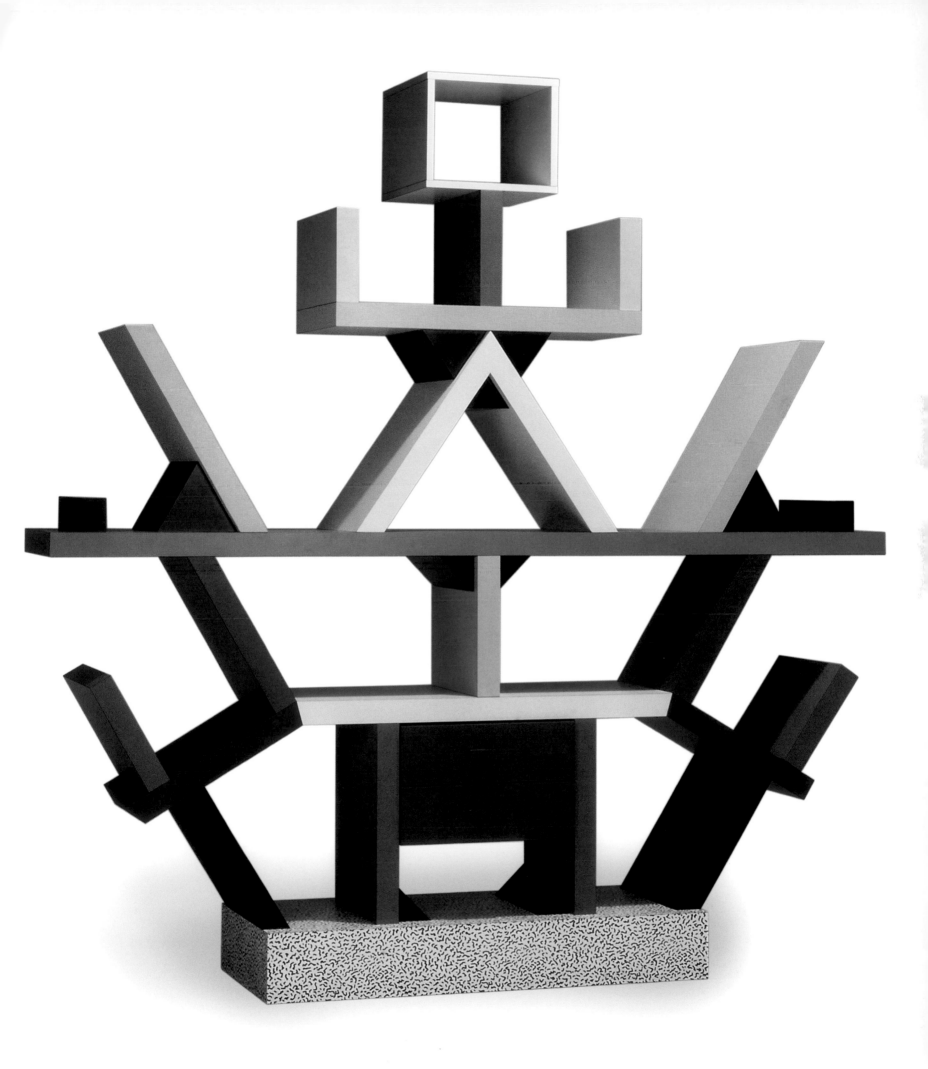

Christopher Breward

THE USES OF 'NOTES ON CAMP'

In the millennium year of 2000 the celebrated American intellectual Susan Sontag was featured in an advertisement for Absolut Vodka, momentarily distracted in her study, streaked mane swept back from her brow, white cotton shirt rolled back from the wrists, collar flicked up, pencil placed on pad. Her lover, the photographer Annie Leibovitz, had taken the photograph and persuaded its subject that it might be re-used for the campaign. As literary theorist Dana Heller observes:

> On the desk immediately before her, as if it were one of her own manuscripts, sits Absolut's 1991 ad featuring only a black thumbprint on white with copy reading, 'Absolut Evidence'. Her novel *In America* is positioned visibly on the desk also, which reinforces the sense that the Absolut ad is something that she might have created.[1]

In obituaries that followed Sontag's death, her appearance in this context was taken as evidence of the author's selling out to a popular culture she had all but rejected in her mature career, but whose colourful surfaces had provided the inspiration for her early forays into radical cultural criticism. It was a delicious irony that brought her intellectual journey full circle. Heller sees no contradiction here, but argues for a continuity in Sontag's work and persona that links her mid-1960s iconoclasm with her incorporation into the celebrity system of the 1980s and 90s. Her point is also the key point of this short essay: that Sontag's most famous early work, 'Notes on Camp', and the manner of her life, can be viewed as primers for understanding certain aspects of postmodernism. Heller's assessment is worth quoting at length:

> [Sontag] addressed – without naming it as such – the paradigm shift that would come to be known as 'the postmodern turn'. Modernism, she wrote, had in the final analysis, 'proved acutely compatible with the ethos of an advanced consumer society.' Indeed, the culture industries were either writing off aesthetic seriousness altogether or incorporating its techniques into their own corporate proliferation of vulgar satisfaction. But what Sontag did not prognosticate quite as clearly was that the intellectual, stripped of her heroic adversarial stature, had also become necessarily commoditized, a feature of the highbrow lifestyle that had been remade, packaged, and sold in accord with advanced consumer capitalism's niche-marketing tactics.[2]

'Notes on Camp' came to prominence in 1964, when Sontag placed it in the literary journal *The Partisan Review*. It brought the talents of the young philosopher to the attention of an international audience following its re-publication in her collection of essays *Against Interpretation* of 1966 and found a particular resonance in the world of fashion, performance, art and design during the following, superficially more austere, decade. Its 58 'jottings' provided a lexicon of style against which both the avant-garde offerings of the first generation of postmodernists and the languid rhetoric of 1970s and early 80s high glamour might be read. The first premise of the essay – 'Camp is a certain mode of aestheticism. It is one way of seeing the world as an aesthetic phenomenon. That way, the way of Camp, is not in terms of beauty, but in terms of the degree of artifice' – is thus a clarion call for those who positioned their work and attitude beyond the more reductive tenets of Modernism.[3] Developing her theme, Sontag went on to suggest 'random examples of items which are part of the canon of Camp'. In so doing, she produced a prophetic notion of stylization that would only be materially and conceptually realized in the postmodernist, post-1960s moment.

Right: 165
Ettore Sottsass, *Basilico* teapot prototype, 1972. Painted wood. Centre Georges Pompidou, Paris (AM 1999–1–80)

Far right: 166
Eric Schmeilt Designs Ltd, Fiorucci shopping bag, 1978. Paper and plastic. V&A: E.896–1978

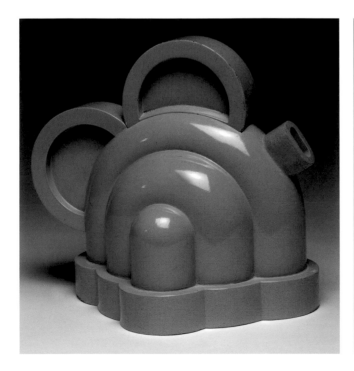

I should like to highlight two case studies, of an object by Ettore Sottsass and another associated with Elio Fiorucci, which attest to Sontag's foresight. Sottsass was perhaps the most forward-looking of a generation of designers that transformed the language of Italian design from the early 1960s, through a philosophical embrace of the world of the image as a context for making and manufacturing. On his trips to the United States in 1956 and 1962, and an exposure to the Beat poets in San Francisco and a nascent Pop Art movement in New York, he would have encountered as fertile a repertoire of new signs and sensations as Sontag recorded in her 'Notes'. This immersion found parallels in the work of Claude Lévi-Strauss, who was simultaneously providing a structuralist, semiological framework for understanding the visual and political challenges of a rapidly expanding consumer culture of relevance to architects, designers and cultural commentators.[4] Interwoven with Sottsass' visits to the United States was an equally revelatory pilgrimage to India in 1961, where, as he later recalled:

> I blanked out the past, ignored mathematical logic and the principles of design ... I ignored the whole philosophy of Madison Avenue, the degrading philosophy of television advertising, the logic of costings, investment, revenue ... I decided to investigate the barest elements of my existence, where all that remains are nerve endings and sensory perception ... where there's nothing more than a triumphant, violent, heroic, victorious and yet tragic sense of belonging to the planet.[5]

Sottsass produced a number of prints, ceramics and models expressing the profound effect that Eastern mysticism had on his vision of the world. His *Basilico* teapot (pl. 165), for example, from the *Indian Memory* series of 1972, evoked the concave stupa of Buddhist ritual. But more than this, it signalled an openness to cultural assimilation that would come to characterize his mature work. It also informed his reflections on modern American life, experienced almost simultaneously with the retreat to South Asia. As architectural historian James Steele notes:

> He was struck by the idea that these two diametric experiences were also different sides of the same coin; that people in each culture had to consume in order to survive, but that the disparity of financial means would result in far different manifestations of consumption ... He began to realize that consumerism is endemic to the human condition, rather than being a luxury, and products can improve that condition and be inspiring and uplifting, if designed appropriately.[6]

On another level the glossy, jade-green curves of *Basilico* (as suggestive of Art Deco cinema architecture as they are of tantric cosmology) also conform closely to several of Sontag's definitions of the Camp object. 'Camp art,' she wrote, 'is often decorative art, emphasizing texture, sensuous surface, and style at the expense of content ... all Camp objects ... contain a large element of artifice. Nothing in nature can be campy ... Rural Camp is still man-made, and most campy objects are

urban.' And 'Camp is a vision of the world in terms of style ... It is the love of the exaggerated, the "off", of things-being-what-they-are-not.'[7] Most importantly, in its avowed rejection of the modernist principles that had constrained Sottsass in his earlier career, *Basilico* makes manifest Sontag's claim that 'Camp taste is a kind of love, love for human nature. It relishes, rather than judges, the little triumphs and awkward intensities of "character" ... Camp taste identifies with what it is enjoying ... Camp is a tender feeling.'[8]

The tender sensibility of Camp was certainly familiar to Sottsass' compatriot Elio Fiorucci, who opened his first eponymous fashion store in Milan in 1967. Claudio Marenco Mores provides a compelling account of its rationale and importance:

> Fiorucci has invented nothing. And discovered everything. What he sells in Milan is something you've already got. Only better. More colourful and with a history made up of citations, experiments and journeys ... He brings to Italy India, China, plastic and American Pop Art ... Andy Warhol may have claimed that the only beautiful thing in Florence is McDonald's, but in his diaries he is quite serious when he speaks of Fiorucci.[9]

Based loosely on a concept pioneered by Barbara Hulanicki's Biba in London, Fiorucci competed with Studio 54 for the title of most 'in' destination for the 'cool' crowd, the 'Them' satirized in Peter York's sharp-sighted essay of the same period.[10] By the late 1970s it was an international phenomenon with a shop in New York designed by Sottsass, Andrea Branzi and Franco Marabelli. The store's collaborations with Keith Haring, Oliviero Toscani and Alessandro Mendini ensured its status as a fulcrum of popular postmodernism. Its carrier bag, produced by Eric Schmeilt Designs in 1978, was emblazoned with a Day-Glo green 'punk meets Flash Gordon' logo and an ad hoc bricolaged graphic of a bright pink television set, purloined from some Asian or Eastern European promotional catalogue (pl. 166). In its brash and glamorous banality it was, like all the other products of the shop, a reflection of Elio Fiorucci's belief that 'fashion and aesthetics are the real writing of our time'.[11]

Again, Sontag provides the interpretation before the fact: this is a revolutionary aesthetic with the capacity to move beyond accepted standards: 'Camp taste turns its back on the good-bad axis of ordinary aesthetic judgment. Camp doesn't reverse things. It doesn't argue that the good is bad, or the bad is good. What it does is to offer for art (and life) a different – a supplementary – set of standards.'[12] In these lines, perhaps, lies the predictive power of her essay and an indication of the reasons why it has become something of a postmodern classic, returned to repeatedly, especially by successive generations of art and design students – and also, one suspects, by the theorists and practitioners of postmodernism itself (see pl. 167). Whilst its content was later repudiated by the author, and by those in the emerging discipline of queer studies who attacked its supposedly homophobic slant, 'Notes on Camp' unsettles the modernist assumption, rife especially in the British (Birmingham) school of cultural studies, that taste is a prescribed set of values rooted only in the politics of class and race.[13] Its introduction offers a far more radical approach:

Taste has no system and no proofs. But there is something like a logic of taste: the consistent sensibility which underlines and gives rise to a certain taste. A sensibility is almost, but not quite, ineffable. Any sensitivity which can be crammed into the mold of a system, or handled with the rough tools of proof, is no longer a sensibility at all. It has hardened into an idea.[14]

In her youthful enthusiasm, Sontag bequeathed a joyous and unfettered lexicon for a new take on the world and her observations, assigning rather than prescribing value and opening up the possibilities of a postmodern subjectivity, even as they predicted her own metamorphosis into 'brand', should be celebrated as such.

167
Jeff Koons, *Louis XIV*, 1986.
Stainless steel. The Nasher
Collection, Dallas, Texas
(1988.A.07) © Jeff Koons

Oliver Winchester

TOMORROW'S BEEN CANCELLED DUE TO LACK OF INTEREST: DEREK JARMAN'S 'THE LAST OF ENGLAND'

Derek Jarman's *The Last of England* (1987) is a difficult film. When probed on its meaning Jarman (pl. 168) replied by quoting Oliver Cromwell's address to Parliament upon its dissolution in 1654: 'For the day of vengeance is in my heart and the year of my redeemer is come ... And I will tread down the people in mine anger, and make them drunk in my fury.'[1] Both a biting political critique of Thatcherism and a loosely contoured elegy written from the standpoint of an all too possible future, the film is a meditation on the state of Britain in the 1980s.[2] Peculiarly British in character, it is simultaneously romantic, conservative and anarchic. It also loosely associates the sick and diseased body politic with the HIV-infected body and stands as the first of Jarman's works to emphatically engage with desire, the social construction of community, illness and memory. Whilst Jarman himself was only diagnosed as carrying HIV on 22 December 1986 (just prior to editing the film), he was undoubtedly aware of the possibility of his positive status when he declared in an interview some months earlier that 'No metropolitan gay man can be sure he will be alive in six years.'[3]

The film darkly imagines an unspecified future for England with desperate characters populating industrial ruins: a ragged figure gnaws at a cauliflower; a crippled businessman fruitlessly pours grain from a bowler hat; a bride manically attends to a baby swaddled in discarded tabloid papers, surrounded by bearded bridesmaids in a macabre satire of matrimony. Towards the film's close the same bride, played by Tilda Swinton, frantically cuts herself free from her wedding dress with a huge pair of shears. Scenes of dejection or hysteria are matched by images of violence: the viewer bears witness to an abortive sexual act between a masked soldier and drunken man on a soiled bedspread with the Union flag; a booted and disaffected youth masturbates over an Old Master painting (a copy of *Amor Vincit Omnia*, used as a prop in Jarman's previous film *Caravaggio*); soldiers, some of whom hide behind balaclavas that are suggestive both of the IRA and the SAS, execute a lone, unarmed man. Perhaps most directly referencing the Iron Lady, one sequence presents a grotesque funeral attended by a Thatcher-like figure who praises a group of gunmen, asking them if they 'enjoyed the Falklands' and demanding that they 'keep up the good work'. The film closes with a boat of huddled refugees departing the country at twilight, a direct reference to the 1855 painting *The Last of England* by Ford Madox Brown, which depicts émigrés leaving England to start a new life abroad.

The visual texture of the film itself adds to the sense of physical and moral decomposition. An intended by-product of the transfer of the Super 8 and 16mm footage to 35mm, the film is saturated with colour, blurred contours and grainy texture, effects that impart a thick and decaying material patina (pl. 170). The footage runs at varying speeds. Flames burn throughout the film; there are shots of surveillance equipment and views of Dungeness nuclear power station, and an audio track featuring sirens and a sampled speech by Adolf Hitler. All combine to provoke a discomforting vision of an England gone horribly awry.

Whilst the film is aesthetically sophisticated, it is nonetheless low-tech in its production values and inventive in its use of imagery. Jarman gathered his friends and associates

168
Derek Jarman, 1980

in the autumn of 1986 for the ten-day shoot in London's East End. Reusing the abandoned set of Stanley Kubrick's *Full Metal Jacket* (1986) in Beckton and a nearby derelict flour mill for the interior sequences, *The Last of England* was shot with very little money and produced in a characteristically informal climate. Unlike conventional feature-length films, no daily rushes were produced as Jarman felt this would give the film vibrancy. Scenes were filmed using a variety of cameras shooting at different angles in both black and white, and colour. Writing in the book that accompanied the film, Jarman remarked that 'The film is documentary. I've come back with a document from somewhere far away. Everything I pointed the camera at ... had meaning, it didn't matter what we filmed. The film is our fiction ... My film is as factual as the news.'[4] Thus the amassed raw footage was less an auteur's singular vision than the document of a collaborative process, a record of serendipitous accidents and improvised moments.

The film's non-synchronous, evocative soundscapes and violent edits recall Jarman's trio of music videos for The Smiths, collectively titled *The Queen is Dead* (1986). Yet whilst Jarman considered that music video was the single most significant shift in cinematic language of the 1980s, he condemned many as 'showy and shallow'.[5] In contrast, Jarman characterized his film's disco scene as deliberately 'staccato, and aggressive ... 1600 cuts in six minutes. The sequence crashes into the film unexpectedly, the pace is relentless. It should wind the audience.'[6] Indeed, *The New York Times* reviewer Janet Maslin dubbed it 'the longest, gloomiest rock video ever made'.[7]

Eschewing traditional narrative coherence or the linear progression of a story line, the film instead works at the level of an immersive cinematic experience; meaning is suggested through an accumulation of sequences, forming what Jarman described as 'dream allegory'.[8] It is the visceral experience of watching *The Last of England* and the way in which Jarman actively prompts psychological effects in the viewer through suggestive juxtapositions that give the work its power. In the journal that accompanied the film's release, Jarman wrote that 'Apart from being stuck with my film for eighty-five minutes, my audience have much greater freedom to interpret what they are seeing, and because of the pace, think about it. I have my own ideas but they are not the beginning or the end.'[9]

Threaded through the film, and added only weeks before its completion, is a set of sequences that provide a reference point for the audience and prevent the film from folding in upon itself, collapsing into incoherence. Jarman is shown writing at his desk, or working on paintings with 'prose poem' voice-overs by Nigel Terry. However, the relationship between these images and the accompanying narration is unclear. The words seem to hover somewhere between commentary and prophesy. As Jarman put it, 'Here the present dreams the past future.'[10]

Time is further complicated in sequences that include various of Jarman's Super 8 films, shot months or years earlier, which he cannibalistically spliced into the film. The relative cheapness of Super 8 equipment and film meant that footage could easily be shot, collected, stored and amassed for use at a later date. Jarman noted that 'These Super 8 films ... are home movies, an extension of my father and grandfather's work', segments of which are also threaded through the film.[11] Jarman's father and his grandfather had both been keen amateur film-makers, and an early sequence in the film splices together views of urban ruin, shot from a moving car window, with footage of Jarman's grandparents carving a roast. Later we see Jarman himself as a toddler playing with his sister Gaye in a sunlit garden. Certainly the recycling of these inherited private images suggests a sense of loss and of time passed; Jarman said that all home movies bespoke 'a longing for paradise'.[12] Yet this plundering of the family archive is complicated by the inclusion of other, less innocuous material, shot by Jarman's father. A career officer in the RAF, Lance Jarman's camera had recorded Second World War bombing raids, views of imperial India and an unsettling militaristic past.

The juxtaposition of fictional sequences with inherited home movie footage, deeply personal for Jarman yet merely evocative to others, brings into question the conventions of each of these film modes. The idyllic home movies suggest memories for the cast of characters who populate the film and their inclusion provokes a strong sense of empathy within the audience. Consequently the emotional response to the dystopian sections of the film is heightened, and the sense of social disintegration magnified. Conversely, however, this juxtaposition of home movies against sequences of imagined ruination highlights the constructed and regulatory nature of the social systems upon which the home movie depends.

Home movies are oddly related to reality. An indexical document of a particular moment in time, the home movie is also deeply enmeshed within the emotionally loaded circumstances of production and viewing – the social institutions of the home and family. As memento, they are implicated in the construction of memory and personal history, and serve as a form of inheritance. Yet conversely their very fragmentary nature works against such a tidy idea. As Tracy Biga has noted in her study of Jarman's work, 'although home movies are shot, they can not be said to be authored.'[13] They do not conform to film convention, and often lack a beginning, middle or end. Though they are without coherent narrative, they nonetheless serve as both document and a vessel of memory.

Quietly and surreptitiously then, in combining inherited and invented images and by oscillating between the personal and the political, shifting temporal registers between an indistinct present, fictional future and mournful past, *The Last of England* disrupts cinematic authority (pl. 169). In its place Jarman creates a continual present that is reminiscent of Fredric Jameson's characterization of the postmodern shattered experience of time and place, where 'as temporal continuity breaks down, the experience of the present becomes powerfully, overwhelmingly vivid and "material"'.[14]

Opposite: 169
The Last of England,
1987. Directed by Derek Jarman, photograph (from accompanying book) by Mike Laye

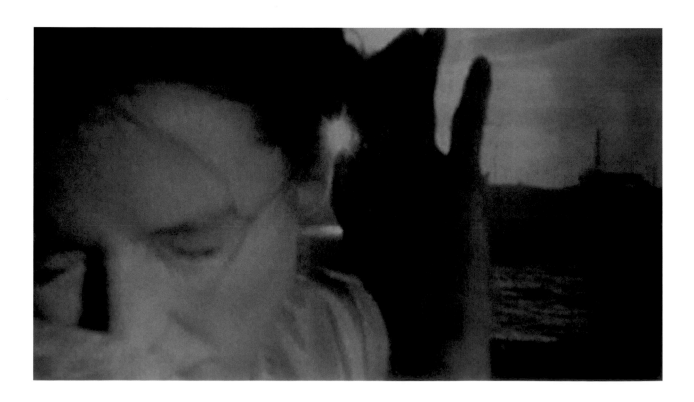

170
The Last of England, 1987.
Directed by Derek Jarman

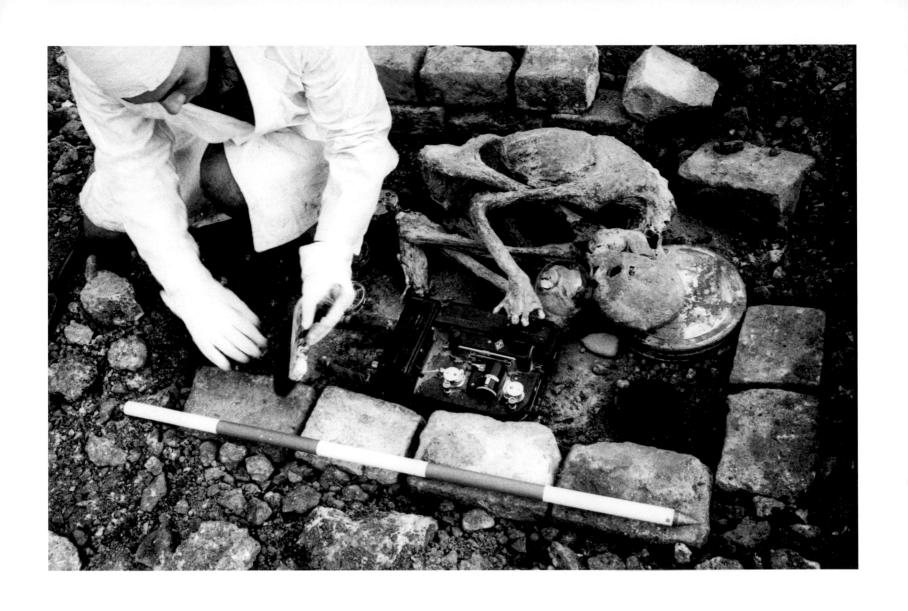

Mari Dumett

UNSETTLED IMAGES: FROM TV SCREEN TO VIDEO-WALL AND BACK AGAIN

From the 1960s through the 1980s, the video-wall asserted a curious presence in the cultural landscape. These multi-monitor constructions sprang up not only in art galleries and museums, but also appeared in nightclubs, security control rooms and the sets of evening newscasts. They helped produce a distinctly postmodern image world for the viewer-consumer. Indeed, arguments have been made for video and television as quintessentially postmodern media.[1] But why did practitioners in such seemingly disparate fields go from using one television to 9, 16, 25, or even 300 monitors? What was to be gained by such exponential multiplication of the screen? Two video-walls, in particular, provide useful, if artificial, snapshots of the history in question.

In 1969, a visitor to the exhibition *TV as Creative Medium* stepped off the elevator in the Howard Wise Gallery in New York City to be confronted by a video-wall. This modest 3 × 3 monitor grid displayed images of a live commercial broadcast, pre-recorded videotapes, and even footage of the viewer him- or herself, captured on camera and looped through a live feedback system. Images flitted from one television to the next via delay cycles and were 'wiped' away every few seconds by a counter-clockwise movement of grey screens (pl. 171).

In 1989, a visitor to the exhibition *Image World: Art and Media Culture* stepped off the elevator in the Whitney Museum in New York City also to be confronted by a video-wall; only this time it is was a 300-plus-monitor behemoth. It displayed an array of appropriated pop culture images distributed via analogue and digital computer technology, with four laser discs. The visuals flashed in time to a thumping disco beat that filled the space (pl. 172).

These two works – *Wipe Cycle* (1969) by Frank Gillette and Ira Schneider and *Fin de Siècle II* (1989) by Nam June Paik – were each positioned as a 'first encounter' within a groundbreaking exhibition. *Wipe Cycle* was one of the earliest video-walls in an art context at *TV as Creative Medium*, the first American exhibition devoted explicitly to video as an art form. Gillette and Schneider themselves represented a new breed of video artists guided by Marshall McLuhan's central tenet: that mediums of communication extend and reconfigure human perception.[2] They had faith in his social prophecies for the electronic age, while increasingly understanding society itself as a cybernetic system of information processing and control.[3] Yet, whereas McLuhan was either naive or indifferent to the relationship between the media and economic and political

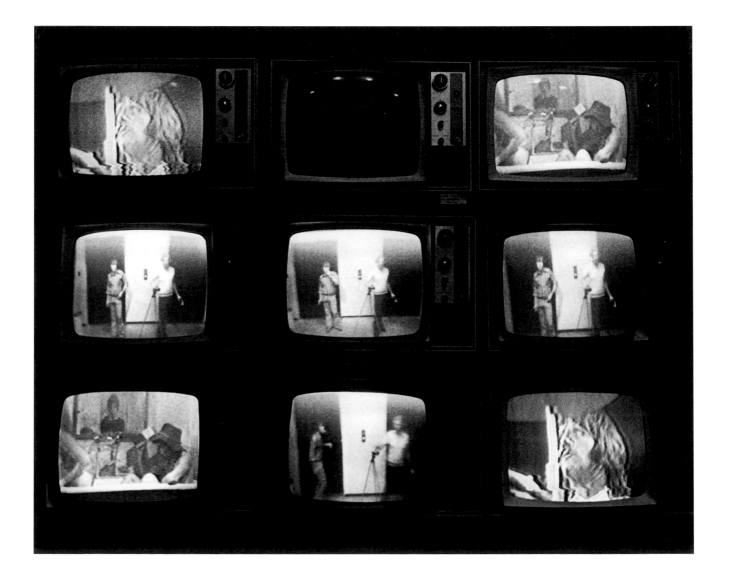

171
Frank Gillette and Ira Schneider, *Wipe Cycle*, 1969. Installation showing live and delayed feedback with broadcast and recorded programming

power in the 1960s, many video artists immediately tuned into the ramifications of television's commercial consolidation. This is why cable television and videotape were so important. Not yet entirely co-opted by corporate interests, these new media were ripe for artistic invention.

In the case of *Wipe Cycle*, videotape facilitated a seamless insertion of the viewer into the transmission, producing a new kind of mediated self-encounter. As Gillette explained: 'It was an attempt to demonstrate that you're as much a piece of information as tomorrow morning's headlines – as a viewer you take a satellite relationship to the information. And the satellite which is you is incorporated into the thing which is being sent back to the satellite – in other words, rearranging one's experience of information reception.'[4] The video-wall activated this 'rearranging' more effectively than any other display format. Through it, artists extended the historical avant-garde technique of collage to electronic media – instantaneously channelling various feeds within a single work – and devised new techniques of feedback and delay so the viewer could see him- or herself not only 'now' but also 8 seconds ago, and 16 seconds ago. With all of these images in juxtaposition and flux, the viewer was (re)produced as screened information, fragmented and dispersed across multiple time-spaces.

Many early video artists wanted to move beyond the limits of everyday TV, beyond a single monitor showing one image on a small screen, beyond its passive audience. One way to do this was by using a projector. But a single 'wall-sized-video' seemed too much like a film; it did not alter the basic relationship of time and distance in images. *Wipe Cycle* offered something different. The multiplication of screens made reference to TV, but it was clearly not a mass media 'entertainment' experience. The viewer was implicated in the work's alternating images, which had to be considered both separately and as part of a larger grouping. Schneider explained: 'The general reaction seems to have been a somewhat objectifying experience, and also a somewhat integrating experience in terms of one's place in the Universe.'[5]

In the late 1960s, this staging of mediated life resonated with the newfound presence of video in the surveillance industry. One's image was increasingly being captured and screened on banks of monitors (video-walls of another kind) via Closed Circuit Television for the eyes of watching security guards. In this electronic advance of Michel Foucault's 'carceral continuum', monitoring became ever more pervasive and individualized, colonizing spaces of everyday life nominally outside the system of social supervision – bank lobbies or the hallways of apartment complexes.[6] The live feedback system of *Wipe Cycle*, by contrast – in which one saw oneself outside oneself, instantaneously – might lead to the realization of one's own status as an actor with the agency to perform beyond established norms.

Twenty years later, Nam June Paik's *Fin de Siècle II*'s massive surface of screens seemed to violently repel any such potential for self-actualization. Critics described the viewing experience as an 'onslaught', a 'flashing and thunderous dispersal of consciousness' that produced a 'vague sense of menace'.[7] It was the showcase work in the first major exhibition dedicated to art's relationship to mass media in the United States, a relationship advanced to such a degree that the curators spoke of an 'image world' rather than emphasize any single medium. Had Guy Debord's 1967 theory of the 'society of the spectacle' become reality?[8] Paik's high-tech, proficient coordination of empty signifiers seemed to suggest it had.

Yet *Fin de Siècle II* shared little of the critical tenor of Debord's analysis. Instead, the piece, and the Whitney show in general, were more akin to the post-structural account of media provided in the contemporary writings of Jean Baudrillard. Paik's video-wall might even be said to have materialized Baudrillard's notion of a society of simulation – an almost self-generating and monolithic machinery of image production, consumed by the 'silent majorities'.[9] Neither art nor theory offered much hope for differentiation between the floating representations of mass media, or understanding of their inscriptions of desire and power. Neither Paik nor Baudrillard seemed to find space for heterogeneous subject positions in the act of reception. They bespoke a fatalistic 'postmodern' millenarianism – the end of (art) history, the end of ideology critique.

What if the productive contribution of *Fin de Siècle II* was to display for viewers the image world of their own making? After the initial feeling of assault, viewers' most common responses ranged from indifference to mild amusement. For several critics the experience was like nothing so much as a night at the Palladium.[10] This New York discotheque had installed large-scale video-walls high above its dance floor earlier in the decade specifically to attract the media-oriented art world (whose members partied in the club's upper echelons decorated with murals by Basquiat, Haring and Clemente). The presence of jumbo video-walls 'exploding' with light and sound in the art museum, just as they had in the nightclub, introduced further ambiguity as to experiences that were to be had (and the meanings produced) within these spaces.

Like *Wipe Cycle*, Paik's video-wall explored the compositional possibilities of electronic collage. The excessive multiplication of the screen, however, opened up a new conversation about knowledge and power. This took place on a material level in terms of the work's corporate sponsorship by Samsung Electronics and Sinsung Electronics of Seoul, Korea – an example of the developing alliance between big capital and the visual arts. But it also happened on an epistemological level. In postmodern art and theory alike, the reliability of sensation – understood as individual, self-contained acts of perception – was called into question more than ever before. *Fin de Siècle II* suggested what Samuel Weber has since referred to as television's 'unsettling tendency'. According to Weber, the TV transmission does not simply overcome distance and separation, as in McLuhan's notion of a 'global village'. Rather, it 'renders them invisible, paradoxically, by transposing them into the vision it transmits'.[11] Television's key trait is therefore its ability to combine the separation (the transmission) with presentness (the viewer's perception) in a luminous display of its fundamentally ambiguous and ambivalent power.

The major networks capitalized on this play, perhaps unwittingly, when they erected huge walls of television monitors behind the anchors of their evening newscasts in

the early 1980s.[12] NBC, ABC and CNN came to rely on the video-wall's imposing object form and its screen capacity to reproduce their command position within the 'information society'. With a chaotic, often global multiplicity of scenes safely contained and coordinated within the grid of monitors, and the viewer inserted into a perpetual psychic looping of uncertainty and reassurance, the nightly news was powerfully visualized as a source of order within a disorderly world.

Paik harnessed this same televisual dynamic in *Fin de Siècle II*. Every few moments, a single giant image radiated across 16 or more of its screens: the chaos of electronic collage abated, and general order was restored. Yet, in an instant, this totalizing image dispersed again. Unlike the video-walls of network news, there was no illusion of ultimate unifying

control. *Fin de Siècle II* displayed the very impossibility of this.

If *Wipe Cycle* represented a 1960s attempt to generate an active, albeit decentred, subject through the principle of feedback, *Fin de Siècle II* suggested that by the late 1980s this particular cybernetic model of agency had become obsolete in the face of a more complex and expansive corporate-media network. Yet both works indicated that any relevant cultural politics would have to analyze mass media's impact on perception, and thus our understanding of ourselves in the world. Most of all, the video-wall's infinite splitting and repetition of the screened image rearticulated in postmodern terms the question of whether a unified world view was even thinkable, much less desirable, at the end of the twentieth century.

172
Nam June Paik, *Fin de siècle II*, 1989. Television sets, laser discs. The Whitney Museum of American Art, New York (93.139)

Ulrich Lehmann

SAMPLING AND THE MATERIALITY OF SOUND

Late modernist positions, including the 'multiplicitous' discourse on the postmodern condition, share a common refusal of binary oppositions. This marks a shift away from the Marxist dialectical tradition that had dominated cultural studies until the late 1960s. Many late modernist writers, such as Jean Baudrillard, couched their discourse in the language of symbolic structures which, so they claimed, extended the material confrontation within systems of production to a more complex sign-system of simulation and representation. However, despite the postmodernist rhetoric concerning simulation, hyperreality and mediation, the fundamental opposition between owners of the means of production and those operating them remains a hallmark of any system of labour. This is true whether one is looking at an object-based system of production or a purely representational one. The following paragraphs inquire into one aspect of the materialist underpinnings of postmodernism, through a reflection on the technique of sampling.

In the present context, sampling is defined both as the structural separation and re-use of audio material, through techniques of analogue or synthetic collage, and as the creating of sound 'events' through mechanical means – for instance, the voltage-controlled oscillators in synthesizers. The word 'sample' embraces the two essential pathways in the development of early electronic composition: *musique concrète* (pioneered at IRCAM – the Institut de Recherche et Coordination Acoustique/Musique – in Paris), which draws upon recorded sound materials, and *Elektronische Musik* (pioneered by NWDR-studio – Nordwestdeutsche Rundfunk – in Cologne), which uses synthesized sound materials. It is important to state that both types of sampling are transformative acts, not simply technological quotations. The de-contextualizing and relocation of the original sample, whether an ambient 'noise' or mechanically produced 'event', becomes a subjective marker that (re)contextualizes its new sonic environment. Thus samples do not necessarily require one form of musical composition, although particular forms in popular music, for instance rap and techno, have explored sampling to the fullest extent.

The cultural trajectory of sampling can be traced through many points of reference: the Futurist music of Luigi Russolo, who used environmental sounds as part of his compositions; Dada poems that de-contextualized and re-ordered bits of language; the use of recording devices to synthesize ambient noise and analogue musical sounds by pioneers of electronic music such as Edgar Varèse; Brion Gysin's and William F. Burroughs' 'cut-up' recordings with spliced tapes; the synthesis of musical instruments and recording devices by composers like Mauricio Kagel and Karlheinz Stockhausen; the impact of digital musical instruments (samplers, sequencers, MIDI) on early dance music in Chicago and New York during the 1980s; and the present dominance of software systems (Ableton Live, Native Instruments' 'Generator') as digital composition tools.

But to speak of sampling in this way is to construct a linear history of deterministic progress – a modernist narrative, in which the 'machine' enters into aesthetic composition as potent metaphor and productive means. In turn, this view would relegate any subsequent departure from such progression to a simple late modernist reversal. Can there exist, in contrast, an account of sampling that would depart from the modernist technological narrative, and justify an understanding of the technique as a postmodernist structural challenge? In considering this question, we should first note that sampling is a means by which technology enters into the very core of the artwork. It can thus be seen as related to the orthodoxy of Walter Benjamin's analysis of the modern 'loss of aura', or Martin Heidegger's discourses on technology. Significantly, however, sampling also brings about a levelling of the traditional hierarchies of sound. 'Composed' (artificially created) sounds are placed on a level with environmental or accidental 'noise'. By the same token, sampling contributes to the tendency toward serialism in music, by which one arrives at an equality of all elements in a composition.[1] This non-hierarchical character affirms a potent postmodernist principle: the deconstruction of cultural hierarchies, ideological structures and power relations. Sampling thus assumes a metaphorical position that combines a complex reaction to technological determinism with structural principles that reverse the linearity of historical progression.

Sampling can be further theorized according to three main structural principles:

Copy: the notion that a pre-formed, found, already existent element is copied and collaged within a sonic ensemble, rather than constituting an 'original composition'. This marks the sample as a postmodernist manœuvre, in that subjectivity is relegated to combinatory impulses rather than primary 'authentic' expression. The compositional technique is a matter of addition and subtraction; it is both quantifiable and measurable.

Pattern: samples are grouped and repeated to form patterns without these appearing (necessarily) as motifs within a progression. Again, this counters subjectivity; measurable structures are built up and dismantled proportionally, rather than following the expressionist dictates of a narrative. Structural integrity is provided not by conventional rhythmic means (for instance, drums or bass lines) but through the repetition of dislocated sounds.

Collage: the sample appears as an alienated particle, sometimes even as a self-referential quotation of a previous sample (as in a remix). Even if the final audio piece has serial qualities achieved through sequencing, it works technically as a collage of unrelated sonic events. The relationship between these events, despite their concrete origins, is not a linear story or 'illustration' of associative audio effects, but a subversion of their initial use and position in sonic space.

In postmodernist discourse, the representation of labour is held to usurp the concrete system of production. From this perspective sampling, especially in its digital format, can be seen as a sonic version of socio-economic relations in industrial capitalism. So for example, Baudrillard, in his emblematically postmodern critique of Marxism and Structuralism *Symbolic Exchange and Death* (1976), provides a polemic on binary structures in language and class conflicts in political practice,

abandoning the dialectic between production and consumption in radically simple terms:

> The end of labor. The end of production. The end of political economy. The end of the signifier/signified dialectic which facilitates the accumulation of knowledge and of meaning, the linear syntagma of cumulative discourse. And at the same time, the end simultaneously of the exchange value/ use value dialectic which is the only thing that makes accumulation and social production possible. The end of linear dimension of discourse. The end of the linear dimension of the commodity. The end of the classical era of the sign. The end of the era of production.[2]

For Baudrillard, the process of simulation leads to the emergence of simulacra, copies without originals, in which 'labour and production ... are reproduced for the sake of the reproduction of the work itself'.[3] The disavowal of the production/consumption dialectic equally negates the possibility of artistic subjectivity, as the work of art loses its aura and appears as a reproduced and copied object.

Sampling seems to exemplify Baudrillard's scheme almost too well: recording and reproduction processes replace productive structures (such as live performance), which had been premised upon subjective expression. However, it would be facile to view sampling simply as postmodernist simulated work. The sample does not escape the relation between production and consumption; on the contrary, it re-formulates that dialectic itself as a copy. The labour process is now an accumulative reproduction of many events within one work. Artistic production is itself quoted, de-contextualized and alienated. Subsequent usage of the sample renders the process even more complex; listening to samples within an associative structure, one can understand them not only as simulations of the original productive structures that gave rise to the sound, but also as de-contextualized elements with their own expressive content. For instance, in Pierre Schaeffer's recording *Étude aux chemins de fer* of 1948 (one of the earliest example of *musique concrète*), six locomotives at the Gare de Batignolles can be heard. These simulations of the sounds of transport are alienated and de-contextualized events, but their repetition mirrors the productive structure of the movement of railways. Appropriately, given the piece's position at a turning point in music history, the sound is both 'musical' and 'concrete'. It affects authenticity as well as simulation.

We can see a political extension of this basic idea in recordings like Underground Resistance's *Assault* (1991) and Public Enemy's *Fight the Power* (1989), where samples are employed to reflect on cultural emancipation by displacing signature sounds (Star Trek sound effects, James Brown riffs) into a context that assaults existing racial and social structures. Through the re-use of existing vocal samples, sound events and rhythmic elements, a new form of production emerges. In this process, labour is not simply a theme – as in Luigi Nono's sampled factory sounds for *La fabbrica illuminata* (1964), or Iannis Xenakis' *Concret P.H.* (1958/68), which includes the sampled sounds of burning charcoal. Rather, in techno and hip-hop there is a critical abstraction and reversal of subjective forms of musical composition. The use of mechanical devices and procedures, ranging from tape cut-ups and turntablism (scratching and looping analogue samples from two or more records, pl. 173) to software programmes, strips sound events of their context and sequences them into repetitive patterns, thereby reflecting on the concrete patterns of control that determine the dialectic between production and consumption which remains operative for post-industrialized societies. This dialectic is further enhanced by the consumption of samples within dance music. The track will, more likely than not, be presented as a 'remix': as base material for DJs (instrumental- or dub-versions, bonus beats, etc.), or as sound pattern for performative display (club mixes). A non-hierarchical, serialized foundation enables a move away from passive listening and toward a de-constructed chain of references and deferrals (cf. Jacques Derrida's concept of *différance*).

Techniques of reproduction, collage, pattern and serialization are not just simulation, then, but a distinctive form of labour. And this is true of sampling in general, not just in music. The process of alienating any object or motif, and de-contextualizing its productive structure, raises awareness of how the dialectic of production and consumption determines socio-economic power relations within the culture industry. Other accounts of postmodernism might claim the sample as an act of reproduction that does not produce subjectivity, but merely simulates it. However, in the sample the authentic event of production is deliberately dislocated to expose the fallacies of accumulative reproduction in post-industrial societies, generating a non-hierarchical reflection on technologically-determined means of production.

**Opposite: 173
Turntables used by
Grandmaster Flash**,
late 1970s. The Experience
Music Project, Seattle,
Washington (1999.181.1&2)

Carol Tulloch

BUFFALO: STYLE WITH INTENT

During the 1980s, London's West End was a stage for experimentation in personal style. Whether you had the courage to be unique, or just followed in the slipstream of fashions that allowed some measure of autonomy, the West End embraced you. Along Old Compton Street and its surrounding lanes, young women and men paraded their look of choice. For women, perhaps it was a 1920s dressing gown worn over Oxford bags and distressed plimsolls; for men, an MA-1 flight jacket with cycling shorts and Doc Martens boots. Inspiration came from a range of sources: second-hand clothes; the street-style influences of the Sloane Ranger; the dying embers of punk, the New Romantics, hip-hop, Lovers Rock reggae and football hooligans nicknamed the Casuals; and the work of an army of independent young British designers such as John Galliano, Bodymap, Joe Casely-Hayford, Mark and Syrie, Anthony Price, Helen Storey and Workers for Freedom. But pre-eminent in this landscape was the British-based Buffalo 'family', whose work in 'styling' (not 'fashion') began to appear in *The Face* and *i-D* from the early 1980s, before spreading to advertising and fashion promotion, music and video. The group was led by Ray Petri, whose march on innovative styling had such power that Nick Logan, the founder of menswear magazine *Arena*, affirmed: 'It's inconceivable that we would have launched it at all without Ray's involvement, and, by implication, his approval.'[1]

Buffalo was a 'gang'[2] of 21 members from different cultural and social backgrounds.[3] It was a meeting of stylists – photographers, models, musicians, music producers and DJs. Through a partnership between Petri, Jamie Morgan and

174
Jamie Morgan (for *The Face*), Nick Kamen, 1984. Styling by Ray Petri

Cameron McVey, the company Buffalo Limited was established to 'create visual identities for fashion and music'.[4] The group adopted a common look, featuring one of the aforementioned flight jackets (in cobalt blue), polo-neck sweater and a photo-shoot-ready posture: the so-called 'Buffalo stance' (pl. 174).

The character of members shone through. The 'black' Swedish-born member Neneh Cherry rocked the standard notion of the pregnant woman when she sang 'Buffalo Stance' on BBC's *Top of the Pops* in 1988, heavily pregnant in a short tight Lycra skirt, bustier, Hi-top trainers and giant hip-hop jewellery. Petri, who was gay, presented himself in the signature details he used as part of his Buffalo styling for magazine pages, a Band-Aid across his eyebrow, with words torn from newspapers inserted into the band of his trademark pork-pie hat.

The postmodernism of Buffalo was partly a matter of method: it formally established the practice and role of the stylist in the creation of fashion narratives, especially through the creation of 'spreads' (these had always been present in magazines, but the term 'stylist' was not generally used until the 1980s). Petri also insisted on the use of 'mixed-race' and 'black' male models in style features, marking a departure from the 'blue-eyed Bruce Weber' look of the early 1980s.[5] This was revolutionary in a fashion industry that still struggles to incorporate ethnic difference in its images and narratives. Yet the core of Buffalo was not its professional techniques, but its attitude – its emphasis on 'the personal', which model Tony Felix defined as the essence of street attitude: 'That way of wearing clothes that comes from the life you have to live. You can't buy it in shops.'[6] Yet Petri was able to make the stance commercial, intuitively blending the looks around him and reproducing the resulting images on the pages of style magazines.

Through the styling and photography of the male body, the configuration of clothes, ornament, and what Petri called the 'right face',[7] Buffalo achieved a 'sublime complexity' in their rejection of the fashion standard.[8] Petri pulled together differing masculine identities drawn from his own transnational hybrid experience:[9] the cyclist, the Native American chief, the Jamaican Rude Boy, the Sapeur, the jazz artist, the boxer, the flasher, the man in skirt, the gangster, the entrepreneur. These were not treated as fragments, as if they existed in some fractured disassociated relationship with an essential manhood, but rather as possible new dimensions to the meanings of masculinity. Petri's practice can be viewed as postmodernist in the sense that Jean-François Lyotard has described: 'Working without rules in order to formulate the rules of what *will have been done*.'[10]

Take, for example, one of Petri's key shoots, entitled 'Killer'. It is one of the most recognized Buffalo images. Styled by Petri and shot by Jamie Morgan, it appeared on the cover of *The Face* in March 1985, and also in a feature inside the issue entitled 'The Harder They Come, The Better' (pl. 175). The eight-page spread was modelled by a boy, a woman and a man in Petri's signature bricolage of materials: paper and cloth, torn text, hats, jewellery and other accessories that should have seemed incongruous, but fitted right in with the overall composition. I saw 'Killer' when it first appeared; at the time I was a fashion student and *The Face* was my chosen style bible. I read it now, wary of applying theoretical dimensions to something that was created so long ago and not consciously

theoretically motivated, in a very different context of identity formation and definition than today. But I read it nonetheless. After all, Petri's styling practice always allowed room for viewers to engage with the image on their own terms.

There is so much going on here: the neatly turned cuff that confirms the small stature of the model, Felix Howard; the slightly crumpled paper handkerchief tucked 'just so' into the pocket of the single-breasted striped jacket; the feather next to the torn-out word 'Killer'. Obviously, the image has a gangster aura. We might take into consideration Stella Bruzzi's thinking on the style of the immigrant, underprivileged gangster in Hollywood movies of the 1930s: 'the gangster has been reduced to a silhouette, a series of metonyms that, as shorthand, signify and substitute for the whole. In his armoury the most consistent of the overdetermined accessories is the essential sharp felt hat.'[11] Bruzzi argues that the gangster engages in a 'fetishism of detail', an exquisiteness of style that signifies a 'desirable (rather than dubious) masculinity' available to all cultural and social groups. These clothes marked a transformation from one stage in a life to the next.[12] Bearing this in mind, and the overtones of the term 'killer' (which in North American slang refers to an excellent, impressive, formidable person), Petri's styling of a boy-man can be seen as a postmodern representation of youth culture's process of self-formation.

The feature 'The Long Goodbye' was the last styled by Petri. By the time it was published in *Arena* in November 1989 he was dead from an AIDS-related illness. A visual hymnal, the spreads, which featured the Kamen Brothers, Barry and Nick, who were also Buffalo members, were shot in stark tones of black and white by Roger Charity. 'The Long Goodbye' reflected Petri's desire to inject romance and melancholy into his work.[13] The jam-on-jam, complex styling perfected in *The Face* has been displaced by a cooler look, appropriate to *Arena*: a mix of high fashion and more accessibly-priced pieces, black suits to order from Anthony Price with biker boots from Johnsons. But Petri's exploration of the dynamics of masculinity was maintained here in his presentation of Barry Kamen, wearing a black and white South American football shirt from World, track pants from Multisports, and (thrown over these) a black cashmere shawl from Liberty. The work is above all pensive, self-conscious of Petri's own looming death.

In this, his last act of Buffalo styling, Petri 'contributes to a postmodern revival of death that values individual choice ... "doing it my way"'.[14] 'The Long Goodbye' seems to contain all the identities that he had lived, all his signature accessories, beginning with the pork-pie hat sitting above the torn text 'ragamuffin' that leads the feature. Put simply, this was styling as autobiography. The head of the Buffalo family was lost, but his legacy remains: his concern for the future of masculinity – not fragmented, always experimental.

Lyotard argued that, in the climate of postmodern media culture, 'You can't introduce concepts, you can't produce argumentation. This type of media (TV, or whatever) isn't the place for that, but you can produce a feeling of disturbance, in the hope that this disturbance will be followed by reflection.'[15] Yet Buffalo was exemplary at engaging with all three: concepts, argumentation and disturbance, all at once. What remains of Petri's work in particular, and Buffalo as a whole, is a style treatise on the possibilities of beauty – an accolade not often equated with postmodernism.

175
Jamie Morgan (for *The Face*), *The Harder They Come, The Better*, 1985 (printed 2000). Black and white gelatin silver print. Felix Howard, styled by Ray Petri. V&A: E.508–2001

Zoe Whitley

DRESSING VICIOUSLY: HIP-HOP MUSIC, FASHION AND CULTURAL CROSSOVER

You see I'm six foot one and I'm tons of fun
and I dress to a T
Ya see I got more clothes than Muhammad Ali
and I dress so viciously
—*Sugar Hill Gang, 'Rapper's Delight'* (1979)

Braggadocio and status obsession have been constant elements of hip-hop culture since its earliest manifestations in 1970s New York (pl. 176). The capitalist boom of the 1980s brought with it a focus on materialism and conspicuous consumption that was right at home with hip-hop's penchant for self-aggrandisement. Competition was integral to earning respect in the culture[1] – competing for wall space as a graffiti tagger, battling for time on the mic as an emcee, and even one-upmanship in constructing a personal identity through one's clothes (pl. 177). Graffiti writers of the time were expressing something that would also be expressed by hip-hop attire. As American journalist and music critic Jeff Chang put it: '[Their statements were] a strike against their generation's invisibility ... They were doing it to be known amongst their peers, to be recognized for their originality, bravado, daring and style. Norman Mailer, one of the first to write seriously about graffiti, got it instantly: the writers were composing advertisements for themselves.'[2]

Fundamental to this strategy of 'advertisement' across hip-hop culture was proving one's self-worth and garnering validation from others, often by impressing with the amount, expense and newness of clothing at one's disposal. As a source of aspiration and a means of flaunting one's belongings, branded goods shared a natural affinity with hip-hop music. British-born Bronx rapper Slick Rick became famous for his

unique story-telling style of rhyming; his arguably best-known song 'La Di Da Di' (with Doug E. Fresh, 1985) is replete with then-popular brands:

I threw on my brand new Gucci underwear
For all the girls I might take home
I got the Johnson's baby powder and the Polo cologne
Fresh dressed, like a million bucks
Put on the Bally shoes and the fly green socks
Stepped out the house stopped short, oh no
Went back in I forgot my Kangol

The brands not only situate the story in a milieu that his listeners can immediately relate to and visualize, but they also establish him as desirable to women and the envy of his male peers.

European fashion houses such as Pierre Cardin, Louis Vuitton, MCM and Gucci carried grand associations in socially deprived areas, even as some waned in popularity with their wealthy white customers. The culture of franchising meant that brands the older generations had associated with socialites and celebrities were now distributed – in name, if not in quality and exclusivity – through department stores or knock-off street vendors. Licensed T-shirts, watches, leisurewear and perfumes were particularly prized when heavily monogrammed with eye-catching logos, which served to garner recognition from others and support hope of class mobility. Rapper Schoolly D name-checked fashion trends in 1985 and 86 singles, such as the crowd-rocking 'Put Your Filas On', 'Gucci Time' and 'Fat Gold Chain'. While authenticity was of course prized, highly visible branding made replicas acceptable and certainly the more affordable option. Name brands, even if mis-spelled or bearing an imprecise logo, proclaimed a degree of fashionability and trend savvy.

The high retail price of a desirable item would be widely known, its prohibitive cost part of its appeal. The wearers of popular casualwear brands such as Kangol and Lee set themselves apart by proclaiming that they could afford named rather than generic clothing. As a result of the prevalence of both counterfeit and stolen goods in the inner cities, a trend arose for keeping the crisp price tag affixed to clothing in order to prove the cash value and authenticity of one's outfit. Memorable lines from Run DMC's 'My Adidas' (1986) prove the point: 'I bought 'em off the Ave with the tags still in 'em/a sucker tried to steal 'em so I caught him and I thwart him/and I walk down the street as I bop to the beat/ with Lee on my legs and Adidas on my feet.'

Many popular brands, like Adidas, were conflicted symbols of street style. As the lyrics above suggest, wearing expensive goods could make one the target of theft from those in the community who could not afford the same items. Equally, it was often those operating outside the law within those economically-deprived communities who could most easily afford designer clothing. This tension is captured in 'The Message' (1982), by Duke Bootee and Melle Mel of Grandmaster Flash and the Furious Five: 'You'll grow in the ghetto, living second rate/ And your eyes will sing a song of deep hate/ The places you play and where you stay/ Looks like one great big alley way/ You'll admire all the number book takers/ Thugs,

176
Jamel Shabazz, street photography from the series *Back in the Days*, 1980s. New York

pimps, pushers and the big money makers/ Driving big cars, spending twenties and tens/ And you wanna grow up to be just like them.' In fact, 'My Adidas', which details Run DMC's international musical success in its first stanza, was created in part as a counterpoint to a community leader in their hometown of Hollis, Queens, who referred to 'felon shoes', insinuating that any Adidas wearer was also a perpetrator of crime in the area. Darryl 'DMC' McDaniels recalls, 'We made it culturally acceptable. We made it a big fashion statement.' Upon hearing lyrics about rapt paying audiences, those who aspired to life beyond their neighbourhood – or owning 50 pairs of shoes – could view Adidas as a statement of big dreams that offered the possibility of transcending their current situation.

The creative appropriation of styles further extended to unintended sartorial branding opportunities. Unlike haute couture, where a designer's vision and aesthetic are purchased for consumption by the client, hip-hop style was generated by people striving to be different, often with limited means, but still wishing to be acknowledged for their flair. With the vogue for wearing gold chains and flashy jewellery, young people began co-opting status symbols into accessories of their own devising. Chief among these was the practice of wearing the ornament off a Mercedes-Benz, Cadillac or even Volkswagen as a medallion, as worn by Beastie Boy Mike D. *The Washington Post* documented the fad in 1987 as further proof of 'an age in which designer names appear on everything'. Brandishing a trophy that speaks to one's boldness and fearlessness, the ornaments were vaunted hints at toughness and irreverence, worn by and for initiates 'to show them off'. Though one might never be able to afford the expensive car itself, it was possible to establish a personal association with a luxury brand.

Some proponents of the hip-hop movement were quick to see that beyond the theorizing about advertising oneself, it was the brands and record labels that largely benefited at the expense of both black consumer patterns and negative cultural representation. Cultural theorist bell hooks describes it thus: 'Really it is for me a perfect paradigm of colonialism: that is to say if we think of rap as a little third world country that young white consumers are able to go to and take out of it whatever they want, we would have to acknowledge that what young white consumers, primarily male – oftentimes suburban – most got energised by in rap music was misogyny, obscenity, pugilistic eroticism and therefore that form of rap began to make the largest sum of money.' With increasing popular appeal, hip-hop not only became the site of wealth generation, but also of exploitation and problematic contradictions: upward mobility and empowerment of disenfranchised youth coupled with reinforced and amplified black stereotypes.

Afrocentrism was a powerful counterpoint. The trend waned in the early 1970s as the Black Power movement was dismantled politically and fell out of favour culturally, re-emerging during the 1980s as a pastiche of references, such as the Pan-African flag, Kente and mud cloths, artisan-style leather medallions, cowrie shell jewellery, and anti-apartheid solidarity T-shirts. Queen Latifah's debut album *All Hail the Queen* (1989) featured the artist in a regal stance wearing a headwrap, with the album graphics in red, black and green

surrounding a silhouette of the African continent. Afrocentrism served to command respect while her rapping skills sustained it:

> A woman can bear you, break you, take you
> now's the time to rhyme can you relate to
> a sister dope enough to make you holler and scream …
> It doesn't make a difference, keep the competition coming.

Black consciousness and African pride were also notably visualized in Willi Smith's costume designs for independent film-maker Spike Lee's *School Daze* (1988). Smith used leather, earth-tone fibres and natural hairstyles to clearly differentiate the politically conscious, African-American students from the campus assimilationist 'wannabes'. Looking to Africa for stylistic cues, a melange of many disparate African references presented an alternative to the sportswear-dominant, brand-obsessed fashion.

The inimitable DJ Afrika Bambaataa, an originator of hip-hop's distinctive use of breakbeats, also possessed a distinctly alternative viewpoint (pl. 178). His was a style that transcended the South Bronx and was embraced by a wider audience through Manhattan's downtown club scene. Bambaataa created a quintessentially postmodern fusion of musical genres: popular film scores, prog-rock, electro and Afrobeat merged into an infectious new sound. 'When hip-hop was coming up, punk rock was also coming up at the same time. So I started having this vision that I've got to grab that black and white audience and bridge the gap.'[3] Afrika Bambaataa and the Soul Sonic Force sampled both Kraftwerk's 'Trans-Europe Express' and 'Numbers' for the now-iconic *Planet Rock* (1982).

178
Afrika Bambaataa, 1983.
Photograph by David Corio.
Courtesy of Celluloid Records,
London

His producer Arthur Baker described Bambaataa's borrowing as 'the quest for the perfect beat'.[4] In his stage performances, as well as in his public persona in the neighbourhood where he brought together youth to form his Zulu Nation, Bambaataa spliced cultural references to create a unique style that borrowed from Native American ceremonial dress, neo-Afrocentric and Afrofuturist sensibilities. His costumes were the embodiment of bridging cultural divides while celebrating blackness and eschewing conformity.

Hip-hop culture's passage from an insular subculture to the mainstream was mediated first by live music performances and then, more completely, by music videos and film. Singers including Blondie's Debbie Harry travelled to the outer boroughs to experience hip-hop parties for themselves and, as early as 1979, shared the stage with artists like the Sugar Hill Gang on New York's indie scene, putting hip-hop increasingly on the radar of predominantly white New Wave, punk and disco audiences. The following year, BET (Black Entertainment Television) was launched as a cable channel broadcasting music performances and programming for a predominantly African-American audience. Rapper Kurtis Blow, best known for the first gold rap single 'The Breaks', appeared in a nationally televised commercial for the soft drink Sprite in 1986. A seminal year in the transcendence of rap music beyond its subcultural confines, it was also the year of 'My Adidas' and Run DMC's genre mash-up 'Walk this Way' with Aerosmith. This musical cross-pollination increased the popular appeal of hip-hop and paved the way for many acts' commercial success.

Mainstream hip-hop was, and remains, a space largely codified as male, even 'hypermasculine',[5] yet women negotiate its gendered terrain. The answer for some was to obfuscate their sexuality, at least initially, by adopting the prevailing sartorial trends worn by young men. MC Lyte, a respected female MC, was 'plagued by accusations of being "masculine", a raspy-voiced young woman in sweats and gold chains, bilevel golden brown hair, and a makeup free face'.[6] Salt-N-Pepa's first album *Hot, Cool and Vicious* (1986) articulated that their femininity was no barrier to rhyming skills: 'To be a female rapper from the heart of Queens/ and see others dream about being supreme/ But once on the scene, we start killing Kings.' Their style of dress equally opened a space to be unapologetically feminine with large earrings, lipstick and tight fitting bike shorts but worn with oversized leather jackets (pl. 179). Salt-N-Pepa's distinctly frank female point of view on sexual empowerment in songs like 'Push It' (1987) and 'Let's Talk About Sex' (1991) would propel them to stardom in the pop music charts.

Hip-hop's polyvalence resists easy summary. The music creates something new out of old samples; likewise, its styles of dress combine appropriation, subversion and hybridity. And like a beat on loop, trends cannibalize themselves: petty-theft auto-emblem medallions were soon sold in jewellery stores in gold and silver versions; eight years after the original, Snoop Dogg released 'Lodi Dodi', updating Slick Rick's choices with Cool Water cologne and Chuck Taylor sneakers. One of the few constants would be this: the market quotes hip-hop style, remixing it and selling it right back to the innovators, now consumers.

179
Salt-N-Pepa (left to right: Sandra 'Pepa' Denton, Deirdra 'Spinderella' Roper and Cheryl 'Salt' James), 1987. Photograph by Janette Beckman

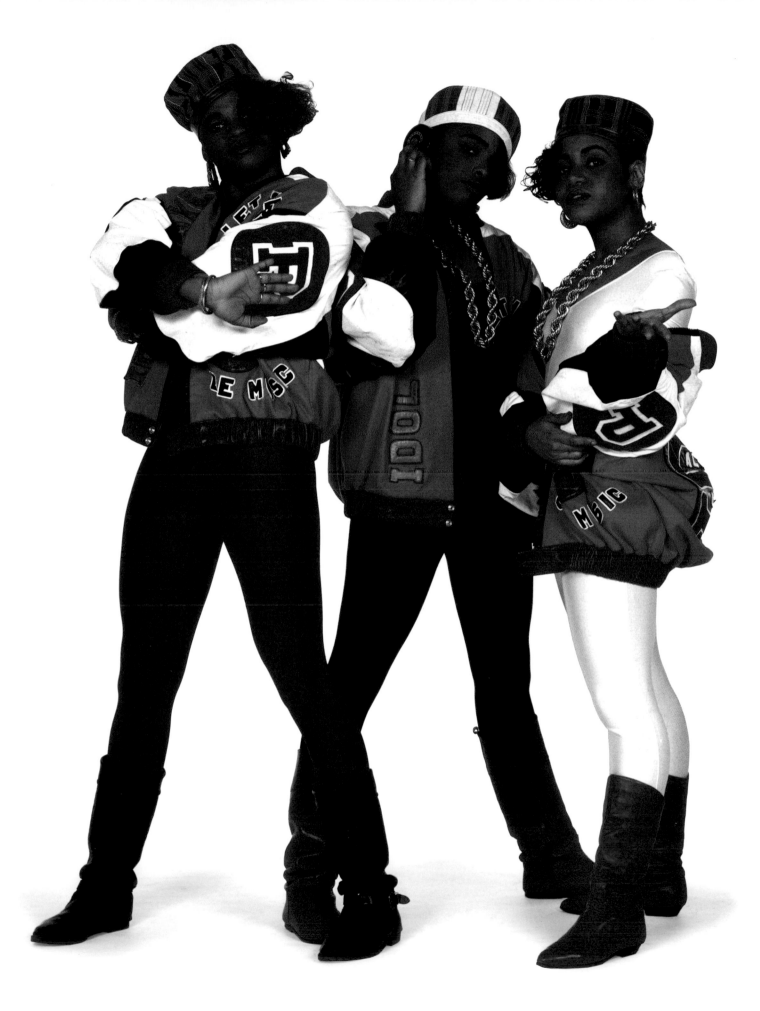

Sujatha Fernandes

WHAT IS 'POST' ABOUT GLOBAL HIP-HOP?

American hip-hop has been seen as quintessentially postmodern, and like other postmodern art forms, it has been defined by pastiche, sampling and fragmentation. The elements of hip-hop culture – particularly the verbal component known as rap – have also been closely integrated into commodity production; its products, such as albums and music videos, have been exploited by multinational corporations for significant commercial gain, and images of the ghetto, black sexuality and the figure of the 'gangsta' are packaged and marketed to white audiences. But what has happened to this culture as it has travelled beyond the confines of American consumer society? How does post-industrial, postmodern New York get re-imagined in the marginal zones of central Havana, or the urban *barrios* of Caracas (pl. 180)?

Hip-hop has been entangled with commodity culture since the early days of the genre, when the Sugar Hill Gang's 1979 hit 'Rapper's Delight' went global. Although graffiti and b-boying had a strong impact through Hollywood films such as *Beat Street* and *Breakin'* (both 1984), it was rap that emerged as the central export commodity by the mid-1980s. In 1986, the group Run DMC signed a $1.6 million endorsement deal with Adidas, cementing the links between the hip-hop lifestyle and consumer products. By the 1990s, the content of rap songs had become heavily brand-identified. Hennessy cognac, for example, received such a boost in sales from its association with hip-hop culture that the French company held a competition where it offered the winner a visit to its plant in the company of a famous rapper.

180
Vagos y Maleantes in Cotiza, Havana, 2003. Photograph by Sara Maneiro

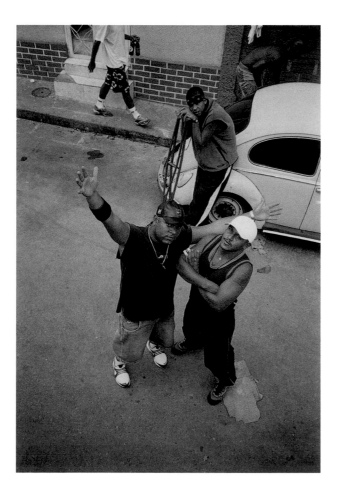

The trope of blackness has been one of the primary ways in which hip-hop culture has become integrated into a postmodern commodity culture. The rapid-fire spread of hip-hop across the globe has largely been due to the race-based identification that it inspires among African and Afro-descendant youth in cities like Havana, Paris, Ghana and Cape Town, as well as young Aboriginal people in Sydney and South Asians in London. At the same time, industry-promoted notions of blackness have been at the heart of a successful marketing strategy that sells records, and associated consumer products and clothing lines, to global audiences.

In the late 1990s, at a concert in the National Writers and Artists Union in Havana, I saw a performance by the Cuban rap group Primera Base. Three young men stood before the microphones. The one in the middle, Rubén Maning, had several thick gold chains around his neck. His shirt was open to reveal a bare torso. He wore plastic sunglasses studded with fake diamonds. Low-slung pants revealed a pair of white boxers with the letter X written in bold at the top. The other two also wore heavy gold chains and black sunglasses.

'It was like this,' opened Rubén, in a grave voice. He bowed his head dramatically. 'The 21 of February 1965, he was shot up in the Audubon Ballroom/ About to give his last speech, before an auditorium of 400 blacks and half a dozen whites/ Yes! That gentleman you know as Malcolm X/ WAS DEAD.' Through the background beat came the piercing tones of a siren, then the sounds of people screaming and crying. A faster beat kicked in, and Rubén performed a homage to Malcolm X. 'I want to be a black just like you, with your great virtue,' rapped Rubén, in an old school flow. 'I want to be a black just like you, a great leader, to be great.' The performance seemed to underscore the powerful ways in which transnational flows of hip-hop culture transported and translated black nationalist symbols.

Primera Base continued the rap. 'Just like you, just like you, nigger.' They chanted the chorus. 'We wanna be a nigger like you/ Just like you, just like you, nigger. A nigger like you.' It was a reality check: I realized that the circulation of the N-word in a global marketplace was also powerful. Even in a country like Cuba, supposedly the last stand against American global influence, one could find the mirror image of a clichéd American commercial culture.

In fact, the stereotypical notions of blackness being promoted by the global music industry intersected neatly with the commodification of Afro-Cuban culture during the 1990s. In the post-Soviet crisis of that decade, Cuba was forced to enter the global market economy. Culture industries were exposed to international entertainment and consumption markets, in an attempt to earn hard currency. Afro-Cuban culture was packaged for sale to tourists and for international audiences alike. One example of this was the Spain-based Cuban rap group Orishas, who utilized representations of blackness on their album covers and videos.

When hip-hop culture first came to Cuba, those rappers who aped Black American accents, postures and slang were often derided as 'miki-miki', or imitators. While the mimicry or strategic use of commodified blackness is one dimension of postmodern culture in global hip-hop, rappers have also manipulated signs of blackness to put forth their own political

agenda. Amidst the contradictions of Cuba's entanglement with the regimes of global capital, underground rappers have sought to bolster their critiques of race relations and embrace blackness as a political identity.

The pioneers of the Cuban underground rap movement were influenced by the early commercial waves of hip-hop, which travelled to Cuba via Miami radio, and television broadcasts of shows like Soul Train. The early Cuban rappers also developed their radical stance in dialogue with American 'conscious' rappers who visited Cuba in person, through the Black August Hip-Hop Collective. Through their lyrics, performances and styles, Cuban rappers have given voice to marginalized communities, in a society that claimed to have solved problems of race. The in-your-face pose of male rappers communicates the frustration and rage of a life on the margins. Women rappers wear headwraps, African clothing and natural Afro hairstyles as an alternative to the hypersexualized images available to women through commercial rap.

While black nationalist rap became popular in Cuba, and some other parts of the African diaspora, elsewhere gangsta rap has resonated. The genre took deepest root in cities like Caracas, Medellín and Cape Town, which were marked by cycles of poverty, incarceration and violence. In these global variations of gangsta — a genre that has moved exclusively towards narratives of accumulation and consumption in recent years — there has also been a reflection upon, and interrogation of, commercial stereotypes. Venezuelan gangsta rap, for example, showcases the postmodern desire for acquiring money and commodities. Rappers are attracted by the promise of material gain and reward, as demonstrated in the song by Guerrilla Seca entitled 'Voy a Hacer Plata' ('I'm Going to Make Money'). For the rapper, life is all about material gain; and his happiness, dignity and self-worth depend on him being able to make money. The status objects of gold-capped teeth, a Rolex watch and bodyguards, all modelled on successful North American rappers, are visible symbols of status and happiness.

Yet gangsta rappers on the periphery realize that this fantasy of wealth is unattainable, and they play with these stereotypes using the kinds of inversions also found in popular cultural forms such as carnival. In the song 'Papidandeando' ('Partying'), the Venezuelan rappers Vagos y Maleantes imagine themselves in a grand mansion with a view of the stars, drinking Crystal and driving a Lamborghini (pl. 181). In this fantasy, wealthy magnates such as John D. Rockefeller, Donald Trump and Bill Gates are shown performing menial labour in the rapper's house. The humour of the song lies in the absurdity of the images of billionaires as cleaners or pool boys. The rich are stuck with the chores, while Vagos y Maleantes are raking in the cash: 'I am higher and higher in my mountain of money that keeps growing and growing.' The rappers plan to make their millions by travelling around the world, creating a mafia of Latino criminals. The ridiculous images of 'bank accounts in Spain and Switzerland with connections in Cotiza' — the poor *barrio* where the rappers live — are a satire on the fraud and corruption of an elite class that would never be available to the ordinary *barrio* resident. Through their music and imagery, these artists parody dominant notions of entrepreneurship and mobility.

The global marketing of hip-hop culture in a postmodern era takes place within a specific set of relations, with the United States as a dominant imperial power. The mediated voice that moves from the margins of one country to the margins of another carries with it an implicit critique of imperialist positionality itself. But the global spread of hip-hop also gives rise to a counter-narrative that goes beyond the commercial-underground divide. As corporate rap emerged as the latest manifestation of commodity culture in the United States, so global hip-hoppers used gangsta rap to make trenchant critiques of racial and economic exploitation. Global hip-hop is not necessarily an antidote to a clichéd and commercial hip-hop culture in the US — there are counter-hegemonic expressions within the US just as there are outside it. But through tropes of blackness, as well as the playful inversions and parodies employed by rappers, postmodernism continues to find purchase in the global manifestation of hip-hop culture.

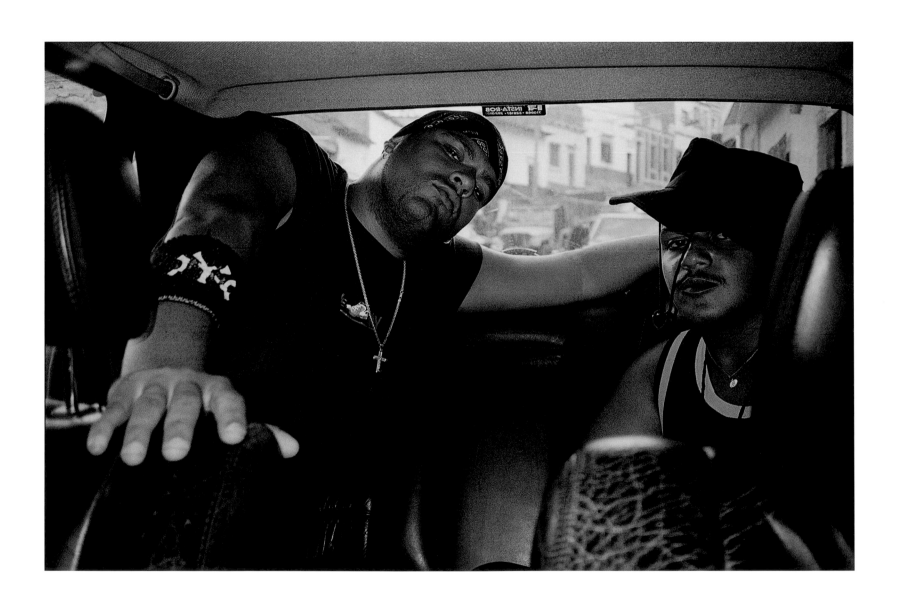

Susanne K. Frantz

KLAUS NOMI: ASTRAL COUNTERVOICE OF THE NEW WAVE

Imagine the contrast: at one moment the slight, two-tone automaton is belting out a march-tempo tune about nuclear obliteration; in the next, he delivers a complex seventeenth-century operatic passage by Henry Purcell. Each rendition arrives by a voice that is already remarkable in the high tenor range, and in falsetto can match the eerie tones of a theremin. Even before hearing a note the audience is ensnared by the luminous otherworldly persona.

If pastiche, re-contextualization, and the interleaving of high and low, past and present, are hallmarks of postmodernism, then Klaus Nomi was its poster boy. From late 1978 until 1983, when his life was cut short, he was a nomenclature-defying microblast with a stage presence as striking as his sound. Born Klaus Jürgen Sperber in 1944 during the period of massive Allied bombing, he was reared by a single mother in post-Second World War Germany. The youth, who later cited Elvis and Maria Callas as his spiritual father and mother, had a promising natural voice and envisioned a career as a classical singer. It is not known what prompted Sperber's move from West Berlin in the summer of 1973 to a country he had never visited and where he had few contacts. During the 1970s and early 1980s Manhattan was in economic distress and street crime was rife. The East Village, where Sperber settled and reinvented himself, was particularly grim, but rents were cheap and the locale attracted a diverse citizenry of self-described outsiders. The city offered Sperber greater professional opportunity and its gay community was alluring. Although homosexual acts had been decriminalized in the Federal Republic of Germany in 1969 and Berlin harboured a long-established scene, Greenwich Village's Stonewall Riots (also in 1969) had helped turn lower Manhattan into an increasingly tolerant milieu for gay men.

The soft-spoken, conservatively attired Sperber could not have given birth to Klaus Nomi without his circle of creative companions; the transition might be described as a group do-it-yourself project. In 1976 he met Joey Arias, who was already an experienced performer and would soon be head of sales and *bon vivant* host of Fiorucci, mid-town's newest and trendiest emporium. Sperber was in his early thirties and ready to accept the younger man's coaxing toward greater self-expression, confidence, and above all else, the celebration of pure fun. Kenny Scharf, student painter of space fantasies, became a friend, as would the artists Keith Haring and Jean-Michel Basquiat. But Sperber gravitated more toward the aspiring actors and musicians conjuring themed events for neighbourhood hangouts. Nightlife centred first on Max's Kansas City and then CBGB's, Mudd Club, Club 57 and Danceteria became favourites.

Music was the overarching connection. By the late 1970s the great tangle of American punk/glam/electronic-techno-synth/retro-future/art rock/et al was loosely embraced by the term 'New Wave'. Sperber's inherent, if largely untrained, vocal gift set him apart from his Lower East Side contemporaries. His low voice extended to baritone, yet his preferred register was much higher. He described himself as a countertenor and sometimes as a contralto or mezzo-soprano, terms associated with female vocalists. The upper male voice has rich precedence in gospel, country, soul and popular music, but Sperber aimed

182
Klaus Nomi, backstage, possibly at the *New Wave Vaudeville Show*, Manhattan, 1978. Photograph by Christina Yuin

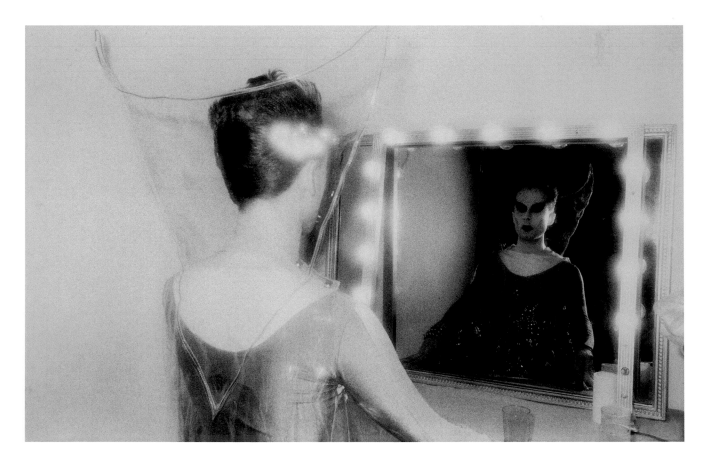

to introduce himself in an operatic manner. His niche remained elusive, however, until the invention of a new persona and a single performance in the *New Wave Vaudeville Show*, an assemblage of quirky downtown entertainers (including Beanie the singing dog).[1]

On 8 November 1978, the curtains parted on what seemed like an apparition from Fritz Lang's 1927 cinematic masterpiece, *Metropolis*. Like the film's *Maschinenmensch* robot, the newborn Nomi stepped stiffly forward with arms opened in an oratorical posture. A loud recorded orchestral cacophony accompanied the dramatic entrance, and then was interrupted by the opening bars of Saint-Saëns' aria 'Mon cœur s'ouvre à ta voix' ('My heart opens to your voice').[2] As his wide eyes stared

beyond the audience, the terrified Nomi sang the aria with a clear and unaffected timbre that could have been a diva's.

From that first performance, Nomi's appearance was destined to be as important as his voice. He wore a futuristic costume that looked sleek and high-tech, even though it originally featured a secondhand, ladies' plastic rain cape. Rather than disguise his obviously receding hairline he emphasized it, combing the hair straight back and up into a low, spiked ridge. The precision haircut was gradually widened at the temples to further triangulate the head. Apart from the prominent wedge of Nomi's nose, the image was doll-like; its *pièce de résistance* was the mouth, drawn with black lipstick into a cupid's bow. Those lips drove home the mask effect, and

implied both the gravitas of Noh theatre and the coyness of Betty Boop. Nomi's visage was proto-goth, however; his movements were too close to a puppet's to be menacing. Without make-up his egg-shaped face was handsome, but nondescript; with it, Nomi became weirdly beautiful – like Columbine and Harlequin rolled into one – and instantly eroticized for both sexes (pl. 182).

While seemingly male, the sexuality of the Nomi character was ambiguous. Gay Liberation was on the rise, but only a few American performers dared to be open about their homosexuality. Those brave individuals included the disco star Sylvester and glam rocker Jobriath. Each was very talented and enjoyed a certain amount of commercial success, but also paid the price of marginalization by the mass market.[3] The glitter look for both gay and straight was waning by the late 1970s, but the titillation of bisexuality, as insinuated by the New York Dolls and then exemplified by David Bowie, remained acceptable.

Nomi's orientation, if one could be discerned, became part of the cultivated illusion that he might not be human at all. To be identified as an alien visitor from another galaxy was not only intriguing, it was also helpful in defusing potential questions about sex. Fascination with advances in space exploration, mixed with a soft spot for kitschy science fiction imagery, had long been adopted in varying degrees of verisimilitude by entertainers. It was not a stretch for Nomi – a lover of comic books, fairytales, toy trains and Mickey Mouse – to immerse himself in the intergalactic *zeitgeist*.

The first person to shape Nomi into something more than a novelty act was Kristian Hoffman, a member of the popular band the Mumps and a fellow performer in *New Wave Vaudeville*. Despite perceived confrontational and angst-ridden aspects there was a playful branch of New Wave, and Hoffman, with his post-punk pop sensibility, steered Nomi in that direction. His repertoire was broadened to envelop three distinct genres: the operatic aria, reinterpretations of select pop songs (both recent and 1930s classics), and original pieces, including 'Total Eclipse', one of three which Hoffman wrote specifically for Nomi. At the composer's urging, and using his arrangements, Nomi tackled several early 1960s and 1970s hits including the histrionic 'Lightning Strikes' by Lou Christie and Donna Summer's 'I Feel Love'. Chubby Checker's bouncy version of 'The Twist' was massaged into a bass-driven dreamy address to planet Earth in which Nomi's voice surged from a whisper to whoops and wails. His crisp diction and Germanic rolled r's added to the deliciously bizarre Teutonic coloratura.

Nomi's big breakthrough came on national American television at the end of 1979. He and Arias were tapped by David Bowie to provide back-up vocals for three songs on the programme *Saturday Night Live*. Arias was a follower of high fashion and in the search for unisex chic outfits for the show he found two long, belted tunics with extended shoulders and matching leggings by French designer Thierry Mugler. A few days after admiring one of Bowie's costumes – an encapsulating unit based on a 1923 design by Sonia Delaunay – Nomi gave sketches of a stylized vinyl 'tuxedo' to the same

costumier to fabricate (pl. 183).[4] Like all of Nomi's attire it was severe, structured and unadorned. That taste encompassed everything from Albert Speer's architecture to the clean lines of the hourglass-shaped Chemex coffee-maker in Nomi's kitchen.

The new costume's rigid black-and-white bodice turned his slender frame into an inverted triangle above a seemingly corseted waist. The combination of oversize torso, delineated legs, white gloves and a bow tie nodded to Nomi's beloved Mickey Mouse, as did the black scalp, now outlined and filled in to form dual lobes arching over plucked brows. Nomi used this signature design to create a flattened profile in a Knave of Hearts style, but unlike the performance artist Leigh Bowery (see pl. 57, p. 53), he did not attempt to reshape his body as sculpture or use it to examine the nature of identity. Whether inspired by the outer space villain Ming the Merciless or a ruffed Renaissance courtier Nomi was always recognizable. The finery was his tool in constructing a loosely defined epic.

Nomi's expropriation and reframing of iconic works might seem to make him a textbook case for Susan Sontag's 'Notes on Camp', but Nomi was not 'campy'.[5] He projected faint irony, but never the insider's wink to the audience signalling a spoof. In his eyes the *Klaus Nomi Show* was genuine musical theatre. It expanded in scale – at first, only Arias and Richards, wrapped head-to-toe in cellophane and go-go-ing behind the almost motionless Nomi – to a cross between Weimar-era cabaret and an Oskar Schlemmer avant-garde dance production. Up to ten performers marched back and forth brandishing cymbals and twirling spiral-banded parasols while a few simply flaunted interesting poses.[6] Nomi might sing with his head and arms poked through a rotating cut-out of a period gown. Or he might perform alongside a *doppelgänger*, 'little sis', who in turn danced with a life-size, acrylic replica of herself.

In 1980, after many years of living hand-to-mouth, Nomi grabbed the chance for international recognition and a modest monthly stipend by signing an ill-considered contract. Within weeks the new management had dismantled the essence of the show, dismissing the original group and substituting a mainstream rock 'n' roll band to appear with Nomi in the documentary film *URGH! A Music War*. In 1981 and 1982 two memorable, but compromised, LP albums were released in Europe, earning Nomi a gold record for sales in France. A series of promotional appearances culminated in Munich on 4 December 1982, when Nomi gave the performance of his life in what proved to be his final public appearance. Standing before a full orchestra he sang a step-by-step ascending and intensifying aria by Purcell, in which the wintry 'Cold Genius' character appeals for the peaceful sleep of death.[7]

Never physically strong, Nomi had complained of increasing fatigue for over a year and there were signs of struggle in his voice. He was eventually diagnosed with AIDS (at first called 'gay cancer') and became one of the earliest casualties of the arts' most devastating scourge. Klaus Nomi died on 6 August 1983, aged 39. Today, decades later, his instinctive and enigmatic synthesis of aesthetic extremes remains the embodiment of an incandescent time and place.

Matthew Hawkins

THREADS AND RAYS: ACCESSORIZING MICHAEL CLARK

What would impel dance performers to abseil buildings, float around on rafts, unstack/articulate/restack inanimate objects or improvise for hours around each other's bodily surfaces? These startling outcomes emerged, simultaneously enough, from the singular politics of the first collective of postmodern dancers in New York. Episodes of their work appeared serially in London and marked, for us, a shifting of thresholds. A fuller gamut of human activity was acknowledged. Plurality was unleashed by notions of conventional entrapment that might be sidestepped; I'm thinking here of traditional musical accompaniment, familiar performative archetypes, narrative assumptions and professional hierarchies. Fresh acts of omission in the form cleared space to reveal what was actually happening. We could now see how dancers thought on their feet. I speak as a dancer who had started very young, and so had acquired a manner of dancing unquestioningly. The postmodern arena made me aware of skills I might employ or shrug off, and the new mode of plurality encouraged my participation. I could reveal my actions, safe in the embrace of new peers.

Michael Clark was also buoyant in this inclusive new realm. He cherished elements of his frisky lifestyle and wove these into his works, transposing his thinking via a serious grip on choreographic draughtsmanship and pace. Yet Michael's was a shared outlook, which invoked a British subculture ready to make itself known, ready to know itself. A new fan base somehow felt its beginnings within his work. What had once been edifice (dance performance) became more like architecture. You could get inside. Soon Michael popped up everywhere, pervading personal space and popular media – not least in glossy new print (pl. 184).

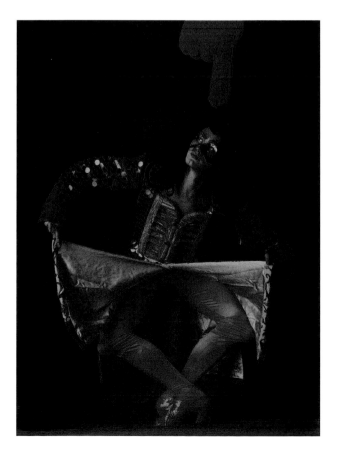

His company showcasing other talented dancer/ choreographers such as Gaby Agis and Matthew Hawkins, Clark works on the leading edge of Modern Dance. Unorthodoxy is his stock in trade: dancing to The Fall, Wire, T Rex; using props like platform shoes, dildos, taped telephone sex; working with young video makers like Charles Atlas; exploring the links between fashion and dance most notably with Bowery and Bodymap's David Holah.

This byline, from a summary item in *The Face*'s 100th issue, makes a good fist of things but is well wide of the mark. Bodymap was a fashion house run by two designers, Stevie Stewart and David Holah. Charles Atlas was pretty seasoned: the best in the business. Modern Dance was, even then, a moribund term (except abroad). There are also a few erroneous details: there were several truncheons littering the work but only ever one dildo, and Gaby Agis and I had our respective things going but operated in Clark's troupe purely as dancers. By airing such qualms I am rating *The Face* as influential but also picking holes, and in doing so I enter the mode of those times. We were hard to please, verging on the bloody-minded. We were brazenly eye-catching but we revelled at the social margins. We did our spadework but were also into hedonism. We craved recognition but were fully intoxicated with what we were doing.

Contrariness aside, what is apposite about *The Face*'s short text on Michael Clark is the fact that it shares a page with items on those massive cultural levellers, 'sampling' (then a novelty) and Channel 4 Youth TV. And then there is Michael's full-page colour portrait, directly opposite in the magazine's layout, showing him poised at the cadence of that phase of his work. Getting there had been a climb, though here he looks unflappable in his tangerine Leigh Bowery frock coat, his bulbous primrose knees thrown east to west, saloon doors a portal to his ribcage, his wig rigid and the Perspex half-mask strategically studded.

There would be but one further manifestation of this kind of ecstatic regalia. In Michael's work *Because We Must* (directed by Charles Atlas and produced for Channel 4), we insinuated ourselves, gripped vice-like in our Leigh Bowery crewelwork carapaces, into the nation's living rooms amid the retro, pounding scariness of Lou Reed's 'Venus in Furs'. Those in the know witnessed a coda – a final candid fling in a d'Offay Gallery event – and a tossing of the sticks.

This unusual dancing had, by now, stormed a few bastions and raised a few eyebrows. Yet a general British public was readily drawn to see Michael Clark and his bundle of like-minded souls; they felt no sense of exclusion. Whether this was postmodern plurality making its influence felt, or a matter of *zeitgeist*, the progress is worth recalling. At first (and against pockets of avuncular resistance) teenage Michael was named dancer in residence at Riverside Studios. His tenancy there comprised a working base that gave him the right kind of motivational shove. Multi-media, edgy and unremittingly top-drawer, Riverside's performing arts/exhibition/film programme wrung the best out of him, against a backdrop of artists in other media industriously at work in Riverside's available housing – when they weren't knocking around in the ebullient bar/foyer area. Emerging discourse, intimate

185
Michael Clark and Karole Armitage at the Riverside Studios, Hammersmith, London, 1982. Contact sheet. Photographs by Chris Harris. Courtesy of Karole Armitage

alliances and creative friction were all intrinsic to the vision of artistic director David Gothard, whose curatorship ensured that Michael's initial manoeuvres shared space with the lucid dance conceptualism of American masters and gusts of free-thinking Dartington alumni. A radically new 'spectator sport' was being ushered in. Whereas beforehand becoming a choreographer had been a near impossible task, for which one was meant to display innate 'talent' and hit some arbitrary 'right note', we were now being shown that it was okay to just 'spill the beans' about a dance's essence. One could be methodical, concentrate on the craft of transparent rendering, and know that Riverside's punters would catch on, quiver even.

In this context Michael lighted on New York diva Karole Armitage (pl. 185). Elegantly SoHo, ballistically renegade and set to thrashing decibels, Karole's Riverside performances enthralled him. The two choreographers were soon in cahoots. Michael nipped over to Manhattan, cast as a dancer in the Armitage line-up, and came back bursting with new credentials. He had also mesmerized Karole's video chronicler Charles Atlas, who embraced the transatlantic commute, becoming a consistent right hand to Michael, lighting and shooting each production to this day. Such are the connective threads and rays that delineate new waves in the public eye.

Amid our ongoing London toil, choreographic signatures were the big priority. We felt that small-scale production would generate the events people would want to see and we were not wrong. Initially, presentation was simple and costumes were anything except disguises. Well prior to the advent of both contemporary dance management infrastructure and wheeled luggage, we personally hauled and laundered our neutral outfits. Lightweight stretch jersey in monochrome shades held sway — we might not even change out of our utility daywear.

A notorious jolt was administered to the prevailing aesthetic when Michael Clark stepped out in a costume designed by Leigh Bowery. This was a creative cleaving that changed everything by showing how a tailored, tactile and fully accessorized look could reveal, rather than conceal, a dancer's essential persona. And there was nothing effete about this costumier and his process. Leigh was colossal and stalwart, yet his eye-to-hand channels were agile. Right from the start, his creations had a boldness and colour to match the sound world inhabited by Clark's choreographies of the time — I'm thinking here of Mark E. Smith's band The Fall, which really was the *ne plus ultra* of post-punk sensibility. Yes oh yes, and never mind the bollocks, these elements hung together most adroitly.

As a wearer of these costumes, I found myself caught up in the art/fashion nexus that followed but this did not seem a premeditated affair. True, Holah and Stewart regularly costumed us in prints and fabrics that they also used in their commercial lines. Bowery removed himself from the fashion business early on, opting instead for a career as a nightclub host and performance artist. Yet he never eschewed the license, clannishness and knowing farce of fashionable attire — this chimed well with the predilection of Clark (and Mark E. Smith) for allegorical satire. For Leigh, fascination with (and subversion of) dress code motored his ideas for some time: that and a preoccupation with craft. Bowery's restless hands turned themselves to cutting, machining, printing, pleating, piping,

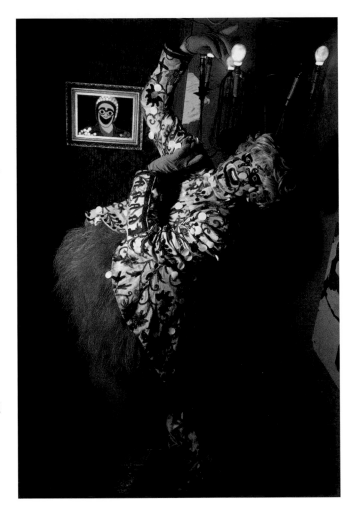

wadding, boning, stuffing — all the manual aspects of exploration that would generate his design ideas. Factor in his energetic club-going — and hence his intimate knowledge of the behaviour of light/heavy, stretch/nonstretch, pricey/cheap fabrics on and around his own dancing body — and it can be seen that his elaborate creations were the product of intense know-how (pl. 186).

He had his hands full, so usually our costumes would arrive very shortly before the deadline or even right on the cusp of our entrances. At first the garments were easy to sling on and we knew they would be flattering in the right dancerly way. We might show a lot of leg. Big headgear gave us extra height and a more defined silhouette. We were happy to be wriggling into this fully considered statement-wear. We came to trust that crucial seams would be indestructible and that generously shaped leg holes would foster confident ease of movement. It certainly upped our adrenaline to await our wardrobe, which would appear in a flurry of technicolour. Later, as the productions became generally more ambitious, there were several other collaborative elements falling into place just prior to curtain up, so it helped to know what and where the costumes might be. Michael quipped that getting Leigh on as a performer would ensure that at least one person's outfit would be fully conceived and run-up in advance.

It was never about staying put. Michael and I both were trained in established institutions and worked in 'legit' troupes

before we moved into avant-garde practice. We sought raw and effective ways in which to honour the investment made in us. Turning up from the Antipodes were adventurers like Bowery and his machinist of the moment, Pearl, with their uninhibited (and not very London) sense of colour and scale. Polytechnic student by day and denizen of Taboo by night, Nicola Bateman befriended Pearl and caught Leigh's eye (pl. 187). Her decorative genius was absorbed by other members of the team. Together, they helped propel the convulsive Clark enterprise out of Riverside Studios, onto proscenium stages and into confrontation with mainstream audiences. This was a tribute to their skill base, which was eclectic and right for the times. It may or may not be incidental to note that, like Leigh, Pearl and Nicola had a flair for performance and were rated as hard-core 'party people'. Given their collective familiarity with the popping of flashbulbs and the shimmering of strobes, it was inevitable that they would crave a new zone of refraction.

Informed by the developing knowledge of what might glint or even dazzle in the beams of Charles Atlas' stage lighting, Leigh entered what we might call his 'sequin period'. The team began to pore over the minute differences between cup sequins (which required seed beads) and flat sequins (which could abut or overlap), or between top-stitch, prick-stitch and gallooning. Leigh became obsessed with the way the wing space in traditional theatres would provide for the act of quick-change. Soon we became vigorous offstage, tossing our used guises into heaps and zipping back on stage in fresh looks at high speed. Having taught himself corsetry skills, a newly christened 'Mr' Pearl began to offer an 'haute-couture' sensibility and our costumes became elaborate as never before in terms of cut, machining and lining (pl. 188). A fresh take on the leg-o'-mutton sleeve was perfected; the contours of gowns were fitted to our anatomy in such a way that heavy flaps and trains would cantilever just right and swirl around us. As technicians, Nicola and Mr Pearl would put in energetic hours of sure-touch embroidery. For the Amsterdam premiere of *I Am Curious Orange* (1989) their labours culminated in an arresting all-night stitching session in public, on the Harwich/Hook-of-Holland ferry. Football fans in transit glimpsed the hallucinatory tableau and belched out hymns of homage. Budget coach parties ogled and cooed.

Bowery-slanted postmodernism was all about homing in on a divide and straddling it until it fell away. Despite his star turns, he was humility itself in his rehearsal of legitimate ballet fundamentals. He was the matrix of our world, getting into our dressing rooms to slather on our glamorously cadaverous make-up, or winching and lacing an entire cast into Mr Pearl's corsets. Making his entrance on stage, he might integrate with the ensemble or pull focus in an unforgettable vignette. And then, during scenes that did not require his presence, we would look up and glimpse him vogueing in the flies.

187
Nicola Bateman in rehearsal for a dance piece by Matthew Hawkins, *c.*1987. Photograph by Fred Whisker

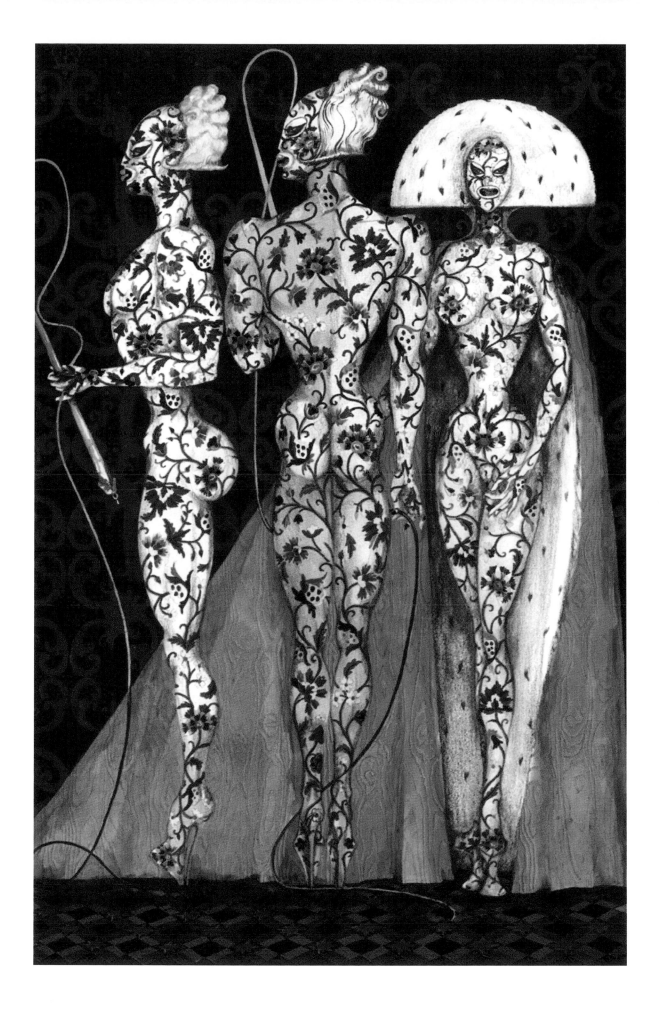

188
Mr. Pearl, *Untitled* (detail),
*c.*1987. Inspired by the costumes
produced for Michael Clark

Bruce Baird

EMBRACED BY THE (SPOT)LIGHT: ŌNO KAZUO, BUTŌ AND 'ADMIRING LA ARGENTINA'

In 1977, after a decade of silence, the 71-year-old dancer and choreographer Ōno Kazuo staged a comeback performance entitled *Admiring La Argentina* (pl. 189). Few could have predicted that he would soon dance to packed houses worldwide as a representative of a Japanese performance genre – butō (or butoh) – an imagistic performance form by turns grotesque, serene, violent and achingly beautiful.

The roots of butō go back to Hijikata Tatsumi, a dancer trained in ballet, jazz, flamenco and German Expressionist dance. In 1959 Hijikata broke with those forms to explore new possibilities of dance and theatre. His first piece, *Forbidden Colours*, shocked the dance world, but was not yet what we know as butō today. It depicted a man sodomizing another, younger man, and then forcing him to kill a chicken – in a performance ostensibly based on Mishima Yukio's novel of the same name and the writings of Jean Genet. But Hijikata turned away from such mimetic narratives. For the next decade, he experimented with widening the scope of dance to include activities such as eating cake, photographing the audience and shaving heads. In the early 1970s Hijikata turned to deeply structured choreography – even specifying the dancers' mental imagery in order to affect the quality of their performance.

His turn to highly structured dances caused the small community of performers to fracture as the movement split into many different kinds of dance, all of which are termed butō, a compound word combining the Chinese characters for 'dance' and 'tread'. Practitioners were divided across several artistic fault lines: improvisation vs. minutely structured dance; spectacle vs. minimalism; emotion and sensation vs. meaning; and arbitrariness vs. authenticity. Some performers exclusively improvise flowing movements in fields and forests, while others construct grand pantomimic spectacles (for example, a badger with a Hitler moustache sodomizing a Japanese peasant blindfolded with the Rising Sun Japanese flag). Today butō occupies a central place in avant-garde performance art in Japan, and includes an eclectic range of styles, making it hard to define. Stereotypically, it is often taken to plumb the depths of humanity and explore the darker side of existence, or provide a privileged aperture to timeless universal truths.

One of the paradoxes of trying to locate that eclectic dance form in relation to postmodernism is that much that might be termed postmodern (Roland Barthes, John Cage, Merce Cunningham) stemmed directly from the encounter of these people with Japan. This has led to the curious debate about whether Japan was already postmodern before postmodernism.[1] Additionally, it makes little sense to speak of the postmodernism of butō as a whole. Its variety mirrors that of postmodern dance, which stretches from the minimalism of Judson Church in

189
Ōno Kazuo, 'Bird' scene from *Admiring La Argentina* (première), 1977. Tokyo

the 1960s (which might be termed modernist) to the multimedia collaborations and boundary blurring of the 80s (which are closer to the postmodernism of other disciplines).[2] The use of improvisation or minimalism in some butō is reminiscent of Judson Church, while the use of randomized choreography elsewhere in butō might be taken as a Japanese analogue of Merce Cunningham.

Butō, then, illustrates a larger truism about postmodernism: however one defines the term, it is but a stage in the development of Western art and design. To be sure, Western artists borrowed selectively from the non-West in creating their arts, but any art from a non-Western country must necessarily intersect with postmodernism in oblique and incomplete ways. However, geo-political power imbalance ensures that even when non-Western arts overlap only partially with postmodernism, they may be pulled into its ambit.

As an example, let us consider Ōno Kazuo and his signature work *Admiring La Argentina*. Born in 1906, Ōno eventually became a physical education teacher (and later janitor) at a Christian all-women's school in Tokyo, and joined the Christian faith. After seeing the German modern dancer Harald Kreutzberg perform, he began to learn German Expressionist dance from the Japanese choreographers Eguchi Takaya and Miya Sōko (both pupils of Weimar dance icon Mary Wigman). The Second World War interrupted his dance training for nine years while he was at the front and then a prisoner of war, but finally in 1949 he gave his first performance. During Ōno's first decade after the war, he worked within the mainstream of Japanese modern dance, but also chafed at its constraints.[3]

Eventually, he attracted the attention of Hijikata, who invited Ōno to appear in a revised version of *Forbidden Colors* in a role based on the characters O-kyō, a male prostitute from the Ueno district of Tokyo, and Divine, the aging prostitute from Genet's *Our Lady of the Flowers*. Dressed in a green negligee, a brick-red sweater, a white lace gown, and cheap vinyl shoes bedecked with fake red flowers, Ōno rose from a seat in the audience and made his way on stage where, after some time, he was attacked by some young men, stabbed with makeshift arrows, killed, and carted away.[4]

Ōno appeared in most of Hijikata's choreography for the next eight years, but then left the stage. In 1977 he returned with *Admiring La Argentina*, a somewhat improvisational solo dance. It consisted of a retrospective of the 'sum and substance' of Ōno's own 'individual trajectory through life', paired with an homage to the flamenco dancer Antonia Mercé y Luque, whom Ōno had seen 47 years previously.[5] Two scenes, 'Death of Divine' and 'Rebirth as a Young Girl', reprised Hijikata's choreography from 18 years before, and show Divine dying and being reborn. Wearing a shawl over a dark soiled dress (perhaps bespeaking a life of penury), Ōno seems to be dancing the pain of the dying prostitute. From the audience, he made his way on stage and backed into the sidewall as if he was a skewered insect, head lolling and arms dangling. Then he knelt — perhaps representing the tubercular Divine vomiting into a toilet — and died. Another scene, 'Daily Bread', featured Ōno in a pair of black trunks miming everyday activities, such as stretching his neck, or engaging in janitorial duties. In the 'Marriage of Heaven and Earth', he leaned back against a piano, looked up and breathed raggedly with his arms splayed out and his mouth open, as Bach's Prelude No. 1 in C Major played in the background. He looks as if the weight of a hard life presses him down. In the second half, Ōno danced an homage to Mercé with vaguely flamenco movements. After that, wearing a plain frumpy yellow dress, he cycled through off-balance depictions of shyness, sadness and menace. He concluded with a military salute.

In 1980 Ōno appeared in the Nancy International Theatre Festival, and made stops in London, Paris and Stockholm (pl. 190). For a septuagenarian performer, who had made only approximately 25 appearances between 1949 and 1976, the response was overwhelming: he was in demand. However, Ōno's encounter with Europe was changing both him and his choreography. Specifically, Lucia Schwellinger has noted that *Admiring La Argentina* became more abstract over time and much lighter in tone.[6]

When critic Jennifer Dunning reviewed his performance at La Mama in 1981 for the *The New York Times*, she wrote of a posing, preening, 'glittering old hag' cloaked in furbelows.[7] To be sure, Dunning was drawn to the power of Ōno's performance — and indeed both versions are magnificent in their own ways — but three things had dramatically altered the dance: lighting, costumes and minor changes in the choreography. The original cyclorama lighting, with Ōno in front of a red-tinged backdrop, caused his face to seem yellowish-green and thus rather sickly. Now a lavender-blue wash of light filled the entire space, making him look more ruddy. The original colour temperature was created with diffuse pools of white light with yellow hues, but now Ōno was given star treatment in sharply focused white spotlights with cooler blue hues. The original costumes of the performance tended toward the plain, or even unkempt and soiled garments, but Ōno switched to camp, frilly costumes. Gone were the military salutes or anything suggesting the horrors of war, and nothing in the mime suggested custodial work. In its place were preening, and what Dunning called 'glints of humor'. Finally, Ōno's originally outspread hands in the 'Marriage of Heaven and Earth' were redirected upwards and thus transformed into a reaching for the heavens, perhaps in a call for help. Dunning's religiously charged description of Ōno as 'messianic' in this sequence seems apt. In short, the dance changed from addressing war, a sick and dying prostitute, custodial tasks, exhaustion and physical education, to being about humour, theatricality and the campy glamour of an aging — but still very elegant — drag queen striving for redemption.

Critical theorist Homi Bhabha argues for a connection between postmodernism and the legacy of colonialism. Imperial expansion brought the curios of Asia, Africa and Latin America to Western metropolitan centres, where they became the basis of challenges to the dominant cultural narrative. Such objects were eventually displayed with due respect for their difference, but in a way that paradoxically demonstrated the 'centrality of the West' and the universality of the Western notion of the 'authentic artist' as an 'atomic individual'.[8] In the dances of Ōno Kazuo, a similar process is at work. Already in 1977 elements of the performance corresponded to some motifs that are characterized as postmodern. If the dance was indeed a self-portrait, then the self depicted was fluidly gendered and, in part, a pastiche of past performances by Hijikata and Mercé:

a set of quotations. Yet one also has to read the 1977 version as, in part, a response to social forces that sought to erase that gender fluidity. The pain that had served as the source for one of those quotations, one part of that self, was still very much visible, as were such things as the war and janitorial duties.

It is not clear where the changes in *Admiring La Argentina* came from but, by 1981, a decidedly more flamboyant postmodernism had overtaken the dance. Perhaps Western lighting designers instinctively gravitated to a flashier lighting scheme, or perhaps Ōno was responding in some way to

newfound fame and the wishes of the audience. The audience still saw in this 'aging coquette' (to again borrow Dunning's words) a path out of rigid gender roles. However, as Bhabha notes, what is often left unrepresented in postmodernism is 'violence, trauma, dispossession'.[9] Through the changes in lights, costumes and choreography, the rebellious fragments of Ōno's original performance and its contexts gave way to a supposedly redemptive flashy surface. In the postmodern age, perhaps this is all we can ask for; but to accept that entails a loss as well.

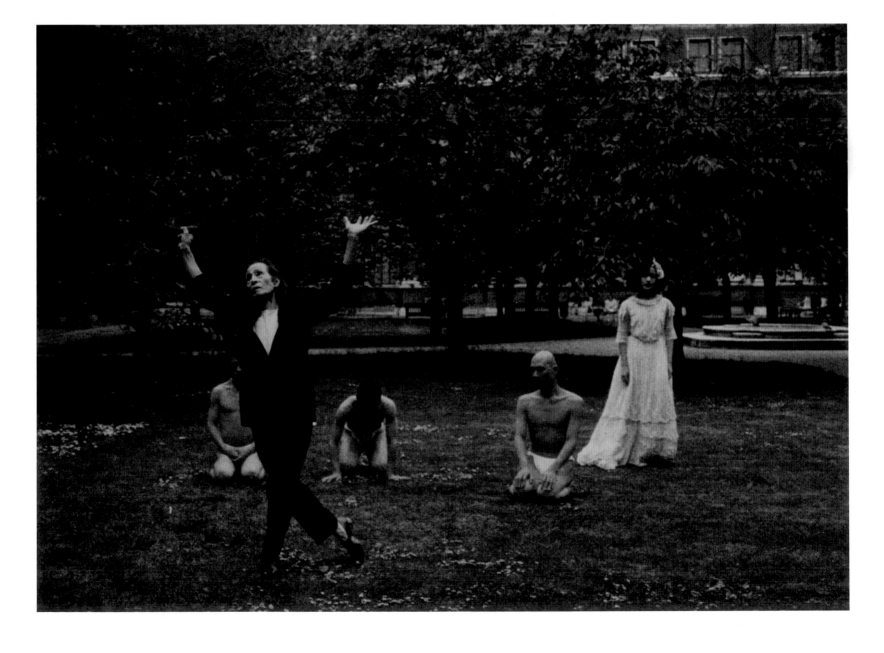

Rebecca Arnold

FASHION, VIOLENCE AND HYPERREALITY

191
Helmut Newton, *Nostalgic Eroticism*, 1975. Photographic print. V&A: PH.283–1980

Price follows her with his gaze and when he hears footsteps from inside coming down the hallway toward us he turns around and straightens his Versace tie ready to face whoever.
—*Bret Easton Ellis*, American Psycho

Bret Easton Ellis' 1991 novel, *American Psycho*, constructed a dark world of anonymity and violence. Its protagonist, Patrick Bateman, has a luxurious lifestyle of fine dining and penthouse apartments, but he is bored, alienated and seemingly interchangeable with any one of his equally blankly rich colleagues. He is also a serial killer, murdering for brief thrills amid the monotony of his life. The novel satirizes capitalism's hollow core. While its characters can buy anything they want, they are trapped in a world of sameness and repetition. The city is a site of decay: of morality, identity, relationships and human connections, as much as of the fabric of the buildings. The only remaining rules appear to be sartorial; dress has become the crucial, perhaps the only, way to express identity and assert status. Characters' outfits are tediously detailed in terms of labels, rather than as markers of a particular trait or emotion. Garments and accessories are listed as in *GQ* or *Vogue*, ready to be consumed, literally and metaphorically, rather than to provide insight into an individual. Bodies are worked on to create hard, muscular shells, each shaped the same as the next, to comprise signifiers of physical and financial success, and as a superstitious barrier against disease and illness. The characters have no personalities, only fashion's simulacra of identity, status and taste. Reagan-era emphasis on individuality has stripped away social connections and left a bland elite, eager to define themselves through consumption and conformity to unwritten codes. Bateman's only fear is wearing the wrong thing, or going to an unfashionable bar. His world is guided by fashion and style magazine diktats. It is a literal interpretation of media fantasies and aspirations, which are driven by advertising and sales' commercial imperatives.

Ellis' writing reinforces the idea of postmodern city life as a daily grind of work and leisure, which is shaped to create an impression, not to express a fulfilling and rounded existence. MOR music, food and clothes present an anodyne monologue. *American Psycho* catalogues Bateman's boredom; his obsessive attention to style seems like an attempt to gain control over his chaotically violent nature, and mask his own repulsion at his monotonous, yuppie lifestyle. His minutely detailed murder spree is the destructive underside of his world, and his designer suits and neatly gelled hair the fragile defence he puts up to prevent himself from spiralling out of control. The horror that the novel slowly reveals is that in the city's vastness, people can disappear without anyone realizing. Despite his colleagues' constant surveillance of each other's clothes and grooming, their lack of any firm connections to one another, and their over-reliance on technology to communicate, means they have no real network or safety net. While they stringently manage their visual appearance, their deaths at Bateman's hands do not even cause a ripple of disquiet.

The novel's ironic, brutal humour was representative of the period of late capitalism. Its bleak, compulsive consumerism and admixture of fashion and violence were part of the cultural

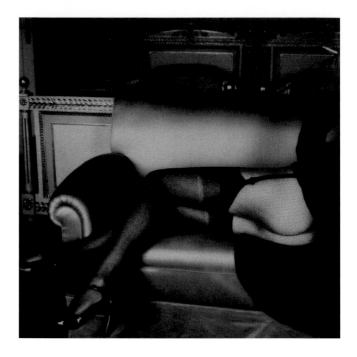

capital of the last quarter of the twentieth century. In Ellis' novel, sex and violence are visceral and excessive, while the clothes he describes blandly conform to current trends.

However, in the 1970s and 80s, fashion imagery itself had become increasingly assertive in its exploration of decadent couture fashions and lingerie. Sado-masochistic garments brought a dangerous charge of violence and eroticism to glossy magazine pages. Through the work of photographers such as Chris von Wangenheim, Guy Bourdin and Helmut Newton, heightened sexuality and brutality had become a regular element of fashion imagery. *The New York Times* described this style of imagery as 'the erotic-surrealistic school of fashion',[1] with its focus on bodies fragmented and cropped to focus on specific areas, such as legs or necks, and models contorted to look like shop window mannequins. These photographers created jarring narratives, and exploited the cinematic possibilities of *Vogue*'s multi-page spreads (pl. 191).

For Bourdin, heightened colour made even the natural seem surreal. His red-haired models lay strewn in ultra-green fields of grass, ran through cities chased by unseen foes, or were trapped in telephone boxes or window displays, half-alive, half-dead (pl. 192). His photography drew upon the deliberate artifice of disco-era fashions, which emphasized surface. The model's skin was daubed with jewel-coloured glitter. Lips shone with cherry-red gloss, hair was frizzed and teased, and clothes were brightly coloured and clung to the models' bodies. If Bret Easton Ellis catalogued the fashionable life of a serial killer, then Bourdin was more interested in the self-destructive impulses and fatal accidents of a hyperrealist world, peopled only by doll-like women, and threatening men who lurked in corners.

Newton and Von Wangenheim were equally absorbed in depicting violence and sexuality, and 1970s fashion imagery was dominated by their dark fantasies. S&M garments were appropriated at all levels of the postmodern fashion system – from Vivienne Westwood and Malcolm McLaren's punk styles to the bourgeois high fashion work of these photographers. While

Newton favoured *film noir*-inspired femme fatales, and glossy S&M scenarios set in luxurious hotel rooms, Von Wangenheim brought together such influences with a satirical eye that critiqued excess and decadence. Models with bug-eyed sunglasses and heavy fur coats were seemingly caught shopping in supermarkets, in a juxtaposition of the outlandish and the mundane. Like Ellis, he saw the black humour of postmodern existence, and the surrealism of everyday life, which was balanced between banality and the hyper-real promise of commercial culture.

It was not just high fashion magazines that explored these themes. *Time* magazine ran an article in 1977 entitled, 'The Sexes: Really Socking It to Women,' which detailed the growth of sex and violence in advertising, marketing and even shop window displays. Bonwit Teller in Boston, for example, had tableaux that showed prostrate mannequins wrapped in rugs and dragged across the floor of its window.[2] While American designer Halston had already dabbled in S&M-inspired window displays, this demonstrated a wider shift towards the mainstream depiction of violence. *Time* commented that this was happening, 'despite the rise of feminism – or perhaps because of it.' Although some of the article's contributors, such as Condé

Nast's editorial director Alexander Lieberman, saw this as merely shock tactics, was Chris von Wangenheim perhaps more accurate when he asked, 'The violence is in our culture, so why shouldn't it be in our pictures?' (pl. 193).

This sentiment was echoed by one of the models in the 1978 film *The Eyes of Laura Mars*, who describes such photographs as 'chic news' – a comment on and reflection of life on the streets of New York City.[3] The film's protagonist, fashion photographer Laura Mars, is a female amalgamation of Bourdin and Newton. Her photographs stage violent scenes of seduction and murder. In one set piece, a female model points a gun at the chest of her seemingly lifeless male counterpart, who has scarlet 'blood' on the surface of his dinner shirt. In another, lingerie-clad models fight against the backdrop of a multi-car pile-up in Columbus Circus. In each case the city has become a nightmare – its intensity and madness acted out by models, who seem to be animated by the chaos around them or driven to the brink by decadent consumerism. Actress Faye Dunaway, who played the title role, described the city in an interview as 'teeming', with 'the feeling of bursting … uncontrollability'.[4] New York in the 1970s was a barely contained mix of artistic verve and urban

192
Guy Bourdin, *Roland Pierre, Summer 1983*, 1983 (2003). Fujiflex Crystal Archive C-type print © Guy Bourdin estate, Courtesy Michael Hoppen Gallery

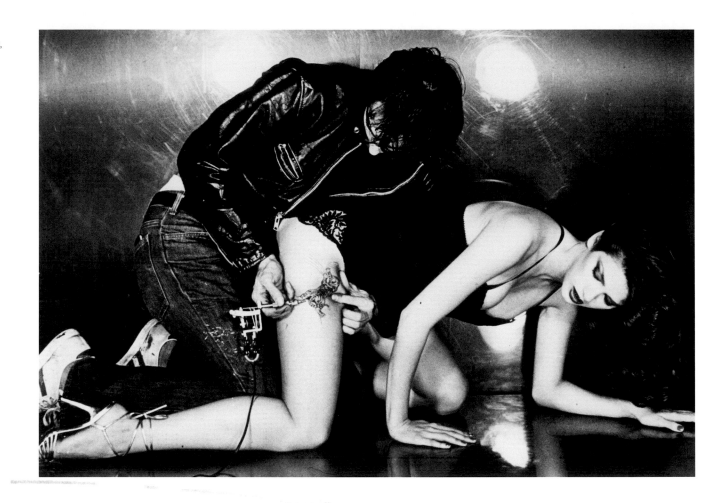

decay and violence, and this was manifested in the contrasts between the chic, deco-inspired interiors of Laura Mars' apartment, and the drama and disorder of the city streets. The film's driving motif – that Mars' photographs match exactly the murder scenes of a serial killer, making her camera seem like a gun – reinforced the blurred relationship between realism and fantasy that dominates fashion imagery.

In the late twentieth century, violence and sex were recurrent themes within fashion photography, and magazines, novels and films were amongst the media that explored these social and cultural anxieties. Postmodernism drew focus to surfaces and transgressions, and fashion was the optimum site for visualizing contradictory impulses of beauty and horror. Fashion imagery displayed a fascination with fragmented bodies, pastiches of earlier art movements, and juxtapositions of high and popular culture. This was, as Von Wangenheim said, because fashion is not only part of contemporary culture, subject to its shifting contexts, but is also able to make manifest hidden fears and desires. The fashion photograph's surface was far more than a mirror of postmodern social and cultural mores. It was also part of the construction of its visual and material meanings, since both fashion and postmodernism are inherently intertextual, self-reflexive and driven by contradiction.

Rick Poynor

BIG MAGAZINES: DESIGN AS THE MESSAGE

The large-format magazine was one of the defining images of visual arts journalism in the 1980s. Size was a way to get a publication noticed and it oozed self-confidence. Big pages were especially attractive to magazines dealing with design and visual culture: photographs were their stock-in-trade and these could be delivered with high impact on spreads with the dimensions of a TV screen. The format – A3 or a close variant – also presented an opportunity to construct the page in new ways that required a different manner of reading. By the end of the decade, these developments could be seen to spectacular effect in *Emigre*, the most experimental magazine of its time, a publication in which graphic and typographic postmodernism reached its zenith.

The format has its origins in the music press and the 1960s alternative press. Weekly publications such as *New Musical Express* (1952–) and *Sounds* (1970–91) in Britain, and *Rolling Stone* (1967–) in the United States, saw themselves as papers, though they incorporated magazine-like elements, and as with a newspaper, the copies were folded for easier distribution and display. The pages of the later San Francisco punk paper *Search & Destroy* (1977–9) were scrappier in composition, befitting the content, but the essentials of the format remained unchallenged. The London literary magazine *Bananas* (1975–9), also printed on newsprint, was an attempt to bring the sensation of news, hot off the presses, to the slower-paced, more sedate world of literary publishing. Art editor Julian Rothenstein's page design, a harbinger of developments to come, was visually inventive, making

plentiful use of illustrations and found imagery to enliven an otherwise standard three-column grid.

As the 1970s ended, the first of a new breed of culture tabloid made its appearance in Rotterdam.[1] Inspired by publications such as Andy Warhol's *Interview* and *Wet*, the self-styled magazine for 'gourmet bathers', *Hard Werken* (1979–82) emerged from a graphic workshop in the city's Lantaren arts lab (pl. 194). The magazine, put together by an editorial group that soon reconfigured itself as a design team, also named Hard Werken, aimed to cover Rotterdam's cultural scene, including literature, theatre, film, poetry, architecture and the visual arts.[2] Its pages were unfolded, and the smooth paper and better quality printing accentuated a design that claimed almost as much of the reader's attention, as a new kind of viewing experience, as the articles. Hard Werken rejected controlled modernist approaches to layout in favour of an intuitive, if not haphazard, assemblage of hand-drawn lettering, distorted typefaces, and photos, captions and other chunks of page furniture scattered at angles. Spreads were agitated and noisy, a jostling collection of elements clamouring in many dialects, rather than a uniform construction addressing the reader in a single modulated voice. If *Hard Werken*'s raucous graphic demeanour looked back to punk, it also looked forward to a decade in which the way things looked, the stylistic signals and nuances projected by elaborately designed surfaces, would come to monopolize attention.

Design now became the message of the big magazines, as well as their means of articulation. Doublespace, a New York design studio, launched *Fetish* (1980–1), with the tag line 'The Magazine of the Material World'. Fending off the accusation that they were engaged in the 'banal advocacy of consumerism' and likening themselves to archaeologists of the present, they set out to record and write about the objects that composed contemporary material culture.[3] This populist, postmodern embrace of 'low' subject matter – the second issue was devoted to various kinds of synthetics – was packaged in a tidier but still vivacious application of the postmodern graphic language developed by Wolfgang Weingart in Basel and April Greiman in the United States. Three decades later, the predictive accuracy of Doublespace's editorial vision and the formal precision of *Fetish*'s design remain striking. However, the funds to sustain this ambitious publication ran out and it was forced to close after three issues. Two new oversized architecture and design magazines, *Metropolis* (1981–) in New York and *Blueprint* (1983–) in London, now made their debut (pl. 195). It was left to these titles, as well as the large-format, though initially still folded, visual arts magazine *ZG* (1980–8), along with conventionally sized style magazines such as *The Face* and *i-D*, to analyse the stylistic imperatives of the object culture and image culture, and the consumerism they fuelled as the 1980s progressed.

In retrospect, it is curious that one of the most graphically uninhibited and original publications of these years (big or otherwise) received little attention for its design and layout at the time.[4] The three issues of *NATØ* (1983–5), published by Nigel Coates and his students at the Architectural Association in London, were a manifesto for a new narrative architecture with its senses ecstatically attuned to trends in postmodern

194
Hard Werken, no. 1, April 1979

195
Blueprint, no. 2,
November 1983

distraction, design itself became a central aim of the exercise. In 1988, in a survey of new magazines, Helene Silverman, art director of *Metropolis*, proposed that 'reading a magazine just for its design is as valid as reading one for its content'.[7] This assumption reflected the increasing visibility of the design gesture across postmodern visual culture, though many observers expressed misgivings: for art director and design historian Steven Heller, design's growing aspiration to become its own content was a 'dubious achievement at best'.[8] Responding to Silverman, American architect Joseph Giovannini mounted a closely argued counterblast against the aggression with which magazines were cutting and mixing words, photographs and graphic devices. 'The style and aesthetics of a page are surreptitiously usurping the meaning traditionally posited in words and images. And graphic design is the chief instrument used in the theft.'[9] This proved to be merely a preliminary skirmish marking the onset of the 'legibility wars' that would dominate digital typography and graphic design in the early 1990s.

Not all the big magazines chose to follow the path of hyperactive design. Although *Blueprint* frequently covered postmodern design and architecture – in the second issue it was already paying a call on Charles Jencks, 'pope of the post-moderns' – its design by art director Simon Esterson remained firmly wedded to a boldly journalistic and highly readable visual style that might be termed tabloid Modernism. *ZG*, probably the most sophisticated of the large-format publications in terms of critical rigour, maintained a pre-postmodern 1970s-style layout, handled by a succession of designers without *Blueprint*'s typographic consistency, flair and command of picture placement (pl. 197). Art magazines otherwise committed to postmodern visual culture's capacity to decentre, destabilize and deconstruct have tended to resist the mediating incursions of design.

In *Emigre* (1984–2009), launched in Berkeley, California by Rudy VanderLans and other émigrés, the large-format magazine became what it had perhaps been destined to be all along: a laboratory for testing postmodern graphic design (pl. 198). *Emigre* began as a 'culturetab' in the spirit of *Hard Werken* and it soon became a forum where VanderLans, as editor and designer, could explore the potential of bitmapped digital typefaces designed by his partner, Zuzana Licko.[10] By 1988 and its 10th issue, devoted to controversial developments in graphic design at Cranbrook Academy of Art, *Emigre* had turned its editorial attention to postmodern visual communication. For some designers, notably the New York modernist Massimo Vignelli, who called it a 'factory of garbage', *Emigre* epitomized everything that had gone wrong in graphic design.[11] Even in the age of postmodern depletion and pastiche, the new held some residual power to shock. In the 32 issues published before *Emigre* switched to a smaller page size in 1995, the magazine proved to be one of the most enduring visual documents of its moment: a restlessly evolving fusion of form and content that bodied forth the mood of polyglot cultural uncertainty with deep reserves of versatility and style.

popular culture and street fashion that most architects ignored (pl. 196). In an earlier manifesto for a 'Nonstraightforward Architecture', Robert Venturi had made the case for architectural elements 'which are hybrid rather than "pure," compromising rather than "clean," distorted rather than "straightforward," ambiguous rather than "articulated" … inconsistent and equivocal rather than direct and clear'.[5] *NATØ* shared Venturi's preference for 'messy vitality over obvious unity' and the first issue overloads the pages with a ragged but intricate collage of text and image, an arena of possibilities that invites the viewer to scan and browse before selecting a reading path, and so experience the kinetic abandon of a new kind of architectural immersion. Hand-scrawled headlines, drawings that wriggle and quiver with spasms of energy, editorial word-bites set in bold capitals reversed out of wavering black strokes, all slice across the solid framework supplied by a perfectly readable four-column grid. Such layouts can be seen as examples of what Nigel Wheale, discussing strategies used in postmodern art, terms 'discursivity'.[6] The design sets up 'interference patterns' between the sensual pleasure of the imagery and layout and the discursive reflections in long texts written by members of the NATØ group.

Publications such as *Hard Werken*, *Fetish* and *NATØ* took the structural components of the magazine page, which always had the potential to encourage non-linear forms of reading, and complicated them. At a certain level of complexity and

Paul Jobling

BETWEEN WORDS AND IMAGES: SIMULATION, DECONSTRUCTION AND POSTMODERN PHOTOGRAPHY

199
Cindy Sherman, *Untitled Film*
Still #2, 1977. Gelatin silver print.
Courtesy of the artist, Sprüth
Magers Berlin London, and
Metro Pictures

death or disappearance of God himself: 'Deep down God never existed ... only the simulacrum ever existed, even ... God himself was never anything but his own simulacrum'.[4] Likewise, he contended that postmodern hyperreality is symbolic of a society in crisis for which, following the trauma of the Holocaust, history no longer seemed to be unfolding according to any positive purpose or master narratives (what Jean-François Lyotard called the *grands récits* in *The Postmodern Condition*, 1979). Hence, people began to take refuge from reality in consumerism and mass media images so as to mourn the loss of concepts such as 'peace' and 'justice' that were once regarded as the basis of a meaningful, truthful reality.

Taking his cue from Baudrillard, Dick Hebdige also mounted an attack on the hollowness of hyperreality, impugning the ludic form and content of *The Face*, a youth culture title launched by Nick Logan in 1980, out of his publishing house Wagadon, for which Neville Brody coined a distinctive graphic style between 1981 and 1986 (pl. 200). In Hebdige's telling criticism, *The Face* was the archetypal postmodern magazine, since it embodied the shift from a history based on the word and writing to one in which 'Truth — insofar as it exists at all — is first and foremost pictured'.[5] Furthermore, much like Baudrillard, he argued that hyperreality is often based on a nostalgic impulse through which 'The past is played and replayed as an amusing range of styles, genres, signifying practices to be combined and recombined at will ... Advertising — the eidos of the marketplace — is pressed into the very pores of *The Face*'.[6]

Certainly, there are many instances of this kind of pastiche in postmodern advertising: from the cannibalization of surrealism in publicity for Benson & Hedges and Van Heusen shirts in the 1970s, to the retro-styled campaigns for Levis 501 or Brylcreem

200
The Face, no. 34, July
1983. Photograph by
Kevin Cummings, design
by Neville Brody

'Today there is a whole pornography of information and communication'.[1] It was in these terms that Jean Baudrillard framed a general debate about postmodern mass media and hyperreality, insisting that in a world over-saturated with images we no longer have the ability to tell representation and reality apart. In 'The Precession of Simulacra' he took things further still, arguing that we take flight from the real world by reproducing images based on other images, that is to say simulacra, which are based on the revival of the Platonic idea that a copy is made of an original which never really existed in the first place: 'It is no longer a question of imitation, nor duplication, nor even parody. It is a question of substituting the signs of the real for the real'.[2] We can discern this kind of simulation in Cindy Sherman's series of performative masquerades, *Untitled Film Stills* (1977–80) (pl. 199). In 1977 Sherman began to use photography to explore the ambiguity of female/feminine identities. In her posed images, we observe any number of 'Cindys' playing out an array of stereotypical cinematic roles, from feisty *film noir* heroine to vulnerable career girl. Although we might claim to have some recollection of the actual movie characters upon which such images are based, as Judith Williamson, an early feminist writer on Sherman, observed, her photographic personae are not straightforward cribs of specific movie stills at all. They are fictions in their own right: representations of cinematic heroines who never even 'existed', who we never really saw in the first place. Thus we are left to ponder their fate in the putative narratives of Sherman's non-sequential photographs.[3]

Baudrillard traced the origins of hyperreality and simulation back to the religious iconography of the sixteenth century, calling the Jesuits 'the most modern minds', since in their veneration of the image of God they were enacting the

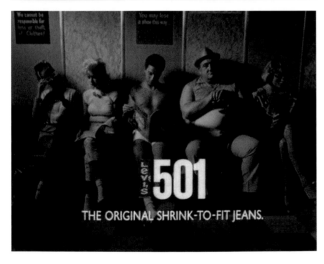

THE ORIGINAL SHRINK-TO-FIT JEANS.

Face did not unequivocally side with the prevailing style culture of the 1980s. Hebdige conveniently overlooks the fact, but witness 'Strategies for the Unemployed', with photographs by Steve Pyke, which explored the impact of youth unemployment in Thatcher's Britain just as photo-essays in *Picture Post* had depicted working-class communities during the Depression.[8] Clearly, the iconography of Kruger and *The Face* is embedded in commercial culture and the mass media; yet it still has the potential to make us think about wider social and political issues.

In insisting that we now live in a world based on simulacra and spectacle, both Baudrillard and Hebdige capsized the correspondence between words and images. It is precisely such matters that are pivotal to deconstruction and the writing of Jacques Derrida, who, rather than espousing hyperreality, set out to interrogate the relationship between reality and representation.[9] Thus he refuted the system of binary oppositions – for instance, Modernism versus postmodernism, high versus low culture, original versus copy, signifier versus signified, and word versus image – and instead wrote of the interrelationship of one concept with another. His philosophical contribution has been to encourage us not just to invert such oppositions, so that one term is always in a position of superiority over another, but also to think about the 'gaps' or 'spaces' between each term. Thus he coined the neologism *différance*, connoting the joint idea of difference and deferral, as a means to ponder the nexus between ostensible binary concepts and to realise that there are multiple readings or layers of interpretation involved in any given text: '*Différance* is a structure and a movement that cannot be conceived on the basis of the opposition presence/absence. *Différance* is the systematic play of differences, of traces of differences, of the spacing by which elements relate to one another.'[10]

Principally, Derrida was concerned with seeking out the blind spots of spoken and written language.[11] Speech, he argued, should not be regarded as being superior – or even anterior – to writing but as dependent on, or qualified, by it, and vice versa. His deconstructivist methodology, however, is not without relevance to thinking through the gaps and/or spaces in other systems of representation. Accordingly, many of the features and fashion spreads in *The Face* raise the question: What is at stake prioritizing words over images or arguing for their interdependence? A pivotal example is 'Who's Shooting Who? – In Beirut It Pays to Know Your Terrorist', with photographs by Oliver Maxwell and styled by Elaine Jones (it appeared in the July 1986 issue). Here the images, if taken literally at 'face' value, connote a parodic ornamental fashion parade of army uniforms. But, when we consider them alongside the accompanying text, which grafts together a potted history of the particular factions involved in the Civil War between Muslims and Christians and specific details of the uniforms the soldiers wear, the piece suggests a more complex imbrication of the 'serious business' of warfare and ideas concerning the decorum and power of military dress.

Looking at things this way, we can also begin to explore Sherman's *Film Stills* beyond their immediate simulacral dimension. For, without exception, she is actor and producer, subject and object, in relation to her photographs, a

in the 1980s (pl. 201). Must we take such images at face value, however? Must we agree with Baudrillard and Hebdige that the constant rehashing of images signifies that 'reality is as thin as the paper it is printed on'?[7] After all, not every hyperreal text is devoid of politics. Thus, in sloganized photographic silkscreens like *Untitled (I Shop Therefore I Am)*, Barbara Kruger co-opted the strategies of advertising rhetoric (which she learnt in her early career as a graphic designer for Condé Nast's *Mademoiselle*) in order to subvert the superficial consumerism of postmodern society (pl. 202). Yet even *The*

performative method that elides the difference between impersonation (this is a part I am playing to try to convince you who I am) and personification (this is who I am beneath the surface, outside the photograph). While Sherman has claimed, 'I don't realise what I've done until I read what someone has written about me', nonetheless she was one of a generation of American photographers, including Robert Mapplethorpe, who embarked on their careers at a time when the politics of liberation, artistic experimentation, and living on the edge had become the norm.[12] Consequently, the confounding of subject and object positions became a central concern for these photographers, whose approach to identities seems to betray an intense preoccupation with the deconstructive sensibility for double-dealing, breaking rules and blurring boundaries. Indeed, in simultaneously adopting the roles of producer and actor, Sherman's work is a trenchant deconstruction of Michel Foucault's premise that the human body is a crucial site for the exercise and regulation of power, involving those who see yet are not scrutinized (photographers, spectators), and those who are seen and impelled to 'a principle of compulsory visibility' (in Sherman's case, herself and other women).[13]

Deconstruction is a challenging, and often perplexing, theory because it does away with traditional modes of classifying and thinking about culture, and Derrida has often been accused of causing confusion and of encouraging indeterminacy. However, it is undecidability, not indeterminacy, that Derrida affirms is at the heart of deconstruction – that is, we can no longer decide things according to pre-existing, universal laws.[14] Instead, what binds us together is a form of collective uncertainty. We should expect to entertain endless possibilities as to how things can be resolved. Yet for all this, deconstruction is an instructive supplement to the aesthetic of simulation and a useful paradigm for exploring not just the differences and correspondences between different kinds of photography, but also the mediation of pictures through words.

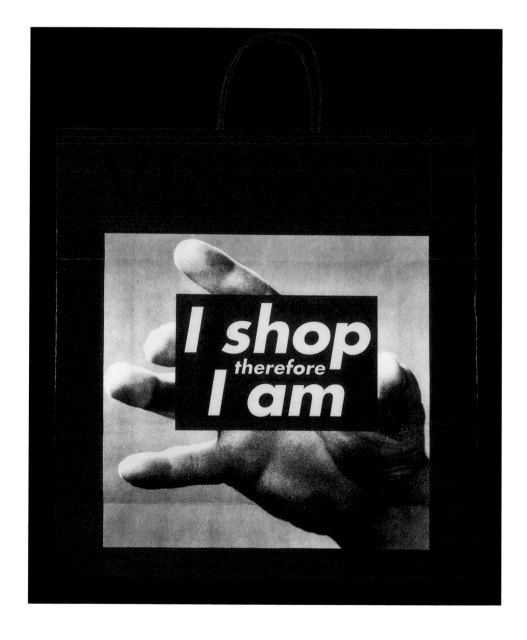

202
Vinçon carrier bag with image by Barbara Kruger, *Untitled (I Shop Therefore I Am)*, c.1987. Line-block printed bag.
V&A: E.2830–1995

Sally Gray

DAVID MCDIARMID, PETER TULLY AND THE ECSTATIC SPACE OF THE PARADISE GARAGE

In the post-747 world of jet travel, Australians Peter Tully and David McDiarmid engaged in a postmodern creative practice that was both local and global. They worked from the early 1970s in Melbourne and Sydney and, after moving to New York in 1979, created art and design that captured the ecstatic sensibility of the underground Black and Hispanic dance club, Paradise Garage. In the wake of the 1969 Stonewall events, the idea of a liberated gay subculture galvanized the movement of men and women from provincial cities and towns to centres such as New York and Sydney. McDiarmid was an early member of Gay Liberation in Australia and an activist artist, who identified his work as 'queer' when that term was radicalized in the 1980s. Tully was a gay cultural activist whose camp wit was materialized in jewellery and costume. As friends, lovers and creative collaborators, both took the idea that the 'personal is political' (originally proposed by Feminists) to heart. They rejected hetero-normative constraints and sought aesthetic means to assert their own personal subjectivity. After moving to Sydney in the early 1970s, they participated in demonstrations that ultimately led to the formation of the Sydney Gay and Lesbian Mardi Gras. They were both subsequently artistic directors of the annual Mardi Gras street parade, dance party and the legendary annual Sleaze Ball.[1]

Though they did not use the term, McDiarmid and Tully were postmodern in their playful dissolution of hierarchies. Their activity bridged art, design, craft, costume and fashion. They decried modernist ideas of 'good taste', and worked with plastics, pop culture, gaudy colour and overtly gay imagery. Their early work appropriated kitsch 1950s domestic products and tourist Australiana. For McDiarmid, use of decorative motifs and craft techniques was linked to the Feminist art movement of the 1970s: 'I loved the process and the stuff that people call inconsequential or decorative … to me it was more significant than that'.[2] Both artists wanted to produce this kind of cultural 'significance', reflecting their queer outsider reality. Another influence was non-Western aesthetics; Tully's travels in New Guinea, Africa, India and Indonesia had engendered a

passion for pre-modern body adornment. Both artists travelled together in Southeast Asia, and Tully explored museum collections in Amsterdam, Paris, New York and Sydney, focusing particularly on tribal dress. Between them they drew on these disparate sources to create jewellery, fashionable garments, handpainted fabrics and dance-floor outfits for the performance of a new gay male urban life.

In June 1979, Tully and McDiarmid arrived in New York – which they saw as a gay nirvana – in time for that year's Gay Pride March. McDiarmid had been introduced to the Paradise Garage – a mixed race, gay dance club in lower Manhattan – in 1977, its first year. He was struck by its inter-racial harmony and its ground-breaking African-American DJ, Larry Levan, who was one of the inventors of house music. The Garage's dance floor was a resonant cultural site at the intersection of gay and African-American emancipatory aspirations. Its multi-racial space went beyond the white 'homo-normativity' of mainstream gay bars and clubs. Tully and McDiarmid were inspired to originate work that responded to the Garage's unique transcultural ambiance and visuality. Levan's compellingly warm sound, the club's sophisticated acoustics, the wordless interpersonal kinetics of the dancers, along with psychotropic drugs, combined to create a kind of immersive pheromone hum in a singularly unfettered inter-racial space.[3] As Tully remarked, this 'was a heavy duty serious business. People took their partying very seriously – it was not to be taken lightly. And rightly so'.[4]

McDiarmid had briefly studied film in Melbourne. His first one-person exhibition, *Secret Love* in Sydney in 1976, included drawings, collages and hand-sewn wall hangings in coloured plastics, a bold exploration of the gay 'closet'. His diverse output included graphic design, fashion design, fabric painting, large-scale street parade sculptures and contemporary art. He was also a DJ for Mardi Gras dance parties and Sydney gay clubs. His *Disco Kwilt* series, made in New York between 1979 and 1982, with titles such as *Party Time* and *Klub Kwilt*, allude to the ecstatic visuality and communal optimism of the Paradise Garage (pl. 203). Made in jewel-coloured, reflective holographic signage material, cut and tiled into traditional quilt patterns, the works' refractive surfaces subvert the familial homeliness of a traditional quilt, evoking instead a homosocial world that was not yet rocked by AIDS.

Tully was initially a jeweller whose work, using plastics and found objects, expanded into performative costume. The welcome reception he found on the Paradise Garage dance floor inspired his invention of a self-designated 'Urban Tribalwear' (pl. 205).[5] For Tully, the Garage's dance floor engendered the concept of a 'tribe' that exceeded the limits of race, ethnicity, sexuality and class: a post-colonial utopia. He stated in a later interview: 'I was looking at urban groups, the punks, blacks, Puerto Ricans, WASPS, gays, and I more or less saw them as little tribes. And so I started making things for my tribe and drawing on my interest in real tribes.'[6]

Using materials that would be optically lustrous under club lighting, Tully made outfits for himself and other dancers. His 1980 *Ceremonial Coat for the Grand Diva of the Paradise Garage* drew, as the title suggests, on the concept of the 'diva', which had been appropriated by queer culture from the grand

203
David McDiarmid, *Heart of Glass* (one of four panels entitled *Self Portrait*), 1990. Reflective holographic foil on board, 60 × 60 cm. Private collection. Reproduced with permission of David McDiarmid Estate

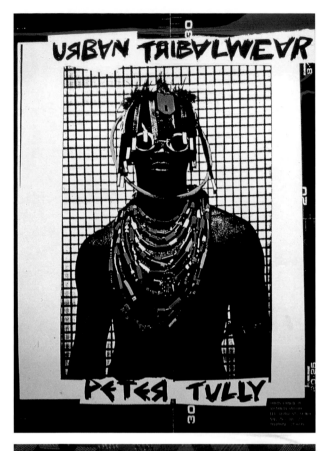

presence of performers like Jessye Norman and Yma Sumac. Tully was also thinking about overblown Victorian history paintings, such as Sir Edward Poynter's 1890 *The Visit of the Queen of Sheba to King Solomon*, which he had seen in the Art Gallery of New South Wales in Sydney.[7] Like his 1984 'costume sculpture' *Mary Don't Ask*, it was made of plastics and found objects (pl. 204). These imposing costumes materialize the originality, charisma and 'attitude' of the Garage's best dance divas.

McDiarmid's work was indelibly marked by the AIDS crisis and his own seropositive diagnosis. From the mid-1980s, he placed his HIV+ identity at the centre of his work. *Heart of Glass* is one of four works, collectively titled *Self-Portrait*, whose prismatic mosaic surfaces, like those of the *Disco Kwilts* series, are achieved by cutting and adhering reflective holographic signage material to painted board (pl. 206). It is composed of a stylized heart, the inverted pink triangle used to mark homosexuals in the death camps of the Third Reich and the graphic symbol for infinity. The corners of the work are marked 'HIV+'. This 'self-portraiture' is a symbolic mapping of the artist's 'pariah' status. While referencing the abjection of AIDS and homophobia, the work also looks ahead to post-mortem infinity and, in its decorative visual intensity, materializes a vibrant evocation of the dance floor.

McDiarmid and Tully resisted the commodification of gay identity, instead espousing a politics of radical pleasure. In the face of the late 1970s conservative backlash against liberationist cultural politics, they created work that insisted on a queer communality of resistance and joy. They placed their own sexuality and subculture at the centre of their work through 'superficially' shiny surfaces, pleasurable decorative detail, 'feminine' craftiness, visual excess and succinct, witty comment. Both artists died of AIDS-related conditions: Tully in Paris in 1992, McDiarmid in Sydney in 1995.

Christopher Wilk

MICHAEL GRAVES AND THE FIGURATIVE IMPULSE

Today, Michael Graves is famous as the designer of numerous buildings for Disney and of a wide range of household items for Target, the mass-market retail chain. Back in 1980, however, he was known only within architectural circles, as one of the so-called New York Five, and as someone who turned his back on his early modernist practice.[1] While Graves was teaching at Princeton University, his unbuilt postmodern designs were being published and discussed in architectural journals (pl. 207). His distinctive drawings were exhibited at New York's Max Protetch Gallery, becoming key examples of the recent commodification of architectural works on paper. Graves later described his lack of architectural commissions at this time as arising from his 'lack of reputation' rather than the result of the oil crises of the 1970s which so greatly affected the architectural world.[2] The completion in 1982 of his Portland Building in Oregon (pl. 208), however, was to change all that. This postmodern landmark heralded a change in his status and was to lead to a steady stream of commissions.

By the beginning of the 1980s, Graves' work was already remarkably wide-ranging and included (in addition to architecture) interiors, furniture, textiles and domestic objects. His designs during these years are paradigmatic of one strand of postmodern historicism, which embraced the language of classicism with considerable rhetorical enthusiasm.[3] Although contemporary reactions to his early work ranged from the intensely admiring to the patently dismissive, an appreciation of Graves' consistency of approach and design language is essential to understanding this significant aspect of postmodernism.

The basis of Graves' thinking was described in his clear and passionate polemic, 'A Case for Figurative Architecture', published in 1982 in the first monograph of his work, just as his most

distinctive early projects were being completed.[4] The essay underpinned his designs intellectually, with the written word strongly reinforcing his architectural rhetoric. In it Graves called for attention to 'the poetic forms of architecture … responsive to issues external to [practical considerations of] the building … the three dimensional expression of the myths and rituals of society … sensitive to the figurative, associative and anthropomorphic attitudes of culture.'[5]

He used the word 'figurative' to describe what he defined as the 'basic elements' of traditional architecture: a column, an arch, a door. Somewhat confusingly for the reader, Graves' use of the term did not specifically invoke the human figure, although his architectural elements often served as metaphors for, or symbols of, the human body. 'Figurative' had particular resonance as the opposite of non-figurative, a label commonly applied to abstract art. Indeed Graves' essay, like his designs, is largely framed as a critique of modernist abstraction, and its resulting excision of the history and language of the classical architecture. 'All architecture before the Modern Movement,' he wrote, 'sought to elaborate the themes of man and landscape' – either through allusion or by mediating the occupant's physical relationship to the landscape beyond. Modernism, by contrast, was inattentive to the human form and to architectural surroundings. It had, in his view, dismembered 'our formal cultural language of architecture'. Figurative architecture was an attempt to re-establish the quasi-umbilical connection to that tradition.

In Graves' early postmodern architecture, 'figures' such as the keystone, pilaster and column are not merely emphasized but often steroidally inflated, so that their significance cannot possibly be missed. A Graves keystone may well support an arch but its most important functions are symbolic, metaphorical or semiotic. It shouts that it is a keystone, reminding the viewer that she/he should be thinking about the nature of architectural composition. A column is also a supporting element but it is, equally importantly, symbolic of the human figure. In contrast to these elements in historic architecture, Graves' interpretations are invariably flat and abstracted, as well as enlarged, reinforcing their rhetorical function.[6] Ironically, this abstraction surely derives at least as much from Graves' own modernist background as from the much-cited influence of the work of neoclassical architects, above all Claude-Nicolas Ledoux (1736–1806).

Neither classical nor neoclassical architecture are specifically mentioned in Graves' essay, with the exception of Andrea Palladio's Villa Rotunda, the plan and interior space of which are favourably compared to Mies van der Rohe's Barcelona Pavilion. Rather he discusses the elements of architecture – floor, wall, window, ceiling – as well as the plan, and even furniture. In fact, Graves writes mainly about architecture as experienced from the inside; it is no coincidence that both interiors and furniture design were an important part of his work at this time. In contrast to a modernist building, Graves argued, when we stand in a traditional building we know instinctively that the floor represents the ground of the natural world and the horizontal top of the wall, the soffit as well as the ceiling symbolizes the sky (it is even 'in some sense celestial'); a properly located window sill, situated at waist height, 'helps

207
Michael Graves, illustration for the cover of *Architectural Review*, 1981

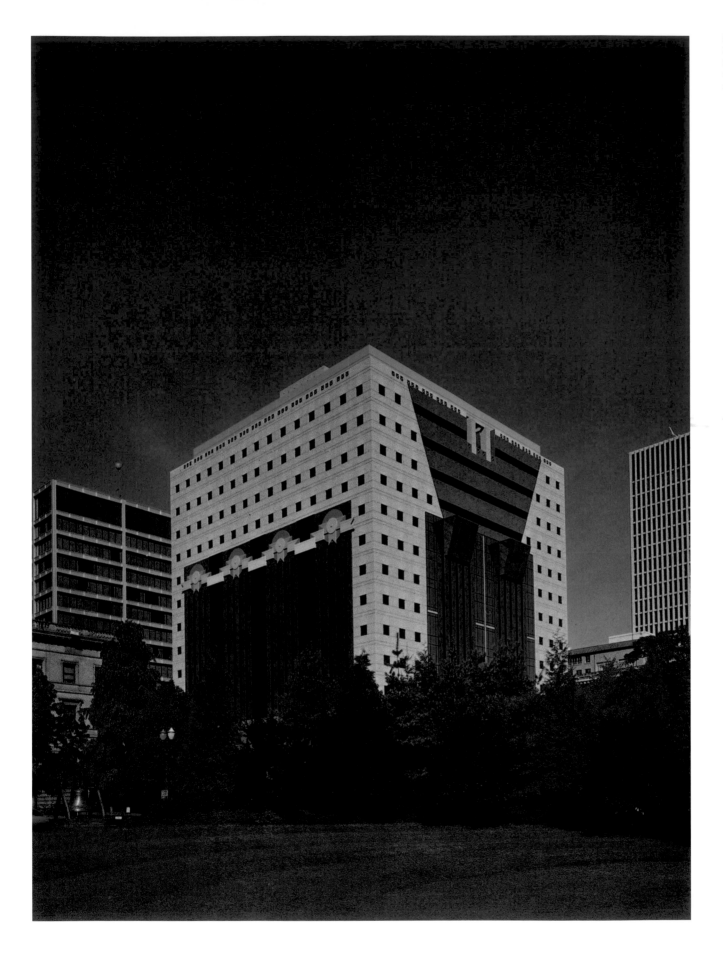

Postmodernism: Style and Subversion, 1970–1990

us to understand our size and presence within the room', while a chair rail both reinforces the human scale and signals the presence of seating in the room, allowing for both a 'pragmatic and a symbolic ... relationship between wall and object'.[7] The interior wall 'has over time accommodated both pragmatic and symbolic divisions', making clear our relationship to the architecture. It is in interior space, wrote Graves, that the occupant is able to appreciate 'the symbolic nature of building', its relationship to nature, its 'cultural association[s]', and its anthropomorphism.

The modernist free-flowing plan did not allow for rooms to have 'a geometric centre', Graves argued. This denied the essential human desire to be at the centre of the spaces we occupy, which he saw as representing our transcendental urge to be at the centre of our universe. For him, modernist abstract space places a 'figural void' at the very centre of architecture, 'oblivious to bodily or totemic reference', ultimately creating 'a feeling of alienation'. Graves' own interiors accordingly sought a sense of enclosure and centredness, and were detailed with what he regarded as the essential 'figures' of traditional, mainly classical, architecture.

While Graves described the interior as a key site for human interaction with architecture, he also acknowledged in a 1981 essay that 'our relationship to furniture [is] somehow closer, more tactile, and therefore more direct than architecture itself'.[8] A chair – with feet, legs, seat and back – was symbolic of the human body, while a horizontal table 'represent[s] values of the landscape or land itself'. Graves was passionately interested in, and knowledgeable about, historic furniture, integrating it within his architectural philosophy. His own collection of neoclassical furniture, especially Biedermeier, and his friendship with fellow architect James Stirling, who also actively collected in this area, informed Graves' numerous designs (pl. 209).[9] His recently adopted anti-modernist spirit, however, blinded him to the undeniable anthropomorphism of most modernist furniture. In his view it was, like modernist architecture, misguidedly obsessed with abstraction and technological imagery. The long history of furniture as a 'metaphor of man' was replaced only during the 1920s, he writes, with furniture as a 'metaphor of machine'. He agreed with his friend, the teacher and critic Colin Rowe, that classical furniture was preferable to modernist furniture because it

209
Michael Graves, Reinhold
Apartment, 1979. New York

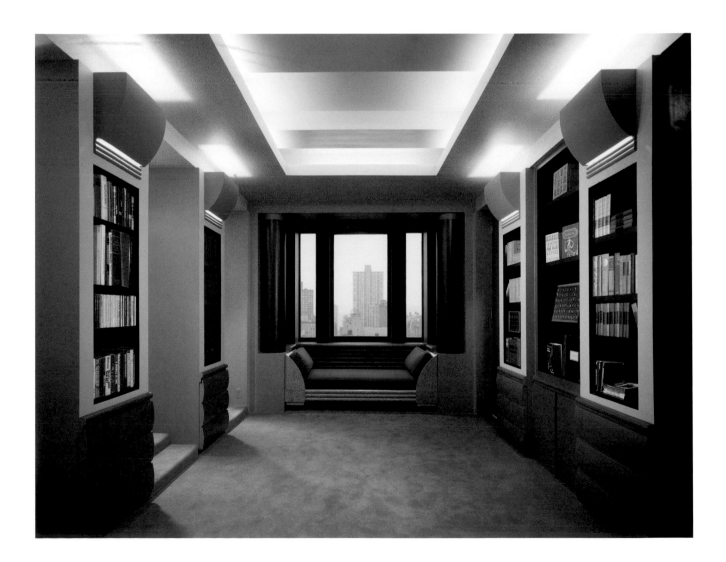

'would accept a variety of … locations and configurations within the room', whereas modernist furniture, he asserted somewhat tendentiously, would not.

Like the modernists they disparaged, many postmodernists rejected existing contemporary furniture as unsuitable for their interiors, and felt compelled to design their own in order to create coherent environments. Graves was one of a number of postmodernists who designed classically inspired (in Graves' case, specifically Biedermeier style) furniture, among them Charles Jencks, Paolo Portoghesi and Hans Hollein. For the modernist-trained Graves, 'the lack of over decoration, gold, etc., on Biedermeier furniture appealed', as did the architectonic character of such furniture: 'miniature pieces of architecture without literal imitation'. And it is indeed true that Graves' own designs refer not to the archaeologically-informed classicism of the eighteenth-century but to the flat surfaces, freer style and distinctly inventive architectural manner of the early nineteenth century.

Both Graves' architecture and his furniture also demonstrated a long-standing interest in the Viennese architect Josef Hoffmann (1870–1956), whose work – like Graves' own – combined elements of geometric abstraction and neoclassicism, including Biedermeier precedents. Graves sought to emulate Hoffmann's 'use of furniture, fabrics, carpeting and objects' and his 'sensitivity to the history of each object and its materials'. Graves sometimes even used reproduction Hoffmann furniture in his interiors (the two chairs in the foreground of pl. 211). An

attraction to early twentieth-century Art Deco similarly allowed Graves to engage with a modernist-influenced form of classicism (or vice versa), which came to be reflected in his work, including his notably figural vanity unit for Memphis (pl. 210). Graves' attraction to these alternative forms of classicism gave his work a distinctive, even complex character.

Key to Graves' interiors was their relationship to the exterior landscape, and perhaps more importantly to an imagined, Arcadian landscape represented within. His domestic interiors literally frame his clients' interaction with nature, by means of vistas and windows. When an exterior view was not available in a room, Graves often created painted or sculpted representations of imaginary landscapes (pl. 211), sometimes making use of that most modernist of techniques, collage. These were sited on axis with the actual exterior views beyond. Graves' many drawings of landscapes filled with architectural figures make clear the importance of this Arcadian theme in his work.

For all the rhetoric of anti-modernism in Graves' writing, his work reveals him as genuinely *post*-modernist, a designer for whom the experience of Modernism is inescapably part of his DNA. His style is not that of a revived ancient Greece or Rome, but an abstracted, sign-driven classicism unconcerned with fidelity to ancient rules of design. This abstraction leads to a flatness, a particular emphasis on surface, which is perhaps the least convincing aspect of his work, but nonetheless reflects its rhetorical integrity and consistency.

Opposite: 210
Michael Graves (for Memphis), *Plaza* vanity unit, 1981. Enamelled wood, mirror and lighting components. Detroit Institute of Art (1990.273.a)

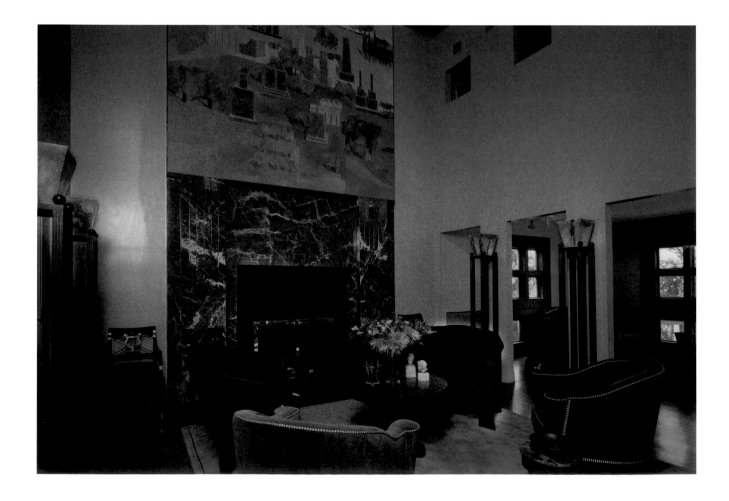

211
Michael Graves, Plocek residence, 1982. Warren, New Jersey

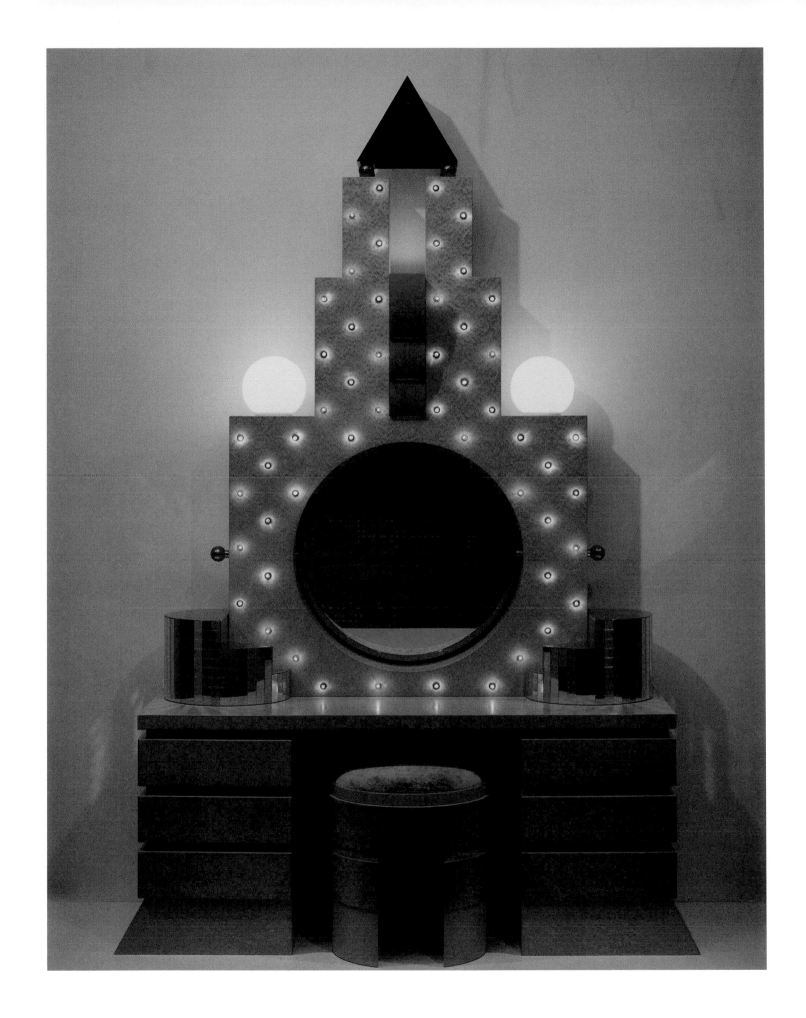

Elizabeth A. Fleming

RIDING THE WAVE OF REAGANOMICS: SWID POWELL AND THE CELEBRITY ARCHITECTS

The New York-based company Swid Powell, founded in 1982 by Nan Swid and Addie Powell, presented its first collection of 54 pieces of porcelain dinnerware, silver-plated tableware and crystal stemware in 1984. The designs had been created by high profile American architects and manufactured in Italy, Austria and Japan. The collection, each item of which was branded on the reverse with the designing architect's signature, was premiered in the major department stores of six American cities. The variety embodied the pluralism of postmodern design: it featured Robert Venturi and Denise Scott Brown's colourful patterns derived from vernacular sources; the architectonic explorations of Michael Graves and Robert A.M. Stern; the figurative work of Stanley Tigerman; and late-modernist plates and objects by Richard Meier and Gwathmey-Siegel (pl. 212). With merchandise price points ranging from $40 to $350, the venture was a sell-out, generating $275,000 in revenues. In addition to attracting a mass consumer audience, the collection caught the attention of the Metropolitan Museum of Art in New York, which acquired prototypes and examples from this original series for its twentieth-century collections in 1985.

Over the next six years, Swid Powell grossed over $10.7 million in sales revenues, with the 1989 collection featuring 189 items designed by 15 architects. In applying the ideas of contemporary architecture to the tabletop industry, Swid Powell was a textbook example of the new entrepreneurial businesses that had begun to transform the design landscape of the United States: companies that were small, agile and outwardly focused on the market, and sought to profit from their difference from traditional corporate enterprise. The new entrepreneurships operated in the context of the growing popularity of supply-side economic theory – the foundation of Reaganomics – which contended that increasing the supply of goods and cash (through tax cuts) would prompt spending and increase revenues on all fronts. As described by leading business and management philosopher Peter Drucker in his 1985 book *Innovation and Entrepreneurship*, these small and medium-sized companies – many of which were less than 20 years old, and none of which made the Fortune 500 list – generated new types of goods, methods of production and market organizations to compete with established businesses.[1]

Into the $5.36 billion industry of dinnerware, tableware and decorative accessories, dominated by the corporate entities of Wedgwood and Lenox, Swid Powell channelled the talent and

212
Michael Graves (for Swid Powell), *The Big Dripper* coffee pot and filter set, 1987. Porcelain, enamel, gilding. Photograph courtesy of Michael Graves Studio.
V&A: C.128 to 132–2009

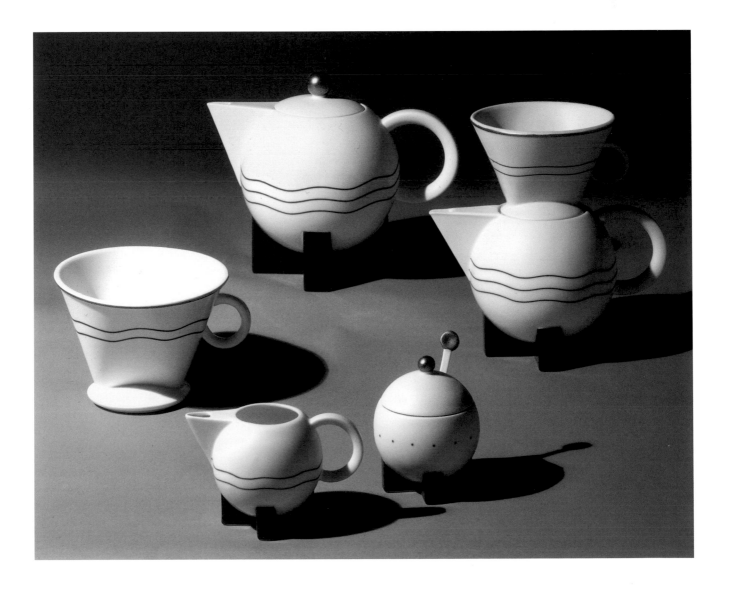

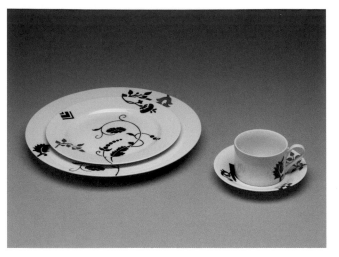

Far left: 213
Ettore Sottsass (for Swid Powell), *Renaissance* pattern place setting, 1986. Porcelain with overglaze transfer-printed decoration. Yale University Art Gallery, New Haven, Connecticut (ILE2007.7.43.1−4)

Left: 214
Ettore Sottsass (for Swid Powell), *Renaissance* dinner service decals, 1985. Transfer ink on paper. Yale University Art Gallery, New Haven, Connecticut (ILE2007.7.48)

resources of high-culture American architecture. The company devised a means for making postmodern design theory, hitherto principally a part of the academic establishment, a commodity that served popular taste and interest. Swid Powell's sales strategy was built around changes in American demographics and lifestyle: a growing population of middle-aged people with higher degrees, often divorced or living in second marriages, and the 'young urban professionals' (yuppies) who came to emblematize the decade's culture of conspicuous consumption. From the outset, Swid Powell and its designing architects had an eye on this market. Stern recalled that 'We were just on a new wave of consumerism in which the consumer was becoming more conscious of brands and of designers, distinguishing product from product.' The conceptual framework of the Swid Powell brand emphasized name recognition and a departure from the status quo.[2]

The architects who created designs for the first Swid Powell collection included Robert A.M. Stern, Charles Gwathmey and Robert Siegel, Arata Isozaki, Richard Meier, Laurinda Spear, Stanley Tigerman, Michael Graves and Robert Venturi (working with Denise Scott Brown, who was largely uncredited at the time). The enterprise began with a luncheon at the Four Seasons Restaurant in New York in November 1982. It evolved through design review meetings, where the architects provided critical assessments of one another's designs and received updates concerning business development, producers and vendors, marketing strategies, public relations, product lines and pricing. The architects eagerly absorbed the information. Stern stated that 'We did talk about the mass producing thing and we also discussed certain realities of the marketplace. For example, I said early on, to Nan and to the group, that we should do china because you could put decals on china. You could take a standard plate ... certainly there are tons of standard shapes and then you can redecorate' (pls 213 and 214). Some of his colleagues were initially horrified by the concept of merely applying decoration, effectively transplanting Venturi and Scott Brown's idea of the 'decorated shed' to the realm of the decorative arts. Nevertheless, after Stern designed the first plate with decals (or transfers) everyone else followed suit, including Meier, Gwathmey-Siegel, and later Steven Holl and Frank Gehry. The company thus demonstrated that the

very mass production that yielded uniformity could also yield the possibility for variation.[3]

The chosen architects recognized that their ideals were subservient to the market's values and preferences. In discussing his products for the company, Richard Meier explained simply that "I did them so they had something to sell ... That was always one of the considerations, how to keep the cost down to keep the price low.' Stern, too, described how the designing architects readily internalized trends in the marketplace: 'Nan and her people would say certain things about what they felt they could sell ... at one moment they said picture frames, picture frames. We need to have picture frames. Everybody wants picture frames. Soon everybody ran and tried to do a picture frame.' From the general to the specific, these architects were consumerist in orientation.[4]

The introduction of Swid Powell's first collection was aptly timed to ride a wave of changes in consumption patterns during the high-flying 1980s. In America, the year 1984 marked the shift from deficit to plenty, and from restraint to ebullience. Reagan had spearheaded reductions in taxes, relieving the wealthiest taxpayers, and deregulated such industries as transportation, television and financial services. The real estate and stock markets boomed. *Newsweek* pronounced 1984 'The Year of the Yuppie' and devoted its entire December edition to chronicling this new, dominant force, which was transforming the cultural and economic landscape of the United States. Educated and highly concentrated in metropolitan areas, this class of consumers had ready access to cash and an eagerness to spend. *The Yuppie Handbook*, published in 1984, discussed the effects of the demographic on consumer aspirations, declaring, 'The name of the game is the *best* − buying it, owning it, using it, eating it, wearing it, growing it, cooking it, driving it, doing whatever with it.' In this prosperous climate, the possession of designer goods communicated an individual's membership of a privileged community.[5]

By 1984, the architects invited by Swid Powell were already enjoying widespread visibility. The year 1983 alone marked the opening of Meier's High Museum of Art in Atlanta, Isozaki's Museum of Contemporary Art in Los Angeles, and Venturi and Scott Brown's Wu Hall at Princeton University. Architects were

now celebrities with brand-name recognition, profiled across a disparate range of print media including *Time*, *Newsweek*, *House Beautiful*, *House & Garden* and *Architectural Digest*; regular articles by critic Paul Goldberger in *The New York Times* and *The New York Times* magazine; and such professional periodicals as *Progressive Architecture* and *Architectural Record*.

The Swid Powell brand enabled baby-boomer consumers to take home, at a reasonable price, leading talent in the field of architecture and design. In a *Newsday* report entitled 'Architects Dish It Out' (5 June 1984), James Revson claimed that 'The noted architect Richard Meier usually doesn't come cheap. The High Museum of Art in Atlanta designed by Meier cost $20 million. But now for a rockbottom price of $40, anyone can own one of his works.' The department store Marshall Field & Company placed full-page advertisements with such headlines as, 'Walk away with a Richard Meier original for considerably less than his normal fee.'[6]

During the following years, Swid Powell's sales grew dramatically. In 1988, the volume of products sold was over 12 times that in 1984 (increasing from 6,255 to 80,287 items). In the dinnerware category, the best-selling design was *Tuxedo* by Gwathmey-Siegel, which accounted for $2.318 million in sales over six years, over 22 percent of the firm's total revenues. Other popular designs included *Chicago* by Gwathmey-Siegel, *Grandmother* and *Notebook* by Venturi and Scott Brown, *Planar* and *Volumetric* by Holl, *Stripes* by Robert and Trix Hausmann and *Corinth* by Michael Graves. Meier, Stern and Ettore Sottsass created the best-selling silver-plated products. Graves' *Big Dripper* and *Little Dripper* led the giftware category. In total, Meier generated the highest sales revenues: $3.564 million through 26 different product lines and a volume of almost 42,000 items sold.[7]

But just as Swid Powell's fortunes seem to have coincided with those of Reaganomics, the company strategy could not maintain its success in the changed economic landscape of the decade's close. In his 1989 inaugural address, the new President George H.W. Bush cautioned Americans that 'We are not the sum of our possessions.' Facing Bush and his countrymen were distressing results from the deregulation and supply-side economic practices of the past eight years. The national debt had nearly tripled, making the United States the biggest borrower of capital worldwide, at a rate of $12 billion per month. America's manufacturing base had diminished. What's more, the debt-structured corporate mergers, take-overs and restructurings which had guaranteed immediate paper profits at the expense of long-term equity

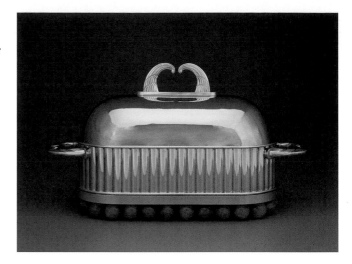

had also damaged the fiscal (and arguably moral) health of corporate America.[8]

Swid Powell's market strategy was ill-suited to the new climate; its overall volume of sales declined by 15 percent in 1989. Undeterred, in 1990 the company introduced the Architects' Collection, which featured a selection of lavish objects designed by 12 architects. Produced in limited editions, the objects were available only at high-end design galleries for premium prices (ranging from $5,000 to $25,000). The world of couture had inspired the Architects' Collection. As Nan Swid explained, 'Think of it as fashion design, when the designer comes out with the extreme and fun wedding gown ... We asked the architects to parallel that. We gave them total creative license.' The architects dreamed up a series of grandiose showpieces made out of 'a king's ransom of precious materials', including sterling silver, gold, mother-of-pearl, lapis lazuli, ebony, onyx and rose quartz (pl. 215).[9]

The Architects' Collection was also an abrogation of the original goal of Swid Powell to offer elite design to a broad public. Not only had the company elected to produce expensive, limited edition art objects, it also chose to exhibit the works in the select galleries of New York City rather than the mainstream department stores it had favoured previously. Though he contributed to the project, in retrospect architect Stanley Tigerman recalls that this 'elite operation' ran counter to current events in America. 'It was un-American to produce those very expensive things.' He believed that the Architects' Collection 'signaled the end of the whole God-damn thing, the end of Swid Powell, the end of postmodernism.'[10]

Jonathan M. Woodham

MARGARET THATCHER, POSTMODERNISM AND THE POLITICS OF DESIGN IN BRITAIN

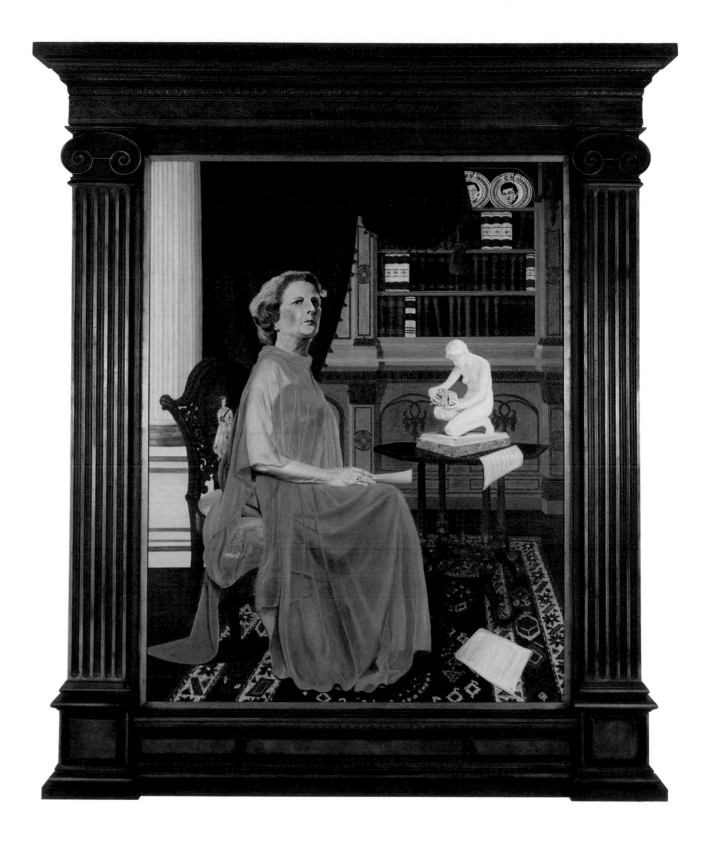

Margaret Thatcher, Postmodernism and the Politics of Design in Britain

As Margaret Thatcher's many statements on the subject vividly testify,[1] she was committed to the importance of design as key to the future success of British industry throughout her premiership (1979–90), years during which postmodernist design flourished in Britain. The spirit of postmodernism can readily be aligned with the primacy of the individual, deregulation and the values of the 'enterprise culture' that gathered pace during the 1980s, as well as its myriad of stylistic guises. Yet Mrs Thatcher was committed to the promotion of a 'good design' ethos throughout her career, one largely formulated in the 1950s (pl. 216).

Mrs Thatcher's earliest encounter with design thinking occurred in the early 1950s, when she attended a lecture at the Royal Court Theatre, London, by Paul Reilly, then the Public Relations Officer at the state-funded Council of Industrial Design (COID, founded 1944).[2] She later recounted how she remembered 'vividly some of the demonstrations he showed us of what was good design and what was not'.[3] The post-war promotion of design was closely allied to a design aesthetic of clean modernist forms that eschewed widespread popular attachment to past styles, decorative pattern and ornamentation. The COID, in tandem with state design education initiatives and various professional bodies,[4] became increasingly associated with promulgating notions of 'improving' taste. In many ways 'good design' was the visual and material counterpoint to the BBC's Third Programme, described by its head as being 'for the alert and receptive listener'.[5] Both initiatives represented a continued belief, often expressed in professional educated circles in the inter-war years, that aesthetic judgment required talent, training, discrimination and taste.[6] A product's aesthetic success was often described in terms of its efficiency, in both use and cost. This rhetoric of modern design was rooted in the utopian socialist agendas of the 1920s and filtered through the Welfare State politics of the 1950s. Yet, detached from its political origins, this modernist design ethos remained with Thatcher throughout her political career. Writing somewhat later in the pages of *Engineering* magazine, she put it thus: 'By "design" I do not just mean "appearance". I mean all the engineering and industrial design which goes into a product from the idea stage to the production stage, and which is so important in ensuring that it works, that it is reliable, that it is good value, and that it looks good.'[7]

Despite what Paul Reilly acknowledged in 1967 as 'The Challenge of Pop'[8] and the failure of the design establishment to meet it, the reign of Modernism and its 'good design' progeny largely held sway in professional and educated design circles until the early 1970s. Reilly recognized that increasingly affluent and independent young adults had embraced attractive, cheap, colourful, irreverent and, above all, ephemeral design. Pop was even acknowledged in official projections of British values overseas, as in James Gardner's 'Swinging London' display in the British Pavilion at Expo 67 in Montreal. Nonetheless, Modernism remained the dominant design aesthetic, coexisting with the Keynesian economic interdependency of government, public and private sectors over a long period of growth. These twin post-war ideals began to fragment in the 1970s, however, and they were to be radically shifted by Mrs Thatcher's policies of the following decade.

'Popular capitalism',[9] or privatization, came to the fore alongside her belief that 'there is no such thing as society',[10] only 'individual men and women'.

During the 1980s there was considerable government commitment to the project of design promotion, including Thatcher's influential No.10 [Downing Street] Design Seminars of 1982 and 1987.[11] However, the extent to which these and other initiatives actually resulted in significant change may be measured against the Design Council chairman's words in his foreword to the *Design Council Annual Report 1986/7*: 'In Britain we have some companies whose design management is as good as any in the world; but they are the exception and mediocrity in design is the rule.' Design management, an increasingly key part of corporate strategizing in the Thatcher era, did not endorse the complexities and idiosyncrasies of a postmodern aesthetic, any more than the emergence in the early 1990s of the 'Young British Artists' was welcomed by the right, even if 'Thatcher's Artists', as critic Andrew Brighton described them, were validated by 'the market, the selling of their work and exhibitions in commercial galleries that supported and acknowledged them'.[12]

A notable project of the early Thatcher years was the TV-am Building (1981–3) at Camden Lock, London, one of the earliest examples of postmodern architecture in Britain (pl. 217). Designed by Terry Farrell, it reflected the influence of Michael Graves, whose Portland Building in Oregon had caused such controversy with its blend of narrative and literary forms, symbolism and wit (see pl. 208, p. 230). Farrell's Breakfast Television Centre, as the TV-am Building was also known, was a radical conversion of an inter-war garage. The building was re-clad in an assemblage of styles and historicist forms, with a dozen large decorative plastic eggcups adorning the roofline – a playful reference to neoclassical architecture as well as to Salvador Dali's Figueres Museum (Catalonia). These Brobdingnagian blue-and-white striped eggcups also looked back to classic British Cornishware, first produced by T & G Green in the 1920s, a period that influenced both the large, external Art Deco-inspired TV-am lettering and the format of the television station's sunrise logo designed by Douglas Maxwell. The early morning symbolism of the eggcups was also echoed in the large sunrise archway over the entrance to the building's forecourt and in the design of the atrium, which depicted the westward course of the sun during the day. The building's exterior complemented the 'Good Morning Britain' TV magazine programme being broadcast from within. The TV-am company may be seen to embody many of the ideals of the Thatcher years, being small-scale and adopting a de-unionized stance. The broadcaster David Frost, one of the founders, interviewed Margaret Thatcher at the company's Camden studios in mid-1985 and said to her: 'Prime Minister, you are always talking very much about how you like to encourage small businesses, so in thanking you for being here this morning, may I say that your presence has greatly encouraged this small business!'[13]

In 1989, towards the end of Margaret Thatcher's premiership and at the height of British postmodernism, an exhibition entitled *British Design: Image and Identity* was shown at the Boijmans Van Beuningen Museum in Rotterdam.

217
Terry Farrell, TV-am Building, hospitality lounge, 1983. London. Photograph by Richard Bryant

which were seen by the establishment as hallmarks of visual culture at the end of the 'designer decade'. In *Design* magazine, the official mouthpiece of the Design Council, it was remarked that 'as a PR exhibition for Britain's image abroad, the exhibition works well, but as PR for the skill and image of British design it is flawed by its bias towards fashion, graphics and one-off furniture'.[19]

The individualistic exhibition graphics by Malcolm Garrett, widely known for his innovative music album cover designs, were dismissed by the Dutch magazine *Trouw* where they were seen as 'art, not design'; the inclusion of five outfits by fashion designer Vivienne Westwood was criticized as gratuitiously enhancing her celebrity status. Nonetheless, the Dutch public responded much more positively to this display of British individualism, even eccentricity, on display throughout the exhibition: 25 television screens showing scenes from British life, ranging from soap operas to the weather forecast; pop music videos; and an array of computers placed on a rusted metal sheet. In the exhibition's last section, devoted to 'The Individualists', four of the nine designers shown originated from overseas, underlining the ways in which British design had absorbed overseas influences without sacrificing its recognizable identity.

What the critics had so disliked in the 1989 Rotterdam *British Design: Image and Identity* exhibition was received much more positively a decade later when the *Lost and Found: Critical Voices in New British Design* touring exhibition opened at the Museum für Kunsthandwerk in Frankfurt in 1999. Showcasing 38 British designers whose reputations were established during the late 1980s and 1990s, it reflected a continued shift away from the retail or corporate sectors, and toward the invigorating influences of punk and postmodernism. In *Lost and Found* there was an emphasis on fresh ways of looking at signs, symbols, process and manufacturing techniques. The exhibition swept aside the boundaries between art, architecture, design, fashion, music and other aspects of popular culture.

Whilst postmodern design may appear to share some attributes with Mrs Thatcher's political agenda – with its emphasis on deregulation and 'enterprise culture', and its commitment to the individual and the private sector – her commitment to technological innovation, funded design consultancy and improved management techniques was far more compatible with the certainties of a modernist aesthetic than the many unpredictabilities and challenges of postmodern design. Only in the late 1990s, with the rhetoric of a New Labour 'rebranded' Britain, did a more open-ended definition of the creative industries actually seem to embrace the fluid languages of postmodernity.

Selected by British and Dutch curators Catherine McDermott[14] and Frederique Huygen,[15] and the Design Council, it received funding of £100,000 from the Foreign Office. In its avowed intention to show British design at the service of business, this controversial exhibition took on the additional, and politically tricky, task of exploring the potential of the European market in the run up to the Maastricht Treaty of 1992. It was also intended to be seen as a late flourish of Margaret Thatcher's 'Designer 1980s', replete with notions of 'enterprise culture'. This was problematic, however, given the dichotomy between 'enterprise culture' and its associated high-profile design celebrities on the one hand, and the design values with which Margaret Thatcher and her supporters would have been comfortable on the other. This difficulty was conveyed by the reviews that covered the exhibition, under headlines like: 'Punk, pageantry and the British designer',[16] 'culture shock'[17] and 'carry on designing and plundering.'[18] The Rotterdam show was heavily criticized in the British design press, with many critics feeling that full-blooded postmodernism did not reflect Britain's contemporary design strengths. Further dissatisfaction stemmed from perceptions that there was insufficient focus on interior design, design for retail and corporate design, all of

A WAY OF LOOKING AT THINGS

In postmodern work of the 1970s and mid-to-late 80s there was huge diversity, with no one unifying philosophy as far as I can remember. In fact, that was half the point. Some work was political, some decorative, some punk, some academic, etc. I think I overlap with this broad trend only to the extent that my work in that period was 'hybrid', a quality common to all my activities since, in ever wider contexts.

My academic training in the early 1970s at the Basel Allgemeine Kunstgewerbeschule was in the controlled yet playful tradition (thank you, Wolfgang Weingart) of classic Swiss graphic design. I entered the school to study typography and textile design. Armin Hoffman – director of both my class and the graphic design programme at the school – said I had to work in graphic design first before I could work in textiles, so I focused on typography. Working with handset type forces you to communicate an idea through the way you handle the lettering itself, without any other illustrative material – it becomes its own narrative. In retrospect, I can see how easily this experience sponsored a way of seeing type – and, in fact, everything – as an object in space. Type as a building, type as a landscape, type in a landscape with other 'objects'.

Cut: to my move to Los Angeles and the discovery of a natural landscape that I felt I could call 'home', the desert, the place that opened my mind to space and time on a completely new scale. During my early collaboration in LA with Jayme Odgers (as Visual Energy, 1978–81), we worked with traditional photographic and typographic art, literally, physically, layering it into a single image pasted up as in traditional collage, airbrushing out the edge conditions, and then re-photographing that – which became the final art. In combination with Jayme's original photography, we used a lot of pre-printed images and illustrations – often with the offset lithography dot-screen 'look' – and then enlarged them, pasted them up, collaged them together (pl. 218). We also utilized a fair amount of appropriation: 'Cut the turnip out of the printed seed pack and paste that onto the Spacemat art', and so on. Original photography combined with painting and typography – the elements interacting, seemingly spontaneously, to create a space of their own.

As my own work evolved, I began to move away from the traditional cut-and-paste, two-dimensional collage process into different paradigms for creating space. My exposure to videography – real space/time – as head of the programme in Visual Communication at CalArts (pl. 220) led to commissions in this medium, as in early TV spots for Esprit, Lifetime Television, US West, etc. In the poster for the exhibition *Pacific Wave* (*c*.1985), which I produced with a 512k version of the first Macintosh computer, I began to explore digital space, both literally and conceptually, zooming into an image of a wave to reveal the information as pixels, which became like snowballs (pl. 221). I was interested in revealing the DNA of the technology in the wave, micro to macro, expressed in spatial relationships and visual hierarchies. In a sense, this is an echo of my earlier interest in textile design, now transformed into the pure textures of technology. This interest was also reflected in the re-naming of my business 'Greimanski Labs: a purely scientific approach' – a tongue-in-cheek characterization of my experimental viewpoint.

In conventional 'paste-up' I would have begun with a sketching phase, perhaps a mock-up of the individual elements printed from photos or sketched from real objects. However, when I began to work with the computer I soon found that everything became much more intuitive, more about process and accidental discovery, since the digital medium enables intuition to extend much further into the design process. I might, for example, shoot a high quality still photo of a video off a TV monitor, then layer that into a half-finished digital composition to see what the image would become. A design is simply a moment – a freeze-frame – in a continuing process. I quickly learned to enjoy not having to preconceive the form that my projects might take, jumping into a void and exploring until something unexpected began to emerge. I developed a floating, yet three-dimensionally gridded visual approach in which static and dynamic X, Y and Z coordinates were at play (pl. 220). There was always an implicit structure that found a point of equilibrium between intuition and conscious choice. I think intuition is the most powerful form of intelligence.

Similarly, working with the Quantel Paintbox in the early 1980s (a sophisticated high-resolution digital image composer designed for broadcast television, video production and the motion picture industry), I was never interested in what it was supposedly good at: the seamless combination of images. I was always interested in the texture of the technology behind it. If I was using video, the video texture became part of the content of the image; if I was using the computer, the pixel texture became part of the content of the image. I want everything to 'be' its medium. The being is the meaning, the meaning the being.

218
April Greiman, design, with Jayme Odgers, photography (for Peter Shire), *Swissiyaki* poster, 1978. Colour offset lithograph and silkscreen

My personal design history has been one ever-evolving synergy with the rapid evolution of technology. That is, my design process has always been in an elaborate state of transformation, from two-dimensional design, to motion graphics, to design for the Internet, opening out more recently to architectural and environmental issues. In fact, for some time now my work has been more to do with the real environment than with graphic design as such, though I still have the same underlying concerns.

I've been teaching at SciArc (the Southern California Institute of Architecture) for nearly 20 years. I continue to appreciate and produce graphic work, but for me the big issues are now found in architecture and the environment. The transition from tiles and tapestries, to environmental graphics, to large-scale work in real space has been essentially effortless, since, in a sense, the approach is the same for architecture as it is for all my design. Now, when I do produce a purely graphic design solution, it reflects the influence of this experience. The website for Roto Architects (www.rotoark.com) is a case in point. Even the company's identifying logotype is a subtly moving object in a real space, like the perception of a building in a landscape, coexisting with other typographic elements in a common 'site'.

Conversely, my large (762 sq. m/8,200 sq. ft) mural project on Wilshire Boulevard for a mixed-use transportation hub takes a hybrid media technique that I might have used in a two-dimensional composition, and translates it into a real space — two juxtaposed walls of a video image produced on the computer and applied to the wall surfaces by conventional sign painters (pl. 219). The viewer is invited to travel through a graphic space that defines an actual space: 'transmedia', as I call it!

If there has been a constant in my journey, whatever the medium or context, it is a desire to create space as I define it: a field of energy, an interplay of elements in a dynamic balance between discipline and play, material and immaterial — all captured in a single, simultaneous moment in time-space.

Opposite: 219
April Greiman, *Hand Holding a Bowl of Rice*, 2007. Digital video image rendered in oil paint. Wilshire Vermont Subway Station, Los Angeles, California

Far left: 220
April Greiman, *Changing Concepts of Space in Architecture and Art* poster for Southern California Institute of Architecture, 1986. Colour offset lithograph. V&A: E.1498−2010

Left: 221
April Greiman, *Pacific Wave − California Graphic Design* exhibition poster, 1989. Colour offset lithograph. V&A: E.1499−2010

Sarah Teasley

ALWAYS ALREADY POSTMODERN? JAPANESE DESIGN AND ARCHITECTURE IN THE 1980S

In his editorial for the April 1981 issue of *The Japan Architect*, architect Kazuhiro Ishii wrote: 'Modernism today in Japan is purer than ever.' Ishii created an opposition between Modernism – which he described as foreign to Japan, and thus needing to be imported and learned – and postmodernism, which he understood as inherently native to Japan. In his view, modern architectural practice in Japan had always felt the presence of the past, rather than rejecting it as European Modernism had done. Ishii wrote, 'If postmodernism in architectural relations can be defined as the situation in which new things do not expel older things but continue to coexist with them in a mélange of variety, then postmodern trends can be found in the historical Japanese design tradition.' Pointing to the eclectic historicism and sophisticated playfulness of the early modern *sukiya* style of residential architecture as evidence, Ishii concluded that the 'hodgepodge and clamorousness' that characterize postmodernism had developed 'not recently, but as a central element of our tradition from long ago.' Or, as he put it, 'the characteristic feature of much Japanese architecture is something closer to the fused miscellaneous variety of postmodernism than to the pure, ordered beauty of modernism'.[1]

Not all of Ishii's peers shared his warmth towards postmodernism. Some found it lacking in integrity, for example Kenzo Tange, for whom 'the energy displayed by the Postmodernists struggles with nothing, challenges no new issues, and seems escapist'.[2] Perhaps more damningly, *The Japan Architect* editor Shozo Baba found the idea of postmodernism not only inaccurate (given Modernism's continuing persistence), but also categorically impossible, since a posthumous name can only be assigned by a subsequent generation, not the generation that wishes to effect a change.[3] Nonetheless, whether describing architecture, graphic design or students' shopping habits, variants of Ishii's argument – that somehow, Japanese culture already incorporated postmodernism's pastiche, collage, irony and citation – appeared frequently throughout the decade, in conversations and debates amongst designers, architects, curators and critics in Japan and overseas. A corollary argument often positioned Japan, with its newly-found economic might and urban culture of mediated hyper-consumption, as a limit case: the ultimate postmodern society. While challenged by some critics in Japan and overseas as a 'techno-orientalist' mirage, the image of Japan as embodying the future was a seductive claim.[4] Its dystopic obverse – the neon-lit, disorientating heterotopias presented in the manga (1982) and anime (1988) versions of *Akira* and Hollywood films like *Blade Runner* (1982) and *Black Rain* (1989) – counterbalanced yet another image of Japan: a country bent on economic world dominance through acquisitions of Los Angeles real estate, Impressionist paintings, French luxury goods and vehicle market share. Meanwhile, critics like Takaaki Yoshimoto countered left-wing intellectuals' concern that personal and corporate consumer exuberance masked the disappearance of political concern by arguing that celebratory conspicuous consumption might be a critical intervention in, even resistance to, late capitalism.[5]

If the 'Japan = postmodern' equation came in multiple flavours, the economic success of 1980s Japan was clear. GNP increased at an annual average of 4.5 percent through the decade, more than twice the rate of major European economies, while industrial productivity grew at the fastest rate in the world.[6] From 1986 until the 'Bubble economy' began to burst in 1990, dizzying stock and land speculation pushed the Nikkei stock exchange and land prices in Tokyo to world record highs. Not all Japanese profited, but spending skyrocketed during the Bubble, particularly amongst students and urbanites who developed a taste for overseas travel, domestic ski holidays, brand-name fashion, and the latest home furnishings and consumer electronics. Advertising firms like Dentsu and Hakuhodo, and department store conglomerates like Isetan and the Seibu Group, shaped consumer trends through targeted marketing, trend forecasting publications and urban redevelopment schemes. Commuter hubs like Shibuya and Ikebukuro were transformed into retail paradises brokered by mega-corporations like the Seibu Group; they were often compared to Tokyo Disneyland, which had opened in 1983.

Increased affluence, information networks and the desire to consume certainly provided both a means for exuberance, spectacle, international outlook and space for playfulness in daily life, and a market for experimental work by designers and architects. And many designers and architects working for both Japanese and international markets incorporated postmodernist style and methods in their work. But how and to what extent did capitalism in 1980s Japan relate to the adoption of the style for armchairs, discotheques and dentists' offices? How did designers define 'postmodernism' in a Japanese context?

As in Western Europe and North America, architectural postmodernism had appeared in Japan by 1980. The Yale-trained Ishii himself provided some of the earliest examples. The starkly two-dimensional façade and outsized, simplified architectural elements of his Gable Building (1980) in Tokyo referenced Western classicism in the vein of Michael Graves in a recognizably postmodernist idiom. His Naoshima Town Hall (1982), by contrast, inflated vernacular Japanese carpentry to giant size, adopting postmodernism's theoretical concerns but quoting local source material. More pointedly, Team Zoo and Atelier Mobile's Nago City Hall (1981) asserted an almost oppositional regional identity by acknowledging both Okinawan vernacular design and climate, and the concrete block construction introduced by the post-1945 American military presence in Okinawa. These two directions – the adoption of international postmodernism's visual style, and the adoption of its methodology – manifest the complexity that arises with any international style. Was postmodernism a matter of appearances, or did it mean behaving in a postmodern way? Whether in Japan or more generally, were these two ever mutually exclusive?

In his Tsukuba Centre Building (1983), Arata Isozaki proposed that the citation of Western elements could conceal a complex ideological critique with local and international targets (see pl. 22, pp. 28–9). At Tsukuba, the quotation of Western architectural history, and the building's exaggerated scale and flatness, seemed a simple reiteration of the international postmodernist mode. But Isozaki argued that the building performed a sophisticated critique of the authoritarian nature common to post-war modernist planning principles and the nation state, including Japan, after 1945:

222
Eiko Ishioka (for Parco department store), *Can the West Wear the East?* Media campaign poster, featuring Faye Dunaway, 1979. Photograph by Kazumi Kurigami

transnational psychedelia with symbols of the modern state (see pls 1 and 2). But whereas the posters of Yokoo and contemporaries like Kiyoshi Awazu took an oppositional stance against consumer society and depoliticization, Parco's campaign used cultural provocation to register itself as a centre for in-the-know consumers.

Indeed, postmodernism in Japan was fickle as all style is, applicable equally for the affirmation of economic growth as for its critique, and political in that promiscuity. Applications of postmodernist style in architecture prove this well: finished in 1983, the same year as Isozaki's Tsukuba Centre Building, the opaque, late modernist façade of Sakakura Associates' S-2 office-hotel block (the Shinjuku Washington Hotel) hid a riotously curved internal atrium and a sunken piazza with the high-pop, neon-glow Lovely Square (pl. 224). Projects like the NS Building combined popularized postmodernism – neon, highly artificial materials, bright colours and strong simplified shapes – with new economic conditions – the NS Building is in Nishi-Shinjuku, a new central business district of skyscrapers developed in the early 1980s – to celebrate the seeming achievement of the post-war economic project.

Whether corporate or individual, urban consumption enabled much postmodernist design in Japan. Despite the avant-gardism of Rei Kawakubo, Kansai Yamamoto and the individualistic 'DC' ('Designers and Characters'), domestic brands popular with sophisticated urban shoppers in the 1980s, the ability to develop a recognizable brand depended upon shopping experience sites and a generation of consumers eager to distinguish themselves through the conspicuous acquisition and possession of knowledge, if not the goods themselves. And postmodernism itself was a commodity to be consumed. Museums, department stores and the press provided access to the latest international design information and positioned postmodernism as a form of popular entertainment through magazines and exhibitions. An example was *KAGU=MOBILIER* (1985), a show of Japanese and French postmodernist furniture organized by the French government's Regional Fund for Contemporary Art (FRAC) that included Isozaki's *Monroe* chair as well as pieces by Shiro Kuramata, Toshiyuki Kita, Morita Masaki and others (pl. 223).[9]

The phenomenon of Japanese designers working and studying abroad was itself not new: Issey Miyake arrived in Paris in 1971, furniture designer Masanori Umeda worked in Milan from the late 1960s, and architects like Ishii joined a long history of predecessors like Kenzo Tange and Fumihiko Maki at Harvard in the post-war period, and Junzo Sakakura and Junzo Yoshimura at Le Corbusier's studio in Paris in the 1920s and 30s.[10] But the emergence of spectacular design projects like Memphis, the visual shock of work by Yohji Yamamoto and Comme des Garçons' Rei Kawakubo on Parisian catwalks, and increased awareness internationally of Japan's economic power coincided in the early 1980s to spotlight Japanese designers operating outside Japan. As Isozaki joined furniture designers Umeda and Kuramata as contributors to Memphis, and 'Japanese fashion' (signifying, ironically, only its Paris-backed proponents) spread virally through boutiques and the fashion press, 'Japanese design' became a hot commodity overseas.

Clichélike similes from historical styles are used extensively in the details, not as vague suggestions, but directly … Starting at one end, I crushed the clear system – of the kind usually preferred for institutional architecture – with the result that fragments overlap, setting up friction, betraying, and then being stitched again with a vague hope that a new statement will merge from among the sutures. One by one, I buried the limitlessly subdivided parts, and all that remains now is the recollection of the interminable nightmare.[7]

Rejecting the 'lucid, coherent institutional style' of neoclassicism or vernacular Japanese stylistic references, Isozaki opted for a 'shifting, revolving, flickering style'[8] whose instability would point to the ambiguous and reclusive character of the post-war Japanese state, unwilling to openly acknowledge the responsibility of claiming any political stance.

Indeed, historical citation could be easily tied to economic growth – leading to the critique of design as wilfully apolitical. Eiko Ishioka's well-known image for the Parco department store (1979) combined the fashion aesthetic of Parisian catwalks and the dance floor at Studio 54 – all fierce cheekbones and shoulder blades – with visual references to an imagined, dynamic pre-modern Japanese past, underlined by the provocative catch copy, 'Can the West Wear the East?' (pl. 222). In its knowing historicism and sharp wit, the image recalls Tadanori Yokoo's silkscreened posters for Tokyo underground theatre performances in the late 1960s, which blended iconic vernacular motifs, Western art historical references and

Conversely, foreign postmodernist designers became a commodity in Japan. During the Bubble years, the exuberant forms of buildings and interiors commissioned from international stars like Philippe Starck and Nigel Coates, whose Café Bongo for Parco (1987) was an epicentre of Shibuya cool, embodied the hyper-consumption of the Bubble ethos, demonstrating Japanese corporations' economic prowess while allowing savvy urbanites to participate in its ludic pleasures. And the mystique of 'Japanese design' and the seemingly bottomless well of job opportunities enabled by the booming economy enticed young designers from the United Kingdom and elsewhere to work in Tokyo. In short, domestic prosperity and the mediatized nature of postmodern global design culture allowed Japanese design's capital to increase internationally, and Japan to consume international design – people and all.

By the mid-1980s, postmodernism had broadened from a conversation internal to architecture to include a popular celebration of urbanism, consumption and design concomitant with the Bubble years of 1986 to 1991. Building projects fuelled by real estate speculation included corporate headquarters as well as monumental public buildings such as Tange's Tokyo Metropolitan Government Building (1986–91), which was infamously destroyed in the film *Godzilla vs. King Ghidorah*, released at the end of 1991 during the first early announcements of economic danger. Like Starck's Asahi Beer Hall (1989, pl. 225), Tange's techno-gothic monolith remains today as a physical reminder of Bubble-era effervescence, and the role of postmodernism in its experience.

Despite our nostalgia for postmodernism and the optimism of the Bubble years now, postmodernism was only ever one of many styles used by designers in 1980s Japan. But to state the often-overlooked obvious, its mix of identifiably international tropes and local responses (which might not have visibly participated in international trends, but nonetheless took a similar stance towards Modernism) collectively formed designers' responses to the specific situation in Japan, within a global network of capital, information, images and people. As examples as disparate as the Tsukuba Centre Building and Café Bongo illustrate, all postmodernism, Japanese and otherwise, can only ever be understood in relation to the networked-yet-local conditions of its specific production. As a global style, what else would we expect?

223
Toshiyuki Kita, *Wink* chairs, 1980. Photograph by Mario Carrieri, courtesy of Studio Toshiyuki Kita

Viviana Narotzky

COMING UP FOR AIR: 1980S SPANISH STYLE CULTURES

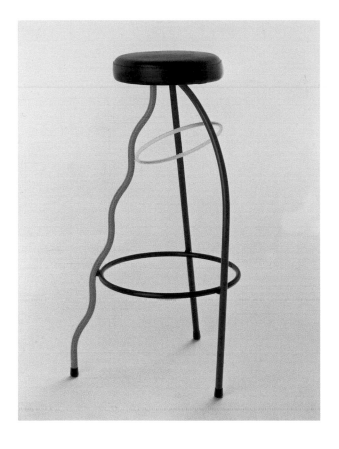

these professionals became local stars; new openings were eagerly awaited social events. With their profusion of designer chairs, stools, tables and accessories, the bars offered cash-strapped youth the opportunity to vicariously consume those objects of desire (pl.226). They were the main public outlets for emerging Catalan furniture design – which would eventually cause a stir at the 1986 Milan Furniture Fair. One of the most renowned of these nightspots, the Nick Havanna bar designed in 1986 by architect Eduard Samsó, was a name-dropper's paradise (pl. 227). It combined the international pedigree of Philippe Starck chairs and a hanging pendulum by Ingo Maurer with local input: tables by Jorge Pensi, stools by the Transatlàntic group, pictograms by Peret and graphics by Carlos Rolando (pl. 228).

By the mid-1980s, the bars had replaced the previous archetype of Barcelona's nightlife, located in the infamous Barrio Chino just off Las Ramblas, which had been more politically intense and bohemian. The downtown scene had once thrived in the maze of streets and watering holes of the old city, peopled with immigrants, transsexuals, prostitutes and drug addicts. Its cast of characters included the cult figure Ocaña. This *loca* ('crazy woman', a slang term for a transvestite) became an icon of Barcelona's underground culture in the 1970s, often parading down the Ramblas dressed as the Virgin Mary or in full flamenco apparel, a one-man demonstration defiantly staging the contradictions of late Francoist cultural mediocrity.[1] But the interface between underground bohemia and radical chic, which seemed to make so much sense during late Francoism and the very early years of the political transition, did not survive the city's transformation. Venues such as the downtown Zeleste, epicentre of late 70s nightlife, were supplanted by Zig Zag, a grey-and-white corridor of a bar, by 1981 the coolest place in town, which in turn spawned the crisp New Wave interiors of Metropol, and later the more high-tech Otto Zutz. Soon designer bars were proliferating, in playful and eclectic styles ranging from hard-edged urban sci-fi fantasy borrowed from films such as *Blade Runner* (1982) and

Emerging from nearly four decades of a stifling fascist dictatorship, Spain in the early 1980s unleashed its long-delayed yearning for rational modernity amid the fragmented confusion of a postmodern world. The initially cautious establishment of a democratic framework soon brought with it deep upheavals, both in social structure and in the nature and quality of everyday life. While Spain's citizens desperately wanted to become 'modern', this necessarily entailed assimilation into a wider economic and cultural environment that was, by then, busily deconstructing that very concept. The country's two main cities, Madrid and Barcelona, plunged headlong into a vortex of intense and highly visible transformation, but they went about exploring the possibilities afforded by the new democratic freedoms in markedly different ways. Barcelona, building on its well-established heritage of architectural panache, embarked on an ambitious process of urban regeneration, and turned to design as the pre-eminent expression of its material and spiritual rebirth. Madrid's answer was *la Movida*, a dizzying counter-culture of irreverence, hyper-creativity and ecstasy.

Barcelona's urban renewal exemplified the 'cultural turn' typical of advanced industrial societies, in which capital investment is directed toward the creation of an urban symbolic economy. Designer bars, in particular, became a new site in the city's exploding geography of design consumption, alongside design-led retail spaces, reclaimed public spaces, nightlife and café culture. The designer bars grew out of a firmly established tradition that included neighbourhood bars, cafés and *tascas*, which are open from early morning until about 11pm, and offer tapas, food and drinks throughout the day. Designer bars, by contrast, are *bares de copas*, or cocktail bars – and open only at night. Each became a showcase for its designer's work, and

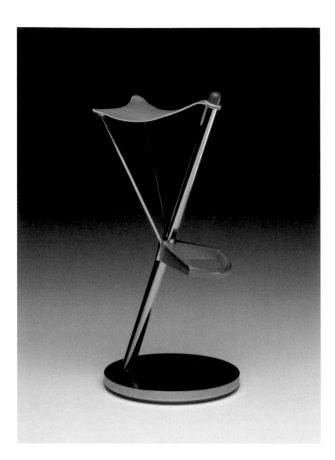

228
Ramon Benedito, Lluís Morillas and Josep Puig (Transatlàntic), *Frenesí* stool, 1985. Chromed steel, titanium. V&A: W.26–2010

force, the 1990 Torres de Ávila, developed in collaboration with Javier Mariscal (pl. 229). This exercise in total design was the apex of the Barcelona designer bar phenomenon. Fittingly, it was located inside the Pueblo Español, a compound created for the 1929 International Exposition, now only a short walk away from Mies van der Rohe's reconstructed German Pavilion. The Pueblo Español, or 'Spanish Village', was a faithful reproduction of a variety of typical building fronts and streets from all the Spanish regions, an early theme park of vernacular architecture. Although it had been left to decay during Francoism, it had come to embody for many Barcelonese the dictatorship's repression of authentic expressions of regional identity, supplanted by stale representations of folklore. In the early 1990s, as part of the Olympic reconstruction of the Montjuic area, it resurfaced as a daytime tourist attraction and a nighttime entertainment ghetto, whose restaurants and bars were protected by fake medieval walls and paid admission. Its long-held status as a chamber of horrors was now eroded by postmodern irony. Las Torres de Ávila was never really integrated into the local experience of urban nightlife, becoming instead a part of the city's tourist circuit, the ultimate commodification of its designer bar culture.

What the Marxist theorist Marshall Berman has termed the 'modernism of underdevelopment', which 'nourishes individual sensibilities without recognizing individual rights', was something Barcelona very much wanted to escape.[2] Madrid seemed to provide a better environment for that condition: *la Movida* maintained the ideal of a less sanitized youth culture throughout the 1980s. The capital's fashionable nightspots were dark, DIY post-punk caves that revelled in the anti-aesthetics of *cutre* – an untranslatable word connoting vulgarity, mediocrity, marginality and dirt. *La Movida* was an exuberant post-dictatorship catharsis, inspired both by New York's 1960s underground and British 1970s punk. Indie pop-rock music became a self-sustaining cultural experiment that initially seemed to eclipse all other fields of artistic production, to the extent that the capital offered little besides a fairly low-brow, raucous musical scene. But *la Movida* also had a long-lasting impact on high-cultural production. Madrid became the centre of a revitalized art world, with new high-end galleries sustaining a more playful, less earnest approach to fine art. In fact, Madrid's creative energy touched virtually all aspects of cultural production, from fashion design and poetry to film, photography and literature. The main shared characteristic of this diverse output was a hedonistic, almost romantic refusal to engage in the political discourses that had defined the previous generation's concerns.

The new youth culture was championed in Pedro Almodóvar's early films as a riot of punks, nuns on acid, working-class matrons, junkies and middle-class transsexuals (pl. 230).[3] But the real power of Almodóvar's work resided in its depiction of all that the spirit of *la Movida* sought to leave behind, revealing the New Wave's closeness to Spain's more conventional culture, both that of Church, family, army and state, and that of washing powders advertised to housewives on national TV. Policemen, priests and deposed monarchs straight from the pages of *Hello!* magazine formed the backbone of his early comedies. It was this contrast, played

Mad Max (1979), as at the bars KGB and Network, to ironic interpretations of classic bourgeois comfort, sometimes teeming with cultural cliché, sometimes casually restrained, as in Claret Serrahima's Universal. Each designer bar provided a sumptuous backdrop where beautiful people could put themselves on display, see and be seen, and catch their fleeting, fashionable reflection in the mirrors of hyper-designed lavatories. Madrid, as the nation's financial centre, was the true home of the Spanish yuppie (the paradigmatic exponent being the banker Mario Conde, an arrogant wearer of double-breasted suits and Brylcreemed hair); and Barcelona did have its *modernos*, who saw themselves as closer in spirit to the creative surge of the capital's *Movida* and its vibrant post-punk youth culture. But for the most part Barcelona's youth had a design-led, commodified outlook: theirs was a quest for cultural capital, accrued through cultural consumption.

By the late 1980s it had all truly gone into overdrive. Possibly the most striking example of self-referential, hyper-formalistic showmanship was to be found in Alfredo Arribas' work. Velvet, which opened in 1988, was an exercise in postmodern rhetoric that was fascinating in its baroque excess. Drawing once again from cinema, as he had done at Network, Arribas offered an explosive mix of the neo-*noir* suburban weirdness that permeated David Lynch's 1986 film *Blue Velvet*, the mannerisms that had characterized the sugar-coated bourgeois kitsch of post-Civil War Francoist tea-rooms, and the lines of Carlo Mollino's organic furniture. Its sensual textures and intense colours were the antithesis of minimalist or high-tech interiors. Still, Velvet's billowing curtains, stylistic eclecticism and plush furnishings paled in comparison with Arribas' next *tour de*

as parody or farce, which sustained Almodóvar's fierce intention to offend the sensibilities of his audience.

On live national TV from 1983, cult arts and music programme *La Edad de Oro* (*The Golden Age*) turned its weekly graveyard slot into one of Spanish youth's preferred hangouts. Through a haze of big hair and marijuana fumes, host Paloma Chamorro interviewed the rising stars of Spain's hip counter-cultural renaissance, some of which, like designer Mariscal, artist Miquel Barceló or Almodóvar himself, would eventually become internationally acclaimed figures. Chamorro's cultural magazine made widely visible Madrid's feverish, drug-fuelled energy. It shared with the rest of Spain the work – and the attitude – of the capital's young artists: Ceesepe's elegant and dangerous depictions of the city's nightlife, Guillermo Perez-Villalta's haunting paintings of architectural interiors, or Ouka Leele's powerful hand-painted photographs, vaguely academic and perverse (pl. 231). *La Edad de Oro* was fearlessly transgressive, wielding the classic 'sex, drugs and rock 'n' roll'

trident to taunt the still powerful ultra-conservative political and religious establishment. Eventually it lost the fight, as official complaints by the Spanish Catholic Church led to the programme being discontinued in 1985.

Madrid and Barcelona's post-dictatorship scenes were a fitting reflection of each city's character. They also represented the spirit of a generation of Spaniards who came of age for the first time in almost half a century, with the freedom to express the creative energy of youth and its unfettered iconoclastic joy. But youth culture during Spain's political transition was soon stripped of its counter-hegemonic qualities, as it was endorsed by the media, the central government, and especially by city councils, with unbridled enthusiasm. Madrid's cutting edge soon found itself playing open-air concerts, and featuring in magazines such as *La Luna de Madrid*, funded by the city council. In Barcelona, meanwhile, aestheticized urban culture received a tribute that would once have been unthinkable: an official guide to the city's designer bars, published in 1986 as a spur to tourism.

230
Ceesepe, *Pepi, Luci, Bom y Otras Chicas del Montón* poster, 1980

Wolfgang Schepers

FURNITURE OUT OF ITS MIND: DÜSSELDORF, 1986

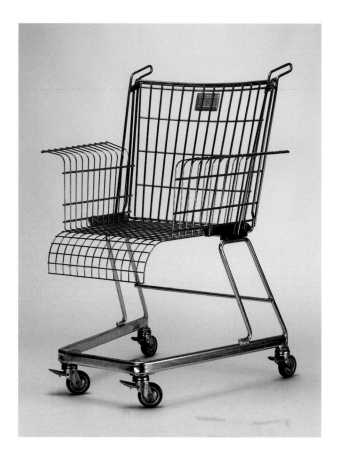

In 1980 I arrived at the Kunstmuseum Düsseldorf as a new curator. My duties included not only caring for the former collection of the Düsseldorf Museum of Applied Arts (which had been merged with the municipal painting collection in the 1920s), but also adding to it – with particular attention to product design. My first significant exhibition, very art historical in character, was entitled *The Chair, For Example: A Ramble Through the Cultural History of Sitting* (1982). I also began building the design collection, which – as I wrote at the time – had previously been oriented toward the hierarchical distinctions of 'the received canon of decorative art'. I thought that we should instead apply the criteria of product innovation: 'We should be interested in objects that represented new formal, functional, psychological, or aesthetic values when they were first designed.'[1] I visited design fairs, pored over company catalogues and, whenever possible, sought gifts from manufacturers.

Slowly it became clear that, for the public, an art museum with a decorative art department (including a large collection of glass) must engage with the present. Our activities took place at a time when Germany was turning increasingly to experimental design, as illustrated by exhibitions such as *Forum Design* (Linz, 1980); *Provocations: Design from Italy* (Hannover, 1982); *Lost Furniture: Beautiful Living* (Hamburg, 1982–3); and *Department Store of the East* (Berlin, Munich and Hamburg, 1984 and 85). But it was really the exhibition *Lost Furniture*, which was more or less an improvised installation in the corridors of the Museum für Kunst und Gewerbe in Hamburg, that connected me with the protagonists of experimental design. I remember well a visit to my office from the designer-

architects Claudia Schneider-Esleven and Rouli Lecatsa, Michel Feith (owner of the gallery Möbel Perdu in Hamburg), and the Düsseldorf-based designer Volker Albus. They proposed an idea for a large exhibition on New Design, a stock-taking exercise of the moment. A simple gathering of 'crazy' furniture seemed to me inadequate, however. I asked them to develop a concept that would help to order, evaluate and examine the currents of New Design. After a short time they came back to me with a proposal. We would not only display the objects, but also – by means of a 'trend catwalk' – would relate them to simultaneous developments in architecture, music and fashion. The following excerpts are taken from the group's concept statement:

Emotional Collage: Furniture Out of its Mind
Samples of an immediate culture
Motto: me, here, now

I spend all day under surveillance, working at a scanning machine, going to and from work in a functional grey container, under surveillance on the streets. When I am at home, before and after work, I live in a functional house, also under surveillance. I want to sit in flowered, kitschy, slanted, quivering, tasteless furniture...

Emotional Collage:
Against the dictates of the spinal column
For the equal rights of the senses, and the spontaneity of vision

On display will be:
The design of today
Contemporary installations and furniture

Objects with attitude, offensive and impartial; on the receiving end of a chaotic urban landscape. The more extreme the environment, the more extreme the response.

We no longer swoon over boring sketches, habitual and fixed notions of use, and predetermined functionality. Products, drawings and materials that seem definite in their meanings gain new content when they are made strange. Improvisation, hybridization, exaggeration, uselessness...

'Form follows function', the famous doctrine of Louis Sullivan, has stamped many generations of designers. But the avant-garde now frees itself from this obsessive idea, and charts new paths for design. This new design will not originate from standard requirements, or anonymous markets; it will question the work of its elders, and their pathetic limitations of necessity...

A unilateral market economy determines all consumer desire. The emptiness that results can be filled only through fantasy and curiosity ... No one style characterizes the new design. Instead there is variety, directness, individuality. Humour makes for invention! It thrives on an abstracted sensuality. Now our furniture can sweat, laugh, cry, groan...[2]

Interestingly, what convinced me about this concept statement – or better, manifesto? – was the functionality, however mannered, of its rejection of classical Modernity. It called for variety, set in diametric opposition to the massive scale of industrial product design. Stylistic pluralism was invoked. It expressed its opposition to the monotony of the (urban) landscape through fantasy and humour (pls 232 and 233).

On the basis of this concept, and with the know-how of the young architects and designers (we were all about 30 years old at the time), about 250 designers and artists were contacted, and asked for images and texts. Over the course of several long discussions – often violently controversial – we determined the list of participants and work to be shown.

From my press release of 18 April 1986:

Under the self-consciously glamorous title *Gefühlscollagen: Wohnen von Sinnen* [*Emotional Collage: Furniture Out of its Mind*], the Kunstmuseum Düsseldorf presents 250 avant-garde works by 120 European designers and design collectives. On display are tables, chairs, sofas, cabinets, lighting, carpets – but also installations. All are recent designs. Most are prototypes, unique objects or limited editions, which bring new ideas to the theme of 'living' … As soon as the Italian groups like Alchymia (1976) and Memphis (1981) brought new psychological, semantic and iconographical values to the design scene, they resounded across Europe. These – mostly young – designers, artists and architects poach all styles, periods, cultures and regions of the everyday. They design and make furniture and objects according to the principles of contemporary art. As with Dada, Surrealism and Pop Art, *objets trouvés* or 'ready mades' (raw materials, pieces of rubbish, etc.) are brought into the home. Form no longer needs to follow function, in the opinion of many of the designers

represented in the exhibition. Now the slogans are 'form follows fantasy', 'form follows fiction', or – at the most extreme – 'form follows myself'. On display for the first time in a German museum are designers from Germany, Britain, France, Holland, Belgium, Austria, Switzerland and Italy, whose objects are ironic, critical, often witty, but above all full of fantasy: responses to normative, mass-produced, functional design.[3]

In the context of this short essay it would be not only impossible, but also probably quite dull, to try to list and describe all 120 of the exhibition's participants. But it is worth naming the designers we included, those whom we felt were most decisive in shaping the history of New Design. From Italy: Studio Alchymia, Andrea Branzi, David Palterer, Ugo La Pietra, Daniela Puppa, Ettore Sottsass Jr, Matteo Thun, Nanda Vigo, Marco Zanuso Jr, and Zeus. From Germany: Volker Albus, Bellefast, Axel Kufus, Kunstflug, Möbel Perdu, Pentagon, Stiletto and Herbert Jakob Weinand. From Britain: Jasper Morrison and Ron Arad's One Off. From France: Philippe Starck and Garouste and Bonetti. And from Czechoslovakia: Borek Sípek.

Quite a few of these protagonists are no longer in the spotlight of the design scene. But in Germany, several have since become professors and have shaped today's up-and-coming designers, such as Volker Albus, Herbert Jakob Weinand and Axel Kufus, as well as the members of the groups Kunstflug (from Düsseldorf) and Pentagon (from Cologne). There is also the legacy of the stunning media impact of the exhibition, and the discussions about design that it initiated. Not only did 35,000 people visit the show in Düsseldorf (pl. 234), but a further 25,000 saw it in Maastricht (where it was shown at the Bonnefanten Museum) and finally, another 110,000 interested onlookers saw it at the design fair Interior '86, in Kortrijk.

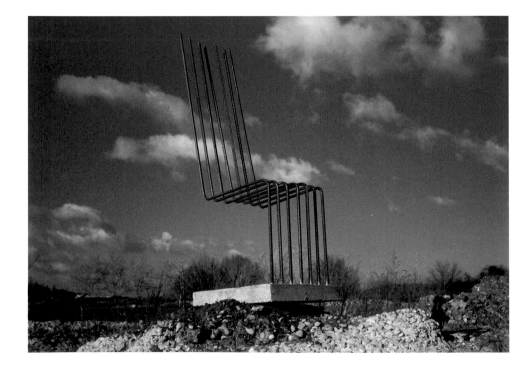

233
Heinz Landes, *Solid* chair, 1986. Concrete reinforced steel

Hardly any of the objects we showed were put into production – this was, of course, never the intention. Rather, New Design performed its work primarily through the media. All the big German design and lifestyle magazines, such as *Stern*, *Vogue* and *Art*, featured the exhibition in elaborate spreads. The major national newspapers, such as *Frankfurter Allgemeine Zeitung*, *Süddeutsche Zeitung* and *Handelblatt*, took the theme of the exhibition seriously, providing critical analysis and assessing its cultural context: 'The wild style of contemporary painting has also taken designers and interior decorators in its grip. Architects, similarly, launch into turbulent flights of creativity, fuelled by their displeasure with the constraining dictates of Modernism.'[4] The critic from the *Süddeutsche Zeitung* wrote: 'After this survey, which unites a relatively indiscriminate set of tendencies under the heading of collage, it now seems the moment to separate the wheat from the chaff. Given the speed of fashion, before all is explained a new trend will inevitably have arrived.'[5]

That the subject of the Düsseldorf exhibition was to some extent 'in the air' was attested by diverse other exhibitions, new galleries, congresses and workshops, all based on similar concepts. The year 1985 had seen the exhibition *Autonomous Furniture: Objects and Installations by Artists* at the Kunst- und Museumsverein Wuppertal, as well as the founding of the Pentagon Gallery in Cologne, the Weinand Design Gallery in Berlin and Galerie Atoll in Kassel.

Then, in 1986, *Prototypes: Avant Garde Design From Berlin* was shown in Rotterdam, the Seitensprünge ('Jumping Sideways') fair was held in Frankfurt, and a workshop devoted to the design of door hardware was hosted by the manufacturer FSB Brakel. The Düsseldorf exhibition also toured to Stuttgart under the title *Need, Art, Desire*.

In 1987, Hamburg staged the exhibition *Design – Dasein: Objects for Sitting, Setting and Living*. This was also the year of Documenta 8 in Kassel. It was the first time in 23 years that design had been included in this international contemporary art fair. The curators at Documenta oriented themselves to the Düsseldorf exhibition; among the participants were Andreas Brandolini, Jasper Morrison and Pentagon.

Finally, Volker Albus and I were invited by François Burkhardt (curator of design for the Centre Pompidou) and Andrea Branzi, the two heads of the exhibition *European Centres for New Design: Barcelona, Düsseldorf, Milan and Paris*, to curate the German section of that show. The exhibition was first shown at the Pompidou in 1991, and then came to the Kunstmuseum in Düsseldorf. Five years after *Emotional Collage: Furniture Out of its Mind*, it was only proper to find a new concept. This became an exploration of the distinct 'dialects' of New Design in the various metropolises, and their interaction with one another, through which New Design was established. As Branzi and Burkhardt wrote in the catalogue, 'After years of fruitful experiment it is now time to show that the New Design is no longer a sporadic expression of marginal groups.'[6] For our contribution to the exhibition we chose not only works by designers who had been in the 1986 show in Düsseldorf, but also works from a broader spectrum that included jewellery, fashion and advertising.

In the 1990s, many designers turned away from postmodernism and toward a 'New Modesty', or 'New Simplicity'. Looking back, *Emotional Collage* can be seen in some ways as the high point of New Design, but also as its end.

Translated by Glenn Adamson

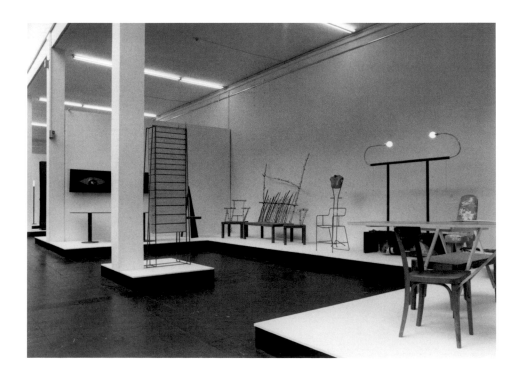

234
Gefühlscollagen: Wohnen von Sinnen (Emotional Collage: Furniture Out of its Mind)
exhibition, Kunstmuseum, Düsseldorf, 1986

Rick Poynor

TRUE STORIES: A FILM ABOUT PEOPLE LIKE US

In a teasing interlude about architecture in the film *True Stories* (1986), directed by David Byrne, the narrator, played by Byrne himself, enthuses about metal buildings. Architects don't realize it, he suggests, but these structures represent the fulfilment of modern architecture's dream. There is no need to engage an architect to build one. 'You just order 'em out of a catalogue, just pick out your colour, the size you want, number of square feet, which style, what you need it for ... You're all set to go into business. Just slap a sign in front.' Here, the 'decorated shed' identified by Robert Venturi, Denise Scott Brown and Steven Izenour in *Learning from Las Vegas* reaches a point of expedient reduction and commercial utility beyond which 'architecture' can progress no further.

True Stories arrived in cinemas around the same time as other American films quickly identified by critics as postmodern, notably David Lynch's *Blue Velvet* and Jonathan Demme's *Something Wild*.[1] Byrne's three-year project, his only full-length feature to date, was unique, though, in making the postmodern culture of the mid-1980s, including the visual environment, its subject. *True Stories* doesn't contain any examples of overtly postmodern design, except for an extraordinary fashion show, with surreal costumes by Adelle Lutz (later Byrne's wife) resembling bricks, a classical column, a wedding cake, leaves and grass, but the film is itself a highly designed postmodern artefact – Byrne studied design at the Rhode Island School of Design – that now looks completely of its era.[2] Baffling as it might have seemed to

1980s viewers expecting a conventional narrative about provincial life in Texas, *True Stories*' report on the fictitious town of Virgil was also highly prescient. Its themes of surburban sprawl, recreational shopping and mall culture, the pervasive influence of advertising and media, the fast-developing computer industry (represented by Virgil's main employer, Varicorp) and the emergence of new social priorities and values would come to preoccupy, and vex, many social commentators and cultural critics.

The film's attitude to these issues is playfully ambiguous. Who is this blandly inquisitive narrator in a cowboy shirt and stetson and why has he come to Virgil (pl. 235)? Although the characters are happy to talk to him about their lives, he isn't situated within the film's world as a professional investigator – journalist, ethnographer or documentary film-maker – with reasons to be telling its story. Yet he repeatedly addresses the audience through a camera that other people in the film mostly appear not to notice. The first time we see Byrne he is delivering a lecture in a theatre, using a screen, through which he then steps. Driving his convertible in front of an obviously projected backdrop, he manipulates the steering wheel with exaggerated, unrealistic movements (pl. 237). Self-reflexive devices such as these characterize the postmodern film. Later, a girl asks whether the other characters can hear the music that has started on the soundtrack, presaging further breaks in the film's illusion of reality. Intertitles announce each section of the narrative. In *True Stories*, Byrne would seem to be playing

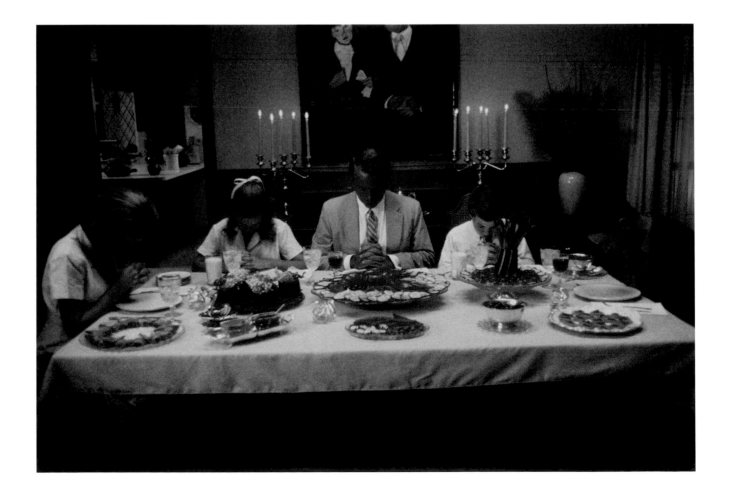

235
True Stories, 1986. Directed by David Byrne, photograph by Mark Lipson

'David Byrne', making the entire film a kind of three-dimensional, illustrated lecture.

True Stories is in any case a hybrid, another characteristic of postmodern cinema. Byrne's source material for many of the people and incidents comes from stories he found in *Weekly World News* and other trashy American tabloids. The musical sequences based on songs written and performed by his band, Talking Heads, derive from the fast-cutting montage style of MTV. Their use as narrative punctuation to reveal character and express emotion, though always in settings where one would expect to hear music, comes from the Broadway or Hollywood musical, and here, too, the film's characters deliver the songs. Byrne grafts documentary devices on to standard generic forms, particularly the romantic comedy and love story, though there are also elements of social satire. The roving narrator device recalls an earlier intrusive narrator in Thornton Wilder's play *Our Town* (1938), and the interwoven multiple narratives can be found in Robert Altman's *Nashville* (1975). Byrne was fully conscious of the hybridizing tendencies of his film, arguing that stealing and mixing was fine so long as it was done with panache.[3]

Irony came to be seen as a pillar of postmodernism. *True Stories'* tone is, however, only ostensibly ironic. A New York hipster, Byrne sounds wide-eyed with wonder and deadpan in the same breath as we meet such curious characters as the Cute Woman, the Lying Woman, the Lazy Woman (who never gets out of bed), and 'dancing fool' Louis Fyne, who advertises for a partner with a sign outside his house saying 'Wife Wanted'. In his song 'The Big Country' (1978), Byrne had looked down from his seat on a plane at the folksy communities of Middle America and seemed to be eulogizing the homeland, until he declared, 'I wouldn't live there if you paid me.' Now, visiting Virgil's mall, he paints a sympathetic picture of consumers choosing to shop where it is convenient, clean and there are bargains to be found. 'People here are inventing their own system of beliefs,' he explains. 'They're creating it, doing it, selling it, making it up as they go along.' Kay Culver, the immaculately groomed wife of Earl Culver, a civic leader, introduces the mall's fashion show – 'Shopping is a feeling,' she lilts. 'Sometimes I get a wobbly feeling. I have a commercial feeling. Be sexy in business. Be successful at night' – before launching into 'Dream Operator', a song full of silky-sweet yearning. At her house, Byrne tells her he saw the show and liked it. Driving around town, he cruises by some bungalow homes. 'Look at this. Who can say it isn't beautiful? Sky. Bricks ... Four-car garage. Hope. Fear. Excitement. Satisfaction.'

Yet this empty Texas range is also an 'imaginary landscape', in Earl Culver's words, where postmodern people out to invent new belief systems, new lives and new products (Varicorp's personnel are leaving to start up creative computer businesses) are becoming disconnected from history and politics. The only politics we encounter in *True Stories* are wildly incoherent conspiracy theories disseminated from, of all places, a preacher's pulpit. Virgil might – or might not – be a fine place to raise

236
True Stories, 1986. Directed by David Byrne, photograph by Mark Lipson

children, but when Culver points out that some people are declining to have them now 'what with the end of the world coming up and all', Byrne hastily agrees he has no plans to procreate. In the next scene, we meet a prowling gang of Virgil's youngsters, tribally clad in the same green T-shirt and petulantly chanting, 'I wanna video. I wanna rock and roll. Take me to the shopping mall'. The Lazy Woman idly channel-hops, shouting with excitement at the ads and reeling off the titles of news programmes, which she clearly regards as meaningless. In 'People Like Us', the anthemic song he has been working up to throughout *True Stories*, Louis Fyne confides that ordinary people 'don't want freedom. We don't want justice. We just want someone to love.' The song is so heartfelt and touching that it is easy to overlook his alarming confession. It works for Louis, though, and he finds a mate.

In 1985, while *True Stories* was in production, Byrne co-directed a video for 'Road to Nowhere', a song by Talking Heads. Like the film, the video begins and ends with an image of the open road stretching to the horizon, and like the film, its answer to the apparent negation of 'nowhere' lies in the consolation of community. Cultural critic Dick Hebdige identifies the 'Road to Nowhere' video as firmly located within postmodernism because of the way it deploys humour — 'the deconstructions and alienation effects are jokes rather than

history lessons' — and he notes that its tone and the hope it invests in ordinary people are essentially affirmative.[4] Hebdige goes so far as to claim that the kind of laughter inspired by the video could help to usher in a 'new order'.

In his *True Stories* book, Byrne describes the Infomart (1985), a huge market for the information technology industry modelled on the Crystal Palace, built by the property developer Trammell Crow as part of the Dallas Market Center. The film-maker's response to the weirdness and audacity of this postmodern conceit was a mixture of laughter and admiration. *True Stories'* dramatic structure grew from images like this encountered on his research visits to Texas. 'The thing about it is,' writes Byrne, 'all of these people [in the film] are right. None of them is wrong. They are setting a good example, and in this film and book I'm teaching myself to appreciate them.'[5] The indeterminacies, the cool ironic posture that ultimately repudiates irony, the final celebration and endorsement of the town's 'special-*ness*', show Byrne coming to terms with the future implications of his pop-ethnographic field trip (pl. 236). The eccentric inhabitants of Virgil, engaged in finding their own ways to live, are building a little Utopia, as Byrne called it, a postmodern 'city of dreams' — in the film's final song — showing what might be possible.[6]

237
True Stories, 1986. Directed by David Byrne, photograph by Mark Lipson

Reinhold Martin

ABSTRACT FIGURAL SYSTEMS

238
Michael Graves (for Alessi), tea and coffee service, 1983. Silver, mock ivory, glazed and laquered aluminium, bakelite and glass. Detroit Institute of Art (1989.0106, a–f)

In 1980, Michael Graves designed a tea service: one of a series created for Alessi by 11 architects, who also included Aldo Rossi, Charles Jencks, Alessandro Mendini and Hans Hollein (pl. 238). The service was produced in a sterling silver limited edition in 1983. Its appearance invites all manner of stylistic comparisons. But what matters most is how we look at this object in and of itself, without reference to sources or quotations that lie outside its frame.

Compare the teapot from the service to Graves' better-known Alessi kettle, which went into production in 1983 (pl. 239). Simpler and more utilitarian in design, the kettle is distinguished by the maroon-coloured plastic bird attached to its spout. The bird whistles when the water boils. It is presumably to be understood as a whimsical flourish that distantly recalls the gargoyles and other beasts perched on archetypal monuments lodged in the collective architectural unconscious. But the bird is also the element in the design that marks the kettle's entry into a new kind of perceptual and cognitive system.

Despite appearances, the kettle is not exactly a stand-alone object, even in the sense that would equate 'object' with 'sign'. Instead, it would be more accurate to describe it as a system of figures, or perceptual units. The bird belongs to a composition that also includes the kettle's squat, conical body and the blue plastic handle that hovers above it with the help of a slender steel arc, all of which combine into a precarious 'gestalt', or perceptual whole. In this sense, Graves' kettle is a figure composed of other figures. But what is the ground from which these figures emerge?

Perceptual plays of figure and ground proliferate in Graves' work, a preoccupation that he shares with colleagues like James Stirling, Richard Meier and Peter Eisenman. This concern is usually associated with the writing and teaching of the architecture critic Colin Rowe, as well as the theories of the early twentieth-century gestalt psychologists, perhaps as these were assimilated into the work of the art historian Rudolph Arnheim and others. The composition of a perceptual 'gestalt' through the emergence of figure from ground, or conversely its frustration in the visual ambiguities inherent in perplexing figures (like Ludwig Wittgenstein's 'duck-rabbit'), posed recurrent, fertile problems to the generation of

formalists to which Graves belongs. As often happens when family lore is inserted into the unfolding of history, however, these problems acquire greater meaning when seen from a different perspective.

It may seem doubtful that an innocent kettle enlivened by a sweet little bird would take its place in the parade of archetypal figures, ambiguous or not, that emerged from this intellectual lineage. However, when considered as a figure/ground problem, the kettle's position is somewhat more dramatic. For a figure to emerge from a ground, a certain hierarchy needs to be established – conventionally, a hierarchy of foreground over background. In the case of the kettle, such a hierarchy could be construed in the product's strenuous effort to stand out on the shelf, so to speak, when seen side-by-side with other, comparable products, whether they are designed by other architects in the Alessi line, or merely assembled into the more general field of domestic commodities. Today, this is called 'branding'.

But branding means more than merely standing out. It means simultaneously overcoming and reproducing the abstraction that is the heart and soul of all commodities, which must submit to exchangeability through the general equivalence that is the basis of a money economy. Even when issued in a limited edition (as in Graves' Alessi tea and coffee service), all commodities are part of a series, which comprises their own iterability, as well as the series of series that includes all other iterations of all other commodities, whether real or imagined.

This series of series is the ground against which Graves' figures emerge. It was the terrain explored by modernist designers as they sought to forge an aesthetic vocabulary out of the new syntax of mass production and circulation. More often than not this ground was composed of repetitive, standardized, or modular units, and was most commonly registered in Modernism's preoccupation with grids and other field-like geometries. Graves and many of his postmodernist colleagues reacted against this tradition, which in the case of his industrial designs meant 'returning' to pre-industrial figuration as an alternative to the rigid, geometrical abstractions of Modernism. But if there is anything that makes Graves' kettle postmodern,

239
Michael Graves (for Alessi), kettle, 1983. Stainless steel and plastic. V&A: M.11–1990

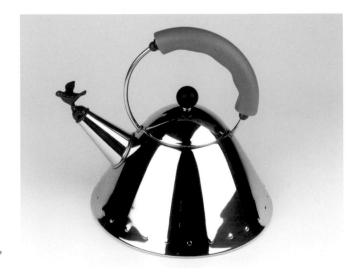

it is its position in a grid of commodities – made exchangeable now not only by the infrastructures of mass production and standardization, but equally importantly, by the play of one figure against the other on the shelves of culture, in such a way as to cancel out the serial, systemic 'ground' out of which they emerged. Their continued circulation on and in this ground encourages the thought that these are no longer disenchanted, inanimate commodities but rather, re-enchanted, re-animated things.

There are at least two other paradigmatic instances of this figural management of perception and cognition in Graves' work. The first is a shopping bag that he designed in 1982 for Bloomingdale's department store, and the second is the pair of hotels that he and his firm completed for Walt Disney World in Florida in 1987.

The Bloomingdale's shopping bag is adorned by a printed image of a semi-classical vase, shown in profile, which emerges out of a darker, patterned background coloured in seasonal hues (pl. 240). The vase profile is undoubtedly an echo of the familiar diagram of figure/ground interplay in which two human profiles are drawn face-to-face, between which emerges the figure of a vase. But where the figure/ground game on Graves' otherwise inconsequential design seems partially to repeat that iconic image, and so entertain shoppers with a dash of visual ambiguity, it actually works to establish a perceptual hierarchy in which the figure/ground play cancels the geometrical abstraction of the bag itself. The Bloomingdale's shopping bag, after all, is already an icon of consumerism. It is the very index of the regime of abstract exchange under which its potential contents circulate; or, to recall our earlier image, it is the metonymic trope by which the abstraction of an infinitely extensible 'grid' of commodities might be registered. At a cognitive level, then, the point of the otherwise innocuous

visual play of the bag's decoration is to replace the stark, serial actuality of that 'grid' and the bag that materializes it with a play of figures that, counter-intuitively, we must understand as *more* rather than less abstract. The figural ambiguity adds to the mystique of commodification rather than diminishing it, by effectively making its ground – the form and logic of the bag itself (or the 'system' of the bag) – invisible.

The two Disney hotels do something similar at another scale (pl. 241). Remove the gigantic swans, fish, clam shells and supergraphics adorning their surfaces, and you have a relatively generic collection of boxes in which are assembled a relatively generic collection of hotel rooms and associated amenities in standardized formats, distributed according to marketing formulas and other administrative protocols associated with what, long ago, the sociologist Georg Simmel described as the 'calculating character' of the money economy. But the postmodern decorations that Graves adds to these otherwise utilitarian modernist boxes, disguised as Beaux-Arts monuments, are more than mere distraction. We can call them structural, in the sense that such apparent superfluities are an essential ingredient for the circulation of commodities in a 'post-industrial' milieu on which the Disney brand lays claim. Like the apparently innocuous play of decorations on Graves' shopping bag, these playful figures cavorting in the Florida sun are fundamental to the perceptual management practised by Disney and other protagonists of the postmodern culture industry. For, in distinguishing these hotels from the background produced by their more standardized competitors, they re-integrate Disney into the grid of commodities at another level, performing a balancing act in which figures circulate abstractly even as they appear to overcome the abstract character of the systems of systems that produced them.

Graves' comprehensive design of this themed environment for Disney mirrors, but does not quite match, the comprehensive redesign of IBM's corporate image accomplished by Eliot Noyes and others in the 1950s. Where Noyes and his colleagues sought a modular systematicity (exemplified by Paul Rand's now-iconic, geometrical redesign of the IBM logo), Graves and other architects working for Disney in the 1980s produced a collage of familiar, visually legible figures, the interplay of which obscured their underlying systematicity.

The resulting tensions are exemplified in the overall form of the two hotels: the low, arching profile of the Swan Hotel, and the flatter arc of the Dolphin interrupted at its centre by a bold, equilateral triangle filled edge-to-edge with a regular array of squarish windows, in which sits a large square opening surmounted by a rectangular slot. The neoclassical allusions of these forms are obvious. But again, they should be read as marking the design's contemporaneity rather than as anachronism. A figure/ground (or figure/field) tension organizes the Dolphin's central triangle in elevation. The simplified neoclassical forms compete with a field of windows (and the standardized, repetitive rooms behind them) for control over the foreground. Likewise for the cartoonish banana leaves painted on its surfaces, and the cartoon gargoyles (or sculptures) perched at its corners. These figures compete for control of the visual field with the repetitive grid of windows and balconies, and the awkward volumes that barely contain them. To the

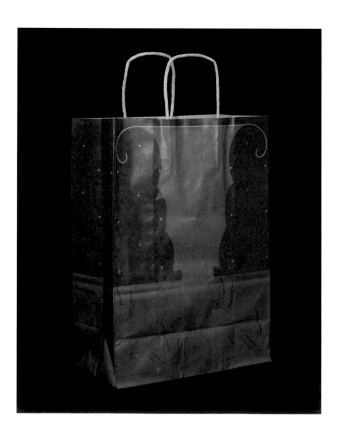

240
Michael Graves, Bloomingdale's shopping bag, 1982

extent that they succeed in attaining visual priority, they render the buildings as empty, decorated 'shopping bags' whose figural exchanges obscure the underlying banality that supports and is supported by them.

So what we are looking at in these playful collections of figures is the dead seriousness of a new type of abstraction that is reproduced and enhanced, rather than overcome, by postmodern design. This is a process by which the carefully measured geometries of industrial capitalism and its offshoots are further abstracted, not to say occulted, into the free-floating play of one figure against another, across an invisible grid, field, or ground. The invisibility of this ground, and not the figures themselves, is what is actually being designed in these postmodern things.

241
Michael Graves, the Swan and Dolphin Resort, 1987. Walt Disney World, Orlando, Florida. Photographs by Victoria Slater-Madert

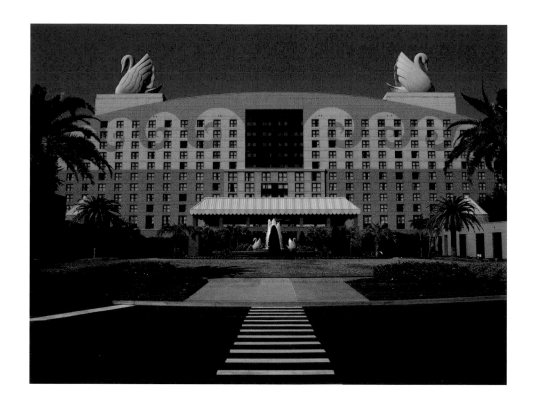

Arindam Dutta

NO DUCHAMPS IN DELHI

Perhaps the greatest paradox about postmodernism is that its intuitions of historical incoherence should be so caught up in the concept of a coherent historical 'break'. At its most vulgar, postmodernist sensibility ensconces itself fully within the West, with capital presumed to have arrived at a new historical stage. In defining itself as a departure from Modernism, however, postmodernism confused the particularity of its own historical circumstance in the narrative formats of the very Modernism that it purported to subsume. It was after all the modernist penchant to periodically announce the radically new. What obtains in the end is a defensive alchemy. Postmodernism tended to forestall any critique of its own historical determinants as possible only on the grounds of yet more 'grand narratives'. And yet, it was hardly innocent of its own periodizing panjandrums. Remember all that blather about post-industrial society? Just on the cusp of the largest-ever expansion of industry worldwide. Or Baudrillard's 'cool space'? Just before we all began to hear about global warming. For that matter, modernists, British ones included, no less tended to perceive their current discomfiture as nothing less than cosmic cataclysms. The double-whammy of Thatcherite disinvestment and Prince Charles' historicism may have presented formidable obstacles, but they were hardly universal or irreversible. With all the talk of indeterminacy and disintegration of grand narratives, you almost wonder if the lights came on at all when we flicked the switch in the 1980s.

Only a decade after the supposed demise of Modernism – of Charles Jencks's 'tragic view' – Blairite New Britain would carve out its new hedonism, once again with a silky-smooth Modernism as its signature style. Evidently, all that British Modernism needed to shake off its funk was infusions from the National Lottery. (In comparison to the propagandist efficacy of Herzog & de Meuron's conversion of a power station into Tate Modern [completed 2000], James Stirling's Clore Gallery at Tate Britain [1982] seems in retrospect hobbled by a lugubrious temporal arrest.)[1] And so an historical account of postmodernism trips up against the postmodernist account of history, revealing at the core of both postmodernism and historicity an 'essence' that both appear to want to undo.[2] Jürgen Habermas upbraided postmodernism in design – with specific reference to the architecture displayed at the 1980 Venice Biennale – as an 'avant-garde of reversed fronts ... sacrificing the tradition of modernity in order to make room for a new historicism'.[3] The 'tradition' so described was one of inchoate artistic factions self-organizing to up-end the normative constraints of culture, institutions and form. An antagonism, anarchism even, defines cultural Modernism's tendency to 'blow up the continuum of history ... the normalizing functions of tradition'. It was this ongoing radical project that appeared, to Habermas, to be on the wane in the 1980s, its eclipse occasioned by the conjoined ascendance of cultural atavism and 'capitalist modernization'.

It is impossible not to note in this requiem for Modernism its undiversified character, little differentiated by the divergences of history. This insistence on historical singularity – of culture, of capitalism, of Modernism – is not an analytical failure; rather, it presents the clandestine elements of exactly what is being argued. The lament for a lapsed avant-garde in Europe and America comprises, in the very marrow of its critical coherence, a lament for Eurocentrism as such. The tendentious denunciation of "historicism" as if arresting the tropes of a "real" appreciation for history, other than presenting the terms for an idealism in reverse, is also little more than parochialism. If postmodernism in the North is characterized by the divestiture of 'psychic depth' from aesthetic production, texts from the South, by contrast, are invested with a remarkable singularity of purpose. One thinks here of Fredric Jameson: 'All third-world texts are necessarily, I want to argue, allegorical, and in a very specific way; they are to be read as what I will call national allegories.'[4] If for the First World intellectual, post-industrial society is marked by the dissolution of modernist irony into pastiche, the foreclosure of Modernity in the underdeveloped world calls forth sententious demonstrations of commiseration, a 'theoretical sorrow'.[5] Nor is it a coincidence that this libidinal patronizing so closely mirrors foreign direct investment of a purely economic sort.

My argument is that the characterization of postmodernism as either a coherent sensibility (Habermas) or a historical 'stage' (Jameson) could only be asserted by confusing a myopic Eurocentrism with global history. By way of elaborating on the relation between these two analytical strains, between the supposed end of Modernism and discontinuities produced in flexible accumulation, let me offer some objects: the designs unveiled by the Government of India for the *Golden Eye* exhibition at the Cooper-Hewitt Museum in November 1985. The project was part of the Festival of India in the United States, which followed similar exercises in Britain and France.[6] I offer the Indian instance here not because it belongs outside the precinct of Eurocentrism – it doesn't – and certainly not as a 'national allegory', but because 'India' was barely visible on the postmodernists' blinkered cultural horizon in the 1980s. Philip Johnson, doyen of American Modernism and postmodernism, could brush off the Smithsonian's funding solicitation for the Festival with a breezy pittance, 'I really have very little interest in the cross culture of India.'[7] Just as the despairing British modernists of the 1980s could hardly anticipate the Lottery windfalls of the 1990s, we can assume that Johnson's unerring eye for the main chance would have taken a very different direction a decade later, when China and India were very much at the centre of the West's economic radar.

Despite that avant-gardist disdain, the *Golden Eye* project might well be considered the successor of postmodernism's opening foray at the 1980 Venice Biennale. The gamut of invited designers were epigones of the postmodern moment: Charles Moore, Bernard Rudofsky, Ivan Chermayeff, Mary McFadden, Frei Otto, Jack Lenor Larsen, Mario Bellini, Milton Glaser, I. M. Pei, Hans Hollein, Ettore Sottsass and Hugh Casson. Take a look at Charles Moore's five miniature models in painted wood, described as 'Sense Boxes', each pertaining to one of the senses, or Chermayeff and Glaser's papier-mâché 'Toy Boxes', or Sottsass' toys, lamps and vases (pls 242 and 243). In contrast to the weighty onus of historicism, the objects are defined by an evident whimsy. Moore's 'Sense Boxes' echo his Piazza d'Italia, Sottsass' combination of platonic forms and primary colours continue his idiosyncratic experiments with primordial

Postmodernism: **Style and Subversion, 1970–1990**

243
Ivan Chermayeff and Milton Glaser, papier-mâché Toy Box, produced by Indian craftsmen for the *Golden Eye* exhibition held at the Cooper-Hewitt Museum, New York, *c.*1985

ur-types. Above all, the implicit tenor of both the design brief and the designers' responses is the disjunction of form from function. Even if meant to be used, all the *Golden Eye* objects strongly repudiate functionalist determination.[8] What prevails instead is a hybrid array of motifs, techniques, materials, signatures and fancies. We easily forget this 'contra-purposive' enunciation of disjunction that remains postmodernism's enduring legacy. What the neo-avant-garde and the critics of the 'culture industry' glibly palm over is the deliberate whimsy with which postmodernism delved into its atavism. (Habermas, in his melancholia, simply didn't get the joke.)

The joke was lost on the *Golden Eye* promoters as well, a sententious cohort who would be the last to label themselves postmodernists. As a semi-industrial nation ensconced within a largely pre-industrial social milieu, India hardly presented the 'post-industrial' scene from which a proper postmodernism could be construed as emerging. The *Golden Eye* designers were therefore tasked to bridge that old chestnut of a discontinuity: between the sensibility of industrial design and non-industrial modes of production. As Chermayeff and Glaser exclaimed: 'One of the boxes has been carved by hand, not a turn of the lathe – it's a wonderful object, elliptical in shape with an inlay ... It all came back in weird shapes – it was a surprise!'[9] In this context of inexact relations between design and production, deliberate whimsy did fulfil a role, a 'function'. As representatives of an imported avant-garde in a territory of low capital accumulation, the designers were asked to ferret out enclaves of artisanal skill that would be strongly exemplified in the finished artifacts. The enigmas or 'surprises' that happened along the way thus had two uses beyond their design-ated purpose: to act as advertising emblems to attract investment into the Indian economy; and to prototype a procedure for labour extraction within this process of capitalization.

It is tempting to ask why design should have been the cutting edge for India's attempt to enter Western markets given that, despite the pipe-dream of marketing *Golden Eye* products in vanity stores, these ethno-chic tchotchkes could be seen as no more than the insignia of India's arrested industrialization.[10] Rather than seeing them as a solution to the conundrums of a pre-industrial society, we must realize their 'conjunctural' status within a politics of culture. Critical here is Indira Gandhi's effort to retain her and her party's centrality within a deficit-prone state struggling to get beyond its foundering tryst with a planned economy. Increasingly paranoid about political opposition that she deemed as fomenting disunity, and hostage to a business lobby more invested in siphoning privileges off the state than developing technological competence, Gandhi's invocation of culture was calculated to promote her own agenda of capitalization. On the one hand, the Festival of India propounded a message of 'continuity' between the ancient and the modern, between pre-modern craft and modern taste. On the other hand, the implicit message, in this new openness to the West, was also of an India gradually breaking with socialism. Under her predecessor Nehru, the critique of untethered capitalism had been not just the province of an oppositional cadre of intellectuals; socialism had also been the crux of the Nehruvian elite's alignment with the state, an alignment reflecting their experience of a depradatory colonial

free-market. A Duchampian, anti-institutional avant-garde would have been markedly misplaced in an institutional context, where both the state and the intellectuals inveighed against the prospect of a market economy. Even as Gandhi – under pain of IMF conditionalities[11] incurred in 1981 – began to inch backward into a fiscal rollback, the Festivals became a venue to proclaim the state's continued vanguardism: activism in the field of 'culture' thus patently dissembled withdrawal in the economic sector.

Given the explicitly socialist cast of the earlier, post-colonial state in India – increasingly jettisoned by the Indira regime's penchant for domestic populism – for this activism to be successful, it was important the *Golden Eye* exhibition cast an international set of modern designers as cultural progressives. It helped, therefore, that the chosen designers should carry a counter-cultural air. Chermayeff, Glaser and Sottsass were all long-term critics of functionalist Modernism; Sottsass had even had an 'Indian phase' in the 1960s and 70s. Rudofsky's résumé also fitted the message: his curatorial record of placing objects 'without designers' in New York's Museum of Modern Art was well suited to the Indian state's own subterfuge in commissioning designers to valorize a lagging economy.

Rather than revert to historicism, then, the postmodern objects of the *Golden Eye* constituted a potent mechanism of forgetting. The larger point to be made, however, is that the description of postmodernism as a reversal of avant-gardist Modernism not only has to draw on a historically selective record, but also misses the import of its own historical moment. In the context of the as-yet unrealized modernity of a regime struggling to extricate itself from an existential morass, the postmodern objects of the *Golden Eye* expressly carried the countenance of an avant-garde. However, they represented neither a return to the past, nor a 'blowing up' of the modernist project; rather, they were a means of deflecting accountability. Ten years later, Tony Blair would expand this strategy further, with far better results than its Indian precursor, although ultimately meeting with the same fate: fiscal crisis. One thing is clear: in the world of capitalist modernization, disrupting the 'continuum of history' is not necessarily a position without profit.

Charles Jencks

POST-MODERNISM COMES OF AGE

Strange as it may sound, post-modern architecture flourished after it was declared dead in the 1990s.[1] Perhaps all it needed was a name change, the disappearance of a moniker that had tantalized people for 20 years. Whatever the case, post-modernism blossomed after the millennium in all but name, especially in architecture. With the return of ornament and pattern-making, the explosive growth in iconic buildings and landmark sculptures – works that are symbolic and highly communicative – many of the PM concerns of the 1970s and 80s have become central to society.

This cryptic rebirth raises the question of how we categorize a period, especially the modern one. Most historians date the Modern Age to the Renaissance for two essential reasons: the birth of the global economy and the nation state. Beyond such determinants there are the words of the participants themselves, the repetitive use of that big brand '*moderna*', and its cognate terms of praise. Architects and historians, such as Filarete and Vasari, used that term positively on countless occasions. If one accepts that both popular and professional usage defines labels, then one might call the period 1970–1990 a post-modern era; but I think that would be a kind of modern mistake. It would be reductive, oversimplifying many different voices, and would erase the important continuities as well as a greater global truth. Much of the world is still embedded in traditional culture. Rather, it makes sense to conceive of history as interacting multiple waves, or parallel bands or rivers that compete and go underground or perhaps re-emerge for short periods. Using this metaphor they can be considered a Darwinian evolutionary tree, but a fallen one where the branches grow sideways, or alternatively a sea of many streams (pl. 244). The advantage of an evolutionary diagram is that it allows the obvious pluralism to exist at the same time as a few big branches, the dominant species.[2]

According to this model there are always many short-wave 'isms' in the arts, the five-year fashions that keep the surface of history bubbling with life. Beneath this agitated plane are deeper medium-wave continuities that are often hidden to the participants, and then below them the more powerful, epochal movements that go deepest. In effect, these larger and deeper streams can be seen as conglomerate bands uniting the themes of the fashions and short-lived movements. Thus post-modernism, like its counterpart late Modernism, is a medium-wave trend that has recurred sporadically since the 1960s. For instance, the later work of Le Corbusier with its veiled metaphor and colourful symbolism, at Ronchamp and Chandigarh, creates the first wave of post-modernism. To cite words as proof, at this time Corb was very critical of the big juggernaut he attacked as 'superficial modernism'.

Four Post-Modern Streams

Like Frank Lloyd Wright and some others at the time, Le Corbusier consciously produced a series of icons for a post-Christian society, and backed them up with an iconography based on nature. As an artist, he constructed an iconostasis several times for the new industrial society, and explicitly coded his architecture as striking enigmas. He challenged secular societies to fathom them, if they could. The results remain some of the most powerful buildings ever produced, sculptural Temples to Nature, reproduced on French and Indian postage stamps, and loved by many. But commercial society also replicated these enigmas as roadside architecture, and petrol stations and banks soon appeared as mini-Ronchamps. The iconic building zig-zagged along for 50 years with a few notable additions to its credit such as the Sydney Opera House, yet it wasn't until Frank Gehry's highly metaphorical museum of 1997 that the Bilbao effect suddenly became global. Driven by the credit Bubble and the necessity of cities to communicate effectively in a competitive market, big commissions swelled with ambition. Restraints were jettisoned, the avant-garde given its head and even prestigious jobs. Large museums, opera houses, Olympic stadia, millennium projects – not to mention the five largest skyscrapers in the world – abruptly launched this post-modern rocket in two directions: upwards at the symbolic heavens and downwards as pretentious kitsch.

For the most part my evolutionary diagram dissociates the one-liners from the seriously good post-modern icons, those of Frank Gehry, Rem Koolhaas and Herzog & de Meuron, or the paradoxical anti-iconic icons of Peter Eisenman, which are also commendable. These shaped landmarks are all complex, are all multiple metaphors that tie-in to the building's functions and space, and all use the enigmatic signifier as did Le Corbusier. Nearly all of them explore cosmic or natural forms and this, I have argued in *The Iconic Building* (2005), is the hidden code underlying the genre. Sometimes the biomimesis is implied in the ornament; at other times the bones, tendons, birds and palm fronds are explicit, as with the work of Santiago Calatrava. But the aim of post-modernism is to find the right balance of taste cultures, high and low.

Just one of 30 iconic landmarks exemplifies the cryptic cosmic code: Rem Koolhaas' Casa da Música in Porto (pl. 245). Designed by Koolhaas with Office for Metropolitan Architecture and Arup-AFA, it won the competition for an iconic function – to become the symbol of a renewed Porto putting itself on the map through music and culture as had Bilbao, Valencia, and so many competing destinations. OMA's enigma came first not only because it solved organizational problems in a fresh way, but because of its geological metaphor. The local Portuguese press christened it 'the diamond that fell from the sky' because the crystalline facets were so transparent in the competition model. Equally PM were the juxtapositions in style, the use of local hand-painted tiles and abstract ones, eighteenth- and twenty-first-century ornament, sensuous materials such as pixellated gold leaf and Brutalist concrete, the traditional and expressionist space. All this double-coding is canonic to the post-modern paradigm.

The biggest movement after the millennium combined pattern-making and ornament, or ran them in parallel streams. Unlike the ornamentalism of the 1970s, this developed without much theory and came more directly from computer production, a new interest in materiality and the analysis of patterns in nature. Brilliant expositions by science writers Ian Stewart and Philip Ball put D'Arcy Thompson's *On Growth and Form* (1917) back on the intellectual map and two computer-architects – Greg Lynn (of FORM) and Lars Spuybroek (of NOX) – wrote about and designed compelling morphological works.

Overleaf: 244
A Sea of Many Streams, Charles Jencks's evolutionary diagram to describe pluralism

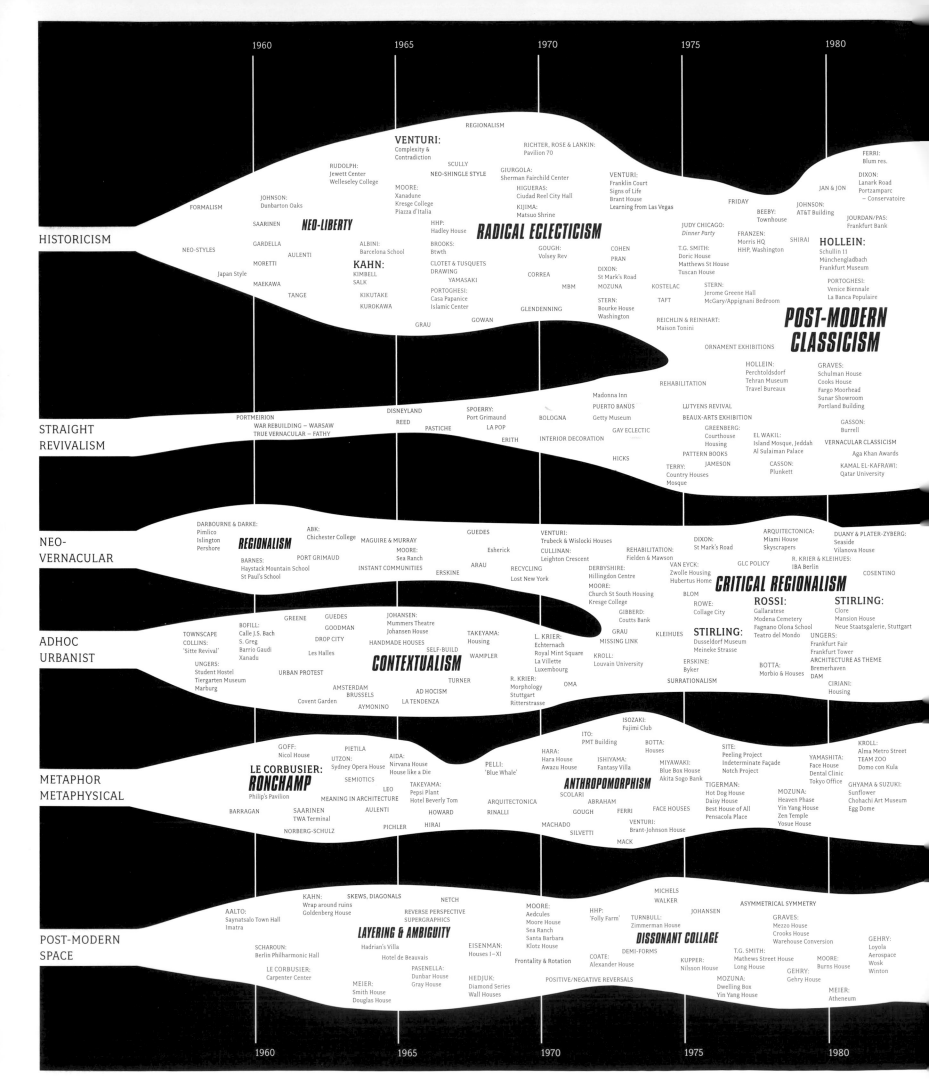

Charles Jencks — Evolutionary Tree of Post-Modern Architecture

Timeline: 1960 — 1965 — 1970 — 1975 — 1980

Left-hand categories (top to bottom): HISTORICISM · STRAIGHT REVIVALISM · NEO-VERNACULAR · ADHOC URBANIST · METAPHOR METAPHYSICAL · POST-MODERN SPACE

HISTORICISM

REGIONALISM

FORMALISM

VENTURI: Complexity & Contradiction

RUDOLPH: Jewett Center, Welleseley College

SCULLY — NEO-SHINGLE STYLE

RICHTER, ROSE & LANKIN: Pavilion 70

JOHNSON: Dunbarton Oaks

MOORE: Xanadune, Kresge College, Piazza d'Italia

GIURGOLA: Sherman Fairchild Center

HIGUERAS: Ciudad Reel City Hall

KIJIMA: Matsuo Shrine

VENTURI: Franklin Court, Signs of Life, Brant House, Learning from Las Vegas

FRIDAY

BEEBY: Townhouse

JOHNSON: AT&T Building

FERRI: Blum res.

DIXON: Lanark Road, Portzamparc – Conservatoire

JAN & JON

JOURDAN/PAS: Frankfurt Bank

SAARINEN

NEO-LIBERTY

HHP: Hadley House

RADICAL ECLECTICISM

JUDY CHICAGO: Dinner Party

FRANZEN: Morris HQ, HHP, Washington

SHIRAI

HOLLEIN: Schullin 11, Münchengladbach, Frankfurt Museum

NEO-STYLES

GARDELLA

AULENTI

MORETTI

Japan Style

ALBINI: Barcelona School

KAHN: KIMBELL, SALK

BROOKS: Btwth

CLOTET & TUSQUETS — DRAWING

YAMASAKI

GOUGH: Volsey Rev

COHEN

PRAN

T.G. SMITH: Doric House, Matthews St House, Tuscan House

PORTOGHESI: Venice Biennale, La Banca Populaire

MAEKAWA

TANGE

KIKUTAKE

KUROKAWA

PORTOGHESI: Casa Papanice, Islamic Center

CORREA

MBM

MOZUNA

KOSTELAC

TAFT

STERN: Jerome Greene Hall, McGary/Appignani Bedroom

STERN: Bourke House, Washington

REICHLIN & REINHART: Maison Tonini

POST-MODERN CLASSICISM

GRAU

GOWAN

GLENDENNING

ORNAMENT EXHIBITIONS

HOLLEIN: Perchtoldsdorf, Tehran Museum, Travel Bureaux

GRAVES: Schulman House, Cooks House, Fargo Moorhead, Sunar Showroom, Portland Building

REHABILITATION

STRAIGHT REVIVALISM

PORTMEIRION

WAR REBUILDING – WARSAW

TRUE VERNACULAR – FATHY

DISNEYLAND

REED

PASTICHE

SPOERRY: Port Grimaund

LA POP

ERITH

Madonna Inn

PUERTO BANUS

BOLOGNA

INTERIOR DECORATION

HICKS

GETTY Museum

GAY ECLECTIC

LUTYENS REVIVAL

BEAUX-ARTS EXHIBITION

GREENBERG: Courthouse, Housing

PATTERN BOOKS

TERRY: Country Houses, Mosque

JAMESON

EL WAKIL: Island Mosque, Jeddah, Al Sulaiman Palace

CASSON: Plunkett

GASSON: Burrell

VERNACULAR CLASSICISM

Aga Khan Awards

KAMAL EL-KAFRAWI: Qatar University

NEO-VERNACULAR

DARBOURNE & DARKE: Pimlico, Islington, Pershore

ABK: Chichester College

MAGUIRE & MURRAY

GUEDES

VENTURI: Trubeck & Wislocki Houses

DIXON: St Mark's Road

ARQUITECTONICA: Miami House, Skyscrapers

DUANY & PLATER-ZYBERG: Seaside, Vilanova House

REGIONALISM

BARNES: Haystack Mountain School, St Paul's School

PORT GRIMAUD

MOORE: Sea Ranch

INSTANT COMMUNITIES

Esherick

ARAU

ERSKINE

CULLINAN: Leighton Crescent

RECYCLING, Lost New York

REHABILITATION: Fielden & Mawson

DERBYSHIRE: Hillingdon Centre

MOORE: Church St South Housing, Kresge College

VAN EYCK: Zwolle Housing, Hubertus Home

GLC POLICY

R. KRIER & KLEIHUES: IBA Berlin

COSENTINO

CRITICAL REGIONALISM

BLOM

ROWE: Collage City

ROSSI: Gallaratese, Modena Cemetery, Fagnano Olona School, Teatro del Mondo

STIRLING: Clore, Mansion House, Neue Staatsgalerie, Stuttgart

GIBBERD: Coutts Bank

GRAU

MISSING LINK

KROLL: Louvain University

KLEIHUES

STIRLING: Dusseldorf Museum, Meineke Strasse

ERSKINE: Byker

SURRATIONALISM

BOTTA: Morbio & Houses

UNGERS: Frankfurt Fair, Frankfurt Tower

ARCHITECTURE AS THEME, Bremerhaven, DAM

CIRIANI: Housing

ADHOC URBANIST

TOWNSCAPE

COLLINS: 'Sitte Revival'

BOFILL: Calle J.S. Bach, S. Greg, Barrio Gaudi, Xanadu

GREENE

GUEDES

GOODMAN

DROP CITY

Les Halles

JOHANSEN: Mummers Theatre, Johansen House

HANDMADE HOUSES

SELF-BUILD

CONTEXTUALISM

TAKEYAMA: Housing

WAMPLER

L. KRIER: Echternach, Royal Mint Square, La Villette, Luxembourg

UNGERS: Student Hostel, Tiergarten Museum, Marburg

URBAN PROTEST

AMSTERDAM, BRUSSELS

Covent Garden

AYMONINO

AD HOCISM

LA TENDENZA

TURNER

R. KRIER: Morphology, Stuttgart, Ritterstrasse

OMA

METAPHOR METAPHYSICAL

ISOZAKI: Fujimi Club

ITO: PMT Building

BOTTA: Houses

SITE: Peeling Project, Indeterminate Façade, Notch Project

KROLL: Alma Metro Street, TEAM ZOO, Domo con Kula

GOFF: Nicol House

PIETILA

UTZON: Sydney Opera House

AIDA: Nirvana House, House like a Die

HARA: Hara House, Awazu House

ISHIYAMA: Fantasy Villa

YAMASHITA: Face House, Dental Clinic, Tokyo Office

LE CORBUSIER: RONCHAMP

Philip's Pavilion

SEMIOTICS

LEO

PELLI: 'Blue Whale'

MIYAWAKI: Blue Box House, Akita Sogo Bank

TIGERMAN: Hot Dog House, Daisy House, Best House of All, Pensacola Place

ANTHROPOMORPHISM

MEANING IN ARCHITECTURE

TAKEYAMA: Pepsi Plant, Hotel Beverly Tom

ARQUITECTONICA

SCOLARI

ABRAHAM

MOZUNA: Heaven Phase, Yin Yang House, Zen Temple, Yosue House

GHYAMA & SUZUKI: Sunflower, Chohachi Art Museum, Egg Dome

BARRAGAN

SAARINEN: TWA Terminal

NORBERG-SCHULZ

AULENTI

PICHLER

HOWARD

HIRAI

RINALLI

GOUGH

MACHADO

SILVETTI

FERRI

FACE HOUSES

VENTURI: Brant-Johnson House

MACK

POST-MODERN SPACE

KAHN: Wrap around ruins, Goldenberg House

SKEWS, DIAGONALS

NETCH

MICHELS

WALKER

AALTO: Saynatsalo Town Hall, Imatra

REVERSE PERSPECTIVE, SUPERGRAPHICS

MOORE: Aedcules, Moore House, Sea Ranch, Santa Barbara, Klotz House

HHP: 'Folly Farm'

TURNBULL: Zimmerman House

JOHANSEN

ASYMMETRICAL SYMMETRY

GRAVES: Mezzo House, Crooks House, Warehouse Conversion

LAYERING & AMBIGUITY

DISSONANT COLLAGE

SCHAROUN: Berlin Philharmonic Hall

Hadrian's Villa, Hotel de Beauvais

EISENMAN: Houses I–XI

Frontality & Rotation

COATE: Alexander House

DEMI-FORMS

KUPPER: Nilsson House

T.G. SMITH: Mathews Street House, Long House

MOORE: Burns House

GEHRY: Loyola, Aerospace, Wosk, Winton

LE CORBUSIER: Carpenter Center

MEIER: Smith House, Douglas House

PASENELLA: Dunbar House, Gray House

HEDJUK: Diamond Series, Wall Houses

POSITIVE/NEGATIVE REVERSALS

MOZUNA: Dwelling Box, Yin Yang House

GEHRY: Gehry House

MEIER: Atheneum

Timeline: 1960 — 1965 — 1970 — 1975 — 1980

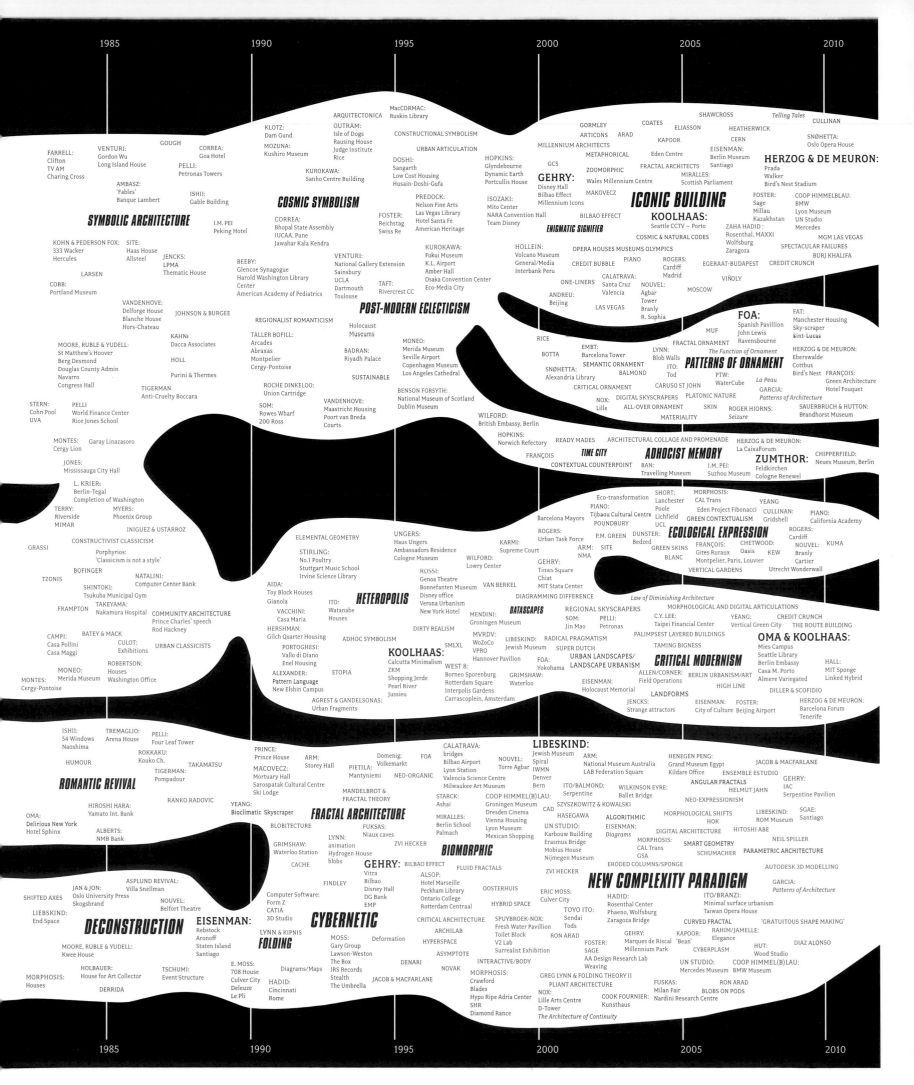

An interesting British reaction set in against the reigning neo-Modernism, as three practices went down three different ornamental routes. The group FAT (Fashion Architecture Taste) drew on Pop graphics and the ornamental amplification of sectional elements to fashion populist, working-class housing; Caruso St John adopted prefab patterns based on ornamental lace; and FOA (Foreign Office Architects) also used nineteenth-century lace patterns in an ingenious emporium for the John Lewis department store in Leicester (pl. 246). This last is probably the most accomplished example of digitized and rhythmical ornament produced to date, with a window wall that morphs into several different contexts as elegantly as any eighteenth-century *rocaille* leapt over the surfaces. A partner of FOA, Farshid Moussavi, also edited two important texts of equal elegance, *The Function of Ornament* (2006) and *The Function of Form* (2009). The two sides to this movement were split between the digital functionalists and the semantic formalists, FOA and NOX versus FAT and the Frenchman Edouard François. But frankly the real story was that global architecture had, by 2005, gone ornamental. And Herzog & de Meuron of all people (former minimalists) had mastered both sides of the split!

One feels competitive change in the air, one senses it through the implosions of my diagram where practises vie for disputed territory, and the story becomes much too complex to tell here in anything more than telegraphese. But note the agitation. Modernists like Shigeru Ban construct adhocist theatres from old shipping containers; David Chipperfield also jumps out of minimalism with his Berlin Neues Museum, stitching together ruins and new fabric in a patchwork of context design; I.M. Pei and Peter Zumthor leave their abstraction to knit together old parts of China and Germany; Norman Foster, the high-tech modernist, also veers toward contextualism in Berlin and becomes a vernacular town planner in the Middle East. 'Frenetic Credit Bubble Creates Musical Chairs,' reads the headline. 'All Change Place'.

Some of this agitation is part of what I have called critical Modernism, in a 2007 book of that name, that is, the continuation of the post-modern critique of erasing memory and not acknowledging the catastrophes of modernization and modernity. Not surprisingly the devastated city of Berlin is where this critical spirit has gone the furthest. This can be seen in the countless works and memorials devoted to catastrophe and in the indexical art mandated to deal with it. Peter Eisenman's Memorial to the Murdered Jews of Europe (2005) typifies the best work, an indexical and iconic marking of tombstones as a chaotic field (pl. 247). The fact that this mesmerizing field was hotly debated in the Reichstag, right next to which it sits (or sprawls), and that this debate liberated the critical temperament of the city is the telling point. Like Barcelona in 1992, one could say that a whole urban culture was coming to terms with the spirit of post-modernism. The plurality of voices, and styles, just underscored the point.

No discussion of post-modernism can leave out its key idea, and visual trope: complexity. From Jane Jacobs and Robert Venturi in the 1960s to the Santa Fe Institute in the 1980s to the New Paradigm in Architecture of the year 2000, complexity theory grew into an underlying assumption of the time. It

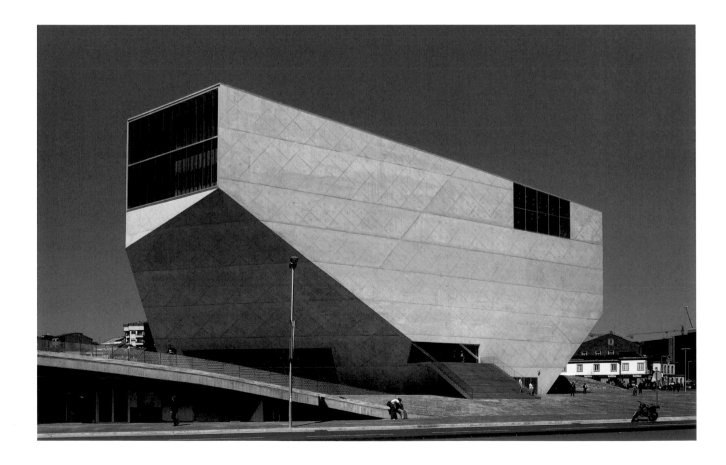

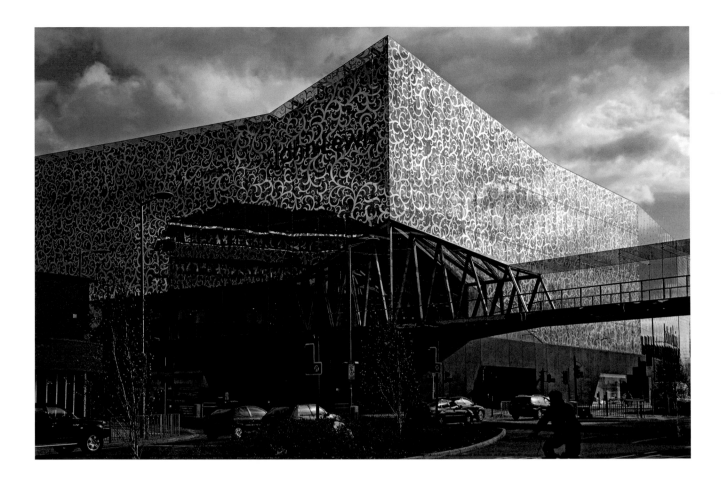

246
Foreign Office Architects,
John Lewis Department Store,
Cineplex and pedestrian
bridges, 2008. Leicester.
Photograph by Peter Jeffree

underpinned biology, chaos theory, weather prediction, stock market analysis, cosmology, fractals, morphology, quantum computing and most of the sciences in between. Again, like 'post-modern', it had a series of aliases that disguised its common identity, probably to everybody's benefit. Architects, at least, could group under about 20 digital labels, each banner more exotic than the last — emergence, folding, cyberspace, scripting, parametric, hypersurface, algorithmic, neoplasmatic, blobitecture, etc. Or, more prosaically, CAD: computer-aided design. With verbal inflation following the economic Bubble, the different labels didn't matter so much; they were a kind of decorative logo-ornament or (to detractors) logorrhoea. But, if one could listen beneath the cacophony, the sound of the complexity paradigm could be discerned, the one that was overturning the modern sciences of simplicity. For, as the Santa Fe Institute predicted, 'the non-linear sciences will be those of the 21st century', and they *did* sublate the previous ones on which modernism rested: that is, Newtonian physics, Darwinian biology and deterministic systems of all kinds.

The complex science of deterministic chaos, for instance, overturned the prevailing view that most systems are linear. Instead, very simple algorithms could generate very complex and indeterminant results, as demonstrated by the most famous fractal of all, the Mandelbrot Set. This simple formula with feedback, $Z=Z^2 + C$, generates infinite complexity, spiky-blobs all the way down and all the way up, forever. Likewise, the algorithmic generation of London's Serpentine Pavilion, by Toyo Ito and Cecil Balmond (2002), was based ironically on the ultimate modernist simplicity: the white square (pl. 248). This unit is rotated and expanded by an algorithm, creating rich complexity in the whole and all its related parts. If Mies van der Rohe's Barcelona Pavilion summarized modern architecture in 1929, then this dancing fractal epitomized post-modernism in 2002, the coming of age of complexity theory.

To argue that these four strands are really post-modern brings me back to the primary question about the way historians classify a period. Many people will understand the continuities of complexity, and themes, from the 1960s to the present; and just as many will assert that they belong to disparate traditions. As Terry Farrell said in the mid-1990s, 'everyone is now a post-modernist' — which, perhaps, can be restated more accurately. Every modernist went 'post' on Tuesday, Thursday and Saturday, but left the main days of the week for orthodoxy. While modernism ruled the waves, the hidden PM streams bubbled along quite happily under the surface, coming of age when no one was looking.

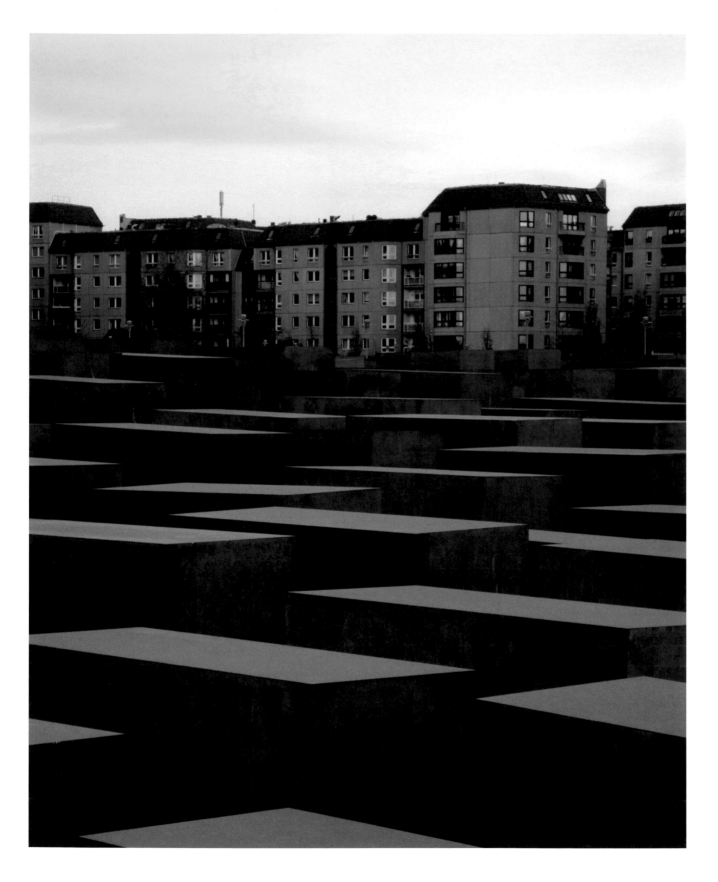

Paul Greenhalgh

THE END OF STYLE?

As the dust begins to settle on the hyperactive site that was postmodernism in the visual arts, we realize that underlying what seemed to be an unfathomable complexity of well-referenced things – all those pinks, laminates, bronze inflatables, ruffs, columns, leopard skins, pottery rock stars, and ironically-piled-up installations – and all that impassioned shouting and writing, there was actually a single core issue connecting much of it: style (pl. 249).

There is no doubt that this apparent rupture in the fabric of modernity was caused to an important degree by intellectual developments that began in the later 1960s. But the reality of postmodernism came later, in a kind of delayed reaction that hit the studio and the street in the 1980s. Personal recollections, objective retrospective analysis of the whole period, and indeed the balance of material in this exhibition all confirm the fact that the 1980s was *the* postmodern decade.

This is especially true in terms of both the academic and the public sphere. It was in the 1980s that widespread debate became the norm, and defenders of the old canon sat angry and mumbling in darkened lecture halls, as the new Italians, Americans and Germans flashed up on the screen. Faculty lounges were full of shouted debates about Schnabel, Immendorf, Sottsass and Slee. But it all went much further than a new or previously unrecognized generation of high practitioners. People wrote supportive and indignant manifestos about the intellectual standing of figurines, pinstripes, tiaras and napkins. It was as though everything that had been denied the right to seriousness in the visual arts for 60 years was fighting for – and winning – space. We all confidently celebrated our lack of confidence about things: suddenly, it seemed, none of us now knew exactly what was beautiful or everlasting; or if we thought we did, none of us was prepared to say so. Ultimately more telling than the plethora of professional activity, of course, was the mass dissemination of actual products onto the scene, and the wide recognition that these were to do with a new movement.

At the time, postmodernism really didn't feel merely like a new twist on the existing state of things, or a stir caused by the rantings of another generation of young turks (we discovered later that most of the key ranters were anything but young). It was palpable and it felt like a revolt, or perhaps like a reformation (or counter-reformation), like a quasi-religious war; and indeed it was, with all the implications of that phrase. Leaving the self-imposed air of superficiality to one side, profound questions were constantly asked. It all remained confident and robust well into the 1990s, before stalling a few years short of the millennium. It has been over for some time now, though unlike Charles Jencks' famous pinpointing of the exact moment of the death of Modernism, there didn't seem to be an exact moment of demise (either then or retrospectively) for postmodernism. It wasn't blown up: it just went to sleep and didn't wake up.

The sense of revolt, I think, came from the destabilization of the established idea of style. In fact, the whole cacophony was to do with style. Postmodernism was a grand debate about the role of style in the world: about its function, significance and its ability to wield power. Style had been the glue that held the Western visual tradition together, the underlying essence that gave substance and direction to the Western continuum. We had carved up our history into styles; style was our signifier of civilization, and here we were, opposing the latest stylistic legitimacy, the virtually *inevitable* International Style, with stacks of tartan and Formica. The hegemonic logic that tied the Parthenon to the Villa Savoye was being challenged, and suddenly it looked far less logical than it did before.

The International Style had blanketed the planet far more completely than Roman columns had ever covered Europe and the Near East, presenting a Western vision of life – apparently without choice or alternatives – to millions. Postmodernism was a challenge to that, and to the underlying intellectual ethos that had made it possible. Postmodernists aimed to generate variegation, complexity, difference and resistance to the reductive, specialized logic of the age of progress, and the (literally) mindless advance of modernization. In many respects, this struggle for style had grand precedents: the debates around neoclassicism, the search for style in the high Victorian period, or the reformist zeal of the *fin de siècle*. Like these, it was a debate about the social, economic, political and aesthetic role of style in modern society. As such, and as many thinkers at the time and since have commented (a number of them in this volume), postmodernism was not 'post' at all, but was very much part of the ongoing struggle inside the parameters of Modernism.

The questions we now face are these: was the postmodern debate the last possible one within the modernist canon to be able to deal with style, and did it bring to an end a phase of modernity? I think the answer in both cases is yes. The postmodern debate was the last grand style debate, and perhaps it was the last possible historical moment at which style could command such scale of meaning and significance.

Style is to do with communication. It simultaneously unites a community, and differentiates one community from another; it divides us into periods, separates the young from the old, and the formal from the informal. For centuries, thinkers have concurred that style is the means by which a culture recognizes itself.

The duration and spread of a style relates directly to the speed of communication at the time. The Modern Age saw radical developments in communication; consequently, there was an increased speed at which styles emerged, succeeded, disseminated and disappeared. Perhaps the proponents of Art Nouveau were the first modernists to self-consciously and aggressively use advertising, mass-marketing and mass-retail outlets. At the time, critics saw its sheer speed as being antithetical to the notion of style. It lasted a mere 17 years or so.

To crudely sum up the work of many thinkers of the last two centuries, styles come into existence in one of two ways: they either emerge organically, or they are consciously invented. They are either 'natural', or they are 'artificial'. This duality across the visual arts was pronounced through the modern period, from the early Enlightenment onward, and has been characterized by a number of oppositions: anthropological /ideological, authentic/inauthentic, vernacular/cosmopolitan.

The International Style was *the* quintessentially 'invented' and 'ideological' style. It was so successful that it lasted longer than any other style in the Modern Age, and almost made the

utopian shift of moving from being an artificial to a natural style. Almost; but not quite. Ubiquity is not enough to naturalize a style: it needs also to be routinely embraced by the masses, and it never was. Nevertheless, it was so powerfully embedded in the cultural and economic power structure of the Western world that it proliferated via ever-developing communications systems, rather than falling victim to them. It staved off, for a remarkably long period, the inevitable cycle of decline that finishes all styles after their dissemination.

During the 1980s, mass-communications systems began to change once again. It was the age in which the personal computer and the Internet appeared, and the cell phone gained real ground, accelerating the move toward ubiquitous, instantaneous and personalized contact. It took time for these developments to transform us. Many of us acquired our first home computers in the mid-to-late 1980s, but for the most part we used them for typing and playing games. The Internet only began to pick up speed, and gain global reach, in the 1990s. Communications were faster in the 1980s, but mechanically things were still substantially the same as they had been in previous decades. In other words, in terms of cultural impact, the 1980s were the last moment of a previous age of communications systems. The style debate was souped-up, frenetic even, but it remained largely within the parameters of that older, modern world. Postmodernism heralded the complexity and fragmentation of the global environment, but it understood these things in terms of largely pre-Internet conditions. Metaphorically speaking, postmodernism reigned through the last gasp of steam power before oil took over.

By the 1990s, however, we came to enjoy a level of communication that had never previously existed. In ever-increasing numbers we can talk to everybody, anytime, anywhere, and know what they are up to. Indeed, most of us get nervous when we are too far away from email and Internet access, or when our cell phones are switched off. It is telling, I think, that the style debate associated with postmodernism lost shape and meaning as communications sped through the 1990s. More interestingly still, as communication moves toward absolute instantaneity, the 'natural' and the 'artificial' notions of style increasingly collapse into one another.

The idea that one can have a natural, vernacular style (whether rural or urban, mechanized or handmade, in the developed or undeveloped world) that has grown organically, through a distinct ethnic community, has been diminished well beyond the impoverished state it was in already. Also, the idea that an artificial style can be developed, debated, ideologically charged, and then steadily introduced to successive communities, likewise no longer sits well in the world. In fact, the very idea of natural and artificial styles has effectively ceased to exist: increasingly, we inhabit a world in which a single, homogenous but spectacularly fragmented idiom dominates all our production, a kind of universal, disparate vernacular, in which imagery flashes up and disappears with increasing rapidity. Style is now dislocated from the social, economic and political power that gave it meaning through the Modern Age.

Perhaps postmodernism will prove to be the last great intellectual struggle committed to the idea of style as a vehicle for modernity, and a signifier of civilization. The next phase of modernity has begun, and we can already see that it has nothing to do with style.

Opposite: 249
Jenny Holzer, *Protect Me From What I Want*, from *Survival*, 1983–5. Times Square, New York, 1985 © 2011 Jenny Holzer, member Artists Rights Society (ARS), NY / DACS, London. Photograph by John Marchael

David Byrne

POST-SCRIPT

My daughter recently asked, 'If modern is now past, and postmodern is almost past, what will the era we're in now be called?' My immediate thought was that contemporary will eventually come to mean a specific time period and/or approach – in which case we will eventually have post-contemporary. Literally that will mean that the post-contemporary work will be made before we get there. The mind boggles.

I never understood why postmodernism had to define itself in the negative – to not say what it aspires to be, but rather what it is not. I have seen my name linked with postmodernism more than once, though I was never sure what it meant. I did know that like many others I was indoctrinated with Modernism in art school and elsewhere (museums usually); but also like many others I felt it had both strayed from its idealistic origins and had become codified, strict, puritanical and dogmatic. I could go on and on, but as one who was briefly a believer I was sadly disillusioned, as only the formerly faithful can be. Besides, as lovely as it is, most modern furniture is often cruelly uncomfortable.

If postmodernism means anything is allowed, then I was all for it. Finally! The buildings often didn't get much more beautiful or the furniture more comfortable, but at least we weren't handed a rule book. Things could be mixed and matched – or mashed up as is said today – and anything was fair game as inspiration. That to me seemed as it should be. A taste of freedom. At least that's the way I took it, though one could see another rule book being written even as we tried to say 'No more damn rule books!' Before too long there was, according to some, a postmodernist look. Time to move on.

250
David Byrne, 1983

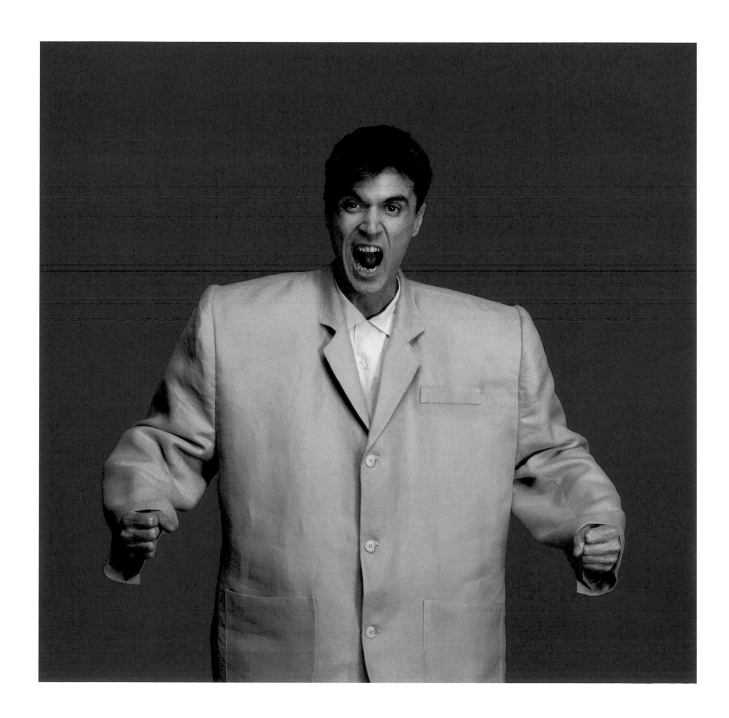

REFERENCES

Preface

1 Grace Lees-Maffei, 'Italianitá and Internationalism: the design, production and marketing of Alessi s.p.a.', *Modern Italy* 7/1 (2002), pp. 37–57; Javier Gimeno Martínez and Jasmijn Verlinden, 'From Museum of Decorative Arts to Design Museum: The Case of the Design Museum Gent', *Design and Culture* 2/3 (November 2010), pp. 259–82.

2 Paul Greenhalgh (ed.), *Art Nouveau: 1890–1914* (London: 2000); Charlotte Benton, Tim Benton and Ghislaine Wood (eds), *Art Deco: 1910–1939* (London: 2003); Christopher Wilk (ed.), *Modernism: Designing a New World* (London: 2006).

3 For a historiography of these two terms, see Perry Anderson, *The Origins of Postmodernity* (London: 1998).

4 David Harvey, *The Condition of Postmodernity* (Oxford: 1990).

5 Louis Menand, 'Saved From Drowning: Barthelme Reconsidered', *The New Yorker* (23 February 2009), p. 68.

Postmodernism: Style and Subversion
Glenn Adamson and Jane Pavitt

1 Talking Heads, 'Once in a Lifetime', from the album *Remain in Light* (Sire Records, 1981).

2 Hal Foster (ed.), *Postmodern Culture* (London: 1985), p. vii.

3 Architectural postmodernism also benefited from a lively publishing culture in the 1970s and 80s, which supported its proliferation. Influential journals like *Perspecta* (Yale University, USA) and *Domus* (Italy) spread the word, and a mini publishing empire was founded on postmodernism by Greek-Cypriot, UK-based publisher Andreas Papadakis, the owner of Academy Editions, who brought Charles Jencks' *The Language of Post-Modern Architecture* to public attention in 1977 and then ran an eclectic stable of featured architects from Léon Krier to Daniel Libeskind through the next decade.

4 Reinhold Martin, *Utopia's Ghost: Architecture and Postmodernism, Again* (Minneapolis, MN: 2010), p. xii.

5 In *Postmodernism, or, The Cultural Logic of Late Capitalism* (Durham, NC: 1991), Fredric Jameson states: 'It was indeed from architectural debates that my own conception of postmodernism … initially began to emerge.' (p. 2).

6 Bret Easton Ellis, *American Psycho* (New York: 1991), p. 24.

7 Charles Jencks, *The Language of Post-Modern Architecture* (London: 1984; orig. pub. 1977), p. 9.

8 Jencks, *The Language of Post-Modern Architecture*, p. 9. See also Andreas Huyssen, 'Mapping the Postmodern', in *New German Critique* 33 (Fall 1984), pp. 5–52.

9 Alessandro Mendini, *Casabella* 391 (July 1974), p. 5.

10 See, for example, Charles Moore, 'Plug it in Rameses, and see if it lights up, because we aren't going to keep it unless it works', first published in *Perspecta* 11 (1967); and Robert Venturi, Denise Scott Brown and Steven Izenour, *Learning From Las Vegas* (Cambridge, MA and London: 1972), both of which attack Archigram's work specifically for its misguided technological determinants.

11 Jean Baudrillard (*Utopie*), 'Utopia e/o Rivoluzione' (Turin: 1969), p. 34, quoted in Sarah Deyong, 'Memories of the Urban Future: The Rise and Fall of the Megastructure', in *The Changing Face of the Avant-Garde: Visionary Architectural Drawings from the Howard Gilman Collection* (New York: 2002), p. 29.

12 David Crowley, 'Spaceship Earth', in David Crowley and Jane Pavitt (eds), *Cold War Modern: Design 1945–1970* (London: 2008).

13 Akira Asada, 'Beginning from an Ending, In Place of an Introduction', in *Arata Isozaki: Works 30, Architectural Models, Prints and Drawings* (Tokyo: 1992), p. 12.

14 Martin, *Utopia's Ghost*, p. xiv.

15 Bruno Zevi, 'Pluralismo e pop-architettura', *L'architettura* 143 (September 1967), p. 283.

16 Robert Venturi, *Complexity and Contradiction in Architecture* (New York: 1966).

17 Venturi, Scott Brown and Izenour, *Learning From Las Vegas*.

18 Rudolf Wittkower, *Architectural Principles in an Age of Humanism* (London: 1949); Colin Rowe, 'The Mathematics of the Ideal Villa: Palladio and Le Corbusier compared', first published in *Architectural Review* 101, March 1947.

19 Moore, 'Plug it in, Rameses', reprinted in Kevin Keim (ed.), *You Have to Pay for the Public Life: Selected Essays of Charles W. Moore* (Cambridge, MA: 2001), pp. 32–43.

20 Umberto Eco, 'Travels in Hyperreality' (1975), in Eco, *Travels in Hyperreality: Essays* (Orlando, FL: 1986), p. 24.

21 Moore, 'Plug it in, Rameses', pp. 32–43.

22 Gillo Dorfles, *Kitsch: The World of Bad Taste* (New York: 1968).

23 Charles Moore, 'You Have to Pay for the Public Life', *Perspecta* 9 (1965), in Keim (ed.), *You Have to Pay for the Public Life*, p. 126.

24 For more on Las Vegas and the formation of postmodernism, see Marianne DeKoven, *Utopia Limited: The Sixties and the Emergence of the Postmodern* (Durham, NC: 2004).

25 Herbert Gans, *The Levittowners: Ways of Life and Politics in a New Suburban Community* (New York: 1982; orig. pub. 1967).

26 Denise Scott Brown, 'Invention and Tradition', first published in David G. de Long, Helen Searing and Robert A.M. Stern (eds), *American Architecture: Innovation and Tradition* (New York: 1986); reprinted in Denise Scott Brown, *Having Words* (London: 2009), p. 14.

27 See Aron Vinegar and Michael Golec, *Relearning from Las Vegas* (Minneapolis, MN: 2008), p. 38. Scott Brown is quoted in Lynn Gilbert and Galen Moore, *Particular Passions: Talks with Women Who Have Shaped Our Times* (New York: 1981), p. 310.

28 Peter Blake, *God's Own Junkyard: The Planned Deterioration of America's Landscape* (New York: 1963).

29 Venturi, *Complexity and Contradiction in Architecture*, p. 104.

30 See Fernanda Pivano (ed.), *Poesia Degli Ultimi Americani* (Milan: 1964).

31 Barbara Radice, *Ettore Sottsass: A Critical Biography* (London: 1993), pp. 62–5.

32 On Sottsass' return to Italy, the *Room East 128 Chronicle* was revived as the shortlived magazine *Pianeta Fresco* ('Fresh Planet' – a Beat term for ecological consciousness), which continued, briefly, to promote the varied interests of psychedelia, anti-war sentiment and the embrace of the sensual to an emergent Italian counter-culture.

33 In Bruno Bischofberger (ed.), *Ettore Sottsass: Ceramics* (London: 1995), p. 86.

34 Paolo Thea, 'Arte Povera as Operation', in *Verso L'Arte Povera, Momenti e aspetti degli anni sessanta in Italia* (Milan: 1989), p. 39.

35 Quoted in Andrea Branzi, *The Hot House: Italian New Wave Design* (London: 1984), p. 55.

36 Alessandro Mendini, 'L'Arca: Breve saggio di filosofia e di etica dell'arte', *Casabella* 411 (1976), p. 59.

37 The writings of Global Tools members are mostly to be found in the pages of *Casabella*; for a description of the launch of the group, see *Casabella* 377 (1973).

38 Manfredo Tafuri, *Architecture and Utopia: Design and Capitalist Development*, trans. Barbara Luigia La Penta (Cambridge, MA: 1976), quoted in Charles Jencks and Karl Kropf, *Theories and Manifestos of Contemporary Architecture*, 2nd edn (Chichester: 1997), pp. 244–5.

39 Tafuri, *Architecture and Utopia*, pp. 141–2, quoted in Felicity Scott, *Architecture or Techno-Utopia: Politics After Modernism* (Cambridge, MA: 2007), pp. 59–60, 138.

40 Ettore Sottsass Jr, 'C'e un posto dover provare?', *Casabella* 337 (1973), p. 7.

41 Sottsass in conversation with Giamperiero Bosoni, in *Modo Italiano*, exh. cat. (Montreal: 2006), p. 331.

42 Manfredo Tafuri, 'The Ashes of Jefferson', in *The Sphere and the Labyrinth: Avant-Gardes and Architecture from Piranesi to the 19th century* (Cambridge: 1997), p. 298, quoted in Scott, 'Architecture or Techno-Utopia', *Grey Room*, no.3 (Spring 2001), p. 114.

43 Jürgen Habermas, 'Modernity – An Incomplete Project', in Foster, *Postmodern Culture*, p. 3. Habermas' paper was first presented as a talk in

September 1980 in Frankfurt, on the occasion of his award of the Adorno Prize.

44 Rowe, 'The Mathematics of the Ideal Villa'; Vincent Scully, 'Archetype and Order in Recent America Architecture', *Art in America* 42 (December 1954), pp. 250–61, on Mies and the Greek temple.

45 See Neil Levine (ed.), *Vincent Scully: Modern Architecture and Other Essays* (Princeton, NJ: 2002), pp. 21–2.

46 Scott, *Architecture or Techno-Utopia*, pp. 59–60.

47 Robert A.M. Stern, 'Gray Architecture as Postmodernism, or, Up and Down from Orthodoxy' (1976), reprinted in Cynthia Davidson, *Robert A.M. Stern: Architecture on the Edge of Postmodernism, Collected Essays 1965–1988* (New Haven, CT: 2009), p. 39.

48 Colin Rowe, Foreword, in *Rob Krier: Urban Space* (London: 1979).

49 Jorge Otero-Pailos, *Architecture's Historical Turn: Phenomenology and the Rise of the Postmodern* (Minneapolis, MN: 2010).

50 Robert Venturi, exhibition statement for *Roma Interrotta* [*Rome Interrupted*] (published as leaflet), Rome, 1978.

51 Aldo Rossi, *The Architecture of the City*, trans. Diane Ghirardo and Joan Ockman (Cambridge, MA: 1982), p. 21.

52 Ibid., p. 27.

53 Martin, *Utopia's Ghost*, p. 157.

54 *Giulio Paolini*, exhib. cat. Staatsgalerie (Stuttgart: 1986).

55 Heinrich Klotz, *The History of Postmodern Architecture*, trans. Radka Donnell (Cambridge, MA: 1988; orig. pub. 1984), p. 130.

56 Arata Isozaki, 'Of City, Nation and Style' (1984), reprinted in Ken Tadashi Oshima, *Arata Isozaki* (London: 2009), p. 107.

57 Ricardo Bofill, in *Ricardo Bofill Taller de Arquitectura*, GA Architect 4 (Tokyo: 1985), pp. 120–1.

58 Charles Jencks and Nathan Silver, *Adhocism: The Case for Improvisation* (London: 1972), p. 115.

59 Leo Steinberg, 'The Flatbed Picture Plane', from *Other Criteria: Confrontations with Twentieth Century Art* (Chicago: 2007; orig. pub. 1972).

60 Douglas Crimp, 'On the Museum's Ruins', *October* 13 (Summer 1980), p. 56.

61 Theodor Adorno, *Aesthetic Theory*, trans. Robert Hullot-Kentor (Minneapolis, MN: 1997), p. 155.

62 For a full description of the building, see Charles Jencks, *Symbolic Architecture* (London: 1985), pp. 37–53.

63 Klotz, *The History of Postmodern Architecture*, p. 398.

64 Peter Selz, *Funk* (Berkeley, CA: 1967); Judith Schwartz et al., *Richard Shaw: New Work*, exhib. cat. Braunstein Quay Gallery (San Francisco: 2007); Martha Drexler Lynn, *The Clay Art of Adrian Saxe*,

exhib. cat. Los Angeles County Museum of Art (Los Angeles: 1994); Ursula Neumann (ed.), *Made in Oakland*, exhib. cat. Oakland Museum and American Craft Museum (Oakland and New York: 2001).

65 Robert Hewison, *Future Tense, a New Art for the Nineties* (London: 1990), p. 103.

66 Roland Barthes, 'The Death of the Author' (1967), reprinted in *Image Music Text* (London: 1978), pp. 142–8; Michel Foucault, 'What Is An Author?' (1969), in Donald F. Bouchard and Sherry Simon, *Language, Counter-Memory, Practice* (Ithaca, NY: 1977).

67 Jean-François Lyotard, *The Postmodern Condition: A Report on Knowledge* (Minneapolis, MN: 1984; orig. pub. 1979).

68 See Jane Pavitt in Crowley and Pavitt (eds) *Cold War Modern*, pp. 117–19.

69 See Barbara Lehmann, 'Bracciodiferro: The Reconnoitring Workshop', in Giampiero Bosoni (ed.), *Made in Cassina* (Milan: 2008). Alessandro Mendini and Gaetano Pesce were the key collaborators in this project.

70 Jean Baudrillard, *Symbolic Exchange and Death* (London: 1993; orig. pub. 1976), pp. 71–2.

71 Deyan Sudjic, *Ron Arad: Restless Furniture*, *Blueprint* monograph (1989), p. 44.

72 A phrase used by the UK post-punk band Orange Juice, on their 1983 track of that title.

73 Nigel Coates, 'Brief Encounter', in Iain Borden, Joe Kerr, Jane Rendell with Alicia Pivaro (eds), *The Unknown City: Contesting Architecture and Social Space* (Cambridge, MA: 2002), p. 317.

74 Nigel Coates, 'Ghetto and Globe', *NATØ* 1 (1983), p. 11.

75 Moore, 'Plug it in Rameses', p. 153.

76 Syd Mead quoted in Neville Wakefield, *Postmodernism: The Twilight of the Real* (London: 1990). See also Giuliana Bruno, 'Ramble City: Postmodernism and Bladerunner', *October* 41 (Summer 1987), pp. 61–74.

77 Derek Jarman, *The Last of England* (London: 1987), p. 235.

78 Radice, *Ettore Sottsass*, p. 216.

79 Alessandro Mendini, 'The Alchimia Manifesto', in Kazuko Sato, *Alchimia: Never-Ending Italian Design* (Tokyo: 1985).

80 Radice, *Ettore Sottsass*, p. 212.

81 Quoted in Branzi, *The Hot House*, p. 144.

82 Museo Alessi, *Design Interviews: Alessandro Mendini*, dir. Francesca Appiani (Verona: 2007).

83 Alessandro Mendini, *Il Mobile Infinito*, Studio Alchymia press release (1981). The authors thank Peter Shire for this document.

84 Quoted in C. Donna, 'Un Designer Gentile', *Zoom* 2 (1980). See also Thimo de Duits, *The Origins of Things: Sketches, Models, Prototypes* (Rotterdam: 2003), pp. 186–7.

85 For more on Thun, see Volker Fischer, *Design Now: Industry or Art?* (Munich: 1989; orig. pub. in German, 1988), p. 207.

86 Poul ter Hofstede, *Memphis: 1981–1988*, exhib. cat. Groningen Museum (Groningen: 1989), p. 18.

87 Cibic performed a similar role for Sottsass Associati in their commissions for Esprit and Fiorucci shop interiors. Though now an accomplished designer in his own right, in retrospect he is amazed at the amount of responsibility he took on: 'If I had someone like I was then working for me today, I'd be scared . . . [I was] not a real professional at all.' Authors' interview with Aldo Cibic, 9 March 2010.

88 Authors' interview with George Sowden, 22 February 2010. See also Andrea Branzi, 'The Decorative Revolution', in *George Sowden: Designing 1970–1990* (Bordeaux: 1999).

89 Authors' interview with Martine Bedin, 25 February 2010. See also Christine Colin et al., *Martine Bedin: Prova d'Autore*, exhib. cat. Musée des Arts Décoratifs Bordeaux (Bordeaux: 2003).

90 Interview with Peter Shire, *Wet* 5 (February 1977), p. 30. Sottsass knew of *Wet* through Barbara Radice, who had done interviews for the magazine.

91 Barbara Radice, *Memphis: Research, Experiences, Results, Failures and Successes of New Design* (London: 1984), p. 122.

92 Sottsass downplayed the importance of titling in Memphis: 'I chose names of Greek girls, Greek prostitutes, or names of hotels like the Excelsior, names of trees, fruits, salads, names are just fun – not to be taken too seriously.' Sottsass, interviewed by Emily Zaiden, in Ronald T. Labaco, *Ettore Sottsass: Architect and Designer* (New York: 2006), p. 109.

93 Ettore Sottsass, 'Ettore Sottsass Interviewed', *Memphis '82* (Milan: 1982), n.p.; reprinted as 'The Situation is Different', *Design* 408 (December 1982), pp. 38–9.

94 Radice, *Ettore Sottsass*, p. 216. For a consideration of this issue of continuity, see Penny Sparke, 'Ettore Sottsass, A Modern Designer', in Labaco, *Ettore Sottsass*.

95 Authors' interview with Peter Shire, 23 August 2009.

96 Among the other artists who showed at the gallery were Michele Oka Doner, Dan Friedman, James Hong and Elizabeth Browning Jackson. See also Barbara Jepson, 'Art Furniture', *American Craft* 45/5 (October/November 1985), pp. 10–17; and Denise Domergue, *Artists Design Furniture* (New York: 1984).

97 Authors' interview with Rick Kaufmann, 25 February 2010.

98 Others included Michael Steinberg's Furniture of the 20th Century in NYC; Laurie Park's Grace Design in Texas; Dan Friedlander's Limn Gallery in San Francisco; Barry Berzac's City Gallery in Chicago; Ron Gawith's Current Gallery in Seattle; Dwight and Rosemarie Reum's Mossa Center in St Louis; and Joe and Janet Schiavo's OLC in Philadelphia. Artemide also continued to distribute Memphis furniture in America until 1985, when it ceded it to Urban Architecture. Authors' interview with Keith Johnson, 8 April 2010; we would like to express particular thanks to Mr Johnson for supporting our research.

99 Sottsass, 'Ettore Sottsass Interviewed'. As Charles Jencks had already noticed, the phrase New International Style 'immediately implies a subsequent demise'. Jencks, 'The New International Style', *Domus* 623 (December 1981), pp. 41–7: 44.

100 'Memphis Stirs Things Up In London', *Design* 410 (1983), p. 5.

101 Authors' interview with Martine Bedin, 25 February 2010.

102 Alessandro Mendini, 'Buying is an Act of Styling', *Domus* 633 (November 1982), p. 1.

103 Grace Jones, 'Fame', from the album *Fame* (Stryx, 1978).

104 *Blade Runner*, dir. Ridley Scott (1982).

105 Judith Butler, *Gender Trouble: Feminism and the Subversion of Identity* (New York: 1990); Donna Haraway, 'A Manifesto for Cyborgs' (1985), reprinted in Haraway, *Simians, Cyborgs, and Women: The Reinvention of Nature* (New York: 1991), p. 150.

106 See Catharine Rossi, 'Furniture, Feminism and the Feminine: Women Designers in Post-war Italy, 1945 to 1970', *Journal of Design History* 22/3 (2009), pp. 243–57; Denise Scott Brown, 'Sexism and the Star System in Architecture' (1989), reprinted in *Having Words*.

107 Kate Linker, 'On Artificiality', *Flash Art* 111 (March 1983), pp. 33–5: 35.

108 Larry McCaffery, 'White Noise/White Heat: The Postmodern Turn in Rock Music', *American Book Review* 12:1 (March/April 1990); reprinted in McCaffery, *Avant Pop: Critical Essays, Collaborations with and Commentaries on Postmodern American Literature and Popular Culture* (Tokyo: 1995). See also McCaffery's later comments on the essay at: www.spinelessbooks.com/whitenoise/index.html (July 2010).

109 Jean-François Lyotard, 'Note on the Meaning of Post-', *The Postmodern Explained: Correspondence 1982–85* (Minneapolis, MN: 1992), pp. 64–8: 67.

110 Guy Debord, *La Société du Spectacle* (Paris: 1967).

111 Rosetta Brooks, 'Blitz Culture', *ZG*, no.1 (1981), pp. 3–4: 3.

112 Alvin Toffler, *Future Shock* (London: 1970), pp. 273–4.

113 Dick Hebdige, *Subculture: The Meaning of Style* (London: 1979). This understanding was rapidly disseminated via the fringe press; already in 1980, *i-D* magazine declared, 'Face facts: all sub-cult visual codes have now been well and truly CRACKED.' Steve Dixon, 'King Codes', *i-D* 13 (1980), p. 6.

114 For an overview, see David Muggleton and Rupert Weinzierl, *The Post-Subcultures Reader* (Oxford: 2003).

115 Tricia Rose, *Black Noise: Rap Music and Black Culture in Contemporary America* (Hannover: 1994), p. 39.

116 Madonna, 'Vogue', from the album *I'm Breathless* (Sire Records, 1990).

117 Tim Lawrence, *Love Saves the Day: A History of American Dance Culture, 1970–1979* (Durham, NC: 2003), p. 46. See also the 1990 documentary *Paris is Burning*, directed by Jennie Livingston.

118 Visage, 'Fade to Grey', from the album *Fade to Grey* (Polydor, 1980).

119 Fredric Jameson, in his early work on mediation, defined the term as the act of making a text at one level of culture 'symbolically identical' to another. He further argued that the shift of concern from 'how a text means' to 'how a text works' creates 'an *interference* between levels, [a] subversion of one level by another'. Jameson, *The Political Unconscious: Narrative as a Socially Symbolic Act* (Ithaca: 1981), pp. 40, 56, 108.

120 Gerald Casale, email to authors, 6 October 2010.

121 On the concept of the post-human, see Steven Best and Douglas Kellner, *The Postmodern Adventure: Science, Technology and Cultural Studies at the Third Millenium* (New York: 2001), p. 187ff.

122 Pascal Bussy, *Kraftwerk: Man Machine and Music* (Wembley: 1993), p. 26. See also Brian Eno, 'The Studio as Compositional Tool' (1979), in Christoph Cox and Daniel Warner (eds), *Audio Culture: Readings in Modern Music* (London: 2004); and Virgil Moorefield, *The Producer as Composer* (Cambridge, MA: 2005).

123 Kraftwerk, 'The Robots', from the album *The Man-Machine* (Kling Klang, 1978).

124 'Authentic inauthenticity' is explained by theorist Lawrence Grossberg as 'an ironic nihilism in which distance is offered as the only reasonable relation to a reality which is no longer reasonable'. Grossberg, *We Gotta Get Out of This Place: Popular Conservatism and Postmodern Culture* (New York: 1992), p. 225.

125 As was noted at the time, Scott's pastiche of science fiction and *film noir* ensured that the 'real' characters in *Blade Runner* were also presented as simulations: 'The irony of the film is that the frame for simulation is not reality but simulation itself: what we view in the cinema is already a totally simulated reality where the humans conform to stereotypes as much as the replicants, coded in the eclectic mixture of movie genres and period styles.' Michael Newman, 'Simulacra', *Flash Art* 110 (January 1983), pp. 38–40: 38. See also Wakefield, *Postmodernism: The Twilight of the Real*, ch.8.

126 Marshall Berman, 'Why Modernism Still Matters', in Scott Lash and Jonathan Friedman (eds), *Modernity and Identity* (Oxford: 1992), p. 47.

127 Laurie Anderson, interview, *South Bank Show*, dir. Nigel Wattis (1982).

128 Laurie Anderson, 'From the Air', from the album *Big Science* (Warner Bros, 1982).

129 Authors' interview with Laurie Anderson, 3 May 2007, London.

130 Authors' interview with Jonathan Ross, 2 September 2009.

131 David Harvey, *The Condition of Postmodernity* (Oxford: 1990), p. 101.

132 Jean-Claude Lebensztejn, 'Photorealism, Kitsch and Venturi', *SubStance*, vol.10, no.2, issue 31: The Thing USA: Views of American Objects (1981), p. 76.

There is also a technical reason for this blankness. A hologram is built from multiple still photos; as in the nineteenth-century daguerreotype process, the sitter is obliged to remain as still as possible.

133 Grandmaster Flash, quoted in Jim Fricke and Charlie Ahearn, *Yes Yes Y'all: Oral History of Hip-Hop's First Decade* (Seattle: 2002), p. 340.

134 A few years later, experimental composer John Oswald would coin the term 'plunderphonics' for such music consisting only of samples. See Oswald, 'Plunderphonics, or Audio Piracy as a Compositional Prerogative' (1985), online at: www.plunderphonics.com/xhtml/xplunder.html; David Sanjek, 'Don't Have to DJ No More: Sampling and the "Autonomous" Creator', in C. Lee Harrington and Denise D. Bielby (eds), *Popular Culture: Production and Consumption* (Malden, MA: 2001), pp. 243–56; Anne LeBaron, 'Reflections of Surrealism in Postmodern Musics', in Judy Lochhead and Joseph Auner, *Postmodern Music/ Postmodern Thought* (New York: 2002), pp. 49–53.

135 Interview with Umberto Eco, in *Fast Company* (October 2002).

136 For further information on these designs, see Peter Saville, *Estate 1–127* (Zurich: 2007).

137 Authors' interview with Vaughan Oliver, 6 October 2010. See also Rick Poynor, *Vaughan Oliver: Visceral Pleasures* (London: 2000).

138 Untitled editorial, *i-D* 10 (1980), p. 6.

139 Neville Brody quoted in Jon Wozencroft, *The Graphic Language of Neville Brody* (London: 1988), p. 96.

140 Dick Hebdige, *Hiding in the Light: On Images and Things* (London: 1988), pp. 161, 166.

141 For an influential subsequent criticism along the same lines, see Tibor Kalman, J. Abbott Miller and Karrie Jacobs, 'Good History/Bad History', *Print* (March/April 1991), reprinted in Michael Beirut et al. (eds), *Looking Closer: Critical Writings on Graphic Design* (New York: 1994).

142 Jon Savage, 'The Age of Plunder', *The Face* 33 (January 1983), pp. 44–9: 45. See also Rick Poynor, *No More Rules: Graphic Design and Postmodernism* (London: 2003), pp. 76–8.

143 Savage, 'Age of Plunder', p. 49.

144 See Jon Pareles, 'Record-it-Yourself Music on Cassette', *The New York Times* (11 May 1987); and Paul Théberge, 'Random Access: Music, Technology, Postmodernism', *The Last Post: Music After Postmodernism* (Manchester: 1993).

145 Martin Amis, *Money: A Suicide Note* (London: 1984).

146 Tom Wolfe, *Bonfire of the Vanities* (New York: 1987).

147 Andy Warhol, *The Philosophy of Andy Warhol (From A to B and Back Again)* (New York: 1975), p. 100.

148 Cathleen McGuigan, 'New Art, New Money', *The New York Times Magazine* (10 February 1985).

149 For a recent account of Warhol's position within the lifestyle-orientated economy of 1980s New York, see Elizabeth Currid, *The Warhol Economy: How Fashion, Art and Music Drive New York City* (Princeton, NJ: 2007).

150 Jameson, *Postmodernism, or, The Cultural Logic of Late Capitalism*, p. 9.

151 Ibid., p. 10.

152 Quoted in *Jeff Koons*, exhib. cat. SFMoMA (San Francisco: 1992), p. 89.

153 Susan Hapgood, 'Irrationality in the Age of Technology', *Flash Art* 110 (January 1983), pp. 41–3.

154 Debate on this question has proliferated in art discourse ever since. For an overview see Johanna Drucker, *Sweet Dreams: Contemporary Art and Complicity* (Chicago: 2005).

155 Lise Skov, 'Fashion Trends, Japonisme and Postmodernism, or What is so Japanese about Comme des Garçons?', in *Theory, Culture and Society* 13/3 (1996), pp. 129–51; Yuniya Kawamura, *The Japanese Revolution in Paris Fashion* (Oxford: 2004).

156 Peter Shire recalls Lagerfeld walking into a showroom of Memphis furniture and declaring, with a swirl of his cape, 'I'll take it all'. The collection was dispersed at auction in 1990. For a description of his current lodgings, see John Colapinto, 'In the Now: Where Karl Lagerfeld Lives', *The New Yorker* (19 March 2007).

157 'Die Schöne Neue Welt des Karl Lagerfeld', *Mode und Wohnen*, no.1 (January 1983), pp. 80–6: 82. Another report noted that Lagerfeld 'was at first stumped by the banality of [the] high-rise architecture' of his Monte Carlo flat. 'He was at a loss as to what to do with the space. Until he remembered Memphis.' Patricia McColl, 'Renegade décor', *The New York Times* (14 August 1983).

158 Quoted in Peter Eisenman, Introduction, *Philip Johnson: Writings* (New York: 1979), p. 20.

159 Alice T. Friedman, *American Glamour and the Evolution of Modern Architecture* (New Haven, CT: 2010).

160 Philip Johnson, 'What Makes Me Tick', lecture, Columbia University, 24 September 1975, in *Philip Johnson: Writings* (New York: 1979), p. 271. Like Lagerfeld, Johnson adopted postmodernism as his personal style of consumption. A profile described his office as follows: 'From the caramel-colored lobby lined with anaemic Andy Warhols, we pass through a veil of "shattered" glass partitions into Johnson's private office . . . furnished with Ed Ruscha prints on the wall and Venturi oxblood chairs around a circular table.' Janet Abrams, 'Now We Are 80', *Blueprint* 35 (March 1986), pp. 26–31: 26.

161 Michael Sorkin, 'Philip Johnson: Master Builder as a Self-Made Man', *Village Voice* (October 1978), reprinted in Sorkin, *Exquisite Corpse: Writing on Buildings* (New York: 1991), p. 12.

162 Alessandro Mendini, 'Dear Philip Johnson', *Domus* 608 (July/August 1980), p. 1; John Jacobus, 'Philip Johnson: His Work, His Times', *Progressive Architecture* (February 1984), pp. 98–100: 100.

163 Jencks, *The Language of Post-Modern Architecture*, p. 131.

164 Beatriz Colomina, 'The Media House', *Assemblage* 27 (August 1995), pp. 55–66: 58.

165 Robert A.M. Stern, 'Drawing Towards A More Modern Architecture', *Architectural Design* 47/6 (1977);

reprinted in Stern, *Architecture on the Edge of Postmodernism: Collected Essays 1964–1988* (New Haven, CT: 2009), p. 103.

166 Magali Sarfatti Larson, *Behind the Postmodern Façade: Architectural Change in Late Twentieth-Century America* (Berkeley, CA; 1993), p. 120.

167 Jameson, *Postmodernism, or, The Cultural Logic of Late Capitalism*, pp. 39–42.

168 Ada Louise Huxtable, *The Tall Building Artistically Reconsidered* (New York: 1986), p. 65.

169 Jencks, Preface, *The Language of Post-Modern Architecture*, p. 7.

170 Kenneth Frampton, 'Towards a Critical Regionalism: Six Points for an Architecture of Resistance', in Foster, *Postmodern Culture*, pp. 16–30.

171 On Mississauga, see Janet Abrams, 'Urbs in 'Burbs', *Blueprint* 40 (September 1982), pp. 48–52. A notable counter-example is the IBA (Internationale Bauausstellung) in West Berlin, a large development with contributions by Hans Hollein, Charles Moore, Aldo Rossi, Stanley Tigerman, and many other leading postmodernists. Completed in 1989, this 'architectural zoo' is generally considered to have delivered commendably pluralist and liveable housing, with Charles Jencks praising the results as 'some of the most dignified and sensible social housing ever produced'. Jencks, *Critical Modernism*, p. 58. See also 'Americans in Berlin', *Architectural Record* (July 1989), pp. 82–94.

172 Harvey, *The Condition of Postmodernity*, p. 66.

173 Martin, *Utopia's Ghost*, p. 122.

174 Fredric Jameson interviewed by Michael Speaks, 'Envelopes and Enclaves: The Space of Post-Civil Society', *Assemblage* 17 (April 1992), pp. 30–7: 32.

175 Jack Solomon, 'Our Decentered Culture: The Postmodern Worldview', in Arthur Asa Berger, *The Postmodern Presence* (London: 1988), p. 37.

176 Harvey, *The Condition of Postmodernity*, p. 288.

177 Richard Bolton, 'Architecture and Cognac', in John Thackara (ed.), *Design After Modernism* (London: 1988), p. 87.

178 For an example of a deluxe postmodernist interior designer in New York – Harrison Cultra – see Peter Carlsen, 'The Spirit of Postmodernism', *Architectural Digest* 40/10 (October 1983), pp. 98–105.

179 Stefano Casciani and Tom Sandberg, *Design in Italia: The Making of an Industry* (Florence: 2008), pp. 31–5. The authors thank Catharine Rossi for this reference.

180 Deyan Sudjic, 'Milan: The Party is Over', *Blueprint* 1 (October 1983) p. 22.

181 Denise Scott Brown, email to the authors, 19 December 2009.

182 Penny Sparke, 'Venturi's Cut-Outs', *Blueprint* 1/9 (August 1984), pp. 24–5: 24.

183 Denise Scott Brown, email to the authors, 9 September 2010.

184 Denise Scott Brown, email to the authors, 17 September 2010.

185 If you use the word Formica in print 'as a shorthand for 60s sleaze,' wrote Maurice Cooper, 'you will get a letter . . . from the public relations department, politely pointing out that they make lots of jolly nice products that aren't the least bit cheap or nasty.' *Blueprint* 13 (December 1984/January 1985), pp. 20–1: 20.

186 Jeremy Myerson and Sylvia Katz, 'Finishing Touch', *Design* 425 (May 1984), pp. 42–3. See also Susan Grant Lewin, *Formica and Design: From the Countertop to High Art* (New York: 1991).

187 Authors' interview with Bernice Wollman, 17 March 2010. A third Formica-sponsored exhibition, *Surface and Edge*, focused on ColorCore's use in jewellery.

188 'Solid Color', *American Craft* 44/3 (June/July 1985), pp. 28–31.

189 Fischer, *Design Now: Industry or Art*, pp. 207, 211. For another early discussion of 'semantic' design in the German press, see Maria Pia Quarzo Cerina, 'Entwürfe der Überschreitung', *Du* (September 1982), pp. 63–5.

190 Deyan Sudjic, 'The Price of Fame', *Blueprint* 1/5 (March 1984), pp. 12–13: 12.

191 Maurice Cooper, 'Bigger than Benetton', *Blueprint* 29 (July/August 1986), pp. 29–31: 31. Esprit also commissioned Kuramata Shiro to design their stores in Hong Kong, Singapore and Japan; see Deyan Sudjic, 'Esprit: The Singular Multiple', *Blueprint* 38 (June 1987), pp. 32–41; 'Faces of the New Japan', *Blueprint* 34 (February 1987), p. 31; and Douglas Tompkins, *Esprit: The Comprehensive Design Principle* (San Francisco: 1989).

192 See Poynor, *No More Rules*, p. 80.

193 E. Ann Kaplan, 'Feminism/Oedipus/Postmodernism: The Case of MTV', in Kaplan (ed.), *Postmodernism and Its Discontents* (London: 1983), p. 36.

194 Robert Venturi, 'Mickey Mouse Teaches the Architects', *The New York Times* (22 October 1972); quoted in Harvey, *The Condition of Postmodernity*, p. 60.

195 Beth Dunlop, *Building a Dream: The Art of Disney Architecture* (New York: 1996). For Frank Gehry's thoughts on designing for Disney, see his interview in Karal Ann Marling (ed.), *Designing Disney's Theme Parks: The Architecture of Reassurance* (Paris: 1997). Not all postmodern architects were willing to toe the line. James Wines tells the amusing story that after pitching his idea for a Mickey Mouse Museum for Disney World (ultimately unrealized), which he had envisioned as a long, unrolling film strip, the executives in his audience had only one reply: 'What, no ears?' Interview with James Wines, 6 October 2009.

196 For a survey, see Dunlop, *Building a Dream*.

197 Louis Marin, *Utopiques: Jeux d'Espaces* (Paris: 1972; English trans. 1984); Wakefield, *Postmodernism: The Twilight of the Real*, p. 99.

198 Greil Marcus, 'Forty Years of Overstatement', in Marling, *Designing Disney's Theme Parks*, p. 203.

199 Steven Fjellman, *Vinyl Leaves: Disney World and America* (Boulder, CO: 1992), p. 16.

200 Our discussion here is indebted to David Doris, 'It's the Truth, It's Actual... : Kodak Picture Spots at Walt Disney World', *Visual Resources* 14 (1999), pp. 321–38.

201 On this point see Martin, *Utopia's Ghost*, ch.1; and Mike Featherstone, *Consumer Culture and Postmodernism* (London: 1991; 2nd edn 2007).

202 Maurice Cooper, 'The Designer as Superstar', *Blueprint* 36 (April 1987), pp. 21–3: 21.

203 Ian McKell, 'Putting on a Bold Face', *Blueprint* 17 (May 1985), p. 19.

204 Glenn Adamson, *Thinking Through Craft* (London: 2007).

205 Norma Broude and Mary D. Garrard, *The Power of Feminist Art* (New York: 1996); Anne Swartz, *Pattern and Decoration: An Ideal Vision in American Art, 1975–1985* (Yonkers, NY: 2007).

206 Authors' interview with Martina Margetts, 28 July 2010.

207 See Tanya Harrod, *The Crafts in Britain in the 20th Century* (New Haven, CT: 1999), pp. 420–32.

208 Rose Slivka, 'Review: Britain Salutes New York Festival', *Crafts* 64 (September/October 1983), pp. 44–5: 45.

209 Theo Crosby, 'Miffed at Modernism', *Crafts* 53 (November/December 1981), p. 13.

210 Peter Fuller, review of 'The Jewellery Project', *Crafts* 63 (July/August 1983), pp. 46–7: 46; Fuller, 'The Craft Revival?', *Crafts* 70 (September/October 1984), pp. 13–15: 14. See also Fuller, *Aesthetics After Modernism* (London: 1983). For a more general attack on postmodernism by Fuller, see 'Should Products Be Ornamented?', *Design* 416 (August 1983), pp. 33–45.

211 Peter Dormer, 'Dyed in the Wool', *Crafts* 69 (July/August 1984), pp. 12–13: 12. Dormer attempted to balance progressive and conservative elements in his books *The New Furniture* (London: 1987) and *The New Ceramics* (London: 1988), both subtitled 'Trends and Traditions'.

212 See Edward S. Cooke, 'Wood in the 1980s: Expansion or Commoditization?', in Davira S. Taragin (ed.), *Contemporary Crafts and the Saxe Collection* (New York: 1993).

213 Nicole Rousmaniere, *Crafting Beauty in Modern Japan* (London: 2007).

214 Authors' interview with Matteo Devecchi, 12 June 2009.

215 Smit and Bakker debated the issue in print; see Cindi Strauss (ed.), *Ornament as Art: Avant Garde Jewelry from the Helen W. Drutt Collection* (Houston: 2007), p. 298.

216 Museo Alessi, *Design Interviews: Alessandro Mendini*, 2008.

217 Jürgen Habermas, 'Modernity: An Unfinished Project', *New German Critique* 22 (Winter 1981), pp. 3–15. See also Habermas, *The Philosophical Discourse of Modernity* (Cambridge: 1984).

218 Rita Felski, *Doing Time: Feminist Theory and Postmodern Culture* (New York: 2000), p. 194. See also Somer Brodribb, *Nothing Mat(t)ers: A Feminist Critique of Postmodernism* (Melbourne: 1992).

219 Ziauddin Sardar, *Postmodernism and the Other: The New Imperialism of Western Culture* (London: 1997), pp. 14, 20.

220 Denis Ekpo, 'Towards a Post-Africanism: Contemporary African Thought and Postmodernism', *Textual Practice*, vol.9, no.1 (1995), p. 122. See also Ian Adam and Helen Tiffin (eds), *Past the Last Post: Theorizing Post-Colonialism and Post-Modernism* (Calgary: 1990); Nelly Richard, 'Postmodernism and Periphery', *Third Text* 2 (1987–8), pp. 6–12.

221 Sottsass quoted in *Contemporary Landscape: From the Horizon of Postmodern Design*, exhib. cat. National Museum of Modern Art (Kyoto: 1985), p. 106; Robert Venturi, '*A Bas* Postmodernism, Of Course', *Architecture* (May 2001), pp. 154–7.

222 Authors' interview with Alessandro Mendini, 12 June 2009.

223 Homi Bhabha, 'Signs Taken as Wonders', in *The Location of Culture* (London: 1994).

224 Donald Barthelme, 'Notes and Comment', *The New Yorker* (11 August 1975), reprinted in Kim Herzinger (ed.), *Not-Knowing: The Essays and Interviews of Donald Barthelme* (New York: 1997), p. 44; Nicolas Bourriaud, *Altermodern: Tate Triennial* (London: 2008).

225 Zygmunt Bauman and Keith Tester, 'On the Postmodernism Debate', in Pelagia Goulimari, *Postmodernism: What Moment?* (Manchester: 2007), p. 23.

226 The period addressed in this book is more or less bracketed by examinations of this dynamic in literature and fine art: Frank Kermode, *The Sense of An Ending: Studies in the Theory of Fiction* (Oxford: 1967); and Yve-Alain Bois and David Joselit et al., *Endgame: Reference and Simulation in Recent American Painting and Sculpture* (Boston: 1986).

227 There is a vast literature on the subject, but Arjun Appadurai's *Globalization* (Chapel Hill, NC: 2001) remains particularly useful. For recent applications in the study of design see Glenn Adamson, Giorgio Riello and Sarah Teasley (eds), *Global Design History* (London: 2011).

228 Aaron Tan and Louise Low, 'Shanghai World Financial Center: Love and Rockets in the Spree Economy', in *Vertigo: The Strange New World of the Contemporary City* (London: 1999); William S.W. Lim, *Postmodern Singapore* (Singapore: 2002); Rob Wilson and Wimal Dissanayake (eds), *Global/Local: Cultural Production and the Transnational Imaginary* (Durham, NC: 2006).

229 Featherstone, *Consumer Culture and Postmodernism*, p. 145.

230 Also contributing to the exhibition and catalogue were the French theorist Jacques Soulillou, post-colonial theorist Homi Bhabha, and the New York critic Thomas McEvilley, who had been a leading critic of the Museum of Modern Art show *Primitivism in 20th Century Art* (1984). See McEvilley, *Art and Otherness: Crisis in Cultural Identity* (New Paltz, NY: 1995).

231 Michael O'Donnell, 'Art in the Jua Kali', in *Recycling* (Hamar, Norway: 2009), p. 4.

232 'Tous ces objets, d'ici ou d'ailleurs, ont en commun d'avoir une aura. Ce ne sont pas de simples objets ou outils à usage fonctionnel et matériel. Ils sont destinés à agir sur le mental et les idées don't ils sont le fruit. Ils sont les réceptacles de valeurs métaphysiques.' Jean-Hubert Martin, Preface, in *Magiciens de la Terre*, exhib. cat. Centre Georges Pompidou (Paris: 1989).

233 For a further exploration and consideration of this aesthetic, see Charlene Cerny and Suzanne Seriff (eds), *Recycled/Re-seen: Folk Art from the Global Scrap Heap* (New York: 1996).

234 *Magiciens de la Terre*, p. 161.

235 Ettore Sottsass, 'Bodys Isek Kingelez', in André Magnin and Jacques Soullilou, *Contemporary Art of Africa* (London: 1996), p. 172.

236 Annie Coombes, 'Inventing the "Postcolonial": Hybridity and Constituency in Contemporary Curating', *New Formations* 18 (Winter 1992), pp. 39–53; as reprinted in Donald Preziosi, *The Art of Art History: A Critical Anthology* (Oxford: 1998), pp. 496–7.

237 Trinh T. Minh-ha, 'Of Other Peoples: Beyond the "Salvage" Paradigm', in Hal Foster (ed.), *Discussions in Contemporary Culture* (Seattle: 1987), pp. 138, 140.

238 New Order, 'Bizarre Love Triangle', from the album *Brotherhood* (Factory, 1986).

239 The video was one of a group that Longo produced in 1986 and 1987 for bands including R.E.M., Living Colour and Megadeth.

240 Peter Saville notes that Longo, an ardent fan of Joy Division, may have been thinking of lead singer Ian Curtis' convulsive performance style when he made these images. Authors' interview, 23 July 2010.

241 For a discussion of 9/11 as a postmodern event, see Maurice Berger (ed.), *Postmodernism: A Virtual Discussion* (Santa Fe: 2003).

242 'There is a new sense that one can simply construct the new self that one wants, freed from the constraints of one's past and one's inherited genetic code. Human evolution may be entering a new phase . . . The search for the absolute "true" self has been replaced by a constant scanning for new alternatives.' Jeffrey Deitch, *Post-Human* (New York: 1992), pp. 27, 36. See also Scott Bukatman, 'Postcards from the Posthuman Solar System', in Neil Badmington, *Posthumanism* (Basingstoke: 2000).

Arch-Art: Architecture as Subject Matter
James Wines

1 Joseph Beuys, 'A Public Dialogue, New York City' (1974), as quoted in Carin Kuoni (ed.), *Energy Plan for the Western Man: Joseph Beuys in America* (New York: 1993), pp. 25–7.

2 Quoted in Donald Wall, 'Gordon Matta-Clark's Building Dissections', *Arts Magazine* (May 1976), pp. 74–9.

3 Ibid.

4 See James Wines, 'Economy of Means: Some Notes on Alternative Architecture', *Journal of Architectural Education* 62/4 (May 2009), pp. 97–104.

5 Ibid.

Our Postmodernism
Denise Scott Brown

1 Robert Venturi, having 'flu, came a week later. For further accounts of our intellectual history, see Robert Venturi and Denise Scott Brown, *Architecture as Signs and Systems for a Mannerist Time* (Cambridge, MA and London: 2004) and Denise Scott Brown, 'Towards an Active Socioplastics', *Having Words* (London: 2009).

2 Robert Venturi, Denise Scott Brown and Steven Izenour, *Learning from Las Vegas* (Cambridge, MA: 1972, revised 1977) and Karin Theunissen, 'Urban analyses by Robert Venturi and Denise Scott Brown and the Topicality of Postmodernism', in Arie Graafland et al. (eds), *The Architecture Annual* 2001/2002, Delft University of Technology (Delft: 2003).

3 Jane Pavitt, personal communication with Denise Scott Brown, February 2010.

4 Glenn Adamson, 'Substance Abuse: Making the Postmodern Object', lecture, Yale University School of Architecture, 12 November 2009.

5 David Crane, 'Chandigarh Reconsidered: the Dynamic City', *Journal of the American Institute of Planners* (November 1960), pp. 280–92; Denise Scott Brown, 'The Redefinition of Functionalism' and 'Mannerism Because You Can't Follow All the Rules of All the Systems All the Time', in Robert Venturi and Denise Scott Brown, *Architecture as Signs and Systems for a Mannerist Time* (Cambridge, MA and London: 2004).

6 See Fred Koetter, review of Robert Venturi, Denise Scott Brown and Steven Izenour, 'Learning from Las Vegas', *Oppositions* 3 (May 1974), pp. 98, 104.

7 HUAC, the House Un-American Activities Committee, was a congressional investigative body in the 1940s and 1950s that paralleled Eugene McCarthy's activities in the US Senate. It was responsible for the blacklisting of Hollywood writers, actors and directors who were accused of Communist sympathies [eds].

On Bricolage
Victor Buchli

1 Claude Lévi-Strauss, *The Savage Mind* (Chicago: 1966), p. 17.

2 Lévi-Strauss, *The Savage Mind*, p. 19.

3 Ibid.

4 Lévi-Strauss, *The Savage Mind*, p. 22.

5 Mary Douglas, *Purity and Danger: An Analysis of the Concepts of Pollution and Taboo* (London: 1966).

6 Lévi-Strauss, *The Savage Mind*, p. 24.

7 Lévi-Strauss, *The Savage Mind*, p. 18.

Kitsch and Postmodern Architecture: Charles Moore's Piazza d'Italia
Patricia A. Morton

1 See, for example, Martin Filler, 'The Magic Fountain', *Progressive Architecture* (November 1978), pp. 81–7; Lake Douglas, 'Piazza d'Italia', *Architectural Review* 987 (1979), pp. 255–6; 'Views', *Progressive Architecture*, 1:79, 2:79, 3:79; Ada Louise Huxtable, 'The Present: The Troubled State of Modern Architecture', *Bulletin of the American Academy of Arts and Sciences*, vol.33, no.4 (January 1980), pp. 30.

2 Filler, 'The Magic Fountain', p. 81.

3 Charles Moore, 'Ten Years Later', *Places*, vol.1, n.2 (1983), p. 28.

4 Linda Hutcheon, 'The Politics of Postmodernism: Parody and History', *Cultural Critique* 5 (Winter 1986–7), p. 185.

5 Charles Jencks, *The Language of Post-Modern Architecture* (New York: 1981), p. 146.

6 John Cook and Heinrich Klotz, 'Charles Moore', *Conversations with Architects* (New York: 1973), pp. 235–6.

7 Ibid.

8 Kevin P. Keim, *An Architectural Life: Memoirs and Memories of Charles W. Moore* (Boston: 1996), p. 77.

9 Filler, 'The Magic Fountain', p. 87.

10 Clement Greenberg, 'Avant-Garde and Kitsch', *Partisan Review* VI, no.5 (Fall 1939), p. 41.

11 Gillo Dorfles, *Kitsch: The World of Bad Taste* (New York: 1969), p. 30.

12 Greenberg, 'Avant-Garde and Kitsch', p. 40.

13 Charles Moore, 'You Have to Pay for the Public Life', *Perspecta* 9 (1965), pp. 57–97; Moore, 'Plug it in Rameses and see if it lights up, because we aren't going to keep it unless it works', *Perspecta* 11 (1967), pp. 32–43.

Irony and Postmodern Architecture
Emmanuel Petit

1 Søren Kierkegaard, *Concept of Irony, With Continual Reference to Socrates: Together with Notes of Schelling's Berlin Lectures*, edited by Howard V. Hong and Edna H. Hong (Princeton, NJ: 1989), p. 19.

2 Maurice Blanchot, *Space of Literature*, trans. Ann Smock (Lincoln, NE: 1982), pp. 255–6.

3 Fredric Jameson, *Postmodernism, Or, The Cultural Logic of Late Capitalism* (Durham, NC: 1991), pp. 391–3.

4 On Hegel's definition of irony as adopted by Kierkegaard, see Reed Merrill, '"Infinite Absolute Negativity": Irony in Socrates, Kierkegaard and Kafka', *Comparative Literature Studies* 16/3 (September 1979), pp. 222–36.

5 Tigerman extracts most of his references to existentialist thinkers from William Hubben, *Dostoevsky, Kierkegaard, Nietzsche, and Kafka: Four Prophets of Our Destiny* (London and New York: 1952 and 1962). Later, Tigerman refers to Mark C. Taylor's *Erring: A Postmodern A/theology* (Chicago: 1984).

6 Tigerman used the expression 'German invasion' to designate Mies van der Rohe's arrival in Chicago in an interview with Barbaralee Diamonstein. Diamonstein-Spielvogel, 'American Architecture Now: Stanley Tigerman', Diamonstein-Spielvogel Video Archive, Duke University Libraries, 1984.

7 The epitaph on Kierkegaard's grave referred to the philosopher as 'That Individual'.

8 Harold Bloom, *Anxiety of Influence: A Theory of Poetry* (New York: 1973).

9 Stanley Tigerman, *Versus, an American Architect's Alternatives*, with essays by Ross Miller and Dorothy Metzger Habel (New York: 1982), p. 9.

10 Stanley Tigerman, *Architecture of Exile* (New York: 1988).

11 Tigerman himself uses the expression 'irreparable wound' in *Architecture of Exile*.

The Presence of the Past: Postmodernism meets in Venice
Léa-Catherine Szacka

1 The exact dates of the meetings were: 14–15 September 1979, 23–24 November 1979 and 1–2 February 1980 (information collected from the personal archives of Robert A.M. Stern and Charles Jencks as well as the Venice Biennale archive: La Biennale di Venezia, ASAC, Fondo Storico, busta n. 630).

2 The exhibitors in *Strada Novissima* were Constantino Dardi; Michael Graves; Frank O. Gehry; Oswalt Mathias Ungers; Robert Venturi, John Rauch and Denise Scott Brown; Léon Krier; Josef-Paul Kleihues; Hans Hollein; Massimo Scolari; Allan Greenberg (on one side); Rem Koolhaas and Elia Zenghelis; Paolo Portoghesi, Francesco Cellini and Claudio d'Amato; Ricardo Bofill Taller de Arquitectura; Charles W. Moore; Robert A.M. Stern; Franco Purini and Laura Thermes; Stanley Tigerman; Studio GRAU; Thomas Gordon Smith; Arata Isozaki (on the other side). Christian de Portzamparc was also part of the group but withdrew at the last moment, deciding that his façade should not be built inside the Arsenale. Portoghesi's façade, first designed as the entrance portal to the street, was built in place of Portzamparc's façade.

3 According to Portoghesi, Ridolfi and Gardella deserved homage not so much for having passed over the Modern Movement but rather for their switch from an architecture controlled by politics to an architecture made of linguistic games. Author's interview with Paolo Portoghesi, 27 March 2008.

4 Robert A.M. Stern, 'The 1980 Biennale', unpublished article for *Architectural Record* (1980; revised 12/09/09 by RAMS).

5 Robert A.M. Stern, 'The 1980 Biennale'.

6 Paolo Portoghesi et al., *The Presence of the Past: First International Exhibition of Architecture – Venice Biennale 80* (London: 1980), p. 12.

7 Paolo Portoghesi et al., *The Presence of the Past*, p. 12.

8 Author's interview with Paolo Portoghesi, 27 March 2008, in Portoghesi's studio in Calcata (Viterbo), Italy.

9 Paolo Portoghesi et al., *The Presence of the Past*, p. 38.

10 Here, the English version of the catalogue says 'that is, the role that had now returned to take on the reflection on history as an active basis for planning', which seems an odd translation from the Italian, 'e cioè al ruolo che oggi torna ad assumere la riflessione sulla storia come base attiva per il progettare'.

11 No date, programme of the façades in the Venice Biennale, personal archive of Charles Jencks.

12 Data from Venice Biennale archive: La Biennale di Venezia, ASAC, Fondo Storico, busta n. 787/9.

13 Nantas Salvalaggio, 'Quando la libertà odora di eresia', *Il Tempo* (31 July 1980).

14 Vittorio Gregotti, 'I vecchietti delle colonne', *La Repubblica* (31 July 1980).

15 Manfredo Tafuri, *History of Italian Architecture 1944–1985*, (Cambridge, Mass.: 1989), p. 187

16 Paolo Portoghesi, 'Facciatisti e facciatosti, Dibattito fra Paolo Portoghesi e Bruno Zevi, a cura di D. Pasti', *L'Espresso*, no.18 (17 August 1980), p. 135.

17 Paolo Portoghesi, 'Facciatisti e facciatosti'.

18 Jürgen Habermas, 'Modernity: An Unfinished Project', *The Post-Modern Reader* (London: 1992), p. 158.

19 Author's interview with Kenneth Frampton, 22 April 2009, via email.

20 Author's interview with Paolo Portoghesi, 27 March 2008, in Portoghesi's studio in Calcata (Viterbo), Italy.

21 From the title of Portoghesi's essay for the exhibition catalogue. Paolo Portoghesi et al. (1980), pp. 9–14.

The Architect as Ghost-Writer: Rem Koolhaas and Image-Based Urbanism
Martino Stierli

1 Jacques Derrida, 'Signature Event Context', *Margins of Philosophy*, trans. Alan Bass (Chicago: 1982), pp. 307–30, here p. 324.

2 See the contribution by Paul Jobling in this volume, pp. 220–23.

3 See Gérard Genette, *Palimpsestes. La littérature au second degré* (Paris: 1982).

4 See John Summerson, *Georgian London* (London: 1947).

5 See Jean-François Lyotard, *The Postmodern Condition: A Report on Knowledge* (Minneapolis, MN: 1984); Perry Anderson, *The Origins of Postmodernity* (London: 1998), pp. 24–36.

6 See in this respect Mike Crang, 'Envisioning urban histories: Bristol as palimpsest, postcards, and snapshot', *Environment and Planning A 28* (1996), pp. 429–52. See also Igor Marjanović, 'Wish You Were Here: Alvin Boyarsky's Chicago Postcards', in Charles Waldheim and Katerina Rüedi Ray (eds), *Chicago Architecture: Histories, Revisions, Alternatives* (Chicago and London: 2005), pp. 207–25, here p. 208.

7 See Shuman Basar and Charlie Koolhaas, 'Disaster, Babies, Glass Bricks: Postcard Archaeology', in Shuman Basar and Stephan Trüby (eds), *The World of Madelon Vriesendorp: Paintings/Postcards/ Objects/Games* (London: 2008), pp. 74–81. On the culture of collecting in the London post-war years, and in particular around the Independent Group, see also the contribution by Charles Jencks in the same volume. Charles Jencks, 'Madelon Seeing Through Objects', in Basar and Trüby, *The World of Madelon Vriesendorp*, pp. 16–24, here p. 20.

8 See www.tulselupernetwork.com/basis.html

9 Rem Koolhaas, 'Why I wrote Delirious New York and Other Textual Strategies', *Any 1*, no.0 (May/June 1993), pp. 42–3, here p. 43.

10 On Boyarsky's postcard collection as well as the associations of Koolhaas and Boyarsky, see Marjanović, 'Wish You Were Here', and Marjanović, 'Alvin Boyarsky's Chicago', *AA Files 60* (2010), pp. 45–52: 49. For a personal account of his relationship to Boyarsky, see Rem Koolhaas, 'Atlanta', in Robin Middleton (ed.), *Architectural Associations: The Idea of the City* (London: 1996), pp. 84–91.

11 'Seminal buildings are represented again and again [in MV and RK's postcard collection], before actual construction begins, and then several times after. You can see the shifts from idealism to realism to retrospectivism.' Basar and Koolhaas, 'Disasters, Babies, Glass Bricks', p. 77.

12 Rem Koolhaas, *Delirious New York: A Retroactive Manifesto for Manhattan*, new edition (New York: 1994), p. 9.

13 Koolhaas, *Delirious New York*, p. 11.

Paper Architecture: The Columbaria of Brodsky and Utkin
David Crowley

1 Francis Fukuyama, *The End of History and the Last Man* (New York: 1992).

2 Boris Groys, *The Total Art of Stalinism. Avant-garde, Aesthetic Dictatorship, and Beyond,* trans. Carl Hanser (Princeton, NJ: 1992), p. 49.

3 See Deutsches Architekturmuseum, *Paper Architecture. New Projects from the Soviet Union* (New York: 1990); Alexey Yurakovsky and Sophie Ovenden, *Immovable Feast: Essays on Soviet/ Post-Soviet Art and Architecture* (London: 1994).

4 Svetlana Boym, *Architecture of the Off-modern* (New York: 2008) p. 29.

5 'Man in the Metropolis: The Graphic Projections of Brodsky and Utkin', in Lois Ellen Nesbit, *Brodsky and Utkin: The Complete Works* (New York: 2003).

6 Sally Laird, in Lisa Appignanesi (ed.), *Novostroika* (London: 1989) p. 5.

7 Marc Garcelon, 'Public and private in communist and post-communist society' and Oleg Kharkhordin, 'Reveal and Dissimulate: A Genealogy of Private Life in Soviet Russia' in Jeff Weintraub and Krishan Kumar (eds), *Public and Private in Thought and Practice. Perspectives on a Grand Dichotomy* (Chicago and London: 1997) pp. 303–65.

8 Walter Benjamin, 'Moscow', in *One Way Street* (London: 1979), pp. 187–8.

9 See K. Gerasmiova, 'Public Privacy in the Soviet Communal Apartment', in David Crowley and Susan E. Reid (eds), *Socialist Spaces: Sites of Everyday Life in the Eastern Bloc* (Oxford and London: 2003), pp. 207–30.

10 For a vivid account of the intrusions of others in the Communal Apartment, see S. Boym, *Common Places: Mythologies of Everyday Life in Russia* (Cambridge, MA: 1994), pp. 121–68.

11 This installation was shown at the Ronald Feldman Gallery, New York. The project has its origins in a series of albums drawn by the artist between 1972 and 1975.

12 Mikhail Epstein, 'Emptiness as a Technique: Word and Image in Ilya Kabakov', in Mikhail Epstein, Aleksandr Genis and Slobodanka Vladiv-Glover (eds), *Russian Postmodernism: New Perspectives on Post-Soviet Culture*, Studies in Slavic Literature, Culture and Society, vol.3 (New York and Oxford: 1999), pp. 299–344.

13 Borys Groys, *Ilya Kabakov: The Man who Flew into Space from His Apartment* (London: 2006), p. 63.

14 Andrzej Turowski, *Existe-il un art de l'Europe de l'est?: Utopie et idéologie* (Paris: 1986).

15 Milan Kundera, *The Book of Laughter and Forgetting*, trans. Aaron Asher (New York: 1999) p. 4.

Photography into Building: The Smithsons and James Stirling
Claire Zimmerman

1 László Moholy-Nagy, 'Produktion-Reproduktion', *Malerei Fotografie Film* (Munich: 1925/27), p. 28. Author's translation.

2 To understand more about what these two historical moments shared, see Mark Crinson and Claire Zimmerman (eds), *Neo-Avant-Garde and Postmodern: Postwar Architecture in Britain and Beyond*, Yale Studies in British Art #21 (New Haven and London: 2010).

3 Mark Girouard, *Big Jim: the Life and Work of James Stirling* (London: 1998), pp. 67–8; Mark Crinson (ed.), *James Stirling: Early Unpublished Writings on Architecture* (London: 2010), pp. 13, 85, 99, n.1.

4 These ideas have been elaborated in two articles on Stirling's work. See Claire Zimmerman, 'James Stirling Re-assembled', *AA Files 56* (November 2007), pp. 30–41; and idem, 'James Stirling's "Real Function"', *OASE 79 James Stirling* (2009), p. 121–41.

5 Reyner Banham, 'The Style for the Job', *New Statesman* 67 (14 February 1964), p. 261; reprinted in Mary Banham (ed.), *A Critic Writes: Essays by Reyner Banham* (Berkeley, CA: 1996), pp. 96–9); James Stirling, 'Anti-Structure', *Zodiac* 18 (1969), n.p.

Postmodern Angel: Shiro Kuramata
Paola Antonelli

1 Paolo Portoghesi, *Postmodern: the Architecture of the Postindustrial Society* (New York: 1984).

2 Carter Wiseman, 'Wright Mania', in *New York* magazine, 28 February 1994, p. 54. The show was entitled *The Architecture of the Ecole des Beaux Arts* and it was curated by Arthur Drexler.

3 Bernard Rudofsky, *Architecture Without Architects* (New York: 1964), p. 58.

4 David Hanks and Anne Hoy, *Design for Living: Furniture and Lighting, 1950–2000* (Paris: 2000), p. 186.

We are All in the Gutter: Retailing Postmodern Fashion
Claire Wilcox

1 Rei Kawakubo, quoted in Yuniya Kawamura, *The Japanese Revolution in Paris Fashion* (London: 2004), p. 137.

2 Deyan Sudjic, *Rei Kawakubo and Comme des Garçons* (London: 1990), p. 114.

3 Sanae Shimizu (ed.) and NHK (Japan Broadcasting Corporation) Unlimited, *Comme des Garçons* (Japan: 2005), n.p.

4 Kawamura, *The Japanese Revolution in Paris Fashion*, p. 133.

5 Sudjic, *Rei Kawakubo and Comme des Garçons*, p. 115.

6 Shimizu and NHK Unlimited, *Comme des Garçons*, n.p.

7 Maria Luisa Frisa and Stefano Tonchi (eds), *Excess Fashion and the Underground in the '80s* (Milan: 2004), p. 263.

8 Unpublished correspondence with the author, July 2010.

9 Roger K. Burton, 'The Destination is the Journey', The Contemporary Wardrobe Collection, www.contemporarywardrobe.com (2003).

10 Interview with the author, 2004.

11 Claire Wilcox, *Vivienne Westwood* (London: 2004), p. 17.

12 Quoted in Wilcox, *Vivienne Westwood*, p. 31.

13 Suzy Menkes, 'Positive Energy: Comme at 40', *International Herald Tribune*, 8 June 2009.

14 Frisa and Tonchi, *Excess Fashion and the Underground*, p. 269.

15 Richard Martin, 'Our Kimono Mind: Reflections on "Japanese Design: a survey since 1950"', *Journal of Design History* 8, no.3 (1995), p. 221.

16 Quoted in Wilcox, *Vivienne Westwood*, p. 15.

17 Shimizu and NHK Unlimited, *Comme des Garçons*, n.p.

Making Memphis: 'Glue Culture' and Postmodern Production Strategies
Catharine Rossi

1 The author thanks Barbara Radice and Renzo Brugola for generously agreeing to be interviewed for this essay.

2 Barbara Radice, *Memphis: Ricerche, Esperienze, Risultati, Fallimenti e Successi del Nuovo Design* (Milan: 1984), p. 26.

3 Barbara Radice, *Memphis: the New International Style* (Milan: 2009; orig. pub. 1981).

4 Ettore Sottsass, 'Sottsass Explains Memphis', *Designer*, vol.1, no.25 (February 1982), p. 6. For more on the Radical Design movement, see Andrea Branzi's *The Hot House: Italian New Wave Design* (London: 1984) with a Foreword by Arata Isozaki; and *MANtransFORMS: an international exhibition on aspects of design, conceived by Hans Hollein [and] sponsored by The Johnson Wax Company, for the opening of the Smithsonian Institution's National Museum of Design, Cooper-Hewitt Museum* (New York: 1976).

5 Interview with Barbara Radice, 12 April 2010. For confirmation of this, see Sottsass, quoted in Giacinto di Pietrantonio, 'Ettore Sottsass', *Flash Art* 136 (October 1987), p. 77.

6 'Memphis' document, 11 December 1980, n.p. Michele De Lucchi Archive.

7 'Paragon and Paradox', *Design*, no.417 (September 1983).

8 Rainbow was set up in 1972 by Fabio Bellotti and produced fabrics for fashion houses including Armani, Krizia and Versace.

9 Flavia Ceramiche had been set up in 1962; Rainbow in 1972; Toso Vetri d'Arte in 1982; UP&UP in 1968. Riforma, the lamp manufacturer owned by Celati, had been set up in 1971.

10 Branzi, *The Hot House*, p. 141.

11 Deyan Sudjic, 'Sottsass and Co.', *Crafts*, no.59 (November/December 1982), p. 42.

12 Ibid.

13 Ernesto Gismondi in Gian Piero Vincenzo, 'Interview: Ernesto Gismondi', *Memphis, 1981–1988* (Groningen: 1989), p. 11.

14 Ettorre Sottsass, in Gian Piero Vincenzo, 'Interview: Ettore Sottsass', *Memphis 1981–1988* (Groningen: 1989), p. 8.

15 'I maestri: Note Biografiche', in Andrea Tosi (ed.), with collaboration of Antonella de Palma, *Memoria del Vetro: Murano e l'Arte Vetraria nelle Storie dei Suoi Maestri* (Venice: 2006), p. 182. In 1990 Toso Vetri d'Arte was bought out by Andrea Boscaro and renamed Compagnia Vetraria Muranese.

16 Wolfgang Schepers, 'Postmodernes Glas-Design', *Neues Glas* 3 (1988), p. 190.

17 See Teal Triggs, 'Scissors and Glue: Punk Fanzines and the Creation of a DIY Aesthetic', *Journal of Design History* 19 (1) (2006), pp. 69–83; *Vetri Glass: Ettore Sottsass Marco Zanini 1986* (Milan: 1986), sales brochure.

18 Ettore Sottsass, Foreword, in Hunter Drohojowska, *Tempest in a Teapot: the Ceramic Art of Peter Shire* (New York: 1991), pp. 19–20. Technically, to call it glue was a misnomer. Shire was actually using slip (liquid clay) to bind the disparate parts of his teapots together.

The Uses of 'Notes on Camp'
Christopher Breward

1 Dana Heller, 'Absolute Seriousness: Susan Sontag in American Popular Culture', in Barbara Ching and Jennifer A. Wagner-Lawlor (eds), *The Scandal of Susan Sontag* (New York: 2009), p. 47.

2 Heller, 'Absolute Seriousness', p. 47.

3 Susan Sontag, 'Notes on Camp', in Elizabeth Hardwick (ed.), *A Susan Sontag Reader* (Harmondsworth: 1983), p. 106.

4 James Steele, 'Imagining Utopia: The Figurative Universe of Ettore Sottsass', in Ronald T. Labaco (ed.), *Ettore Sottsass: Architect and Designer* (London: 2006), p. 79.

5 Steele, 'Imagining Utopia', p. 75.

6 Steele, 'Imagining Utopia' p. 79.

7 Sontag, 'Notes on Camp', pp. 107–8.

8 Sontag, 'Notes on Camp', p. 119.

9 Claudio Marenco Mores, *From Fiorucci to the Guerilla Stores: Shop Displays in Architecture, Marketing and Communications* (Venice: 2006), pp. 60–4.

10 Peter York, 'Them', in Peter York (ed.), *Style Wars* (London: 1980), pp. 112–28.

11 Mores, *From Fiorucci*, p. 71.

12 Sontag, 'Notes on Camp', p. 114.

13 On Sontag's repudiation of 'Notes on Camp', see Terry Castle, 'Some notes on "Notes on Camp"', in Ching and Wagner-Lawlor (eds), *The Scandal of Susan Sontag*, pp. 30–1. For a 'queer-studies' critique of Sontag, see Moe Meyer (ed.), *The Politics and Poetics of Camp* (London: 2000). For the 'classic' British cultural studies approach to popular culture, see Richard Hoggart, *The Uses of Literacy* (Harmondsworth: 1958) and Dick Hebdige, *Subculture: The Meaning of Style* (London: 1979).

14 Sontag, 'Notes on Camp', p. 106.

Tomorrow's been cancelled due to lack of interest: Derek Jarman's *The Last of England*
Oliver Winchester

1 Michael O'Pay, *Derek Jarman. Dreams of England* (London: 1996), p. 159.

2 'Tomorrow's been cancelled, due to lack of interest' is quoted from Derek Jarman, *The Last of England* (London: 1987), p. 159, the book he wrote to accompany the film of the same name.

3 Tony Peake, *Derek Jarman* (London: 1999), p. 337.

4 Jarman, *The Last of England*, p. 170.

5 Ibid., p. 12.

6 Ibid., p. 14.

7 Jim Ellis, *Derek Jarman's Angelic Conversations* (Minneapolis, MN: 2009), p. 134.

8 Jarman, *The Last of England*, p. 188.

9 Tracy Biga, 'The Principle of Non-narration in the Film of Derek Jarman', in Chris Lippard (ed.), *By Angels Driven: The Films of Derek Jarman* (Westport, PA: 1996), p. 134.

10 Jarman, *The Last of England*, p. 188.

11 Ibid., p. 54.

12 Ibid., p. 76.

13 Biga, 'The Principle of Non-narration', p. 17.

14 Reproduced in Giuliana Bruno, 'Ramble City: Postmodernism and Blade Runner', in *October* 41 (Summer 1987), p. 70.

Unsettled Images: From TV Screen to Video-Wall and Back Again
Mari Dumett

1 In 1970, Gene Youngblood argued the historically specific qualities of television and video as artistic mediums (even if the era was not yet named 'postmodern'). Two decades later, Fredric Jameson could 'presuppose' video to be postmodernism's dominant cultural form. See Gene Youngblood, *Expanded Cinema* (New York: 1970); Fredric Jameson, *Postmodernism, or, The Cultural Logic of Late Capitalism* (Durham, NC: 1991).

2 Perhaps more than any other artist, Paik fits this description of the video pioneer. 'TV Bra for Living Sculpture', Paik and Charlotte Moorman's collaborative contribution to *TV as Creative Medium*, performed a 'cybernetic subject' granted agency via negative feedback.

3 Especially influential at the time were Marshall McLuhan, *Understanding Media: the Extensions of Man* (New York: 1964); and Norbert Wiener, *Cybernetics, or, Control and Communication in the Animal and the Machine* (Cambridge, MA: 1948; 2nd edn 1961).

4 Jud Yalkut, 'Frank Gillette and Ira Schneider, Parts I and II of an Interview', originally published in *The East Village Other*, vol.4, no.35 (30 July 1969) and vol.4, no.36 (6 August 1969); reprinted in *Radical Software* (Summer 1970), pp. 9–10.

5 Ibid.

6 Michel Foucault, *Discipline and Punish: the Birth of the Prison*, trans. Alan Sheridan (New York: 1977).

7 David Deitcher, 'When Worlds Collide', *Art in America*, vol.78, no.2 (February 1990), pp. 120–6, 189, 191; Johannes Birringer, 'Video Art/ Performance: A Border Theory', *Performing Arts Journal*, vol.13, no.3 (September 1991), pp. 54–84.

8 Guy Debord, *Society of the Spectacle* (New York: 1994; orig. pub. in French, 1967; 1st English trans., 1970).

9 Baudrillard developed this notion in texts such as *Simulations* (New York: 1983); *In the Shadow of the Silent Majorities: or, the End of the Social and Other Essays* (New York: 1983); and *Symbolic Exchange and Death* (London: 1993).

10 Both Deitcher and Birringer make the nightclub association, see n.7.

11 Samuel Weber, *Mass Mediauras: Form, Technics, Media*, edited by Alan Cholodenko (Stanford, CA: 1996), p. 122.

12 Rosemarie Haag Bletter notes this new studio design in her essay, 'Viewing the TV Image', *Design Quarterly*, no.116 (1981), pp. 2–8.

Sampling and the Materiality of Sound
Ulrich Lehmann

1 See Karlheinz Stockhausen, in *Texte zur Musik*, vol.4 (Cologne: 1989), p. 550.

2 Jean Baudrillard, *Symbolic Exchange and Death*, trans. Iain Hamilton Grant (London: 1993; orig. pub. 1976), p. 8.

3 Baudrillard, *Symbolic Exchange and Death*, p. xi.

Buffalo: Style with Intent
Carol Tulloch

1 Nick Logan, 'Myths and Legends', in Mitzi Lorenz (ed.), *Buffalo* (London: 2000), p. 148.

2 Lorenz (ed.), *Buffalo*, pp. 13, 152–3.

3 The group's members were Ray Petri, Barry Kamen, Nick Kamen, Cameron McVey, Mitzi Lorenz, Felix Howard, Howard Napper, Jamie Morgan, Leon Reid, James Lebon, Marc Lebon, Brett Walker, Jean-Baptiste Monodino, Naomi Campbell, Neneh Cherry, Roger Charity, Simon De Montford, Tony Felix, Jack Negri, Talisa Soto and Wade Tolera.

4 Paul Rambali, 'A Walk on the Style Side,' in Lorenz (ed.), *Buffalo*, p. 171.

5 Rambali, 'A Walk on the Style Side', p. 167.

6 Rambali, 'A Walk on the Style Side', p. 172.

7 Lesley White, 'Talent', *The Face* 61 (May 1985), p. 44.

8 Steven Conner, 'Postmodernism', in Michael Payne (ed.), *A Dictionary of Cultural and Critical Theory* (Oxford: 1997), p. 431.

9 Ray Petri was born in Dundee. He emigrated in the early 1960s, aged 15, with his family to Australia. By the late 1960s he was back in Europe, settling in London. From then on, he travelled extensively, for example, to Rhodesia (Zimbabwe), Jamaica, the United States and Europe.

10 Jean-François Lyotard, *The Postmodern Condition: A Report on Knowledge* (Manchester: 1984; orig. pub. 1979), p. 81.

11 Stella Bruzzi, *Undressing Cinema: Clothing and Identity in the Movies* (London and New York: 1997), p. 76.

12 Bruzzi, *Undressing Cinema*, p. 74.

13 Barry Kamen, quoted in Rambali, 'A Walk on the Style Side', p. 168.

14 Elizabeth Hallam and Jenny Hockey (eds), *Death and Material Culture* (Oxford and New York: 2001), p. 94.

15 Jean-François Lyotard, 'Brief Reflections on Popular Culture', in Lisa Appignanesi (ed.), *Postmodernism: ICA Documents* (London: 1989), p. 182.

Dressing Viciously: Hip-Hop Music, Fashion and Cultural Crossover
Zoe Whitley

With the author's thanks to Deborah Willis.

1 S. Craig Watkins, *Hip Hop Matters: Politics, Pop Culture and the Struggle for the Soul of a Movement* (Boston: 2005), p. 98.

2 Jeff Chang, *Can't Stop Won't Stop: A History of the Hip-Hop Generation* (New York: 2006), p. 74.

3 Jim Fricke and Charlie Ahearn, *Yes Yes Y'all: Oral History of Hip-Hop's First Decade* (Cambridge, MA: 2002), p. 309.

4 Pascal Bussy, *Kraftwerk: Man Machine and Music* (Wembley: 1993), pp. 122–3.

5 Watkins, *Hip Hop Matters*, p. 72; Imani Perry, *Prophets of the Hood: Politics and Poetics in Hip Hop* (Durham: 2004), p. 133.

6 Perry, *Prophets of the Hood*, p. 133.

Klaus Nomi: Astral Countervoice of the New Wave
Susanne K. Frantz

The author gratefully acknowledges information from interviews and correspondence with: first and foremost, Joey Arias, executor of the Klaus Nomi Estate, and also Eileen 'Snooky' Bellomo, Salomé Wolfgang Cihlarz, Katharina Eisch-Angus, Tony Frere, Michael Halsband, Kristian Hoffman, Tanya Indiana, Ronald A. Johnsen, Katy 'Katy K' Kattelman, Gabriele La Fari, Ann Magnuson, Hubert Münster, Kelsey Kristin Read, Adrian 'Boy Adrian' Richards, Eberhard Schoener, Page Wood, Christina Yuin. Appreciation is also extended to Beverly Adams, Rüdiger Trautsch and Marvin J. Taylor, Fales Library & Special Collections, New York University.

1 *New Wave Vaudeville Show*, 8, 9, 15 and 16 November as well as unknown additional dates in December 1978. Held in the Polish Army Veterans of America's hall (known as Irving Plaza) on Irving Place, New York City.

2 From the opera *Samson et Dalila* by Charles-Camille Saint-Saëns, premiered 1877.

3 Ironically, the 1970s disco group Village People was comprised of homosexual stereotypes, but not all members were gay.

4 Created by Delaunay for Tristan Tzara's play *Cœur à gaz*.

5 Susan Sontag, 'Notes on Camp,' *Partisan Review* XXXI (Fall 1964).

6 The *Klaus Nomi Show* members morphed over the years, but core original multi-tasking associates included performers Joey Arias, Janus Budde, Tony Frere, Adrian Richards, Kenny Scharf, Ruben Toledo, and musicians George Elliott, Kristian Hoffman, Joe Katz, Man Parrish and Page Wood. Oskar Schlemmer designed and choreographed *Das Triadische Ballet*

(*The Triadic Ballet*) over several years and premiered the completed work in 1922.

7 'What Power art thou, who from below...' from the opera *King Arthur* by Henry Purcell (composer) and John Dryden (librettist), premiered 1691. *Klassic-Rock-Nacht* presented by Eberhard Schoener conducting the Orchester des Bayerischen Rundfunks, Munich.

Embraced by the (Spot)Light: Ōno Kazuo, Butō and *Admiring Argentina*
Bruce Baird

1 Steven Heine and Charles Wei-hsun Fu, 'From "The Beautiful" to "The Dubious": Japanese Traditionalism, Modernism, Postmodernism', *Japan in Traditional and Postmodern Perspectives* (Albany, NY: 1995), p. x.

2 Sally Banes, 'Is It All Postmodern?', *TDR*, vol.36, no.1 (Spring 1992), pp. 58–61; and Roger Copeland, 'Is it Post-Postmodern?', *TDR*, vol.36, no.1 (Spring 1992), pp. 64–7.

3 Kazuko Kuniyoshi, 'Ankoku butō tōjō zenya: Ōno Kazuo sakuhin "Rōjin to umi" kara mita 1959 nen' ['The Eve of the Birth of Butō: 1959 from the vantage point of Ōno Kazuo's *Old Man and the Sea*'], *Choreologia*, no.31 (2008), pp. 22–33.

4 Nario Gōda, '"Hijikata butō": sakuhin notto' ['"Hijikata's Butō": Notes on the Performances'], *Asubesutokan Tsûshin*, vol.6 (January 1988), pp. 40–6.

5 K. Ohno, Y. Ohno and T. Mizohata, *Kazuo Ohno's World: from Without and Within* (Wesleyan, CT: 2004), p. 150.

6 Lucia Schwellinger, *Die Entstehung des Butoh* [*The Emergence of Butoh*] (Munich: 1998), p. 153.

7 Jennifer Dunning, 'The Dance: Kazuo Ohno', *The New York Times*, 31 July 1981.

8 Homi K. Bhabha, 'Postmodernism/Postcolonialism', *Critical Terms for Art History* (Chicago: 1996), pp. 319–20.

9 Bhabha, 'Postmodernism/Postcolonialism', p. 321.

Fashion, Violence and Hyperreality
Rebecca Arnold

1 'Guy Bourdin: Obituary', *The New York Times* (7 April 1991).

2 'The Sexes: Really Socking It to Women', *Time* (7 February 1977).

3 *The Eyes of Laura Mars*, dir. Irvin Kershner, 1978.

4 *The Eyes of Laura Mars* featurette, 1978, available at www.youtube.com/watch?v=aKQG4h2qt7E (March 2010).

Big Magazines: Design as the Message
Rick Poynor

1 Steven Heller, 'Culture Tabloids', *Design Literacy: Understanding Graphic Design* (New York, 2nd edn: 2004), pp. 126–9. See also Steven Heller, *Merz to Emigre and Beyond: Avant-Garde Magazine Design of the Twentieth Century* (London and New York: 2003).

2 See Paul Hefting and Dirk van Ginkel, *Hard Werken > Inízio: From Cultural Oasis to Multimedia* (Rotterdam: 1995).

3 Jane Kosstrin, Terence Main and David Sterling, 'Editorial', *Fetish* 2 (Fall 1980), p. 4.

4 See William Owen, *Magazine Design* (London: 1991).

5 Robert Venturi, *Complexity and Contradiction in Architecture* (London: 1977), p. 16.

6 Nigel Wheale (ed.), *The Postmodern Arts: An Introductory Reader* (London and New York: 1995), p. 120.

7 Helene Silverman, 'Design o' the Times', *i-D* 35, no.2 (March/April 1988), p. 51.

8 Steven Heller, 'The Shock is Gone', *i-D* 35, no.2 (March/April 1988), p. 63.

9 Joseph Giovannini, 'A Zero Degree of Graphics', in Mildred Friedman and Phil Freshman (eds), *Graphic Design in America: A Visual Language History* (Minneapolis, MN and New York: 1989), p. 202.

10 See Rudy VanderLans and Zuzana Licko with Mary E. Gray, *Emigre: Graphic Design into the Digital Realm* (New York: 1993) and *Emigre No. 70, The Look Back Issue: Selections from Emigre Magazine #1–#69, 1984-2009* (Berkeley, CA: 2009).

11 'Massimo Vignelli vs. Ed Benguiat (Sort Of)', *Print* XLV:V (September/October 1991), p. 91.

Between Words and Images: Simulation, Deconstruction and Postmodern Photography
Paul Jobling

1 Jean Baudrillard, 'The Ecstasy of Communication' (1983), in Hal Foster (ed.), *Postmodern Culture* (London: 1985), p. 130.

2 Jean Baudrillard, *Simulacra and Simulations*, trans. S.F. Glaser (Ann Arbor, MI: 1994), p. 2.

3 Judith Williamson, 'Images of "Woman"', *Screen* 24 (November 1983), p. 102: 'The image suggests that there is a particular kind of femininity in the *woman* we see, whereas in fact the femininity is in the image itself, it *is* the image.'

4 Baudrillard, *Simulacra and Simulations*, p. 4.

5 Dick Hebdige, 'The Bottom Line on Planet One – Squaring Up to The Face', *Ten.8*, no.19 (1985), p. 41.

6 Hebdige, 'The Bottom Line on Planet One', p. 47.

7 Hebdige, 'The Bottom Line on Planet One', p. 41.

8 'Strategies for the Unemployed' appeared in *The Face*, January 1986. See also 'Tyneside', *Picture Post* (17 December 1938), with photographs by Humphrey Spender; and 'Enough of all this!', *Picture Post* (1 April 1939), with photographs by Bill Brandt.

9 The following works by Jacques Derrida are instrumental texts concerned with deconstruction: *'Speech and Phenomena' and Other Essays on Husserl's Theory of Signs* (1967), trans. D.B. Allison (Evanston, ILL: 1973); *Writing and Difference* (1967), trans. Alan Bass (London: 1978); *Of Grammatology* (1967), trans. Gayatri Chakravortry Spivak (Baltimore: 1976); *Positions* (1972), trans. Alan Bass (London: 1981); *Dissemination* (1972), trans. Barbara

Johnson (London: 1981); and *Margins of Philosophy* (1972), trans. Alan Bass (Chicago: 1982).

10 Derrida, *Positions*, p. 27.

11 Christopher Norris, *Derrida* (London: 1987), p. 84.

12 Cindy Sherman, quoted from BBC, *Arena* (1993), 'Cindy Sherman: There's Nobody Here But Me'.

13 Michel Foucault, *Discipline and Punish, the Birth of the Prison*, trans. A. Sheridan (New York: 1977), p. 187.

14 Jacques Derrida, 'Signature, Event, Context' in *Glyph* 1 (Baltimore: 1977), pp. 162–254.

David McDiarmid, Peter Tully and the Ecstatic Space of the Paradise Garage
Sally Gray

1 Tully returned to Sydney from New York in late 1980 and McDiarmid in late 1987. Tully was Mardi Gras artistic director from 1982 to 1986 and McDiarmid from 1988 to 1990.

2 David McDiarmid, interviewed by Carmela Baranowska, 1992 [no date], transcript in McDiarmid estate papers, State Library of New South Wales, Sydney.

3 This description is based on my own experience of being a female (and Feminist) dancer in the almost all-male environment of the Paradise Garage between 1979 and 1984. All my visits to the club were in the company of McDiarmid, or McDiarmid and Tully and others. For firsthand accounts from other dancers, see Josell Ramos (dir.), *Maestro* DVD, one hour 17 minutes, Sanctuary (New York: 2005).

4 Tully, in John McPhee, *Peter Tully: Urban Tribalwear and Beyond* (Canberra: 1991).

5 *Urban Tribalwear* was the title of Tully's 1981 exhibition at the Crafts Council of Australia Gallery, Sydney and *Urban Tribalwear and Beyond* was a retrospective exhibition of Tully's work, curated by John McPhee, at the National Gallery of Australia, 1991. The posters for these, and Tully's other exhibitions, were designed by McDiarmid.

6 Tully, in McPhee, *Peter Tully*, n.p.

7 Personal communication with artist Ron Smith (Gay and Lesbian Mardi Gras artistic director, 1986–8), February 2010, Sydney.

Michael Graves and the Figurative Impulse
Christopher Wilk

1 *Five Architects, Eisenman, Graves, Gwathmey, Hejduk, Meier* (New York: 1972).

2 E-mail interview with Michael Graves, 2 July 2010.

3 Surveys of this strand of postmodern historicism include Charles Jencks, *Post-Modernism, the New Classicism in Design* (London: 1987) and Robert A.M. Stern, *Modern Classicism* (London: 1988).

4 Michael Graves, 'A Case for Figurative Architecture', in Karen Wheeler, Peter Arnell and Ted Bickford (eds), *Michael Graves 1966–1981* (New York: 1982), pp. 11–13. Unless otherwise noted, all quotations in this essay come from these pages.

5 Among the literature on the figurative in architecture is Christian Norberg-Schulz, *The Concept of Dwelling* (New York: 1985), *passim* and especially chapter VI, where he draws on Martin Heidegger's use of the word 'figure' in 'The Origin of the Work of Art', published in *Poetry, Language, Thought* (New York: 1971, edition cited), pp. 63–4. See also Norberg-Schulz's essay, 'Michael Graves and the Language of Architecture', in Karen Vogel Nicholas, Patrick J. Burke and Caroline Hancock (eds), *Michael Graves Buildings and Projects 1982–1989* (Princeton, NJ: 1990), pp. 6–14.

6 Linguistic metaphors abound in Graves' writing. In 'A Case for Figurative Architecture' (see n.4), he refers to 'elements … used in a slang version' (p. 11), to 'a larger, external natural text within the building narrative' or to 'the full text or language of the architecture' (p. 12).

7 The last quotation in this sentence comes from Michael Graves, 'Thoughts on Furniture', in *Furniture by Architects* (Cambridge, MA: 1981), n.p.

8 Ibid.

9 E-mail interview with Michael Graves, 2 July 2010. This is the source for all following quotations.

**Riding the Wave of Reaganomics:
Swid Powell and the Celebrity Architects**
Elizabeth A. Fleming

1 Peter F. Drucker, *Innovation and Entrepreneurship: Practice and Principles* (New York: 1985), pp. 1, 3, 9, 11, 35.

2 Drucker, *Innovation and Entrepreneurship*, 222–3, 95, 100; Swid Powell Design, Swid Powell Design General Correspondence File 83030, Richard Meier & Partners, New York, NY; Robert A.M. Stern, interview with author, New York, NY, 1 February 2000.

3 Agenda, Swid Powell Design Creative Board Design Review, 18 January 1983; Notes, 15 February 1983; and Agenda, Swid Powell Creative Board Design Review, 5 April 1983, Swid Powell Design General Correspondence File 83030, Richard Meier & Partners, New York, NY. The original agendas from those first design review meetings also include Meier's handwritten notes from the sessions. Robert A.M. Stern, interview with author, New York, NY, 1 February 2000. Although Swid Powell never retailed plates designed by Gehry, the company worked with him as early as November 1984 to develop a pattern, which incorporated sketches of fish. Swid Powell produced the plates in prototype only. See Frank Gehry, Swid Powell Archive, Collection of Nan Swid, New York, NY.

4 Richard Meier, interview with author, New York, NY, 20 August 2001; Robert A.M. Stern, interview with author, New York, NY, 1 February 2000.

5 Haynes Johnson, *Sleepwalking Through History: America in the Reagan Years* (New York: 1991), pp. 13–14, 139–92, 215–44, 372–407; Bruce J. Schulman, *The Seventies, The Great Shift in American Culture, Society, and Politics* (New York: 2001), 218–54; 'The Year of the Yuppie', *Newsweek* (31 December 1984); Marissa Piesman and Marilee Hartley, *The Yuppie Handbook* (New York: 1984), 39 as cited in Schulman, *The Seventies*, 244. For a related discussion of the consumption and social function of designer status symbols, see Peter Dormer, *The Meanings of Modern Design, Towards the Twenty-first Century* (London: 1990), pp. 116–41.

6 James A. Revson, 'Architects Dish it Out', *Newsday* (5 June 1984), 5; Barbara Plumb, 'Big-Name Architects Create Exciting Table Accessories', *Vogue* (October 1984), 510.

7 Gross Sales, Run Date 1/15/90, Swid Powell Archive.

8 As quoted in Johnson, *Sleepwalking Through History*, 442; ibid., 438–52.

9 Gross Sales, Run Date 1/15/90, Swid Powell Archive; Lisa Gubernick, 'Step 1: Go to Lunch', *Forbes*, 9 July 1990, 104; Suzanne Slesin, 'Architects Show How to Set a Grand Table', *The New York Times* (29 November 1990), C6.

10 The Architects' Collection premiered at the downtown Urban Architecture Design Gallery, located at 575 Broadway, in December 1990. The Peter Joseph Gallery, a newly launched gallery at 745 Fifth Avenue specializing in art-furniture, exhibited the collection from May through June 1991. Stanley Tigerman, interview with author, Chicago, 28 August 2001.

**Margaret Thatcher, Postmodernism and the
Politics of Design in Britain**
Jonathan M. Woodham

1 Many thousands of documents – speeches, interviews, writings and seminars – are archived on the Margaret Thatcher Foundation website (www.margaretthatcher.org) (May 2010).

2 The COID was renamed the Design Council in 1972. Paul Reilly was appointed as Director of the COID/ Design Council from 1959 to 1977.

3 Quoted from a speech given by Mrs Thatcher at the Schools Design Prize presentation at the Institute of Civil Engineers, London, on 19 December 1981.

4 For example, the Society of Industrial Artists, which in 1963 became the Society of Industrial Artists and Designers and was renamed the Chartered Society of Designers in 1986.

5 G.R. Barnes, 'For the Alert and Receptive Listener', *Radio Times* (29 September 1946), p. 5.

6 D. LeMahieu, *A Culture for Democracy: Mass Communication and the Cultivated Mind in Britain between the Wars* (Oxford: 1988).

7 Margaret Thatcher, 'Product Design and Market Success', *Engineering* (May 1992).

8 Paul Reilly, 'The Challenge of Pop', *Architectural Review* (October 1967), pp. 255–7.

9 This euphemism for privatization was used, inter alia, at the Lord Mayor's Banquet, London, and 10 November 1986.

10 See n.4.

11 Other initiatives include the national 1983 Design for Profit campaign, run through the Department of Trade & Industry (DTI), and the Design Council/DTI report on *Policies and Priorities for Design* (1984).

12 Andrew Brighton, 'Thatcher's Artists', *Oxford Art Journal*, vol.22, no.2 (1999), p. 132.

13 Margaret Thatcher, interview for TV-am with David Frost, TV-am Studios, Camden Lock, London, 7 June 1985. The Design Council had also emphasized the importance of small-scale entrepreneurship in the 1981 exhibition *Small Firms Big Business*.

14 Catherine McDermott, *Street Style* (London: 1987).

15 Frederique Huygen, *British Design: Image and Identity* (London: 1989).

16 Rick Poynor, 'Punk, pageantry and the British designer', *Blueprint* 86 (April 1989), p. 10.

17 Bridget Wilkins, 'Culture Shock', *Graphics World* 78 (May–June 1989), p. 43ff.

18 Jonathan Glancey, 'Carry on Designing and Plundering', *Independent* (March 1989), p. 39.

19 Lucy Young, 'Flying the Flag in Rotterdam', *Design* 485 (May 1989), pp. 18–19.

**Always Already Postmodern? Japanese Design
and Architecture in the 1980s**
Sarah Teasley

1 Kazuhiro Ishii, 'Japanese Modernism Today', *The Japan Architect*, April 1981, p. 5. The *sukiya* style is derived from teahouse architecture, but was also used in other residential buildings in early modern Japan.

2 Kenzo Tange, 'Expressing the Mature Communications Society – Tange', *The Japan Architect*, no.8311 (December 1983), pp. 8-12.

3 Shozo Baba, 'Prematurely Posthumous', *The Japan Architect*, no.294 (October 1981), p. 5.

4 For 'techno-orientalism', see David Morley and Kevin Robins, 'Techno-Orientalism: Japan Panic', *Spaces of Identity: Global Media, Electronic Landscapes and Cultural Boundaries* (London: 1995) and Toshiya Ueno, 'Japanimation and Techno-Orientalism: Japan as the Sub-Empire of Signs', in *Documentary Box*, vol.9, no.1 (1996), online at http://www.yidff.jp/docbox/9/box9-1-e.html. Other important contemporary criticism of Japan as 'information society' includes Hiroshi Kashiwagi's essays in *Kapuseru-ka jidai no dezain* [*Design in the Era of Capsulization*] (Tokyo: 1988) and *Dogu to media no shakaigaku* [*The Sociology of Tools and Media*] (Tokyo: 1989), and Shunya Yoshimi, *Toshi no doramaturugi* [*The Dramaturgy of the City*] (Tokyo: 1987).

5 The relationship between postmodernism and politics in Japan is discussed in a number of essays in Masao Miyoshi and H. D. Harootunian (eds), *Postmodernism and Japan* (Durham: 1989). Most chapters first appeared as articles in Japanese in the contemporary thought journal *Gendai shiso*, vol.15, no.12 (December 1987), then in English in the *South Atlantic Quarterly*, vol.87, no.3 (Summer 1988). See also Akira Asada, *Kozo to chikara* [*Structure and Power*] (Tokyo: 1983).

6 Andrew Gordon, *A Modern History of Japan: From Tokugawa Times to the Present* (Oxford and New York: 2003), pp. 298–9.

7 Arata Isozaki, 'Of City, Nation and Style', *The Japan Architect*, no.321 (January 1984), pp. 8–13.

8 Ibid., p. 12.

9 'News Gallery', *The Japan Architect*, no.326 (June 1984), p. 4.

10 For travelling architects, see Ken Tadashi Oshima, *Constructing Kokusai Kenchiku: International Architecture in Interwar Japan* (Seattle: 2009).

Coming Up for Air: 1980s Spanish Style Cultures
Viviana Narotzky

1 See Ventura Pons' 1978 film *Ocaña, Retrato Intermitente*.

2 Marshall Berman, *All That Is Solid Melts Into Air*, 1982 (New York: 1988, 2nd edn), p. 231.

3 Pedro Almodóvar's early films included *Pepi, Luci, Bom y Otras Chicas del Montón* (1980), *Laberinto de pasiones* (1982), *Entre tinieblas* (1983) and *¿Qué he hecho yo para merecer esto?* (1984).

Furniture Out of its Mind: Düsseldorf, 1986
Wolfgang Schepers

1 Wolfgang Schepers, 'Designsammlung im Aufbau', in *Kunstmuseum Düsseldorf, Führer durch die Sammlungen* [*Kunstmuseum Dusseldorf Collection Guide*] (1986), p. 124.

2 Quoted from Volker Albus, Christian Borngräber, Design-Bilanz, *Neues Deutsches Design der 80er Jahre in Objekten, Bildern, Daten und Texten* [*New German Design of the 1980s, in Objects, Images, Dates and Texts* (Cologne: 1992), pp. 260–1.

3 See also my contribution to the catalogue for *Gefühlscollagen – Wohnen von Sinnen* [*Emotional Collage: Furniture Out of its Mind*] (Cologne: 1986).

4 Monika Zimmermann in the *Frankfurter Allgemeine Zeitung*, cited in Albus et al., *Neues Deutsches Design der 80er Jahre*, p. 69.

5 Dorothee Müller in the *Süddeutsche Zeitung*, cited in Albus et al., *Neues Deutsches Design der 80er Jahre*, pp. 69–70.

6 Andrea Branzi and François Burkhardt, *Neues Europäisches Design* [*New European Design*] (Berlin: 1991).

True Stories : A Film about People Like Us
Rick Poynor

1 Fredric Jameson, *Postmodernism, or, The Cultural Logic of Late Capitalism* (London: 1991), pp. 287–96.

2 See John Howell, *David Byrne* (New York: 1992), Sytze Steenstra, *We are the Noise between Stations: A philosophical exploration of the work of David Byrne, at the crossroads of popular media, conceptual art, and performance theatre* (Maastricht: 2003) and Sytze Steenstra, *Song and Circumstance: The Work of David Byrne from Talking Heads to the Present* (New York and London: 2010).

3 Mat Snow, 'A Talking Head's Guide to the Big Country', *New Musical Express* (6 September 1986), p. 27.

4 Dick Hebdige, *Hiding in the Light: On Images and Things* (London and New York: 1988), p. 240.

5 David Byrne, *True Stories* (London: 1986), p. 18.

6 Robin Denselow, 'Talk of the Truth', *Guardian* (16 September 1986).

No Duchamps in Delhi
Arindam Dutta

1 For greater detail on 1990s Britain, see Arindam Dutta, 'Marginality and MetaEngineering', in Arindam Dutta, Timothy Hyde and Daniel M. Abramson (eds), *Governing By Design* (in progress).

2 See Jorge Otero-Pailos, *Architecture's Historical Turn: Phenomenology and the Rise of the Postmodern* (Minneapolis, MN: 2010).

3 Jürgen Habermas, 'Modernity versus Postmodernity', in *New German Critique*, no.22 (Winter 1981) p. 5. See this entire issue for a discussion on the relationship between tradition and postmodernism.

4 Fredric Jameson, 'Third-World Literature in the Era of Multinational Capitalism', *Social Text*, no.15 (Autumn 1986), p. 69.

5 '... pluralist aesthetes of the First World are, willy-nilly, participants in the production of an exploitative society ... [They] follow the necessities and contingencies of what [they see] as [their] historical moment. There is a convenient colloquial name for that as well: pragmatism. Thus his emotions at [the subjection of the Third World] are mixed: sorrow (theory) and joy (practice). Correspondingly, we grieve for our Third-World sisters; we grieve and rejoice that they must lose themselves and become as much like us as possible in order to be "free," we congratulate ourselves on our specialists' knowledge of them.' Gayatri Chakravorty Spivak, foreword to her translation of Mahasweta Devi's 'Draupadi', in *In Other Worlds: Essays in Cultural Politics* (New York: 1987), p. 179.

6 The Festivals of India were initiated and partially hosted by the Indian government initially in Britain, followed by similar events in France, the USA, Japan and the USSR. They comprised both an itinerant set of shows as well as events originated by institutions in these countries. The scale of the Festivals was immense: the USA version, for instance, included more than a hundred events organized by museums, libraries and universities across the country coinciding with the events hosted by the Indian government.

7 Philip Johnson, letter to Wilton S. Dillon, Director, Office of Smithsonian Symposia and Seminars, dated 14 February 1985, Box titled 'Fund Raising', Smithsonian Institution Archives, Accession Number 01-114, Box 5 of 24.

8 For a more extensive discussion on the concept of 'use' in the history of design, see Arindam Dutta, 'Design: On the Global (R)Uses of a Word', in *Design and Culture*, vol.1, issue 2 (2009).

9 Steven Holt, 'Collaborations', *iD* magazine (November/ December 1985), p. 33.

10 See Rajeev Sethi, 'A Draft Proposal for the Golden Eye follow-up', Smithsonian Institution Archives, Accession number 01-114, Record Unit 532, Box 30 of 32.

11 IMF: the International Monetary Fund. 'Conditionalities' are conditions extracted from sovereign countries soliciting IMF loans to cut down on government spending and subsidies.

Post-Modernism Comes of Age
Charles Jencks

1 As the reader will find, I keep the hyphenated post-modernism current from the 1970s through the 1980s to keep the emphasis on pluralism, evident in such mixed identities as Anglo-Irish, Black-American etc. Also the hyphen gives equal acknowledgement to parent and offspring. The streamlined version, postmodernism, stems from the French and academic usage that became more common in the 1990s, but I find that a bit too modern, and totalizing.

2 For many evolutionary trees and discussion, see my 'Architectural Evolution' in Mark Garcia (ed.), *The Diagrams of Architecture* (London and New York: 2010), pp. 288–309.

With the exception of the essay by Bruce Baird, all Japanese names are given according to western convention, with the given name preceding family name.

SELECT BIBLIOGRAPHY

A

Agger, Ben, *The Virtual Self: A Contemporary Sociology* (Hoboken, NJ: 2003)

Ahearn, Charlie and Fricke, Jim (eds), *Yes Yes Y'all: The Experience Music Project Oral History of Hip-Hop's First Decade* (Cambridge, MA: 2002)

Anderson, Perry, *The Origins of Postmodernity* (London: 1998)

Arakawa, Shusaku et al., *Europalia 89, Japan in Belgium* (Brussels: 1989)

Arnold, Rebecca, *Fashion, Desire and Anxiety: Image and Morality in the Twentieth Century* (London: 2001)

Ash, Juliet and Wilson, Elizabeth (eds), *Chic Thrills: A Fashion Reader* (London: 1992)

B

Baird, George and Jencks, Charles, *Meaning in Architecture* (New York: 1969)

Barnard, M., 'Fashion, Clothing and Postmodernity', in M. Barnard, *Fashion as Communication* (London: 1996)

Barr, Marleen S., *Envisioning the Future: Science Fiction and the Next Millennium*, (Middletown, CT: 2003)

Barrie, Dennis, *Surface and Ornament*, exhib. cat., Contemporary Arts Center, Cincinnati (Cincinnati: 1986)

Basar, Shumon and Trüby, Stefan, *The World of Madelon Vriesendorp* (London: 2008)

Baudrillard, Jean, *Simulacra and Simulation* (Ann Arbor, MI: 1994)

Bell, David, *Introduction to Cybercultures* (London: 2001)

Berger, A.A. (ed.), *The Postmodern Presence: Readings on Postmodernism in American Culture and Society* (Walnut Creek, CA: 1998)

Berger, Maurice (ed.), *Postmodernism: A Virtual Discussion* (Santa Fe: 2003)

Blake, Peter, *Form Follows Fiasco: Why Modern Architecture Hasn't Worked* (Boston: 1974)

Bloomer, K.C., Moore, C. and Yudell, R.J., *Body, Memory and Architecture* (New Haven, CT: 1977)

Branzi, Andrea, *Aldo Cibic: Designer* (Milan: 1999)

Branzi, Andrea, *Il Design Italiano, 1964–1990* (Milan: 1996)

Branzi, Andrea, *Learning from Milan: Design and the Second Modernity* (Cambridge, MA: 1988)

Branzi, Andrea, *The Hot House: Italian New Wave Design* (London: 1984)

Branzi, Andrea and Burkhardt, François (eds), *Neues Europäisches Design* (Berlin: 1991)

Branzi, Andrea and Muschamp, Herbert, *Ettore Sottsass: The Architecture and Design of Sottsass Associates* (New York: 1999)

Branzi, Andrea and Branzi, Nicoletta, *Domestic Animals: The Neoprimitive Style* (Cambridge, MA: 1987)

Branzi, A., Marzano, S. and Mendini, A., *Television at the Crossroads* (London: 1995)

Brownlee, D. B., Delong, D. G. and Hiesinger, K. B., *Out of the Ordinary: Robert Venturi, Denise Scott Brown and Associates*, exhib. cat., Philadelphia Museum of Art (Philadelphia, PA: 2001)

Buck, Alex and Vogt, Matthias (eds), *Michael Graves* (Berlin: 1994)

Burkhardt, François and Morozzi, Cristina, *Andrea Branzi* (Paris: 1997)

Burnham, Jack, *Software*, exhib. cat., Jewish Museum, New York (New York: 1970)

Buruma, Ian, *Behind the Mask: On Sexual Demons, Sacred Mothers, Transvestites, Gangsters, and Other Japanese Cultural Heroes* (New York: 1984)

Butler, Judith, 'Contingent Foundations: Feminism and the Question of 'Postmodernism'', in Judith Butler and Joan W. Scott (eds), *Feminists Theorize the Political* (London: 1992)

C

Callinicos, Anthony, *Against Postmodernism* (Oxford: 1989)

Castells, Manuel (ed.), *High Technology, Space and Society* (Beverly Hills, CA: 1985)

Castells, Manuel, *Rise of the Network Society* (Hoboken, NJ: 1996)

Cerny, Charlene and Seriff, Suzanne K. (eds), *Recycled, Re-seen: Folk Art from the Global Scrap Heap*, exhib. cat., Santa Fe Folk Art Museum (Santa Fe, NM: 1996)

Chambers, Iain, *Urban Rhythms: Pop Music and Popular Culture* (London: 1985)

Clammer, John, *Postmodernism and Japan* (Durham: 1989)

Coleridge, Nicholas, *The Fashion Conspiracy: A Remarkable Journey Through the Empires of Fashion* (London: 1988)

Collins, Michael, and Papadakis, Andreas, *Post-Modern Design* (New York: 1989)

Colomina, Beatriz, *Sexuality and Space* (New York: 1992)

D

Davidson, Cynthia (ed.), *Robert A. M. Stern: Architecture at the Edge of Postmodernism, Collected Essays 1965–1988* (New Haven, CT: 2009)

Davis, Douglas A., *Art and the Future: A History/Prophecy of the Collaboration Between Science, Technology and Art* (New York: 1973)

Davis, Fred, *Fashion, Culture and Identity* (Chicago: 1992)

Davis, Mike, 'Urban Renaissance and the Spirit of Postmodernism', in *New Left Review* 151 (1985), p. 112

Davis, Mike, *City of Quartz: Excavating the Future in Los Angeles* (London: 2006)

Dent-Coad, Emma, *Spanish Design and Architecture* (London: 1990)

Dertouzos, Michael L. (ed.), *The Computer Age: A Twenty-Year View* (Cambridge, MA: 1979)

Dietz, Matthias and Mönninger, Michael, *Japan Design* (Cologne: 1992)

Drexler, Arthur (ed.), *The Architecture of the Ecole des Beaux-Arts* (New York: 1977)

Driskell, David C. (ed.), *African American Visual Aesthetics: A Postmodernist View* (Washington, DC: 1995)

Drucker, Johanna, *Sweet Dreams: Contemporary Art and Complicity* (Chicago: 2005)

Dyens, Oliver, *Metal and Flesh: The Evolution of Man* (Cambridge, MA: 2001)

E

Earle, J., Katzumie, M. and Jean-Pierre, *Japan Style*, exhib. cat., Victoria and Albert Museum/Japan Foundation/Kodansha International, London (London: 1980)

F

Featherstone, Mike, *Consumer Culture and Postmodernism* (London: 1991)

Featherstone, Mike, *Undoing Culture: Globalization, Postmodernism and Identity* (London: 1995)

Felski, Rita, *Doing Time: Feminist Theory and Postmodern Culture* (New York: 2000)

Fischer, Volker (ed.), *Design Now: Industry or Art?* (London: 1989)

Foster, Hal (ed.), *The Anti-Aesthetic: Essays on Postmodern Culture* (Port Townsend, WA: 1983)

Francis, Richard and Nanjo, Fumio, *A Cabinet of Signs: Contemporary Art From Post-Modern Japan*, exhib. cat., Tate Liverpool (Liverpool: 1991)

Friedman, Dan (ed.), *Dan Friedman: Radical Modernism* (New Haven, CT: 1994)

Frith, Simon, *Sound Effects: Youth, Leisure, and the Politics of Rock* (London: 1983)

G

Gates, Henry Louis Jr (ed.), *'Race', Writing and Difference* (Chicago: 1985)

Graham, Elaine L. (ed.), *Representations of the Post/Human* (Piscataway, NJ: 2002)

Greiman, April, *Hybrid Imagery: The Fusion of Technology and Graphic Design* (New York: 1990)

Griswold del Castillo, R., McKenna, T. and Yarbro-Bejarano, Y. (eds), *Chicano Art: Resistance and Affirmation, 1965–1985* (Los Angeles: 1991)

Goude, Jean-Paul and Hayes, Harold (eds), *Jungle Fever* (New York: 1981)

H

Hagströmer, Denise, *Swedish Design* (Stockholm: 2001)

Hall, Stuart, *Representation: Cultural Representation and Signifying Practices* (London: 1997)

Haraway, Donna, *Simians, Cyborgs and Women: The Reinvention of Nature* (New York: 1991)

Harrod, Tanya, *The Crafts in Britain in the Twentieth Century* (London and New Haven, CT: 1999)

Harvey, David, *The Condition of Postmodernity* (Cambridge, MA: 1990)

Hayles, Katherine N., *How We Became Posthuman* (Chicago, 1999)

Hays, Michael K. (ed.), *Architecture Theory Since 1968* (New York: 1998)

Hebdige, Dick, *Subculture: The Meaning of Style* (London: 1979)

Hebdige, Dick, *Hiding in the Light: On Images and Things* (London and New York: 1988)

Hiesinger, Kathryn B. and Fischer, Felice, *Japanese Design: A Survey Since 1950*, exhib. cat., Philadelphia Museum of Art (Philadelphia, PA: 1994)

Holborn, Mark, *Beyond Japan: A Photo Theatre* (London: 1991)

Hutcheson, Linda, 'The Politics of Postmodernism: Parody and History', in *Cultural Critique* 5 (Winter 1986/87), pp. 179–207.

Huxtable, Ada Louise, *The Tall Building Artistically Reconsidered: The Search for a Skyscraper Style* (New York: 1984)

Huyssen, Andreas, *After the Great Divide: Modernism, Mass Culture, Postmodernism* (Bloomington, IN: 1986)

I

Isozaki, Arata, *The Island Nation Aesthetic* (London: 1996)

Isozaki, Arata and Tadashi Oshima, Ken, *Arata Isozaki* (New York: 2009)

J

Jacobson, Linda (ed.), *Cyber Arts: Exploring Art and Technology* (San Francisco: 1992)

Jameson, Fredric, 'Architecture and the Critique of Ideology', in Joan Ockman (ed.), *Architecture, Criticism, Ideology* (Princeton, NJ: 1985), pp. 51–87

Jameson, Fredric, *Postmodernism, or, The Cultural Logic of Late Capitalism* (Durham, NC: 1991)

Jencks, Charles, *The Language of Post-Modern Architecture* (New York: 1977)

Jencks, Charles, *Symbolic Architecture* (London: 1985)

Jencks, Charles (ed.), *The Post-Modern Reader* (London: 1992)

Jencks, Charles, and Baird, George, *Meaning in Architecture* (London: 1969)

Jencks, Charles, and Silver, Nathan, *Adhocism: The Case for Improvisation* (London: 1972)

K

Kaplan, E. Ann (ed.), *Postmodernism and Its Discontents* (New York: 1988)

Kawamura, Yuniya, *The Japanese Revolution in Paris Fashion* (Oxford: 2004)

Keim, Kevin P. (ed.), *An Architectural Life: Memoirs and Memories of Charles W. Moore* (Boston: 1996)

Keim, Kevin P. (ed.), *You Have to Pay for the Public Life: Selected Essays of Charles W. Moore* (Cambridge, MA: 2001)

Klotz, Heinrich, *Moderne und Postmoderne: Architektur der Gegenwart, 1960–1980* (Braunschweig: 1984)

Koda, Harold, 'Rei Kawakubo and the Aesthetic of Poverty', in *Dress* 11 (1985), pp. 5–10

Koolhaas, Rem, *Delirious New York: A Retroactive Manifesto for Manhattan* (London: 1978)

Koren, Leonard, *New Fashion Japan* (Tokyo: 1984)

Koselleck, Reinhart and Tribe, Keith (trans.), *Futures Past: On the Semantics of Historical Time* (Cambridge, MA: 1985)

Krier, Leon, 'Forward Comrades, We Must Go Back', in *Oppositions* 24 (Spring 1981), pp. 26–37

Kumar, Krishan, *From Post-Industrial to Post-Modern Society: New Theories of the Contemporary World* (Oxford: 1995)

L

Larson, Magali Sarfatti, *Behind the Postmodern Façade: Architectural Change in Late Twentieth Century America* (Berkeley, CA: 1993)

Lemert, Charles, *Postmodernism Is Not What You Think* (Hoboken, NJ: 1997)

Lipsitz, George, *Dangerous Crossroads: Popular Music, Postmodernism and the Politics of Place* (New York: 1994)

Lyotard, Jean-François, *The Postmodern Condition: A Report on Knowledge* (Minneapolis, MN: 1979)

M

Madsen, Deborah L., *Postmodernism: A Bibliography, 1926 –1994* (Amsterdam: 1995)

Malossi, Giannino (ed.), *Volare: The Icon of Italy in Global Pop Culture* (New York: 1999)

Marcus, Greil, *Lipstick Traces: A Secret History of the Twentieth Century* (Cambridge, MA: 1989)

Martin, Reinhold, *Utopia's Ghost: Architecture and Postmodernism, Again* (Minneapolis: 2010)

McCoy, Katherine and McCoy, Michael, et al., *The New Cranbrook Design Discourse* (New York: 1990)

McLeod, Mary, 'Everyday and "Other" Spaces', in D. Coleman, E. Danze and C. Henderson (eds), *Architecture and Feminism* (New York: 1996)

Miyoshi, Masao and Harootunian, Harry (eds), *Postmodernism and Japan* (Durham: 1989)

Muggleton, David, *Inside Subculture: The Meaning of Style* (Oxford: 2000)

N

Newman, Charles, *The Post-Modern Aura: The Act of Fiction in an Age of Inflation* (Evanston, IL: 1985)

O

Otero-Pailos, Jorge, *Architecture's Historical Turn: Phenomenology and the Rise of the Postmodern* (Minneapolis and London: 2010)

P

Papadakis, Andreas C. (ed.), *Architectural Design: The New Classicism in Architecture and Urbanism*, vol.58, 1/2 (1988)

Papadakis, Andreas C. (ed.), *Art & Design: The Post-Modern Object*, vol.3, 3/4 (1987)

Papadakis, Andreas C. (ed.), *Architectural Design: Deconstruction in Architecture*, vol.58, 3/4 (1988)

Papadakis, Andreas C. (ed.), *Art & Design: The New Modernism: Deconstructionist Tendencies in Art*, vol.4, 3/4 (1988)

Powell, Kenneth, *Graves Residence* (London: 1995)

Poynor, Rick, *No More Rules: Graphic Design and Postmodernism* (London: 2003)

R

Radice, Barbara, *Memphis: Research, Experiences, Results, Failures and Successes of New Design* (New York: 1984; London: 1985)

Radice, Barbara, *Jewelry by Architects: From the Collection of Cleto Munari* (New York: 1987)

Radice, Barbara, *Ettore Sottsass: A Critical Biography* (London: 1993)

Reichardt, Jasia, *Cybernetic Serendipity*, exhib. cat., Institute of Contemporary Arts, London (London: 1968)

Rowe, Colin, *The Mathematics of the Ideal Villa, and Other Essays* (Cambridge, MA: 1976)

S

Sante, Luc, *Low Life: Lures and Snares of Old New York* (New York: 1991)

Schmidt Campbell, Mary (ed.), *Tradition and Conflict: Images of a Turbulent Decade, 1963–1973* (New York: 1985)

Scott Brown, *Denise, Having Words* (London: 2009)

Shields, Rob (ed.), *Lifestyle Shopping: The Subject of Consumption* (London: 1992)

Skov, Lise, 'Fashion Trends: Japonisme and Postmodernism', in John Whittier Treat (ed.), *Contemporary Japan and Popular Culture* (Richmond, VA: 1996)

Skov, Lise and Moeran, Brian (eds), *Women, Media and Consumption in Japan* (Richmond, VA: 1995)

Sparke, Penny, *Japanese Design* (London: 1987)

Sparke, Penny, *Italian Design: From 1988 to the Present* (London: 1988)

Spiller, Neil, *Cyber Reader* (London: 2002)

Sudjic, Deyan, *Rei Kawakubo and Comme des Garçons* (London and New York: 1990)

Sudjic, Deyan, *Ron Arad* (London: 2001)

T

Tenner, Edward, *Our Own Devices: The Past and Future of Body Technology* (New York: 2003)

Thompson, Michael, *Rubbish Theory* (Oxford: 1979)

Tobin, Joseph (ed.), *Re-Made in Japan* (New Haven, CT: 1992)

Turner, Bryan, *Orientalism, Postmodernism and Globalism* (London: 1994)

V

Vanderlans, R., Licko, Z., Gray, M.E. and Keedy, J., *Emigre: Graphic Design Into the Digital Realm* (New York: 1993)

Venturi, Robert, *Complexity and Contradiction in Architecture* (New York: 1966)

Venturi, Robert, '*A bas* Postmodernism, Of Course', *Architecture* 90 (May 2001), pp. 154–7

Venturi, Robert, Scott Brown, Denise, and Izenour, Steven, *Learning from Las Vegas* (Cambridge, MA and London: 1972)

Vinegar, Aron, and Golec, Michael, *Relearning from Las Vegas* (Minneapolis: 2008)

W

Wallace, Michele, 'Modernism, Postmodernism, and the Problem of the Visual in Afro-American Culture', in R. Ferguson, M. Gever, T. T. Minh-ha and C. West (eds), *Out There: Marginalization and Contemporary Cultures* (Cambridge, MA: 1990)

White, Hayden, *Metahistory: The Historical Imagination in Nineteenth-Century Europe* (Baltimore, MD: 1973)

White, Hayden, *Tropics of Discourse: Essays In Literary Criticism* (Baltimore, MD: 1978)

White, Hayden, *Figural Realism: Studies in the Mimesis Effect* (Baltimore, MD: 1999)

White, Nicola, *Reconstructing Italian Fashion* (Oxford: 2000)

Wilcox, Claire (ed.), *Radical Fashion* (London: 2001)

Wolfe, Tom, *Kandy-Kolored Tangerine-Flake Streamline Baby* (New York: 1965)

Wolfe, Tom, *From Bauhaus to Our House* (New York: 1981)

CONTRIBUTORS

Glenn Adamson
Glenn Adamson is Head of Course at the V&A for the V&A/RCA MA course in the History of Design. He is co-editor of the *Journal of Modern Craft*, and the author of *Thinking Through Craft* (2007) and *The Craft Reader* (2009). His other publications include *Industrial Strength Design: How Brooks Stevens Shaped Your World* (2003).

Jane Pavitt
Jane Pavitt is Dean of Humanities and Head of the History of Design Department at the Royal College of Art. Her work focuses on design since 1945, and particularly on strategies for presenting design through museum exhibitions and collections. She has curated a number of design exhibitions for the V&A including *Brand.New* (2002), *Brilliant* (2004) and *Cold War Modern: Design 1945–1970* (2008).

Essays by

Paola Antonelli
Paola Antonelli is Senior Curator in the Department of Architecture and Design at the Museum of Modern Art (MoMA), New York. Formerly lecturer at University of California, Los Angeles, she has contributed to many publications, including *Domus*, *Abitare* and the *Harvard Design Review*.

Rebecca Arnold
Rebecca Arnold is Oak Foundation Lecturer in the History of Dress and Textiles at the Courtauld Institute of Art, London, where she runs an MA course in the History of Dress. She has lectured internationally and published widely on twentieth-century and contemporary fashion. Her written work includes *Fashion, Desire & Anxiety: Image and Morality in the Twentieth Century* (2001), *The American Look: Fashion, Sportswear and the Image of Women in 1930s and 1940s New York* and *Fashion: A Very Short Introduction* (both 2009).

Bruce Baird
Bruce Baird teaches Japanese theatre, cinema and philosophy at the University of Massachusetts Amherst. His book, *Hijikata Tatsumi and Butoh*, will be published in 2011.

Christopher Breward
Christopher Breward is Head of the Research Department at the V&A. He completed his postgraduate study on the V&A/RCA MA course in the History of Design and has held lecturing posts in the History of Art and Design at Manchester Metropolitan University and the Royal College of Art. Before working at the V&A he was Head of Research at London College of Fashion, University of the Arts London, where he holds a Visiting Professorship. His personal research interests lie in fashion history, and he has published widely on fashion's relation to masculinity, metropolitan cultures and concepts of modernity.

Victor Buchli
Victor Buchli is Reader in Material Culture at University College London. He is the author of a number of publications including *An Archaeology of Socialism* (1999), *Archaeologies of the Contemporary Past* (2001, with Gavin Lucas) and *The Material Culture Reader* (2002). He is also a founding and managing editor of *Home Cultures*, the interdisciplinary journal for the study of the domestic sphere.

David Crowley
David Crowley is Professor and Head of the Department of Critical Writing in Art & Design at the Royal College of Art, London.

Mari Dumett
Mari Dumett received her Ph.D. from Boston University, and is currently the Luther Gregg Sullivan Fellow in Art History at Wesleyan University, Connecticut. She researches modern and contemporary art, with a particular focus on post-1945 international performance and video. She is currently writing a book about the artists' collective Fluxus entitled *Corporate Imaginations: Fluxus Strategies for Living*, and recently curated the exhibition *George Maciunas* at the Contemporary Art Museum, St. Louis.

Arindam Dutta
Arindam Dutta is Associate Professor of Architectural History at the Massachusetts Institute of Technology. He is the author of *The Bureaucracy of Beauty: Design in the Age of its Global Reproducibility* (2007). He is currently at work on a book on art, activism and India's turn towards neo-liberalism in the 1990s.

Sujatha Fernandes
Sujatha Fernandes is an Assistant Professor of Sociology at Queens College and the Graduate Center of the City University of New York. She is the author of *Cuba Represent! Cuban Arts, State Power, and the Making of New Revolutionary Cultures* (2006) and *Who Can Stop the Drums? Urban Social Movements in Chávez's Venezuela* (2010). Her upcoming memoir, *Close to the Edge: In Search of the Global Hip Hop Generation* will be published in Autumn 2011.

Elizabeth A. Fleming
Elizabeth A. Fleming, President of Converse College in South Carolina, holds an MA in the History of Design from the V&A/RCA and a Ph.D. from Yale University. In the USA, she has worked with the Gibbes Museum of Art, Metropolitan Museum of Art, The Frick Collection, Yale University Art Gallery and the J. Paul Getty Trust, and in the UK with the V&A. She has taught at Parsons School of Design, New York.

Susanne K. Frantz
Susanne K. Frantz is an art historian and independent curator based in the USA, and is the former Curator of Twentieth-Century Glass at the Corning Museum of Glass. She is preparing a biography of Klaus Nomi.

Sally Gray
Sally Gray is an Australian Research Council Postdoctoral Fellow at the College of Fine Arts, University of New South Wales Sydney. Her current research is concerned with transnational aspects of style in the postmodern city.

Paul Greenhalgh
Paul Greenhalgh is Director of the Sainsbury Centre for the Visual Arts at the University of East Anglia. His former roles include those of Director and President of the Corcoran Gallery of Art, Washington D.C.; President of NSCAD University (Nova Scotia, Canada); and Head of Research at the V&A. His published work includes *Ephemeral Vistas* (1989), *Modernism in Design* (1990), *Art Nouveau* (2000), *The Persistence of Craft* (2005), *The Modern Ideal* (2005) and *Fair World* (2011).

April Greiman
April Greiman is a thinker, artist and designer who has been instrumental in the acceptance and use of advanced technology in the arts and the design process since the early 1980s. She has had solo exhibitions at the Pasadena Museum of California Art (2006) and the Visual Arts Gallery at the School of Visual Arts, New York (2008). Greiman studied at the Allgemeine Kunstgewerbeschule (General Arts Trade School) in Basel, Switzerland and the Kansas City Art Institute. She moved to Los Angeles in 1976, establishing her multi-disciplinary practice, currently called Made in Space.

Matthew Hawkins
Matthew Hawkins is a freelance dance artist with an international practice in choreography, performance and education. British-born and trained, he first attracted notice as a dancer with The Royal Ballet and soon after as a founder member of the Michael Clark Company. Subsequently he has gained recognition as an award-winning author of choreographic works in the UK and elsewhere.

Charles Jencks
Charles Jencks studied under the Modern architectural historians Siegfried Giedon and Reyner Banham. His early publications – *Meaning in Architecture* (1969, edited with George Baird), *Adhocism* (1972, edited with Nathan Silver) and *The Language of Post-Modern Architecture* (1977) – were instrumental in framing and initiating debate about Post-Modern design, building and urbanism. He has since published many other works on Late, Neo and Post-Modern architecture. Jencks now divides his time between lecturing, writing and building (notably gardens and sculpture).

Paul Jobling
Paul Jobling is a Senior Lecturer in the School of Humanities, University of Brighton. He is an internationally recognized expert in the history and theory of graphic design and photography since the nineteenth century, and has published widely on the intertextuality of word and image, issues of identity in advertising and fashion photography, magazine design and photo-documentary in Britain.

Ulrich Lehmann
Ulrich Lehmann is Research Professor at the University for the Creative Arts, Rochester (Kent). He studied philosophy, sociology, art history and modern languages in Frankfurt, Paris and London. His research interest is the history of modern material culture from the end of the eighteenth century to the present day.

Reinhold Martin

Reinhold Martin is Associate Professor of Architecture in the Graduate School of Architecture, Planning and Preservation at Columbia University, where he directs the Ph.D. programme in architecture, and Director of the Temple Hoyne Buell Center for the Study of American Architecture, Columbia. He is a founding co-editor of the journal *Grey Room* and author of *The Organizational Complex: Architecture, Media, and Corporate Space* (2003) and *Utopia's Ghost: Architecture and Postmodernism, Again* (2010).

Patricia A. Morton

Patricia Morton is Associate Professor of Architectural History at the University of California Riverside. Her publications include *Hybrid Modernities: Architecture and Representation at the 1931 International Colonial Exposition in Paris* (2000) and essays on race and gender issues in Modern architecture. Her current research includes projects on 'bad taste', popular culture and postmodern architecture, and on human geography and French colonial architecture.

Viviana Narotzky

Viviana Narotzky is President of ADI-FAD, the Industrial Design Association of Barcelona, and a Trustee of the Spanish Design History Foundation. She has been Director of the History of Design MA course at Kingston University, Senior Research Fellow at the Centre for the Study the Domestic Interior based at the Royal College of Art and Tutor on the RCA/V&A History of Design MA course. Her book *La Barcelona del Diseño* (2008) addresses design and architecture in the Catalan city from the 1960s.

Emmanuel Petit

Emmanuel Petit is an Associate Professor in the School of Architecture at Yale University. He is an architect from the Swiss Federal Institute of Technology in Zurich (Dipl.Arch. ETH), and he received his Ph.D. in the history and theory of architecture from Princeton University. He is editor of *Philip Johnson: The Constancy of Change* (2009); his forthcoming book is entitled *Irony, or, The Theoretical Opacity of Architecture.*

Rick Poynor

Rick Poynor is a writer, editor, lecturer and curator, specializing in design, media and visual culture. His most recent exhibition was *Uncanny: Surrealism and Graphic Design* (2010) at the Moravian Gallery in Brno, Czech Republic. His books include *Obey the Giant: Life in the Image World* (2001) and *No More Rules: Graphic Design and Postmodernism* (2003).

Catharine Rossi

Catharine Rossi recently completed her Ph.D. in the V&A/RCA History of Design department, with a thesis on the role of craft in post-war Italian design. She has published in *The Journal of Design History* and the *Journal of Modern Craft* and teaches at the University of Brighton.

Wolfgang Schepers

Wolfgang Schepers began working at the Kunstmuseum In Düsseldorf In 1980, acting as a Deputy Director from 1993 to 1998. Since 1999 he has been the Director of the Museum August Kestner in Hannover.

Denise Scott Brown

Denise Scott Brown is an architect, planner and urban designer, and a theorist, writer and educator, whose work and ideas have influenced architects and planners worldwide. Scott Brown participates in the broad range of Venturi, Scott Brown and Associates' projects in architecture and is principal-in-charge for many projects in urban planning, urban design and campus planning. *Having Words*, a selection of her writings, was published in 2009.

Martino Stierli

Martino Stierli is a Switzerland-based historian of modern art and architecture. He holds a Ph.D. from ETH Zurich, where he teaches at the Institute for the History and Theory of Architecture. Stierli is the author of *Las Vegas im Rückspiegel* (2010) as well as the co-curator of the international travelling exhibition *Las Vegas Studio: Images from the Archives of Robert Venturi and Denise Scott Brown* (2008–10).

Léa-Catherine Szacka

Léa-Catherine Szacka is an architect and architectural historian. Her Ph.D. thesis 'Exhibiting the Post-Modern: Three Narratives for a History of the 1980 Venice Architecture Biennale' is in preparation at the Bartlett School of Architecture, London.

Sarah Teasley

Sarah Teasley (Ph.D., University of Tokyo) is a design historian specializing in furniture, product and architectural design in Japan since the nineteenth century. Her publications include *20th Century Design History* (2005, with Chiharu Watabe) and *Global Design History* (2011, with Glenn Adamson and Giorgio Riello). She teaches on the V&A/RCA MA course in the History of Design, and in Critical and Historical Studies at the Royal College of Art.

Carol Tulloch

Carol Tulloch is a Reader at the CCW Graduate School, and a member of the Transnational Arts, Identity and Nation Research Centre (TrAIN), at the University of the Arts, London. She is also the TrAIN/V&A Fellow at the V&A Museum. Tulloch was the co-curator of the V&A exhibition *Black British Style* (2004) and has published and curated widely on the history of dress, visual and material culture.

Thomas Weaver

Thomas Weaver teaches at the Architectural Association School of Architecture in London and is also the editor of *AA Files*. He has previously taught architecture at Princeton University and the Cooper Union, New York, and edited *ANY* magazine in addition to numerous other architectural publications.

Zoe Whitley

Zoe Whitley is Curator of Contemporary Programmes at the V&A, and curated the museum's exhibition *Uncomfortable Truths* (2007). She holds an MA from the V&A/RCA course in the History of Design.

Claire Wilcox

Claire Wilcox is Senior Curator of Modern Fashion at the V&A. She devised *Fashion in Motion* (1999–2011) and curated the exhibitions *Satellites of Fashion* (Crafts Council, 1998), *Radical Fashion* (2001), *Versace at the V&A* (2002), *Vivienne Westwood* (2004) and *The Golden Age of Couture: Paris and London 1947–1957* (2007). Her published work includes *Modern Fashion in Detail* (1998), *Satellites of Fashion* (1998), *A Century of Bags* (1998), *Bags* (1999), *Radical Fashion* (2001), *The Art and Craft of Gianni Versace* (2002), *Vivienne Westwood* (2004) and *The Golden Age of Couture* (2007). She is a trustee of the Royal School of Needlework and on the editorial board of *Fashion Theory*.

Christopher Wilk

Christopher Wilk is Keeper of Furniture, Textiles and Fashion at the V&A. He came to the museum in 1988, and from 1996 until 2002 led the V&A team creating the British Galleries 1500–1900. He has published and lectured widely on modern furniture. His books include *Thonet: 150 Years of Furniture* (1981), *Marcel Breuer: Furniture & Interiors* (1981) and *Frank Lloyd Wright, the Kaufmann Office* (1993). He also contributed to and edited *Western Furniture, 1350 to the Present Day* (2001).

Oliver Winchester

Oliver Winchester is Assistant Curator on the V&A exhibition *Postmodernism: Style and Subversion, 1970–1990* (2011). He has worked in the Contemporary Team at the V&A, and at the Barbican Art Gallery, London.

James Wines

James Wines is founder and President of SITE, a New York-based architecture and environmental arts organization chartered in 1970. In this role, he leads a multi-disciplinary practice that includes buildings, public spaces, environmental art works, landscape designs, master plans, interiors, video productions, graphics and product designs. His book *De-Architecture* was published in 1987 and, during the past two decades, there have been 22 monographic books and museum catalogues published on his drawings, models and built works for SITE. He has designed more than 150 projects for private and municipal clients in 11 countries.

Jonathan M. Woodham

Jonathan Woodham has been Director of the Centre for Research & Development at the University of Brighton since 1998. He was made Professor of Design History in 1993 and, in the following year, played a key role in establishing the University of Brighton's Design Archives. He has been invited to lecture in 20 countries and has been a consultant internationally to many research councils, universities and museums. He has published over 100 books and articles, the most widely known of which are perhaps his *Twentieth Century Design* (1997) and the *Oxford Dictionary of Modern Design* (2004). The former has sold 45,000 copies worldwide.

Claire Zimmerman

Claire Zimmerman is Assistant Professor of Architecture and the History of Art at the University of Michigan. Her published work has explored the relationship between architecture and photography in the Weimar years and since. More recent projects concern the role of images in the growth of architectural ideas in the late twentieth century, and the importance of media representation in the increasingly globalized exchange of ideas about architectural modernity.

ACKNOWLEDGMENTS

Curating an exhibition on postmodernism is not something either of us undertook lightly. It is only thanks to the many friends and colleagues both inside and outside the V&A that we have made it through with our fascination with the subject intact (arguably, the most important qualification for such a project). We have received assistance of every kind: intellectual, practical and personal.

First and foremost, we would like to thank Oliver Winchester, the project's assistant curator, who was with us from the beginning and has shouldered much of the work all the way through. His contributions have been both extensive and crucial. An equally deep thanks goes to the rest of the core project team: Rosie Wanek and Sarah Gage, Exhibitions Department; cost consultants Sor Lan Tan and Keith Flemming; Tom Windross, our indefatigable publication editor; and our wonderfully inventive exhibition designers Carmody Groarke, graphics specialists at APFEL (A Practice for Every Day Life, who also designed this book), lighting designer David Atkinson (DALD), and Lol Sargent and Peter Key from our AV consultants Studio Simple. We also would like to thank all the contributing authors to this book – 39 strong – who have both informed our own understanding of the subject and added their own diverse perspectives.

Countless others at the V&A have also contributed hugely to the project. Space does not permit us to mention everyone, but we would particularly like to thank: Jo Ani, Sarah Armond, Jo Banham, Christopher Breward, Olivia Colling, Clare Davis, Mark Eastment, Richard Edgcumbe, Alice Evans, Nadine Fleischer, Catherine Flood, Alun Graves, Poppy Hollman, Elinor Hughes, Annabel Judd, Rebecca Lim, Linda Lloyd Jones, Leanne Manfredi, Beth McKillop, Roisin Morris, David Packer, Jana Scholze, Laura Sears, Daniel Slater, Abraham Thomas, Eric Turner, Rowan Watson, Claire Wilcox, Damien Whitmore, Christopher Wilk, Ghislaine Wood, Helen Woodfield and director Mark Jones.

We benefitted greatly from the assistance of several interns through the course of the project. We would like to recognize them all here, and thank them for their time and energy: Ana Baeza, Orianna Fregosi, Lauren Fried, Tiffany Jow, Serena Lambert, Sarah Maafi, Kasia Maciejowska, Alexandra Walker, Leanne Wierzba and Marilyn Zapf. Catharine Rossi not only contributed to this book, but in the course of her Ph.D research provided valuable assistance on Italy.

The V&A Research Department has been, as always, a fertile and stimulating environment in which to develop such a project, and we are grateful to our colleagues for their advice and support. We would like to thank our colleagues in the RCA/V&A History of Design Department for their continued support also, and the students of the course for their enthusiastic and critically minded responses to the subject. Jane Pavitt is indebted to the University of Brighton, and especially Anne Boddington and Jonathan Woodham, for supporting her research in the early phase of this project, during her long period of employment as the V&A/University of Brighton Research Fellow, until 2010.

The broader art and design community has also been remarkably generous in supporting our efforts. On behalf of everyone at the V&A, we would like to thank:

Jane Adlin (The Metropolitan Museum of Art, New York), Raj Ahuja, Laurie Anderson, Paola Antonelli (Museum of Modern Art, New York), Guido Antonello, Yoshiko Amiya (Arata Isozaki and Associates), Francesca Appiani, Paolo Arao (Robert Longo Studio, New York), Arendt Fox LLP., Joey Arias, Karole Armitage (Armitage Gone! Dance), Juliet Ash (RCA), Lucy Askew (Tate), Paul Astbury, Fred Baier, Paul Baines (Mute Records), Debbie Baker (Michael Graves Studio), Carole Barlot (Musée Collection of Theirry Mugler, Paris), Stefano Basilico, Martine Bedin, Marc Benda (Friedman Benda Gallery), Sylvia and Garry Knox Bennett, Barry Bergdoll (Museum of Modern Art, New York), David Benedict, Jonathan Bignell, Bruno Bischofberger, Graham Rains-Bird, Aude Bodet (Centre national des arts plastiques, Paris), Elizabeth Gomersall Bradley, Andrea Branzi, Chloé Braunstein, Josie Brown, Graziella Lonardi Buonotempo (Incontri Internaztionali d'Arte, Rome), Charles Carpinelli, Michael Clark, Shaun Cole, Garth Clark & Mark Delvecchio, Rebecca Cleman (Electronic Arts Intermix, New York), Nigel Coates, Rossella Colombari, Alice Cowling (Peter Saville Studio), Mark Crinson, David Crowley, Felicity Dale Scott, Emma Davies (Terry Farrell & Partners), Pierre Degen, Damian Delahunty, Matteo Devecchi (Devecchi Milano), Thimo de Duits (Museum Boijmans Van Beuningen, Rotterdam), Loles Duran (Estudio Mariscal, Barcelona), Peter Dunn, Jim Edwards (Michael Hoppen Gallery, London), Al Eiber, Jansen Emmons (Experience Music Project/ Seattle Science Fiction Museum), Caroline Evans, Djarel Ex (Museum Boijmans Van Beuningen, Rotterdam), Terry Farrell (Terry Farrell & Partners, London), Beatrice Felis (Atelier Mendini, Milan), Fulvio Ferrari, Felix Flury (Gallery SO, London), Dominique Forest

(Musée des Arts Décoratifs, Paris), Adrian Forty, Hélène de Franchis (Studio La Città, Verona), Barry Friedman, Paul Galloway (Museum of Modern Art New York), Vicki Gambill (Broad Art Foundation, Santa Monica, California), Howard Ganek, Frank O. Gehry, Anna Gili (Anna Gili Design Studio), Tara Goldsmid, Pamela Golbin (Musée des Arts Décoratifs, Paris), Rafael Gomes (Vivienne Westwood), John Gordon (Yale University Art Gallery), Paul Gorman, Jean Paul Goude, Alessandro Guerriero, Laurence Graff, April Greiman (Made in Space Inc.), Margherita Guccione (Architecture MAXXI, Rome), Lynn Gumpert (Grey Art Gallery, New York), Brad Hampton (Laurie Anderson Studio), Tanya Harrod, Paul Hartnett, Sarah Hasted (Hasted Hunt Gallery, New York), Matthew Hawkins, Kathryn Hiesinger, Philadelphia Museum of Art, Kurt Helfrich, Matthew Heller (Jerde Partnership International), Joanne Heyler (Broad Art Foundation), Charles Hind (RIBA), Ann Janss (Ken Price Studio), Amber Jeavons (Nigel Coates Studio), Charles Jencks, Jonathan Ross (Gallery 298, London), Keith Johnson (Urban Architecture, Inc.), Guy Julier, Peggy Kaplan (Ronald Feldman Fine Arts, Inc.), Daniela Karasová (Uměleckoprůmyslové Muzeum v Praze), Willem Kars, Kristina Kaufman (Parsons, The New School for Design, New York), Zerek Kempf (Steinbach Studio), Kilimanjaro Communications, Jenny Kloostra (Groninger Museum, Groningen), Dr. Helena Koenigsmarková (Uměleckoprůmyslové Muzeum v Praze), Kurt Koepfle (Pentagram, New York), Heather Kowalski (Andy Warhol Museum), Michael Krzyzanowski, Richard Lagrange (Centre national des arts plastiques, Paris), Virginie Laguens (Jean Paul Goude studio, Paris), Kieran Lancini (Madame Tussauds, London), Danny Lane, Denise M.C. Lee (SITE, New York), Loraine Leeson, Rachel and Jean-Pierre Lehmann, Barbara Lehmann (Cassina S.p.A.), Annie Lennox, Andrew Logan, Robert Longo, Matthew Lyons (Lehmann Collection, New York), Michele de Lucchi, Tristan Lund (Michael Hoppen Gallery, London), Adele Lutz, Martina Margetts, Caspar Martens, Reinhold Martin, Ray McCarville, Joe McDermott (Philadelphia Museum of Art), Carol McNicoll, Howard Meister, Alessandro Mendini (Atelier Mendini), Peter Miller (Bard Graduate Center, New York), Frédéric Migayrou (Centre Georges Pompidou), Toshio Mizohata (Kanta Incorporated), Celia Morrissette, Emilio Paolo Moronni, Jed Morse (Nasher Sculpture Center, Dallas, Texas), Ernest Mourmans (The Galerie Mourmans, Maastricht), David Muggleton, Alessandro Munari, Irena Murray, Marco Nocella (Ronald Feldman Fine Arts, Inc., New York), Amy Ogata (Bard Graduate Center, New York), Vaughan Oliver, Jorge Otero-Pailos, Alfred Pacquement (Musée national d'art moderne/Centre de création industrielle, Centre Georges Pompidou, Paris), Nathalie Du Pasquier, Gaetano Pesce, Ugo La Pietra, Michael Pilmer & the members of Devo, Jeff Pine, Pamela Popeson (Museum of Modern Art, New York), Rick Poynor, Mark B. Prizeman, Nicola Probert, Max Protetch and the Max Protetch Gallery, Josep Puig (Benedito Design, Sant Cugat del Vallès), Ivana Quilezová (Uměleckoprůmyslové Muzeum v Praze), Geraldine Ramphal, Zandra Rhodes, Simone Riva (CSAC-Universita Di Parma), Benjamin J. Rosenthal (Bard Graduate Center, New York), Cora Rosevear (Museum of Modern Art, New York), Timothy Rub (Philadelphia Museum of Art), Judy Rudoe (British Museum, London), Cinzia Ruggeri, Cathie Sacho, Ben Saltzman (Michael Graves & Associates), Piero Sartogo, Peter Saville, Paula Scher, Frank Schreiner (Stiletto Design Supplier), Ellen van Schuylenburch, Chloe Seddon (Michael Clark Company), Peter and Donna Shire, Nathan Silver, Gilbert and Lila Silverman, Melinda Simms (Experience Music Project/Seattle Science Fiction Museum), Susan Slepka Squires (Space Age Trust, Seattle), George J. Sowden (Sowden Design), Penny Sparke, Danielle Spencer (Todo Mundo Ltd., New York), Sara Stacey (SITE, New York), Valerie Steele (Fashion Institute of Technology, New York), Haim Steinbach, Nadine Stenke (Assistant to Ai Weiwei), Robert A. M. Stern, Jeremy Stick (Nasher Sculpture Center, Dallas, Texas), Joseph Strasser, Cindy Strauss (Museum of Fine Arts Houston), Shehnaz Suterwalla, Nigel Talamo, Sandra Tatsakis (Museum Boijmans Van Beuningen, Rotterdam), Marvin Taylor (Fales Library, New York), Sarah Teasley, Ann Temkin (Museum of Modern Art, New York), Elaine Tierney, Bobbye Tigerman (Los Angeles Museum of Contemporary Art), Daniel Tolson (Christie's), Venturi Scott Brown and Associates, Inc., Madelon Vriesendorp, Serena Vergano (Ricardo Bofill Taller de Arquitectura, Bareclona), Anna Wagner, Larry Warsh, Tom Weaver, Catherine Whalen, William Whitaker (The Architectural Archives of the University of Pennsylvania, Philadelphia), Elisabeth Whitelaw (CAAC The Pigozzi Collection, Paris), Gareth Williams, Tom Wilson (Design Museum, London), James Wines (SITE, New York), Inge Wolf (Deutsches Architekturmuseum, Frankfurt-am-Main), Bernice Wollmann Rubin and Warren Rubin, Gloria Wong, John Woodham (ABET Inc.), Nick Wright and Swati Shah.

And finally, to our families, especially Tim, Milo and Iris Burne and Peter, Joyce, David and Arthur Adamson. Space does not permit us to recognize everyone who has lent us assistance over the past four years. But we hope that all who contributed, in ways large and small, will take some pleasure from this publication and the exhibition that it accompanies. Postmodernism is a difficult thing to explain even under the best of circumstances; but at least, thanks to all who helped, those are exactly the circumstances we had.

LENDERS

The V&A is grateful to the individuals, institutions and collections
that have made this exhibition possible.

The Andrew Logan Museum of Sculpture, Berriew
Annie Lennox Collection, London
Arata Isozaki & Associates, Tokyo
The Architectural Archives of the University of Pennsylvania, Philadelphia
Joey Arias
Karole Armitage (Armitage Gone! Dance), New York
CAAC – The Pigozzi Collection, Geneva/Paris
Cassina Collection, Milan
Centre National des Arts Plastiques (CNAP), Paris
Centre Pompidou, Paris
Nigel Coates
Design Museum, Gent
Deustsche Architekturmuseum (DAM), Frankfurt-am-Main
Experience Music Project, Seattle
Jean-Paul Goude
Michael Graves & Associates, New Jersey
Jenny Holzer Studio, LLC, Hoosick Falls, New York
Charles Jencks
Jerde Partners Inc, Venice, California
Guy Julier
Madelon Koolhaas-Vriesendorp
Kunstmuseum Basel, Switzerland
Carol McNicoll
Metropolitan Museum of Art, New York
Meulensteen Gallery, New York
Museum Boijmans Van Beuningen, Rotterdam
Museum of Fine Arts, Houston, Texas
Museum of Modern Art, New York
Nasher Sculpture Center, Dallas, Texas
Vaughan Oliver
Ōno Kazuo Butoh Research Office, Shinagawa
Pentagram, New York
Philadelphia Museum of Art, Philadelphia
Michael Pilmer (Devo Obsesso), Raleigh, North Carolina
Rick Poynor
Rachel & Jean-Pierre Lehmann Collection, New York
Jonathan Ross Hologram Collection, London
Peter Saville
Berhard Schobinger (Gallery S O), London
Tate, London
Terry Farrell & Partners, London
Todo Mundo, New York
Uměleckoprůmyslové Muzeum v Praze (Museum of Decorative Arts), Prague
Venturi Scott Brown & Associates, Inc., Philadelphia
Vivienne Westwood Ltd, London
Vulcan Inc., Seattle
Larry Warsh
Nick Wright & Swati Shah
Yale University Art Gallery, New Haven

The Victoria and Albert Museum is also grateful to those lenders who
wish to remain anonymous.

PICTURE CREDITS

All images are © The Victoria and Albert Museum, London, except:

Acconci Studio, New York: pl. 115
Eredi Aldo Rossi. Courtesy Fondazione Aldo Rossi/Deutsches
 Architekturmuseum: pl. 16
Arcaid: pls 149 and 151–2
Architectural Archives of the University of Pennsylvania: pl. 120
Karole Armitage: pl. 185
Photograph by Robyn Beeche: pl. 158
Benedito Design: pl. 228
Blueprint Magazine: pl. 195
Bohuslav Horák Studio: pl. 6
Braunstein/Quay Gallery: pl. 125
Richard Bryant/Arcaid/Corbis: pl. 18
CAAC, Geneva – The Pigozzi Collection, Geneva: pls 109–10
Photograph by Robert Carra: pl. 163
Ceesepe: pl. 230
Chanel, Paris: pl. 82
Charles Moore Foundation: pl. 127
Photograph by Ole Christiansen: pl. 186
Christie's Images: pls 77 and 164
Cooper-Hewitt National Design Museum, New York/Scala, Florence: pls 242–3
Corbis: pls 9–10
Design Museum Gent: pl. 5
Detroit Institute of Art/Bridgeman Art Library: pls 210 and 238
Deutsches Architekturmuseum: pls 22–3
Peter Dunn and Loraine Leeson: pl. 76
Editoriale Domus S. p. A., Rozzano Milano (Italy), all rights reserved: pl. 38
Photograph by Arthur Elgort: pl. 156
Esto/Peter Aaron: pl. 209
Estudio Mariscal: pls 226 and 229
Experience Music Project, Seattle: pl. 173
Photograph by Deborah Feingold: pl. 250
Photograph by Mark Fiennes, Courtesy of Susan Grant Lewin: pl. 91
Foreign Office Architects/Peter Jeffree: pl. 246
Photography courtesy Frank Lloyd Gallery/Anthony Cunha: pl. 102
Friedman Benda, New York: pls 1–2 and 154
Gaetano Pesce Studio: pls 31–2
The Gallery Mourmans, The Netherlands: pl. 34
Getty Images: pls 177–9 and 225
Photograph by Addison Godel: pl. 20
Jean-Paul Goude: pls 4, 54–6
April Greiman: pls 218–21
Hans Haacke/VG Bild-Kunst: pl. 216
Bari Hahn: pl. 129
Michael Halsband/Landov, New York: pl. 183
Photograph by Lizzie Himmel: pl. 78
Atelier Hollein: pl. 140
Jenny Holzer Studio: pl. 249
IRE Productions/Kobal Collection: pl. 87
John Portman & Associates Archive: pls 85–6
Charles Jencks: pl. 26
Jonathan Ross Hologram Collection: pl. 63
Photograph by Kazumi Kurigami: pl. 222
Gary Knox Bennett: pl. 126
Jeff Koons: pls 80–81, 167
Kunstmuseum Düsseldorf: pl. 234
Otto Künzli: pl. 103
Ladd Company/Warner Brothers/Kobal Collection: pl. 61
Photograph by Kevin LaTona/Studio Sola: pl. 52
La Cittá Gallery, Verona: pl. 19
Ouka Leele: pl. 231
Photograph by Mike Laye/Image Access: pl. 169
Lehmann Maupin Gallery, New York: pl. 106
Levi Strauss & Co: pl. 201
Photograph by Peter Lindbergh: pl. 157
Photograph by Mark Lipson: pls 235–7
Photograph by Anastasia Loginova: pl. 247

James Mackay/LUMA: pls 168 and 170
Duccio Malagamba/RIBA Library Photographs Collection: pl. 245
Estate of Gordon Matta-Clark on deposit at the Canadian Centre for Architecture, Montreal
 © 2010 Estate of Gordon Matta-Clark/Artists Rights Society (ARS), New York, DACS,
 London: pl. 113
Photograph by Sara Maneiro: pls 180–81
Photograph by Robert Maxwell: pl. 136
The Estate of David McDiarmid, Courtesy of Sally Gray: pls 203 and 205–6
Norman McGrath: pls 128, 130 and 211
Atelier Mendini: pls 7, 40 and 105
Metropolitan Museum of Art, New York: pl. 88
Michael Graves & Associates: pls 207–8, 212 and 240
Michael Hoppen Gallery, London: pl. 192
Ahmed Mito/Studio Mito: pl. 108
Photograph by Michel Momy: pl. 159
Photograph by Jamie Morgan: pls 174–75
Museum Boijmans Van Beuningen, Rotterdam: pl. 43
Museum of Fine Arts, Houston/Gallery S O London: pl. 30
Museum of Fine Arts, Houston/Gijs Bakker: pl. 104
Museum of Modern Art, New York/Scala, Florence: pls 15, 21, 24 and 155
Museum of Modern Art, New York (Agnes Gund Purchase Fund)/Scala, Florence: pl. 198
Museum of Modern Art, New York (Jon Cross and Erica Staton, Digital Design Collection
 Project, Luna Imaging)/Scala, Florence © Eredi Aldo Rossi: pl. 17
Occhiomagico: pl. 50
Photograph by Vaughan Oliver: pl. 69
OMA, Rotterdam: pls 145–6
Ōno Kazuo Dance Studio: pl. 189
Pentagram: pl. 95
Peter Saville Studio: pls 66–7
Photograph by Gianni Pettena: pl. 114
Philadelphia Museum of Art, Philadelphia, PA/DACS, London: pl. 28
Collection Centre Pompidou, Dist. RMN/Georges Megeurditchian: pl. 165
Photograph by Paolo Portoghesi: pls 141–4
Powerhouse Museum, Sydney: pl. 204
Photograph by Sven Prinzler: pl. 153
Pritam & Eames: pl. 97
Private collection: pls 3, 13–14, 89 and 107
Rex Features: pl. 57
Robert Longo Studio and Metro Pictures: pl. 112
Ronald Feldman Fine Arts, New York: pls 147–8
Sakakura Associates: pl. 224
Photograph by Jordi Sarrá: pl. 227
Sartogo Architetti Associati: pl. 138
Ira Schneider: pl. 171
Photograph by Jacques Schumacher: pl. 79
Photograph by Craig Scott: pl. 27
Photograph by Jamel Shabazz: pl. 176
Cindy Sherman, Sprüth Magers Berlin, London, and Metro Pictures: pls 65 and 199
SITE: Architects, Artists, and Designers: pls 116–18
Photograph by Victoria Slater-Madert: pls 96 and 241
Photograph by Timothy Soar: pl. 123
Stiletto Design Studio: pl. 233
Studio Toshiyuki Kita: pl. 223
Tate Gallery, London/Robert Longo Studio, New York: pl. 111
Terry Farrell and Partners: pl. 217
Stanley Tigerman: pls 8, 132–4
Masanori Umeda: pl. 45
University of Oregon: pl. 137
Archives of the Venice Biennale: pl. 131
Venturi, Scott Brown & Associates, Inc.: pls 11, 12, 119, 121–2, 124 and 139
Photograph by Richard Waite: pl. 248
Photograph by Fred Whisker: pl. 187
Whitney Museum of American Art: pl. 172
Betty Woodman and Meulensteen Gallery, New York: pl. 98
Bill Woodrow: pl. 35
Photograph by Christina Yuin: pl. 182
Yale University Art Gallery: pls 213–15
Yale University Library: pl. 150

INDEX

WITHDRAWN

Books are to be returned on or before
the last date